always up to date

The law changes, but Nolo is on top of it! We offer several ways to make sure you and your Nolo products are up to date:

1 Nolo's Legal Updater

We'll send you an email whenever a new edition of this book is published! Sign up at **www.nolo.com/legalupdater**.

2 Updates @ Nolo.com

Check **www.nolo.com/update** to find recent changes in the law that affect the current edition of your book.

3 Nolo Customer Service

To make sure that this edition of the book is the most recent one, call us at **800-728-3555** and ask one of our friendly customer service representatives. Or find out at **www.nolo.com**.

please note

We believe accurate, plain-English legal information should help you solve many of your own legal problems. But this text is not a substitute for personalized advice from a knowledgeable lawyer. If you want the help of a trained professional—and we'll always point out situations in which we think that's a good idea—consult an attorney licensed to practice in your state.

NOLO

3rd edition

The Public Domain:

How to Find & Use Copyright-Free Writings, Music, Art & More

By Attorney Stephen Fishman

NOLO

Third Edition	MAY 2006
Editor	RICHARD STIM
Book Design	TERRI HEARSH
Production	MARGARET LIVINGSTON
Proofreading	ROBERT WELLS
Index	PATRICIA DEMINNA
Printing	DELTA PRINTING SOLUTIONS, INC.

Fishman, Stephen.
 The public domain : how to find & use copyright-free writings, music, art, & more/ by
Stephen Fishman -- 3rd ed.
 p. cm.
 Includes index.
 ISBN 1-4133-0454-0 (alk. paper)
 1. Public domain (Copyright law)--United States. I. Title.

KF3022.Z9F57 2006
346.7304'82--dc22

2005058980

For information on bulk purchases or corporate premium sales, please contact the Special Sales
Department. For academic sales or textbook adoptions, ask for Academic Sales. Call 800-955-4775
or write to Nolo, 950 Parker Street, Berkeley, CA 94710.

About Our Cover

Astrid plays an integral role at Guide Dogs for the Blind
(www.guidedogs.com)—her pups become loyal helpers
and confidence-boosters to visually impaired people.
In much the same way, Nolo books and software will
guide you step by step through the unfamiliar legal
tangles of life's big events.

Acknowledgments

Many thanks to all the folks at Nolo for their outstanding work, including Terri Hearsh, Richard Stim, Bob Wells, and Patricia Deminna.

Thanks also to the following people who generously contributed advice and/or information:

- Leslie Wildman
- Professor Emmy Werner
- Roger A. Sayles
- Eric Eldred
- Lynn Nagrani and all the other people at the Public Domain Information Project
- Joan Liffring-Zug Bourret of Penfield Press.

Finally, special thanks to Stanley Jacobsen, without whose indefatigable research assistance this book would never have been completed.

Table of Contents

8 Computer Software

9 Architecture

10 Maps

11 Choreography

12 Databases and Collections

17 The Internet and the Public Domain

18 Copyright Protection: How Long Does It Last?

19 Copyright Notice Requirements

20 Traps for the Unwary: Trademark and Publicity Rights

Appendixes

Index

Introduction to the Public Domain

Are you a screenwriter looking for a novel or story to adapt? A musician who needs a song to record? A filmmaker in need of footage? An author or publisher searching for photos, graphics, or illustrations for your latest project? A website operator in search of this type of content and more? If your answer to any of these questions is "yes," you could be in luck. The content you need may be free for the taking. It may lie in a land of creative riches known as the public domain. You just have to know how to recognize and find it. This book is a type of treasure map that shows you how.

A. What Is the Public Domain?

As used in this book, the words "public domain" mean creative works that for one reason or another are not protected by copyright law and are ordinarily free for all to use. There are literally billions of creative works—including books, artwork, photos, songs, movies, and more—in the public domain. All of these works, no matter what form they take, are called "works of authorship" or, more simply, "works."

Some of the most famous examples of public domain works that you can use in any way you choose are:

- *Hamlet*, by William Shakespeare
- *Moby Dick*, by Herman Melville, and
- The 5th Symphony by Ludwig van Beethoven.

1. Copyright and the Public Domain

To safely use public domain works, you must first know a little about copyright law, which is a federal law that protects all kinds of works of authorship including books, magazines, newspapers and other writings, music, art and sculpture, photography, films and videos, choreography, architecture, computer software, and maps.

The owner of a work protected by copyright is given a bundle of exclusive rights, including:

- reproduction rights—that is, the right to make copies of a protected work
- distribution rights—that is, the right to sell or otherwise distribute copies to the public
- the right to create adaptations (also known as "derivative works")—that is, the right to prepare new works based on the protected work, and
- performance and display rights—that is, the right to perform a protected work in public, such as a stageplay, or display a work in public.

If someone wrongfully uses material covered by a copyright, the owner can sue to obtain compensation for any losses suffered. In this sense, a copyright is a type of property—it belongs to its owner and the courts can be asked to punish anyone who uses it without permission.

However, copyright protection does not last forever, and some works are not entitled to any copyright protection at all.

When a work enters the public domain for any reason, the rights listed above do not apply. In other words, the work can be freely copied, distributed, adapted, or performed or displayed in public without asking anyone's permission or paying a fee. For example, you don't need to obtain permission to copy and distribute a play by Shakespeare, adapt it into a movie, or perform it in public. That is because Shakespeare's plays were first published so long ago that copyright law does not protect them.

"Public domain" means what it says— public domain works belong to the public as a whole. Anyone is free to use them any way they wish. No one can ever obtain copyright protection for public domain material. Once a work enters the public domain it usually stays there forever. (See Chapter 2 for a more detailed discussion of copyright law.)

2. What Is in the Public Domain?

A work of authorship may be in the public domain for a variety of reasons. For example:
- the work was published before there was a copyright law
- the work's copyright protection expired
- copyright protection was lost or never acquired for some reason
- the copyright owner dedicated the work to the public domain, or
- the work was never entitled to copyright protection.

A vast treasure trove of creative works are in the public domain for one or more of these reasons. They include many great classics of world art and literature, such as the works of Shakespeare, Dickens, Bach, and Beethoven. But the public domain does not just include dusty old books and other works published hundreds years ago.

All works published in the United States before 1923 are in the public domain. But there are also millions of works published as recently as 1963 that are in the U.S. public domain. Indeed, copyright experts estimate that 85% of all the works of authorship first published in the United States between 1922 and 1963 are in the public domain.

But the public domain does not end there. Even works published today with full copyright protection contain elements that are unprotected and, thus, in the public domain. This includes, for example, the facts and ideas contained in a work of nonfiction. Other newly published works are denied copyright protection completely, including U.S. government works and many blank forms.

3. How Can You Use the Public Domain?

The only limit on how you can use public domain materials is your own imagination. For example:
- Web developers can use the public domain as a free source of content,

including writings, photography, artwork, and music

- creative writers can adapt public domain works into new works—for example, create screenplays based on public domain novels, stories, and plays
- musicians can perform and record public domain music without paying permission fees
- publishers can freely republish public domain works
- artists can freely copy public domain artworks
- filmmakers can freely use public domain footage, and
- librarians can copy public domain works for their collections.

4. Why Have a Public Domain?

At first glance, the concept of the public domain may see unfair to creative people. After all, once a work enters the public domain, the author or his or her heirs can no longer collect royalties from sales of copies or otherwise profit from it. Why should this be?

The reason we have copyright laws is to encourage authors to create new works and thereby promote the progress of human knowledge. The encouragement takes the form of an economic incentive—authors are given a monopoly over the use of their works. By selling or licensing their rights they can earn a livelihood and create even more works. However, enriching authors is not the primary goal of copyright law. The primary goal is to foster the creation of new works that will one day enter the public domain where they can be freely used to enrich everyone's lives.

a. Our Intellectual Commons

Towns and cities of the 18th and 19th centuries often had a place called a commons: a centrally located unfenced area of grassland that was free for all to use. The public domain is, in essence, our intellectual and artistic commons. This commons benefits us all in a variety of ways:

- **New works are created from public domain materials.** Just a few famous examples include musicals such as *Les Miserables* (based on a public domain novel by Victor Hugo) and *West Side Story* (based on Shakespeare's *Romeo and Juliet*); the animated films *Snow White, Pinocchio, Beauty and the Beast,* and *The Little Mermaid*; and a recent spate of films based on the works of Shakespeare and Jane Austen. If the original works had remained under copyright, the cost of creating new versions of them may have been too high or they may not have been obtainable at any price.
- **Low-cost editions of public domain materials are available.** When a work enters the public domain, it often becomes available to the public in many low-cost editions. This is

possible because copyright owners do not get royalty payments. Also, anyone can publish a public domain work, so competitive pressures keep prices lower. For example, when F. Scott Fitzgerald's first novel, *This Side of Paradise*, entered the public domain in 1996 nine new editions were published by nine different publishers, some costing just a few dollars.

- **The public domain promotes artistic freedom.** When a work is protected by copyright, the owner has the legal right to restrict how it is used. Some copyright owners rigidly control new performances and other uses of well-known works. For example, the estate of the Irish playwright Samuel Beckett exercises complete control over the staging of his plays. It banned a production in Edinburgh, Scotland, of Beckett's classic play *Waiting for Godot* because the tramp characters were played by women. The Kurt Weill Foundation, which holds the copyrights on the late composer's music, prevented famed German cabaret singer Ute Lemper from transposing some Weill songs to a pitch that better suited her voice.

 The D'Oyly Carte Opera Company, which controlled the copyrights over the comic operettas of Gilbert and Sullivan, required every new production to be staged exactly the same as the original performance— not a note of music could be sung

differently. However, when Gilbert and Sullivan's work entered the public domain, this control ended. Gilbert and Sullivan operettas, and other great PD works, such as the works of Shakespeare and Beethoven, can be performed in new ways, given new interpretations and new meanings. This prevents classic works from becoming mummified.

- **Scholars and others may freely use public domain materials.** Scholars, researchers, historians, biographers, and others can freely quote and use public domain materials. This enriches their works and makes some projects possible that might otherwise be blocked by the copyright owners of important materials, often the descendants of famous people.

No one benefits more from the public domain than authors do. This is because new expression is not created from thin air. All authors draw on what has been created before. As one copyright expert has noted, "transformation is the essence of the authorship process. An author transforms her memories, experiences, inspirations, and influences into a new work. That work inevitably echoes expressive elements of prior works." Litman, "The Public Domain," 39 *Emory Law Journal* 965 (1990). Without the public domain, these echoes could not exist.

Transformation of *The Secret Garden*

Back in 1911, Frances Hodgson Burnett wrote a novel called *The Secret Garden*. It tells the story of Mary Lennox, a lonely girl sent to live with her uncle Archibald in Yorkshire after her parents died from a cholera epidemic in India. The novel became a children's classic, beloved by millions. Its U.S. copyright expired on January 1, 1987. Its copyright in most of the rest of the world expired in 1995, at which point anyone was free to use the novel without obtaining permission from the former copyright owner or paying any permission fees (which would be substantial for such a well-known novel). *The Secret Garden* has since been transformed in a variety of ways—here are just a few examples:

- a made-for-TV adaptation, *The Secret Garden*, starring Gennie James and Derek Jacobi (1987)
- a musical, *The Secret Garden*, music by Lucy Simon, book & lyrics by Marsha Norman (1991)
- a film adoption, *The Secret Garden*, starring Maggie Smith (1993)

- two sequels based on Burnett's characters, *Return to the Secret Garden* (1999) and *Back to the Secret Garden* (2001)
- a cookbook, *The Secret Garden Cookbook: Recipes Inspired by Frances Hodgson Burnett's the Secret Garden*, by Amy Cotler and others (1999)
- an electronic book version on a CD-ROM, *The Secret Garden* (1996)
- a BBC Playhouse Video, *The Secret Garden* (1988), and
- two audiobooks, *The Secret Garden*, read by Johanna Ward and *The Secret Garden* read by Josephine Bailey (2003).

If the original novel, *The Secret Garden*, were not in the public domain, it's unlikely that many of these projects could have been undertaken because the permission fees would have been too great or the copyright owners would not grant permission at any price. This is another example of how the public domain enriches us all.

b. The Public Domain Can Save You Money

On a more mundane level, the public domain can save you money. Copyright owners generally charge a fee for permission to use their works. Such permission fees can range from $100 or less to copy a photo or a few pages from a book to millions of dollars to adapt a work into a movie or play.

Copyright permission fees are unnecessary when a work is in the public domain (however, this doesn't mean that public domain works are always free; see Section A7). For example, to use a well-known Irving Berlin song such as "Blue Skies" in a television commercial, you might have to pay Berlin's heirs—the copyright owners of his songs—as much as $250,000. But you can use one of Berlin's many songs that have already entered the public domain—such as "Alexander's Ragtime Band"—for free.

But, you don't have to be a rich television or movie producer to take advantage of the public domain. Here are real-life examples of some projects by ordinary people that were made possible only because public domain materials were available:

- Leslie, a composer, set to music dozens of public domain poems by Emily Dickinson. Had the poems still been under copyright, her project would probably have been financially impossible, because permission fees to adapt the works of famous authors are often enormous.

- Mary Beth wanted to create an old-fashioned illustrated reading book for home-schooled children, but was daunted by how much the copyright holder wanted to charge for illustrations from schoolbooks discarded in the 1940s (but still under copyright). She used public domain illustration instead and saved the permission fee. Her book is now selling like hotcakes to others who home-school their children.

- Harvey invented a new kind of computer music playback system, but couldn't market it because the electronic media royalty on copyrighted songs is around $2,000 per song. So instead he found a bunch of public domain songs and paid no royalties at all.

- A local senior center wanted to put on a copyrighted musical, but the permission fee would have cost more than the gate receipts. They used a public domain musical instead and got to keep all the money.

- Palmer wanted to open a bookstore/cafe with live music to entertain the patrons. But he couldn't afford the music license fee charged by ASCAP, a songwriter's permission agency. So instead he found a variety of musicians who could play public domain music as well as their own compositions. His was the first of several public domain cafes and nightclubs that have done very well in Columbus, Ohio.

5. How Do You Know If a Work Is in the Public Domain?

The public domain has been aptly compared to "a vast national park without ... a guide for the lost traveler, and without clearly defined roads or even borders." (Krasilovsky, "Observations on the Public Domain," *Bulletin,* Copyright Society of USA.) This is because it can often be difficult to know whether a work is in the public domain.

Public domain materials don't look any different than works still protected by copyright. The fact that a work contains a copyright notice—the © followed by the publication date and copyright owner's name—does not necessarily mean it really is protected by copyright law; people often place notices on works that are actually in the public domain (see Chapter 2, Section B1). The absence of a copyright notice also does not necessarily mean a work is in the public domain.

There is no list or database of all the works that are in the public domain. It would be impossible to create one since so much material is in the public domain. Moreover, the U.S. Copyright Office, the federal agency that registers copyrights, will not tell you if a work is in the public domain. It's a waste of your time even to ask them.

You have to determine whether a work is in the public domain yourself by understanding and applying some basic copyright rules. Sometimes this is easy; sometimes it can be very difficult. This book is designed to walk you through the process. If this task is too daunting, you can hire an attorney or copyright expert to help you. (See Chapter 23 for tips on how to hire an attorney to help you.)

6. How Do You Find Public Domain Materials?

Public domain materials are everywhere. There are hundreds of public domain works in your local bookstore and even more in your local library. Millions of public domain works sit in archives and museums. There may even be some in your attic or basement. Many public domain works can be accessed through the Internet or private dealers. Each chapter of this book dealing with specific types of public domain works lists a variety of sources of public domain materials.

7. Are Public Domain Works Always Free?

The fact that a work is in the public domain does not necessarily mean that it is freely available for your use. Even though a work is in the public domain, the physical substance in which it is embodied— whether it be on paper, canvas, clay, film, or videotape—is usually still owned by somebody. The owner could be a library, archive, museum, private collector, or nearly anyone else.

The owner enjoys all the rights of any personal property owner. This means the owner may restrict or even deny public access to the work or charge for access or the right to make copies. This is usually not a problem for written works, which can be found in bookstores, libraries, and archives, but it is a problem for other types of works.

For example, museums and individual collectors usually control access to valuable works of art that are in the public domain. They often own all available photographs of such works. Getting permission to use such photographs or to take new ones can be difficult and expensive.

You may also have to pay fees to obtain access to and make use of public domain photographs, film, and music from collectors, private archives, and other sources.

B. Dealing With Public Domain Gray Areas

Following the step-by-step procedures in this book will help you determine whether a particular work you want to use is in the public domain. But often the answer will not be clear; the law can often be foggy. There may be questions about a particular work that are unanswerable. The law may not be clear or definitive on whether copyright or some other legal protection covers a particular work. Or someone may simply think that they own a copyright in a work when they really don't. Throughout

this book we highlight these uncertainties with an icon that looks like this:

These foggy areas are far more common than you might think. For example, problems may arise when someone makes a copy of a public domain work and changes it in some way. It can be hard to determine for certain whether or not the changes merit new copyright protection. If you apply the rules outlined in later chapters, you might decide that the work should not be protected. But the person who created the original work may not agree.

In another example, creators of digital copies of public domain photos might claim that the copies are protected by copyright (see Chapter 6, Section B5a.i). It's likely such claims are not legally valid, but we don't know for sure because there have been no definitive court rulings on the issue. If you use digital copies without permission, the company that made them may complain and perhaps even sue you for copyright infringement.

When faced with foggy areas, how should you proceed? If you think it's likely the work is in the public domain should you go ahead and use it, even if there is no definitive answer? Or should you treat the work as copyrighted and ask permission to use it? Should you consult a lawyer?

No book can tell you what to do in every real-world situation. However, we can show you when it is more or less likely someone

will complain or even sue you if you treat a work as in the public domain.

Whenever you see a fog icon in the text, you should first answer the following threshold question: Are you going to use the material to directly compete with someone's business? If so, you should consult an attorney, because these types of uses invite lawsuits. Here is one recent example of this problem:

At great expense, a company called the Bridgeman Art Library Ltd. obtained from several art museums the exclusive right to make and sell photographs of hundreds of public domain art masterpieces. Bridgeman licensed to the public both regular art photos and digital photos on CD-ROMS and through its website. A company called Corel Corp. obtained more than 150 images from the Bridgeman collection and published them without obtaining Bridgeman's permission. The images were included on clip-art CD-ROMs and placed on the Corel website where they could be downloaded for a few dollars each, far less than Bridgeman charged. Corel was directly competing with Bridgeman and costing it licensing fees. Bridgeman sued Corel, claiming the photos were copyrighted, even though the paintings they portrayed were in the public domain. Bridgeman ultimately lost its suit, but whether photos of public domain paintings are themselves in the public domain remains a gray area. *Bridgeman Art Library Ltd. v. Corel Corp.*, 25 F.Supp.2d 421 (S.D. N.Y. 1999); see Chapter 5, Section N2.

People and companies often get so upset about competitive uses that they file lawsuits even where the material involved is not especially valuable. For example, a company that published cookbooks and cooking magazines filed a copyright infringement lawsuit when a competitor copied and republished several yogurt recipes contained in a cookbook called *Discover Dannon—50 Fabulous Recipes With Yogurt*. The suit was ultimately lost. *Publications Int'l Ltd. v. Meredith Corp.*, 88 F.3d 473 (7th Cir. 1996).

If you do not intend to use the work to compete with someone's business, it might be relatively safe for you to treat it as being in the public domain. However, you should carefully consider the following two factors before deciding on what to do:

- the likelihood your use will be discovered, and
- the economic value of the material.

The smaller the chance of discovery, the more willing you should be to use materials whose public domain status is uncertain. Likewise, the lower the economic value of the materials, the safer it is for you to treat them as being in the public domain.

1. What Is the Likelihood of Discovery?

No one can complain about your using a work unless they know about it. People get in trouble using works they believe are in the public domain when they publish the

work or otherwise make it available to the general public—for example, by placing it on the Internet. Here is a recent example:

> **EXAMPLE:** Texas resident Peter Veeck placed a copy of the Denison, Tex., municipal code on his Web page. Veeck assumed the code was in the public domain because it was a government statute. However, it turned out that a private company called the Southern Building Code Congress International (SBCCI) had written the code. The company creates and sells model codes to local governments. SBCCI claimed that it owned the copyright in the code and demanded that Veeck remove it from his website. When he refused, SBCCI sued him for copyright infringement. Whether the private companies that create and sell these private codes can claim copyright in them is a public domain gray area (Veeck ultimately prevailed; see Chapter 3, Section C3b). However, it's likely that SBCCI would never have discovered that Veeck copied the code had he not placed it on the Internet, which is, of course, accessible to anyone with computer access.

The chances of discovery are virtually nil if you use a work for your personal use or make it available only to a restricted group of people. In the example above, SBCCI would never have discovered that Peter Veeck copied its code if he only used it for himself or a small group of friends.

Similarly, there is little risk of discovery if a piano teacher photocopies an arrangement of a musical work that may not be in the public domain; or if a choir director makes copies of a choral work for a local church chorus; or a teacher makes a few copies of a chapter from a book for a class.

Of course, people who use public domain materials do frequently want to publish them, place them on the Internet, or make them as widely available as possible. This doesn't necessarily mean that you can't use the material. But, if there are questions over the public domain status of a work, you should consider the economic value of the work.

2. How Valuable Is the Material?

If an individual or a company feels that you have cheated them out of a substantial permission or licensing fee, there is a good chance you'll receive a complaint or be sued if your use is discovered.

Examples of materials that were deemed valuable enough for someone to sue include:

- the famous children's novel *Bambi: A Life in the Woods*
- a published collection of about 150 works of classical music by such famous composers as Beethoven, Bach, Bartok, and Brahms
- a collection of thousands of copies of legal decisions by U.S. courts
- a database containing over 90 million residential and business phone

numbers that cost millions of dollars to compile

- a published book listing used car prices
- 150 photographs of public domain paintings by such masters as Rembrandt and DaVinci,
- Martin Luther King's "I Have a Dream" speech, and
- a *New Yorker* Magazine cartoon by Saul Steinberg.

On the other hand, complaints or lawsuits are far less likely where the work you want to use has little economic value. Many—probably most—public domain works fall into this category. It's often not worth the time and trouble to complain about works that are not worth much. And it certainly makes no financial sense to hire a lawyer and file a lawsuit over such a work. The damages that can be obtained if such a lawsuit is successful are just not large enough to justify the expense involved.

Even if someone does complain in these cases, you can probably resolve the complaint if you stop using the work or pay a nominal permission fee. Examples of public domain works that often have little economic value include old postcards, articles and books by obscure authors, artwork by unknown artists, and sheet music for long-forgotten popular songs. One way to tell if a gray-area work is valuable is to determine whether anyone is selling either the original or copies to the public. If not, the materials probably have little or no value.

C. What If Someone Challenges Your Public Domain Claim?

Sometimes, a person or company will claim that materials you have used are not in the public domain and that they, in fact, own the copyright in them.

Often in these cases you'll receive a letter from an attorney asking that you "cease and desist" from any further uses of the materials. You can find numerous examples of cease and desist letters at the website Chilling Effects Clearinghouse (www .chillingeffects.org). You should respond immediately that you have received the letter and are investigating the claims. Don't ignore such a letter. This will only make it more likely that you will be sued and help make you look like a "bad guy" to a judge or jury.

Library of Congress, Prints & Photographs Division, FSA-OWI Collection

1. Handling the Claim Yourself

You may be able to handle the claim yourself. This is particularly likely where the material isn't very valuable. If it is clear that the materials involved are in the public domain, you may be able to get the other side to drop its complaint by showing your documentation and explaining why the material is in fact in the public domain (see Section D below). Some people don't understand what public domain means, so you may have to explain this too (see Section A above).

If you have made a mistake and the materials are not in the public domain or they inhabit a gray area, you may be able to resolve the matter by offering to pay a small permission or licensing fee or stop using or distributing the work.

Obviously, you should seek to settle the complaint if the work you are using turns out to be protected by copyright. But, even if you think the claim is not valid, it may be cheaper and easier to settle than to fight.

EXAMPLE: Eric Eldred, a Massachusetts-based technical analyst, has digitally scanned and placed on his website copies of dozens of public domain works, including books by Nathaniel Hawthorne, Oliver Wendell Holmes, William Dean Howells, and Joseph Conrad. In one case, however, a museum's publishing department claimed that excerpts from a book on canoeing he placed on his site were not in the public domain and that it owned the copyright in the work. The museum asked him to remove the material from his website. Eldred was certain the material was in the public domain; nevertheless he agreed to the museum's demand. He says that "I decided to remove the book just because these public institutions complained that I was stealing their income."

2. Hiring a Lawyer

You should contact an attorney knowledgeable in copyright law if:

- you believe the claim is not valid and don't want to agree to the other side's demands, or
- the materials involved are highly valuable and any permission or licensing fee would be substantial, or
- the other side insists that you stop using the materials, but this would be impossible or very expensive for you to do—for example, you have used them in a book or film you've already distributed to the public.

Information about finding and evaluating an attorney is provided in Chapter 23.

D. Documenting Your Use of Public Domain Materials

It is important to document your research into the public domain status of every work

you plan to use, unless you plan to use it purely for your own private enjoyment. Any work that will be shown to the public in any way should be documented. This is because it is not uncommon for people and companies to make false claims of copyright ownership in public domain materials. Such people could threaten to sue you if they discover you've copied or otherwise used materials they claim to own. Also, if you need to obtain insurance for your project against libel, slander, or other errors or omissions, your documentation can help convince an insurer or broadcaster that they will not face any copyright problems.

We provide you with three aids to help you determine the public domain status of a work and document how you came to your conclusion. At the beginning of each chapter dealing with a particular type of creative work we include a chart showing how to determine the copyright status of a work. Next to the chart you will see a checklist. By following the step-by-step instructions on this checklist, you will be able to determine the copyright status of the particular work you are researching. We also include a worksheet (Appendix C) to document how you determined the status of a particular work, if you are ever challenged for using it (see the sample below).

You should create a permanent file for each work of authorship you plan to use. In the file you should include a completed checklist and worksheet, along with a narrative description of your research, if you feel it is necessary. You should also take the following steps:

- Keep the original work or a copy—for example, photographs, articles, sheet music. If this is not possible because the material is too big—for example, an entire book or can of film—you should attempt to keep a copy of the work in storage somewhere and make a notation in the worksheet where it is stored.

- If the work is in the public domain because the copyright has expired, include a photocopy of the work's copyright notice showing the date the work was published (also include a copy of the title page, if any).

- If the work is in the public domain because it's a U.S. government work, include a copy of the title page or other page showing it was created by or for the government.

- If the work has been dedicated to the public domain, include a copy of the public domain dedication.

- If you've conducted a copyright renewal search or had the U.S. Copyright Office or private search firm conduct one for you, keep a copy of the results.

- If you've sent email to anyone to confirm that material is in the public domain, print it out along with the responses you've received and keep the copies in your file.

- Keep any postal correspondence in this file as well.

1. Instructions for Using the Public Domain Documentation Worksheet

a. Type of Work

Insert the type of public domain work you're using—for example, photograph, graphic work, text, or sheet music.

b. Title

Insert the title of the work—for example, the title of the public domain article, novel, photograph, or artwork. If there is no title or the title is not available, create a title that helps to identify the work—for example, "Two children sitting in World War II rubble."

If you're using a work originally printed in another work—for example, a photograph within a book—insert that title as well. For works from magazines or journals, insert the title and volume or issue number.

c. Source

List where you got the work, whether a library, archive, private collection, bookstore, or other source. If the work is from a website, insert the URL (the location on the Internet where you find the work). This code usually looks something like this: www.nolo.com.

d. Author Name

Insert the name of the author (the person who created the work). The author may not be the same as the copyright owner. If no author is listed—for example, you're using a newspaper article without a byline, or the author is "anonymous" or uses a pseudonym —include that information.

e. Publisher's Name

Insert the name of the company that published the work. If no publisher is listed, say "unknown."

f. Identifying Numbers

Many works are identified by code numbers such as the ISBN, ISSN, LCCN, or Dewey Decimal number catalogue numbers for textual works. If the copyright registration number is available, list it here as well.

g. Date of Publication

If the work has been published, list the year here. If the date is not known, say "unknown." If the work is unpublished, say "unpublished."

h. Country of First Publication

If you know the country in which the work was first published, list it here. If you don't know, state "unknown." Leave this space blank if the work is unpublished.

Public Domain Documentation Worksheet

Type of Work _Sheet Music_

Title _Minute Waltz_

Source/Location _Piano Pieces the Whole World Plays_

Author _Frederic Chopin_

Publisher _D. Appleton and Company_

Identifying Numbers _Op. 64_

Date of Publication _1915_

Country of Publication _USA_

How the Work Is Used _Reproduced for piano students_

Reason Work Is in the Public Domain _Copyright expiration_

i. How the Work Is Used

Indicate where and how you will use the work. For example, if you're creating a book, insert the page number in the book in which the work is used; if the work will be used in a website, insert the page or URL.

j. Reason Work Is in the Public Domain

Insert the reason why the work is in the public domain, such as:

- the work is ineligible for copyright protection
- the work's copyright protection expired
- the work was published before 3/1/89 without a valid copyright notice
- the work was dedicated to the public domain.

E. How to Use This Book

This book can be used to determine the copyright status of a work already in your possession, or you can use it to learn what types of works are in the public domain in general. Either way, after reading this introduction, turn to Chapter 2, which provides a useful overview of copyright law and the ways many people are using and abusing the public domain.

Next, you should read the chapter covering the particular type of work you're interested in. Separate chapters cover:

- writings of all types (Chapter 3)
- music (Chapter 4)
- art (Chapter 5)
- photography (Chapter 6)
- film and television (Chapter 7)
- computer software (Chapter 8)
- architecture (Chapter 9)
- maps (Chapter 10)
- choreography (Chapter 11)
- compilations and collections (Chapter 12), and
- titles (Chapter 13).

If you are interested in general information about a particular form of creative work, you should begin by reading the chapter that focuses on that type of work. Each chapter begins with a chart showing the process of determining the public domain status of that type of work. If you have a specific work you are researching, you should use the checklist at the beginning of the chapters listed above. (Chapter 13 does not have a checklist or chart because the process of determining public domain status for titles is relatively easy.) By following the directions on these checklists, you will be directed to the proper chapters and sections in the book to answer the series of questions necessary to decide if a particular work is in the public domain.

Some legal rules are common to all types of creative works. These issues are dealt with in separate chapters and, where necessary, you will be instructed to read those chapters and answer the appropriate question on the checklist.

These include chapters on:

- works first published abroad (Chapter 15)
- how long copyright protection lasts (Chapter 18)
- where and how copyright notices must appear (Chapter 19), and
- legal problems involving trademarks and the right of publicity (Chapter 20).

It may be necessary for you to research Copyright Office records to determine whether many works are in the public domain, particularly those published during 1923-1963. Chapter 21 explains how to do this research.

You should always keep in mind that all the chapters listed above deal only with the public domain in the United States. Many works that are in the public domain in the United States are still protected by copyright outside the United States and vice versa. The public domain outside the United States is covered in Chapter 16.

If you determine that the work you want to use is not in the public domain, you might still be able to use it without permission because of a legal exception to copyright law called "fair use." See Chapter 22 for a detailed discussion of your alternatives when a work is not in the public domain.

Finally, additional legal resources are available in Chapter 23.

Icons Used in This Book

To aid you in using this book, we use the following icons:

 Guides you through the process of determining public domain status using checklists.

 The caution icon warns you of potential problems.

 This icon indicates that the information is a useful tip.

 This icon refers you to helpful books or other resources.

 This icon alerts you to uncertainty or conflicts in the law.

 This icon indicates when you should consider consulting an attorney or other expert.

 This icon refers you to a further discussion of the topic elsewhere in this book.

This icon lets you know when you can skip information that may not be relevant to your situation.

The Use and Abuse of Copyright

The legitimate use of copyright law protects the authors of creative works and allows them to profit from their work. Below we describe the general protections that copyright law provides. We also outline how people and companies unscrupulously abuse the public domain and claim copyright protection where none exists.

A. What Copyright Protects

The copyright law gives creators or owners of creative works the legal right to control how the works are used. This section provides an overview of the copyright law and introduces some important concepts that will appear again and again in later chapters.

For a detailed discussion of copyright law, refer to: *The Copyright Handbook: How to Protect & Use Written Works*, by Stephen Fishman (Nolo), or *Copyright Your Software*, by Stephen Fishman (Nolo).

1. Copyright Law: A Short History

The U.S. Constitution gives Congress the power to protect works of authorship by enacting copyright laws. But it is up to Congress to actually write the copyright laws and decide on the details of what should be protected and for how long. The first federal copyright law was enacted in 1790. The federal copyright laws have been amended many times since then. The last major revision occurred in 1976 when an entirely new copyright law called the Copyright Act of 1976 (18 U.S.C. Section 101 and following) was passed by Congress. This Act took effect in 1978. However, many of the basic copyright rules in effect under the law in existence before 1978 still apply to works that were published before that year. Time and again throughout this book you'll see that copyright rules differ for works published before and after 1978.

Like most laws, the copyright law is not perfectly crafted. Some of its provisions are ambiguous, poorly written, or simply don't cover every situation that arises in real life. When people get into disputes with each other about how to apply or interpret the copyright laws, it's ultimately up to the federal courts to resolve them. Their decisions on how to interpret and apply the copyright laws are legally binding on the public and other courts, and in effect, become part of the law itself.

Unfortunately, the courts don't always agree on how to interpret the copyright laws. Moreover, there are some questions about the copyright laws that have yet to be addressed by the courts. As a result, there are a number of important copyright issues for which we currently have no clear answers.

Finally, there is a federal agency called the United States Copyright Office that is in charge of registering copyrights and helps advise Congress on copyright matters. The Copyright Office is part of the Library of

Other Laws Protecting Works of Authorship

Copyright is by far the most important law that protects works of authorship. However, in some situations other laws also give power to creators or owners of works of authorship to control how their works are used. These laws may prevent you from using some materials that are not protected by copyright. They include:

- **The right of publicity:** A patchwork of state laws protects against the unauthorized use of a person's name or image for advertising or other commercial purposes (see Chapter 20).

- **Trademark laws:** Brand names such as Nike and Avis, as well as logos, slogans, and other devices that identify and distinguish products and services are protected under federal and state trademark laws (see Chapter 20).

- **Patent laws:** Federal laws that protect inventions—everything from new types of mousetraps to satellites. This book does not cover inventions. However, a special type of patent called a design patent may be used to protect a new, original ornamental design embodied in a manufactured object. The design can be a surface ornament such as a pattern on a beer mug or consist of the shape of the article itself such as the shape of a Rolls-Royce automobile or silverware set (see Chapter 5).

- **Trade secrecy laws:** State and federal trade secret laws protect some business information. An example of a trade secret would be a confidential marketing plan for the introduction of a new software product or the secret recipe for a brand of salsa. The extent of trade secret protection depends on whether the information gives the business an advantage over competitors, is kept secret, and is not known by competitors (see Chapter 14).

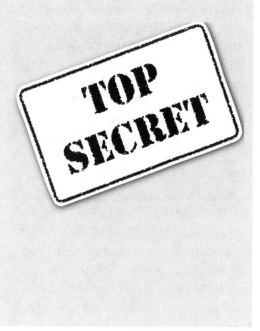

Congress, not the judiciary. Although it has made public its views on many copyright issues, the Copyright Office's views on copyright matters are not binding on the public or the courts. The courts do, however, usually give them some weight. So in considering questions of copyright law that have not been settled by the courts, it helps to know the Copyright Office position in deciding whether to use a particular work. The Copyright Office does not decide whether a particular work is in the public domain. This is ultimately up to the courts to determine.

State Copyright Laws

Before 1978, the United States had a two-tier copyright system: published works were protected by the federal copyright law (provided they met the requirements discussed below), while unpublished works were protected by state copyright laws, also called common law copyright. These state laws were enforced by state courts and were completely separate from the federal copyright that protected published works throughout the United States. However, in 1978 this system was abandoned. Federal copyright law now protects both published and unpublished works. As a result, common law copyright has relatively little application today. But, it might apply in some cases to protect works that have never been written down or otherwise preserved (see Chapter 14, Section D3).

2. What Is Copyright?

As explained in Chapter 1, Section A1, a copyright is a legal tool that provides the creator of a work of authorship the right to control how the work is used, including the exclusive right to reproduce, distribute, adapt, display, and perform the work. For example, the author of a book or musical composition has the exclusive right to publish it.

3. What Can Be Protected by Copyright?

Copyright protects works of authorship. A work of authorship is any creative work created by a human being that can be communicated to other humans, either directly or with the aid of a device such as a film projector. Works of authorship include, but are not limited to:

- writings of all types
- musical works, including song lyrics
- plays
- photographs
- databases
- maps
- artworks, sculpture, and graphics
- movies and videos
- computer software
- sound recordings
- pantomimes and choreographic works, and
- architectural drawings and blueprints and the design of actual buildings.

These are the types of works we deal with in this book.

4. Three Requirements for Copyright Protection

Not all works of authorship are entitled to copyright protection. A work is protected only to the extent it satisfies the following three fundamental requirements. If only part of a work meets these requirements, only that part will be protected.

a. Requirement #1—Fixation

The most basic requirement that a work of authorship must meet to qualify for copyright protection is that it must be fixed in a "tangible medium of expression." The copyright law is not picky about how a work is fixed; any medium from which it can be read back or heard, either directly or with the aid of a machine, will suffice. In other words, a work will be protected if it is written on a piece of paper, typed on a typewriter, painted on canvas, saved on a computer disk, recorded with a tape recorder, filmed with a camera, or preserved by any other means.

The federal copyright law does not protect works that have not been fixed in some way. For example, it doesn't protect something someone says but never writes down or otherwise preserves. However, as mentioned in "State Copyright Laws" above, state law might be used to protect such unfixed works (see Chapter 14, Section D3).

b. Requirement #2—Originality

A work fixed in a tangible form is protected by copyright only if it is original. If only part of a work is original, only that part will be protected. But a work need not be novel—that is, new to the world—to be protected. For copyright purposes, a work is original if it—or at least a part of it—owes its origin to the author. A work's quality, ingenuity, aesthetic merit, or uniqueness is not considered. In short, the copyright law does not distinguish between the Great American Novel and a letter from a six-year-old to her Aunt Sally; both are entitled to copyright protection to the extent they were not copied by the author—whether consciously or unconsciously—from other works. So long as its author independently created a work, it is protected even if other similar works already exist.

The originality requirement has extremely important ramifications for the public domain. Because of this requirement, someone who merely makes an exact copy of a public domain work is not entitled to receive a copyright on the reproduction. Something new must be added for the work to be copyrighted. And it is only the new material that is protected, not the unchanged public domain material.

> **EXAMPLE:** Actress Emma Thompson created a screenplay from the classic public domain novel *Sense and Sensibility* by Jane Austen. In doing so, she added a good deal of new material, including some scenes and dialogue

that were not in the novel. She also organized the work into cinematic scenes, cut material that did not fit into a two-hour movie, added camera directions, and so forth. Only this new material was protected by copyright. All the material Thompson copied from Austen's novel remains in the public domain.

c. Requirement #3— Minimal Creativity

Finally, a minimal amount of creativity over and above the independent creation requirement (Requirement #2 above) is necessary for copyright protection. Works completely lacking in creativity are denied copyright protection even if they have been independently created. However, the amount of creativity required is very slight. A work need not be novel, unique, ingenious, or even any good to be sufficiently creative. All that's required is that the work be the product of a very minimal creative spark. Most works of authorship—including catalogue copy, toy instructions, and third-rate poetry—make the grade.

But there are some types of works that are usually deemed by judges to contain no creativity at all. For example, a mere listing of ingredients or contents, such as in a recipe, is considered to be completely lacking in creativity and cannot be protected by copyright (but explanatory material or other original expression in

a recipe or other list can be protected). Telephone directory white pages have also been deemed by judges to lack even minimal creativity. Other listings of data may also completely lack creativity (see Chapter 12).

Like the originality requirement, the creativity requirement works to prevent someone who makes an exact copy of a public domain work—for example, a photocopy of a public domain drawing—from receiving copyright protection. Other types of exact copies of public domain works—for example, photographs of public domain paintings—may also fail the minimal creativity requirement (see Chapter 5, Section N2).

Moreover, certain types of changes made to public domain works, even though original, are not copyrightable because they are not minimally creative. For example, transposing a public domain musical composition from one key to another is not minimally creative and such a transposition is not protected by copyright (see Chapter 4, Section H1).

5. How Is a Copyright Created and Protected?

How a copyright is created and protected differs for works published before and after 1978. Before 1978, state copyright law automatically protected unpublished works that were original and minimally creative the moment they were created. Then, when

such a work was published with a valid copyright notice it automatically obtained protection under the federal copyright law and its state law protection ended.

Starting in 1978 this all changed. The federal copyright law was amended to protect all unpublished works as well as published materials. Unpublished works created before 1978 automatically lost their state law protection and acquired a federal copyright. Copyright protection for all works created after 1978 begins the instant a work meets the three requirements set forth in the previous section—that is, the moment an original and minimally creative work is fixed in a tangible medium of expression. There is no waiting period and it is not necessary to register with the Copyright Office. Copyright protects both drafts and completed works, and both published and unpublished works.

a. Copyright Notices

Before March 1, 1989 all published works had to contain a copyright notice (the © symbol or the word Copyright or abbreviation Copr. followed by the publication date and copyright owner's name) to be protected by copyright. Works published before March 1, 1989 without a valid copyright notice are now in the public domain unless the failure to include a proper notice was excused (see Chapter 19).

Although use of copyright notices has been optional since 1989, they still are usually placed on published works. Indeed, their use is often abused (see Section B1 below).

It's important to understand that neither the Copyright Office nor anyone else polices or regulates the use of copyright notices. It is not necessary to obtain government permission to place a notice on a work. People often place copyright notices on public domain works they copy and/or resell to the public. As discussed in Section B1, the penalties for placing a notice on a public domain work are very small.

b. Registration

Both published and unpublished works of authorship may be registered with the U.S. Copyright Office in Washington, DC. This involves sending the Copyright Office one or two copies of the work along with a registration form and fee. However, registration is not mandatory. It is not required to establish or maintain a copyright. For this reason, many works have never been registered. Even so, these works may still be protected by copyright.

6. Limitations on Copyright Protection

The purpose of copyright is to encourage intellectual and artistic creation. Paradoxically, giving authors too much copyright protection could inhibit rather than enhance creative growth. To avoid this,

some important limitations on copyright protection have been developed.

a. Copyrights Only Last for a Limited Time

The single most significant limitation on copyright protection is that copyright protection lasts for only a limited time. Just how long a copyright lasts depends on when it was created or published. When a work's copyright expires it enters the public domain, where it can be used freely by everyone (see Chapter 18).

b. Ideas and Facts Are Not Protected

Copyright only protects the particular way an author expresses facts and ideas. Copyright does not protect the facts or ideas themselves; facts and ideas are free for anyone to use. To give an author a monopoly over the facts and ideas contained in his work would hinder intellectual and artistic progress, not encourage it. For example, imagine how scientific progress would have suffered if Charles Darwin could have prevented anyone else from writing about evolution after he published *The Origin of Species* (see Chapter 14).

c. Fair Use

To foster the advancement of the arts and sciences there must be a free flow of information and ideas. If no one could quote from a protected work without the author's permission—which could be withheld or given only upon payment of a permission fee—the free flow of ideas would be stopped dead. To avoid this, a special "fair use" exception to copyright protection was created. An author is free to copy from a protected work for purposes such as criticism, news reporting, teaching, or research, so long as the value of the copyrighted work is not diminished (see Chapter 22).

d. Certain Works Are Ineligible for Copyright Protection

Finally, certain types of works are ineligible for copyright protection, even if they satisfy the fixation, originality, and creativity requirements discussed above. Most significant among these are works created by U.S. government employees (see Chapter 3, Section C2).

B. The Looting of the Public Domain

The public domain contains a lot of very valuable material. Indeed, with the rise of new technologies such as the Internet, the market value of some public domain works has grown enormously in recent years. So, there is money to be made from selling copies of public domain works. And, in the best American tradition, money is being made. Unfortunately, some of the business practices used by

Money and Savings Illustrations, Dover Publications

people and companies selling copies of public domain works are illegal, unethical, or antithetical to the fundamental purposes of the public domain.

1. Spurious Copyright Claims in Public Domain Materials

Out of ignorance, greed, or a combination of the two, people and companies who sell copies of public domain works often claim copyright in the copies and place copyright notices on them. You can find copyright notices and various warning statements on copies of works that have been in the public domain for centuries, such as the music of Bach or Shakespeare's plays. For example, the Arden Shakespeare edition of Shakespeare's *King Henry IV, Part II,* contains the legend "No part of this book may be reprinted, reproduced or utilized in

any form or by any electronic, mechanical or other means … without permission in writing from the publishers."

Ordinarily, a copy of a public domain work is itself in the public domain. Something new must be added to the original work for a valid copyright claim to arise. For example, if you add notes or new illustrations to a public domain book, the new material would be copyrighted. But the original text remains in the public domain.

By claiming copyright in public domain materials, these unscrupulous people try to intimidate the public into paying permission fees or royalties for works that should be free for all to use. This practice is tantamount to someone fencing off a portion of a national park and charging the public a fee for admission.

Is it illegal to claim copyright in a public domain work? Yes, it is; but the penalties for violations are laughably small. Claiming copyright in public domain works is a federal crime, but the maximum penalty for engaging in this sort of criminal conduct is a fine of $2,500. 17 U.S.C. Section 506(c). Moreover, no one has ever been prosecuted for violations.

Individuals are not allowed to bring their own copyright lawsuits against people who make spurious copyright claims. Although it might be possible to sue under other legal theories, as a practical matter it's usually too expensive and difficult to file a lawsuit to establish that a copyright claim is spurious.

In effect, the federal government encourages spurious copyright claims. The

potential economic rewards for making such claims are great, while the possibility of getting caught and paying a price is small.

This book will help you recognize when copyright claims are, in fact, spurious.

2. Use of Contracts to Restrict the Public Domain

Just as pernicious as spurious copyright claims is the widespread use of contracts to restrict how the public can use public domain materials. These contracts are commonly called licenses.

A person or company that sells copies of public domain works or allows the public to make copies of public domain works in its possession has every legal right to charge a fee for the copies or access. However, in addition to doing this, many owners of public domain works require users to sign license agreements restricting how the works can be used.

Such licenses take many forms. Some are preprinted form contracts you are re-quired to sign, while others are negotiated agreements tailored to particular individuals or institutions. If the public domain materials are distributed online or on a CD-ROM, the license will often be a click-wrap license—that is, a license that appears on a computer screen when the user attempts to access the materials. The user must accept the license by clicking on a button—usually marked with the word "accept"—before he or she can access the materials.

Some book publishers even attempt to impose license-like restriction on how you may use public domain materials. For example, Dover Publications, the largest publisher of public domain clip-art in book form, typically includes the following statement in its clip-art collections:

You may use the designs and illustrations for graphics and crafts applications, free and without special permission, provided that you include no more than 10 in the same publication or project.

Licenses are commonly used in electronic books, even where the book is merely a republication of a public domain work. For example, a publisher who created an e-book version of the public domain novel *Middlemarch* by George Eliot included a license agreement in the book, the terms of which permitted readers to copy only ten text sections into their computer's clipboard memory every ten days, and to print no more than ten pages of the novel each day.

a. License Restrictions

Among other things, these license agreements impose restrictions on how the licensee (the person obtaining or accessing a copy of the work) can use the work. Typically, the licensee is barred from making more than a specific number of copies or reselling them to the public. The licensee may even be barred from creating new works from the public domain materials or displaying or performing them in public.

If the licensee violates the restrictive terms contained in a license, the licenser (person who owns the copies of the public domain materials) can't sue for copyright infringement because the materials are in the public domain—they have no copyright protection. Instead, the licenser threatens or actually does sue the licensee for violating the license. This is a suit under state law for breach of contract.

In effect, people who use such licenses are trying to use contracts to obtain the same exclusive rights that are provided under copyright law, rights they can't get because the work is in the public domain.

b. Are License Restrictions Legal?

Many copyright experts believe that licenses imposing copyright-like restriction on how the public may use public domain materials should be legally unenforceable. This is because the federal copyright law preempts (overrides) state contract law and prevents people from using contracts to create their own private copyrights. Moreover, there are sound policy reasons for holding such license restrictions unenforceable—their widespread use diminishes the public's access to the public domain.

However, the first court that has ruled on this issue held that a license restricting the use of public domain materials was enforceable. The case involved a CD-ROM containing 95 million business telephone listings. The listings were all in the public domain (see Chapter 12), but the CD-ROM contained a click-wrap license agreement requiring users to agree to certain restrictions before they could access the information. For example, the license barred purchasers of the CD-ROM from copying, adapting, or modifying the listings. When Matthew Zeidenberg copied the listings and placed them on his website, the company that owned the CD-ROM successfully sued him for violating the license. The court held that the license restrictions were enforceable even though the listings were in the public domain. *ProCD v. Zeidenberg*, 86 F.3d 1447 (7th Cir. 1996).

Since the *ProCD* case was decided, a majority of courts have gone along with its reasoning and enforced license restrictions on public domain materials. This has led to even more widespread use of licenses.

The best that can be said now is that it's not really clear whether license restrictions on the use of public domain materials are legally enforceable. Even if you think a license is not legally enforceable, the licenser may disagree and sue you for damages. Even if you win such a suit, the legal expenses could be ruinous, and it is quite possible you could lose.

The experience of a company called Jurisline.com illustrates how, as a practical matter, it can be impossible to ignore or fight a company that uses licenses to try to restrict use of public domain materials. Jurisline was started by two young attorneys who wanted to create a website providing free access to court decisions—the written opinions issued by state and federal judges. Such decisions are not protected by copyright (see

Chapter 3, Section C3). Jurisline purchased 60 CD-ROMs containing thousands of such decisions from a legal publisher called Lexis and placed them on its website. Lexis required all purchasers of the CD-ROMs to agree to a license prohibiting copying. When Lexis and its parent company, the publishing giant Reed-Elsevier, discovered what Jurisline had done they immediately filed suit, claiming that the copying violated the terms of the license. Jurisline argued that the license was not legally enforceable because the legal decisions were in the public domain and the license was preempted (superseded) by the federal copyright law. Unfortunately, the federal trial court judge sided with Lexis, holding that the license was enforceable. The judge reasoned that the license was not preempted because it only bound the people who agreed to it. Unlike a copyright, it could not be enforced against the world at large. *Matthew Bender v. Jurisline.com*, 91 F.Supp.2d 677 (S.D. N.Y. 2000). (Unlike the appeals court decision in the *ProCD* case mentioned above, this trial judge's opinion is not binding on any other court.)

Rather than go on with the litigation and ultimately appeal the judge's ruling, Jurisline decided to pack it in. It simply didn't have the financial resources to continue the legal fight. Jurisline entered into a settlement with Lexis in which it agreed to remove from its website all the decisions it copied from the CD-ROMs. The website later shut down.

c. What Should You Do About Licenses?

When it comes to such restrictive license agreements, the best advice is to avoid them like the plague. A license (or any other contract) is enforceable only against a person who signs it or otherwise agrees to it. People who don't agree to it are not legally bound by it.

You may have to work harder to find public domain materials not subject to license agreements. For example, instead of quickly and easily obtaining a public domain photo from a stock photo agency that uses licenses, you'll have to dig through an archive or local historical society that will let you make copies without signing a license.

However, in some cases it may be impossible to obtain public domain materials you need without agreeing to a license. Always read any agreement carefully and try to negotiate with the licenser to limit the restrictions as much as possible so that you'll be able to live with the license.

3. Legislative Shrinking of the Public Domain

As if widespread spurious copyright claims and use of restrictive licenses weren't bad enough, Congress has gotten into the act. Egged on by huge corporate copyright owners such as the Hollywood film

studios, Congress passed a series of laws dramatically reducing the public domain. Millions of foreign works that used to be in the public domain in the United States have had their copyrights restored (see Chapter 15). Millions more domestic works that were scheduled to enter the public domain during the next two decades have had their copyrights extended (see Chapter 18). Because of these new laws, no additional published works will enter the public domain in the United States until the year 2019.

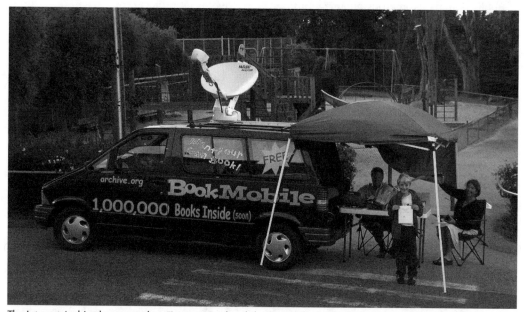

The Internet Archive has created an "Internet Bookmobile." Using the latest digital and print-on-demand technology, it can download works via satellite from the Internet and print inexpensive copies of over 20,000 public domain books. The bookmobile travels around the country making free copies of public domain books for schools, libraries, conferences, retirement homes, museums, and others. For more information, including a schedule of the Bookmobile's travels, check out www.archive.org/texts/bookmobile.php#thebookmobile.

Fighting for the Public Domain

While Congress has acted to shrink the public domain, and the business community has exploited it, a grassroots movement to preserve it has sprouted. Librarians, legal scholars, historians, artists, musicians, archivists, website creators, and many others have grown increasingly alarmed at the attacks on the public domain. Numerous organizations and groups have begun to help educate the public about the public domain's importance, agitate for its preservation, and encourage copyright owners to dedicate their works to the public. Because of this new consciousness of the public domain's importance, Congress will never again be able to remove millions of works from the public domain or extend the term of copyright without a fight. Among these organizations are:

- The Creative Commons (www.creativecommons.org)
- The Internet Archive (www.archive.org)
- The Electronic Freedom Foundation (www.eff.org)
- Public Knowledge (www.publicknowledge.org)
- The Free Expression Policy Project (www.fepproject.org)
- Electronic Commons (www.ecommons.ca)
- Center for Arts and Culture (www.culturalpolicy.org)
- The Berkman Center for Internet and Society at Harvard Law School (http://cyber.law.harvard.edu/home).

Chapter 3

Writings

Writing Checklist

1. Is the work eligible for copyright protection? (See Section C.)
 - ☐ Yes: Continue.
 - ☐ No: Skip to line 6.

2. Has the work been published? (See Section D.)
 - ☐ Yes: Continue.
 - ☐ No: Skip to line 4.

3. Date of publication: _____

 Country of publication: _____

4. Has the work's copyright expired? (See Section E.)
 - ☐ Yes: Skip to line 6.
 - ☐ No: Continue

5. Is the work in the public domain due to lack of a copyright notice? (See Section F.)
 - ☐ Yes: Continue.
 - ☐ No: Skip to line 7.

6. Does a copyright trap apply? (See Section G.)
 - ☐ Yes: Copyrighted portions of work may not be freely used. Do not continue.
 - ☐ No: Entire work is in public domain and may be freely used. Do not continue.

7. Is the work a derivative work? (See Section G1.)
 - ☐ Yes: Skip to line 9.
 - ☐ No: Continue.

8. Is the work a compilation? (See Section G2.)
 - ☐ Yes: Continue.
 - ☐ No: None of the words in the work are in the public domain. However, ideas, facts, and other elements may be in the public domain. See Chapter 14. Do not continue.

9. Is material in derivative work or compilation in the public domain? (See Section G.)
 - ☐ Yes: Public domain words may be freely used, as may public domain elements such as ideas and facts (see Chapter 14).
 - ☐ No: None of the words in the work are in the public domain, but the work may contain public domain elements such as ideas and facts (see Chapter 14).

This chapter will help you determine if a published or unpublished written work is in the public domain, including all types of fiction and nonfiction books, plays, screenplays, poetry, magazines, newspapers, pamphlets, letters, diaries, advertising copy, and any other work that consists primarily of written words.

⚠️ **It Is Possible for a Work to Be in the Public Domain in the United States but Protected by Copyright in Another Country, and Vice Versa.** This chapter only covers the public domain in the United States. If you want to know whether a work is in the public domain in a country other than the United States, see Chapter 16.

A. What Can You Do With Public Domain Writings?

Billions of written works are in the public domain, ranging from literary masterpieces

Books, Reading and Writing Illustrations,
Dover Publications

such as Shakespeare's plays to the most trivial and mundane cliches written for old advertising copy. You can use these public domain works in any way you desire, limited only by your imagination. Here are some common ways people use writings in the public domain:

1. Republishing Public Domain Writings

When a written work enters the public domain, anyone is free to republish it without obtaining permission from the former copyright owner. Nor is it necessary to pay the author, or more likely his or her heirs, a royalty. This makes it possible to publish cheap editions of works in the public domain. For example, when *This Side of Paradise*, the first novel by the famed Jazz Age novelist F. Scott Fitzgerald, entered the public domain in 1996, publishers printed nine new editions, some available for just a few dollars each.

Classic public domain writings, usually works of fiction, drama, and poetry, are constantly being republished. You can find many in the literature section of any bookstore, including the works of Dickens, Hawthorne, Melville, Keats, Shelley, Shaw, Shakespeare, and many others. One company, Octavo, is even publishing high-quality photographic reproductions of classic public domain books on CD-ROMs. You can find examples of its work on the Internet at www.octavo.com.

Mom, Pop, and the Public Domain

One small publisher that has had success republishing public domain works is Penfield Press, a mom and pop operation located in Iowa City, Iowa. It specializes in republishing works of special interest to people of Scandinavian and Eastern European descent. Among the public domain works it has republished are the novels and short stories of Swedish writer Selma Lagerlof, the first woman to win a Nobel Prize for literature. In 1997, Penfield printed about 1,500 copies of Lagerlof's 1891 novel *Gosta Berling's Saga* and sold them all within two years, primarily through the online bookseller Amazon.com. This was the first time the novel had been reprinted in more than 60 years. For more information about Penfield Press, visit their website at www .penfield-press.com.

2. Quoting From Public Domain Writings

A major advantage to using works in the public domain is that you do not need permission to quote from them. When a work is protected by copyright, you often need to obtain permission from the copyright owner to quote from it. Payment may be demanded for such permission. There are no standard fees for such permissions. They may range from a few dollars to hundreds or thousands of dollars, depending on the work involved and what is done with it. For example, *The Wall Street Journal* charges $240 to use six or more paragraphs from a front-page article and $180 to quote the same number of words from an inside article.

In some cases, permission to quote may be unavailable at any price. This is what happened when author Ian Hamilton attempted to write an unauthorized biography of the notoriously reclusive novelist J.D. Salinger. Hamilton wanted to quote from some of Salinger's personal letters. Salinger not only denied permission, he successfully sued Hamilton for copyright infringement when he attempted to use the quotations without permission.

There are also many cases where the heirs of famous people have refused to permit biographers and historians to use copyrighted materials. For example, the late poet Sylvia Plath's family and executor have refused to allow serious literary biographers to quote from Plath's copyrighted works because they didn't like the content of the biographies.

In some circumstances, authors may quote from a copyrighted work without permission. The legal concept of "fair use" allows authors to use small portions of another writer's work without permission for some purposes, including scholarship, education, and news reporting. But applying the rules of fair use can be difficult and confusing. And simply claiming "fair use" does not mean that the author or his

heirs won't sue you anyway. (For a detailed discussion of fair use, see Chapter 22.) By contrast, when a work enters the public domain, the rules are simple and clear: You may quote freely from a public domain work, using as much or as little as you want, for whatever purpose. You do not need to obtain permission or pay for the use.

Plagiarism, Attribution, and the Public Domain

If you copy from a public domain writing, do you have to credit the author? The United States Supreme Court has answered "no," holding that there is no legal requirement to provide any attribution when public domain works are copied and placed into new works. *Dastar Corp. v. 20th Century Fox Film Corp.*, 123 S.Ct. 2041 (2003). (See Chapter 20 for a detailed discussion of *Dastar*.) However, just because there is no legal requirement to give credit to the creators of public domain works, doesn't mean you need not do it. There is still something called plagiarism.

Plagiarism occurs when someone poses as the originator of words he did not write, ideas he did not conceive, or facts he did not discover. Although you cannot be sued for plagiarizing a public domain work, the process can result in professional penalties. For example, in the case of college professors and journalists, it may result in termination; in the case of well-known historians, it can result in public humiliation.

To avoid charges of plagiarism, authors of scholarly works (histories, biographies, legal and scientific works, and the like) always give proper credit to the sources of their ideas and facts, as well as any words they borrow. This is so even if the work borrowed from is in the public domain. Authors of less serious works—for example, how-to books—often attribute direct quotations, though do not always give credit for ideas and facts they borrow. It is neither customary nor necessary for authors of works of fancy, such as novels and plays, to credit the sources of their inspiration—regardless of the source—but they should give proper attribution to direct quotations.

3. Copying Public Domain Writings

Commercial copy shops such as FedExKinko's may require that you obtain written permission from the copyright holder before allowing you to photocopy a copyrighted work. For example, FedExKinko's copying policy—posted at its website (www.kinkos. com) and published as a brochure available in every FedExKinko's store—provides that "FedExKinko's requires written permission from the copyright holder in order to reproduce any copyrighted work."

No such permission is needed when a work is in the public domain. You may freely photocopy any public domain writing and use the copies in any way you wish. However, before asking a copy shop to photocopy a public domain work, you should ask what proof they need that the work you want copied is not protected by copyright.

You are also free to make digital copies of public domain writings and place them on the Internet or email them to colleagues, friends, or coworkers. Copies of thousands of classic public domain works have been posted on the Internet (see Section I).

What Is a Digital Copy?

Obviously, you can't place a public domain book or magazine article on the Internet. The work has to be reduced to digital form—a series of ones and zeros that can be read and stored by computers and which is then translated by computer software into letters and numbers on a computer screen that can be read by humans. Digital copies of written works are usually created by using a digital scanner—a device similar to photocopy machine, except it makes digital rather than physical copies. Another, much more time consuming, way to make a digital copy is to simply retype a work into a computer.

4. Performing Public Domain Writings in Public

You ordinarily need to obtain permission to perform a copyrighted play or other dramatic work in public. Permission fees to perform well-known plays by Eugene O'Neill, Arthur Miller, Neil Simon, and other famous authors run into the many thousands of dollars. In contrast, public domain plays can be performed for free. This includes, for example, the complete works of Shakespeare. There is yet another advantage to performing a public domain play or other dramatic work: Neither the author or his or her heirs has any control over the performance. You can cut, rewrite, or otherwise alter the play in any way you wish.

Plays in the Public Domain

Public domain works are in constant use in the theater world. Public domain plays are often staged, and new plays and musicals are created from public domain works. In New York City alone, these were some of the public domain plays being performed during one recent season:

- *Arms and the Man*, an 1894 play by George Bernard Shaw
- *The Alchemist*, a 1610 play by Ben Jonson
- *King John*, by William Shakespeare
- *Othello*, by Shakespeare
- *The Merry Wives of Windsor*, by Shakespeare
- *The Voysey Inheritance*, a 1905 play by Harley Granville-Barker

At the same time, the following plays and musicals adapted from public domain works graced the New York stage:

- a musical version of James Joyce's public domain story *The Dead* (published as part of the *Dubliners* collection in 1916)
- an updated dramatic adaptation of Fyodor Dostoyevsky's 1868 novel *The Idiot*
- *The Bomb-Itty of Errors*, a hip-hop adaptation of Shakespeare's *The Comedy of Errors*.
- a dramatization of H.G. Wells's 1898 novel *War of the Worlds*
- a dramatization of Charlotte Bronte's 1847 novel *Jane Eyre*
- the musical *Les Miserables*, based on the 1862 novel by Victor Hugo
- *Kiss Me Kate*, a Cole Porter musical loosely based on Shakespeare's *The Taming of the Shrew*
- the musical *The Phantom of the Opera*, based on the 1911 novel by Gaston Leroux
- the musical *Jekyll and Hyde*, based on the 1886 novel *The Strange Case of Dr. Jekyll and Mr. Hyde,* by Robert Louis Stevenson.

"Familiarity breeds contempt."
—Publius Syrus, *Maxim* (42 BC)

"...familiarity will grow more contempt."
—Shakespeare, *Merry Wives of Windsor* (c. 1598)

"I find my familiarity with thee has bred contempt."
—Miguel de Cervantes, *Don Quixote* (1605)

"Familiarity breeds contempt, and children."
—Mark Twain (1835-1910)

5. Creating New Works From Public Domain Writings

Perhaps most important of all, anyone is free to create a new work based upon a public domain writing—for example, create a screenplay or stage play based on a public domain novel or short story. Such works are called derivative works. Classic public domain works such as the novels of Jane Austen or Charles Dickens are recycled over and over again in new movies, plays, and other derivative works.

Authors may also create new stories using characters from public domain novels and other literary works. One outstanding example is the novel *Mr. Timothy*, by Thomas Bayard, which uses the character Tiny Tim from Charles Dickens's classic tale *A Christmas Carol*. Bayard's story concerns a grown-up Tiny Tim who becomes involved with a series of grisly murders in 1860 London. Examples of the many different types of derivative works that can be created from public domain writings are listed in Section G1.

In contrast, if a work is protected by copyright, you must obtain permission to create a derivative work from it. Such permission usually doesn't come free, if it is given at all.

B. Checklist for Determining Copyright Status

There are three main ways a written work enters the public domain. If it is not in the public domain one way, it could be in another.

To know for sure whether a work is in the public domain or protected by copyright you need to look at each of these pathways:

1. Many works are not eligible for copyright protection and automatically enter the public domain the moment they are created.

2. A work may enter the public domain because its copyright has expired. Millions of works fall into this category, including most of the best-known public domain works, such as Shakespeare's plays.

3. A work may enter the public domain because it was published before 1989 without a valid copyright notice. However, it can be difficult to tell for sure which works published without notices really are in the public domain. Determining public domain status from the first two pathways is like driving on a highway, but this pathway is more like struggling along an overgrown jungle trail.

Also, if you determine that a work is not in the public domain, this does not necessarily mean you can't use it. Many elements in copyrighted works are in the public domain even though the work as a whole is not—this includes the facts and ideas contained in a written work. See Chapter 14 for a detailed discussion of public domain elements in copyrighted writings.

In addition, in some situations it is legally permissible to quote from copyrighted writings without permission on the grounds of fair use. The fair use privilege is covered in detail in Chapter 22.

Attention Screenwriters: Free Ideas

Want to write a screenplay, but short on ideas? Adapt an already published novel by somebody else. Getting permission to create a screenplay from a novel by Stephen King, Michael Crichton, or John Grisham may cost millions of dollars. But there are tens of thousands of novels and other literary works by far better writers that are in the public domain and available for free. The following chart lists just a few classic novels that are in the public domain and that can be freely adapted into a screenplay. Many of them have already been filmed, but this doesn't mean they can't be filmed again. For example, William Shakespeare's *Romeo and Juliet* has been adapted 34 times since 1900 for the movies, according to the Internet movie database at www.imdb.com.

This list represents an infinitesimal fraction of all the written works that are in the public domain, but may give you an idea of just how rich the public domain treasure trove is.

Author	Title	Publication Date
Adams, Henry	Democracy	1880
Alcott, Louisa May	Little Women	1868
Anderson, Sherwood	Winesburg, Ohio	1919
Austen, Jane	Pride and Prejudice	1813
Austen, Jane	Emma	1816
Austen, Jane	Sense and Sensibility	1811
Beerbohm, Max	Zuleika Dobson	1911
Bennett, Arnold	The Old Wives' Tale	1908
Bronte, Charlotte	Jane Eyre	1847
Bronte, Emily	Wuthering Heights	1847
Carroll, Lewis	Alice's Adventures in Wonderland	1865
Carroll, Lewis	Through the Looking Glass	1871
Christie, Agatha	The Mysterious Affair at Styles	1920
Cleland, John	Fanny Hill	1749
Collins, Wilkie	The Woman in White	1860
Conrad, Joseph	Lord Jim	1900
Conrad, Joseph	Nostromo	1904
Cooper, James Fenimore	The Last of the Mohicans	1826
Dickens, Charles	Bleak House	1853
Dickens, Charles	Great Expectations	1861

Attention Screenwriters: Free Ideas

Author	Title	Publication Date
Doyle, Sir Arthur Conan	*The Principal Works in Fiction*	1913
Dreiser, Theodore	*Sister Carrie*	1900
Eliot, George	*Middlemarch*	1871-2
Fielding, Henry	*Tom Jones*	1749
Fitzgerald, F. Scott	*This Side of Paradise*	1920
Forster, E.M.	*Howard's End*	1910
Galsworthy, John	*The Man of Property*	1906
Goldsmith, Oliver	*The Vicar of Wakefield*	1766
Haggard, H. Rider	*She*	1887
Hardy, Thomas	*The Mayor of Casterbridge*	1886
Hughes, Thomas	*Tom Brown's Schooldays*	1857
Irving, Washington	*The Sketch Book*	1820
James, Henry	*Portrait of a Lady*	1881
Joyce, James	*Dubliners*	1914
Kipling, Rudyard	*The Jungle Book*	1894
Lawrence, D.H.	*Sons and Lovers*	1913
Lewis, Sinclair	*Babbitt*	1922
London, Jack	*The Call of the Wild*	1903
Maugham, W. Somerset	*Of Human Bondage*	1915
Melville, Herman	*Moby Dick*	1851
Poe, Edgar Allan	*The Complete Works*	1902
Scott, Sir Walter	*Ivanhoe*	1819
Shelley, Mary	*Frankenstein*	1818
Sterne, Laurence	*Tristram Shandy*	1760-67
Stowe, Harriet Beecher	*Uncle Tom's Cabin*	1852
Swift, Jonathan	*Gulliver's Travels*	1726
Tarkington, Booth	*Alice Adams*	1921
Thackeray, William Makepeace	*Vanity Fair*	1847-48
Trollope, Anthony	*The Way We Live Now*	1875
Twain, Mark	*The Adventures of Tom Sawyer*	1876
Twain, Mark	*The Adventures of Huckleberry Finn*	1886
Wells, H.G.	*The Time Machine*	1895
Wharton, Edith	*The Age of Innocence*	1920
Wodehouse, P.G.	*My Man Jeeves*	1919

To help you determine the status of a written work, we include a checklist at the beginning of this chapter for you to follow. Each step in the process is described in a numbered line on the checklist with a reference to one or more of the sections listed below or to other chapters in the book, as necessary. As you answer each question you will be led to the next appropriate question by marking "yes" or "no" on the checklist at the appropriate line. At the end of the process you should know whether the work you want to use is in the public domain.

We have also included a worksheet (Appendix C) you may use to document how you determined that a particular work was in the public domain. By filling out the sheet, you will be able to document your research and conclusions should anyone challenge your right to use the work.

What If the Work Is Not in the Public Domain? If you find that the work you want to use is not in the public domain, you may be able to use it anyway under a legal exception called "fair use" (see Chapter 22). If you do not qualify for this exception, you will need to obtain permission to use the work. For a detailed discussion of how to obtain copyright permissions refer to *Getting Permission: How to License & Clear Copyrighted Materials Online & Off*, by Richard Stim (Nolo).

C. Is the Work Eligible for Copyright Protection?

Copyright law never protects certain works, regardless of when they were created and whether or not they have been published. These works are ordinarily free for the taking by anyone. Such works include:

- Republications or reprinting of works in the public domain (Section C1)
- Works by United States government employees and officers (Section C2)
- Laws and court decisions (Section C3)
- Individual words, names, slogans, and short phrases (Section C4)
- Many blank forms (Section C5)
- Information that is common property, such as standard calendars (Section C6)
- Food and drink recipes (Section C7)
- Works dedicated to the public domain —that is, works whose authors have voluntarily relinquished their copyright protection (Section C8).

If a work you want to use could fall into any of the above categories, read the appropriate section below. If you determine that the work is in the public domain on any of these bases, you should mark "no" on Line 1 of the checklist at the beginning of this chapter and skip to Line 6 on the checklist. If the work does not fall into any of these categories, you should mark "no" on Line 1 and proceed to Line 2 of the checklist.

Here's a Shortcut: If the work you're interested in doesn't fall into any of the categories listed above, it is not in the public domain if it was published after 1988. However, even though such a work is not in the public domain as a whole, it will usually contain elements that are in the public domain, such as facts or ideas. Refer to Chapter 14 to read about these.

1. Copies of Public Domain Works

Works that are simply copied from other works are not protected by copyright. If the original work is in the public domain, the copy will be as well. For example, a newly published copy of Mark Twain's novel *The Adventures of Tom Sawyer* (whose copyright expired long ago) is as much in the public domain as the original published version. You are free, in most cases, to make actual copies of every page of a reprint or use it in any other way you want. U.S. copyright law does not protect typefaces, so even if a publisher uses a new typeface for a new edition of a public domain work, you are still free to photocopy the text (see Chapter 5, Section F7).

However, some publishers who reprint public domain works add new material, for example, a new introduction, explanatory notes, photos, or illustrations. This new material would be entitled to copyright protection, but the original public domain work would still remain in the public domain. For example, if new illustrations were added to a new edition of *The Adventures of Tom Sawyer*, you couldn't copy the illustrations without permission, but you are still free to copy the novel itself—that is, Mark Twain's words. (See Section G1 below for a detailed list of the various ways publishers and others change or augment public domain writings.)

Publishers and others who add new material to reprints of public domain works typically include copyright notices in the reprints. Although legally permissible, such notices may mislead or confuse people into thinking that the original works themselves are protected by copyright when actually they are in the public domain (see Section H).

2. U.S. Government Works

All written works by the United States (federal) government are in the public domain. This is true whether the work is published or unpublished.

A work is a U.S. government work if it was prepared by an officer or employee of the federal government as part of that person's official duties. "Officers" include all elected and appointed officials of all branches of the U.S. government—for example, the president, members of Congress, cabinet members, and judges, as well as lower-level U.S. government officials and members of the federal bureaucracy.

As you might imagine, there is a massive number of U.S. government works in the public domain. Just a few examples of

public domain U.S. government works include:

- most, but not all work published by the United States Printing Office
- all IRS publications, forms, rulings, and other IRS documents
- official speeches, letters, and other documents by the president, Congress, and other federal government officers and employees, and
- published and unpublished documents by the Copyright Office, Patent and Trademark Office, and other federal agencies.

However, not everything created by U.S. government officers or employees is automatically in the public domain. Works created outside official government duties are eligible for copyright protection. Moreover, private contractors working for the U.S. government may obtain copyright protection for some works they create.

U.S. government agencies may, but are not required to place notices in their works stating that they are in the public domain. The form of such notices varies; one example is provided below:

This is a work of the U.S. government and is not subject to copyright protection in the United States. Foreign copyrights may apply.

If you find a notice like this, the work is in the public domain. However, absence of such a notice doesn't necessarily mean the work is not public domain. You'll need to do more investigation to see if one of the exceptions noted below applies.

Copyrighted Works Containing U.S. Government Materials

U.S. government writings are frequently included within copyrighted works published by the private sector. For example, a work on U.S. population trends could include material from the U.S. Census Bureau; a biography of Franklin Roosevelt could include lengthy quotations from his official speeches and letters. Including such U.S. government materials within another work does not take them out of the public domain.

If a privately published work consists mostly of U.S. government materials, the copyright notice must identify those portions of the work that are not government materials and are thus protected by copyright. This enables you to tell which portions of the work are in the public domain. For example, a work on U.S. population that consists primarily of six appendixes containing U.S. Census Bureau documents could contain a copyright notice like this: "Copyright © by Joe James 2004. No protection is claimed in works of the United States government as set forth in Appendixes 1-6."

By Linda Allison, copyright © Nolo 2000

The Three Levels of Government

You need to know what level of government a document or other work comes from before you can know whether it's in the public domain. There are three basic levels of government in the United States.

- The United States (or federal) government which is headquartered in Washington, DC, and includes the Executive Branch, Congress, the Supreme Court and other federal courts, and federal agencies such as the IRS, Department of Defense, and Copyright Office.
- The 50 state governments, headquartered in the 50 state capitals, including the state governors, legislatures, state courts, and state agencies such as your state's motor vehicle agency.
- The thousands of city, county, and other local governments located throughout the United States. This includes local mayors, city councils, and local government agencies such as your local planning department or school district.

Only works by employees or officers of the U.S. government are automatically in the public domain. State and local governments can claim copyright in works they create, subject to one exception for government edicts discussed below.

It is usually not difficult to tell what level of government a written work emanates from. If the work has been published, the cover or title page will usually indicate what government agency wrote the work. If the work is an unpublished letter, memo, or other item, the stationery on which it is written will usually show where it comes from. However, if you're not sure whether the work was created by a U.S. government agency, call or write them and ask.

1001 Cartoon-Style Illustrations, Dover Publications

a. Works Created Outside of Official Duties

Only works created by U.S. government employees or officers as part of their official duties are in the public domain. In other words, the work must be created as part of the job of the employee or officer. For example, a personal letter written by President Nixon or General Douglas MacArthur would not be in the public domain, since such a letter would not have been created as part of their official duties. Similarly, a court held that certain speeches written by Admiral Hyman Rickover (the father of the nuclear Navy) were not created as part of his official duties since the speeches in question did not concern his Navy duties and were delivered on his free time. *Public Affairs Assocs., Inc. v. Rickover*, 284 F.2d 262 (D.C. Cir. 1960).

Nor would a book or article written by a government employee outside of his or her duties be in the public domain even if it involved government activities. Memoirs written by public officials or employees after they leave office are not in the public domain, even if they discuss what they did when they were in the government. Thus, for example, White House conversations recounted for the first time by President Gerald Ford in his memoirs, written after he left office, were not in the public domain. *Harper & Row Publishers v. Nation Enterprises*, 723 F.2d 195 (2d Cir. 1983).

The fact that a government employee or officer occasionally uses a government office, secretary, or other government facility to help create a work does not mean that the work was created as part of the employee's duties. Government employees sometimes use such facilities to create works that are not within their job duties. Such a work would not be in the public domain (but the employee might be subject to discipline for misusing federal facilities). For example, the speeches by Admiral Hyman Rickover mentioned above were found not to be in the public domain even though his Navy secretary typed them.

Nor is a work in the public domain simply because it is printed by the U.S. government. Such a work could be copyrighted, for example, if an independent contractor created it for the government (see below).

b. Works by Independent Contractors

The U.S. government often hires independent contractors to help create written works of all kinds. Works created for the federal government by independent contractors—meaning people who are neither U.S. government officers nor employees—can be protected by copyright. It all depends on what the government decides at the time the independent contractor is hired. If the government wants the work to be in the public domain, it can require the independent contractor to sign a work-made-for-hire agreement. In this event, the U.S. government, not the contractor who actually wrote the work, would be

considered the author of the work for copyright purposes. The work would be in the public domain.

On the other hand, if the U.S. government does not require the contractor to sign a work for hire agreement, the work would be protected by copyright. The copyright could be owned either (1) by the contractor who created it, or (2) by the U.S. government if it required the contractor to assign his or her copyright to it.

If the contractor gets copyright ownership, the U.S. government gets a license to use the work. The U.S. government's license is a nonexclusive, irrevocable, worldwide license to use, modify, reproduce, release, perform, display, or disclose the work. The U.S. may use the work for government-related purposes without restrictions. It also may permit people outside the government to use, modify, reproduce, release, perform, display, or disclose the work on its behalf. The government's license includes the right to distribute copies of the work to the public for government purposes—for example, on government websites. This means that, even if a contractor holds a copyright in a work created for the government, you could use it if you get the government's permission to do so on its behalf. Of course, you could also get permission from the contractor. Finally, you could use it without obtaining permission if your use constitutes a fair use. (See Chapter 22, Section C.)

When a contractor obtains ownership of a work created under a contract with a U.S. government civilian agency or NASA, federal regulations require the contractor to place a copyright notice on it acknowledging U.S. government sponsorship (including the contract number). The notice must be on the work when it is delivered to the government, published, or deposited for registration with the U.S. Copyright Office. (Federal Acquisition Regulation (FAR) 52.227-14 (www.arnet.gov/far).) Here's a suggested format for such a notice:

COPYRIGHT STATUS: This work, authored by _____ employees, was funded in whole or in part by _____ under U.S. government contract _____, and is, therefore, subject to the following license: The government is granted for itself and others acting on its behalf a paid-up, nonexclusive, irrevocable worldwide license in this work to reproduce, prepare derivative works, distribute copies to the public, and perform it publicly and display it publicly, by or on behalf of the government. All other rights are reserved by the copyright owner.

It is possible, however, for published works to lack a copyright notice and for unpublished works to not have any notices or warning statements. For this reason, always look for other signs that a work

Public Domain Does Not Mean Public Access

The fact that U.S. government written works are in the public domain—that is, not protected by copyright—does not mean they are always accessible to the public. Millions of government documents are classified for national security reasons and are not made available to the general public. This includes, for example, most works created by employees of the Central Intelligence Agency, FBI, and State Department. Many other documents are not publicly available for reasons of privacy—for example, tax records kept by the IRS and health records maintained by the National Institutes of Health. Eventually, many classified documents do become publicly available.

For example, the National Security Agency has declassified thousands of documents created by the VENONA Project. VENONA was the code name used for the U.S. Signals Intelligence effort to collect and decrypt the text of secret Soviet spy agency messages in the 1940s. These messages provided extraordinary insight into Soviet attempts to infiltrate the highest levels of the U.S. government. The National Security Agency has placed copies of many of these decrypts on its website at www.nsa.gov/docs/venona. Because U.S. government employees created them, they are in the public domain and may be freely copied.

Members of the public may obtain copies of many U.S. government documents through the Freedom of Information Act, a federal law that requires federal agencies to make certain types of records publicly available. A few examples of the wide variety of records that citizens have obtained under the Freedom of Information Act include: reports on silicone breast implants from the Food and Drug Administration; statistics on boycotts from the Department of Commerce; and records on the assassination of President Kennedy from the FBI and the CIA.

However, not every government document can be obtained under the Freedom of Information Act. The government won't release documents if doing so would violate privacy or security rules.

The American Civil Liberties Union (ACLU) has created a guide to using the Freedom of Information Act. You can order a copy through the ACLU website (www.aclu.org) or by calling 800-775-ACLU.

was created by contractors. For example, contractors and/or their company will usually be given credit on the title page or somewhere else in the document, or the contractors' company may be referred to in the work in some way that makes it clear that independent contractors created it.

If you suspect independent contractors have created a work, it is a good idea to call, write, or email the government agency involved to ask if the work is in the public domain or if you need permission from the government agency or the contractor to use it.

c. Works by State and Local Government Employees

The rule that U.S. government works are in the public domain does not apply to works by state and local government employees; those works may be protected by copyright. For example, a state tax pamphlet or booklet on air pollution or water conservation published by a city or county may be protected. However, there is one exception: State and local government laws and court decisions are in the public domain (see Section C3).

Not all state and local governments claim copyright in their publications, but many do. Some may claim copyright in some publications, but not in others. However, the trend seems to be for state government agencies to claim copyright protection as a way to earn extra income. For example, in 1999 the California State Legislature sponsored a seminar for state agency personnel in which legal and publishing experts spoke about ways the state could earn more money from its many publications.

You can tell that copyright is claimed if you find a copyright notice (a © symbol or the word "Copyright" followed by a publication date and copyright owner's name) on a work in the name of the state or local government entity. However, the absence of a copyright notice doesn't necessarily mean copyright isn't being claimed, because use of a copyright notice is not mandatory for works published after March 1, 1989 (see Chapter 19). If you're not sure whether copyright is claimed in a particular state or local publication or unpublished document, call, write, or email the agency involved and ask them.

The District of Columbia and Puerto Rico are treated the same as states for these purposes.

d. Foreign Government Works

Subject to one exception for government edicts, materials prepared by any foreign government with which the U.S. has copyright relations (see Chapter 15) are entitled to claim copyright protection in the United States. Also included in this category are works prepared by the United Nations and any of its agencies such as UNESCO, and the Organization of American States.

Not all foreign governments claim copyright in their official publications,

but many do—for example, the United Kingdom and Canada have something called Crown Copyright that protects most government publications. You must research the law of the country involved to know if it claims copyright in its publications (see Chapter 16).

e. Quasi-Governmental Organizations

Some organizations that you might think are U.S. government agencies really aren't. Instead, they are quasi-governmental organizations or independent corporations established under U.S. government auspices. Such organizations are allowed to claim a copyright in their publications and other works. These include, for example:

- the Smithsonian Institution, which is an "independent trust instrumentality" of the United States
- the U.S. Postal Service, which became an independent corporation in 1970, and
- the Corporation for Public Broad-casting, which is a private nonprofit corporation established and partly funded by Congress.

Organizations such as these normally place copyright notices on their published works, Web pages, and other copyrighted materials. But, if you're not sure whether an organization whose material you want to use is a U.S. government agency or a quasi-government organization, call or write them and ask.

The Smithsonian Exception

As mentioned above, the Smithsonian Institution is not considered part of the federal government. However, the Smithsonian does receive some funding from the U.S. government and the U.S. government pays some of the people who work there. The Smithsonian regards works created by employees paid by the government to be in the public domain. But the Smithsonian does claim copyright in all works created by employees it pays itself (such workers are called trust fund employees). The Smithsonian also ordinarily acquires copyright ownership on works created on its behalf by outside independent contractors.

Unless a Smithsonian Institution publication or other document specifically states that it is in the public domain, the only way you can determine for sure if it is in the public domain is to contact the Institution and ask.

Smithsonian Institution, Library of Congress, Prints and Photographs Division, Historic American Buildings Survey, HAS, DC, WASH, 520B-16

f. Certain Technical Data

The U.S. Department of Commerce runs something called the Standard Reference Data Program. This program creates publications and databases of technical data regarding metals, chemicals, industrial fluids and materials, and similar items for technical problem-solving, research, and development by scientists and engineers. The Commerce Department is allowed to claim a copyright in such standard reference data. 15 U.S.C. Section 290(e).

g. Anticounterfeiting Rules

Although federal government documents are ordinarily in the public domain, federal anticounterfeiting laws may prevent you from freely copying some of them. These laws apply to such documents as negotiable bonds and passports.

To prevent counterfeiting, federal law requires that some materials can only be photocopied in black and white, single-sided, and must be reduced to 75% or enlarged to 150% of their original size. The requirements cover:

- treasury notes
- gold certificates
- Internal Revenue stamps
- postal money orders, and
- government, bank, or corporation bonds and securities. 18 U.S.C. Section 504.

Some other documents can only be copied in black and white, including:

- passports

- U.S., state, or foreign government identification cards
- driver's licenses
- Social Security cards
- birth certificates
- immigration papers, and
- certificates of U.S. citizenship.

In addition, U.S. government securities, notes, and other obligations may not be used in advertisements. 18 U.S.C. Section 475.

Paper currency may be reproduced in black and white if reduced to at least 75% or enlarged to at least 150% of its original size. Currency may also be reproduced in color if the reproduction is:

- one-sided
- reduced to at least 75% or enlarged to at least 150% of the bill's original size, and
- all negatives, plates, digitized storage medium, graphic files, and any other thing used to make the reproduction that contain an image of the currency are destroyed and/or deleted or erased after their final use. 31 C.F.R. Section 411.

3. Laws and Court Decisions

For our political and legal system to function properly, we must all have free access to official legal documents such as judicial opinions, legislation, public ordinances, administrative rulings, and similar items. For this reason, all such works are in the public domain. This rule applies to all levels of government—local, state, and federal, and even includes foreign government laws and legal rulings. Thus, all laws, from the United Nations Charter to your local zoning regulations, are in the public domain.

a. Privately Published Laws and Decisions

Federal and state judges frequently issue written opinions when they decide court cases. These opinions are a vital resource for understanding how the courts interpret the laws passed by Congress and the state legislatures.

In the United States, most of the opinions by the federal and state courts are collected and published by private legal publishers, as are most of the laws passed by the Congress and state legislatures. These publishers cannot claim copyright in the text of the decisions and laws themselves, but they are entitled to a copyright in some material they create and add to these publications.

For example, editors at legal publishing companies typically write summaries of the court decisions they publish. These summaries (called headnotes) are copyrighted, but the legal opinions themselves are in the public domain.

Other elements typically added to court rulings by legal publishers have been found by the courts not to be protected by copyright. These elements include the names of the lawyers, parties, court, and date of decision; and the procedural history of the case. *Matthew Bender v. West Publishing Corp.*, 158 F.3d 674 (2d Cir. 1998). In addition, a court found that brief descriptive titles and chapter and article headings added to a collection of government statutes were not protected by copyright. *State of Georgia v. Harrison Co.*, 548 F.Supp.110 (N.D. Ga. 1982). One federal court has ruled that unique page numbering systems used in legal publications do not merit copyright protection, and other courts are likely to follow that ruling. *Matthew Bender v. West Publishing Corp.*, 158 F.3d 674 (2d Cir. 1998).

Individual Court Decisions Appear to Be Fair Game So Long as They Are Stripped of the Material Added by the Private Legal Publisher. But copying an entire published volume of legal opinions produced by a private legal publisher (or a substantial portion of it) and reproducing the opinions in the same order they appeared in the volume could violate the publisher's compilation copyright in the volume as a whole. Consult a copyright attorney before attempting to do such copying.

i. Digital Copies of Court Decisions

Legal opinions are now being digitally copied and reproduced on both commercial and nonprofit websites. Copyright notices are often included on these legal decisions. Copyright may be claimed in the various computer coding systems, formatting, and other technological enhancements used by a website, but not in the text of the legal opinions themselves. Digital copies of public domain texts are almost certainly not copyrightable (see Section G1).

When it comes to using digital copies of public domain legal decisions, there is one further complication. The companies selling such digital copies on websites and CD-ROMs frequently require purchasers or subscribers to agree to restrictions on how the digitized decisions may be used. These restrictions are usually contained in licenses that the purchaser is required to accept before buying the product. These licenses typically prevent users from republishing the decisions. If you violate the terms of the license, the publisher cannot sue you for copyright infringement because the decisions are in the public domain. But the company might sue you for breach of contract. This is what happened when a website called Jurisline placed online thousands of legal decisions it copied from 60 CD-ROMs purchased from the legal publisher Lexis. Lexis immediately filed suit, claiming that the copying violated the terms of a license that the person who bought the CD-ROMs agreed to. Following an adverse court ruling that the license was legally enforceable, Jurisline.com settled the dispute by agreeing to remove the court decisions it had copied from the CD-ROMs from its website.

You can avoid potential problems with licenses by going to a law library and copying the cases in the printed bound volumes, instead of using digital copies on CD-ROMs and website. Published books are not subject to license restrictions.

It is unfortunately not clear whether license restrictions on public domain works are legally enforceable, because courts around the country have not reached a clear consensus on this issue. Anyone considering violating a licensing agreement they signed for use of public domain works should consider the danger of getting sued and seek legal help before taking any action. For a detailed discussion of licenses, see Chapter 2, Section B2. For a general discussion of how to deal with public domain gray areas, see Chapter 1, Section B.

State Copyright Claims

Some states are attempting to assert copyright claims in their laws. For example, the Minnesota Office of the State Revisor claims copyright on the historical notes, editorial notes, format, and captions included in the official published version of the Minnesota state statutes. However, no copyright is claimed in the text of the statutes themselves. While the practice has not yet been challenged, it is likely that, according to current copyright law, the format and captions are not protected by copyright. But the copyright claim for the notes might be valid. Notes are not laws and states are entitled to claim copyright in works created by their employees (other than laws and court rulings).

Many states also claim copyright protection for regulations—that is, rules adopted by state agencies that interpret and enforce state laws. For example, the State of California claims copyright in the regulations made available to the public on a state website (www.calregs.com). Regulations ordinarily have the force of law, so it's likely that copyright claims in state regulations are spurious and would not be upheld by the courts.

Such state copyright claims would almost certainly not apply to your copying of state laws and regulations for your personal use, but the state might take action if you published or otherwise tried to commercially exploit them, for example, by publishing them in a book or on a website.

b. Copyrighted Model Codes

Creating a local building code, planning ordinance, or similarly complex legislation is a time-consuming and difficult task. To make this drafting process easier, private publishers have written what are called model codes. Instead of writing their own codes from scratch, many governments license and use the models.

For decades, publishers of such model codes have claimed copyright in their creations. Local laws, codes, and ordinances based on such codes often contain copyright notices in the publisher's name or some other indication that copyright is claimed by the publisher. In a significant victory for public domain proponents, a federal appellate court found that model codes enter the public domain when they are enacted into law by local governments.

The case came about when Peter Veeck posted the local building codes of Anna and Savoy, two small towns in north Texas, on his website. Both towns had adopted a model building code published by Southern Building Code Congress International, Inc. (SBCCI). Veeck made a few attempts to inspect several towns' copies of the Building Code, but he was not able to locate them easily. Eventually, Veeck purchased the model building codes directly from SBCCI; he paid $72 and received a copy of the codes on disk. Although the software licensing agreement and copyright notice indicated that the codes could not be copied and distributed, Veeck cut and pasted their text onto his website. Veeck's

website did not specify that the codes were written by SBCCI. Instead, he identified them, correctly, as the building codes of Anna and Savoy, Texas.

SBCCI sued Veeck for copyright infringement. Veeck lost in the trial court, but ultimately won on appeal. The court held that the model codes were in the public domain because:

- The law is always in the public domain, whether it consists of government statutes, ordinances, regulations, or judicial decisions; and
- When a model code is enacted into law, it becomes a fact—the law of a particular local government. Indeed, the particular wording of a law is itself a fact, and that wording cannot be expressed in any other way. A fact itself is not copyrightable; nor is the way that a fact may be expressed if there is only one way to express it. Since the legal code of a local government cannot be expressed in any way but as it is actually written, the fact and expression merge and the law is uncopyrightable. *Veeck v. Southern Building Code Congress International, Inc.*, 293 F.3d 791 (5th Cir. 2002).

The *Veeck* decision's reasoning has the effect of placing in the public domain every model code that has been adopted by a government entity. Any person may reproduce such a code, as adopted, for any purpose, including placing it on a website. However, model codes that have not been adopted by any government body are protected by copyright.

After *Veeck*, you are on very safe ground if you copy a government statute, ordinance, or regulation itself, even if it is word-for-word the same as a model code. However, if you do what Peter Veeck did, and copy a model code you obtain directly from a model code publisher, make certain it has been adopted by a government body and note what body has in fact done so. Also, be careful to check that the version adopted by the government entity is the same as you obtain from the model code publisher. If, like Veeck, you place a code on the Web or otherwise republished it, make clear that you are republishing a code that has been adopted by one or more government bodies. Don't state that you are republishing the publisher's model code as a model code.

c. Quasi-Official Legal Documents

Some types of privately created works are adopted by, or receive official approval from, government agencies. Such documents, in effect, obtain a quasi-official status, but courts have ruled that they do not enter the public domain. The rationale for this is that such documents are not themselves official laws. Rather, the law requires that citizens consult or use these privately published documents to fulfill their obligations. For example:

- The American Medical Association created and published a medical

procedure coding system that was adopted by the federal Health Care Financing Administration for use in completing Medicare and Medicaid claim forms. The system was ruled to be protected by copyright. *Practice Management Information Corp. v. The American Medical Association*, 121 F.3d 516 (9th Cir. 1997).

- The insurance regulations of several states required that the used car prices listed in the *Red Book*—a privately published used car price guide—be used as a standard for insurance payments. It was ruled not in the public domain. *CCC Information Services v. Maclean Hunter Market Reports*, 44 F.3d 61 (2d Cir. 1994).

- A tentative map for a residential subdivision prepared by a private developer was approved by the town council and therefore had legal effect, but did not enter the public domain. *Del Madera Properties v. Rhodes & Gardner, Inc.*, 637 F.Supp. 262 (N.D. Cal. 1985).

4. Words, Names, Slogans, and Other Short Phrases

Individual words are never protected by copyright, even if a particular person invents them. For example, the word "newspeak," invented by George Orwell for his novel *1984*, is in the public domain. If individual words were copyrighted people would be discouraged from using them and the growth of our language would be greatly retarded. As explained by the U.S. Supreme Court, "words are the common property of the human race and are as little susceptible of private appropriation as air or sunlight." *Holmes v. Hurst*, 174 U.S. 82 (1899).

Names, whether of individuals, products, or business organizations or groups, are likewise not protected by copyright. Titles also are not copyrightable (see Chapter 13).

Ordinarily, slogans and other short phrases are not protected by copyright—for example, the phrases "Gift Check," "Priority Message," and "Contents Require Immediate Attention" used in a direct mail advertising campaign were held to be in the public domain. *Magic Mktg. v. Mailing Servs. of Pittsburgh*, 634 F.Supp. 769 (W.D. Pa. 1986). Likewise, short lists of numbers used to identify various types of screws—for example, "402-10-202-10"— were too brief to qualify for copyright protection. (*Southco Inc. v. Kanebridge Corporation*, 390 F.3d 276 (2004).) Such phrases will not be registered by the Copyright Office. 37 C.F.R. Section 202.1(a).

However, courts have made exceptions in the cases of some highly creative and well-known literary phrases. For example, courts have held that the following phrases are copyrightable:

- "E.T. phone home" from the movie *E.T.—The Extra-Terrestrial. Universal City Studios v. Kamar Indus., Inc.*, 217 U.S.P.Q. 1162 (S.D. Tex. 1982).

- "When there is no room in hell ... the dead will walk the earth" from the movie *Night of the Living Dead. Dawn*

Assocs. v. Links, 203 U.S.P.Q. 831 (N.D. Ill. 1978).

- "Look!... Up in the sky!... It's a bird!... It's a plane!... It's Superman!" from a trailer for the *Superman* television show. *DC Comics v. Crazy Eddie*, 204 U.S.P.Q. 1177 (S.D. N.Y. 1977).

Use of such phrases is particularly likely to be barred by the courts where they are used for commercial purposes in, for example, an advertisement.

⚠️ **Any of the Items Discussed in this Section Could Have Protection Under State and Federal Trademark Laws If They Are Used In Connection With the Sale of a Product or Service.** Using a person's name to help sell a product or service could also violate the person's right to publicity. (See Chapter 20 for a detailed discussion.)

5. Blank Forms

Blank forms designed solely to record information are in the public domain. The U.S. Copyright Office will not register them (37 C.F.R. Section 202.1c). According to the Copyright Office, this includes such items as time cards, graph paper, account books, standard bank checks that don't contain illustrations, scorecards, address books, diaries, report forms, and order forms.

Forms such as these typically consist only of simple arrangements of horizontal and vertical lines with perhaps a few short headings. The headings are so obvious that their selection cannot be said to be even minimally creative. Some examples are a baseball scorecard with columns headed "innings" and lines headed "players" or a travel diary with headings for "cities," "hotels," and "restaurants." Below is an example of an account book ledger design the Supreme Court held was not entitled to copyright protection in *Baker v. Seldon*, 101 U.S. 99 (1879):

However, courts generally find more elaborate and creative forms can obtain copyright protection, even if they consist primarily of blank spaces to be filled in. For example, a court held that the following baseball pitching statistics form was copyrightable:

THE HARTFORD COURANT: Sunday, May 6, 1984

■ SCOREBOARD ■

Today's Games

This form, the first of its kind, lists four items of information about each day's games—the teams, the starting pitchers, the game time, and the betting odds—and then lists nine items of information about each pitcher's past performance, grouped into three categories. The court held that the selection of this particular combination of baseball statistical categories required enough creativity to merit copyright protection. *Kregos v. Associated Press*, 937 F.2d 700 (2d Cir. 1991).

Forms that contain substantial text—for example, forms that contained detailed instructions, and insurance policies, contracts, and other legal forms—are protected by copyright. However, where there are only a few ways to express the facts and ideas contained in such forms, a legal rule called the merger doctrine might severely limit protection (see Chapter 14).

For example, one court held that insurance bond forms and indemnity agreements were entitled to copyright protection. But the court said that because the forms contained standard language that would have to be included in any form designed to accomplish the same purpose, only verbatim copying of the exact wording would constitute copyright infringement. *Continental Casualty Co. v. Beardsley*, 253 F.2d 702 (2d Cir. 1958).

Even if an individual form is in the public domain, a work consisting of multiple forms could be protected by copyright as a compilation. In this event, copyright protection extends only to the compiler's selection and arrangement of all the forms as a group. (See Chapter 12 for detailed discussion of compilations.)

In many cases it may be difficult to tell for sure whether a blank form is in the public domain, or whether it contains enough information to be copyrighted. See Chapter 1, Section B, for a detailed discussion of how to deal with such public domain gray areas.

6. Information That Is Common Property

According to the U.S. Copyright Office, works consisting of information that is common property are in the public domain. Examples of such works include standard calendars, height and weight charts, tape

measures and rulers, schedules of sporting events, and lists or tables taken from public documents or other common sources. 37 C.F.R. Section 202.1(d).

However, new material added to such works is protectable. Although a standard calendar is not protected by copyright, photos, illustrations, or quotations added to a calendar can be protected. But copyright protection only extends to this new material, not to the standard calendar itself.

Food and Drink Spot Illustrations, Dover Publications

7. Food and Drink Recipes

A mere listing of ingredients for a recipe is not copyrightable. However, if a cookbook author spices up his or her recipes with explanatory material, such material is protectable. One court has suggested that this could include advice on wines to go with the meal, hints on place settings and appropriate music, or tales of a recipe's historical or ethnic origin. *Publications Int'l Ltd. v. Meredith Corp.,* 88 F.3d 473 (7th Cir. 1996). Photographs or drawings included in a cookbook would also be copyrightable unless taken from other public domain sources.

Keep in mind, however, that it is only the individual bare-bones recipes that are in the public domain. A collection of numerous recipes can be protected as a compilation. But in this event the copyright only extends to the selection and arrangements of all the recipes as a whole. The individual recipes are still not protected. (See Chapter 12 for a detailed discussion of compilations.)

Copyright never protects a procedure, discovery, or system itself, only the way an author expresses it. For example, if someone writes a book describing how to grow an organic garden using minimal water, the words in the book are protected, but the gardening procedure is not. Anyone can read the book and use the procedure it describes. Likewise, anyone can read a cookbook and use a recipe it describes— that is, create a dish based on the recipe.

8. Works Dedicated to the Public Domain

Authors need not enjoy copyright protection if they don't want it. Instead, they may dedicate their work to the public domain. This means they give up all their rights in the work forever and anyone may use the work without asking their permission.

There is no prescribed formula for dedicating a work to the public domain. The author or other copyright owner simply has to make clear his or her intentions. For example, stating "This work is dedicated to the public domain" on a book or article's

Some Recipes Can Be Patented

A recipe, unaccompanied by original literary expression, cannot be protected by copyright. However, federal patent laws may protect a novel, nonobvious recipe. (See Chapter 2, Section A, for more on patents). To be novel, the recipe must never have been published or used before. To be nonobvious, the recipe must be one that a cook of ordinary skill would not be expected to devise. Few recipes could meet both requirements. However, some recipes have been patented—for example, a recipe for lasagna was patented in 1999. Using this recipe, a person could cook lasagna in 30 minutes (rather than the usual 45) without using a pan. (Pat. No. 5,939,113.)

If a recipe is patented, you couldn't use it to create the dish described in the recipe without the patent owner's permission. However, you could copy the patent itself as published by the USPTO. According to the USPTO, when a patent is issued, the patent description and drawings are published into the public domain as part of the terms of granting the patent to the inventor. As such, they are not subject to copyright restrictions (www.uspto.gov/main/ccpubguide.htm). But, there doesn't seem much point in publishing a patented recipe if no one could actually use it without the patent owner's permission.

You can tell that a recipe has been patented if it contains a patent notice—the words Patent or Pat. followed by a patent number. If a patent has been applied for but not yet obtained, a "patent pending" notice may be used. However, patent notices are not always used, so the absence of a notice does not conclusively mean a recipe has not been patented. The best way to determine if a recipe has been patented is to do a patent search. You can do this online for free at the United States Patent and Trademark Office (USPTO) website (www.uspto.gov). The USPTO has classified all patents by number; food recipes are classified under number 426. You can find a list of the subclasses within this classification at www.uspto.gov/go/classification/uspc426/sched426.htm. For a detailed discussion of patents and patent searching, see *Patent It Yourself*, by David Pressman (Nolo).

title page would be sufficient. It's not even necessary to make the dedication in writing. It could be done orally, but it's always best to write something down to avoid possible misunderstandings.

Be careful, however, where an author sends mixed messages—for example, by stating that his work is in the public domain, but restricting how the public may use it with the statement: "This work is public domain but may not be posted on the World Wide Web without my permission." When a work is dedicated to the public domain, the author may not

restrict how it is used. A statement like this leaves it unclear whether the author really intended to dedicate the work to the public domain. It's wise to seek clarification from the author or ask permission for the restricted use.

Similarly the use of the phrase "copyright free" by the author need not mean the work is dedicated to the public domain. The words "copyright free" are often used to describe works (particularly photos and clip-art) that are under copyright, copies of which are sold to the public for a set fee rather than under a royalty arrangement.

If you have determined that the work is not eligible for copyright protection for any of the reasons outlined in Section C above, you should mark "no" on Line 1 of the checklist at the beginning of this chapter and skip to Line 6. If you determine that the work is eligible for copyright protection, mark "yes" on Line 1 and proceed to Line 2.

Dedicating Works to the Public Domain Through the Creative Commons

The Creative Commons, a nonprofit organization designed to foster the public domain, has establish a program to help copyright owners dedicate their works to the public domain. Copyright owners may dedicate their works to the public domain immediately; or, they can elect to use what the Commons calls "Founders' Copyright"— the original copyright term adopted by the first copyright law in 1790. This consists of an initial term of 14 years after publication, and an additional 14 years if the copyright owner wants it. The copyright owner fills out an online application and sells the copyright to the Creative Commons for $1, and then the organization gives them an exclusive license to the work for 14 or 28 years. If desired, users of the dedicated works can be required to provide attribution to the original author. Works so dedicated to the public domain are listed in the Creative Commons website so people can easily find them. For detailed information, see the Creative Commons website at www .creativecommons.org.

O'Reilly & Associates, a major publisher of computer and technical books, has decided to use the Founders Copyright for its publications, if their authors agree. Hundreds of its titles will be released to the public domain. A list of these can be found on the Creative Commons website.

D. Has the Work Been Published?

If a work can be protected by copyright, as discussed above, you must decide whether it has been published for copyright purposes. Being published for copyright purposes has a specific legal meaning. The answer to this question is vitally important, because it is used to determine whether the work is in the public domain because its copyright has expired or because it lacks a valid copyright notice.

1. Has the Work Been Distributed to the General Public?

A written work is published for copyright purposes when the copyright owner, or someone acting on his or her behalf, makes it available to the *general* public. In other words, any interested member of the public may obtain a copy. *Burke v. National Broadcasting Co.*, 598 F.2d 688 (9th Cir. 1979).

The copies do not necessarily have to be sold for publication to occur; they can also be leased or rented, loaned, or even given away. For example, they can be handed out to the public for free on a street corner or left in a public place for anyone to take. Nor is it necessary for large numbers of copies to be distributed. So long as the work has been made freely available to the general public, it makes no difference if just one copy has been sold or distributed. See

Gottsberger v. Aldine Book Publishing Co., 33 F. 381 (C.C.D. Mass. 1887).

Obviously, if a work is printed and copies are offered for sale to the general public in bookstores, through mail order, or by any other means of public distribution, a publication has occurred. The same holds true for magazines, newspapers, and all other written works made available to the public at large.

However, a publication does not occur simply because an author signed a publishing contract or delivered a manuscript to a publisher, magazine, or newspaper editor. Copies of the work must actually have been printed and distributed, or at least sent to retail dealers for distribution. See *Press Publishing Co. v. Monroe*, 73 F. 196 (2d Cir. 1896).

To be published a work doesn't necessarily have to be disseminated to the public through normal distribution channels like, for example, bookstores, magazine and newspaper racks, subscriptions, or mail order. Other, nontraditional means of distribution can also constitute a publication. For example, courts have ruled that publication occurred where:

- copies of several speeches by Admiral Hyman Rickover (the father of the nuclear Navy) were made freely available to the press and anyone else who requested them. *Public Affairs Associates v. Rickover*, 284 F.2d 262 (D.C. Cir. 1960), and where
- about 200 copies of a manuscript were mimeographed and mailed to

various persons interested in the subject matter with a letter saying they should pass the work on to others after they read it. *White v. Kimmell*, 193 F.2d 744 (9th Cir. 1952).

2. Has the Work Been Performed or Displayed, But Not Distributed?

For a publication to occur for copyright purposes it is crucial that *copies* of the work be made available to the general public. For this reason, merely performing or displaying a work in public is not considered a publication. For example, performing a play in public is not a publication. Copies of the play must be made available to the general public, not just to the actors. *Ferris v. Frohman*, 223 U.S. 424 (1912).

Similarly, delivering a public lecture, speech, or sermon is not a publication. This is so regardless of the size of the audience that hears the speaker. For example, courts have held that Martin Luther King's "I Have a Dream" speech was not published when it was delivered before over 200,000 people at the Lincoln Memorial and broadcast live on television and radio to millions. *Estate of Martin Luther King Jr., Inc. v. CBS Inc.*, 194 F.3d 1211 (11th Cir. 1999).

Publicly displaying a manuscript, letter, or similar item in, for example, a library or museum exhibit also does not constitute a publication.

3. Has the Work Received Only Limited Distribution?

A publication occurs for copyright purposes only when copies are made available to the *general* public—that is, to anyone who wants a copy. In contrast, publication does not occur where copies are limited to a selected group of people for a limited purpose without the right of further distribution, reproduction, or sale. *Academy of Motion Picture Arts & Sciences v. Creative House Promotions*, 944 F.2d 1446 (9th Cir. 1991).

For example, publication would not occur where:

- an author distributes a small number of copies of a manuscript to colleagues or friends for comment and criticism with the understanding that the work may not be duplicated or circulated
- an author or publisher sends a limited number of copies of a work to reviewers so they can write reviews
- a playwright makes copies of a play available to the actors who will perform it
- a teacher distributes texts at a seminar for use only by attendees at the seminar, or
- a company produces an in-house newsletter for its employees who are expressly prohibited from reproducing it or disseminating it outside the company.

Tips for Determining Whether a Work Is Published

Here are some practical tips for determining whether a written work has been published.

Is the Work a Copy?

Publication occurs when *copies* of a work are distributed to the general public. If you know that the item you have is an *original* manuscript, letter, memoir, or other writing, you don't have a copy. Copies of the work may have been made and distributed, but you can't know this without doing some investigating.

On the other hand, if the work is clearly a copy, there's a good chance it has been published. Printed, as opposed to hand-written or typed, works likely are copies. The exceptions would be where the copies were never offered for public distribution or were only distributed to a select audience (see Section D3 above).

The fact that the copy has been professionally printed tends to indicate it has been published, but is not the sole factor. Many unpublished works have been professionally printed, particularly those that have been the subject of limited publication. For example, a syllabus or outline for an educational seminar may be printed yet not published for copyright purpose. You should take the steps listed here until you are convinced that you know whether the work you are investigating has been published or not.

Is There a Copyright Notice?

If you have a copy of the work you should first look for a copyright notice. If a copy of a work has a notice, you can usually assume it was published. However, as mentioned above, authors sometimes place copyright notices on unpublished manuscripts. Such works are still unpublished. If the work looks like an unpublished manuscript, because it is handwritten or was created on an old-fashioned typewriter, don't assume it has been published just because it has a notice. (See Section F for a detailed discussion of what a copyright notice is.)

Are There Other Signs of Publication?

If a copy of a work lacks a notice, it could still have been published. Examine the work carefully for telltale signs. For example:

- **Is the name of a publisher listed on the work?** This almost certainly means the work has been published unless, for some reason, copies of the work were printed but never distributed to the public.
- **Does the work contain a selling price?** This almost certainly means it was offered for sale to the public.
- **If the work is a book, does it contain a Library of Congress Catalog Number (LCCN)?** Since 1900, the Library of Congress has assigned a

Tips for Determining Whether a Work Is Published (continued)

unique identification number for each published book in its catalogued collections. The LCCN is usually printed on a book's copyright page (usually the page on the back of the title page). An LCCN consists of two digits followed by a hyphen and five more digits—for example, 67-12345; it sometimes has the letters CIP typed below it. If a book has an LCCN, it almost certainly has been published. However, if a book has been printed and distributed, but is recalled before it is actually offered for sale to the public, then it has not been published for copyright purposes.

- **Does the work have an international standard book number (ISBN)?** Since 1970, published books have also contained an international standard book number (ISBN). This is a ten-digit number preceded by the letters ISBN. The ISBN is used for cataloguing and ordering purposes. The ISBN can usually be found on the back of a book's title page and/or the back of the book cover (nowadays it's printed in the Universal Product Code (UPC) box (the bar code)). If a book has an ISBN, it definitely has been published.
- **Does the work have an international standard serial number (ISSN)?** Since the mid-1970s, published magazines,

journals, and other periodicals have used an international standard serial number (ISSN) for ordering and cataloguing purposes. An ISSN is an eight-digit number preceded by the letters ISSN—for example, ISSN 1234-5678. The ISSN can usually be found on the same page as the serial publication's masthead or on the page containing instructions for ordering the publication. If a periodical has an ISSN, it definitely has been published.

However, the absence of all these elements doesn't necessarily mean the work is unpublished. For example, a handwritten pamphlet lacking all of these elements would nevertheless be considered published if copies were created and made available to the general public—for example, handed out to the public on street corners.

Check Copyright Office Records

If you're still sure not sure whether the work is published, you can check Copyright Office records to see if the book has been registered. When a work is registered, the applicant must indicate on the registration application whether the work has been published. However, not all published works are registered, so the Copyright Office may have no record for it. (See Chapter 21 for a detailed discussion of how to search Copyright Office records.)

Tips for Determining Whether a Work Is Published (continued)

Check Library Catalogues

Check the card catalogue of the Library of Congress in Washington, DC. You can do this in person or online through the Library's Web page (http://catalog.loc.gov). If a work is listed in the catalogue as published, you can safely assume it has been published. However, contrary to popular belief, the Library of Congress does not contain copies of all works published in the United States. A work may be published but not be in the Library's card catalogue.

Check *Books in Print*

Two reference guides, called *Books in Print* and *Books Out of Print,* can reveal whether a work has been published relatively recently. As its title implies, *Books in Print* lists books that are available for sale to the public, and are, by definition, published. *Books Out of Print* lists books that used to be available, but are now out of print. Books listed in this work are also published for copyright purposes—a book need not still be in print to have been published.

You can access *Books in Print* and *Books Out of Print* online for a fee (www .booksinprint.com).

Check Online Bookstores

Online bookstores such as Amazon.com and Barnesandnoble.com contain much the same information as *Books in Print*. Searching under the title or author's name will reveal whether a work has been published recently.

You might also try checking online bookstores that specialize in used books. They may have older books in their database that don't show up in *Books in Print* or Amazon.com. If the work is listed in such a store's database, you know it's been published. Three of the best-known online used bookstores are alibris.com, powells.com, and bibliofind.com.

Contact the Author

If you think the author is still alive, you can try contacting him or her to ask if the work has been published. But it's probably wise not to mention that you're trying to determine if the work is in the public domain. For detailed information on how to track down authors, see *Getting Permission: How to License & Clear Copyrighted Materials Online & Off,* by Richard Stim (Nolo).

Google Digitizes Public Domain Books

In 2005, the Web search company Google .com announced that it had entered into agreements with several major research libraries to digitally scan millions of books from their collections and make them available on the Internet as part of Google's book search service (http://books.google .com). Google announced that it would make freely available to Internet users full copies of books published in the United States before 1923. These works are all clearly in the public domain because their copyrights have expired. Google will allow access to only a few pages of works published after 1923. Many of these works are in the public domain because their copyrights were never renewed, but Google apparently thinks it is not feasible to research this.

The Authors Guild filed suit against Google in late 2005, claiming that its plan to make digital copies of copyrighted books without first obtaining permission from their copyright owners constituted copyright infringement. Whatever the outcome of this lawsuit, it will have no impact on Google's efforts to make pre-1923 public domain works freely available.

Google is not the only entity with big plans to digitize books. Yahoo.com, the Internet Archive, the University of California, and others have created the Open Content Alliance (OCA) (www. opencontentalliance.org). The OCA plans to digitize hundreds of thousands of books and make them freely available on the Internet. Unlike Google, the OCA will only digitize public domain books.

Given all this activity, it seems certain that virtually every available book published in the United States before 1923 will be freely available on the Internet within the next ten or 20 years.

4. Date and Country of Publication

If you determine that the work you're interested in has been published, you should also determine the year of publication and the country where it was first published. Both these factors will affect how long the U.S. copyright in the work lasts (see Chapter 18).

a. Date of Publication

You only need to know the year, not the exact date, a work was first published. You can usually determine the publication date from the work itself. The vast majority of published written works have copyright notices. The date in the notice is the year date of publication—for example, © 1966 by Scrivener & Sons. (See Chapter 19 for a detailed discussion of copyright notices.)

However, if the work lacks a copyright notice, but you have determined that it was published, you'll have to look elsewhere for clues about when the work was published. It may contain a date of publication somewhere else—for example, on the title page. If not, try the following:

Check the Library of Congress Card catalogue. You can do this in person at the Library in Washington, DC, or online through the Library's Web page (http:// catalog.loc.gov). The Library's catalogue contains the publication dates for millions of written works in the Library's collection.

Check Copyright Office Records. If the work was registered with the U.S. Copyright Office, checking Copyright Office registration records will reveal when it was first published. Many of these records can be researched online (see Chapter 21). However, not all published works are registered with the Copyright Office, so there may be no record for it.

Check Reference Works. There are hundreds of reference works that may be able to tell you when a written work was published. For example, in the realm of literature these include such works as *Contemporary Authors, Contemporary Literary Criticism,* and the *Dictionary of Literary Biography,* all published by Gale Research. Go to a public or university library with a good reference section and ask the reference librarian for assistance. If you're too busy to go to a library, you can post your research questions on the Internet at www.ipl.org (click "Ask a Question") and a reference librarian will email you with advice.

Research the Author. Researching the author of the work may reveal when the work was published. If the author is well-known, a biography or critical study may have a detailed publication history for his or her works.

Use the Internet. Many helpful reference works and much information about authors and their works are available on the Internet. Do a Web search using the author's name, the name of the work involved, and the publisher. There may be a website devoted to the author or even to the particular work, or some online reference with detailed information about the work. A good place to find a list of Internet reference resources is the Internet Public Library at www.ipl.org.

Contact the Publisher. Contact the work's publisher and ask them to tell you when the work was first published.

b. Country of Publication

Unfortunately, a work's country of publication is not listed in the copyright notice. However, books, magazines, newspapers, and other written works typically say where they were published or printed. You can often find this information on the title page or the same page as the copyright notice. If you can't find the country of publication from the work itself, try using the resources listed above—they will ordinarily provide the country of publication as well as the publication date.

If the work has been published, check "yes" on Line 2 of the checklist at the beginning of this chapter. Include the date and country of publication in Line 3 before continuing to Line 4. If the work has not been published, jump to Line 4.

E. Has the Work's Copyright Expired?

Copyright protection does not last forever. When it ends the work enters the public domain. Indeed, the greatest single body of public domain materials is made up of works for which U.S. copyright has expired. Works published in the United States as recently as 1963 could be in the public domain because their copyright expired. Moreover, the copyright for millions of unpublished works expired on Jan. 1, 2003. Because determining the expiration date of a copyright is complex, we have devoted an entire chapter to it. Once you have determined whether the work has been published, you should refer to Chapter 18 for a detailed discussion of copyright duration to determine if copyright protection has expired.

If a work was published after 1963, its copyright has not expired and you need not read Chapter 18 unless you want to know when the work's copyright will eventually expire. You should mark "no" on Line 4 of the checklist at the beginning of this chapter and continue to Line 5.

If you determine that the work has an expired copyright, mark "yes" on Line 4 and skip to Line 6. If the copyright is still in effect, mark "no" on Line 4 and continue to follow the instructions on Line 5.

F. Is the Work in the Public Domain Due to Lack of a Copyright Notice?

Only published works need copyright notices. If a work was never published, it does not need a copyright notice and you do not need to read any more of this section. You should mark "no" on Line 5 of the checklist at the beginning of this chapter and move on to Line 6.

Some works have entered the public domain because they lack a proper copyright notice. They must be published works and they must have been published before 1989, because in that year copyright notices became optional. Examine the work carefully to determine if it has a notice. A copyright notice on a written work must contain three elements:

- the familiar © symbol, the word "Copyright," or the abbreviation "Copr."
- the publication year date, and
- the name of copyright owner.

For example, a proper copyright notice will often look like this:

© 1945 Ralph Cramden

You can usually find the notice on the page immediately following the title page of a book or on the title page itself. Copyright notices for magazines, newspapers, journals, and other periodicals are usually found on the title page, the first page of text, or under the title heading. The notice may also appear in a magazine's masthead.

If you're interested in a work that has been published as part of a larger work—for example, an article published in a magazine or newspaper—it's sufficient that the larger work has a notice. For example, a notice in the name of a magazine will cover all the articles in the magazine.

If the work has a notice in the format described above, it will not be in the public domain for lack of a proper notice. There is no need to read Chapter 19, which explains copyright notice requirements in detail. Mark "yes" on Line 5 of the checklist at the beginning of this chapter and move on to Line 6.

However, if the work has no notice or the notice lacks one of the three elements described above—copyright symbol © or word Copyright, publication date, copyright owner's name—it could be in the public domain. Read Chapter 19 for detailed guidance on how to determine whether a published work is in the public domain because it lacks a valid copyright notice.

If you determine that the work is in the public domain because it lacks a copyright notice, mark "yes" on Line 5. The work is in the public domain. However, you must still read Section G below to avoid several possible copyright traps. If the work has a valid copyright notice or the lack of a notice is excused, mark "no" on Line 5. The work as a whole is not in the public domain. Skip to Line 7 to determine if the work is a derivative work.

G. Does a Copyright Trap Apply?

The copyright law contains some traps for the unwary that might lead you to believe that a work is in the public domain when parts of it might be protected by copyright. This can be so even if you think the work is in the public domain because it's ineligible for copyright protection (see Section C), its copyright has expired (see Section E), or it was published before 1989 without a valid copyright notice (see Section F). If the work is a derivative work or collective work, it may still contain copyrighted elements. Conversely, even if the work as a whole is protected by copyright, substantial portions of it may be in the public domain if it is a derivative or compilation. It's important that you understand what these traps are so you can avoid them.

1. Is the Work a Derivative Work?

When a work enters the public domain you are free to use it any way you want. You can simply republish the work in its original form. For example, Shakespeare's plays have been republished over and over again through the centuries. On the other hand, you can also transform or adapt a public domain work to create a new and different work. Such a work is called a derivative work.

A derivative work is a work that is based upon or adapted from a preexisting work. A good example of a derivative work is a screenplay based on a written work, like the many films and TV programs based on Dickens's tale *A Christmas Carol*. To create such a work, the screenwriter must take a novel's words, characters, and structure, then add his or her own new expression to it. The screenwriter must organize the material into cinematic scenes, add dialogue and camera directions, and delete prose descriptions and other material that can't be filmed. The result is a new work of authorship that can be separately protected by copyright: a screenplay that is clearly different from the novel, yet clearly based upon, or derived from it.

Of course, all works are derivative to some extent. Authorship is more often than not a process of translation and recombination of previously existing ideas, facts, and other elements. Rarely, if ever, does an author create a work that is entirely new. For example, writers of fiction often draw bits and pieces of their characters and plots from other fictional works they have read. The same is true of writers of factual works. However, a work is derivative for copyright purposes only if its author has taken a substantial amount of a previously existing work's expression—that is, the author's original words and the structure and organization of the material.

How much is substantial? Enough so that the average intended reader of the work would conclude that it had been adapted from or based upon the previously existing expression. There is no precise numerical formula that can be applied here. You must use your common sense. This is what judges and juries do when they are called upon to decide whether one work infringes upon another.

The right to create derivative works is one of the exclusive rights a copyright owner has. So long as a work is under copyright, permission must be obtained from the copyright owner to create a derivative work from it. However, once a work enters the public domain anyone can create a derivative work from it without permission and can obtain copyright protection for the material added to create the new work.

An uncountable number of derivative works have been created from public domain works. This creates a real trap for the unwary because a work you might think is in the public domain could be a derivative work that is entitled to some copyright protection. Before you conclude that any work is in the public domain you

must make sure that it is not a protected derivative work. This is usually not difficult.

a. Types of Derivative Works

There are many different ways a public domain written work may be adapted or transformed into a derivative work protected, at least in part, by copyright law. The following list shows the various types of derivative works that can be created from writings. It lists what preexisting material the derivative work author takes and what new material he or she adds to create the derivative work.

i. Editorial Revisions and Elaborations

Preexisting material taken: The entire text of any preexisting work.

New material added: Editorial revisions and/or other new material such as new illustrations and photographs.

> **EXAMPLE:** An economist, takes Adam Smith's classic public domain work on economics, *The Wealth of Nations*, and updates and revises it to reflect current economic thinking. He adds several new chapters and revises the other chapters in light of recent developments. The new edition is a derivative work based on, but not designed to take the place of, the original edition.

ii. Fictionalizations

Preexisting material taken: A substantial portion of the protected material contained in a factual work (biography, history, etc.).

New material added: Editing, reorganization, new dialogue, descriptions, and other new material needed to transform the preexisting nonfiction work into a novel, play, screenplay, or other work of fiction.

> **EXAMPLE:** Art takes General Ulysses S. Grant's memoirs (whose copyright expired long ago) and transforms them into a stageplay. To do so, he deletes prose descriptions, adds new dialogue, organizes the work into scenes and acts, and adds new scenes and incidents that weren't in the memoirs. But he also retains as much of Grant's expression—his words—as possible. The play is a derivative work based on the nonfiction memoirs.

iii. Dramatizations

Preexisting material taken: All or a substantial part of the material in a fictional work not meant to be performed in public—that is, a short story, novel, or poem.

New material added: Editing, reorganization, new dialogue, and other new material needed to transform the work into a work that can be performed in public—for instance, a stageplay or screenplay.

EXAMPLE: Leslie takes Charles Dickens's public domain novel *Great Expectations* and transforms it into a screenplay.

iv. Translations Into a New Medium

Preexisting material taken: All or a substantial portion of the text of a written work in one medium—for example, a published book.

New material added: Transfer of the work into a new medium.

> **EXAMPLE:** Audio Books hires an actor to make a recording of the novel *Vanity Fair* by Thackeray and markets the tape as an audio book. The recording is a derivative work based on the written public domain novel.

v. Translations Into a New Language

Preexisting material taken: All the material contained in a preexisting work.

New material added: Translation of the work into a new version in another language.

> **EXAMPLE:** Mark Twain's public domain novel *The Adventures of Tom Sawyer* is translated into French. To do so, the translator takes Twain's expression (the words contained in the novel) and replaces them with French words. The resulting translation is a derivative work based on the original English-language novel.

vi. Abridgments and Condensations

Preexisting material taken: A substantial portion of a work's protectable material.

New material added: Editing and other revisions that transform the work into a new, shorter version.

> **EXAMPLE:** *Reader's Digest* condensed books creates an abridged version of Herman Melville's public domain novel *Moby Dick*.

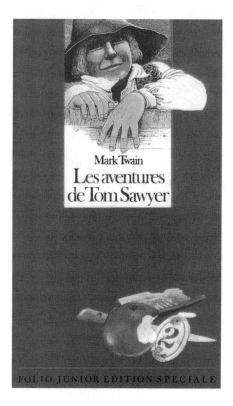

Mark Twain
Les aventures
de Tom Sawyer

FOLIO JUNIOR EDITION SPECIALE

vii. Annotations

Preexisting material taken: All or a substantial portion of a work's protected material.

New material added: Notes and/or other materials that clarify the meaning of the preexisting text.

> **EXAMPLE:** The annotated version of Lewis Carroll's work *Alice in Wonderland* is a derivative work prepared from the original public domain version of the book.

b. Extent of Copyright Protection for Derivative Works

Whenever a derivative work is created from a public domain work, only the new material added by the author of the derivative work is entitled to copyright protection. The original work remains in the public domain, as do those portions of the original work that are used in the new derivative work, since they come entirely from the original public domain material.

Thus, in all the examples of derivative works listed above, only the *new* material added is protected by copyright. For example, the author of a screenplay based on Dickens's public domain novel *Great Expectations* is entitled to copyright protection only for the new material she adds to create the screenplay—for example, new dialogue or scenes. Anyone may create his or her own screenplay of *Great Expectations.* Such a person may copy freely from the public domain novel, but may not copy without permission any new elements present in the prior screenplay.

c. Changes Not Entitled to Copyright Protection

To create a derivative work, an author must make more than merely trivial or minuscule changes to the original work. Changes that are unoriginal or completely uncreative do not merit copyright protection. To be protectable, a derivative work must differ from the preexisting work in some meaningful way.

Examples of changes to preexisting written works that courts have held do *not* merit copyright protection include:

- 40,000 changes to a book, consisting "almost entirely of elimination and addition of punctuation, changes of spelling of certain words, elimination and addition of quotation marks and correction of typographical errors." *Grove Press, Inc. v. Collectors Publication, Inc.*, 264 F.Supp. 603 (C.D. Cal. 1967).

- translating a list of 850 single words and 45 short phrases from Arabic into English and then transliterating the Arabic words into Roman letters with phonetic spellings. *Signo Trading Int'l, Ltd. v Gordon*, 535 F.Supp. 363 (N.D. Cal. 1981).

- changing the language of a public domain form for the sale of merchandise from a sales contract to a service contract, a change requiring

only a few minor wording changes. *Donald v. Uarco Business Forms*, 478 F.2d 764 (8th Cir. 1973).

- Making minor wording changes to the well-known Cajun sayings "We *gon* pass a good time, *cher*," and "You *gotta* suck *da* head on *dem der* crawfish." (*Emanation, Inc. v. Zomba Recording, Inc.*, 2003 U.S. App. LEXIS 17146 (5th Cir. 2003).)

Works such as these receive no copyright protection at all if the original is in the public domain. For example, if a publisher merely corrects punctuation and spelling errors in a public domain work and republishes it, you are free to copy the entire republished work.

In some cases it may be difficult to tell for certain whether the changes someone has made to a public domain work are significant enough to merit copyright protection. See Chapter 1, Section B, for detailed guidance on how to deal with such public domain gray areas.

d. Scholarly Editions

Scholarly or "definitive" editions of famous public domain writings are constantly being published. These include, for example, new editions of the works of Mark Twain, Shakespeare, Thomas Hardy, D.H. Lawrence, and many others. Copyright is frequently claimed in these new editions because they contain copyright notices.

New editions of public domain works can be copyrighted derivative works if they contain annotations or substantial editorial revisions or additions. However, copyright protection extends only to the new material added to the original public domain work. For example, if a publisher adds a preface and explanatory notes to a new edition of Charles Dickens's *Great Expectations*, the additions are copyrighted. But Dickens's words remain in the public domain.

What about changes to the public domain text itself—can these be copyrighted? Changes that consist only of correcting misspellings and typographical errors or standardizing punctuation are not copyrightable because they are not sufficiently original or creative. However, some scholarly editions of classic public domain works add new material. If this has never been published before, it is copyrightable. For example, a new edition of D.H. Lawrence's 1915 novel *The Rainbow*

Books, Reading and Writing Illustrations, Dover Publications

contains previously unpublished material from Lawrence's manuscript. This new material is protected by copyright. In this case, Lawrence's heirs own the new material, since Lawrence originally wrote it. The editors or their publisher would own new material created by the editors of the new edition.

New editions that don't include any unpublished material may also be copyrightable—for example, where an editor prepares a "definitive" edition of a public domain work from multiple prior editions. *Matthew Bender v. West Publishing Corp.*, 158 F.3d 674, n. 14 (2d Cir. 1998). This would be true, for example, where prior editions of a public domain work contain many differences in content and the editor must pick and choose among all the differences to devise what the editor views as a "definitive" version of the work. The editor's selection of which portions of the work to include in his or her "definitive" edition would be copyrightable. But, again, the actual words contained in the work would remain in the public domain.

If copyright is claimed in a new edition of a public domain work, it will ordinarily contain a copyright notice. Sometimes the notice will indicate the elements of the work where copyright is claimed. Unfortunately, this is not always the case (see Section H below). Explanatory notes may also reveal what changes or additions have been made to the original text. Checking Copyright Office registration records for the work may also be helpful (see Chapter 21).

EXAMPLE: A new "definitive" edition of Mark Twain's classic novel *The Adventures of Huckleberry Finn* was published in 1996. This edition contained substantial new material from Twain's handwritten manuscript, which had been lost for decades. The new material was copyrighted, even though the original published version of the novel entered the public domain in 1942. (See Chapter 18, Section B, for a detailed discussion of this issue.)

The new edition contained an excellent copyright notice that made clear that copyright was only being claimed in the previously unpublished material and in an introduction, foreword, and afterword written by the editors of the work. The notice says:

Previously unpublished text, foreword, and afterword copyright © by The Mark Twain Foundation

Introduction copyright © by Justin Kaplan

In addition, the new edition contained extensive editorial notes that allow the reader to determine what material was added and what was taken from the original version of the novel. By referring to these notes, one can avoid using any of the copyrighted material.

The easy way to avoid problems is to avoid using new editions of public domain works in which copyright is claimed. Use an older edition or one that doesn't include

a copyright notice. Although, technically speaking, use of copyright notices is optional on works published since 1989 (see Chapter 19), in practice they are almost universally used in books, magazines, and other written publications in which copyright is claimed. Absence of a notice strongly indicates that no copyright is being claimed in the publication. This is particularly likely to be true where a public domain work is republished.

e. Digital Copies of Public Domain Writings

The rise of the Internet as one of the most important communications mediums of our time has led to the widespread practice of making digital copies of public domain works for use on the World Wide Web and commercial online services such as Dialog, Nexis, Lexis, and Westlaw. Such public domain works include U.S. government works, laws and court decisions, and works whose copyright has expired, such as the novels of Charles Dickens or the poetry of Lord Byron.

To create the digital copy, the work is normally either scanned with a computer scanner (a device that makes a digital copy of a printed page or photo) or retyped into a computer. The people and companies who do this often place copyright notices on their digital copies. They apparently are claiming the digital copies are protectable derivative works. Are they? Probably not.

Downloading Material From the Internet

You need to be careful when you download (copy to your own computer) public domain writings from the Internet. You could inadvertently download copyrighted material. For example, if you download a public domain document from a Web page, you could end up downloading not only the public domain work itself, but the HTML (Hypertext Markup Language) code used to design the Web page. This code may be copyrighted. You can avoid this by downloading only the public domain elements of a website instead of the whole site. For example, you could download just the words of the public domain document and save them with a word processing program such as Microsoft Word without copying any of the website's code. It is also possible to remove HTML coding with text editor software.

In 1988, the Copyright Office issued a policy decision regarding the ability to copyright typefaces that said, "digitization of … a pre-existing copyrightable work does not result in a new work of authorship. The digitized version is a copy of the pre-existing work and would be protected as such, but no new work of authorship is created. A novel may be digitized and stored in an electronic medium. Protection depends on the status of copyright in the novel; digitization does not add any new

authorship." *Copyright Office Policy Decision on Copyrightability of Digitized Typefaces,* 53 Federal Register 189 (Sept. 29, 1988).

Under this view, an exact digital copy of a preexisting work is copyrighted only if the preexisting work is protected. If the preexisting work is in the public domain, the digital copy is too. This is because an exact digital copy of a written work does not require any originality or even minimal creativity—two of the requirements for copyright protection. A digital copy of a text is no more a copyrightable work of authorship than a photocopy of a page of text.

The Copyright Office's view is persuasive and is in line with the long-standing policy of the courts that "a copy of something in the public domain will not, if it be merely a copy, support a copyright.... [T]o support a copyright there must be at least some substantial variation, not merely a trivial variation such as might occur in the translation to a different medium." *L. Batlin & Son, Inc. v. Snyder*, 536 F.2d 486 (2d Cir. 1976).

The Copyright Office's observation is not binding on the courts, but would likely be given some weight by them. Moreover, it was bolstered by a court decision that exact photographic reproductions of old master paintings were not sufficiently original to merit copyright protection as derivative works. *The Bridgeman Art Library, Ltd. v. Corel Corp.*, 25 F.Supp.2d 421 (S.D. N.Y. 1999); see Chapter 5). There would seem to be even less originality involved in making a digital copy of a text than a photograph of a painting.

In addition, courts have consistently held that translations of computer programs from a form of computer code readable by humans (source code) to a form readable only by computers (object code) do not create protectable derivative works. Transforming a written text from letters on a page to digital ones and zeros that can be understood only by a computer should likewise not create a protectable derivative work.

So, even if a digital copy of a public domain text has a copyright notice, it likely is not protected by copyright. To enjoy such protection, something new must be added to the text. If you find a copyright notice on a Web page containing a copy of a public domain text, elements such as the format of the Web page and the computer code used to create it may be copyrighted, but the copied public domain text is not.

However, there has been no definitive court ruling on this issue. It is possible, therefore, that the creator of a digital copy could sue you if you download and distribute the digital copy without permission (assuming the creator could prove that you did so). There's a very good chance you'd win such a suit, but you'd still have to go through the trauma and expense of litigation.

For detailed guidance on how to deal with gray areas of the public domain, such as whether digital copies of public domain works are also public domain, see Chapter 1, Section B.

You can avoid even the possibility of this happening by retyping the digital copy or copying it by hand rather than downloading it into your computer and thereby copying the digital copy. The maker of such a digital copy holds no copyright in the words themselves; they might only argue that they hold a copyright in the transformation of the words into a digital format that a computer can read. Alternatively, you can always copy the original public domain document if you have access to it.

f. Microfilms of Public Domain Works

In order to save space, many public domain written works have been microfilmed and the original copies discarded by libraries and archives. This is particularly common for public domain newspapers and magazines. It's not unusual to find copyright notices on such microfilm editions of public domain works, usually in the name of the company that created the microfilm. However, a microfilm—that is, a photograph—of a public domain text is almost certainly not copyrightable because no creativity is required to take such a photo. Indeed, a microfilm of a text should be no more copyrightable than a photocopy. The creation of such copies is a purely mechanical act that does not result in any copyrightable authorship.

Where a number of public domain works are collected together in a single microfilm edition, there may be a limited copyright in the selection and arrangement of the entire work, but not in the individual microfilms themselves (see Chapter 12).

g. When Derivative Work Is Public Domain but Original Is Not

It's possible for a derivative work to enter the public domain while the original work, upon which it is based, is still protected by copyright. This can happen, for example, if the derivative work was published before 1964 and its copyright was not renewed on time 28 years after its publication, but the original work was renewed on time. (See Chapter 18 for an explanation of timely renewal.) It could also happen if the derivative work was published before March 1, 1989 without a valid copyright notice while the original work had a valid notice. (See Chapter 19 for more on this issue.)

If the derivative work enters the public domain does this mean the original work automatically becomes public domain too? The answer is no. The original work remains copyrighted, as do those portions of the original included within the derivative work. All that enters the public domain are the new elements that the creator of the derivative work added to the original work.

> EXAMPLE: George Bernard Shaw's 1913 play *Pygmalion* was turned into a movie (starring Leslie Howard and Wendy Hiller) in 1938. The copyright in the movie, a derivative work based upon the play, was not renewed in

1966 and therefore entered the public domain in 1967 (see Chapter 7). However, the copyright on the play was renewed on time by Shaw in 1941 and remained under copyright through 1988. The court held that the fact that the movie was in the public domain had no effect on the copyright status of the original play. It was still entitled to a full term of copyright protection. In addition, those portions of the play (dialogue, story) that were used to make the derivative film were also still protected by copyright through 1988. *Russell v. Price*, 612 F.2d 1123 (9th Cir. 1979).

Because the original work is still protected by copyright, the derivative work may not be used without permission from the owner of the original work. This is because by using the derivative work one ordinarily must also use those portions of the original work included within it. This meant that the film *Pygmalion* could not be distributed without permission from Shaw's estate (the holder of the copyright in the play *Pygmalion*). Distributing the film without such permission violated the copyright in the original play. (But after 1988, the play entered the public domain and both the movie and the play could be distributed without such permission.)

The only exception to the permission requirement in this situation would be where only the new public domain elements added to create the derivative work are used.

EXAMPLE: Assume that a student edition of Tennessee Williams's plays was published in 1960. The work contained copious notes and annotations created by the editors. The student edition was a derivative work—an annotation. The notes and annotations were protected by copyright as were the plays themselves. However, the student edition's copyright was not renewed in 1988 and the work entered the public domain (see Chapter 18). Williams's plays are still protected by copyright, but the notes and annotations are in the public domain. You can freely copy these notes from the student edition, but you cannot use the plays themselves without permission from Williams's estate.

h. Avoiding Problems With Derivative Works

Unless you're careful, you could end up using a work you think is in the public domain that is really a protected derivative work. Here's a real-life example:

In 1912 the Senate Commerce Committee conducted extensive hearings on the *Titanic* disaster at which many of the survivors testified. The lengthy reports of these hearings were published by the Government Printing Office. The report, a U.S. government work, was in the public domain. Some 86 years later, Pocket Books published a one-volume version of this report. You might think this work was also

in the public domain, but you'd be wrong. It is a protected derivative work.

This is because the Pocket Books version was not an exact copy of the report. Rather, a reporter from *The New York Times,* Tom Kuntz, edited the multivolume report into a single 570-page volume and added an introduction and a number of public domain photographs. This made the work an editorial revision—one type of protected derivative work (see Section G1). The new expression Kuntz added to the original public domain report is protected by copyright—that is, his selection and editing of the material to include in the book and his introduction. None of the individual words, sentences, or paragraphs is protected, but the work as a whole is. You can copy selected portions of the book, but you can't copy the *entire* book without

Senate Commerce Subcommitte Investigation, Library of Congress

The Titanic Disaster Hearings, by Tom Kuntz

The New York Times, April 16, 1912

permission. To do would violate Kuntz's copyright in his selection and editing.

This is why you should always examine a published work carefully for a copyright notice, even if you think it should be in the public domain. If it contains a notice, it may be a derivative work. If you look at the copyright notice included in the Pocket Books edition of *The Titanic Disaster Hearings*, you'd find it states "Introduction and compilation copyright © 1998 by Tom Kuntz." This makes it quite clear what portions of the work are copyrighted.

You can avoid having to ask permission to use a derivative work based on a public domain work by using only those portions of the work copied from the original work. But this is not always possible. For example, it would not be possible to use any portion of an English translation of a foreign-language public domain work, since the entire translation is protected.

Another option is to find and use the original work—for example, although a 1995 English translation of Homer's *Iliad* is copyrighted, the original Greek version is in the public domain. Or, you can use an earlier derivative work that is in the public domain—for example, a translation of *The Iliad* published in 1920 is in the public domain (because the copyright has expired) and may be copied freely.

If you determine that the work is a derivative work, check "yes" on Line 7 and skip to Line 9. If the work is not a derivative work, check "no" and continue to Line 8.

2. Is the Work a Compilation?

Besides derivative works described in the previous section, there is yet another way an author can create a copyrightable work from public domain materials. This is by creating a compilation.

A compilation is a work created by selecting, organizing, and arranging previously existing material in such a way that the resulting work as a whole constitutes an original work of authorship. Compilations differ from derivative works because the author of a compilation makes no changes in the preexisting material and need not add any new material of her own. Moreover, protectable compilations can be created solely from material that is in the public domain.

a. Fact Compilations (Databases)

One basic type of protectable compilation is a fact compilation or database. This type of compilation is created by selecting and arranging facts or other items that are not works of authorship and are therefore in the public domain. These types of compilations are discussed in detail in Chapter 12.

b. Collective Works

Selecting preexisting materials that are separate and independent works of authorship into one whole work may also create a compilation. Such compilations are called collective works. Many written works are collective works.

> **EXAMPLE:** Elliot compiles an anthology of the 25 best American short stories published during the 1990s. Each story is a separate and independent work that was protected by copyright the moment it was created. However, Elliot has created a new protectable collective work by selecting and arranging the stories into a collective whole, that is, a collection of the best short stories of the 1990s.

Other examples of collective works include newspapers, magazines, and other periodicals in which separately protectable articles are combined into a collective whole, encyclopedias consisting of independently protectable articles on various topics, and collections of the various writings by a single author. Collective works are discussed in detail in Chapter 12.

If you determine that the work is a compilation, check "yes" in Line 8 and continue to Line 9. If the work is not a compilation, check "no." None of the words in the work are in the public domain, but the work may contain public domain elements such as ideas and facts (see Chapter 14). Do not continue.

H. Misuse of Copyright Notices

Public domain works are constantly being used to create new derivative works and collective works. If public domain writings are used to create a new derivative work or collective work, the work is entitled to contain a copyright notice when it is published.

The best practice when this is done is for the publisher to indicate in the notice what elements of the public domain work are copyrighted. For example, the copyright notice for an English translation of Caesar's *Gallic Wars* states: "Translation copyright © by 1985 by Anne Wiseman, Illustrations copyright © 1985 by Barry Cunliffe."

However, there is no legal requirement that the copyright notice explicitly state what elements of the work are copyrighted. The notice only need state the name of the copyright owner of the derivative or collective work and the date it was published. In fact, many publishers don't bother to make clear what portion of the work the notice covers. Thus, for example, the copyright notice for *The Oxford Anthology of English Literature*, states simply "Copyright © 1973 by Oxford University Press, Inc."

Though legal, a notice such as this is extremely misleading. A reader unfamiliar with the niceties of copyright law might believe that the notice means that Oxford University Press holds the copyright to the entire work. In fact, it means no such thing. *The Oxford Anthology of English Literature*

consists of a collection of literary works that are almost all in the public domain because their copyrights have expired, such as poems by Wordsworth and Keats, a novella by Joseph Conrad, and a portion of a work by Thomas Carlyle. Despite what the copyright notice says, Oxford University Press does not own a copyright in these works. It only holds a copyright in the new material added to these works to create the anthology—that is, to the selection of the materials included in the anthology and to introductions and notes written for the anthology by its editors. The literary works themselves are in the public domain and may be copied freely.

An even worse example is the reprinting of the novel *Ben-Hur* by Regnery Publishing, Inc. The copyright notice for this work states "Copyright © 1998 by Regnery Publishing." This novel, first published in 1880, is in the public domain. The copyright notice applies only to a short introduction Regnery added to its edition of the novel.

To add insult to injury, Regnery also includes the following statement after the misleading copyright notice: "All rights reserved. No part of this publication may be reproduced or transmitted in any form or by any means electronic or mechanical, including photocopy, recording, or any information storage and retrieval system now known or to be invented, without permission from the publisher, except by a reviewer who wishes to quote brief passages with a review written for inclusion in a magazine, newspaper, or broadcast."

This statement has absolutely no legal effect and appears to be included by the publisher in an effort to intimidate readers into not copying or otherwise using the novel. In fact, anyone is free to photocopy, transmit or record *Ben-Hur* without the publisher's permission. It's only the new introduction that can't be used.

Remember, anyone can place a copyright notice on any written work. You don't need permission from the Copyright Office or anyone else to do so. The fact that a work has a notice doesn't mean that all or part of it isn't in the public domain.

When you find a copyright notice on a work that contains public domain material, you need to investigate carefully to figure out what new authorship has been added to the preexisting public domain materials. Only this new authorship is entitled to copyright protection, no matter what the copyright notice says. If you can't tell from the work itself what new material has been added, you could try checking Copyright Office registration records (see Chapter 21) or comparing it with earlier versions of the same work.

I. Sources of Public Domain Writings

Generally, it is easier to obtain public domain writings than any other type of public domain work. This is because an institution exists whose primary function is to preserve for posterity books and other

written works, many of which are in the public domain: the library. Large municipal and university libraries contain millions of public domain writings.

1. Specialty Libraries

If you're interested in finding public domain writings in a particular field, there are thousands of libraries containing special collections—everything from aardvarks to zoology. However, the fact that a library has a work you want doesn't necessarily mean they'll give you unfettered access to it. If the work is rare or valuable, the library might not permit you to remove it from the premises or might not even give you access to it in the first place. Although virtually any library will permit you to copy a work by hand, you may need special permission to photocopy or photograph the work.

a. Print Resources for Finding Libraries

The reference section of a your public library will likely have one or more of the following guides to specialty libraries:

- *Gale's Directory of Special Libraries and Information Centers* (Gale)
- *Gale's Research Center Directory* (Gale)
- *Subject Collections*, by Lee Ash and William G. Miller (R.R. Bowker)
- *The New York Public Library Book of How and Where to Look It Up*, edited by Sherwood Harris (Stonesong Press).

b. Internet Resources for Libraries and Archives

Thousands of libraries all over the world maintain websites that describe their collections. You can also conduct online searches of many libraries' card catalogues. Following is a list of some useful library websites:

- www.yahoo.com/r/lb
 A listing of library websites at the Yahoo Internet Directory
- http://catalog.loc.gov
 The extensive website of the Library of Congress located in Washington, DC. The Library of Congress is the largest library in the world.
- www.uidaho.edu/special-collections/Other.Repositories.html
 A listing of over 3,700 websites describing holdings of manuscripts, archives, rare books, historical photographs, and other primary sources.

2. Public Domain Writings on the Internet

Digital copies of thousands of public domain works have been posted on the Internet by hundreds of individuals and organizations. Federally funded programs to digitize and place on the Internet milions of public domain books are now underway.

Some of the best sites for online books are:

- The On-line Books Page, which has over 10,000 listings; the internet

address is: www.digital.library
.upenn.edu/books

- the Internet Public Library, which
 has over 7,700 listings; the internet
 address is www.ipl.org/reading/books
- Project Gutenberg, which has over
 6,000 listings (http://promo.net/pg/
 index.html)
- Project Bartleby, maintained by
 Columbia University (www.bartleby
 .com/index.html)
- www.ibiblio.org contains links to
 many websites with public domain
 materials.
- The Universal Library, sponsored by
 Carnegie Mellon University. Its goal is
 to digitize one million books by 2005;
 (www.ul.cs.cmu.edu/html/index.html).
- Wikipedia—an online encyclopedia—
 contains many public domain links
 (http://en2.wikipedia.org/wiki/
 Wikipedia:Public_domain_resources).

Information about, and links to, these and
other public domain projects can be found
at the Internet Archive (www.archive.org).

Many other websites contain public domain
materials. For example, the extensive website
maintained by the IRS at www.irs
.gov contains virtually every IRS form and
publication. Most other U.S. government
agencies have websites as well. Lots of
nongovernment websites contain public
domain materials as well. For a detailed
discussion of the public domain and the
Internet, refer to Chapter 17.

3. Reprints of Public Domain Works

Classic public domain works such as
Shakespeare's plays and Dickens's novels
are constantly being republished in new
editions. These are readily available in
bookstores and through online booksellers
such as Amazon.com.

In addition, one U.S. publisher specializes
in republishing more obscure public domain
works. This is Dover Publications, which
publishes over 500 public domain books
each year on science, mathematics, art,
literature, history, and social science. Some
recent titles include *The Influence of Sea-
power Upon History*, by A.T. Mahan, and
Concerning the Spiritual in Art, by Vassily
Kandinsky. You can obtain a catalogue of
its publications by writing to Department
GI, Dover Publications, Inc., 31 East 2nd St.,
Mineola, NY 11501.

4. Used Bookstores

Copies of public domain books, magazines,
and other printed works may also be
obtained from used bookstores. It's now
possible to purchase used books through
the Internet. Three of the best known
websites for used books are www.alibris
.com, www.bibliofind.com, and www
.powells.com. These first two websites
can access the stock from many used
bookstores.

5. U.S. Government Works

A vast number of U.S. government works, all in the public domain, are available. For example, the U.S. Government Printing Office sells more than 20,000 different publications that originated in various federal government agencies; their phone number is 202-783-3238; some materials are available for free from their website at www.access.gpo.gov. A list of all GPO publications available for sale can be found at http://bookstore.gpo.gov.

Most federal agencies have their own libraries and archives, mostly located in Washington, DC. Government Depository Libraries throughout the country also have mountains of U.S. government publications.

You can find a list of all government depository websites on the World Wide Web at www.gpoaccess.gov/libraries.html.

An excellent guide to both government and nongovernment libraries and archives in the Washington, DC, area is *The Look-It-Up Guide to Washington Libraries & Archives,* by Laura Bergheim. This book includes separate sections on federal, university, public, and special libraries. There are also special sections on the Smithsonian Institution libraries, the Library of Congress, and the National Archives.

A list of hundreds of sources of U.S. government materials can be found in the book *Information U.S.A.,* by Matthew Lesko (Penguin Books). ■

Chapter 4

Music

Music Checklist

1. Has the music been published? (See Section C.)

 ☐ Yes: Continue.

 ☐ No: Skip to line 3.

2. Date of publication: _____

 Country of publication: _____

3. Has the copyright in the music expired? (See Section D.)

 ☐ Yes: Skip to line 5.

 ☐ No: Continue.

4. Is the music in the public domain due to lack of a copyright notice? (See Section E.)

 ☐ Yes: Continue.

 ☐ No: Work as a whole is not in public domain. Skip to line 9.

5. Is the music a derivative work? (See Section F.)

 ☐ Yes: Continue.

 ☐ No: Continue.

6. Is the music an arrangement or adaptation? (See Section G.)

 ☐ Yes: Continue.

 ☐ No: Continue.

7. Is the music a collective work? (See Section H.)

 ☐ Yes: Continue.

 ☐ No: Entire work is in the public domain. Do not continue.

8. Is new material copyrighted? (See Sections F, G, and H.)

 ☐ Yes: Work as a whole is not in public domain. Continue to line 9 to determine if work contains public domain elements.

 ☐ No: Entire work is in the public domain. Do not continue.

9. Does the music have public domain elements? (See Section I.)

 ☐ Yes: Public domain elements may be freely used.

 ☐ No: No part of the work is in the public domain.

This chapter deals with two forms of music: sheet music and sound recordings. Few sound recordings are in the public domain, but vast amounts of sheet music and musical scores are. This sheet music—and the lyrics published along with it—represents one of the richest parts of the creative treasure trove that is the public domain. Most of the sheet music for the greatest classical music ever written is in the public domain, as is the sheet music for many popular and traditional songs. (See Appendix A for a list of hundreds of famous songs that are in the public domain.)

Many Works That Are in the Public Domain in the United States Are Still Protected by Copyright Abroad, and Vice Versa. This chapter only covers the public domain in the United States. For a detailed discussion of the public domain outside the United States, see Chapter 16.

A. The Difference Between Music and Sound Recordings

Musical compositions—such as pop songs, classical symphonies, or operas—are protected by copyright. Protection begins once the composer creates and fixes the composition in some tangible form, traditionally by writing it down using musical notation, commonly in the form of sheet music. However, a composition can also be fixed by recording it on cassette tape or any other recording medium.

Since copyright expires after a number of years, vast numbers of musical compositions, from one or two pages of sheet music to full-length musical scores, are in the public domain. (See Chapter 18 for details on when copyrights expire.)

Before the advent of recording devices in the late 19th century, copyright protection for sheet music and musical scores was all that was necessary to protect the rights of composers, since it was not possible to save their music for later replay. But with the advent of recording devices, a second form of music copyright—called "sound recording" copyright—was created to protect recorded performances. Sound recording copyright only protects the way a musical composition is performed and recorded. There can be many sound recordings of a composition, but there is only one underlying musical copyright for the song. For example, there are hundreds of recordings of the song "Yesterday," each with its own sound recording copyright. However, there is only one musical composition copyright for the song.

Very few sound recordings are in the public domain, a situation that won't change for many decades. For a detailed discussion of why, read Section K below. Because of this reality, this entire chapter—except Section K—concerns sheet music, not musical recordings.

B. What Can You Do With Public Domain Sheet Music?

When sheet music is in the public domain, it is freely available to be performed in public, recorded, copied and distributed, and used to create new types of musical works. All of this can be done without asking permission or paying permission fees to composers, music publishing companies, or anyone who previously controlled the copyright on a piece of music.

1. Publicly Performing Sheet Music

You might be surprised to learn that copyrighted sheet music cannot be freely performed in public. With some exceptions noted below (nonprofit or religious performances), permission from the copyright owner—typically, a music publisher—is needed to perform sheet music at a place open to the public or where a substantial number of people outside the normal circle of a family and social acquaintances are gathered. This includes, for example, performing sheet music live over the radio or on television, performing a song in a nightclub or concert hall, webcasting a performance, playing sheet music during a football game half-time, or playing live music at a dancing school.

The permission fees for these types of public performances are called performance royalties. Almost all music publishers, composers, and songwriters belong to performance rights societies. These companies offer license agreements allowing music to be publicly performed in return for a fee. The best known of these societies are ASCAP and BMI. The fees charged vary according to the nature of the use—they may range from a few hundred dollars at bars or dancing schools to many thousands of dollars to perform music in a large concert hall or on television.

No performance royalties need be paid when sheet music is in the public domain. It can be publicly performed at any place, for any reason, for free.

2. Recording Sheet Music

Permission must also be obtained to record a copyrighted song or other musical composition on an audio recording such as a compact disc or cassette recording. The fees for this permission are called mechanical royalties. Mechanical royalty rates range from about six cents to eight cents per copy. For example, if you wanted to make 10,000 compact discs of a copyrighted song, you'd have to pay $600 to $800 in mechanical royalties to the music publisher.

In contrast, public domain music can be recorded for free. Of course, tens of thousands of recordings of public domain classical music have been made. But classical music is not the only public domain music that is recorded. For example, performers such as Peter, Paul and Mary, Pete Seeger, and Joan Baez have made fortunes recording public domain folk songs, like "John Henry" and "Down by the Riverside."

Nonprofit or Religious Musical Performances Are Permitted

It is legal to publicly perform copyrighted music without obtaining permission from the copyright owner in the following situations. This includes performing sheet music or playing a musical recording before a live audience.

- **Religious services.** No permission is needed to use music at a house of worship. This exemption applies to both religious and nonreligious music so long as it is performed in the course of religious services. However, permission is required to broadcast music performed at a religious service and to copy sheet music used for religious purposes.

- **Free shows.** No permission is needed if sheet music or a musical recording is played before a live audience, performers are not paid, and admission is not charged.

- **Shows for charitable or educational purposes.** No permission is needed if sheet music is used or a music recording is played before a live audience, so long as the performers are not paid, the net proceeds are used exclusively for education, charitable, or religious purposes, and the music publisher is notified and given more than ten days to object. If the publisher objects, permission must be obtained.

- **Agricultural fairs.** Permission is also not required to perform sheet music or play a musical recording for a live audience at nonprofit agricultural or horticultural fairs.

- **Fraternal and veterans events.** Permission is not required when nonprofit veterans' organization like the American Legion or fraternal groups like the Elks or Shriners perform sheet music or play musical recordings, provided that the general public is not invited and the net profits are used exclusively for charity.

- **Sorority and fraternity events.** Permission is not required to perform music or play music recordings at college fraternity and sorority social functions, provided that the purpose is solely to raise funds for charity. 17 U.S.C. Section 110.

From Public Domain to Public Domain

Musician Dave Alvin and his brother used to collect old blues, folk, rhythm & blues, and country recordings, including many long-out-of-print reissue albums on obscure labels. When looking for material for a solo album in 2000, Alvin decided to use many of these public domain songs. The result is *Public Domain*, a recording released by Oakland's Hightone Records (www.hightone.com). Among the songs recorded by Alvin were "Shenandoah," "Walk Right In," "Short Life of Trouble," "What Did the Deep Sea Say," "Engine 143," "Delia," and "The Murder of the Lawson Family." Because the songs were in the public domain, Hightone Records didn't have to pay any mechanical royalties to use them.

Public Domain, Dave Alvin, Ⓟ © copyright Hightone Records

3. Reproducing Sheet Music

Permission is also required to republish copyrighted sheet music or lyrics in a book or magazine, on a website, to photocopy them, or to reproduce lyrics on album liner notes. The fees for this vary widely. Of course, if sheet music and lyrics are in the public domain, you may reproduce them in any way you want for free. No permission is necessary from anybody.

Teaching From the Public Domain

Fred, a piano teacher based in Northern California, has photocopied the sheet music for hundreds of public domain piano pieces. These range from the works of classical composers such as Chopin to folk and traditional songs. He found the sheet music in used bookstores, flea markets, and in newly published collections of public domain music. He keeps his public domain music collection in a large filing cabinet and from time to time makes photocopies of various pieces to give to his students. Because the music is in the public domain, he may photocopy it freely for any purpose.

4. Using Sheet Music in Audiovisual Works

Permission is also required to play copyrighted sheet music or lyrics in a movie, television show, commercial, or video. These types of permissions are called synchronization licenses or videogram licenses, depending on the use. These are the most expensive permissions of all. For example, you may have to pay as much as $250,000 to use a famous Gershwin song in a television commercial. Fees for using copyrighted music in a movie can range from just a few thousand dollars to $25,000 or more.

Again, public domain sheet music may be performed in an audiovisual work without paying these permission fees.

5. Using Sheet Music in Digital Works

You have to pay for permission as well if you want to record and include copyrighted sheet music in a digital product such as a computer or video game or multimedia CD-ROM program. Royalty rates for such uses vary. To use a song in a video game, you may have to pay a royalty of 0.5% to 1% of the retail price of the game. Royalties for multimedia CD-ROM uses are typically between five and 15 cents per unit.

Of course, you may make your own recording of public domain sheet music

and include it on a digital product without having to pay any permission fees.

6. Adapting Sheet Music

If you want to borrow or adapt a melody or lyric from a copyrighted song and use it in a new song of your own, you must obtain permission from the music publisher. In the case of well-known works, permission may not be available at any price. Permission must also be obtained to create and publish or perform an entirely new arrangement of a copyrighted work.

Once a song or other musical composition enters the public domain, you may adapt it in any way you wish. Thousands of the greatest melodies ever written by the greatest musical geniuses are free for the taking.

Classical composers have been borrowing from each other for centuries. For example, there is a long tradition in classical music of creating variations—taking a theme or melody from another composer and adapting it into a new work. Beethoven, Hayden, Schubert, Chopin, Brahms, Tchaikovsky, and many other classical composers all created variations. Classical composers have also drawn heavily from folk music—for example, Brahms's *Hungarian Dances* and Liszt's *Hungarian Rhapsodies* are based on ancient Hungarian gypsy tunes, while many of Bach's melodies are based on traditional

airs. Even popular music has found its way into classical works. For example, Charles Ives's Fourth Symphony quotes such famous public domain songs as "Yankee Doodle" and "Turkey in the Straw." The Center for the History of Music Theory and Literature, at Indiana University's School of Music, has compiled an extraordinary bibliography listing hundreds of examples of composers who have borrowed from preexisting works. It can be found on the Internet at www.music.indiana.edu/borrowing.

But classical composers aren't the only ones who borrow. Many popular song-writers have created hits by adapting public domain music, including:

- "Besame Mucho" (1944), based on the "Nightingale" aria from *Goyescas* by Enrique Granados
- "A Fifth of Beethoven" (1976), based on Beethoven's Fifth Symphony
- "Good Night Sweetheart" (1931), based on themes from Schubert's Symphony in C and the Liszt *Preludes*
- "Love Me Tender" (1956), based on "Aura Lee" by George Poulton
- "The Lion Sleeps Tonight" (also called "Wimoweh") (1962), based on a traditional African song.

Public domain music is also constantly being adapted for movies, television, commercials, elevator music, and many other uses.

Everything Old Can Be New Again

A four-member pop band called angel corpus christi was looking for tunes for a new album they planned to record. A member of the band happened upon an old folk song collection for sale at a flea market. Among the songs in the collection was the traditional British song "Froggy Went a Courtin'," originally written to lampoon the marriage of a British king. The band borrowed the public domain melody and added a new lyric about a slacker who lives with his mother. The band recorded the song under the title "Slacker Son." A portion of the lyric from the old version went as follows:

Froggy went a courtin' and he did ride, uh huh.

Froggy went a courtin' and he did ride, uh huh.

Froggy went a courtin' and he did ride, Sword and pistol by his side, uh huh.

The new lyric went like this:

Mrs. Sawyer's got a slacker son
Mrs. Sawyer's got a slacker son
Drinkin' Slurpees at the store
An hour later back for more
Mrs. Sawyer's got a slacker son.

Because "Froggy Went a Courtin'" was in the public domain, angel corpus christi was free to alter the lyric and record the song without obtaining permission from or paying royalties to a music publisher.

How to Use This Chapter

To help you determine the status of a musical work, we have created the checklist at the beginning of this chapter for you to follow. Each step in the process is described in the checklist and each line has a reference to one or more of the sections listed below or to other chapters of this book. If you have a particular work you are researching, start at Line 1 on the chart. As you answer each question you will be led to the appropriate section or chapters necessary to answer the next question on the checklist. At the end of the process you will know whether the work you want to use is in the public domain.

We have also included a worksheet you may use to document how you determined that a particular work was in the public domain (Appendix C). By filling out the sheet, you will be able to document your research and conclusions should anyone challenge your right to use the work. (See Chapter 1, Section D, and Appendix C.)

What If the Work Is Not in the Public Domain? If you find that the work you want to use is not in the public domain, you may be able to use it anyway under a legal exception called "fair use" (see Chapter 22). If you do not qualify for this exception, you will need to obtain permission to use the work. For a detailed discussion of how to obtain copyright permissions refer to *Getting Permission: How to License & Clear Copyrighted Materials Online & Off*, by Richard Stim (Nolo).

C. Has the Sheet Music Been Published?

The first question you need to answer to determine whether sheet music is in the public domain is whether or not it has been published. This will determine how long the copyright in the work lasts and whether it had to contain a copyright notice when it was published.

Sheet music is published for copyright purposes when the copyright owner—or someone acting on behalf of the copyright owner—makes one or more copies of the music available to the *general* public. In other words, any interested member of the public may obtain a copy. *Burke v. National Broadcasting Co.*, 598 F.2d 688 (9th Cir. 1979).

If sheet music is printed and the copies offered for sale to the general public in music stores, bookstores, through mail order, or by any other means of public distribution, publication has occurred. But to be published a work doesn't necessarily have to be disseminated to the public through normal distribution channels such as music stores. Nontraditional means of distribution can also constitute a publication —for example, where a songwriter/performer sold copies of his songs to audiences or sold them to the public through a website.

Moreover, the copies don't necessarily have to be offered for sale for a publication to occur: they can also be leased or rented, loaned, or even given away—for example, where copies of a symphony or choral work

are rented to orchestras and choruses. Nor is it necessary for large numbers of copies to be distributed. So long as the work has been made available to the general public, it makes no difference if just one copy has been sold or distributed. *Gottsberger v. Aldine Book Publishing Co.*, 33 Fed. 381 (C.C.D. Mass. 1887).

1. Sheet Music Is Not Published by Public Performance

For a publication to occur for copyright purposes it is crucial that *copies* of the work be made available to the general public. For this reason, merely performing music in public is not a publication. This is so whether the music is performed before a

Humorous Victorian Spot Illustrations,
Dover Publications

live audience or a performance is broadcast to the public by radio or television. Copies of the sheet music must be made available to the general public for publication to occur. *Ferris v. Frohman*, 223 U.S. 424 (1912).

2. Music Not Published by Pre-1978 Recordings

Prior to 1978, a song or other musical work was published for copyright purposes only when copies of the sheet music were publicly distributed. Distribution of sound recordings made before 1978 does not constitute a publication of the music on the recording.

> **EXAMPLE:** Imagine that the song "Do Wa Wa" was written in 1958 and recorded by the Baddelles in 1959. The recording was publicly distributed throughout 1959 by Stim Records, Inc. However, the sheet music for the song was never copied and publicly distributed. As a result, the song was not published for copyright purposes, even though thousands of people bought the recording.

This rule was changed beginning January 1, 1978. So sound recordings made and distributed after that date *do* result in publication of the music on the recording.

> **EXAMPLE:** The song "What the Gnu Knew" was written in 1944, and recorded in that year and then again in 1950, 1962, 1968, and 1979. The sheet

music for the song was never copied and distributed. However, the song was published when the 1979 recording was publicly distributed.

3. Determining Whether Sheet Music Is Published

There are a number of ways to determine whether sheet music has been published.

a. Examine a Copy

If you have a copy of the sheet music, examine it carefully. You can be virtually certain that sheet music has been published if it has been professionally printed and contains a copyright notice; the familiar © symbol followed by the date of publication and copyright owner's name—for example, © 1945 by Good Music, Inc. The copyright notice normally was printed on the first page or on the title page (or the cover, in the case of sheet music for a single song).

⚠️ **If the Copy of the Music You're Examining Isn't the Original Edition or a Facsimile of the Original,** the publication date in the notice may not be the date the original version of the music was published (see Section H).

If the sheet music lacks a copyright notice, it could still have been published. Look for telltale signs of publication. For example:

- **Is the name of a music publisher listed on the work?** This almost certainly means the sheet music has been published unless, for some reason, copies of the work were printed but never distributed to the public.
- **Does the sheet music contain a selling price?** This almost certainly means it was offered for sale to the public.

b. Check Music References

If you're still not sure whether the work is published, you will need to do some research. There are many music reference works that you can consult to determine whether a work has been published. Most of these also give the date of publication that can be used to determine whether the copyright in the work has expired. (See Section C4 for a list of references.)

c. Check Music Stores

Try visiting or calling a music store that carries sheet music to see if they sell copies of the piece. If they do, the work has been published.

d. Check Copyright Office Records

You can also check the Copyright Office's records to see if the sheet music has been registered. When a work is registered, the applicant must indicate on the registration application whether the work has been published. However, not all published

music is registered, so the Copyright Office may have no record for it. (See Chapter 21 for a detailed discussion of how to search Copyright Office records.)

e. Check Library Catalogues

Also, check the card catalogue of the Library of Congress in Washington, DC. You can do this in person or on the Internet through the Library's website at www.loc.gov. If a work is listed in the catalogue as published, you can safely assume it has been published. However, contrary to popular belief, the Library of Congress does not contain copies of all works published in the United States. A work may be published but not be in the Library's card catalogue.

4. How to Determine the Year a Musical Work Was Published

It's not enough to determine that a musical work was published at some time. To determine whether the copyright has expired, you must find out the year it was originally published. (The exact date isn't necessary, just the year.) There are several ways to determine this.

a. Examine the Copyright Notice

If you have access to the sheet music, simply look at the publication date in the copyright notice. This will usually be on the first page or the title page.

Note carefully, however, that unless the sheet music you're examining is the original published version or a copy of it, it's quite possible that the date in the notice is not the date the music was first published. When public domain music is republished, you'll often find copyright notices containing recent publication dates. For example, one edition of several Chopin piano works contains a 1987 copyright notice. Of course, Chopin's music was not originally published in 1987. In these cases, the music publisher is claiming copyright protection for a new arrangement or edition of the work (see Section G) or a compilation copyright for the selection and grouping of the work in a sheet music collection (see Section H).

The publication date in copyright notices such as these only represents the year the arrangement or collection was published, not the year the original version of the work was published. Therefore, this date is useless for determining whether the copyright in the original version of the work has expired. You will usually need to do a little more research to determine the original publication date of a work.

b. Use Music Reference Works

There are many music reference works you can consult to determine whether a work has been published—that is, if it's not listed as published you can assume it's unpublished. You can also use these works to help determine when a work has been published.

MY BUDDY

Original Version

By GUS KAHN and
WALTER DONALDSON

These references include the following:

Biographical Dictionaries of Music. There are several biographical musical dictionaries that alphabetically list the names of composers and give the dates of publication for many of their best-known works. Of course, you must know the name of the composer of a song to efficiently use such a work. Such works include:

- *Baker's Biographical Dictionary of Popular Music* (Ruhlmann)
- *The Da Capo Companion to 20th Century Popular Music*, by Phil Hardy and Dave Laing (Da Capo Press)
- *The Harvard Biographical Dictionary of Music*, Don Michael Randel (Editor) (Harvard University Press Reference Library)
- *The Oxford Dictionary of Music*, Michael Kennedy and Joyce Bourne (Editors) (Oxford University Press).

Musical Biographies. Hundreds of biographies of well-known composers have been written. These will generally list the composers' works (at least the well-known ones) and often provide publication dates.

Song Lists. These works list songs alphabetically or by composer and give the date of publication:

- *The Book of World-Famous Music*, by James J. Fuld (Dover Publications). A stunning work of scholarship, this book gives the complete publication history for hundreds of well-known works, popular, folk, and classical.
- *The Da Capo Catalog of Classical Music Compositions*, by Jerzy

Chwialkowski (Da Capo Press). This work lists all the known works created by 132 of the best-known classical composers. However, it usually gives the dates such works were created, not the dates they were first published. This limits its usefulness for the researcher. However, it does include the publication date for every George Gershwin song.

- *The Great Song Thesaurus*, by Roger Lax and Frederick Smith (Oxford University Press). This work lists thousands of popular songs starting in 1226. If a work is listed here, you can be certain it was published sometime. However, note carefully that the dates provided in this book are not always the dates the works were actually published, but rather the dates they became popular (which could be some time after initial publication).
- *The Oxford Companion to Popular Music*, by Peter Gammond (Oxford University Press), lists thousands of popular songs. When a © is included with a date, this is the date the work was first published.
- *Who Wrote That Song?*, by Dick Jacobs & Harriet Jacobs (Writer's Digest Books), gives the publication dates for over 12,500 American popular songs. This is probably the cheapest and best resource if you want to know the publication date of any relatively well-known American popular song.

Guides to Public Domain Music. Appendix A to this book contains a list of hundreds of well-known popular songs that are in the public domain because their copyright has expired. Several other similar lists have been created. However, with the exception of the list on the Public Domain Music website, these tend to be very expensive or hard to find. They include:

- *Public Domain Music Song List.* The Public Domain Music website (www .pdinfo.com) has an alphabetical, searchable list of over 3,000 public domain songs available for free to anyone with Internet access.
- *Music In the Public Domain*, by Marji Hazen, is no longer available in print but the content—over 5,000 songs in the public domain—is available at www.pdinfo.com
- *Public Domain Music Bible, Vols. 1 & 2*, Scott A. Johnson (Editor) (Public Domain Research Corp.). Each volume lists several thousand public domain songs. However, the cost is $377 per volume. The same information can be obtained from the other resources listed here.
- *The Mini-Encyclopedia of Public Domain Songs, 1998*, by Barbara Zimmerman (Bz Rights Stuff Inc.). This book bills itself as "a listing of the best-known songs in the Public Domain in print today." The book

contains over 800 well-known songs. The book is available in print form or on diskette for IBM compatible or Macintosh computers. It costs $299 and may be obtained from Amazon.com and BarnesandNoble.com.

- *Directory of Public Domain Music.* Lists over 15,000 titles in the public domain. It costs $95. It may be ordered from Katzmarek Publishing at P.O. Box 326, Clearwater, MN 55320; telephone: 320-558-6801; Fax: 320-558-6637; URL: http://hometown .aol.com/KATZMAREK/pdmusic.htm.

Year-by-Year Musical Bibliographies. There are several musical bibliographies that attempt to list all the sheet music published in a given year. These include:

- *Popular Music, 1900-1919*, by Barbara Cohen-Stratyner (Gale Research 1988). All the songs listed here are in the public domain.
- *Popular Music: An Annotated Index of American Popular Songs. Volume 5: 1920-1929* (Adrian Press, 1969). All the songs listed in this book for the years 1920-1922 are in the public domain.
- *Variety Music Cavalcade, 1620-1969: A Chronology of Vocal and Instrumental Music Popular in the United States*, by Julius Mattfeld (Prentice Hall, 1971). This is a year-by-year list.

Special Rules for Music First Published Outside the U.S.

Special rules apply to music that was first published outside the United States. Much foreign music that used to be in the public domain had its copyright renewed on Jan. 1, 1996. This included foreign works whose copyrights expired because they were never renewed and works published in countries with which the United States had no copyright relations.

Of particular interest to the classical music world is the fact that all music published in the Soviet Union before 1973 used to be in the public domain in the United States because the two countries had no copyright relations before that year. The copyright in all this music has been restored provided that it is still under copyright in Russia or the other nations of the former Soviet Union. This includes, for example, most of the works by the great Soviet composers Prokofiev, Khachaturian, and Shostakovich, as well as early works by Schnittke, Gubaidulina, Shchedrin, Denisov, and others.

ASCAP, the music collective rights agency, has a searchable list posted on its website of many works in its repertory that have had their copyright restored; the URL is: www.ascap.com/restored_works/restore_index.cpm.

See Chapter 15 for a detailed discussion.

5. Determining the Country in Which Music Was Published

In addition to the year date of publication, you need to know the country in which the sheet music was published. Published sheet music and musical scores usually show the country of publication. You'll normally find it on the title page or the same page as the copyright notice. If not, try using the following resources:

Check the Library of Congress Card Catalogue. You can do this in person at the Library in Washington, DC, or online through the Library's Web page (http://catalog.loc.gov). The Library's catalogue contains the publication dates for millions of written works in the Library's collection.

Check Copyright Office Records. If the sheet music was registered with the U.S. Copyright Office, checking Copyright Office registration records will reveal where it was first published. Many of these records can be researched online (see Chapter 21). However, not all published musical works are registered with the Copyright Office, so there may be no record for it.

Check Music Reference Works. Check the music reference works listed in the previous section. These will often provide the country of publication.

Research the Composer. Researching the composer of the work may reveal where the work was published. If the composer is well-known, a biography or critical study may have a detailed publication history for his or her works.

Use the Internet. Many helpful reference works and much information about composers and their works are available on the Internet. Do a Web search using the composer's name, the name of the work involved, and the publisher. There may be a website devoted to the composer or even to the particular work, or some online reference with detailed information about the work. A good place to find a list of Internet reference resources is the Internet Public Library at www.ipl.org.

Contact the Publisher. The work's publisher will likely be able to tell you where the work was first published.

■ If you have determined that the work you are researching has been published for copyright purposes, mark "yes" on line 1 of the checklist at the beginning of this chapter and fill in the date and country of publication in Line 2 before moving on to Line 3. If the work has not been published, mark "no" and go directly to Line 3 on the checklist.

D. Has the Copyright in the Music Expired?

Copyright protection does not last forever. When it ends the work enters the public domain where it remains forever. The greatest single body of public domain music is works for which the U.S. copyright has expired. This includes most classical music

and many popular songs by such famed composers as Irving Berlin.

Unfortunately, determining whether a copyright has expired can be somewhat complex. You'll need to determine which of several possible copyright terms apply to the work in question. Sheet music published as recently as 1963 could be in the public domain. On the other hand, music created over one hundred years ago (and more) could still be protected by copyright.

Copyright terms for all creative works are the same no matter what type of work it is, so they are discussed in detail in one place: Chapter 18. Turn to that chapter to determine whether the copyright in a work you're interested in has expired.

⚠ **You Cannot Determine Whether the Copyright for a Work Has Expired Unless You Know Whether It Has Been Published, and If So, the Year and Country of Publication.** If you haven't already done so, be sure to read Section C above for a detailed discussion of when music is published. Do this before you read Chapter 18.

■ If you determine that the music you want to use is in the public domain because the copyright has expired, mark "yes" on Line 3. There is no need for you to read Section E below. However, you should skip to Line 5 on the checklist and proceed from there. If the copyright on the work has not expired, mark "no" on Line 3 and continue on to Section F below.

E. Is the Music in the Public Domain Due to Lack of a Copyright Notice?

Before reading this section, you should have determined whether the sheet music you want to use has been published for copyright purposes (see Section C above). If the sheet music was never published, it doesn't need a copyright notice. You don't need to read any more of this section. Go on to Section F.

If sheet music was published before 1989 without a valid copyright notice, it could be in the public domain. A copyright notice on a work of sheet music must contain three elements—the familiar © or the word Copyright or abbreviation "Copr.," the publication date, and name of copyright owner—for example: © Buddy Budapest 1945. You can usually find the notice on the title page or first page of sheet music. If the sheet music has been published as part of a collection, it's sufficient that the collection itself has a notice. Each individual piece included in such a collection need not have its own notice (although they often do).

If the work has a notice in the format described above, it will not be in the public domain for lack of a proper copyright. There is no need to read Chapter 19, which explains copyright notice requirements in detail. Go on to the next section.

However, if the work has no notice or the notice lacks one of the three elements described above, it could be in the public domain. Read Chapter 19 for detailed guidance on how to determine whether a published work is in the public domain because it lacks a valid copyright notice.

If you determine that the music is in the public domain because it lacks a valid copyright notice, mark "yes" on Line 4 and continue on to Line 5. If you mark "no" on Line 4, the work as a whole is not in the public domain. You should skip to Line 9 to see if the work has elements you may use.

F. Is It a Derivative Work?

A derivative work is one that is based on or adapted from one or more preexisting works. A classic example of a derivative work is a movie based on a novel. The movie is a new work based on or adapted from the preexisting novel. Musical works can also be derivative works. Examples include:

- musical arrangements or orchestrations of preexisting works—for example, when unique harmonies are added to a folk song
- musical adaptations in which original melodies and rhythms are reworked —for example, a jazz version of the "Battle Hymn of the Republic"
- adding lyrics to an instrumental work or rewriting or translating the lyric for an existing song

- abridgments of existing musical works
—for example, creating a new 30-
minute version of a four-hour Wagner
opera
- new instrumentation—for example,
changing an orchestral work into a
form playable on the piano or other
keyboard or changing a piano piece
into a work for orchestra (as Ravel did
many times), and
- new published editions of sheet music
in which the editor adds substantial
new copyrightable material (see
Section G3).

1. No Permission Needed Where Preexisting Work Is in Public Domain

When a composer creates a musical work,
one of the rights he or she receives through
copyright is the exclusive right to create
derivative works from it. That is, only the
composer or other copyright owner has the
right to fashion a new work based on the
existing work. However, when musicians
obtain permission to record a copyrighted
song, they are ordinarily given some latitude
to make minor changes. But substantial
changes to the structure, such as altering
the lyrics or melody, require explicit per-
mission. For example, you would need to
obtain permission from Cole Porter's estate
to alter the lyrics or melody of the famous
1932 Porter song "Night and Day."

In addition to permission to create your
derivative work, you would also need
permission to reproduce those portions of
the original copyrighted song included in
your new work.

Once a work enters the public domain,
all the composer's or other copyright
owner's exclusive rights come to an end.
Anyone can play or record the work and
can create a derivative work from the public
domain work without obtaining permission.
For example, you are free to create new
versions of any of Stephen Foster's songs—
such as "Beautiful Dreamer," "Oh! Susanna,"
or "Jeanie With the Light Brown Hair"—
since the copyright for these songs expired
long ago.

2. Only New Material Is Copyrightable

When a person creates a derivative work
from preexisting public domain music,
only the new material added to the old
work can be copyrighted by the creator of
the derivative work. All the public domain
material included in the derivative work
remains in the public domain. For example,
if you took a portion of a Chopin nocturne
and added a lyric to it, the new lyric would
be copyrighted, but none of Chopin's music
would be. Anyone else would be free to
use the same Chopin nocturne, but they
could not copy your lyrics without your
permission.

If you determine the work is a
derivative work, mark "yes" on
Line 5 and continue to Line 6. If it is not a

derivative work mark "no" and continue to Line 6.

G. Is It an Arrangement or Adaptation?

If you go into the sheet music department of any music store and examine recently published sheet music for the works of such composers as Bach, Beethoven, and Chopin, you'll be surprised to find copyright notices in the music publishers' names. The same is true for many old popular music gems such as the songs of Stephen Foster and traditional songs such as "Greensleeves" that have been around for centuries.

The copyright in the original versions of classic works such as these expired long ago; or, in the case of extremely old works such as the music of J.S. Bach, they were never entitled to copyright protection in the first place. As explained in detail in Chapter 18, all such works are in the public domain. So why are music publishers claiming copyright by placing copyright notices on them?

The publisher's copyright claim may be completely spurious. This would be the case, for example, where a publisher reprints an exact copy of the original sheet music for a work in the public domain and simply adds a copyright notice. A straight reprinting of a public domain work is not entitled to any new copyright protection. Such a reprint may be copied as freely as the original version of the work.

Usually one of two things is happening when music publishers place copyright notices on public domain works:

- the publisher is claiming that its edition of the work is a copyrightable arrangement or adaptation, or
- the work is published as part of a sheet music collection for which the publisher claims a compilation copyright.

Arrangements and adaptations are discussed in this section. Copyright for sheet music compilations is discussed in Section H.

If the music you're interested in is not an arrangement or part of a music collection, you can skip sections G, H, and I and go on to Section J, which discusses where to find public domain sheet music.

There is hardly a single well-known public domain work for which someone hasn't claimed to have made a new arrangement and claimed a new copyright. For many popular public domain musical works, hundreds of arrangements have been registered with the Copyright Office—for example, over 300 arrangements for the public domain song "America the Beautiful" have been registered since 1950.

In some cases, these claims are valid and the creator or publisher of the arrangement is entitled to copyright protection for the material added to the original work. However, in many other cases the changes in the new arrangement are not significant enough to merit copyright protection.

Unfortunately, it can be difficult to determine which arrangements are protected by copyright and which are not. Refer to Chapter 1 for detailed guidance on how to deal with such public domain gray areas.

Music Publishers Have an Economic Incentive to Claim a Copyright

Music publishers have a strong incentive to claim copyright protection when they republish public domain music: money. The published sheet music for a public domain song usually costs several dollars. It only costs a few cents a page to photocopy sheet music (and the money for photocopying doesn't go to the publisher). If a music publisher is able to convince you that its publication is protected by copyright and may not be photocopied, it will make money because you'll have to buy its sheet music rather than make a copy. If you want more than one copy, you'll have to buy several copies. This can add up to millions of dollars in sales for sheet music publishers.

1. Avoiding Problems With Arrangements

Musical arrangements present a hornet's nest of copyright problems. But fortunately there are two simple ways to avoid these problems.

a. Use the Original Public Domain Song

You completely avoid worries about copyrighted arrangements where you use the original public domain version of the song. This involves either using the original sheet music for the work or a later published edition that is identical to the original. How do you know if a later published edition of a song or other musical work is identical to the original? Often, the sheet music publisher will tell you so somewhere on the work. The absence of a copyright notice in the publisher's name is also a sure sign that the work is not a new arrangement. Publishers almost always add new copyright notices to new arrangements.

You can also tell that the music in a newly published edition is the same as the original public domain music where the edition consists of exact copies of the original sheet music. These copies are in the public domain and can be copied freely—a music publisher doesn't get a new copyright by publishing an exact copy of public domain sheet music. However, the publisher may have a collective work copyright in the work as a whole (see Section H). Many sheet music collections consist of exact copies of the original sheet music. Before the advent of modern-day computers and printing processes, sheet music printing plates were quite expensive to make. For this reason, most music collections were reprints of the original sheet music using the original plates. But, even today many exact copies of public

domain sheet music are being made. The photo in Section G3 below is an example of a facsimile copy of public domain sheet music.

Section J below lists many resources for finding the original public domain versions of songs and other musical compositions.

b. Use Public Domain Arrangements

Many arrangements of public domain songs are also in the public domain because their copyrights have expired. For example, if the publication date in the copyright notice is before 1923, the copyright in the arrangement has expired. You can use the arrangement freely.

> EXAMPLE: G. Schirmer, the well-known publisher of classical music, published an edition of a Beethoven sonata. The edition contains a number of editorial comments and new fingerings. Schirmer claimed copyright in the edition and included a copyright notice on the title page. However, the copyright notice reveals that the G. Schirmer edition was published in 1894. Even if the changes Schirmer's editors made to the original public domain version of the sonata were copyrightable, this edition is in the public domain because it was published before 1923.

Even if the date in the notice is after 1923, the arrangement could still be in the public domain. All works first published in the United States between 1923 and 1963

had to be renewed during the 28th year after publication or they entered the public domain. Thus, even if the arrangement contained material protected by copyright, it will be in the public domain if the copyright was not renewed during the 28th year of publication. You must check Copyright Office records to see if a renewal was filed (see Chapter 21). If you discover that no renewal was filed, it is in the public domain and you may use the work for any purpose.

> EXAMPLE: The Remick Music Corp. published an arrangement by pianist Eddie Duchin of the well-known popular song "My Buddy" by Gus Kahn and Walter Donaldson. The original version of "My Buddy" was published in 1922 and is therefore in the public domain. The copyright notice for the Duchin arrangement contains a 1935 publication date. The arrangement would only retain its copyright if Remick filed a renewal notice 28 years after it was published, in 1963. Copyright Office records must be checked to determine if the arrangement was renewed.

2. Using Arrangements for Which Copyright Is Claimed

Unfortunately, it may not always be possible to obtain a copy of the original public domain version of a song or an arrangement that is in the public domain. The only

readily available version of a work in the public domain may be a recently published arrangement for which copyright is claimed. In this situation, you must decide how to deal with the arrangement. You have two options:

- you can treat the copyright claim as valid and seek permission from the music publisher to copy, record, or otherwise use the work, or
- you can determine whether the arrangement is really copyrightable and, if not, treat it as if it is in the public domain.

If you decide to treat the copyright claim as valid and seek permission from the music publisher to copy, record, or otherwise use the work, there is no need to read the rest of this section. If you want to determine whether the arrangement really has copyright protection, follow the step-by-step approach described below.

For detailed guidance on how to obtain permission to use copyrighted music, refer to *Getting Permission: How to License & Clear Copyrighted Materials Online & Off*, by Richard Stim (Nolo).

a. Step #1: Determine What Changes Have Been Made

Before you can know whether an arrangement is or is not copyrightable, you must determine exactly what changes have been made to the original public domain work. It can be very difficult to determine just what changes have been made, because an arranger or publisher is not required to explain on the arrangement how it has been altered from the original. If the arrangement has been registered with the Copyright Office, the copyright registration will contain a brief description of how the work was changed. But this is usually too general to be of much help—for example, it may simply say "new arrangement for piano and orchestra."

In many cases the only way to know for sure what changes have been made is to compare the arrangement with the original unaltered version of the work. You'll have to obtain a copy to compare with the new arrangement. Obviously, if you have access to the original public domain version, you can simply use it to copy, adapt, or play rather than bother with the new arrangement. In this event, you can skip the rest of this discussion.

Fortunately, it may be possible to determine what changes have been made in an arrangement without obtaining a copy of the original public domain version of the music—for example:

- You may be intimately familiar with the original version of the music and not need to compare the original with the arrangement to see what changes were made.
- The music publisher may indicate what changes were made. This information is often on the same page as the copyright notice or in a preface or introduction.

The well-known piano music collection *Easy Classics to Moderns* published by

Consolidated Music Publishers provides a good example of how a publisher may let you know what changes were made to public domain music. It contains a foreword on the title page that says:

> *All selections are in their easy original form ... are neither re-arranged or simplified. In very rare cases pieces have been transposed to more suitable keys, but are otherwise unaltered. Marks of phrasing and expression are often editorial additions, especially in music of the Purcell-to-Beethoven period.*

b. Step #2: Determine Whether the Arrangement Is Copyrightable

After you determine what changes the arranger or editor has made to the public domain version of the music, you must decide whether the changes are worthy of copyright protection. Use the guidelines in Section G3 below to decide whether the changes are substantial and copyrightable, or trivial or obvious and therefore uncopyrightable. If you decide the arrangement is clearly not copyrightable, you may elect to treat it as a public domain work. If you decide the changes are copyrightable, you must obtain permission to use the arrangement. However, even if you're certain an arrangement is not copyrightable, a music publisher may disagree with you and complain or even sue you for copying it. Before you do such copying, read Chapter 1 for a detailed discussion of how to weigh the risks involved.

In some cases, it will be clear that an arrangement is not copyrightable—for example, where the only change is the transposition of the work from one key to another. In other cases where far more substantial changes have been made, it may be difficult to decide whether they merit copyright protection or not. It may be possible to remove the changes and create your own public domain version of the music (see "Getting Paid for Your Own Arrangements of Public Domain Works," in Section G3, below). But if this is not possible, refer to Chapter 1 for detailed guidance on how to deal with public domain gray areas.

Beware of Collective Works. Be careful if the work you want to use is printed in a collection—that is, an edition that contains a number of individual works. Even if an arrangement for a particular piece in such a collection is not copyrightable, the publisher may have a valid collective work copyright in the collection as a whole. That is, a copyright in the manner in which all the individual pieces in the collection were selected and placed (see Section H).

3. Which Arrangements Are Copyrightable?

Some arrangements or adaptations of public domain music can obtain copyright protection, many others cannot.

Unfortunately, the legal standards in this area are hazy. It is generally accepted, however, that an arrangement, adaptation, or alteration of a public domain musical work must be the result of originality and at least a minimal amount of creativity to obtain a valid copyright.

It is easier to tell when an arrangement is not original than when it is. No originality exists where the changes to a work in the public domain are:

- obvious, routine, or typical
- trivial
- mechanical in nature, or
- dictated solely by musical convention or tradition.

This is so even where substantial effort, skill, or musical training is required to make such changes. For example, "cocktail pianist variations" of a piece that are "standard fare in the music trade by any competent musician" are not copyrightable. *Woods v. Bourne,* 841 F.Supp. 118 (S.D. N.Y. 1994). Likewise, changes to a public domain work that can be created by music computer software with just the press of a key—for example, transposing a work from one key to another—cannot obtain a valid copyright (see Section G3, Subsection b).

For an arrangement to be copyrightable, "there must be something of substance added making the piece to some extent a new work with the old song embedded in it but from which the new has developed." See *Woods v. Bourne Co.*, 60 F.3d 978 (2d Cir. 1995). In other words, the changes must be substantial or great enough so that the arrangement is to some extent a new work. In the case of a popular song, examples of such substantial changes would be such things as "unusual vocal treatment, additional lyrics of consequence, unusual altered harmonies, novel sequential uses of themes." *Woods v. Bourne,* 841 F.Supp. 118 (S.D. N.Y. 1994).

One way to determine whether an arranger has exercised the requisite originality and creativity is to ask whether the arranger had to choose among a number of aesthetic choices in creating the arrangement. Without choice, there can be no originality and no copyright protection.

Below are examples of the types of changes that are frequently made to public domain music along with discussions as to whether such changes are copyrightable.

The sheet music for the song "Glow Worm" is reproduced below. Below is a copy of the original sheet music, which is in the public domain because it was published in 1912 and the copyright has expired. (See Chapter 18 for a detailed discussion of copyright terms.) The next illustration is an exact copy of the original sheet music published in 1994 by the well-known music publisher Hal Leonard. The only difference from the original is that Hal Leonard has added guitar chord charts showing guitarists what chords to play if they accompany a singer of the song. This change is clearly not copyrightable—guitar chord charts are in the public domain and adding them to a song is a totally mechanical act. Nevertheless, Hal Leonard has added a copyright notice to the sheet music in its

Copy of the original sheet music published in 1912

Copy of the original sheet music published in 1994 by Hal Leonard

name dated 1994. Hal Leonard is apparently claiming copyright protection for his arrangement. This claim is clearly spurious.

Copyright Notices Are Not Conclusive

Even if a work contains a copyright notice, it may not actually have copyright protection. Anyone can put a copyright notice on any work. No permission is required from the Copyright Office or any other government agency. All a copyright notice means is that someone claims that a work is protected by copyright law.

A copyright notice is not necessarily valid, even if the work has been registered with the Copyright Office. A Copyright Office opinion that an arrangement has copyright protection is not binding on you or the courts. In several instances courts have determined that arrangements registered with the Copyright Office were not copyrightable.

For example, a music publisher called Bourne Co. registered with the Copyright Office 16 different arrangements for the song "When the Red, Red, Robin Comes Bob, Bob, Bobbin' Along." When Bourne attempted to enforce its claimed copyright in these arrangements in court, the judge held that they did not merit copyright protection because they were not sufficiently original. *Woods v. Bourne*, 60 F.3d 978 (2d Cir. 1995).

a. New Editions

Public domain music is often republished in new editions and the publishers of such new editions often claim copyright in them. However, despite what music publishers may claim, new editions of public domain music are not protected by copyright.

As mentioned above, one type of new edition that is clearly not copyrightable is a reproduction of a public domain work—that is, an edition that is simply an exact copy of the original work. Making an exact copy of a piece of sheet music is purely a mechanical act. No new authorship is added in such an edition so there is nothing that can be copyrighted. There is also no copyrightable authorship in a new edition where the changes consist only of a new typeface or different size type. U.S. copyright law does not protect typefaces (see Chapter 5).

Often, editors who assemble a new edition of a public domain work will correct misprints in the original or later editions of the work. Although extremely helpful, such corrections are not "original" in the copyright sense and are definitely not copyrightable.

On the other hand, many new editions, particularly of classical music, contain significant editorial comments. These may consist of historical notes, music criticism, or detailed guidance on how the music should be played. Comments such as these are protected by copyright. However, the public domain music they accompany

remains in the public domain and may still be copied freely.

b. Transpositions and Recleffing

Transposition is transferring music from one key to another, note for note—for example, transferring a piece from the key of F to the key of B flat. Public domain musical works are often transposed from their original keys to make them easier to sing or play.

Here is an example of transposing a portion of the public domain song "My Bonnie" from F to B flat:

"My Bonnie" in F

"My Bonnie" in B flat

Since the relationship of all the notes to one another remains the same, and all that is required is the simple act of measuring intervals between the notes, transposition is a purely mechanical act that clearly does not merit copyright protection. The B flat version of "My Bonnie" is as much in the public domain as the F version.

The process of recleffing very old public domain music written in obsolete clefs into the modern bass or treble clefs also does not earn copyright protection. This is also a purely mechanical act.

c. Keyboard Reductions

In a keyboard reduction, an arranger takes a work written for instruments other than the piano or other keyboards, such as a symphony or opera, and arranges it to be played on the piano or other keyboard instrument. Keyboard reductions may be copyrightable, depending on whether the keyboard arranger exercised significant aesthetic choices in creating the arrangement.

It's likely that most reductions of complex music such as orchestral works and operas are copyrightable. Many aesthetic choices must be made when arranging a piano version of a symphony of opera that originally contained many lines of music intended to be played by different

Harpsicord (English, 1781), *Classical Music Illustrations*, Dover Publications

instruments. Obviously, some of the original music will probably have to be left out or simplified, since a pianist with only ten fingers cannot replicate the sound of an entire symphony orchestra. Such a piano arrangement could be written in many different ways and it's likely that no two arrangers would do it in exactly the same way. Reductions or arrangements where the arranger significantly alters the music—for example, adds new melodies or harmonies —can also obtain copyright protection.

On the other hand, some piano reductions are clearly not copyrightable because the music is created in a mechanical way. One example would be a piano reduction of a choral work that consisted merely of writing out for piano the same notes that the chorus sings.

d. New Harmonies

Adding new harmonies to a public work may result in a copyrightable arrangement if the harmonies are original and not dictated solely by the melody or musical conventions. However, conventional harmonies driven by the melody or dictated by accepted rules of musical composition are not original and are therefore not copyrightable. See *Northern Music Corp. v. King Record Distrib. Co.*, 105 F.Supp. 393 (S.D. N.Y. 1952). Of course, music experts could differ as to which harmonies are original and which are not, so determining which arrangements of this type are copyrightable and which are not is difficult.

e. Fingering Suggestions

Many new editions of public domain music contain fingering suggestions that were not included in the original version of the work. Some fingering suggestions are copyrightable, but many are not.

Often, fingering suggestions are intended to make a piece of music easier to play. These often consist of standard fingerings that have been used for centuries. This type of fingering is not original and should not be copyrightable since it is dictated solely by the need to make the piece playable. No aesthetic choices are involved—that is, the piece doesn't sound any different because of the fingering suggestions.

Usually, it's not difficult for a person who knows about music to tell the difference between standard fingerings added for playing ease and nonstandard fingerings. The Bach minuet reproduced below is a good example of an instance where a music publisher has added extremely simple, standard fingerings to public domain music.

G Major
Minuet

J.S. Bach

On the other hand, some fingering suggestions are not made to make a piece of music easier to play. Instead, they may

be suggestions intended to change how a piece sounds when played by accomplished musicians. Choices in fingering or bowing methods can significantly affect how a musical work sounds, particularly in compositions for string instruments. Fingering suggestions such as these may be copyrightable if they are not obvious or dictated by musical conventions.

If you're not sure whether the fingerings merit copyright protection, the safest course is to assume that they are copyrightable. In these cases, you can still use the sheet music if you eliminate the fingerings.

f. Rhythm

Standard rhythms such as a bossa nova or waltz beat are not copyrightable, but new and original rhythms can be. If you're not sure whether the rhythm is new or standard, it's safest to assume that it is protected by copyright.

g. Dynamic Markings

Dynamic markings consist of words and symbols composers add to sheet music telling musicians how loud or soft to play the music. Much public domain music was published without any dynamic markings because musicians didn't need them: musicians knew the conventions that dictated how the music should be performed. Later editions often added dynamic markings. Such markings are not copyrightable if they are dictated by musical convention or are copied from earlier

editions of the music that are in the public domain.

However, changes in dynamics could be copyrightable if they are not obvious and they significantly alter the sound of the piece. In other words, simply adding the word "fortissimo" to a public domain work does not result in a copyrightable arrangement. But changes in dynamics that alter the very essence of the work could be copyrightable.

It may be difficult to discern with any certainty whether dynamic markings are or are not obvious. In these cases the safest course is to assume that they are copyrightable. However, you can still use the sheet music if you eliminate the markings.

Obtaining Expert Music Help

If you do not know enough about music to judge whether an arrangement is sufficiently original to merit copyright protection, you'll need to obtain assistance from someone who does. Ideally, this would be a person intimately familiar with the genre of music involved—classical, popular, religious, etc. Only such a person can tell you whether the changes made to create the arrangement are obvious, routine, trivial, mechanical, or dictated by musical conventions. Few lawyers have this level of musical expertise. You would be better off consulting with an experienced musician, music teacher, musicologist, or composer.

h. Simplified Versions

Popular public domain music is often republished in simplified versions designed to be easier for novice musicians to play. Music publishers often claim copyright in these simplified arrangements. However, simplified versions are not protected by copyright if the simplifications are trivial, mechanical, or obvious—for example, simplifying the chords or transposing the work to an easier key.

However, a truly radical simplification of a piece could hold a valid copyright. For example, one arranger has taken Chopin's piano masterpiece "Ballade No.1 in G Minor Opus 23," a work comprising 14 pages of difficult-to-play music, and reduced it to a simple one-page work called "Theme From Ballade Opus 23." All that remains of the original work is a simplified version of the famous theme. In effect, the arranger has created a new work using the theme. This work is fully entitled to copyright protection. See *It's Easy to Play Chopin*, arranged by Daniel Scott, (Wise Publications 1988).

Performing Arts Illustrations, Dover Publications

Getting Paid for Your Own Arrangements of Public Domain Works

If you create your own arrangement of a public domain work that you believe is copyrightable, you are entitled to register it with the Copyright Office and, if it's published, place a copyright notice on it in your name. This entitles you to collect permission fees if your arrangement is performed in public or recorded. Fees for public performances are collected by the music performing rights societies ASCAP, BMI, and SESAC. Fees for recordings are usually collected by the Harry Fox Agency. Typically, these agencies will pay you a royalty for an arrangement of a public domain work equal to 10% to 20% of what they would pay for a completely original song. However, if your changes are very substantial, they may agree to pay more. A musicologist may be retained to compare your arrangement with the original public domain version to see how substantial your changes are.

You must join ASCAP, BMI, or SESAC to collect performance royalties. They all have excellent websites at www.ascap .com, www.bmi.com, and www.sesac .com. The Harry Fox Agency website is at www.harryfox.com. For a detailed discussion of how to earn money from music, refer to *Music Law: How to Run Your Band's Business*, by Richard Stim (Nolo).

Using Arrangements Without Getting Sued

Here are two things you can do that will most likely prevent a music publisher from complaining about your use of their arrangements:

- **Don't use new elements.** Don't use those elements of the music that the publisher has added or changed. For example if you want to photocopy a work for which the publisher has added dynamic markings or guitar chord diagrams, white out or cover up the markings or diagrams before you do the photocopying. The resulting photocopy will be a clean public domain version of the work. Alternatively, instead of photocopying the work, you could copy it out by hand or on a computer using music notation software. When you do the copying, leave out the elements the publisher has added or changed.
- **Create your own public domain version of the work.** If you don't have access to the original public domain version of the work, but you can find a number of different arrangements, you may be able to create your own public domain version of the work using the arrangements. You do this by carefully examining the arrangements and looking for the elements common to them all. These elements must have been taken from the original public domain version of the work. By copying just these elements, you can create your own public domain version of the work.

If you determine the work you are researching is an arrangement or adaptation, mark "yes" on Line 6 and continue reading Section H below. If it does not fit into either category, mark "no" on Line 6 and continue reading Section H below.

H. Is the Music a Collective Work?

Sheet music for public domain works is often published in collections containing many individual works. For example, the collection *Easy Classics to Moderns* published in 1956 by Consolidated Music Publishers contains the sheet music for 142 individual works by over two dozen classical composers, almost all of which are in the public domain. Such a collection is called a collective work for copyright purposes.

When a music publisher collects and publishes together the sheet music for a number of public domain works, it may be entitled to claim copyright protection for the collective work it creates. But the publisher is entitled to only a very limited form of copyright protection. All that is protected is the *selection and grouping* of the preexisting public domain material, not the preexisting material itself. This is often called a "thin" copyright. The copyright status of the preexisting material used to create a collective work is unaffected by the collective work's existence. Thus, if the preexisting material was in the public domain, it remains in the public domain.

EXAMPLE: In 1987, Dover Publications published a collective work of music entitled *Alexander's Ragtime Band and Other Favorite Song Hits, 1901-1911*. The work consisted of exact copies of the original sheet music for 49 songs published between 1901-1911, all of which are in the public domain. Dover was entitled to claim a copyright for its selection of the music to include in the collection and include a copyright notice for the collective work, which it did. However, this collective work copyright only protects the collection as a whole. None of the individual pieces is protected. Their inclusion in the new collective work does not revive their expired copyrights.

⚠ **Beware New Arrangements.** Sometimes, the material included in music collections consists of new arrangements of public domain songs. In this event, the individual pieces may be copyrighted if the changes in the new arrangements are substantial enough to merit copyright protection (see Section G). In these cases the publisher is entitled both to a collective work copyright in the collection as a whole and copyright in the new arrangement of the public domain works.

However, not all collective works are entitled to even thin copyright protection. A collective work cannot obtain copyright protection at all if not even minimal creativity was required to compile it or if it doesn't contain sufficient material.

1. Minimal Creativity Required

A collective work is entitled to the limited copyright protection it receives only because the author/compiler had to use creativity and judgment to create it. For example, Dover Publications in the example above used creativity and judgment in selecting which of the thousands of songs published between 1901 and 1911 should be included in its collection of just 49 songs from that decade.

However, if a collective work was created without using even minimal creativity and judgment, it will not be entitled to any copyright protection at all—that is, it will be in the public domain.

How can you tell if a collective work contains sufficient creativity to be entitled to thin copyright protection? A collective work is copyrightable if either the selection or grouping of the material is minimally creative. In some collections, both the selection and grouping are minimally creative. In others, only one is.

A selection is minimally creative if it is based on the compiler's opinion about something subjective—for example, the compiler's selection of the "best" Bach fugues or the "100 Greatest Romantic Songs Ever Written." Here, the compiler must use selectivity and judgment to decide which fugues are "best" and which of the thousands

of romantic songs ever written are the "greatest."

But a selection is not minimally creative if it does not require individual judgment. For example, no judgment is needed to compile a collection consisting of *every* Bach fugue.

Similarly, the way the individual pieces in a collection are ordered or placed is entitled to copyright protection only if done in a way that requires the exercise of the compiler's subjective judgment. An ordering or placement is not entitled to copyright protection if done in a mechanical way. An alphabetical or chronological grouping is purely mechanical and not entitled to copyright protection. Thus, for example, a collection of Stephen Foster's songs placed in alphabetical order by title would not be entitled to copyright protection. But a grouping on some other basis could be—for example, from worst to best in the compiler's opinion.

Saxophone player from *864 Humorous Cuts from the Twenties and Thirties*, Dover Publications

2. Small Collections Not Protected

In addition to the minimal creativity requirement, a collective work must consist of more than a few elements to have copyright protection. The Copyright Office has stated that a collective work of fewer than four items does not meet this threshold. For example, a collection of three Beethoven sonatas could not hold a copyright as a collective work. It's very likely that courts would follow this rule and you can too.

3. How Much of a Collective Work Can You Copy?

The thin copyright of a collected work protects only the selection and/or grouping of the material. None of the individual pieces in the collection are protected. This means you may copy any individual piece included in the collection, so long as it does not have a valid copyright as a new arrangement.

But you are not limited to copying just individual pieces. You may copy any amount of a collection as long as you don't copy the publisher's copyrighted selection and/or arrangement. Let's take as an example Dover Publication's collection *Alexander's Ragtime Band and Other Favorite Song Hits, 1901-1911* mentioned above. The selection of 49 songs included in this collection is copyrighted, but the grouping is not because it is in alphabetical order. You may copy all 49 songs and sell them individually. This would not infringe

on Dover's selection—that is, its decision as to which songs to include in a collection of 49 favorite songs originally published during 1901-1911. But you could not sell all 49 together, since this would be copying Dover's selection. You could, however, copy all 49 songs, add another 51 songs, and publish a collection of the "100 best songs 1901-1911." Again, this would not be copying Dover's selection of 49 favorite songs, 1901-1911.

Let's consider an example where only the grouping is copyrighted. If a publisher published a collection of all of Stephen Foster's songs and grouped them by theme, it would have a copyright in the grouping, but not in the selection, since every Foster song has been included. No creativity was required to make such a selection. You could copy every song in the collection and group them in some other way without violating the publisher's copyright in its selection—for example, you could group them alphabetically or chronologically. But you could not claim copyright protection for your grouping, since chronological and alphabetical groupings are not protected by copyright law.

Again, however, what you may not do is copy the publisher's selection or grouping. This could get you sued. This is exactly what happened with regard to the collection *Easy Classics to Moderns* published by Consolidated Music Publishers, mentioned at the beginning of this section. Consolidated's collection included a selection of six piano pieces by Bela Bartok published

under the title *Six Miniatures*. This was the first time these six pieces had ever been published together. One of Consolidated's competitors later published a collection of its own entitled *World's Favorite Classic to Contemporary Piano Music*. This collection included the same six Bartok pieces in the same order Consolidated had published them. Consolidated sued the publisher for copyright infringement and won. The court held that the selection and grouping of the six Bartok pieces was original and that Consolidated's copyright was violated when all six were copied in the subsequent collection. *Consolidated Music Publishers, Inc. v. Ashley Publications, Inc.*, 197 F.Supp. 17 (S.D. N.Y. 1961).

If you determine the work is a collective work, mark "yes" on Line 7. If you have marked "yes" on Lines 5, 6, or 7, move on to Line 8 to determine if the work contains material that is copyrighted. The copyrighted portions of the work may not be freely used. If you marked "no" in Lines 5, 6, and 7, the entire work is in the public domain. You need not continue reading this chapter.

I. Does the Music Have Public Domain Elements?

If you determine that the copyright in a piece of music has not expired and that it did not enter the public domain because

of a faulty copyright notice, the work as a whole is not in the public domain. However, it may still contain elements that are in the public domain. These may be freely copied or otherwise used although the entire work may not.

1. Music Copied From Public Domain Sources

Composers have been borrowing from each other for hundreds of years. Here is a list of just a few well-known popular songs based on previously existing works, all of which are now in the public domain:

- "Goin' Home" (1922) was based on the Largo from Dvorak's symphony *From the New World* (1893).
- "Hello Mudduh, Hello Faddah" (1963) was based on Ponchielli's "Dance of the Hours" from the opera *La Gioconda* (1876).
- "Love Me Tender" (1956) was based on "Aura Lee" by George Poulton (1861).
- The "Marine's Hymn" (1919) was based on a theme from the opera *Genevieve de Brabant* by Offenbach (1868).
- "Night on Disco Mountain" (1977) was based on "Night on Bald Mountain" by Mussorgsky (1887).

Any portion of a song or other musical composition copied from a public domain source is itself in the public domain. Incorporating it into a new song does not revive its copyright status. Only the new material, if any, added by the composer of the new song is copyrightable. For example, the lyric written by Alan Sherman for the comic song "Hello Mudduh, Hello Faddah" is copyrighted, while the melody (based on a public domain opera) is not. Anyone can write a song based on this public domain melody, but they cannot use Sherman's lyric without permission.

2. Ideas

Ideas are not protected by copyright, only the particular way a creative person expresses his or her ideas is protected. For example, the idea to write a song about young love is not copyrightable. Only the particular way a composer expresses this idea is protected.

3. Simple Melodies

Extremely short simple melodies are generally not copyrightable. For example:

- A court ruled that a three-note phrase consisting of C, D flat, C, sung over a background C note played on the flute was "a common building block." The court noted that the phrase was used over and over again by major composers in the 20th century, particularly the 1960s and 1970s. The six-second phrase was "sampled" by the hip-hop group Beastie Boys on one of its albums. *Newton v. Diamond*, 2003 U.S. App. LEXIS

22635; Copy. L. Rep. (CCH) 28,692 (9th Cir. 2003).

- A four-note musical phrase consisting of the notes A, G, F, and C was held not to be copyrightable. The court noted that this identical phrase appeared in many other songs and to grant a copyright in such a "musical commonplace" would improperly curb musical composition generally. *Granite Music Corp. v. United Artists Corp.*, 532 F.2d 718 (9th Cir. 1976).

- An advertising jingle for a brand of beer consisting of the words "Tic Toc," juxtaposed by "Time for Muehlebach" scored to the notes C and G to produce the sound and tempo of a clock ticking. *Smith v. Muehlebach Brewing Co.*, 140 F.Supp. 729 (W.D. Mo. 1956).

- The melody for the song "Johnny One-Note" (excluding the break) (*Compendium of Copyright Office Practices*, Section 403).

In addition, melodies copied from other previously existing musical works are not copyrightable. Obviously, such melodies are not original.

4. Song Titles

Song titles ordinarily are not copyrightable. For this reason, many songs have the same or similar titles (see Chapter 13 for detailed discussion of titles).

5. Musical Forms

Musical forms and structures are all in the public domain. For example, the traditional AABA 32-bar structure for popular songs is in the public domain. Anyone can write a song in this format.

6. Information That Is Common Property

Certain types of musical information are called common property, which means they are available to everyone and are always in the public domain. This includes diatonic and chromatic scales and standard chords.

Chord charts consisting of standard chords may be copyrightable as compilations, even though the individual chords are in the public domain. That is, the selection and arrangement of the chord chart as a whole may be copyrighted. Method books consisting of public domain chords, scales, exercises, and public domain music likewise may be copyrightable as compilations (see Section H).

If you determine a work has public domain elements, mark "yes" on Line 9. You may use those elements freely and without permission. If you determine the work has no public domain elements, mark "no" on Line 9. If you find that the work you want to use is not in the public domain, you may be able to use it anyway under a legal exception called "fair use" (see Chapter 22). If you do not qualify for

this exception, you will need to obtain permission to use the work. For a detailed discussion of how to obtain copyright permissions refer to *Getting Permission: How to License & Clear Copyrighted Materials Online & Off*, by Richard Stim (Nolo).

J. Sources of Public Domain Sheet Music

Once you determine that a musical work is in the public domain, you must obtain a copy of the public domain version of the work. Fortunately, there are many sources to use.

1. Libraries

You might be surprised to discover how much public domain sheet music is at your local library. Some libraries may allow you to freely copy their public domain music, others may attempt to impose restrictions on copying, particularly when the sheet music is quite valuable, old, or fragile. Following is a list of many of the finest music libraries in the United States. Many have special collections in particular areas of music.

> Berklee College of Music
> Stan Getz Media Center
> 150 Massachusetts Ave.
> Boston, MA 02115
> 617-266-1400
> http://library.berklee.edu

Boston Public Library
Box 286
Boston, MA 02117
617-536-5400
www.bpl.org/WWW/music/music.html

Columbia University
Music Library
701 Dodge Hall
New York, NY 10027
212-280-4711
www.columbia.edu/cu/libraries/indiv/music

Eastman School of Music of
The University of Rochester
Sibley Music Library
27 Gibbs St.
Rochester, NY 14604
716-274-1000
http://sibley.esm.rochester.edu

Free Library of Philadelphia
Music Department
Logan Square
Philadelphia, PA 19103
www.library.phila.gov

Harvard University
Eda Kuhn Loeb Music Library
Cambridge, MA 02138
617-495-2794
http://hcl.harvard.edu/loebmusic

Indiana University
William & Gayle Cook Music Library
Morrison Hall
Bloomington, IN 47405
812-855-8632
www.music.indiana.edu/muslib.html

Johns Hopkins University
Peabody Conservatory of Music
21 East Mt. Vernon Place
Baltimore, MD 21202
301-659-8154
www.peabody.jhu.edu/home.php

Library of Congress
Music Division
James Madison Memorial Building
Room 113
101 Independence Ave. SE
Washington, DC 20540
202-707-5507
http://lcweb.loc.gov/rr/perform/guide

New York Public Library for the
Performing Arts
Music Division
11 Amsterdam Ave.
New York, NY 10023
212-870-1650
www.nypl.org/research/lpa/lpa.html

Oberlin College
Conservatory of Music Library
Oberlin, OH 44074
216-775-8280
www.oberlin.edu/~library/conlib/cons
.html

University of California, Berkeley
Music Library
240 Morrison Hall
Berkeley, CA 94720
510-642-2623
www.lib.berkeley.edu/MUSI

University of California, Los Angeles
Music and Arts Library
1102 Schoenberg Hall
405 Hilgard Ave.
Los Angeles, CA 90024
213-825-4881
www.library.ucla.edu/libraries/music

University of Chicago
Music Collection
Joseph Regenstein Library
1100 East 57th St.
Chicago, IL 60637
312-702-8451
www.uchicago.edu

University of Michigan
Music Library
3239 Moore Building,
North Campus
Ann Arbor, MI 48109
734-764-2512
www.lib.umich.edu/music

University of Washington
Ethnomusicology Archives
School of Music, DN-10
Seattle, WA 98195
206-543-0974
www.lib.washington.edu/Music

Yale University
Irving S. Gilmore Music Library
98 Wall St.
New Haven, CT 06520
203-432-0495
www.library.yale.edu/musiclib/muslib
.htm.

2. Music and Book Stores

Although the sheet music publishing
industry is just a shadow of what it was
during the early part of the 20th Century,
sheet music is still being published, both
for public domain works and more recent
works. You can find sheet music in many
large bookstores and, of course, in music
stores.

However, you need to be careful when
you use recently published editions of
public domain music. Many sheet music
publishers claim copyright in their editions
of public domain music. Sometimes these
copyright claims are justified, often they are
not (see Section F).

3. The Internet

An increasing amount of public domain
sheet music is being posted on the Internet.
One website alone, the Lester S. Levy
collection, has over 29,000 pieces. You
can download this sheet music (the URL is
below) and then print it out.

**Not All "Free Sheet Music" Is in the
Public Domain.** There are many
websites offering downloads of "free sheet
music." However, the music is not in the
public domain. The operators of these
sites are infringing on the copyrights of the
owners of this music and you will too if you
download it. Here's a simple rule of thumb
you can use: Any music on these websites
published after 1963 is very likely not in the
public domain. If it was published in 1963
or before, it could be in the public domain
or it could be copyrighted. If you follow the
procedure we outline in this chapter you
will be able to determine if the music is in
the public domain or not.

Here are several websites with download-
able public domain sheet music:
- Werner Icking Music Archive: http://
icking-music-archive.org
- My Sheet Music: www.dalymusic.com
- Historic American Sheet Music: http://
scriptorium.lib.duke.edu/sheetmusic
- The Lester S. Levy Sheet Music
Collection: http://levysheetmusic.mse
.jhu.edu
- Library of Congress Music for the
Nation—American Sheet Music, 1870-
1885: http://memory.loc.gov/ammem/
smhtml/smhome.html
- Sheet Music Online: www
.sheetmusic1.com/NEW.GREAT
.MUSIC.HTML
- Sheet Music USA: www
.sheetmusicusa.com

- University of California at Berkeley, California Sheet Music Project: www .sims.berkeley.edu/~mkduggan/neh .html
- University of North Carolina, Chapel Hill Sheet Music Library: www.lib .unc.edu/music/eam.html.

The people who created these websites were usually very careful only to include sheet music that was clearly in the public domain. Just to make sure, however, look for the copyright notice on the music. If the date is before 1923, you're assured the music is in the public domain.

4. Music Publishers

Many music publishers republish public domain music. One publisher deserves special mention: Dover Publications, Inc. Dover specializes in republishing public domain works of all kinds, including music. It publishes many volumes of public domain music, including classical, popular, and folk. Unlike many music publishers, Dover usually doesn't attempt to claim copyright in public domain works. You can obtain a free catalogue of Dover's music publications by writing to Dept. 23, Dover Publications, Inc., 31 East 2nd St., Mineola, NY 11501. Indicate in your letter that you're interested in music.

5. Private Companies

There are several private companies that have substantial libraries of public domain sheet music and sell copies to the public. These include:

Public Domain Research Corp.
P.O. Box 3102
Margate, NJ 08202
Telephone: 800-827-9401
Fax: 609-822-1628.

This company publishes the *Public Domain Report Music Bible*, a list of over 2,100 public domain songs. Copies of the sheet music for over 1,500 of these songs are available for $6.95 per title.

Royalty-Free Music, Inc.
P.O. Box 326
Clearwater, MN 55320
Telephone: 320-558-6801
Fax: 320-558-6637
URL: http://members.aol.com/ FreeMus2U/musicat.htm.

This company claims to have 50,000 to 80,000 public domain songs in its library and charges $2.20 to $4.00 per song plus $2.00 shipping and handling.

Luck's Music Library
Box 71397
Madison Heights, MI 48071
Telephone: 810-583-1820.

Luck's specializes in classical music.

Public Domain Music
www.pdinfo.com
email: comments@pdinfo.com.

The people who run this website sell the sheet music for over 1,500 public domain songs, mostly in the form of collections published by Dover Publications. They have a searchable database on their website showing which songs they have.

K. Sound Recordings

In the early part of the 20th Century composers and music publishers made most of their money from the sale of sheet music. Of course, this is no longer true. Today, most of the money in music is made from the sale of recordings of musical performances.

Legal protection for a recording of a musical composition is completely separate and distinct from protection for the composition itself. Legally speaking, the recording is a separate work in its own right, consisting of the performance of the composition and the work of the record producer in fixing the performance in a recording.

Very few sound recordings are now in the public domain. Unfortunately, this situation will not change until well into the 21st Century—indeed, substantial numbers of U.S. sound recordings will not start to enter the public domain until the year 2043. The following sections discuss in detail why this is. If you're not interested in these legal details, you can skip the rest of this section.

1. Sound Recordings Made Before Feb. 15, 1972

Before February 15, 1972 sound recordings (as opposed to musical compositions) were not protected by the federal copyright laws. Instead, if someone felt their copyright to a musical recording was being infringed, they had to sue in state courts, relying on state antipiracy laws and state common law copyright. The laws of almost every state make it a criminal offense to manufacture, distribute, sell, or offer to sell sound recordings without the owner's permission. Penalties for violations include fines (up to

Edison Home Phonograph, c. 1896. Library of Congress, Motion Picture, Broadcasting, and Recorded Sound Division

$250,000 in California) and jail time. But the federal government has decided that state protection for recordings made before February 15, 1972 must end no later than February 15, 2067. At that time, all music recorded before 1972 will enter the public domain.

Moreover, these state statutes typically do not have any cutoff dates for when state law protection begins. That is, by their own terms they appear to apply to all pre-1972 recordings, even those made during the earliest days of sound recording. Indeed, they even apply to foreign recordings that are in the public domain in their countries of origin. (*Capitol Records, Inc. v. Naxos of America, Inc.*, 4 NY3d 540 (2005).) Theoretically, then, unauthorized duplication of a recording made as early as 1900 (or even earlier) could result in prosecution. As a practical matter, however, there is a good chance that no one would care if you copied such an early recording unless, perhaps, it was made by a very famous artist such as the opera legend Enrico Caruso.

In one of the few cases involving such early recordings, Capitol Records filed suit against a small European recording company that copied and distributed in the U.S. recordings made in the United Kingdom in the 1930s by the renowned classical musicians Yehudi Menuhin and Pablo Casals. The recordings were in the public domain in the United Kingdom, but not in the United States. (*Capitol Records, Inc. v. Naxos of America, Inc.*, 4 NY3d 540 (2005).)

2. Sound Recordings Made or Published After Feb. 15, 1972

Starting on February 15, 1972 federal copyright protection began to apply to sound recordings. All sound recordings published—that is, distributed to the public—on or after February 15, 1972 and before 1978 are protected by copyright for 95 years from the publication date. Unpublished recordings made during this time period continue to be protected by state law.

A new federal copyright law took effect on Jan. 1, 1978 that gave protection to both published and unpublished sound recordings created anytime during or after that date. The copyright for such works lasts for 95 years from the publication date or for 70 years after the composer dies. As a practical matter it makes little difference which term applies right now since the earliest such recordings will enter the public domain is the year 2049 (for works created by composers who died in 1978; see Chapter 18 for a detailed discussion of copyright terms).

However, there is one small group of recordings made after 1972 that is in the public domain: those published between January 1, 1978 and March 1, 1989, that contained no valid copyright notice on the recording or album cover. The copyright notice for a sound recording consists of a capital "P" surrounded by a circle, the year of publication, and the name of the copyright owner. After March 1, 1989 copyright notices were made optional.

Sound Recordings on the Internet

Millions of sound recordings have been converted into digital form and placed on the Internet. A digital copy of a sound recording is a derivative work. Making the copy and making it publicly available over the Internet without the copyright owner's permission constitutes copyright infringement unless both the sound recording and the underlying composition are in the public domain. Claims that the wholesale copying of sound recordings on the Internet is a fair use have been rejected by the courts; most notably in a case involving Napster, a website that provided music file-sharing software to Internet users and facilitated unauthorized downloading of sound recordings. The Napster website was shut down as a result. *A&M Records, Inc. v. Napster, Inc.*, 239 F.3d 1004 (9th Cir. 2001). (Napster has since reappeared under new ownership as a pay per use site.)

Of course, people continue to upload and download music files without permission, committing copyright infringement. Recording industry groups have begun to file lawsuits against individuals who do this, and are working to try to get colleges to prevent their students from engaging in the activity. Remember, since very few recordings are in the public domain in the United States, virtually none of the music files being shared over the Internet are public domain in this country. Some recordings have entered the public domain in foreign countries, but it is still illegal for someone in the U.S. to download a recording that is copyrighted in the U.S., even if the download comes from an Internet server in a foreign country where the recording is in the public domain. (For more information on the public domain outside the U.S., see Chapter 16.)

Recordings published during this ten-year period without a valid notice may have entered the public domain. However, not all have done so, and it can be very difficult to determine which ones have. (See Chapter 19 for a detailed discussion.)

3. Foreign Sound Recordings

The legal protection scheme for sound recordings made outside the United States is complex. But the upshot of all the rules described below is that virtually no foreign sound recordings are in the public domain in the U.S.

Recordings Made After 1972: These recordings receive the same copyright protection as recordings made in the U.S.— they are protected for the life of the creator and for 70 years after his death, or for 95 years from the date of publication.

Recordings Made 1923-1972: In the past, foreign sound recordings made before 1972 were treated the same as U.S. recordings—that is, they were not protected

Artistotipia Record Label, Russia, c. 1908

by the federal copyright law. However, this changed on January 1, 1996 when a special law restored federal copyright protection for foreign works published during 1923-1989 that were in the public domain in the U.S. However, the restoration applied only to foreign works that were still under copyright in their countries of origin on January 1, 1996. (See Chapter 15 for a detailed discussion.)

What if a foreign sound recording was in the public domain in its country of origin on Jan. 1, 1996? Then it is not entitled to federal copyright protection. But this does not mean that it can be freely used. Reason: It is entitled to protection under state anti-piracy laws. In the first case on the issue, New York's highest court found that recordings created in Great Britain in the 1930s were entitled to protection under New York's anti-piracy law even though they were in the public domain in Great Britain because their British copyrights had expired in the 1980s. (*Capitol Records, Inc. v. Naxos of America, Inc.*, 4 NY3d 540 (2005).) Because of this decision no foreign recordings made during 1923-1972 are in the public domain in the U.S., even if they are in the public domain in their countries of origin.

Recordings Made Before 1923: Federal copyright protection is not available for foreign sound recordings made before 1923. However, it appears that they are protected by state antipiracy laws, just like recordings made during 1923-1977.

Public Domain Status of Sound Recordings Outside the United States. Large numbers of sound recordings have entered the public domain in many foreign countries. In these countries, including most of Europe and Canada, recordings are protected for 50 years after publication. As a result, over-50-year-old recordings of musical compositions by composers who died over 70 years ago are public domain in these countries. Unless the law changes— something music industry groups seek— more recordings will enter the foreign public domain every year. However, these recordings are not in the public domain in the United States. (See Chapter 16 for a detailed discussion of public domain status outside the U.S.)

4. U.S. Government Sound Recordings

The only substantial body of sound recordings that are in the public domain are made by U.S. government employees as part of their jobs or by nonemployees working for the government. (See Chapter 3, Section C2, for a detailed discussion.)

The buildings of the U.S. National Archives, located in and around Washington, DC, have more than 90,000 sound recordings; the bulk of these are spoken-word recordings, not musical recordings. These recordings are primarily from U.S. government

agencies, but there are also some from private, commercial, and foreign sources. They include 1930s-era recordings of performances of the Federal Theater and Music Projects of the Works Progress Administration. There are also recordings of press conferences, panel discussions, interviews, and speeches promoting and explaining policies and programs of some 75 federal agencies. Additional recordings include World War II propaganda broadcasts in German, Japanese, and Italian; American propaganda broadcasts in many languages; and news coverage of war campaigns. Other recordings include oral arguments before the U.S. Supreme Court during the 1955-74 sessions, entertainment broadcasts (usually supporting a federal activity), documentaries and dramas relating to U.S. history, proceedings of political conventions, campaign speeches, and extensive news coverage. Many of the commercial broadcast recordings are not in the public domain.

The National Archives has an extensive website that contains detailed information about its audiovisual holdings. The URL is: www.archive.gov.

Even If a Sound Recording of a Person's Voice Is in the Public Domain, Using the Speaker's Voice for Advertising Purposes —for Example, in a Radio Commercial— Could Violate His or Her Right of Publicity. See Chapter 20 for a detailed discussion. ■

Chapter 5

Art

This chapter will help you determine if a work of art is in the public domain. It is divided into two parts:

- Part I covers original works of art, and
- Part II covers reproductions of artworks, such as photographs of original works of art.

Original art and art reproductions require different steps to decide if they are in the public domain. This is because both original works of art and reproductions are considered by the copyright law to be works of authorship entitled to their own separate copyright protection, if they satisfy the legal requirements discussed below. A reproduction can even maintain copyright protection after the original enters the public domain.

Many works that are in the public domain in the United States are still protected by copyright outside the country and vice versa. This chapter only covers the public domain in the United States. For a detailed discussion of the public domain abroad, see Chapter 16.

Collage artist Claudine Hellmuth created this collage using various public domain materials, including old postage stamps (purchased on Ebay), an old railroad schedule, the title from a 1911 sheet music (found in a second-hand bookshop), and a drawing of a woman (copied from a Dover book of public domain drawings). Hellmuth's book *Collage Discovery Workshop* (North Light Books), describes how to create collage art from public domain materials. Other examples of her work can be viewed at her website (www.collageartist.com).

Part I: Original Works of Art

Original Art Checklist

1. Has the art been published? (See Section C.)

 ☐ Yes: Continue.

 ☐ No: Skip to line 3.

2. Date of publication: _____

 Country of publication: _____

3. Has the copyright in the art expired? (See Section D.)

 ☐ Yes: Skip to line 6.

 ☐ No: Continue.

4. Is the art in the public domain due to lack of a copyright notice? (See Section E.)

 ☐ Yes: Skip to line 6.

 ☐ No: Continue.

5. Is the art eligible for copyright protection? (See Section F.)

 ☐ Yes: Art is protected by copyright. Do not continue.

 ☐ No: Continue.

6. Is art protected by design patent? (See Section H.)

 ☐ Yes: Use of art is restricted by patent. Do not continue.

 ☐ No: Art is in public domain.

7. Will you use art in advertising or on merchandise? (See Section G.)

 ☐ Yes: Determine if the use is restricted by trademark laws. (See Chapter 20.)

 ☐ No: Art may be freely used for your purposes.

This portion of the chapter covers original works of art, which include:

- original paintings, drawings, and sculpture
- the ornamental or artistic features of useful articles, such as furniture and other items that we use in daily life
- works of artistic craftsmanship—also called applied art—such as ceramics, glassware, and toys and fabric and clothing designs.

A. What Good Is Public Domain Art?

The works of , Michelangelo, and Rembrandt are yours to use for free because they are in the public domain, as is a vast amount of other art created through the ages.

1. Using Public Domain Art

The fact that a work of art is in the public domain can make your life easier in a variety of ways. To illustrate, let's compare two well-known paintings, one that is in the public domain and one that is not: the *Mona Lisa* by Leonardo Da Vinci and *American Gothic* by Grant Wood. The *Mona Lisa* is of course in the public domain because it was completed in 1506 and was published before the first copyright law came into existence in 1790. The famous Grant Wood painting of a farm couple is not in the public domain because it was created in 1930. Its copyright will last at least until 2026. (See Chapter 18 for more on how long copyright protection lasts.)

The *Mona Lisa* is owned by the French government and hangs in the Louvre Museum in Paris. Unlike many museums, the Louvre permits the public to take photographs of its public domain paintings without advance permission. However, such a photo would probably not be of professional quality because you are not allowed to use a flash and the *Mona Lisa* is kept inside a large glass case. In any event, traveling to Paris for this purpose might be too expensive or inconvenient.

Fortunately, because the *Mona Lisa* is in the public domain, you can copy, distribute, or display an existing professional-quality photograph of the *Mona Lisa* without obtaining permission from the Louvre Museum or the French government. You may, however, have to obtain permission from the photographer who took the picture (see Section N2).

In contrast, because Grant Wood's *American Gothic* is still under copyright, you cannot reproduce a photo of the painting without obtaining permission from Wood's heirs. When a painting or other artwork is under copyright, the copyright owner has the exclusive right to create copies of it, including photos.

In addition, because the *Mona Lisa* is in the public domain, you may create your own copy of it—for example, draw or paint it from memory or from a photograph. You

can publish or otherwise distribute your copy without seeking permission from anyone—for example, place it on T-shirts. This is not the case with *American Gothic*.

Grant Wood, American 1891-1942, *American Gothic*, oil on beaverboard, 1930, 74.3 x 62.4 cm, Friends of American Art Collection, All rights reserved by The Art Institute of Chicago and VAGA, New York, NY, 1930. Photograph ©2000. The Art Institute of Chicago. All Rights Reserved.

Moreover, because the *Mona Lisa* is in the public domain, you may create a new derivative work from it without obtaining permission. A "derivative" work is a work based on or adapted from a preexisting work. For example, you could create a *Mona Lisa* sculpture, animated cartoon character or computer icon, or even paint a copy of the *Mona Lisa* with a beard (Marcel Duchamp did this in a painting called "*L.H.O.O.Q.*"). The only limit on how you may use the *Mona Lisa* is your own imagination. Tens of thousands of derivative works have been created from the *Mona Lisa*. Someone in Japan even created a copy of the *Mona Lisa* made out of toast. A fascinating website called "*Mona Lisa*: Images for the Modern World" (www .studiolo.org/Mona/MONALIST.htm) has compiled hundreds of examples of ways people have used the *Mona Lisa* image.

None of these things may be done with *American Gothic* without first obtaining permission. (The only possible exception might be creating a parody version of the painting; this could constitute a fair use not requiring permission, but this is far from clear and you could easily get sued for doing it; see Chapter 22.)

2. The Problem of Access

Theoretically, once a work of art enters the public domain it can be copied freely by anyone for any use. However, to make a copy you must first have access to the original. And here lies the problem: Owners of works of art in the public domain are under no obligation to give anyone access to copy the work. Even when a work of art is in the public domain, the canvas, marble, clay, or other physical substance in which it is embodied is still owned by somebody—

whether a museum, gallery, or private collector. Since a work of art is a piece of personal property as well as a work of authorship, the owner enjoys all the rights of any personal property owner. Copyright protection may expire or never exist in the first place, but personal property rights attach to all works of art and last forever.

Private owners of public domain works of art are under no obligation to allow anyone into their home to make copies of the art or even to view it. And most major museums in the United States restrict the public from taking photographs of their collections. Some museums forbid photography entirely or permit only amateur photographs that are of low quality and therefore not publishable. Other museums instruct visitors that they may use photos for personal use only. Still others require visitors to sign camera permits in which they agree not to reproduce any photos they shoot in the museum.

If you want a high-quality publishable photograph or other copy of a painting or other artwork, you must ask the museum to provide you with one. You will be charged a fee for this and usually required to sign a license agreement restricting how you may use the photograph or other copy (see Chapter 2). Such licensing fees are a major source of income for many art museums. Moreover, many museums will not agree to license their works for products that might compete with their own products, such as calendars and note cards.

B. Deciding If Original Art Is in the Public Domain

How to Use This Part

To help you determine the status of an original artwork, we have created the checklist at the beginning of this part for you to follow. Each step in the process is described in the checklist and each line refers to one or more of the sections listed below or to other chapters of this book. If you have a particular work you are researching, start at Line 1 on the chart. As you answer each question you will be led to the appropriate section or chapters necessary to answer the next question on the checklist. At the end of the process you should know whether the work you want to use is in the public domain.

We have also included a worksheet (Appendix C) to document how you determined that a particular work was in the public domain. By filling out the sheet, you will be able to document your research and conclusions should anyone challenge your right to use the work. (See Chapter 1, Section D, and Appendix C.)

What If the Work Is Not in the Public Domain? If you find that the work you want to use is not in the public domain, you may be able to use it anyway under a legal exception called "fair use" (see Chapter 22). If you do not qualify for this exception, you will need to obtain permission to use the work. For a detailed

discussion of how to obtain copyright permissions refer to *Getting Permission: How to License & Clear Copyrighted Materials Online & Off*, by Richard Stim (Nolo).

C. Has the Art Been Published?

The first question you must answer is whether the artwork was published and, if so, when. This will govern when the work enters the public domain.

Art is published for copyright purposes when the copyright owner, or someone acting on his or her behalf, makes it available to the *general* public. In other words, any interested member of the public may obtain a copy; or, in the case of one-of-a-kind artworks, at least has an opportunity to obtain the work. *Burke v. National Broadcasting Co.*, 598 F.2d 688 (9th Cir. 1979).

1. When Art Becomes Published

One of the following actions must be taken for artwork to be considered published for copyright purposes.

a. General Distribution of Copies of the Work

Art is published for copyright purposes whenever copies are made and made available to the general public. Such copies may consist of photographs, postcards, prints, lithographs, castings from a statue, and other reproductions.

> **EXAMPLE:** A Picasso sculpture commissioned by the City of Chicago was deemed published for copyright purposes when pictures of a large model of the sculpture were published in Chicago newspapers and national and international magazines, and postcards of the model were sold to the public. *Letter Edged in Black Press, Inc. v. Public Building Commission of Chicago*, 320 F.Supp. 1303 (N.D. Ill. 1970).

Most of the world's most famous artworks have been photographed and the photos published in books, museum catalogues, postcards, and other ways. All such artwork has been published for copyright purposes. But a work need not be famous to be published this way. Any work of art that has been photographed and distributed in this way has been published for copyright purposes.

b. Offering the Work for Sale to the General Public

A work of art is also published when it is offered for sale to the general public—for example, by the artist, through an art dealer, a gallery, or in a public auction. It does not matter whether a transaction is actually completed. The simple act of offering the artwork for sale qualifies as publication for copyright purposes. The date the article

is offered for sale becomes its date of publication. *Roy Export Co. Establishment v. CBS, Inc.*, 672 F.2d 1095 (2d Cir. 1982). The only qualification is that the offering must be to the general public. Sales or offerings to a restricted group of potential buyers do not result in publication (see Section C2).

> **EXAMPLE:** Grandma Moses created a painting entitled *Over the River to Grandma's House* and exhibited it to the public in her studio. An unidentified buyer came by and purchased it that same day. A court held that this constituted publication of the work. *Grandma Moses Properties, Inc. v. This Week Magazine*, 117 F.Supp. 348 (S.D. N.Y. 1953).

c. Disseminations With No Restrictions

Artwork is also published when it is sold, lent, gifted, or otherwise distributed to a select group of people, or even one person, provided that the artist has placed no restrictions on reproducing, distributing, or selling the work, or copies of it, to the general public. The reason for this rule is that such a work may ultimately become available to the general public. That is, the person or group that receives the work may eventually make it available to the public.

> **EXAMPLE:** Assume that Grandma Moses was commissioned by a wealthy art collector to create a painting. Upon

completion, the painting was delivered to the collector and Grandma was paid. Grandma placed no restrictions on what the collector could do with the painting—for example, he could offer it for sale to the public or sell photographs of it. This transaction published the painting for copyright purposes.

d. Allowing a Work to Be Copied by the Public

Simply putting a work on display and allowing the public to copy it is not enough to make the work published for copyright purposes, as long as the work was created after 1977. Before then, a work of art was considered published if it was displayed to the public and the public was allowed to copy it freely. This would have been the case where a piece of art was displayed in a public park, art gallery, or museum and there was no effort to stop people from making replicas, drawings, photos, or other artworks based on the original work.

An artwork was not considered published if the general public was allowed to view the piece, but was prevented from making copies or replicas of it, by, for example, placing guards near the object to prevent copying of the work.

> **EXAMPLE:** English painter W. Dendy Sadler created a picture called *Chorus*, and later exhibited it to the public at the Royal Academy in London for three

months. The U.S. Supreme Court held that the exhibition of the work did not result in its publication for copyright purposes because the Royal Academy's bylaws barred the public from copying works on exhibition and there were officers present in the gallery to enforce the rule. *American Tobacco Co. v. Werckmeister*, 207 U.S. 284 (1907).

As a practical matter, it will be difficult for you to determine whether a work of art displayed in public prior to 1978 has been published. It would be necessary to review the copying policies of every museum or gallery where it was shown to determine if copying was allowed in any of them. So, unless you're prepared to do some extensive research, you should assume that pre-1978 paintings, drawings, and similar works have not been published solely because they were publicly displayed.

On the other hand, sculptures, frescoes, friezes, and other artworks permanently displayed in public places such as parks and plazas and exteriors of public buildings before 1978 likely would be considered published, since the public is ordinarily allowed to freely copy such works.

Beginning in 1978, the law changed. Any display of a work after 1977—even if copying was allowed—will never result in publication of the work for copyright purposes.

2. Limited Publications

Publication occurs for copyright purposes only when any interested member of the public can obtain a copy of the work—for example, can purchase a photo or bid on the work at a public auction or sale. In contrast, publication does not occur where a work is only made available to a definitely

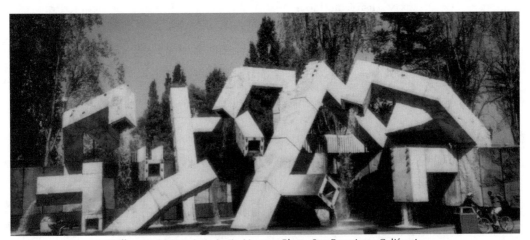

Vaillancourt Fountain in Justin Herman Plaza, San Francisco, California

selected group of people for a limited purpose and without the right of further diffusion, reproduction, distribution, or sale. This type of limited distribution is called "limited publication" and is not considered publication for copyright purposes. *White v. Kimmel*, 193 F.2d 744 (9th Cir. 1952).

Examples of limited publications include where:

- an artist distributes prints or copies of his or her work to colleagues for comment with the understanding that the copies are not to be sold or further reproduced or distributed, or
- copies of an artist's work are distributed to newspapers or magazines for review or criticism (however, if the work was printed in a newspaper or magazine it would be published; see Section K).

3. Finding the Date and Country of Publication

If you determine that a work of art has been published, you must also determine when and where it was published before you decide when its copyright protection ends. Many artworks contain dates, but these are usually the date the work was created, which may not be the same year it was published.

As a practical matter, it may be difficult to determine the exact date a painting, sculpture or other work of art was first published—that is, was first offered for sale or first copied. This is particularly true for works of art that are centuries old. Such works may be offered for sale and copied over and over again through the years. However, it is not necessary to determine the exact date when a work was first published. It is sufficient if you can determine that it was published in the United States any time before 1923 or published outside the United States any time before 1909. If it was, the work is in the public domain. Works published for the first time in the United States during 1923-1963 are also in the public domain if their copyright was not renewed. (See Chapter 18 for a detailed discussion.)

Art published after 1963 cannot be in the public domain due to copyright expiration. But it could be public domain for other reasons, such as failure to use a copyright notice (see Section E) or because it's ineligible for copyright in the first place (see Section F).

Probably the easiest way to determine if a work of art was published during the dates mentioned above is to search for a published photographic reproduction. If you can find a photo of the work in an artbook, art catalogue, postcard, or newspaper it must have been published at least as of the date of the photo. The country the photo was published in will be the country of publication of the original artwork as well.

Art reference works may also be helpful. For example, they may tell you when and in

what country a work was offered for sale to the public (another way art is published for copyright purposes). Other useful resources to finding both the date and country of publication of a work of art include:

The Library of Congress Card Catalogue. If the artwork has been reproduced in a book, magazine, or other work, it may be listed in the Library of Congress card catalogue. The catalogue entry will usually show both the country and date of publication. You check the catalogue in person at the Library in Washington, DC, or online through the Library's Web page (http://catalog.loc.gov).

The Internet. There are thousands of websites devoted to art. There may be a website that provides a detailed publication history of the work you're interested in. Do a search with an Internet search engine such as Google using the artist's name and the name of the work of art. A list of useful art websites is contained in Section I1.

Copyright Office Records. If either the original artwork or a reproduction was registered with the U.S. Copyright Office, checking Copyright Office registration records will reveal when and where it was published. Many of these records can be researched online (see Chapter 21). However, many published artworks are not registered with the Copyright Office, so there may be no record for them.

Art Museums. An art museum that collects the artist's works may be helpful. You can find a list of art museum websites at www .gallery-guide.com. *The Official Museum Directory,* by the American Association of Museums (American Association of

Museums and National Register Publishing Co.) lists more than 6,000 museums in the United States and is revised annually.

If you are unable to determine the date and country of publication of the artwork, you will not be able to determine if its copyright has expired or if it is in the public domain due to lack of a valid copyright notice. However, you don't need the date and country of publication to determine whether it is in the public domain because it is ineligible for copyright protection. So skip to Section E and see if it is in the public domain on this basis. If not, you should assume the work is not in the public domain.

If you determine that the work has been published, mark "yes" on Line 1 of the checklist at the beginning of this part and continue to Line 2, filling in the date and country of publication (see Section 3 above) before continuing to Line 3. If you determine the work has not been published, skip Line 2 and proceed to Line 3.

D. Has the Copyright in the Art Expired?

Copyright protection does not last forever. When it ends, the work enters the public domain. Some art published as recently as 1963 could be in the public domain. But some art created over 100 years ago or more could still be protected by copyright. The greatest single body of public domain

art comes from works for which the U.S. copyright term has expired. But determining whether a copyright has expired can be complex. You'll need to determine which of several possible copyright terms apply to the work in question.

Copyright terms are the same for all copyrighted material, including art, music, and writings, so they are discussed in detail in Chapter 18. Turn to that chapter to determine whether the copyright in a work you're interested in has expired and fill in the answer on the checklist under Line 3.

If you determine that the copyright has expired, mark "yes" on Line 3 of the checklist at the beginning of this part and skip to Line 6. If the copyright has not expired, mark "no" on Line 3 and proceed to Line 4.

E. Is the Art in the Public Domain Due to Lack of a Copyright Notice?

Before reading this section, you must determine whether the artwork has been published for copyright purposes (see Section C). If the art was never published it doesn't need a copyright notice. You don't need to read any more of this section. Skip Line 4 on the checklist at the beginning of this part and proceed to Line 5.

If the artwork was published before 1989, it could be in the public domain if it lacks a copyright notice. Examine the work carefully to determine if it has a notice—the familiar © symbol or the word "Copyright" or abbreviation "Copr."—and the name of the copyright owner—for example: © Ralph Raphael. If the artwork was published before 1978, the notice didn't have to contain a publication date. If it was published between Jan. 1, 1978 and March 1, 1989 a publication date was required, except for jewelry, toys, and other useful articles containing pictorial or graphic works.

The notice can be hand drawn or painted anywhere on the front or back of a canvas or piece of drawing paper or anywhere on a sculpture or piece of applied art such as jewelry or toys.

If the work has no notice, it could be in the public domain. Since many artists failed to place copyright notices on their works, many artworks published before 1989 have entered the public domain for this reason. Read Chapter 19 for detailed guidance on how to determine whether a published work is in the public domain because it lacks a valid copyright notice.

If the art has a valid notice or the lack of a notice is excused, you can forget about it being in the public domain for lack of a notice. You should mark "no" on Line 4 and proceed to Line 5. If you determine that the art is in the public domain because it lacks a copyright notice, you should mark "yes" on Line 4 and skip to Line 6.

F. Is the Artwork Eligible for Copyright Protection?

Even if you determine that the artwork has a proper copyright notice and its copyright protection has not expired, it could still be in the public domain. Some types of artwork can never be protected by copyright; they will be in the public domain unless other laws protect them like, for example, trademark law.

1. Art Lacking Minimal Creativity

Art must be minimally creative to be protected by copyright (see Chapter 2 for a detailed discussion of creativity and copyright). However, the amount of creativity required is very slight. Almost any work satisfies the creativity test. It can have substantial or little artistic merit or aesthetic value. Copyright protects everything from the most accomplished painting or sculpture by a professional artist to a child's finger painting.

However, according to the U.S. Copyright Office, there are some types of artwork that completely lack creativity and are, therefore, ineligible for copyright protection. These include:

- standard ornamentation such as chevron stripes, a conventional fleur-de-lys design, or a plain, ordinary cross
- two- or three-dimensional geometric figures or shapes such as a hexagon, ellipse, cone, cube, or sphere

Clipart from Printers Dingbats, Graphic Source Library, Graphic Products Corporation, 1989

- standard symbols such as an arrow or a five-pointed star, and
- simple coloration—for example, a textile design consisting simply of the colors green and blue.

Copyright Office views are not binding on the courts, but it makes good sense to follow its views. They are given some deference by the courts and if you are sued for using a particular artwork, it will help you defend yourself if you followed a Copyright Office guideline.

Although these types of artistic creations are not individually protected by copyright, they may obtain copyright protection if they are combined in a new, creative way. For example, a mobile or collage consisting of a number of geometrically shaped pieces such as spheres and cones may obtain copyright protection as a whole even though the individual pieces would, under Copyright Office definitions, be in the public domain. In addition, all of these works could be protected by state and federal trademark laws if they are used as part of the packaging design used to sell a product or service (see Section P).

2. Artistic Ideas, Styles, and Techniques

Copyright law only protects the particular way an artist expresses his or her ideas, not the ideas themselves. For example, the idea of painting a bowl of fruit is not protected by copyright. Anyone can paint a bowl of fruit, but you cannot copy the exact way another artist paints a bowl of fruit unless the work is in the public domain. For example, Cezanne's famous paintings of bowls of fruit are almost all in the public domain and can be copied freely. Likewise, the idea of creating a doll whose face has an upturned nose, bow lips, and evenly spaced eyes is in the public domain. However, the particular way this idea has been expressed in the Barbie doll is protected by copyright. (*Mattel, Inc. v. Goldberger Doll Manufacturing Co.*, 365 F.3d 133 (2d Cir. 2004).)

Similarly, artistic styles are always in the public domain. For example, anyone can create a painting in the cubist or impressionist style. Copyright only protects the exact way an artist expresses an artistic style. For example, cubism is in the public domain, but a particular painting by Cubist painter Georges Braque is not.

Artistic techniques are also not protected by copyright. This includes, for example, two-point perspective or the drawing techniques an artist uses to create the illusion of a sphere on a two-dimensional surface such as a piece of paper. Anyone is free to use these techniques, which have been around for centuries.

3. Works Lacking Human Authorship

Copyright only protects works created by human beings. Works produced by mechanical processes or random selection, without any contribution by a human author, are not protected by copyright. For example, a linoleum floor covering featuring a multicolored pebble design that was produced by a mechanical process in unrepeatable, random patterns is not protected by copyright. Similarly, a work owing its form to the forces of nature is not protected by copyright—for example, a piece of driftwood is not protected by copyright even if it has been polished and mounted.

However, the presence of human "choices" would make a work of art created by a machine protected by copyright. For example, spin art is protectable because the person using the spin art machine decides what colors to use and when to drop the paint onto the spinning platter.

Natural rock

4. Useful Articles

"Useful articles" are items whose intrinsic function is utilitarian—for example, automobiles, boats, household appliances, furniture, work tools, and clothing. The utilitarian or mechanical aspects of useful articles are not protected by copyright—for example, the serrated edge of a knife is not protected by copyright.

However, the design of a useful article or work of applied art is subject to copyright protection to the degree that:

1. it contains pictorial, graphic, or sculptural features, and
2. such features can be identified as existing independently of the utilitarian object in which they are embodied.

Copyright protects such design features if they are physically or conceptually separable from the useful article.

Two-Dimensional Representations of Useful Articles Protected by Copyright

A two-dimensional representation of a useful article—for example, a drawing, painting, or photograph of a chair—is protected by copyright even though the useful article is not. But copyright only extends to the drawing, painting, or photograph, not to the useful article itself. That is, you can't copy a copyrighted painting of a chair, but you may build the chair itself. Thus, for example, an inventor's copyright in drawings for a new type of pistonless engine only protected the drawings themselves, not the inventor's idea depicted in the drawings of how to create such an engine. (*Rozenblat v. Sandia Corp.*, 2003 U.S. App. LEXIS 21940 (7th Cir. 2003).)

a. Physically Separable Features

Any feature that can be physically separated from a utilitarian object and stand on its own as a work of art, is protected by copyright, provided that it is minimally creative and original. For example, the hood ornament on a Rolls-Royce can be removed from the car and stand on its own as a sculpture.

b. Conceptually Separable Features

Unlike the Rolls-Royce hood ornament mentioned above, many artistic features

contained in utilitarian objects cannot be physically separated from the object. A good example is a coffee mug that contains a painting of a rose. You can't physically remove the painting from the mug. But this doesn't mean the painting can't be copyrighted.

In cases such as these, the art is protected by copyright if you can *imagine* it being separated from the useful article and existing on its own without destroying the basic shape of the useful article.

For example, it's easy to imagine removing the rose painting from the coffee mug mentioned above. You could imagine the painting existing on canvas or any other medium. In your mind the coffee mug is left without the painting, its basic shape unchanged. As a result, the painting of the rose is protected by copyright.

Courts call features such as the rose painting "conceptually separable," meaning you can separate them in your mind from

the utilitarian objects on which they are embodied. Sometimes it's easy to tell that an artistic feature is conceptually separable from its utilitarian object. For example, a two-dimensional painting, drawing, or other graphic work is clearly conceptually separable when it is printed on or applied to useful articles such as textile fabrics, wallpaper, containers, and the like.

However, in other cases, the line between unprotected-by-copyright works of industrial design and protected-by-copyright works of applied art is not always clear. Courts have employed a number of tests to determine whether a utilitarian object contained conceptually separable features, and the results have not always been consistent. For example, copyright protection was granted to a belt buckle but denied to a light fixture designed in a modernistic style.

Since it can be very difficult to determine whether the artistic features of a utilitarian object are protected by copyright, it's advisable to seek legal advice before copying such an object for commercial purposes. (See Chapter 23 for guidance on how to evaluate, hire, and manage an attorney.)

c. Patent and Trademark Protection for Useful Articles

In some cases, the purely decorative or ornamental aspects of a useful article may qualify for protection as a trademark or be protected by a design patent.

Cup was created in Adobe Photoshop using the image of a cup licensed from Eyewire

Trademark protection would be available where the decorative aspects of an article are used to advertise or sell a product—a good example is the distinctive shape of a Coke bottle. Patent protection is available where a useful article contains novel and unobvious ornamental features (see Section H).

5. Jewelry and Other Applied Art

"Applied art" refers to works of artistic craftsmanship such as jewelry, toys, and wall plaques. Unlike useful articles, their intrinsic purpose is artistic or decorative, rather than utilitarian.

Copyright protects the artistic aspects of a work of applied art so long as they are minimally creative and original. The protected aspects of such a work may be either sculptural or pictorial in nature—for example, carving, cutting, molding, casting, shaping the work, arranging the elements into an original combination, or decorating the work with pictorial matter such as drawings or paintings.

However, works of applied art that are not minimally creative are not protected by copyright. For example, a jeweled pin consisting of three parallel rows of stones is not protected by copyright, while a pin consisting of a sculpted bee is. Reason: Placing three stones one over the other is not even minimally creative, while sculpting a bee most definitely is. But, most jewelry designs are minimally creative and protected by copyright.

Even if the individual design elements used to create a piece of jewelry are in the public domain, the jewelry may still be protected by copyright if a minimal amount of creativity was required to select and combine those elements. For example, a court held that a gold and silver ring with a bridge-like motif was copyrightable even though the elements—a channel of princess-cut diamonds on the shank of the ring, the suspending of a marquis-shaped diamond above the shank to create the "bridge" effect, and use of flared gold supports to hold the marquis diamond in a tension setting—were all familiar designs in the public domain. The court stated that these elements were combined so as to create a more stylistic and flowing look than any prior bridge ring. *Weindling International Corp. v. Kobi Katz Inc.*, 2000 U.S. Dist. LEXIS 14255, 56 U.S.P.Q. 2D (BNA) 1763 (S.D. N.Y. 2000).

The utilitarian or mechanical aspects of a work of applied art are not protected by copyright. For example, the purely functional clasp on a jeweled pin is not protected by copyright, while the design of the pin itself may be.

Copyright © 2000 by Maira Dizgalvis. Bracelet incorporates a traditional Latvian symbol

6. Fabric Designs and Clothing

Fabric designs are protected by copyright, but only if they are original and minimally creative. Copyright protection has been extended to a plaid design consisting of intersecting diamonds and to pansy and rose designs. However, standard designs that have been around for years are in the public domain—for example, polka dots or traditional plaids.

Clothing and dress designs ordinarily are not protected by copyright. In the words of one court: "A garden variety article of wearing apparel is intrinsically utilitarian and therefore a nonprotected by copyright useful article. Equally nonprotected by copyright are the elaborate designs of the high fashion industry, no matter how admired or aesthetically pleasing they may be." *Whimsicality Inc. v. Rubie's Costumes Co.*, 721 F.Supp. 1566 (E.D. N.Y. 1989).

However, it is possible for specific ornamental or design elements contained in clothing to be protected by copyright, even though the piece of clothing as a whole is not—for example, a detailed embroidery, or a two-dimensional drawing or graphic work affixed to a portion of a garment might be protected by copyright. In one case, for example, drawings of strawberries, daisies, hearts, and tulips on children's bedclothes were held by a court to be protected by copyright. *Samara Brothers Inc. v. Wal-Mart Stores Inc.*, 1998 WL 896648 (2d Cir., Dec. 28, 1998).

As a general rule, clothing designs can't be protected under the state and federal trademark laws. This is because trademark law doesn't protect functional objects such as clothing. However, clothing designers can rely on trademark laws to protect their brand names and logos—for example the company name "Levi's."

All of this means that clothing designers have little legal protection against "style piracy." The fashion industry has been asking for a special form of legal protection for clothing designs for years, but Congress has yet to act.

7. Typeface Designs

A "typeface" is the design or style of the letterforms used for printing type. A "font" is a typeface of a particular style and size. Typefaces were originally carved from wood and then cast in metal. Today, however, typefaces are created on computers and added to word processors and other programs used to create and print documents. If you use a word processing program, you know that you can produce your writing in a variety of fonts such as Courier, Arial, and Impact.

Many typefaces have been around for hundreds of years, but there are many others that have been designed quite recently. Regardless of when they were created, typefaces or fonts are not protected by copyright in the United States. This is so whether they are generated by a computer program, or represented in drawings, hard metal type, or any other form. In other words, they are in the

public domain. One very significant result of this rule is that a public domain work does not receive a new copyright when it is reprinted in a new typeface. Both the words and the typeface are in the public domain. Thus, for example, you are free to copy a public domain writing you find on the Internet even if the person who posted it on the Web changed the font from the original.

a. Font Software Is Protected by Copyright

Font software programs (computer programs used to generate typefaces) can be protected by copyright. But this protection is limited to the computer code. It does not extend to the output these programs create: the typefaces themselves. Moreover, some font software programs have been dedicated to the public domain. (See Chapter 8 for a detailed discussion of public domain software.) Theoretically, this means that even though font software may be protected, you should still be able to copy the font itself—for example, by drawing or photographing it or creating your own program to generate a similar font. Unfortunately, things are not so simple— typefaces may be protected by licenses or laws other than copyright.

b. Other Protections for Typefaces

The large companies that sell font software don't want people copying their fonts, even though they aren't protected by copyright. For this reason, they usually include licensing agreements along with their programs. Among other things, these licenses typically bar users from making any unauthorized copies of the fonts generated by the program. The enforceability of such provisions is questionable. (See Chapter 2 for a detailed discussion of this issue.)

In addition, a few font software companies have obtained design patents for some of their fonts. For example, Adobe obtained design patents for its Garamond, Minion, and Utopia typeface families. You can usually tell if a font program has been patented: Ordinarily, the word Patent or the abbreviation Pat. and the patent number will appear on the packaging or in the program itself.

It's likely, however, that few typefaces qualify for design patent protection. This is because a typeface must be both novel and nonobvious to qualify for a patent. Few typefaces are either—most consist of reworkings of preexisting designs. (See Section H for a detailed discussion of patents.)

Finally, you should be aware that state and federal trademark laws protect some of the names given to fonts. For example, the name Helvetica is a protected trademark. This means that although the font itself may not be protected, the name could be. So, although the Helvetica typeface may be freely copied, the name may not be used to advertise the typeface to the public. (See Chapter 20 for a detailed discussion of trademarks.)

An excellent discussion of the legal issues surrounding typeface designs may be found at a website maintained by the font foundry Southern Software Inc. The URL is: www.ssifonts.com/Myths.htm.

8. Art Created by U.S. Government Employees

Works of authorship created by U.S. government employees as part of their job are ordinarily in the public domain. This includes works of art and art reproductions. However, there are some exceptions. For example:

- The U.S. Postal Service has been legally entitled to claim copyright in postage stamp designs at least since 1970, when the former Post Office was remade into an independent corporation. However, the Service did not begin to claim copyright in its stamp designs until 1978. You'll find copyright notices on sheets of stamps published during or after 1978. However, if you reproduce pre-1978 public domain postage stamps in color, the reproduction must be at least 50% larger or 25% smaller than the original stamp. Black and white reproductions can be any size. Copyrighted postage stamps may be used without obtaining permission from the U.S. Postal Service in editorial matter in newspapers, magazines, journals, books, stamp catalogues, and stamp albums. If an uncanceled postage stamp is depicted in color, it must be less than 75% or more than 150% of life size.

Graf Zepplin 1933 air mail stamp

- Federal government agency seals, logos, emblems, and insignias may not be reproduced on articles—for example, on T-shirts—without government permission. This includes, for example, the NASA insignia logo (the blue "meatball" insignia) and the Presidential Seal. In addition, such items may not be used in advertisements, posters, books, stationery, plays, motion pictures, telecasts, or on any building in a manner that conveys a false impression of sponsorship or approval by the U.S. government or any department or agency. This prohibition is intended to help prevent fraud.

- U.S. currency may be reproduced in black and white or in color, but only if the reproduction is one-sided, less than 75% or more than 150% the size of actual currency, and if all the negatives, plates, digitized storage medium, and everything else used in the creation of the image are destroyed after final use. On the other hand, U.S. coins may be reproduced in

photographs, illustrations, movies and slides in any size.

- Special federal laws protect the characters of the Woodsy Owl used by the Department of Agriculture, the Crash Test Dummies used by the Department of Transportation, and Smokey Bear used by the U.S. Forest Service. These may not be reproduced without permission.

Moreover, certain organizations that you might think are part of the U.S. government are not considered to be so. This includes the Smithsonian Institution and all of its branches and the National Gallery of Art in Washington, DC. Both are independent quasi-governmental entities that are entitled to claim copyright in the works their employees create, and in fact do so.

Information concerning art owned by the U.S. government can be accessed from the General Services Administration website at www.gsa.gov/pbs/pt/pts/cultural.htm.

9. Art Dedicated to the Public Domain

Artists need not enjoy copyright protection if they don't want it. Instead, they may dedicate their work to the public domain. This means they give up all their rights in the work forever and anyone may use the work without asking their permission.

There is no prescribed formula for dedicating a work to the public domain. The artist or other copyright owner simply has to make clear his or her intentions. For example, stating "This work is dedicated to the public domain" on the work would be sufficient. It's not even necessary to make the dedication in writing. It could be done orally, but it's always best to write something down to avoid possible misunderstandings.

However, it is not at all common for artists to dedicate their work to the public domain; so it's not likely you'll encounter any.

If you have determined that the artwork is not eligible for copyright protection or has been dedicated to the public domain, mark "no" on Line 5 of the checklist at the beginning of this part and proceed to Line 6.

If you determine the work is eligible for copyright protection, mark "yes" on Line 5. The work is not in the public domain and you will need permission to use it. For a detailed discussion of how to obtain copyright permissions refer to *Getting Permission: How to License & Clear Copyrighted Materials Online & Off*, by Richard Stim (Nolo).

G. Do You Intend to Use the Art in Advertising or on Merchandise?

Even if a work is in the public domain—that is, not protected by copyright—it may receive some legal protection under state and federal trademark laws. These laws can

prevent someone from using a work of art in advertising, product packaging, or on merchandise such as T-shirts, mugs, and plates.

A trademark is any word, symbol, device, logo, or symbol that identifies and distinguishes one product from another. A service mark is the same as a trademark, except it is used to identify a service rather than a product. Trade dress means the total image and overall appearance of a product or service—for example, the shape, size, color or color combinations, texture, or graphics.

Any work of art can function as a trademark, service mark, or aspect of trade dress. This includes, for example:

- a statue used to identify a restaurant
- the image of a dog listening to a gramophone used to identify RCA recordings, and
- the unique star shape used to identify Mercedes cars.

RCA, Radio Corporation of America, "His Master's Voice." *Nipper*, painting by Francis Barrand, used as RCA trademark since 1900

Even art that doesn't qualify for copyright protection may be trademarked. For example, copyright does not protect simple ornamentation such as chevron stripes (see Section F). However, such stripes could be protected by the trademark laws if they are used as a product logo or part of a product's packaging, as in the chevron logo used by the Chevron Corporation for its gas stations.

Trademark laws may also protect the nonfunctional aspects of product shapes and containers. For example, trademark protection has been extended to the shape of a Coke bottle and the front grill on a Rolls-Royce.

For artwork to receive trademark protection, it must be used to identify or distinguish a product or service that is currently being sold to the public. Typically, the owner of a trademark will help the public identify it by using a trademark notice on or near the trademark. A trademark notice may consist of the symbols ®, TM, SM, or the words "Registered in U.S. Patent and Trademark Office" or "Reg.U.S. Pat & Tm. Off." If you see such a notice anywhere on or near any work you want to use, be sure to check to see if it is a protected trademark.

But, keep in mind that trademark protection does not confer an absolute monopoly on the use of the mark. Even if a work of art or design is trademarked, you may still use it without permission for purposes other than advertising or product packaging or on merchandise. Indeed, you

may still, in many situations, be able to use it for some advertising or merchandise purposes. (See Chapter 20 for a detailed discussion of trademarks.)

If you plan to use the artwork for advertising or merchandise, mark "yes" on Line 7 and read Chapter 20 to see if your use will violate trademark laws.

H. Is the Art Protected by a Design Patent?

Federal patent law protects inventions—everything from new types of mousetraps to satellites. This book does not cover inventions. You may be surprised to learn, however, that patent law can also protect the ornamental design of a useful article such as a clock or cement mixer. This is where design patents come in.

Design patent protection is only available for ornamental features contained in or on manufactured objects such as automobiles, boats, household appliances, furniture, and work tools. Patent protection is not available for art not contained on such objects—for example, a painting, sculpture, or drawing. If the artwork you're interested in is not contained in a manufactured object, you can skip this section. Mark "no" on line 6. The artwork is in the public domain and can be used freely.

A design patent may be used to protect a new, original ornamental design embodied in a manufactured object. The design can be a surface ornament such as a pattern on a beer mug or may consist of the shape of the article itself such as the shape of a Rolls-Royce automobile or silverware set.

Unlike copyright protection, patent protection is not automatic: one must apply for a patent from the U.S. Patent and Trademark Office in Washington, DC, a process that can take years. Three basic requirements must be met to obtain a design patent:

1. The design must be novel—that is, the exact same design must not have been used before.
2. The design must be nonobvious—that is, the design may not be one that a designer of ordinary capability who designs articles of the type involved could be expected to devise.
3. The design must be ornamental—it must create a pleasing appearance and not be dictated by purely functional considerations.

Most designs don't qualify for design patent protection because they are not novel or nonobvious. But, if the government issues a design patent, it lasts for 14 years.

In the past, design patents haven't been very popular. They were expensive and difficult to get and many of them were invalidated by the courts because they failed to satisfy the novelty or nonobviousness requirements. However, courts have been taking a more liberal view toward design

patents in recent years and their popularity is increasing.

How can you tell whether a useful object is protected by a design patent? One way is to look for a patent notice. Although not mandatory, patent owners typically place patent notices on their works: the word "Patent" or "Pat." followed by the patent number. However, patent notices are not always used, so the absence of a notice does not conclusively mean the object is not patented.

Another easy way to determine if a design patent protects a manufactured object is to ask the manufacturer. A more difficult way is to conduct a patent search—a search of the U.S. Patent and Trademark Office's records. Such searches can be conducted online or at special patent and trademark depository libraries.

For a detailed discussion of design patents, see *Your Crafts Business: A Legal Guide,* by Richard Stim (Nolo).

Finally, since design patents only last for 14 years, you can safely assume any object that has been sold to the public for over 14 years is not protected by a design patent. You can usually determine how long an item has been sold by contacting the manufacturer. Another way to determine the age of a design patent is to conduct a patent search.

Most patent records can be searched for free on the Internet. For detailed guidance on patent searching, see *Patent Searching Made Easy: How to Do Patent Searches on the Internet & in the Library*, by David Hitchcock (Nolo).

If you determine that a design patent protects the artwork you are researching, mark "yes" on Line 7. The work is protected by a design patent and is not in the public domain. You'll need to obtain a license to use it. For detailed guidance on how to obtain a license to use artwork and merchandise containing art, see *Getting Permission: How to License & Clear Copyrighted Materials Online & Off*, by Richard Stim (Nolo).

I. Sources of Original Art

Original works of art are usually owned by museums, private collectors, or art galleries. As mentioned above, private collectors and galleries are under no legal obligation to permit the public to view their works. Museums ordinarily are open to the public, although they often do not permit copies of their works to be made without permission.

1. Museum and Artist Websites

Most well-known and many smaller art museums have websites. You can find a listing of many of these at the Yahoo directory at: http://dir.yahoo.com/arts/museums__galleries__and_centers.

Another useful website is the Gallery Guide Online, which lists over 1,500 museums and galleries (www.galleryguide.org).

You can also find a website for a particular museum by searching under its name in an Internet search engine such as Google.

There are many websites devoted to individual artists. Two websites that list these are:

- Art History Resources on the Web: http://witcombe.bcpw.sbc.edu/ARTHLinks.html
- World Wide Art Resources: http://wwar.com/artists1.html.

Using an Internet search engine to search under a particular artist's name will likely reveal many additional websites.

2. Art Reference Books

The following art reference books may also be useful:

Art Information and the Internet, by Lois Swan Jones (Oryx Press). Comprehensive guide to Internet art resources.

Art Information: Research Methods and Resources, by Lois Swan Jones (Kendall/Hunt). Explains how to find art data.

World's Master Paintings: From the Early Renaissance to the Present Day, by Christopher Wright (Routlege). Lists works in public museums by 1,300 painters.

Museums of the World. (Munich: K.G. Saur Verlag, 1981.) Lists major museums of the world.

The Official Museum Directory, by the American Association of Museums (American Association of Museums and National Register Publishing Co.). Lists more than 6,000 museums in the United States and is revised annually.

The Dictionary of Art, 34 volumes, edited by Jane Turner (Grove). The most authoritative art encyclopedia.

Part II: Art Reproductions

Art Reproduction Checklist

1. Is the original work of art in the public domain? (See Section J.)

 ☐ Yes: Continue.

 ☐ No: Work is not in the public domain. Do not continue.

2. Has the reproduction been published? (See Section K.)

 ☐ Yes: Continue.

 ☐ No: Skip to line 4.

3. Date of publication: _____

 Country of publication: _____

4. Has the copyright in the reproduction expired? (See Section L.)

 ☐ Yes: Reproduction is in the public domain. Skip to line 8.

 ☐ No: Continue.

5. Is the reproduction in the public domain due to lack of a copyright notice? (See Section M.)

 ☐ Yes: Reproduction is in the public domain. Skip to line 8.

 ☐ No: Continue.

6. Does the reproduction lack originality? (See Section N.)

 ☐ Yes: Reproduction is in the public domain. Skip to line 8.

 ☐ No: Continue.

7. Has the reproduction been dedicated to the public domain? (See Section O.)

 ☐ Yes: Reproduction is in public domain. Continue.

 ☐ No: Reproduction is protected by copyright, but may contain public domain elements.

8. Will you use reproduction in advertising or on merchandise? (See Section P.)

 ☐ Yes: Determine if your use is restricted by trademark laws. (See Chapter 20.)

 ☐ No: Reproduction may be freely used for your purpose.

Because of the difficulty of obtaining access to original works of art, most people have to rely on reproductions. These include (but are not limited to) photographs, prints, lithographs, photoengravings, collotypes, silk-screen prints, mezzotints, and three-dimensional reproductions of sculpture.

When such reproductions are in the public domain, you may freely copy and reproduce them and create new works based upon them *provided that the original artwork is also in the public domain.* For example, a public domain photo of an artwork that is also in the public domain can be freely used on a website. Using computer software such as Photoshop, you may also freely alter the image and copy and reproduce it.

How to Use This Part

To help you determine the status of a reproduction of an original artwork, we have created the checklist at the beginning of this part for you to follow. Each step in the process is described in the checklist and each line refers to one or more of the sections listed below or to other chapters of this book. If you have a particular work you are researching, start at Line 1 on the chart. As you answer each question you will be led to the appropriate section or chapters necessary to answer the next question on the checklist. At the end of the process you should know whether the work you want to use is in the public domain.

We have also included a worksheet (Appendix C) to document how you determined that a particular work was in the public domain. By filling out the sheet, you will be able to document your research and conclusions should anyone challenge your right to use the work. (See Chapter 1, Section D, and Appendix C.)

What If the Work Is Not in the Public Domain? If you find that the work you want to use is not in the public domain, you may be able to use it anyway under a legal doctrine called "fair use." If your intended use doesn't qualify as a fair use, you will need to obtain permission to use the work. See Chapter 22 for a detailed discussion of your options where you determine a work is not in the public domain.

J. Is the Original Work of Art in the Public Domain?

As explained below, some art reproductions are copyrighted and some are not. But, one rule applies to all reproductions: If the original artwork is not in the public domain, the reproduction is not either. You must always determine the copyright status of the original before deciding whether the reproduction is copyrighted. (For a detailed discussion of copyright protection for original artworks, see Part I above.)

It is possible for a reproduction to be in the public domain while the original artwork is still protected by copyright. For example if a photograph of a famous copyrighted

artwork lacks originality, it would be in the public domain. However, if the original artwork is still protected by copyright, the reproduction could not be used without permission from the copyright holder of the original. But there would be no need to obtain a separate permission from the creator of the reproduction.

If the original artwork is in the public domain, mark "yes" on Line 1 of the checklist at the beginning of this part and continue to Line 2. If the original work is not in the public domain, the reproduction is not either. Mark "no" on Line 1. See Chapter 22 for a detailed discussion of your options where you determine a work is not in the public domain.

K. Has the Reproduction Been Published?

The answer to this question determines how long the copyright lasts and whether it has to contain a copyright notice. As with any work, an art reproduction is published when it is made available to the general public on an unrestricted basis. For example, a photo of a public domain painting is published when it is offered for sale to the general public in an art book, postcard, poster, or slide. The same rules apply to art reproductions and photographs. Read Chapter 6 for a detailed analysis of publication.

If the reproduction has been published, mark "yes" on Line 2, enter the year and country of publication in Line 3, and continue to Line 4. If the reproduction has not been published, mark "no" on Line 2 and skip to Line 4.

L. Has the Copyright in the Reproduction Expired?

The copyright in an art reproduction published as recently as 1963 could be in the public domain. The copyright in many unpublished reproductions expired in 2003. The rules for how long copyright lasts are the same for all types of work. Read Chapter 18 for a detailed discussion of copyright duration to see if the work you are interested in using has entered the public domain because its copyright expired.

If, after reading Chapter 18, you decide that the copyright in the reproduction has expired, you should mark "yes" on Line 4 of the checklist at the beginning of this part. If you determine, as described above in Part I, that the original work is also in the public domain, then the reproduction will be free of copyright protection. If this is the case, you should proceed to Line 8 on the checklist. If the copyright has not expired, mark "no" on Line 4 and proceed to Line 5.

M. Is the Reproduction in the Public Domain Due to Lack of a Copyright Notice?

If the copyright in a reproduction has not expired, it could still be in the public domain if it fails to comply with copyright notice rules. You should carefully examine the reproduction to see if it contains a copyright notice—a © symbol or the word "copyright" or the abbreviation "Copr." and the copyright owner's name. Copyright notices for photographs published before 1978 don't need to have a publication date. Art reproductions published from Jan. 1, 1978 through March 3, 1989 do need a publication year date, except for postcards, greeting cards, stationery, jewelry, toys, dolls, and useful articles.

If the work lacks a notice and you know it was published before 1989, it may have entered the public domain. Unfortunately, it is not always easy (or even possible) to determine if such works are in the public domain. (See Chapter 19 for a detailed discussion.)

If the reproduction was never published, or published after March 1, 1989, it doesn't need a copyright notice and you can skip Chapter 19.

If you determine that the art is in the public domain because it lacks a copyright notice, mark "yes" in Line 5 and proceed to Line 8. If the reproduction has a notice or the lack of notice is excused, mark "no" on Line 5 and proceed to Line 6.

N. Does the Reproduction Lack Originality?

If copyright protection for an art reproduction has not expired and it has a proper copyright notice, it may still be in the public domain for another reason: lack of originality. A reproduction of a public domain work of art is entitled to copyright protection only if it is original. It cannot be simply an exact copy of the original artwork. Reproductions that lack originality are in the public domain. There are undoubtedly a vast number of art reproductions that are not protected by copyright on this basis—these may include reproductions created as recently as last week. If the original artwork is also in the public domain, these reproduction may be freely used.

Determining whether an art reproduction contains sufficient originality to be protected by copyright is a judgment call and reasonable minds can differ. If you're not sure whether a reproduction merits copyright protection, refer to Chapter 1 for detailed guidance on how to deal with foggy areas in the law of the public domain.

Here we examine the originality requirement for works other than photographs and digital copies. We deal with these categories separately below because photographs present special problems that have yet to be resolved by the courts.

1. Reproductions Other Than Photographs

Reproductions other than photographs include lithographs, phototoengravings, and three-dimensional reproductions of sculpture. The amount of originality required for such works to receive copyright protection is fairly small. All that is required is that the creator of a reproduction contribute something more than what the courts have called "a merely trivial variation" on the original public domain work. The contribution must be a substantial variation, "something recognizably his [the creator's] own." *Alfred Bell & Co. v. Catalda Fine Arts,* 191 F.2d 99 (2d Cir. 1951).

For example, mezzotint engravings of public domain old master paintings were found protected by copyright because the engraver had to use skill and judgment to create the engravings—that is, the engraver had to decide how to portray the paintings through the use of different lines and dots on a metal plate producing varying degrees of light and shade. Such engraving was a very different operation than creating the original public domain paintings with a brush and paints. Thus, the engravings were not mere "slavish" copies. They required an independent act of creation by the engraver. *Alfred Bell & Co. v. Catalda Fine Arts.*)

On the other hand, purely trivial or minuscule variations are not enough to make a reproduction protected by copyright, even if they require great technical skill and effort. For example, one court ruled that a plastic version of a public domain cast iron mechanical coin bank was not protected by copyright because the plastic bank was substantially the same as the public domain cast iron version, except that it was made from plastic and was slightly smaller. *L. Batlin and Son, Inc. v. Snyder,* 536 F.2d 486 (2d Cir. 1976).

Similarly, art reproductions made by purely mechanical or photomechanical processes are not protected by copyright. This includes photocopying—for example, a photocopy of a public domain pen-and-ink drawing is not protected by copyright as an art reproduction. Both the original drawing and the photocopy are in the public domain. On the other hand, a photocopy of a montage made of several public domain drawings would be protected by copyright.

Likewise, the act of transferring a work of art from one medium to another is not by itself sufficient to give copyright protection to the copy. Rather, a copy in a new medium is protected by copyright only where the copier makes some identifiable original contribution. For example, transferring a painting on canvas to a coffee mug or plate does not by itself result in a copyrighted reproduction.

EXAMPLE: In the late 1960s, John McConnel created the first "Earth Flag" by copying a photograph of the Earth taken by Apollo astronauts onto a piece of blue fabric. The flag became a well-known symbol of the environmental movement. Some 30 years later, the

Alamo Flag Company created and sold an almost identical flag. The company that McConnel licensed his flag design to sued Alamo for copyright infringement and lost. The court held that the original Earth Flag was in the public domain because it was not a copyrightable work of authorship. The photo of the Earth McConnel used was taken by government employees and no creativity was required to reproduce it on a flag-size piece of cloth. The flag was nothing more than a public domain photo transferred from paper to fabric. As such, it was itself in the public domain and could be freely copied. McConnel did not have a copyright over the idea of creating a flag with a photo of the Earth—like all artistic ideas, this was in the public domain. *Earth Flag Ltd. v. Alamo Flag Co.*, 153 F.Supp.2d 349 (S.D. N.Y. 2001).

2. Photographs of Public Domain Artwork

Photographs of public domain artwork deserve special treatment. Except for those relatively rare occasions where we go to museums or art galleries, most of us rely on photographs to view public domain art works. These may be published in art books, art slides, art exhibition catalogues, postcards, or posters. Legal protection for photographs in general is discussed in Chapter 6. This section focuses solely on the question of whether photographs of public domain art works are protected by copyright as art reproductions.

The most recent court decision on this question held that photographs of public domain paintings lack originality and are therefore in the public domain. The case involved the Bridgeman Art Library Ltd., a company that has obtained the exclusive rights to license photographs of hundreds of public domain art masterpieces from various museums. Corel Corp. allegedly obtained more than 150 images from the Bridgeman collection and published them without obtaining Bridgeman's permission. The images were included on clip-art CD-ROMs and placed on the Corel website where they could be downloaded for a few dollars each.

Bridgeman sued Corel claiming that the unauthorized duplication of the photos was copyright infringement. The court held that no infringement was involved because the photos were in the public domain. The court found that the photos lacked originality and therefore could not be copyrighted as art reproductions. As noted above, a reproduction of a public domain work of art is protected by copyright only if there is some nontrivial variation on the original public domain work. The court noted that the whole purpose of taking the photos was to make "slavish copies" of the public domain originals—that is, to reproduce the underlying public domain works with absolute fidelity. While this took both effort and skill, it did not require

originality. The photos stood "in the same relation to the original works of art as a photocopy stands to a page of typescript, a doodle, or a Michelangelo drawing." *Bridgeman Art Library Ltd. v. Corel Corp.*, 25 F.Supp.2d 421 (S.D. N.Y. 1999).

The *Bridgeman* case has attracted much attention in the art world. Some people seem to think it means they can now freely copy photographs of public domain art. However, this is not true, for the following reasons:

- Although the reasoning of the *Bridgeman* case is persuasive and is in line with some other cases that have held that exact photographic reproduction of public domain art are not protected by copyright, the case does not establish the law for the entire United States. It is merely a decision by one federal district court trial judge in New York. Other courts are not bound by the ruling and are free to disagree with it.

- The federal courts are only bound by decisions made by the federal courts of appeal or the U.S. Supreme Court. Unfortunately, none of these courts has ruled on whether photographs of public domain art are protected by copyright. As a result, this remains a legal question without a definitive answer.

- People who take and publish photos of public domain artworks have claimed in the past and will continue to claim copyright protection for their photos—look at any artbook containing photos of public domain art and you'll find a copyright notice and likely a warning statement barring any copying of the book without permission.

- The fact that copyright claims in photos of public domain art are made does not mean that such claims are legally valid. However, if you copy a photo of a public domain painting or drawing without permission, you could get sued for copyright infringement, notwithstanding the *Bridgeman* decision. The existence of the *Bridgeman* case will be helpful to your case. Indeed, you probably have a very good chance of winning. But there is no guarantee that you will win. Moreover, even if you win you'll still have to go through the expense and trauma of court litigation.

- In reaction to the *Bridgeman* decision, companies, museums, and other organizations that publish art photos are relying on license agreements more than ever—that is, they require people who purchase or obtain permission to use their photos to agree to a license (a type of contract) limiting how they may use the photos. In this way, they can sue for breach of the license agreement if someone violates the terms of the license. However, there are limits on the effectiveness of licenses. For example, in the *Bridgeman* case Corel was able

to obtain the photos from a third party without signing a license. Moreover, the legal enforceability of such licenses is questionable. (See Chapter 2 for a detailed discussion.)

- The *Bridgeman* case only dealt with photos of two-dimensional artworks —paintings, frescoes, and drawings. Photos of three-dimensional works such as sculpture may be protectable as art reproductions because there are many ways to photograph a three-dimensional object, particularly a large one—choices as to lighting, angle, and so forth that may add originality to the reproduction.
- The *Bridgeman* case has no application at all to cases where a photographer makes something other than a "slavish copy" of a public domain work—that is, a reproduction as faithful to the original as photographic technology allows. For example, a photo of the *Mona Lisa* would be protected by copyright if the photographer lit it in such a way that only *Mona Lisa*'s face was visible, not the background.

Whether a photograph of a public domain work of art is protected by copyright remains a gray area. Before copying such a photo, refer to Chapter 1 for detailed guidance on how to deal with these foggy areas in the law on public domain.

In many cases photos of public domain artworks are in the public domain for reasons that have nothing to do with the originality issue. For example, a photo published initially in the United States between 1923-1963 is in the public domain if its copyright was not renewed on time, as may be photos published before March 1, 1989 without a valid copyright notice (see Chapter 19). Using photos in these categories will virtually eliminate the possibility of getting sued.

3. Digital Reproductions

The newest method of reproducing a work of art is to create a digital reproduction and store it on a computer. Such reproductions are found on many websites on the Internet and on CD-ROMs and DVDs offered for sale to the public. The most common way of creating a digital reproduction is to use a computer scanner to create a digital copy of a photograph of the artwork. In some cases, the original work is scanned rather than a photograph—for example, an original drawing could be scanned. Photographing a work of art with a digital camera can also create a digital reproduction.

As mentioned above, art reproductions made by purely mechanical means such as photocopying cannot obtain copyright protection. It follows logically, then, that a photograph of an original work of art intended to be an exact copy of the original

should not have copyright protection. For this reason, the Copyright Office has refused to register many scanned images of public domain artworks. However, some companies that own digital copies of public domain artworks continue to claim copyright in them. Such claims are probably spurious, but you might still be threatened with a lawsuit if you treat such companies' digital copies as public domain. (See Chapter 1 for detailed guidance on how to deal with such public domain problem areas.)

Moreover, if a scanned image of a public domain artwork is altered in some way, it may acquire copyright protection. For example, a person who scans a photo of a landscape painting by John Constable could change the color of the sky, move the location of a brook or even remove a human figure. This sort of thing is easily done with computer technology. Such changes represent new authorship that is protected by copyright.

Digital copies created by directly photographing artworks with digital cameras present the same legal issues as traditional photographs taken with film cameras discussed in the previous section.

If you determine that the reproduction lacks originality, mark "yes" on Line 6 of the checklist at the beginning of this part and skip to Line 8. If you decide the reproduction is original, mark "no" on Line 6 and continue to Line 7.

O. Is the Reproduction Dedicated to the Public Domain?

People who create protected-by-copyright art reproductions need not enjoy copyright protection if they don't want it. Instead, they may dedicate the reproduction to the public domain. This means they give up all their rights in the work forever and anyone may use the work without asking their permission.

There is no prescribed formula for dedicating a work to the public domain. The creator or other copyright owner simply has to make clear his or her intentions. For example, stating, "This work is dedicated to the public domain" on an art photo would be sufficient. It's not even necessary to make the dedication in writing. It could be done orally, but it's always best to write something down to avoid possible mis-understandings.

Be careful, however, where a creator sends mixed messages. For example, if a photographer states that his art photos are in the public domain, but then attempts to restrict how the public may use them—for example, by saying "This work is public domain but may not be posted on the World Wide Web without my permission." When a work is dedicated to the public domain, the author may not restrict how it is used. A statement like this leaves it unclear whether the author really intended

to dedicate the work to the public domain. It's wise to seek clarification from the creator or ask permission for the restricted use.

Similarly the use of the phrase "copyright free" by the author need not mean the work is dedicated to the public domain. The words "copyright free" are often used to describe photos and clip-art that are under copyright, but are sold to the public for a set fee rather than under a royalty arrangement.

Dedicating an Art Reproduction to the Public Domain Does Not Mean That the Original Work of Art Enters the Public Domain as Well. You must be sure the original artwork is in the public domain before deciding to use a reproduction that has been dedicated to the public domain. (See Part I above.)

If the reproduction has been dedicated to the public domain, mark "yes" on Line 7 and proceed to Line 8. If the work has not been dedicated to the public domain, mark "no" on Line 7. In this case, the work is not in the public domain, but it may have public domain elements that you are free to use. See Section Q for a more detailed discussion on the issue of using public domain elements of copyrighted works.

P. Will You Use the Reproduction in Advertising or on Merchandise?

An art reproduction in the public domain may receive some legal protection under the state and federal trademark laws if someone is using it in advertising, product packaging, or on merchandise such as T-shirts, mugs, plates, etc. If this is the case, you may be prevented from using the reproduction for similar purposes. Read Section G above and then refer to Chapter 20 for a detailed discussion of the trademark laws.

If you plan to make a commercial use of the art reproduction, refer to Chapter 20 to see if your intended use is restricted by state and federal trademark laws. If so, you'll need permission for the use. If you do not plan to make use of the work for commercial purposes as outlined above, mark "no" on Line 8. You are free to use the work in any way you choose.

Q. Are Elements of the Reproduction in the Public Domain?

Art reproductions receive limited copyright protection. Even if an art reproduction as a whole is not in the public domain, it will likely contain individual elements that are in the public domain. These may be

copied freely even if the work as a whole may not be.

All that is protected in an art reproduction is the new authorship added to the original public domain work. For example, a fabric designer reproduced public domain designs on a fabric in such a manner that by arranging varying colors the flat surface looked like three-dimensional embroidery. Copyright only protected the three-dimensional effect, not the elements of the design directly copied from the public domain designs. *Millworth Converting Corp. v. Slifka*, 276 F.2d 443 (2d Cir. 1960).

You are always free to copy the original public domain work. But you don't have to go back to the original. You can copy the copy so long as you don't copy the original elements that make the copy different than the original. For example, you can use a mezzotint engraving of the *Mona Lisa* to paint your own version of the *Mona Lisa*. But you can't make an exact copy of the engraving—that is, copy each line and dot made by the engraver.

R. Sources of Art Reproductions

There are many sources of reproductions of public domain artworks, including many museums and private companies such as the Bridgeman Art Library. Unfortunately, many of these sources will charge you a fee for the reproduction and may also require you to accept a license agreement that attempts to restrict what you can do with the reproduction. This section focuses on places where you can obtain reproductions for free and without agreeing to a license.

1. Libraries

Libraries house many books and other works that contain reproductions of public domain art. If the book is also in the public domain, you may safely copy all the illustrations. For example, you may be able to find an artbook of Salvador Dali drawings published in the 1950s that is in the public domain because the copyright was never renewed. Or, if you're looking for humorous illustrations of life in Victorian England, you can find many in the British magazine *Punch* that was published during the 19th century and is in the public domain because the copyright expired. Find a library that has copies of *Punch* and you're home free. See Chapter 3 for a discussion of how to determine when books, magazines, and other publications are in the public domain.

Some libraries may allow you to take such materials home where you can scan, photograph, or photocopy them. However, in many cases you may not be permitted to remove the materials from the library. In this event, you must ask for permission to photocopy, scan, or photograph them in the library. Some libraries may grant this permission for free (often with the proviso that you give credit to the library). Others will refuse or demand payment. You must ask to find out.

There are art reference books that index art reproductions in books and exhibition catalogues. These are by no means comprehensive, but can give you an idea where to look. Among these are:

Index to Two-Dimensional Art Works, by Yala H. Korwin (Scarecrow). Covers 250 books published 1960-77.

World Paintings Index, (First and Second Supplements) by Patricia Pate Havlice (Scarecrow). Indexes works of art in 2,481 books and catalogues from 1940-1989.

The International Directory of Art Libraries website is a directory of over 3,000 libraries around the world with special art collections. The URL is http://artlibrary .vassar.edu/ifla-idal.

See Chapter 3, Section I1, for a detailed discussion of how to locate libraries, particularly those with special collections.

2. The Internet

There are thousands of digital copies of photos of public domain artworks on the Internet, available for downloading. Many are available at websites maintained by art museums, such as the Louvre Museum. Others are at sites maintained by university art departments or art fans. Unfortunately, these images are usually of low quality. Moreover, the owners of these sites often claim copyright in these images. As discussed in Section N3, however, such claims are highly suspect.

A comprehensive guide to Internet art resources is the book *Art Information on the Internet,* by Lois Swan Jones (Oryx Press).

Another good way to find such a website is to conduct a search on a Web search engine such as Google using the artist's name. Many artist websites are also listed on the following websites:

- Art History Resources on the Web: http://witcombe.bcpw.sbc.edu/ ARTHLinks.html
- World Wide Art Resources: http:// wwar.com/artists1.html.

You can find a list of museum websites at the Yahoo directory. The URL is:

http://dir.yahoo.com/Arts/Museums_ Galleries_and_Centers.

If you're an America Online user, type "Image Exchange" and go to "Museums and Exhibits Online"

3. Clip-Art Collections

"Clip-art" refers to artwork that is sold to the public for the specific purpose of being copied and republished. Such clip-art is available in book form, on CD-ROMS, and over the Internet.

There are several types of clip-art. Much clip-art consists of reproductions of public domain works—for example, photos of public domain paintings and drawings or reproductions of illustrations taken from public domain books. For example, Dover Publications publishes a clip-art book containing copies of illustrations from a

catalogue published in 1907. Some clip-art has been dedicated to the public domain.

You can find thousands of collections of public domain clip-art on the Internet. Some of this clip-art has been dedicated to the public domain, some is copied from public domain sources. For example, one website (http://members.aol.com/guron/index.htm) contains line illustrations of Gilbert and Sullivan operettas copied from 19th century magazines. To find other clip-art sites, conduct an Internet search. Use the search terms "clip art" and "public domain."

There are also hundreds of clip-art collections published in book form. You can find listings for these by searching the Amazon.com or BarnesandNoble.com websites under "clip art." Probably the leading publisher of clip-art books of public domain works is Dover Publications. You can obtain a catalogue of Dover books by writing to Dept. 23, Dover Publications, Inc., 31 East 2nd St., Mineola, NY 11501. Indicate in your letter that you're interested in clip-art.

⚠ **Be Very Careful Before Using Clip-art You Find on the Internet.** Many websites contain clip-art that is "free," but not in the public domain. Such clip-art is licensed to the public for free for certain uses, but restrictions are imposed on how it may be used. Often, for example, "free" clip-art may only be used for personal purposes, while permission is required for commercial uses. Such restrictions are often placed in a "terms of use" section on a clip-art website. When clip-art is in the public domain, there are no restrictions on how you may use it.

Another problem is that the creators of some clip-art websites have copied copyrighted clip-art from other websites, books, and other sources. They may state that the clip-art is in the public domain when it really isn't. For this reason, it's advisable to email the webmaster of the site for verification that the clip-art really is in the public domain. Print and file the email response if you use the clip-art. This is a particularly good idea if you will use the clip-art for commercial purposes.

a. Limited Copyright Protection for Clip-Art Collections

Clip-art collections of public domain art may be entitled to limited copyright protection as compilations. For example, a clip-art collection consisting of drawings of birds compiled from several public domain publications is entitled to a compilation copyright. Such a copyright extends only to the selection and arrangement of the collection as a whole, not to the individual selections themselves. Such a compilation copyright does bar a person from copying the entire collection and selling it to the public. The compiler of the collection may also claim copyright for the reproductions themselves. However, slavish reproductions of public domain art are likely not protected by copyright (see Section N2), so such copyright claims are highly suspect.

Illustration of Gilbert and Sullivan's *The Mikado*. (http://members.aol.com/guron/index.htm)

Persia: Bird and plant figure, *Visual Elements, World Traditional Folk Patterns*, Rockport Publishers

NASA

Old Fashioned Animal Cuts, Dover Publications

Art for Instant Printing, by James Benbow Bullock, Dixie Bugle Co.

Vintage Cartoons, Graphic Source Clip-Art, Graphic Products Corporation

b. Royalty Free or "Copyright Free" Clip-Art

Many clip-art collections consist of copies of works that are not in the public domain. Such clip-art is often sold for a flat fee or a subscription fee. Clip-art sold on this basis is often referred to as "royalty free" or "copyright free." The term copyright free does not mean that the clip-art is in the public domain. Rather, it's intended to mean that no royalties above the flat fee or subscription fee need be paid for use of the clip-art.

c. Licensing Clip-Art

People and companies that sell clip-art often use license agreements that restrict how the purchaser may use the clip-art. If the clip-art is sold on a CD-ROM, the agreement is typically printed somewhere on or in the case and may be repeated on your computer screen when you start to use the CD-ROM. Clip-art downloaded from the Internet is often accompanied by "click-wrap" agreements that require clicking on a button entitled "Okay" or "I Agree."

Always read these agreements carefully. They contain a list of do's and don'ts that are often far more restrictive than required under copyright law. Their legal enforceability is unclear, particularly where the clip-art is in the public domain (see Chapter 1).

Dover Publications, the largest publisher of public domain clip-art in book form, typically includes the following statement in its clip-art collections:

You may use the designs and illustrations for graphics and crafts applications, free and without special permission, provided that you include no more than 10 in the same publication or project.

It's highly unlikely that a statement like this in a book is legally enforceable. ■

Chapter 6

Photography

Photography Checklist

1. Has the photograph been published? (See Section B1.)

 ☐ Yes: Continue.

 ☐ No: Skip to line 3.

2. Date of publication (see Section B2): _____

 Country of publication (see Section B2): _____

3. Has the copyright in the photograph expired? (See Section B3.)

 ☐ Yes: Photograph is in public domain. Skip to line 6.

 ☐ No: Continue.

4. Is the photograph in the public domain due to lack of a copyright notice? (See Section B4.)

 ☐ Yes: Photograph is in public domain. Skip to line 6.

 ☐ No: Continue.

5. Is the photograph eligible for copyright protection? (See Section B5.)

 ☐ Yes: Photograph is protected by copyright. Do not continue.

 ☐ No: Photograph is in public domain. Continue.

6. Does the photograph contain copyrighted material? (See Section B6.)

 ☐ Yes: Permission may be needed by owner of materials. Do not continue.

 ☐ No: Continue.

7. Is your use of the photograph restricted by trademark or right of publicity. (See Section B7.)

 ☐ Yes: Permission may be needed from owner of materials.

 ☐ No: Photograph may be freely used for your purposes.

Photographs include any product of the photographic process, such as prints, negatives, slides, and film-strips. Since the invention of photography in 1839, it's likely that billions of photographs have been taken, many millions of which are in the public domain.

⚠️ **Many Works That Are in the Public Domain in the United States Are Still Protected by Copyright Outside the United States and Vice Versa.** This chapter only covers the public domain in the United States. For a detailed discussion of the public domain abroad, see Chapter 16.

A. What Good Are Public Domain Photographs?

Everyone likes to look at photographs. They are constantly being used in books, magazines, newspapers, posters, postcards, and even in documentary films. Nobody knows how many photos have been posted on the Internet, but the number must be well into the millions.

Ordinarily, you need to obtain permission to use someone else's copyrighted photograph. This permission usually isn't free. For example, high-end stock photo agencies—companies that specialize in licensing photos to the public—usually charge at least $150 per photo, often much more. Famous photos may cost thousands of dollars to use. If you want to use a photo more than once, additional fees may have to be paid.

When a photo is in the public domain, you are free to copy, reproduce, display, or alter it without obtaining permission from anyone. For example, you can use it in a book or article or post it on your website. However, there are some exceptions to this rule: Permission may be needed if the photo contains people or trademarks and you intend to use it for advertising or on merchandise (see Section B7).

Public domain photos are not always free, because you may have to pay a fee to obtain actual or digital copies of them, but they are usually much cheaper than copyrighted photos. Moreover, there are thousands and thousands of public domain photos that can be obtained for free from books, newspapers, and magazines sitting on library or archive shelves.

How to Use This Chapter

To help you determine the status of a photograph, we have created the checklist at the beginning of this chapter for you to follow. Each step in the process is described in the checklist and each line refers to one or more of the sections listed below or to other chapters of this book. If you have a particular work you are researching, start at Line 1 on the chart. As you answer each question you will be led to the appropriate section or chapters necessary to answer the next question on the checklist. At the end of the process you should know whether the work you want to use is in the public domain.

We have also included a worksheet (Appendix C) to document how you

Free Pictures: Worth a Thousand Words

Emmy Werner, a developmental psychologist at the University of California at Davis, wanted to write a book about the experiences of children during World War II. She realized that including pictures taken of children during the war would greatly enhance the book. So she traveled to the National Archives in College Park, Md., where she was given access to hundreds of photos of children taken during World War II by the U.S. Army Signal Corps. All these photos were in the public domain because they were taken by U.S. government employees—soldiers whose job was to document the war (see Section C4 below). She chose about 40 photos to include in her book. She had a private company duplicate the photos at a cost of from $5 to $10 each. This was the only expense involved. Because the photos were in the public domain, she did not have to obtain permission to use them or pay any permission or license fees. Werner's book, *Through the Eyes of Innocents: Children Witness World War II*, was published in early 2000. The moving photo of two children below is from the frontispiece of the book.

determined that a particular work was in the public domain. By filling out the sheet, you will be able to document your research and conclusions should anyone challenge your right to use the work. (See Chapter 1, Section D, and Appendix C.)

What If the Work Is Not in the Public Domain? If you find that the work you want to use is not in the public domain, you may be able to use it anyway under a legal exception called "fair use" (see Chapter 22). If you do not qualify for this exception, you will need to obtain permission to use the work. For a detailed discussion of how to obtain copyright permissions refer to *Getting Permission: How to License & Clear Copyrighted Materials Online & Off*, by Richard Stim (Nolo).

B. Deciding Whether Photographs Are in the Public Domain

The first step in determining the public domain status of a photograph is to decide if it has been published.

1. Has the Photograph Been Published?

To determine how long a particular photograph retains copyright protection, you must determine whether it was published properly under the rules of copyright law and, if so, when. The answer to these questions will determine how long the copyright in the photo lasts.

Like any work of authorship, a photograph is published for copyright purposes when the copyright owner, or someone acting on his or her behalf, makes the photo available to the *general* public. In other words, any interested member of the public may obtain a copy. *Burke v. National Broadcasting Co.*, 598 F.2d 688 (9th Cir. 1979).

For example, photographs are published when they are reproduced in newspapers, magazines, books, postcards, sets of slides, greeting cards, posters, T-shirts, mugs, or any other item that is sold or otherwise made available to the general public.

Of course, many photographs have never been made available to the general public, including many that are quite old. For example, your own family snapshots collected in a family photo album likely have never been published. Moreover, photos are not deemed published when they are displayed to the public in an art gallery or museum.

2. Finding the Date and Country of Publication

If you determine that the photograph you're interested in has been published, you should also determine the year of publication and the country where it was first published. Both these factors will affect

how long the United States copyright in the photo lasts (see Chapter 18).

a. Date of Publication

You just need to know the year, not the exact date, the photo was first published. You can usually determine the publication date from the work itself. First, look for a publication date in the copyright notice. Photos published before 1978 didn't have to include a publication date in their copyright notices, but they often had them anyway—for example, © 1986 by Kim Kodak. Photos published 1978-1989 did need a publication date in the notice. (See Chapter 19 for a detailed discussion of copyright notices.)

Photos are sometimes published alone, as in a postcard. In this event, they will often contain their own individual copyright notices. However, photos are also often published as part of a larger work—for example, books, magazines, and newspapers. Photos published in this way will sometime have their own notice, but often they won't. In this event, the copyright notice for the larger work will provide you with the publication date for the photo (books, magazines, and newspapers have always needed a publication date in their copyright notices). However, be sure to check any photo credit or acknowledgment section in the work to make sure the photo wasn't previously published before it was included in the work you have.

If the photo lacks a copyright notice with a date, you'll have to look elsewhere for clues about the publication date. Try the following:

Examine the Work for a Date. Examine the work in which the photo was published—for example, a newspaper—for a publication date. Most published works contain some indication of when they were published. Look on the title page, the masthead, the page after the title page, and anywhere else that seems logical.

Check the Library of Congress Card Catalogue. Check the Library of Congress card catalogue to see if it has as a record for the larger work in which the photo was published or for the individual photo itself. You can do this in person at the Library in Washington, DC or online through the Library's Web page (http://catalog.loc .gov). The Library's catalogue contains the publication dates for millions of works in the Library's collection.

Check Copyright Office Records. If either the individual photo or the larger work in which it was published (if any) was registered with the U.S. Copyright Office, checking Copyright Office registration records will reveal the publication date. Many of these records can be researched online (see Chapter 21). However, not all published works are registered with the Copyright Office, so there may be no record for it.

Check Reference Works. There are hundreds of reference works that may be able to tell you when a work was published. Go to a public or university library with a good reference section and

ask the reference librarian for assistance. If you're too busy to go to a library, you can post your research questions on the Internet at www.ipl.org and a reference librarian will email you with advice.

Research the Photographer. Researching the photographer or the author of the larger work in which the photograph was published, may reveal the publication date. If the photographer or author is well known, a biography or critical study may have a detailed publication history for his or her works.

Use the Internet. Search the Internet using the name of the photographer, the name of any larger work in which the photograph was published, and the name of the author and publisher of that work. There may be a website devoted to the photographer, author, or even to the particular work, or some online reference with detailed information about the work. A good place to find a list of Internet reference resources is the Internet Public Library at www.ipl.org.

Contact the Publisher. If the photo was published in a larger work such as a book or newspaper, contact the work's publisher and ask them to tell you when the work was first published.

b. Country of Publication

Unfortunately, a work's country of publication is not listed in the copyright notice. However, most published works typically say where they were published or printed. You can often find this information on the same page as the copyright notice. If you can't find the country of publication from the work itself, try using the resources listed above—they will ordinarily provide the country of publication as well as the publication date.

If you determine that the photograph has been published, mark "yes" on Line 1 and proceed to Line 2. If the photograph has not been published, check "no" on Line 1 and skip to Line 3 of the checklist at the beginning of this chapter.

3. Has the Copyright in the Photograph Expired?

Once you determine if a photo has been published, you can figure out whether its copyright has expired. When copyright expires in a work, it enters the public domain. The greatest single body of public domain photos available for use in the United States is works for which the U.S. copyright term has expired.

Unfortunately, determining whether a copyright has expired can be somewhat complex. You'll need to determine which of several possible copyright terms apply to the work in question. Photos published as recently as 1963 could be in the public domain. On the other hand, photos created over 100 years ago (and more) could still be protected by copyright.

The length of a copyright is the same no matter what type of work is involved

(photos, art, writings, music, etc.), so they are discussed in detail in Chapter 18. Turn to that chapter now to determine whether the copyright in a photo you're interested in has expired.

➡️ If the photograph you're interested in was published after 1963, its copyright protection has not expired. If you wish, you may skip to Chapter 18, however, and read that chapter if you want to know exactly when the photo's copyright will eventually expire.

📶 If you decide that the photo's copyright has expired, mark "yes" on Line 3 of the checklist at the beginning of this chapter and skip to Line 6. If the copyright has not expired, mark "no" on Line 3 and continue to Line 4.

4. Is the Photograph in the Public Domain Due to Lack of a Copyright Notice?

➡️ Before reading this section, you must determine whether the photograph you want to use has been published for copyright purposes. If the photo was never published, it doesn't need a copyright notice and you don't need to read any more of this section. Skip to Section B5.

If a photo was published before 1989, it could be in the public domain if it lacks a copyright notice. A copyright notice for a

photograph must contain three elements—the familiar © symbol, the word "Copyright" or the abbreviation "Copr.," the publication date, and the name of copyright owner—for example:

© 1965 by Amos Adams.

Examine the photo carefully to determine if it has a notice. It can be anywhere on the front or back of the photo. Photos are very often published as part of larger works—for example, in books, magazines, and newspapers. It's sufficient that the larger work has a copyright notice—the individual photos included within it need not have their own notices (though they often do). For example, a notice in the name of a magazine will cover all the photos in the magazine. However, there is one exception to this rule: Photos contained in advertisements published in magazines, newspapers, and similar works must contain their own copyright notices.

You can usually find the notice for a book on the page immediately following the title page or on the title page itself. Copyright notices for magazines, newspapers, journals, and other periodicals are usually found on the title page, the first page of text, or under the title heading. The notice may also appear in a magazine's masthead.

Read Chapter 19 for detailed guidance on how to determine whether a published work is in the public domain because it lacks a valid copyright notice.

If the work has a notice in the format described above, it is not in the public domain for lack of a notice. Mark "no" on Line 4 and continue to Line 5. If the work lacks a proper notice and you determine that it is in the public domain because no excuse applies, mark "yes" on Line 4. The photograph is in the public domain. But you must skip to Line 6 to make sure the photograph is not protected by other laws.

5. Is the Photograph Eligible for Copyright?

Certain types of photographs are ineligible for copyright protection. These may be copied or otherwise freely used unless your use violates publicity rights (see Section B7), trademark rights (see Section B7), or if the subject of the photograph is copyrighted (see Section B6).

a. Photographs Lacking Originality

Only photographs that are original can have copyright protection. There are three ways a photograph is deemed to be original:

- there may be originality in the way the photograph is made—for example, such elements as choice of time and light exposure, camera angle or perspective, deployment of light and shadow from natural or artificial light sources, and effects achieved by use of filters and developing techniques

- there may be originality in the arrangement of the people, scenery, or other subjects depicted in the photograph, or
- a copyright may be created because the photograph records a scene unlikely to recur—for example, a battle between an elephant and a tiger. *Bridgeman Art Library Ltd. v. Corel Corp.*, 25 F.Supp.2d 421 (S.D. N.Y. 1999).

The vast majority of photographs qualify as sufficiently original under one or more of these criteria. This includes, for example, a photo of the New York Public Library, which a court ruled qualified for copyright protection under the first criterion listed above. Photographs made from photo footage of the John F. Kennedy assassination taken by an amateur cameraman named Abraham Zapruder were also considered protected under the third criterion listed above.

However, there are some types of photographs that lack originality:

- prints from a photographic negative
- a photograph of a photograph that is an exact copy of the original
- a photograph that is an exact copy of a page of text or other printed matter.

Photographs that lack originality are not protected by copyright. However, this does not necessarily mean that they may be freely used. A print, negative, or photograph of a preexisting photograph can only be freely copied or otherwise used if the original negative or photograph is

in the public domain. If not, permission is needed from the copyright owner of the original photograph. Similarly, a photograph of a page in a book may not be freely used unless the book is in the public domain (see Section B6).

Some courts have held that exact photographic copies of paintings, drawings, or other two-dimensional works of art completely lack originality. However, this has not been definitively decided. (See Chapter 5 for a detailed discussion of copyright protection for art photos.)

i. Mechanical Copies of Public Domain Photographs

A public domain photograph can be copied by mechanical means using a photocopy machine or a computer scanner, which makes a digital copy that can be stored on a computer and printed out.

A photocopy of a public domain photo is also in the public domain, since a photocopier applies no originality to the public domain work. The only exception is where the copier alters the settings on the photocopy machine to create something other than an exact copy of the original photo.

A computer scan of a public domain photograph that is an exact copy of the original is also likely in the public domain. Such a digital copy is fundamentally no different from making a photocopy of a photograph with the photocopy machine. Again, the only exception would be where

the person making the scan changes or alters the original public domain photograph—for example, changes a black and white photo into color. Such alterations are easy to do with computer technology and can obtain copyright protection for the altered copy. But only the changes can be copyrighted, not the original photo.

People who create digital copies of public domain photographs by computer scanning often claim copyright in the copies. These claims are probably spurious where the digital copy is an exact or "slavish" copy of the original photo. Nevertheless, you could get sued for copyright infringement if you copy such digital copies. See Chapter 1 for detailed guidance on how to deal with such public domain gray areas.

b. Photographs by U.S. Government Employees

Works of authorship created by U.S. government employees as part of their job are ordinarily in the public domain, including photographs. For example, the photos taken by astronauts while on the moon are in the public domain—as are all other NASA photos—as well as tens of thousands of photos taken during World War II by the U.S. Army Signal Corps.

However, photographs of federal government agency seals, logos, emblems, and insignias may not be reproduced on articles —for example, on T-shirts— without government permission. This

includes, for example, the NASA insignia logo and the Presidential Seal. In addition, such photographs may not be used in advertisements, posters, books, or stationery in a manner that conveys a false impression of sponsorship or approval by the U.S. government or any government department or agency.

Moreover, certain organizations that you might think are part of the U.S. government are not considered to be so. These include the Smithsonian Institution and all of its branches and the National Gallery of Art in Washington, DC. Both are independent quasi-governmental entities that are entitled to, and do, claim copyright in works created by their employees. (See Chapter 3, Section C, for a more detailed discussion.)

If you decide the photograph is not eligible for copyright protection, mark "no" on Line 5. The photograph is in the public domain. But you must continue to Line 6 to make sure there are no other restrictions on your use of the work. If the photo is eligible for copyright protection, mark "yes" on Line 5. The photo is not in the public domain and you must seek permission to use it from the copyright owner.

6. Does the Photograph Contain Copyrighted Materials?

Even if a photograph is in the public domain, you may not be able to use it if the subject matter in the photo is protected under copyright law.

a. Nature Is Public Domain

Nobody "owns" the natural world around us. For example, anyone can photograph Yosemite National Park, a human face, or a natural object such as a vodka bottle. However, a photo of a natural object is entitled to copyright protection if it contains sufficient detail to make it minimally creative. In that case, you don't have the right to copy such a photo. *Ets-Hopkin v. Skyy Spirits, Inc.*, 323 F.3d 763 (9th Cir. 2003).

For example, anybody can create a photograph of a peach. Although peaches are in the public domain, a photo of a peach that makes creative use of lighting or perspective cannot be copied without permission. You could also infringe on a prior peach photo if you took your photo yourself, but copied the way the prior photo looked. *Yankee Candle Co. v. The Bridgewater Candle Company*, 259 F.3d 25 (1st Cir. 2001).

b. Photos of Copyrighted Works

Photographs are often made of copyrighted works of authorship such as paintings, drawings, and sculptures. Less frequently, photographs may also be taken of other types of works of authorship such as the pages in a copyrighted book. Such photographs are derivative works—new works created by transforming a preexisting work. The owner of the preexisting work has the exclusive right to create such derivative works for as long as his or her work is protected by copyright.

It is possible for a photograph of a work of art such as a painting to be in the public domain while the art itself is still protected by copyright. In this event, you would need to obtain permission from the copyright owner of the work of art to reproduce or otherwise use the photograph (but no permission would be needed from the owner of the photograph).

Architectural Photographs

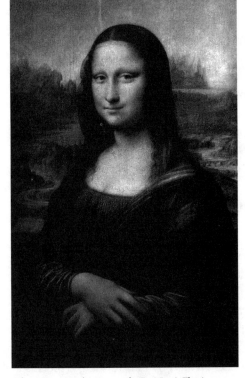

The *Mona Lisa* by Leonardo Da Vinci, The Louvre

Although buildings can be protected by copyright (see Chapter 9) they may always be photographed without permission if they can be viewed from a public place—for example, a public street. When an architectural photograph enters the public domain it may ordinarily be used freely without permission from the owner of the copyright in the building itself. But there is one possible exception: If the building serves as a trademark—that is, it helps identify a product or service sold to the public—a photograph of it may violate the trademark laws if the photograph is also used as a trademark. For example, the distinctive pyramid shaped Transamerica building in San Francisco serves as a trademark for the Transamerica Corporation. Using a photo of the building to advertise or promote a product or service could violate Transamerica's trademark rights. This could be so even if the photo was not protected by copyright.

EXAMPLE: Sam finds a photograph of Grant Wood's painting *American Gothic* that was published as a postcard in 1960. The copyright in the postcard was not renewed on time, so it entered the public domain on January 1, 1979 (see Chapter 18, Section A, for detailed explanation of copyright renewal requirements). However, the original Grant Wood painting is not in the public domain. This means that permission to reproduce the postcard would have to be obtained from Grant Wood's estate, but not from the photographer.

You don't have to worry about permissions if the subject of the photograph and the photograph itself are in the public domain —for example, a public domain photograph of the *Mona Lisa*. The *Mona Lisa* has always been in the public domain, so a public domain photo of it may be used freely.

7. Will You Use a Photograph for Commercial Purposes?

There are some special legal concerns where a photograph contains people or trademarks. A trademark usually consists of a word, phrase, logo, or other graphic symbol used to identify a product or symbol. Trademarks include product logos, brand names, company names, product packaging, or the distinctive shape of a product such as a Coke bottle. If you see the ® or TM symbols in a photograph you know it contains a trademark.

If you intend to use a photograph containing people or trademarks for advertising or other commercial purposes—for example, on merchandise such as T-shirts, coffee mugs, dishes, and ashtrays—you need to make sure that your use does not violate state right of publicity laws or state and federal trademark laws. Such violations could occur even though the photograph is in the public domain, meaning not protected by copyright.

For example, there are likely hundreds of photographs of Elvis Presley that are in the public domain (all those published before 1964 that never had their copyright renewed). Even so, you can't use such a photo in an advertisement for a product or service without consent from the Presley estate. Doing so will likely get you sued for violating Presley's right of publicity.

Similarly, there are many photographs containing the Coca-Cola name and logo that are in the public domain. Even so, you may not use such a photo for any advertising or commercial purpose without violating the Coca-Cola company's trademark rights.

In contrast, right of publicity and trademark laws are not violated when you use a photograph containing people or trademarks for noncommercial purposes— that is, editorial or informational uses, such as using a photo in a news story, nonfiction book, or documentary photo or video.

 Right of publicity and trademark laws are discussed in detail in Chapter 20.

C. Sources of Public Domain Photographs

No one has ever made a count, but it is likely that there are many millions of public domain photographs. The problem is finding them. There are a variety of sources.

 The following books provide detailed guidance on how to find photographs:

- *Picture Research: A Practical Guide*, by John Schultz (Routledge)
- *Finding Images Online* (Pemberton Press)
- *The Picture Researcher's Handbook: An International Guide to Picture Sources and How to Use Them*, by Hilary Evans (Van Nostrand Reinhold)
- *Practical Picture Research*, by Hilary Evans (Routledge-Blueprint).

1. Libraries

A great way to find public domain photos is in public domain books, magazines, newspapers, and other publications. The photos in any book, magazine, or newspaper published before 1923 are in the public domain.

Books and other publications published during 1923-1963 are also in the public domain if the copyright was never renewed. Photos contained in such nonrenewed publications may also be in the public domain. You must check both the photo credits in the publication and Copyright Office records to determine this (see Chapter 21).

Of course, the best way to find old books, magazines, and newspapers is in libraries. There are many different types of libraries, including public libraries, academic libraries, and historical society libraries. Many have special collections in particular subject areas. Some have special photographic collections. (See Chapter 3, Section I, for a detailed discussion of how to find libraries.)

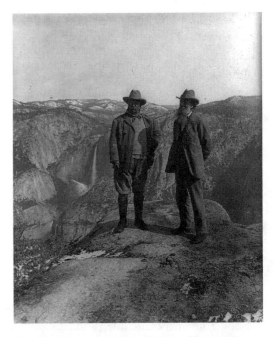

Theodore Roosevelt and John Muir on Glacier Point, Yosemite Valley, California. Library of Congress, Prints and Photographs Division

Some libraries will permit you to photograph, photocopy, or scan photos in their public domain materials free of charge. Others will charge a fee or require you to hire a photographer approved by the library. Others may refuse permission to make any copies. You must ask to find out.

2. Special Photography Collections

Several libraries contain outstanding collections of photographs, as do several museums that specialize in photography.

a. Library of Congress

The Library of Congress in Washington, DC, has a particularly outstanding photography collection, containing millions of images. These can be accessed from:

Prints and Photographs Reading Room
Library of Congress
James Madison Building
Room LM-337
Washington, DC 20540-4730.

The Prints and Photographs Reading Room has an excellent website at http://lcweb.loc.gov/rr/print. The site includes an online catalogue that lists many, but not all, of the Library's images.

The Library of Congress has a Photoduplication Service that, for a fee, will provide copies of virtually any public domain photograph in the Library's

collection. Its website is at: http://lcweb.loc.gov/preserv/pds. A price list for photo reprints is at www.loc.gov/preserv/pds/photo.html.

You can write, call, or email the Photoduplication Service at:

Library of Congress
Photoduplication Service
101 Independence Avenue, SE
Washington, DC 20540-4570
Telephone: 202-707-5640
photoduplication@loc.gov
Fax: 202-707-1771.

b. George Eastman House

The George Eastman House International Museum of Photography and Film in Rochester, N.Y. (named after the founder of Kodak), is a museum that houses over 400,000 photographs. It has an outstanding website at www.eastman.org.

The House is located at:

900 East Avenue
Rochester, NY 14607
716-271-3361
Fax: 716-271-3970.

c. New York Public Library

The New York Public Library contains a special collection called the Miriam & Ira D. Wallach Division of Art, Prints and Photographs. It houses over 200,000 photographs from 1839 to the present. Its

highly informative website is at: www.nypl
.org/research/chss/spe/art/photo/photo
.html.

The Division is located at:

Room 308
The New York Public Library
5th Avenue and 42nd Street
New York, NY 10018-2788
212-930-0837.

3. Archives

Millions of public domain photos are
contained in archives throughout the
United States. By far the largest of these
is the National Archives and Records
Administration (NARA). NARA's holdings
include an estimated eight million
photographs and graphic images from the
1850s to the present in the holdings of the
Still Picture unit; five million photographs
and graphic images in the holdings of the
Presidential Libraries; and nine million
aerial photographs in the holdings of
the Cartographic and Architectural unit.
These include photos taken by every U.S.
government agency.

NARA has a vast website (www/archives
.gov) with mountains of information, and
many public domain photographs you can
download.

Some, but far from all, of NARA's holdings
have been listed in an online catalogue
called ARC (short for Archival Research
Center). You can also use ARC to access

digitized versions of over 58,000 selected
photographs and posters from NARA's
holdings. You can find the ARC home page
at www.archives.gov/research_room/arch/
index.html.

Not all the photos in NARA's holdings
are in the public domain. But those that are
can ordinarily be reproduced. You can do
this yourself by going to NARA's Maryland
facility. But it will likely be more convenient
to hire a private company to make the
reproductions for you. A list of companies
approved by NARA that do this work can be
found at the NARA website. You must have
the specific NARA item numbers for the
photos you want to order. You can obtain
these several ways:

- by searching ARC (but only a minority
 of NARA holdings are listed)
- by contacting the NARA reference
 department at the following address:

 Still Picture Reference
 (NWCS-Stills Reference)
 Room 5360
 National Archives at College Park
 8601 Adelphi Road
 College Park, MD 20740-6001
 Telephone: 301-713-6625, Ext. 234
 Fax: 301-713-7436

- by conducting research in person at
 the NARA Still Picture Research Room
 in Maryland, and
- using certain NARA hard-copy sources
 (for a minority of holdings).

Of course, there are many archives other than the National Archives. Most of them have websites. Tulane University has an outstanding website that serves as an index of archival indexes. From here you can link to every archive and archival resource in the online world. The URL is: www.tulane .edu/~lmiller/ArchivesResources.html.

Here are two other websites with lists of archives:

- www-personal.umich.edu/~kjostert/ archives.html
- www.uidaho.edu/special-collections/ Other.Repositories.html.

4. U.S. Government Agencies

All photographs taken by U.S. government agency employees are in the public domain. This includes, for example, NASA photographs of all aspects of space exploration and astronomy. NASA has millions of photographs in various archives. Due to current budget constraints, NASA does not make copies of images available to the general public. Copies may be made available to qualified mass media representatives and NASA research partners by contacting the Public Affairs Office from the responsible NASA Center. Copies of many NASA photos may be ordered from several private companies. You can find a list of these at www.hq.nasa.gov.

However, several hundred thousand NASA photos may be downloaded from the NASA Image Exchange (NIX), an online database containing photos from many NASA archives. Several of the NIX servers have available large, high-resolution versions of images for the purpose of high-quality printing. Many of these TIF or JPEG files can produce 8" x 10" 300 DPI full-color images on color laser or ink jet printers. The NIX URL is http://nix .nasa.gov.

Information about all the NASA photo collections and links can be found at: www.nasa.gov.

Many U.S. government agencies besides NASA also have interesting photographs. Many of these can be found in the NARA archive. You can also try contacting the agency directly. Almost all U.S. government agencies have websites. You can find a list of these on the Yahoo directory at: http://dir.yahoo.com/Government/U_S_ Government/Agencies.

NASA

5. The Internet

You need to be very careful about using public domain photos from the Internet. Many websites contain photos that are claimed to be in the public domain but really are not. These include, for example, the hundreds of websites that contain digital copies of photographs of fashion models and movie stars. Virtually none of these photos—copied from magazines, videos, and other sources—are in the public domain. Remember, the fact that a copy of a photo is posted on the Web does not mean it is in the public domain. (See Chapter 17 for a detailed discussion of how to determine whether material on the Internet is in the public domain.)

That said, there are many photographs on the World Wide Web that are legitimately in the public domain. For example, hundreds of public domain photographs can be downloaded from the National Archives website (see Section C3).

A website called Art History Resources has links to many websites containing public domain photos. The URL is http://witcombe.bcpw.sbc.edu/ARTHprints.html#photography.

Another website with links to public domain photo websites is Public Domain Pictures (www.princetonol.com/groups/iad/links/clipart.html). Wikipedia—an online encyclopedia—also contains many links to public domain photos (http://en2.wikipedia.org/wiki/Wikipedia:Public_domain_image_resources).

The website Public Domain Photo (www.pdphoto.org) contains digital copies of many photos that have been dedicated to the public domain or are public domain for other reasons.

Another way to find public domain photos on the Internet is to conduct a search with a search engine such as Google. Try using the search terms "public domain" and "photographs" or search according to the subject matter of the photograph—for example, "civil war."

The following websites have thousands of images that are copyrighted but that can generally be downloaded and used for free, even for commercial purposes:

- morgueFile (www.morguefile.com)
- Image*After (www.imageafter.com)
- Bigfoto (www.bigfoto.com).

6. Stock Photo Houses

There are hundreds of stock photo houses in the United States. They are sometimes known as image banks. Many of these have public domain photographs in their stock. For example, Corbis (www.corbis.com) contains the entire photo collection of the Bettmann Archive—a gigantic archive of 19th and 20th Century historic photos, many thousands of which are in the public domain.

Unfortunately, you ordinarily cannot obtain photos from stock photo houses for free, even if they are in the public domain. A stock photo house will charge you for a

copy of a public domain photo. Depending on the nature of your use, you may only have to pay a one-time fee or may have to pay recurring royalties. Payments may range from $50 or less to several hundred dollars per photo.

You may also be required to agree to a license agreement restricting how you may use the photo—for example, you may be permitted only to use the photo in a book you're writing. Any other uses may require additional payments to the stock photo house. The legal enforceability of such licenses is unsettled, but you could find yourself a defendant in a lawsuit if you break such an agreement. (See Chapter 2.)

Many stock photo houses even claim copyright protection for copies of public domain photos. Such claims are likely spurious, but you could easily get sued if you treat the photograph as being in the public domain.

However, if you don't mind paying for public domain images, using a stock photo house is often the fastest and easiest way to find the photo you want.

a. Useful Websites

The easiest way to find a stock photo house is to use the World Wide Web. Type "stock photos" into your Internet search engine or try www.berinsteinresearch.com/pics.htm. (This site provides a category directory with links to various online photo resources.)

b. Published Stock Photo Guides

In addition, the following books contain detailed guidance on how to find stock photo houses:

- *Stock Photo Desk Book*, Exeter Company, 767 Winthrop Road, Teaneck, NJ 07666; 201-692-1743; Fax: 201-692-8173, email: exeter@webspan. net

- *Finding Images Online*, Pemberton Press, Berinstein Research, P.O. Box 1305, Woodland Hills, CA 91365; 818-865-0523

- *Photograph Agency Council of America Directory*, P.O. Box 308, Northfield, MN 55057-0308; 800-457-PACA; email: paca@earthlink.net.

Chapter 7

Movies and Television

f a picture is worth a thousand words, a moving picture must be worth at least ten thousand. But the cost of purchasing or licensing moving images for your own projects is also much higher. One can easily spend thousands of dollars for a few short clips of archival material. But there are many ways to save money on archival clips by using the public domain. Public domain movies are discussed in Part I and television programs are discussed in Part II. Part III lists sources for public domain films and videos.

Many Works That Are in the Public Domain in the U.S. Are Still Protected by Copyright Outside the United States, and Vice Versa. This chapter only covers the public domain in the United States. For a detailed discussion of the public domain outside the United States see Chapter 16.

Part I: Films

Film Checklist

1. Has the film been published? (See Section B.)

 ☐ Yes: Continue.

 ☐ No: Skip to line 3.

2. Date of publication (see Section B2): _____

 Country of publication (see Section B2): _____

3. Has the copyright in the film expired? (See Section C.)

 ☐ Yes: Film is in the public domain. Skip to line 6.

 ☐ No: Continue.

4. Is the film in the public domain due to lack of a copyright notice? (See Section D.)

 ☐ Yes: Film is in the public domain. Skip to line 6.

 ☐ No: Continue.

5. Is the film protected by copyright? (See Section E.)

 ☐ Yes: Film is protected by copyright. Do not continue.

 ☐ No: Film is in the public domain. Continue.

6. Does the film contain copyrighted material? (See Section F.)

 ☐ Yes: Determine if permission may be needed by owner of materials. Then proceed to line 7.

 ☐ No: Continue.

7. Will you use the film for advertising or other commercial purposes? (See Section G.)

 ☐ Yes: Determine if the use is restricted by trademark or right of publicity laws. (See Chapter 20.)

 ☐ No: Film may be freely used for your purposes.

A. What Good Are Public Domain Films?

Unless you're a silent film fan, it's not likely that your favorite movie is in the public domain. Few sound films made by the major Hollywood studios are in the public domain. Most public domain films consist of silent films, obscure or low-budget sound films made before 1963, nontheatrical films such as educational films and industrial films made before 1963, and films made by the U.S. government. However, this amounts to a huge treasure trove of public domain film footage that may have a variety of uses and save you substantial money.

When a film enters the public domain, you are free to use it in any way you wish without obtaining permission from the former copyright owner. For example:

- you may show the film to the public (there is one movie theater in Los Angeles that shows only silent films, many of which are in the public domain)
- you may make copies of the film, whether on film or videocassettes, and sell them to the public
- you may remake the film—for example, the 1937 public domain film *A Star Is Born* has been remade twice, and
- you may copy portions of the film and use the clips in new films.

How to Use This Section

To help you determine the copyright status of a film, we have created the checklist at the beginning of this section for you to follow. Each step is described in the checklist and each line refers to one or more sections below or to other chapters of this book. If you have a particular work you are researching, start at Line 1 on the checklist. As you answer each question you will be led to the appropriate section or chapters necessary to answer the next question on the checklist. At the end of the process you will know whether the film you want to use is in the public domain.

We have also included a worksheet (Appendix C) you may use to document how you determined that a particular work was in the public domain. By filling out the sheet, you will be able to document your research and conclusions should anyone challenge your right to use the work.

What If the Work Is Not in the Public Domain? If you find that the film you want to use is not in the public domain, you may be able to use it (or at least part of it) anyway under a legal exception called "fair use" (see Chapter 22). If you do not qualify for this exception, you will need to obtain permission to use the work. For a detailed discussion of how to obtain copyright permissions refer to *Getting Permission: How to License & Clear Copyrighted Materials Online & Off,* by Richard Stim (Nolo).

B. Has the Film Been Published?

Copyright protection begins when a film or other work is officially published and ends when it enters the public domain. The first step in determining whether a particular film is in the public domain is to determine its publication date.

Like any work of authorship, a film is published for copyright purposes when the copyright owner or someone acting on his or her behalf makes copies available to the *general* public. In other words, any interested member of the public may obtain a copy. *Burke v. National Broadcasting Co.*, 598 F.2d 688 (9th Cir. 1979).

Publication occurs only when copies of a film are made available to the public for purchase, rental, or loan. Showing a film to the public in theaters or on television does not constitute publication for copyright purposes. This is true even if thousands or millions of people have seen the film.

1. Film Distribution Methods

Before the invention of the VCR, copies of theatrical films were almost never sold to the public. Instead, they were leased or rented to film distributors and theater owners. The process worked like this: Once the film was produced, prints of the film were transferred to an independent film distributor that made several hundred copies and sent them to its branch offices (also called "exchanges") around the

world. The exchanges entered into film rental agreements with exhibitors who then showed the films to the public. Before 1949, several major studios owned their own distribution companies and theaters.

Because films were rarely made available for public sale, determining an official publication date has been difficult for these older films. However, a consensus has developed among copyright experts, the film industry, and the courts that films were published for copyright purposes when copies were placed in exchanges for distribution to theater operators. *American Vitagraph, Inc. v. Levy*, 659 F.2d 1023 (9th Cir. 1981). It is safe, then, to assume that any film that has been distributed and shown to the general public in movie theaters has been published for copyright purposes.

For films that were sold to the public, like educational films sold to schools, publication began at the time they were first offered for sale or rental to the public.

Films are also published when videotape copies are sold or rented to the public. However, the consumer VCR is such a recent technology that this form of publication is largely useless for our purposes. In other words, a film must have been published long before the VCR became commonplace for it to be in the public domain. The only exceptions are those films published on videotape during the 1970s and 1980s without a copyright notice—but there are probably very few films in this category (see Section D). Films that are released directly to video, bypassing

a release in theaters, are published for copyright purposes when they are first offered for sale to the general public.

2. Determining Publication Date and Country

If you have a copy of the film, take a look at the copyright notice—the symbol © or word copyright followed by a year date and name of the copyright owner—for example: © Copyright 1935 Paramount Pictures, Inc. The date in the notice is the date the copyright owner states the film was first published. You can ordinarily find the copyright notice for a film either at the beginning or end of the film as part of the title or credits. If you have a videotape of a film, a copyright notice may be printed on the packaging. However, this may not always be the date the film was first published. Unfortunately, film studios often used Roman numerals for the dates in their copyright notices, apparently believing this lent prestige to their films. If you're not an expert on how to decipher Roman numerals, you can find a chart on how to translate them into Arabic numbers in Appendix B.

If you don't have a copy of the film, the easiest way to determine whether or when a film was published is to use the Internet Movie Database website at www .imdb.com. This will give you the year the film was "released," which would ordinarily have been the year it was placed in exchanges for distribution. The

Internet Movie Database contains detailed historical information on over 200,000 films and videos. If you check the "release information" link you can often find the exact date the film was released, which is more information than you really need, because knowing the year is sufficient.

If you do not have access to the Internet, or if the film you are searching for is not on the database, there are a number of printed film guides that may help. Perhaps the best one-volume film guide is *Halliwell's Film and Video Guide* (HarperReference), which is updated each year. If you can't find a reference to a film in Halliwell's or a similar one-volume guide, try consulting the multi-volume *AFI Catalog of Feature Films*, published by the American Film Institute. The most comprehensive national filmography, it consists of a series of volumes providing documentation on all films produced in the United States from 1893 to 1970. A library with an outstanding film collection or film archive may have a copy.

If none of these methods result in finding a publication date, you will be able to determine the publication date for a film by examining copyright registration records— provided that the film was registered with the Copyright Office (not all films were; see Chapter 21). However, this is usually not necessary, since the history of motion pictures has been so well documented in books and on the Internet.

In addition to the publication date, you need to know the country in which the film was first published. Check the Internet Movie Database (www.imdb.com). It will

ordinarily indicate a film's country of origin and may also show the film's release dates in various countries. The various film reference works discussed above may also prove helpful. Checking the Copyright Office registration records for the films will also reveal the country of origin, copyright owner, and publication dates for a film. (See Chapter 21 for a detailed discussion.)

You may have problems checking the status of British films, because they were often released with different titles in the United States and Great Britain. The Internet Movie Database will usually show these alternate titles. Also, a book called *The British Film Catalog 1895-1970,* by Denis Giford, lists more than 15,000 British films, often including their U.S. titles. This book is out of print, but you may be able to find it in a good collection of film materials or purchase it from used booksellers.

If you determine that the film has been published, mark "yes" in Line 1 and proceed to Line 2 and list the year, date, and country of publication. If the film has not been published, check "no" in Line 3 and skip to Line 4 of the checklist at the beginning of this section.

C. Has the Copyright Expired?

Once you have determined the official publication date of a film, you can determine whether its copyright protection has expired. Remember, once copyright has expired, the work of art has entered the public domain and may be used for any purpose without paying a fee to the creator or former owner of the product. (With a few possible restrictions detailed in Section G.)

The largest single group of public domain films are those whose copyright has expired. Generally, these are older films, but some films published as recently as the early 1960s are in the public domain. Copyright duration in general is discussed in detail in Chapter 18. Read that chapter now to get a general background. Then read the rest of this section, which applies these general rules specifically to films.

1. Films Published in the U.S. Before 1923

All films published in the United States before January 1, 1923 are in the public domain. Since sound films did not become popular until the 1927 release of *The Jazz Singer*, all these public domain films are silent films. However, there are many works of interest in this group, including famous films by Charles Chaplin, Buster Keaton, and Harold Lloyd. Even those silent movies that aren't artistically exciting may contain interesting historical footage.

For an excellent introduction to the glories of the silent film era, see *The Parade's Gone By*, by Kevin Brownlow (University of California Press). In addition, you can find a list of dozens of websites about all aspects of silent films at: www.cs .monash.edu.au/~pringle/silent/faq/sites.html.

All pre-1923 newsreels (of which there were many) are also in the public domain. These were collections of filmed news events, much like today's television news, and are the only film record we have of the early years of the 20th century. They are a treasure trove of public domain film footage on thousands of subjects, from early attempts at flight to the rural electrification of the country and the creation of the automobile. Be aware, however, that many early newsreels contain phony recreations of historic events rather than authentic on-the-scene footage, and their creative lineage is difficult to trace.

Unfortunately, film preservation experts estimate that 85% of all silent films have been lost. Many were simply thrown away, while many others were allowed to deteriorate until their chemically unstable nitrate film stock turned to dust. For a detailed study of the sad history of film preservation, see *Nitrate Won't Wait*, by Anthony Slide (McFarland & Company).

The Four Horseman of the Apocalypse, Metro, 1921

See Part III below for more reference materials on how to locate public domain silent films.

2. Films First Published in the U.S. During 1923-1963 and Not Renewed

Under the copyright law in effect at the time, all films published between 1923 and 1963 received an initial copyright term of 28 years. They were also eligible to receive a second term of 67 years if the copyright owner (or someone acting on their behalf) filed a renewal application with the Copyright Office during the 28th year after publication. If the copyright owner failed to do this, the film entered the public domain on January 1 of the 29th year after the year it was published. (See Section B above for a detailed discussion of publication.)

> EXAMPLE: *Little Shop of Horrors*, a cult classic horror film directed by Roger Corman and starring Jack Nicholson, was published in 1960, but not renewed during 1988. As a result, it entered the public domain on Jan. 1, 1989. Had it been renewed, it would have been protected by copyright for 95 years, or until the end of 2055.

The compilers of the *Film Superlist* (see below) estimate that about 20,000 theatrical films are in the public domain because they were never renewed. One third of all films published between 1912 and 1939 were not

renewed. Of course, most of these were silent films that were not renewed because their owners viewed them as having no value after the introduction of films with sound. Nevertheless, there are a number of well-known films made during the late 1920s, 1930s, 1940s, and 1950s that are in the public domain because they were not renewed. These include:

- *A Star Is Born*, (1937), directed by William Wellman and starring Janet Gaynor and Fredric March
- *The General*, (1927), directed by and starring Buster Keaton
- *The Gold Rush*, (1925), directed by and starring Charlie Chaplin
- *McClintock!* (1963), starring John Wayne
- *Of Human Bondage*, (1934), starring Bette Davis, and
- *Nothing Sacred,* (1937), starring Carole Lombard.

The major Hollywood film studios—Metro-Goldwyn-Mayer, Paramount, Warner Brothers, Universal, Columbia, RKO, and Twentieth Century Fox—generally took care to renew their films, although even they sometimes made mistakes. For example, MGM missed renewing some films released in 1950 and Universal did not renew 11 features copyrighted during the summer of 1938.

More commonly, however, it was small studios and independent producers who neglected to renew their films. This was particularly likely where they were no longer in business by the time renewal was required (28 years after the film was first released). Some studios that are notorious for failing to renew their films are Hal Roach Studios, Chesterfield, Invincible Pictures, and KBS Films.

Particularly likely not to be renewed were "B" pictures (low-budget films), such as low-budget westerns, horror films, exploitation films, and serials. These include many early John Wayne westerns, B-movies such as *Teenagers From Outer Space* (1959), and Francis Ford Coppola's first directorial effort—a "nudie cutie" film called *Tonight for Sure* (1961).

Even more likely not to have been renewed are nontheatrical films—that is, films never meant to be shown in movie theaters, such as industrial films, training films, and educational films. (Make sure, however, that such films were sold or leased to the public—if not, they were not published for copyright purposes and, therefore, they didn't have to be renewed. The copyright for such unpublished films will not expire for many years.)

To determine whether a film has been renewed, you ordinarily must search Copyright Office records. You can do this yourself (many of the records are available online) or hire the Copyright Office or a private search firm to do it for you. (See Chapter 21 for a detailed discussion of copyright renewal searches.) However, there are special problems posed by films that were not renewed. These problems exist in part because film is a collaborative medium combining many different works of authorship.

Even if the film was not renewed, there are several problems you must resolve before you can finally decide whether the film is in the public domain.

The Film Superlist

You can avoid going to the trouble of checking Copyright Office renewal records yourself or hiring someone to do it for you if you can find a copy of a publication called *The Film Superlist: 20,000 Motion Pictures in the Public Domain,* by Johnny Minus and William Storm Hale (7 Arts Press). The compilers of the Superlist have gone through all the Copyright Office renewal records for films and noted which were renewed. The List consists of three volumes, covering 50,000 films from the years 1894–1939, 1940–49, and 1950–59. It can be obtained from the Hollywood Film Archive, 8391 Beverly Blvd., PMB 321, Hollywood, CA 90048 (323-655-4968). Copies of this expensive reference guide can also be found in some research libraries.

a. Problem #1: Was the Film First Published Outside the U.S.?

Before 1996, thousands of foreign films published during 1923-1963 entered the public domain in the United States because they were never renewed. These included such classics as *Grand Illusion* (France,

1937), *Breathless* (France, 1959), *The Bicycle Thief* (Italy, 1949), *The Blue Angel* (Germany, 1931), *The Third Man* (United Kingdom, 1949), and *Yojimbo* (Japan, 1962).

However, a new law took effect on January 1, 1996 that automatically restored copyright protection for most foreign works—including films—that fell into the public domain because they were not renewed on time. The full term of copyright protection was restored to all these films. Ordinarily, they are protected for 95 years from the date of publication. (See Chapter 18 for a detailed discussion of copyright terms.) This law has greatly decreased the number of films in the public domain in the United States.

Copyright restoration was made for any film first published outside the United States during 1923-1963 that, at the time of publication:

- had at least one author that was a citizen or resident of a country other than the United States. The author of a film is usually a film studio or production company—for example, Germany's famed UFA Studios.
- was first published outside the United States and not published in the United States until 30 days after the initial foreign publication, and
- whose copyright term has not expired under the copyright laws of the country in which it was first published.

No Copyright Restoration for Some Foreign Films

There is one group of foreign films that were not renewed on time that still do not qualify for copyright restoration: Those that had entered the public domain in their home countries as of Jan. 1, 1996. Copyright terms for films in most Western European countries last at least 70 years (usually much longer), so virtually no films from these countries fall into this group. But, many non-European countries—for example, Japan—protect films for as few as 50 years. Some films from these countries may have entered the public domain in their home countries as of January 1, 1996 and therefore were not eligible for restoration of their U.S. copyrights. As a result, they remain in the public domain in the U.S. (See Chapter 15 for a detailed discussion.)

In addition, some foreign films entered the public domain in their home countries due to a failure to comply with legal requirements. For example, seven films released in Mexico in the late 1940s were in the public domain in that country because they were never registered with the Mexican government (a formality that is no longer required). The films entered the U.S. public domain because they were never renewed, and their copyrights could not be restored because they were public domain in Mexico. *Alameda Films v. Authors Rights Restoration Corporation, Inc.*, 331 F.3d 472 (5th Cir. 2003).

The great bulk of foreign films published during 1923-1963 that were never renewed satisfy these requirements and are no longer in the public domain. In fact, it is usually a waste of time to determine whether such films were renewed or not. You should simply consider that any film in this category has a valid copyright for 95 years from the date of publication. But, see "No Copyright Restoration for Some Foreign Films," above, for some films that have not had their copyrights restored.

If the country of origin for a film is somewhere in Western Europe, you can safely assume that the copyright is intact in the United States. If the film originated outside of Western Europe, it may not have qualified for copyright restoration because it is in the public domain in its home country. But to determine this, you'll have to research the copyright law of this country. (See Chapter 16 for a discussion of copyright terms in many foreign countries.)

b. Problem #2: Is the Film Based on a Preexisting Work?

Many films are based on preexisting works, particularly novels, plays, and short stories. For example, the 1940 Cary Grant film *His Girl Friday* is based on the famous 1928 play *The Front Page*.

It is possible for a film to enter the public domain because it was not renewed on time, but for the work it was based on to still be protected because it was renewed on time. When this happens, the preexisting work remains protected by copyright, as

do those portions of the film based on the copyright-protected previous work. As a practical matter, this means you cannot use the film without obtaining permission from the copyright owner of the preexisting work.

For example, the film *His Girl Friday* was not renewed and therefore entered the public domain in 1969. However, the play *The Front Page* was renewed and will be protected by copyright until the year 2024. This means that the film *His Girl Friday* is basically unusable unless you obtain permission from the copyright owners of *The Front Page*. But you don't need to obtain permission from the producers of *His Girl Friday*.

The upshot of all this is that whenever you determine that a film has not been renewed on time, you must also check to see if it was based upon a preexisting work. If it was, you must determine if that work is also in the public domain. You can freely use the film only if the preexisting work is also in the public domain.

To do this, you must determine if and when the preexisting work was published. Read Chapter 3 for detailed guidance on how to determine whether novels, plays, short stories, and other written works are in the public domain. If the preexisting work was published during 1923-1963, you'll have to check Copyright Office records to see if it was renewed. You can do this yourself (many of the records can be searched on the Internet) or hire someone to do it for you. (See Chapter 21 for a detailed

discussion of copyright renewal searches.) If the preexisting work was not renewed, it is in the public domain.

If the preexisting work is still under copyright, you'll have to wait until it expires before you can use the film based upon the prior work, or make an arrangement with the owner of the preexisting work to use it. Usually this means you have to pay a fee to obtain a license for use.

How can you tell if a film is based upon a preexisting work? If you have a copy, look at the credits. They will usually indicate whether the film was based on a prior work. Also, check the listing for the film on the Internet Movie Database (www.imdb .com)—the writer's credit area will usually show if the film was based on a prior work. You can also determine this by checking the American Film Institute catalogues mentioned above (in Section B2) as well as many other film encyclopedias. Copyright Office registration records will also reveal this information (see Chapter 21 on how

His Girl Friday, Columbia, 1940

Screenplays Become Public Domain When Films Do

Does a screenplay upon which a film is based enter the public domain when the film does? This is not an idle question. If the screenplay does not enter the public domain when the film does, you would need permission from the owner of the screenplay to use the public domain film. Several screenplay owners argued that their screenplays did not enter the public domain because the screenplays were not published when the films were made and distributed. As unpublished works, the screenplays didn't have to be renewed and still had copyright protection even though the films made from them were in the public domain because they were not renewed on time. Federal appellate courts in both New York and California have rejected this argument. In cases involving the films *McClintock!* and *The Little Shop of Horrors* the courts held that the publication of a film publishes as much of the screenplay as is used in the film. This means that you can safely assume that the portion of the screenplay used in the film enters the public domain when the film does. *Shop-talk, Ltd. v. Concorde-New Horizons, Corp.*, 168 F.3d 586 (2d Cir. 1999), *Batjac Productions, Inc. v. Goodtimes Home Video Corp.*, 160 F.3d 1223 (9th Cir. 1998).

The Saga of *It's a Wonderful Life*

Undoubtedly the most famous film that ran afoul of the preexisting works rule discussed above is the Christmas classic *It's a Wonderful Life,* starring James Stewart and directed by Frank Capra. This 1947 film was never renewed and was thought to have entered the public domain for this reason in 1976. Spelling Entertainment, the owner of the studio that made the film, apparently believed that it was in the public domain and initially made no effort to enforce its copyright. It was because the movie was thought to be in the public domain that television stations all around the country began playing it repeatedly during the Christmas season and ironically, this is why the film, not a hit when it was first released, became so popular. However, in 1996 Spelling Entertainment had a change of heart and decided that *It's a Wonderful Life* was not in the public domain. Spelling asserted that the film was not in the public domain because it was based on a short story that was still protected by copyright. Whether this claim is legally valid is not clear. The movie contains so few elements from the short story that it's quite possible that a court would rule that it's not really based on it at all. Nevertheless, Spelling sent warning letters to television stations not to air *It's a Wonderful Life* without permission. Fearing a lawsuit, the stations complied. In summary, we really don't know whether *It's a Wonderful Life* is in the public domain or not. But we do know that if you use it without permission you'll risk getting sued by Spelling.

to obtain copies of such records). Another useful guide is the book *Filmed Books and Plays*, by A.G.S. Enser (Andre Deutsch Limited), which lists books and plays from which films have been adapted.

c. Problem #3: Is the Music in the Public Domain?

Most theatrical films contain music, including background music and songs. It may seem amazing, but no court has ever decided the question of whether the music included in a film that was not renewed is also in the public domain.

Film music presents a hornet's nest of unresolved copyright problems—for example, no one knows for sure if music was published for copyright purposes when it was included in a film. Before 1978, music ordinarily was published only when copies of sheet music were distributed to the public. Recording or playing music in public didn't constitute publication. (See Chapter 4.) Since it's unclear if film music was published when the film was, no one knows for sure how long the copyright in such music lasts or if it had to be renewed.

The simplest way to avoid these problems is not to use music contained in films that lost their copyright protection because they were not timely renewed.

But if you want to use such music, you must first check Copyright Office renewal records to see if the music was separately renewed. In many cases songs (and even background music) written for films were separately copyrighted and registered

with the Copyright Office. If renewed, this music would still be under copyright, even though the film it was first used in is not. Look in the Copyright Office records under the composer's name, the name of the movie, the name of the film studio, and the name of any songs. Many of these renewal records can be searched online. (See Chapter 21 for a detailed discussion of how to do renewal search.) If there is no renewal record for the film music, you may elect to use it. It probably is in the public domain, but be aware that there is an element of risk involved.

See Chapter 1 for a detailed discussion of how to deal with public domain gray areas such as use of music in films that have not been renewed.

If you determine that the film's copyright has expired, mark "yes" on Line 3 of the checklist at the beginning of this chapter and skip to Line 6. If the copyright has not expired, mark "no" on Line 3 and continue to Line 4.

D. Is the Film in the Public Domain Due to Lack of a Copyright Notice?

Any film first published in the United States before March 1, 1989 had to have a copyright notice on it or it entered the public domain, unless the lack of

notice was excused or cured. A copyright notice consists of the symbol ©, the word Copyright or the abbreviation "Copr." followed by the date the film was published and the name of the copyright owner—for example, Copyright 1940 RKO Pictures, Inc.

It's not likely you'll find many films published before 1989 without a copyright notice. Most films were so expensive to make that their owners took great care to ensure they contained copyright notices. Probably the most famous American film published without a copyright notice is the 1968 horror classic *Night of the Living Dead*. This film entered the public domain the moment it was published without a notice and can be used by anyone for any purpose except if one of the actors' right of publicity is involved (see Section G).

Foreign filmmakers failed more often than Americans to place copyright notices on their films, since notices were not required in most foreign countries. There used to be many foreign films in the public domain in the United States because they lacked a copyright notice. However, the copyright in the great majority of these films was automatically restored on January 1, 1996 under the law discussed in Section C2a above.

If you do find a film first published in the United States without a notice, read Chapter 19 to determine if it is in the public domain.

If the film has a copyright notice in the format described above, or was published after March 1, 1989, it is not in the public domain for lack of a notice. Mark "no" in Line 4 and continue to Line 5. If the film was published without a notice before 1989 and you determine that it is in the public domain because no excuse applies, mark "yes" in Line 4. The film is in the public domain. Skip to Line 6.

E. Is the Film Protected by Copyright?

Certain categories of films are never protected by copyright and are in the public domain regardless of when they were published.

1. U.S. Government Films

You may be surprised to learn that Uncle Sam, not Sam Goldwyn, is the largest film producer in the United States. The various branches of the U.S. government have produced thousands of films—everything from World War II combat footage made by the U.S. Army Signal Corps to training films for expectant mothers.

All films created by U.S. government employees as part of their job automatically enter the public domain the moment they are created. Technically, even secret films created by the government are in the public domain, but they are protected by other laws from use by the public.

Films created for the government by non-employees are also in the public domain unless the government allowed the non-employee to claim copyright in the film. If

the government film has a copyright notice, it is likely that the private vendor who created it holds the rights to the film.

See Section M for a detailed discussion of how to obtain copies of such U.S. government films.

2. Copies of Public Domain Films

An exact copy of a public domain film cannot hold a copyright. This is true even where a film is transferred from one format to another—for example, from 35-millimeter film to videotape.

Thus, a company that makes exact copies of public domain films and sells them to the public cannot hold a copyright in the material. Some companies specialize in making copies of public domain films and newsreels and reselling them. Of course, they can charge you for buying a copy of the material. Many of these companies will try to license the copies to you in an effort to restrict how you use it. (See Part III below for more on this issue.)

However, people and companies that make and sell copies of public domain

films often make changes or add new elements to the films. For example, a new soundtrack may be added to a silent film in the public domain, a black and white film in the public domain may be colorized, or a public domain film may be dubbed from English into another language. Changes such as these are protected by copyright if they are minimally creative. (See Chapter 2 for a detailed discussion of creativity and copyright.)

Not only are new soundtracks and colorizations copyrightable, but courts have held that "panned and scanned" versions of wide-screen films are copyrightable as well. "Pan and scan" means creating a reduced-size version of a film so it will fit on a television screen. The process is copyrightable because minimally creative artistic decisions must be made about how much of each frame should be chopped off. Remixing or making a stereo version of a one-channel film soundtrack is also copyrightable since creativity must be employed to remix and balance the sounds. *Maljack Productions, Inc. v. UAV Corp.*, 964 F.Supp. 1416 (C.D. Cal. 1997).

Gertie on Tour, Rialto Productions, 1921. Library of Congress, Broadcasting and Recorded Sound Division

However, copyright protection only extends to changes, not to the original public domain film. For example, if remixed soundtrack music is added to a public domain film, you can still use the original film, just don't use the copyrighted soundtrack without permission. However, it's hard to see how you could use a pan and scan version of a public domain film without violating the copyright in the panning and scanning.

People who make such changes to public domain films often register their new versions with the Copyright Office. For this reason, when you check Copyright Office registration and renewal records for a film, you'll often find original copyright records and renewal records for a new version of film that was itself never renewed. For example, the original version of Buster Keaton's 1927 silent classic *The General* was never renewed, and therefore entered the public domain in 1956. However, in 1953, Raymond Rohauer, a film collector and distributor, created a new version of the film that contained new editing, an introduction, and music. This version was registered with the Copyright Office in 1953 and renewed on time in 1981. The changes made in this new version of *The General* are still under copyright, but the original film remains in the public domain, as are those original elements included in Rohauer's version.

If you determine that the film is eligible for copyright protection, mark "yes" in Line 5 of the checklist. The film is not in the public domain and you must seek permission from the copyright owner to use it unless your use constitutes a fair use (see Chapter 22). Do not continue. If you determine that the film is ineligible for copyright protection, mark "no" in Line 5. The film is in the public domain. Continue to Line 6 to see if other legal restrictions apply to your use of the work.

F. Does the Film Contain Copyrighted Visual Art?

Films sometimes include footage of copyrighted works of visual art—for example, paintings, sculptures, photographs, posters, and toys. It's possible for a film containing such footage to be in the public domain while the work of visual art is still protected by copyright. This could occur, for example, where the copyright in the film was not renewed while the copyright in the artwork was renewed, or the artwork was never published and therefore didn't have to be renewed, or where the film was made by a U.S. government agency.

If the artwork appears in the film for only a few seconds, or is unidentifiable because it is obscured or out of focus, you don't need to obtain permission to use it. These uses of art in a film constitute a fair use. (See Chapter 22 for a detailed discussion of fair use.) However, if the art is still under copyright, permission may be needed from the copyright owner.

In this event, it is prudent to check to see if the art really is still protected by

copyright. (See Chapter 5 for a detailed discussion of copyright protection for art.) It may be difficult to identify the artist or copyright owner if the art is not identified in the film or is not well known. There is no need to include a copyright notice for any artwork that appears in a film. The studio that made the film may have a record of who created it, but it's unlikely you could obtain access to such records.

If you're unable to determine whether or not the art is in the public domain, the safe course is to remove the footage containing the art or obscure it, or obtain permission to use it from the copyright owner (if you can find the owner).

If you determine the film footage you wish to use contains copyrighted materials, mark "yes" in Line 6 of the checklist. You may need to obtain permission from the owner of the materials. Continue to Line 7. If you determine the film footage does not contain copyrighted materials, mark "no" in Line 6 and continue to Line 7 to determine if your intended use of the film violates publicity or trademark rights.

G. Do You Plan to Use the Film for Advertising or Other Commercial Purposes?

There are some special legal concerns where a film contains people or trademarks. A trademark usually consists of a word, phrase, logo, or other graphic symbol used to identify a product or symbol. Trademarks include product logos, brand names, company names, product packaging, or the distinctive shape of a product such as a Coke bottle.

If you intend to use a film containing people or trademarks for advertising or other commercial purposes—for example, in a television commercial—you need to make sure that your use does not violate state right of publicity laws or state and federal trademark laws. Such violations could occur even though the film footage is in the public domain—that is, not protected by copyright.

For example, the footage of the actor Jack Nicholson in the film *Little Shop of Horrors* is in the public domain because the film was never renewed. Even so, you can't use such footage in a TV commercial for a product or service without consent from Nicholson. Doing so will likely get you sued for violating Nicholson's right of publicity.

Similarly, there are probably many public domain films containing the Coca-Cola name and logo. Even so, you may not use such footage for commercial purpose without violating the Coca-Cola company's trademark rights.

In contrast, right of publicity and trademark laws are not violated when you use public film footage containing people or trademarks for noncommercial purposes— that is, editorial or informational uses, such as using it in a documentary. (Publicity and trademark laws are discussed in detail in Chapter 20.)

Part II: Television Programs

Television Programs Checklist

1. Has the television program's copyright expired? (See Section H.)

 ☐ Yes Skip to line 4.

 ☐ No: Continue.

2. Is the television program in the public domain due to lack of a copyright notice? (See Section I.)

 ☐ Yes: Skip to line 4.

 ☐ No: Continue.

3. Was the program created by the U.S. government? (See Section J.)

 ☐ Yes: Continue.

 ☐ No: Program is protected by copyright. Do not continue.

4. Does television program contain copyrighted visual art? (See Section K.)

 ☐ Yes: Determine whether permission is needed for your use. Continue.

 ☐ No: Continue.

5. Will you use program for advertising or other commercial purposes? (See Section L.)

 ☐ Yes: Determine if your use is restricted by trademark or right of publicity laws. (See Chapter 20.)

 ☐ No: Program may be freely used for your purposes.

"Indian Head" B&W television test pattern. Originated by RCA in 1939

Television programs include television broadcasts that were recorded on videotape or film, and works filmed with video cameras for distribution on videocassettes. It does not include movies that were transferred to videotape after they were first shown in theaters (such videos follow the rules outlined in Part I above).

The good news about television programs is that there are thousands of them made by the U.S. government that are in the public domain. The bad news is that it may be impossible to determine whether many commercially broadcast TV shows are in the public domain or not.

How to Use This Section

To help you determine the copyright status of a television program we have created the checklist at the beginning of this section for you to follow. Each step is described in the checklist and each line refers to one or more sections listed below or to other chapters of this book. If you have a particular work you are researching, start at Line 1 on the checklist. As you answer each question you will be led to the appropriate section

or chapters necessary to answer the next question on the checklist. At the end of the process you will know whether the television program you want to use is in the public domain.

We have also included a worksheet, Appendix C, you may use to document how you determined that a particular work was in the public domain. By filling out the sheet, you will be able to document your research and conclusions should anyone challenge your right to use the work.

What If the Work Is Not in the Public Domain? If you find that the television program you want to use is not in the public domain, you may be able to use it (or at least part of it) anyway under a legal exception called "fair use" (see Chapter 22). If you do not qualify for this exception, you will need to obtain permission to use the work. For a detailed discussion of how to obtain copyright permissions refer to *Getting Permission: How to License & Clear Copyrighted Materials Online & Off*, by Richard Stim (Nolo).

H. Has the Television Program's Copyright Expired?

Television broadcasting began in earnest in the late 1940s. Any television programs, published in the United States from this time until the end of 1963 that were not

renewed on time 28 years after their first publication are now in the public domain. Television programs published after 1963 didn't have to be renewed and ordinarily receive 95 years of copyright protection. They won't enter the public domain for many decades.

Copyright duration rules are discussed in detail in Chapter 18, and how to determine whether a copyright was renewed is covered in Chapter 21.

However, before you turn to those chapters, there is an unresolved threshold question that must be considered: Were any television programs published for copyright purposes before 1963? If not, they didn't have to be renewed and are not in the public domain. Unfortunately, there is no definitive answer to this question.

1. What Is Publication?

A television program is published for copyright purposes when the copyright owner, or someone acting on his or her behalf, makes it available to the *general* public. In other words, any interested member of the public may obtain a copy. *Burke v. National Broadcasting Co.*, 598 F.2d 688 (9th Cir. 1979).

Broadcasting a program on television does not constitute publication. Copies of the TV program must be distributed to the public. Of course, television programs are published when they are sold or leased to the public in videocassette tapes. But commercial sales of TV programs to the

public didn't begin until long after 1963. Only TV programs published before 1964 can be in the public domain because they were not renewed on time.

2. Were Television Programs Published When Syndicated?

Given the nature of the broadcasting industry at the time, the only way television programs could conceivably have been published before 1964 is if they were taped or filmed and the tapes or films were syndicated. Syndication occurs when a television program is licensed to local television stations. After popular television programs were initially broadcast on the networks they were often syndicated, often years after the initial broadcast. A perfect example is the *I Love Lucy* television series, which was filmed before a live audience during the 1950s and has been in syndication ever since.

However, most programs such as talk shows, sporting events, news, and variety and game shows were only aired once and never syndicated. Programs such as these have never been published for copyright purposes.

Unfortunately, two federal trial courts have held that such syndication did not amount to publication. This was because the syndication agreements prohibited the television stations from making copies of the TV programs or from licensing them to other stations. *Paramount Pictures Corp. v. Rubinowitz*, 217 U.S.P.Q. 48 (E.D. N.Y.

1981); *NBC v. Sonneborn*, 630 F.Supp. 524 (D. Conn. 1985).

These decisions by federal trial courts are not binding on other courts and other courts might have a different view. Moreover, some leading copyright experts believe they were wrongly decided. However, they are not encouraging. The best that can be said is that as of now there is no clear answer as to whether syndication of a television program amounts to publication.

3. What Should You Do?

So, what should you do? The conservative course of action is to assume that programs syndicated before 1964 are not in the public domain, even if they were not timely renewed. This means that no television programs are in the public domain because their copyrights have expired.

The riskier course of action is to rely on the assumption that programs syndicated in 1964 and earlier have been published for copyright purposes. Therefore, if they were syndicated before 1964, they had to be renewed 28 years later or they entered the public domain. This means you must find out if the program was syndicated before 1964. You must then research the Copyright Office renewal records to find out if the program was renewed. This is easy to do because most of the records you need are available online at the Copyright Office website. (See Chapter 21 for a detailed discussion of researching copyright renewals.)

However, even if the program was not renewed, your problems are not over. The program may still not be in the public domain. This would be the case where the television program was initially published outside the United States before 1964 or the program was based on a preexisting work such as a novel or play that is still under copyright. In addition, it's unclear whether music used in television programs that were not renewed is in the public domain. (See Section C2, Subsection c, above for a detailed discussion of the exact same issues with regard to movies.)

If you determine that the television program's copyright has expired, mark "yes" in Line 1 of the television checklist at the beginning of this section. The program is in the public domain. Skip to Line 4 to determine if there are other legal restrictions on your use of the program. If you determine that the program's copyright has not expired, mark "no" in Line 1 and continue to Line 2.

I. Is the Television Program in the Public Domain Due to Lack of a Copyright Notice?

Any television program first published in the United States before March 1, 1989 without a valid copyright notice may be in the public domain. A copyright notice consists of the symbol © or the word

Copyright followed by the date the program was published and the name of the copyright owner—for example, Copyright 1980 CBS, Inc.

As explained in Section H1, it's unclear whether television programs were published for copyright purposes when they were syndicated. But publication would have occurred where television programs were made available to the public for sale or rental on videocassettes. But note carefully that such sales or rentals must have occurred before March 1, 1989. After that date no notice is required on any published work.

There are probably not large numbers of television programs that were published before March 1, 1989 without a copyright notice. One notable exception is the television series *Star Trek*, which was broadcast its entire first year without a copyright notice. However, this did not result in those programs entering the public domain because a court held that they had not been published for copyright purposes when initially broadcast or syndicated. *Paramount Pictures Corp. v. Rubinowitz*, 217 U.S.P.Q. 48 (E.D. N.Y. 1981).

Even if the program was published without a notice, it may not be in the public domain. The lack of notice could have been excused. See Chapter 19 for a detailed discussion of copyright notice requirements.

If the program has a copyright notice, or was published after March 1, 1989, it is not in the public domain for lack of a notice. Mark "no" in Line 2 and continue to Line 3. If the program was published without notice before 1989, read Chapter 19 to see if the program is in the public domain. If you determine that it is in the public domain mark "yes" in Line 2 and skip to Line 4.

J. Is It a U.S. Government TV Program?

Fortunately, there is one group of television programs that are definitely in the public domain: Those created by U.S. government employees as part of their jobs. U.S. government agencies have created tens of thousands of television programs on a wide variety of topics. See Section M below for advice on how to obtain copies of such videos.

If the U.S. government created the program, mark "yes" in Line 3 of the checklist. The program is in the public domain. Continue to Line 4 to see if there are other restrictions on your use of the program. If the U.S. government did not create the program, mark "no" in Line 3. The program is not in the public domain and you will need to obtain permission to use the work. For a detailed discussion of how to obtain copyright permissions refer to *Getting Permission: How to License & Clear Copyrighted Materials Online & Off*, by Richard Stim (Nolo).

K. Does the Program Contain Copyrighted Visual Art?

Television programs sometimes include footage of copyrighted works of visual art—for example, paintings, sculptures, photographs, posters, and toys. It's possible for a film containing such footage to be in the public domain while the work of visual art is still protected by copyright. This could occur, for example, where the program was made by a U.S. government agency.

If the artwork appears in the program for only for a few seconds, or is unidentifiable because it is obscured or out of focus, you don't need to obtain permission to use it. These uses of art in a television program constitute a fair use. (See Chapter 22 for a detailed discussion of fair use.)

However, if the art is still under copyright, permission may be needed from the copyright owner if it appears in its entirety or in a close-up shot for more than a few seconds. In this event, it is prudent to check to see if the art really is still protected by copyright. (See Chapter 5 for a detailed discussion of copyright protection for art.)

It may be difficult to identify the artist or copyright owner if the art is not identified in the film or is not well known. There is no need to include a copyright notice for any artwork that appears in a television program.

If you're unable to determine whether or not the art is in the public domain, the safe course is to remove the portion of the program containing the art or obscure it, or obtain permission to use it from the copyright owner (if you can find the owner).

If the program contains copyrighted visual art, mark "yes" in Line 4 and determine if permission is needed for your intended use. Then continue to Line 5 to determine if your intended use of the program violates publicity or trademark rights. If the program does not contain copyrighted visual art, mark "no" in Line 4 and continue to Line 5 to determine if your intended use of the program violates publicity or trademark rights.

L. Will You Be Using Public Domain TV Programs for Advertising or Other Commercial Purposes?

There are some special legal concerns where a television program contains people or trademarks. A trademark usually consists of a word, phrase, logo, or other graphic symbol used to identify a product or symbol. Trademarks include product logos, brand names, company names, product packaging, or the distinctive shape of a product such as a Coke bottle.

If you intend to use a television program containing people or trademarks for advertising or other commercial purposes—for example, in a television commercial—you need to make sure that your use does not violate state right of publicity laws or

state and federal trademark laws. Such violations could occur even though the program is in the public domain—that is, not protected by copyright.

In contrast, right of publicity and trademark laws are not violated when you use public domain film or television programs containing people or trademarks for noncommercial purposes—that is, editorial or informational uses, such as use in a documentary. Publicity and trademark laws are discussed in detail in Chapter 20.

Part III: Sources of Public Domain Films and TV Programs

Even the cheapest stock footage usually costs at least $50 a second, or $1,200 per minute. Footage from copyrighted theatrical films is often impossible to obtain at any price. So you can save a huge amount of money by using public domain footage. The problem is finding it. There are three main sources:

- the U.S. government
- program archives, and
- commercial program suppliers.

For a comprehensive guide to program archives and other sources of public domain movies, see *Footage: The Worldwide Moving Image Sourcebook*, by Philip Kadish (Second Line Search).

M. The U.S. Government

The U.S. government maintains a vast collection of films and videos. Most of these were produced by U.S. government agencies and deal with historical events and a wide cross-section of American life.

1. National Archives

The National Archives and Records Administration (NARA) facility in College Park, Maryland, houses one of the world's largest audiovisual collections, with more than 300,000 reels of film and more than 200,000 sound and video recordings. Much of the collection consists of U.S. government works that are in the public domain, but it also includes newsreels and other privately produced works that may be in the public domain or still under copyright.

NARA has a vast website (www.archives .gov). Detailed information about NARA's film and video holdings is at the Web page: www.archives.gov/research_room/media _formats/film_sound_video.html.

If a film or video in the NARA collection is in the public domain, you may copy it yourself or have a lab copy it for you. But first you'll need to find what you want. This can be a daunting task.

a. Searching the NARA Collection

Some of NARA's motion picture and video holdings are listed in an online database called ARC (short for Archival Research

Catalog). However, ARC does not cover all motion picture, sound, and video unit holdings. The ARC database may be accessed at www.archives.gov/research_room/arc/index.html.

If using ARC does not prove effective, you have three alternatives:

1. Go in person to the Motion Picture Research Room and search their many catalogues and finding aids. You may also view films and videos at the Room before deciding to make or purchase copies. Detailed information about the Research Room can be found at www .archives.gov.

 The Motion Picture Research Room is located at:

 > National Archives at College Park
 > 8601 Adelphi Road
 > College Park, MD 20740-6001.

2. Ask the Motion Picture Reference staff to help you. You may make inquiries by phone, postal mail, or email. They will respond within ten days. Send your inquiries to:

 > Motion Picture Reference
 > (NWCS-Motion Reference)
 > Room 3340
 > National Archives at College Park
 > 8601 Adelphi Road
 > College Park, MD 20740-6001
 > Telephone: 301-713-7060
 > Fax: 301-713-6904
 > email: mopix@nara.gov.

If you send email, be sure to include a complete mailing address, fax number, and a daytime phone number in your email.

3. Hire a film researcher to search NARA's holdings for you. Three companies that do such research are:

 > Film/Audio Services, Inc.
 > 430 West 14th St., Rm. 311
 > New York, NY 10014
 > 212-645-2112

 > Media Research Associates Inc.
 > 502 Greenbriar Drive
 > Silver Spring, MD 20910
 > 301-585-2400

 > Public Domain Images
 > National Press Building, Suite 2024
 > Washington, DC 20045
 > Phone: 202-255-8063
 > Fax: 202-478-0808
 > email: Scott@PDimages.com.

A longer list of freelance researchers is available through the reference desk at the National Archive.

b. Obtaining Copies of NARA Films and Videos

Unlike almost all other film archives, NARA permits users to make their own copies of public domain materials from publicly accessible ¾" and VHS machines. To do this, you must go to the Motion Picture Research Room at the NARA facility in College Park, Maryland (see the previous

section). You may use your audiovisual equipment or rent a dubbing station available in the Motion Picture Research Room. By taking advantage of this policy, footage researchers and resellers have accumulated huge footage libraries that they sell or license to the public.

The downside of making copies this way is that the quality is not always good. The videotapes are, in most cases, copies of actual films or original video masters. They have usually been viewed many times on machines that are in good repair but, because of their tremendous usage, are not usually capable of producing broadcast-quality product. These copies are fine for amateurs and personal use.

To obtain a broadcast-quality copy of archive materials, it is necessary to hire one of the vendors approved by the archive. If your copying request is approved, the National Archives supplies to vendors a high-quality copy (called an intermediate) of the original film or video from which the vendor makes a reproduction. Vendors will usually copy an entire reel or videotape. If you only want portions of the video or reel, you must be present at the time of the transfer and instruct the technician what to copy. This usually adds some expense to the process and most often it is cheaper to order a whole reel unless you truly want only a very short portion of a reel or videotape. Vendors also provide many other services, including master positive and duplicate negative reproductions of motion picture film.

Following is a list of vendors approved by the National Archives. This list is current as of early 2000. A more recent list may be available at the NARA website (www.archives.gov.

Atlantic Video, Inc.
(Film to video & video to video)
Attn: Dick Hobza
650 Massachusetts Avenue, NW
Washington, DC 20001
Tel: 202-408-0900
Fax: 202-408-8496
email: AtlVideo@aol.com

Bono Film and Video Services
(Film to film, film to video, & video to video)
Attn: Tim Bono
3200 Lee Highway
Arlington, VA 22207
Tel: 703-243-0800
Fax: 703-243-6638
email: BonoLabs@aol.com

Colorlab
(Film to film, film to video, & video to video)
Attn. Christine Rice or Vanessa Castro
5708 Arundel Ave.
Rockville, MD 20852
Tel: 301-770-7281
Fax: 301-770-7284
email: archivalfilm@colorlab.com

Erickson Archival Telecine, LLC
(Film to video & video to video)
11900-E Baltimore Avenue
Beltsville, MD 20705
Fax: 301-210-9991
email: EricksonArchival@aol.com

Henninger/Capitol Video
(Film to video & video to video)
Attn. Constance Cleveland
2601-A Wilson Blvd.
Arlington, VA 22201
Tel: 703-908-4117
Toll-Free: 888-243-3444
Fax: 703-243-5697
email: ccleveland@henninger.com

Interface Video Systems, Inc
(Film to video & video to video)
Attn. Arthur Brooks
1233 20th Street, NW
Washington, DC 20036
Tel: 202-457-5820
Fax: 202-296-4492
email: arthur.brooks@mail
.interfacevideo.com

Roland House, Inc.
Attn: Fred Russo
2020 North 14th St.
Suite 600
Arlington, VA 22201
Tel: 703-525-7000
Fax: 703-525-2082
email: frusso@rolandhouse.com.

Before you hire a vendor, NARA must approve your copying request. The procedure to obtain such approval is

explained at www.archives.gov. If you don't have access to the Internet, you can have NARA fax you several brochures with the same information. Call NARA's fax-on-demand line at 301-713-6905 and ask for one or more of the following items:

3500 General Information About Ordering Reproductions
3502 How to Order Broadcast Quality Copies
3503 How to Order Non-Broadcast Video Copies
3504 Stock Film Ordering Requirements
3505 Motion Picture Archival Copy Abbreviations
3506 NA Form 14110, Item Approval Request List (Rev. 3-98).

You must call from a fax machine for the fax-on-demand system to work. You can't call from a telephone.

c. Other NARA Facilities

NARA's facility in College Park, Maryland, is not the only NARA facility that has films and videos. The various presidential libraries have large audiovisual collections as well. You can find a list of these library Web pages and contact information at www.archives.gov/presidential_libraries/addresses/addresses.html.

In addition, NARA has many other facilities throughout the country that may contain useful materials, particularly records from federal agency offices outside of Washington, DC. You can find a list of these at www.archives.gov.

d. Fax on Demand

NARA has produced a number of helpful pamphlets describing its film and video holdings and procedures. You can obtain copies by fax-on-demand. Call 301-713-6905 from a fax machine, punch in the appropriate code, and the pamphlet will be immediately faxed to you.

A list of the available pamphlets can be found on the NARA website at www.nara.gov/publications/faxondemand. You can also obtain a list by fax.

2. National Audiovisual Center

The National Audiovisual Center's (NAC) collection includes over 9,000 U.S. government audiovisual and media productions, usually in video format, grouped into more than 600 individual subject headings. Subject areas include training in occupational safety and health, fire services, law enforcement, and foreign languages. Information and educational materials include areas such as history, health, agriculture, and natural resources. NAC videos are often more recent than those in the National Archives collection.

The NAC has an excellent website at www.ntis.gov/nac. Their materials are listed in an online searchable catalogue and you can order directly from the website.

The NAC catalogue entries indicate whether there are any copyright restrictions in effect for the video. Most NAC materials are in the public domain, but some have been obtained from private sources and may be under copyright.

3. NASA

Hundreds of public domain videos on all aspects of space flight and astronomy are available from NASA. The *NASA Video Catalog* may be accessed online at www.sti.nasa.gov/Pubs/Videocat/videocat.pdf.

The Jet Propulsion Laboratory also has a video catalogue that can be accessed online at: www.jpl.nasa.gov.

Videos designed for classroom use may be obtained from NASA's Central Operation for Resources for Educators (CORE). CORE has an online video catalogue at http://core.nasa.gov.

NASA also has numerous short videos and digital animations that can be viewed online and downloaded.

For more information about NASA materials, you may contact:

> NASA Headquarters
> Office of Public Affairs
> Media Services Division
> News and Imaging Branch
> Code PM
> 300 E St., SW
> Washington, DC 20546
> 202-358-1900
> www.nasa.gov.

4. Other Federal Agencies

Other federal agencies may have films
and videos. The book *Scholar's Guide to
Washington D.C. Media Collections*, by
Bonnie Rowan & Cynthia Wood (Woodrow
Wilson Press & Johns Hopkins Press),
contains extensive information about
government film collections in Washington,
DC. Another approach, is to call or write the
agency you think may have useful material
and locate its video library. A list of federal
government agency websites can be found
in the Yahoo Internet directory at: http://
dir.yahoo.com/Government. Click "U.S.
Government," then "Agencies."

N. Film Archives

A film archive is a nonprofit organization
dedicated to preserving both public domain
and copyrighted films. There are dozens of
film archives in the United States. You can
obtain a list of virtually every major film
archive in the U.S. at this website: www
.filmpreservation.org/sm_index.html. Other
lists are contained in the books *Footage:
The Worldwide Moving Image Sourcebook*,
by Philip Kadish (Second Line Search),
and *Nitrate Won't Wait*, by Anthony Slide
(McFarland).

By far the largest archives are:

George Eastman House
International Museum of
 Photography and Film
900 East Avenue
Rochester, NY 14607
Phone: 716-271-3361
Fax: 716-271-3970
Website: www.eastman.org

Library of Congress
Motion Picture, Broadcasting and
 Recorded Sound Division
LM 338
101 Independence Avenue, SE
Washington, DC 20540-4690
Phone: 202-707-5840
Fax: 202-707-2371
Website: http://lcweb.loc.gov/rr/
mopic

Charlie Chaplin, *The Immigrant,* The Mutual Company,
1917

Museum of Modern Art Department
of Film and Video
11 West 53rd Street
New York, NY 10019
212-708-9400
Website: www.moma.org

National Archives and Records
Administration (see Section M1
above)

UCLA Film and Television Archive
302 East Melnitz
Box 951323
Los Angeles, CA 90095-1323
310-206-5358
Website: www.cinema.ucla.edu.

Film archives have thousands of public films sitting in their vaults. There is no single central catalogue or database showing which archive has which film. You must contact each archive individually to find out what they have. The book *Nitrate Won't Wait* contains an appendix listing some of the subject matter contained in the major archives listed above. Also, refer to the book *Footage: The Worldwide Moving Image Sourcebook*, by Philip Kadish (Second Line Search).

Film archives obtain most of their films through donations from film studios, independent producers, and private collectors. Unfortunately, it has been a very common practice when such donations are made for film archives to agree not to sell or license copies of the donated films without the donor's permission. These restrictions generally apply not only to copies of films that are still under copyright, but to public domain films as well. As a result, there are thousands of public domain films sitting in film archives that may only be viewed at the archive. Copies may not be purchased or licensed. This is true not only for private archives, but for federally funded film archives such as the Library of Congress.

To put it mildly, this is an exasperating situation. After all, what's the point of preserving a public domain film if the public can't use it? But the situation isn't completely bleak. Many archival agreements for donations of films by private collectors or independent producers and distributors provided for limited-term restrictions of ten to 35 years. Since some of these agreements were made as long as 20 years ago, access to these films is now, or soon will be, available.

In addition, not all the films in film archives are subject to such donor restrictions. For example, the Library of Congress has an extraordinary collection of over 3,000 silent films from 1894-1915 that are not subject to any restrictions, copies of which may be purchased. These films were copied from paper prints—rolls of paper strips—deposited in the Copyright Office as part of the registration of early motion pictures. For more information, see the website http://lcweb.loc.gov/rr/mopic/earlymps.html#pape.

A description of all the major film holdings in the Library of Congress can be found at

this Web page: gopher://marvel.loc.gov:70/00/research/reading.rooms/motion.picture/collections/mpcoll.

If you don't have Internet access, a detailed description of the Library of Congress's film holdings can be found in the book *Footage: The Worldwide Moving Image Sourcebook*, by Philip Kadish (Second Line Search).

O. Commercial Film and Video Suppliers

Another major source of public domain films and videos is commercial suppliers—that is, companies in the business of selling films and videos. Some commercial suppliers will sell copies of public domain films outright, others will only license them—that is, they require customers to sign license agreements restricting how they may use the films; for example, barring them from making copies. The legal enforceability of such licenses is unclear, but you could get sued if you violate one. (See Chapter 2 for a detailed discussion.)

There are two important things you should know about commercial suppliers. First, the quality of their prints can be very poor, particularly for films that are sold rather than licensed. Second, some of the films and videos they label as public domain are really under copyright. This may be because some commercial suppliers don't understand the copyright law.

For example, some suppliers appear to be unaware that most foreign films that used to be in the public domain because they weren't renewed or lacked a copyright notice have had their U.S. copyrights restored. Some continue to sell, as public domain films, foreign films whose copyright has been restored. In other words, a supplier may inadvertently (or intentionally) misrepresent public domain status. Unfortunately, the only prudent course is to research the status before purchasing a copy.

Also, there are a number of commercial video suppliers selling copies of many early television programs they claim are in the public domain. As discussed in Section H, whether they really are in the public domain may be a question with no clear answer.

1. Silent Films

Hundreds of silent films are available for purchase. An outstanding book called *Silent Films on Video*, by Robert Klepper (McFarland), tells you where you can find copies of over 700 silent films. The following two websites also provide lists of suppliers of silent films:

- www.cinemaweb.com/silentfilm
- www.silentsaregolden.com/silentvideolist.html.

A list of dozens of websites covering all aspects of silent films can be found at: www.cs.monash.edu.au/~pringle/silent/faq/sites.html.

2. Well-Known Suppliers

Following is a list of some of the best-known commercial suppliers. See the following section for directories listing many more.

Critics Choice Video
800-367-7765

Discount Video Tapes
818-843-3366
email: jr@discountvideotapes.com
www.discountvideotapes.com

Facets Video
800-331-6197

Kino International Corp.
333 West 39th Street
New York, NY 10018
800-562-3330
email: kinoint@infohouse.com
www.kino.com

Movies Unlimited
800-523-0823
www.moviesunlimited.com

Nostalgia Family Video
P.O. Box 606
Baker City, OR 97814
541-523-9034

PanAmerican Video
8581 Santa Monica Blvd.
Suite 470
Los Angeles, CA 90069
800-726-2634
email: panam@panamvideo.com

Video Oyster
www.videooyster.com

Video Yesteryear
Box C
Sandy Hook, CT 06482
203-797-0819
email: video@yesteryear.com
www.yesteryear.com.

3. Directories

The best single print resource about film and video research is *Footage: The Worldwide Moving Image Sourcebook*, by Philip Kadish (Second Line Search). This book is the film research bible. It gives detailed descriptions of 3,000 moving-image sources, including hundreds of listings for public domain material.

Other useful guides include:

- *Bowker's Complete Video Directory* (R.R. Bowker).

 Volume One covers approximately 37,000 entertainment and performance videos including feature films, music videos, cartoons, television films, and plays. Volumes Two and Three list over 52,000 documentaries, sports, educational, and other special interest films.

- *Buyer's Guide to 50 Years of TV on Video*, by Sam Frank (Prometheus Books).

 Lists 50,000 television films from 1948 to the present.
- *Film & Video Finder* (Access Innovations).

 This index lists 160,000 educational, informational, and documentary films and videos.

- *The Video Source Book*, (Gale Research Inc.).

 Guide to 126,000 films currently available on videotape or videodisk from more than 1,770 distributors. It lists feature films, shorts, documentaries, educational, and training videos available for purchase or rental. ■

Chapter 8

Computer Software

Software Checklist

1. Is the software dedicated to the public domain? (See Section A.)

 ☐ Yes: Software is in public domain. Do not continue.

 ☐ No: Continue.

2. Was the software created by the U.S. government? (See Section B.)

 ☐ Yes: Software is in public domain. Do not continue.

 ☐ No: Continue.

3. Has the copyright in the software expired? (See Section C.)

 ☐ Yes: Software is in public domain. Do not continue.

 ☐ No: Continue.

4. Is the software in the public domain due to lack of a copyright notice? (See Section D.)

 ☐ Yes: Software is in public domain. Do not continue.

 ☐ No: Continue.

5. Does the copyrighted software contain public domain elements? (See Section E.)

 ☐ Yes: Public domain elements may be freely used unless protected by means other than copyright.

 ☐ No: No aspect of software is in the public domain.

Computer software is what makes computers work. Without software a computer would be just a box filled with electronic parts. Although computers and the software they use are relatively new technologies, a surprisingly large amount of software is in the public domain. This is because many software creators have elected to dedicate their programs to the public domain.

Anyone is free to use public domain software any way they desire. You can freely copy it, modify or adapt it to create new software, give it away, or even sell it to the public. It can be placed on websites or the source code can be printed in computer programming textbooks and magazines. The only limit to what you can do with public domain software is your own creativity and imagination.

Public domain software falls into the following categories:

- software dedicated to the public domain
- software created by the U.S. government
- software whose copyright has expired, and
- software in the public domain because it was published before 1989 without a valid copyright.

Each category is discussed in turn below. Public domain elements contained in copyrighted software are discussed in Section E.

How to Use This Chapter

To help you determine the copyright status of computer software, we have created the checklist at the beginning of this chapter for you to follow. Each step is described in the checklist and each line refers to one or more sections listed below or to other chapters of this book. If you have a particular software work you are researching, start at Line 1 on the checklist. As you answer each question you will be led to the appropriate section or chapters necessary to answer the next question on the checklist. At the end of the process you will know whether the software you want to use is in the public domain.

We have also included a worksheet (Appendix C) that you may use to document how you determined that a particular work was in the public domain. By filling out the sheet, you will be able to document your research and conclusions should anyone challenge your right to use the work.

A. Is the Software Dedicated to the Public Domain?

Software dedicated to the public domain accounts for, by far, the largest amount of software available without copyright restrictions. Much of it can be found on the Internet or in computer programming texts, which often contain code dedicated

to the public domain that programmers are encouraged to copy.

While copyright protection is automatically given to a new creative work, the author or owner of the work is free to reject that protection and dedicate a product to the public domain. By doing so, the author gives up all ownership rights in the work, which allows anyone to copy or use the work in any way they want to without obtaining permission.

Dedication of a work of authorship to the public domain is more common with computer software than for any other type of work. There is a long tradition in the software programming community of sharing work with others and not seeking to profit from the work. These programmers simply want to create good software and experience the satisfaction of having others use and appreciate it.

Of course, software giants like Microsoft don't dedicate their software to the public domain. Individual programmers working on their own—hobbyists, students, academics, and others with a strong libertarian streak—have created most software dedicated to the public domain. Public domain dedicated software is usually not a slick, commercial-looking product, but it may still get the job done. In fact, it may work better than a commercial product designed for the same purpose.

The Public Domain and the Molecule

One example of software that has been dedicated to the public domain is a program called RasMol. This program allows chemistry students and researchers to view molecular structures in three dimensions. The structures can be rotated and even animated. Below is an example of a molecular structure graphic created using RasMol:

RasMol was developed by Roger A. Sayle during the early 1990s. It is currently the most widely used molecular graphics program in the world, with nearly three quarters of a million users.

Because RasMol has been dedicated to the public domain, anyone is free to copy it and even sell it without obtaining permission from its creator. At least eight publishers currently bundle it with CD-ROMs or textbooks and several companies sell it as a stand-alone product for profit. Because he dedicated his program to the public domain, Sayle receives no royalties from these companies. Nevertheless, Sayle says he's happy that he dedicated RasMol to the public domain. He was recently awarded a medal by the Biochemical Society for his contributions to the advancement of science.

RasMol has its own website at www.umass.edu/microbio/rasmol.

Authors who dedicate software to the public domain give up all their copyright rights. This means you can use their software any way you wish without restriction. You can revise it and incorporate it into other software, charge the public for copies of it, or do anything else you wish.

1. How to Tell Whether Software Is Dedicated to the Public Domain

There is widespread confusion in the software community about what the words "public domain" mean. Many people believe that public domain software is software that is given away for free. This is not the case. Both public domain software and software protected by copyright can be given away for free—for example, on the Internet. Indeed, most of the software given away for free on the Internet is not in the public domain.

So long as it's free, why should you care whether software is in the public domain or not? Because only public domain software can be used by anyone for any purpose. Copyrighted software, even if you obtained it for free, is still controlled by the copyright owner. You could, for example, be prevented from reselling or altering the software without permission of the copyright owner.

There is no official form for dedicating a creative work to the public domain. The author must simply state clearly somewhere on the work that no copyright is claimed in the work—for example "This program is public domain" or other words to this effect.

If the software has been dedicated to the public domain, you will ordinarily find a statement like this on the software itself. It may be on one of the first screens you see as the software is loading into your computer, or in a file on the program known as a "readme" file or in the Frequently Asked Questions (FAQ) file or a manual distributed with the program.

For example, the RasMol program mentioned above ("The Public Domain and the Molecule") contains a FAQ that says "The RasMol molecular graphics package is 'public domain,' which in the legal definition is more than just freely redistributable but actually free of all intellectual property rights." A small Internet utility program called IC Helper contains a Read Me file that says "This code is released into the public domain and can be used, modified, etc. as desired."

If the words "public domain" appear on software you would have a very strong defense if the owner later claimed the software wasn't really in the public domain and attempted to sue you for copyright infringement. Indeed, you'd very likely win the lawsuit. But you still might have to go through the trauma and expense of a lawsuit. It's best to make sure in advance that the software is really in the public domain and avoid even the possibility of getting sued later on.

For this reason, examine all the documentation that comes with the program to make sure its creator really intended to dedicate it

to the public domain. You should be tipped off that the creator either didn't really intend to dedicate the program to the public domain or may simply be confused about what the words "public domain" mean if:

- you are required to agree to a license restricting how you use the program
- you are asked to register the software
- any type of restrictions are imposed on your use of the software
- the software is described with any of the words listed in the following section, or
- the creator places a copyright notice on the software.

In this event, you should contact the creator and ask if the software has been dedicated to the public domain. Explain that this means not only is the software free, but that it is not protected by copyright and can be used by the public in any way, even sold. (Most software contains some kind of contact information for the creator, whether an email address, website, or postal address.)

2. Software Not in the Public Domain

Following is a list of terms commonly used to describe software that is distributed for free but is *not* in the public domain. The software is copyrighted and users are often required to agree to license agreements (whose terms are usually quite generous). If the software you're interested in is de-

scribed with one of these terms, it isn't in the public domain.

There is nothing wrong with using such software, but you should be aware that it comes with legal restrictions on how it is used. Make sure you understand these restrictions. They will usually be spelled out in a Read Me file, license agreement, manual, or other documentation included within the software or inside its packaging.

- **Free software.** Free software (also called freeware) is open source software that is licensed under the most commonly used open source license—the GPL (General Public License). Like all open source software, free software may be freely used, but is not necessarily available for free—that is, without financial cost.

- **Shareware.** Shareware refers to a method of marketing software by making trial copies available to users for free. If the user wishes to keep the software, he or she is supposed to pay the shareware owner a fee. Shareware is fully protected by copyright and may be used only in the manner and to the extent permitted by the owner.

- **Open source software.** Open source software is copyrighted and it can either be sold or given away. However, it must be distributed under an open source license that guarantees users' rights to read, use, modify, and redistribute the software freely. The source code must be made

WillMaker 8, copyright © by Nolo

available so users can improve or modify the program. Many parts of the UNIX operating system, (including the Linux program) were developed this way. For more information, see www .opensource.org.

- **Copyleft software.** This software contains a provision requiring users who publicly distribute modifications to license them as open source software.
- **Semifree software.** This is software that is not free, but comes with permission for individuals to use, copy, distribute, and modify it so long as they do so solely for nonprofit purposes. PGP (Pretty Good Privacy), a popular program used to encrypt email, is one example.

3. Potential Problems Using Public Domain Software

There is one potential problem when you use software that someone says has been dedicated to the public domain: It may actually be copyrighted. Anyone can place a copy of a program on the Internet and say that it has been dedicated to the public

domain. This doesn't mean it really is. For this reason, it's wise to trace its history to make sure it really has been dedicated to the public domain. This is not something you need to worry much about if you just intend to use the program yourself. However, you should always do this before you publicly distribute the program or incorporate it into a program of your own you plan to publicly distribute. Most software lists the name of the person(s) who created it and provides contact information for them, whether an email address, website, or postal address. Contact the creators and verify that they really are the creators of the program, and they have dedicated it to the public domain. Make sure they understand what public domain means.

If you can't find any information about the creators of the program, ask the people in charge of the place where they got it from, who created it, and how they know it was dedicated to the public domain. For example, if you obtained the software from a website, contact the webmaster and ask him or her for this information.

If you determine the software has been dedicated to the public domain, mark "yes" in Line 1 on the checklist at the beginning of this chapter. The software is in the public domain. You don't need to read the rest of this chapter. If the software has not been dedicated to the public domain, mark "no" in Line 1 and continue to Line 2.

B. Was the Software Created by the U.S. Government?

Any work created by U.S. government employees as part of their job duties is in the public domain, including software. Creative works made for the U.S. government by outside contractors are also in the public domain unless the government allows the contractor to retain ownership in the product. (See Chapter 3, Section C, for a detailed discussion.)

Thousands of software programs have been created by U.S. government employees and contractors and are in the public domain. These include, for example, weather forecasting programs created by the National Weather Service, mapmaking programs created by the U.S. Geological Survey, and aeronautical programs created by NASA.

Although they are in the public domain, not all of these programs are publicly available. For example, the Department of Defense or the CIA probably have a good deal of top secret software that the public is not allowed to see. However, some government-created public domain software is available to the public. Some can even be downloaded from the Internet. For example, public domain software created by the U.S. Geological Survey that is used to view USGS geographic data can be downloaded from the USGS website at www.usgs.gov. In 2001, NASA released more than 200 of its scientific and engineering software applications for public use. The Robert C. Byrd National Technology Transfer Center (www.nttc.edu) distributes more than 500 programs created by NASA.

Profiting From Government Software

Because it's in the public domain, U.S. government software can be freely copied and distributed to the public *(unless the government places restrictions on its use for security or other reasons)*. It can even be sold for a profit. That is what Ralph Carmichael, a retired NASA employee, has done. He obtained copies of 23 programs developed by NASA for use by aeronautical engineers, airplane designers, and aviation technicians. Some of these programs had been given by NASA to major airplane manufacturers, but few had been updated for the desktop computers that are in widespread use today. Many of the programs had never left NASA's labs. Carmichael updated the programs to run on desktop computers. He then copied the software onto a CD-ROM and is selling it through his own website for $295. This is perfectly legal because the software is in the public domain. You can find his website at www.pdas.com.

If you determine that the software was created by or for the U.S.

government, mark "yes" in Line 2 on the checklist. The software is in the public domain. You need not read the rest of this chapter. If the software was not created by the U.S. government, mark "no" in Line 2 and continue to Line 3.

C. Has the Copyright in the Software Expired?

Copyright protection does not last forever. When it expires, the work enters the public domain. (See Chapter 18 for a detailed discussion of copyright expiration.)

The only software now in the public domain because of copyright expiration is software published before 1964 that was not renewed on time with the Copyright Office during the 28th year after publication. This software entered the public domain at the start of the 29th year after publication. For example, a program published in 1960 that was not renewed during 1988 entered the public domain on January 1, 1989. You must check Copyright Office renewal records to determine if a renewal registration was filed for a software program (see Chapter 21). Of course, not much software was published before 1964, and what was published probably has little or no value today. Moreover, note that this rule applies only to published software. Copyright protection for all unpublished software, whenever it is written, will last over 70 years, because

unpublished works are protected for the life of the author plus 70 years.

1. When Is Software Published?

Software is published for copyright purposes when it is sold, licensed, rented, lent, given away, or otherwise distributed to the public. Selling copies to the public through retail outlets or by mail order, publishing code in a magazine, selling a program at a widely attended computer show, and selling or licensing it for use by educational institutions are all examples of publication.

However, publication occurs only when software is made available to the general public on an unrestricted basis. Distributing copies of software to a restricted group of users does not constitute publication. For example, sending copies to a few friends or beta testers would not constitute a publication. Similarly, a court held that software used by a company's salespeople solely for sales presentations for customers was not published. *Gates Rubber, Inc. v. Bando American*, 798 F.Supp. 1499 (D. Colo. 1992).

If you decide the copyright on the software has expired, mark "yes" in Line 3 of the checklist. The software is in the public domain. You need not read the rest of this chapter. Mark "no" in Line 3 if the copyright in the software has not expired. Continue to Line 4.

D. Is the Software in the Public Domain Due to Lack of a Copyright Notice?

Another relatively small group of public domain software is software published in the United States before March 1, 1989 without a valid copyright notice. Before March 1, 1989 all works initially published in the United States had to contain a copyright notice or they entered the public domain unless the lack of notice was excused for some reason.

A copyright notice consists of a "c" in a circle or the word Copyright or abbreviation Copr., the year of publication, and the copyright owner's name—for example: © 1985 by Phil Fates.

Copyright notices for software can be found in a variety of places, including:

- the package or box the software comes in
- the manual and other written documentation
- the computer disks or other media containing the software, and
- the computer screens.

If you don't find a copyright notice in any of these places on software published before March 1, 1989 the software could be in the public domain. Unfortunately, it can be difficult to know for sure, because there are a number of exceptions to the notice requirement. See Chapter 19 for a detailed discussion of copyright notices and the public domain.

If you decide the software is in the public domain because it was published before 1989 without a proper copyright notice, and the lack of notice is not excused, mark "yes" in Line 4 of the checklist. The software is in the public domain. You need not read the rest of this chapter. If the software is not in the public domain due to lack of a copyright notice, proceed to Section E below to see if elements of the work might be in the public domain.

E. Does the Copyrighted Software Contain Public Domain Elements?

All works of authorship contain elements that are not protected by copyright. Unless these elements are protected by some means other than the copyright law, they may be copied freely even though the work as a whole may not. Because software is part of a machine—a computer—it contains many elements that are dictated by the need for maximum efficiency and standardization. To prevent software programmers from using copyright to obtain a monopoly over such elements and thereby stifle the competition, courts have held that they are in the public domain even though the software program as a whole is protected by copyright.

The courts have developed some general rules defining what software elements cannot

be protected by copyright. These rules are discussed in detail below. Unfortunately, they are rather vague, and reasonable people could easily disagree about how to apply them. Moreover, there are not many examples of how the courts have applied them to help guide us.

In addition, because copyright protection for software is more limited than for other creative work, most software developers use legal protections in addition to copyright to help protect their works. For example, much software is now being patented, and developers usually require users to agree to license agreements restricting how they may use the software. (See "Protecting Software by Other Means," below.)

Because it's difficult to determine which individual elements of a software program are in the public domain, and because such elements may be protected by means other than copyright, it is advisable that you consult an attorney before you do any wholesale copying of software that has not been dedicated to the public domain, created by the U.S. government, or fallen into the public domain due to lack of a copyright notice or copyright expiration.

The following six rules describe the type of software elements that are in the public domain, even though the program as a whole is not:

1. Rule #1: Ideas, Systems, or Processes Are in the Public Domain

Copyright only protects the expression of an idea, system, or process, not the idea, system, or processes itself. Ideas, procedures, processes, systems, mathematical principles, formulas or algorithms, methods of operation, concepts, facts, and discoveries are not protected by copyright. 17 U.S.C. Section 102(b). Thus, the basic idea for a computer program cannot be copyrighted, only the particular way a programmer expresses the idea is protected.

EXAMPLE: While a student at the Harvard Business School in the late 1970s, Daniel Bricklin conceived the idea of an electronic spreadsheet—a "magic blackboard" that recalculated numbers automatically as changes were made in other parts of the spreadsheet. Eventually, aided by others, he transformed his idea into VisiCalc, the first commercial electronic spreadsheet. The program, designed for use on the Apple II, sold like hotcakes and helped spark the personal computer revolution.

Of course VisiCalc was protected by copyright. Nevertheless, others were free to write their own original programs accomplishing the same purpose as VisiCalc. The copyright law did not give Bricklin any ownership rights over the idea of an electronic spreadsheet, even though it was a revolutionary

Protecting Software by Other Means

Copyright law is not the only legal means available to protect computer software. Because so many elements contained in most software programs can't be copyrighted, software developers usually supplement their copyright protection with other forms of protection. These include:

- patents—the federal law that protects inventions
- licenses—contracts restricting how you may use software, including when you can copy it
- trade secrets—state laws protecting valuable information that is not generally known, and
- trademarks—federal and state laws protecting product names, logos, and designs.

You ordinarily don't need to worry about any of these types of legal protections when software has been dedicated to the public domain, created by the U.S. government, or had its copyright expire because it was published before 1964 and not renewed. It's theoretically possible, but not likely, that software published before 1989 without a valid copyright notice could be protected by a license or trade secrecy.

However, you should worry about these types of protection if you're interested in copying elements of a software program that are not protectable by copyright, particularly if it is relatively new or popular software. The elements of the software that are not protected by copyright could still be protected by one or more of these other means. As a result, copying them could get you sued.

Understanding all these complex laws and how they apply to software is a difficult task. Explaining them in detail would take a book in itself. This is why it's important for you to consult a knowledgeable attorney before copying software not in the public domain as a whole. For more information about all the laws used to protected software, refer to *Software Development: A Legal Guide*, by Stephen Fishman (Nolo). This book is out of print, but is available in many libraries. A helpful legal treatise available in many law libraries is *The Law and Business of Computer Software*, edited by D.C. Toedt III (Clark Boardman Callaghan).

advance in computer programming. The copyright in VisiCalc extended only to the particular way VisiCalc expressed this idea—to Visicalc's actual code, its structure and organization, and perhaps to some aspects of its user interface.

Very soon, many competing programs were introduced. The most successful of these was Lotus 1-2-3, originally created by Mitchell Kapor and Jonathan Sachs. Building on Bricklin's revolutionary idea, Kapor and Sachs expressed that idea in a different, more powerful way. Designed for the IBM PC, their product—Lotus 1-2-3—took advantage of that computer's more expansive memory and more versatile screen display capabilities and keyboard. In short, Lotus 1-2-3 did all that VisiCalc did, only better. VisiCalc sales plunged and the program was eventually discontinued.

2. Rule #2: Elements Dictated by Efficiency Are in the Public Domain

Programmers usually strive to create programs that meet the user's needs as efficiently as possible. The desire for maximum efficiency may operate to restrict the range of choices available to a programmer. For example, there may only be one or two efficient ways to express the idea embodied in a given program, module, routine, or subroutine. If a programmer's choices regarding a particular program's structure, interface, or even source code

are necessary to efficiently implement the program's function, then those choices will not be protected by copyright. In other words, no programmer may have a monopoly on the most efficient way to write any program. Paradoxically, this means that the better job a programmer does—the more closely the program approximates the ideal of efficiency—the less copyright protection the program will receive.

EXAMPLE 1: The Lotus 1-2-3 basic spreadsheet screen display resembling a rotated "L" was not protected by copyright because there are only a few ways to make a computer screen resemble a spreadsheet; nor was the use of "+," "-," "*," and "/" for their corresponding mathematical functions; or use of the enter key to place keystroke entries into cells. The use of such keys was the most efficient means to implement these mathematical functions. *Lotus Dev. Corp. v. Borland Int'l, Inc.*, 799 F.Supp. 203 (D. Mass. 1992).

EXAMPLE 2: A cost-estimating program's method of allowing users to navigate within screen displays (by using the space bar to move the cursor down a list, the backspace key to move up, the return key to choose a function, and a number selection to edit an entry) was not protected. A court noted that there were only a limited number of ways to enable a user to navigate through

a screen display on the hardware in question while facilitating user comfort. The court also found that the program's use of alphabetical and numerical columns in its screen displays was not protected. The constraints of uniformity of format and limited page space (requiring either a horizontal or vertical orientation) permitted only a very narrow range of choices. *Manufacturers Technologies, Inc. v. Cams*, 706 F.Supp. 984 (D. Conn. 1989).

3. Rule #3: Elements Dictated by External Factors Are in the Public Domain

A programmer's freedom of design choice is often limited by external factors such as:
- the mechanical specifications of the computer on which the program is intended to run
- compatibility requirements of other programs that the program is designed to operate with
- computer manufacturers' design standards, and
- the demands of the industry being serviced.

EXAMPLE: A cotton cooperative developed a program for mainframe computers called Telcot that provided users with cotton prices and information, accounting services, and the ability to consummate cotton sales transactions. Former employee-

programmers of the cooperative created a version of the cotton exchange program that worked on a personal computer. The two programs were similar in their sequence and organization. The cooperative sued for infringement, but lost. The court held that many of the similarities between the two programs were dictated by the structure of the cotton market. The programs were designed to present the same information as contained in a cotton recap sheet, and there were not many different ways to accomplish this. *Plains Cotton Cooperative Assoc. v. Goodpasture Computer Service, Inc.*, 807 F.2d 1256 (5th Cir. 1987).

4. Rule #4: Standard Programming Techniques and Software Features Are Public Domain

Certain programming techniques and software features are so widely used that they have become standard in the software industry. To create a competitive program, a software developer may have no choice but to employ these standard techniques and features because users expect them. Courts treat such material as being in the public domain—it is free for the taking and cannot be owned by any single software author, even though it is included in a work that is capable of obtaining copyright protection.

EXAMPLE: A court held that the following basic elements of the

Macintosh user interface were not protected because they were common to all graphical user interfaces and were standard in the industry:

1. overlapping windows to display multiple images on a computer screen

2. iconic representations of familiar objects from the office environment, such as file folders, documents, and a trash can

3. opening and closing of objects in order to retrieve, transfer, or store information

4. menus used to store information or control computer functions

5. manipulation of icons to convey instructions and to control operation of the computer. *Apple Computer v. Microsoft Corp.*, 779 F.Supp. 133 (N.D. Cal. 1992).

5. Rule #5: User Interfaces Receive Very Limited Copyright Protection

The user interface of a computer program is the way a program presents itself to and interacts with the user. It consists principally of the sequence and content of the display screens that appear on a computer's monitor (permitting the user to select various options or input data in a prescribed format) and the use of specific keys on the computer keyboard to perform particular functions. The look and feel of a program's interface can be very important to the user (a well-designed interface makes a

program much easier to use) and therefore very valuable to the program's owner. It's possible to copy the way a user interface looks and works without copying any computer code.

Unfortunately, after years of litigation involving some of the most famous software interfaces in the world, we still don't have a definitive answer as to what extent user interfaces are protected by copyright. However, the two most important legal decisions on user interfaces—involving the Macintosh interface and the Lotus 1-2-3 computer spreadsheet program—held that they receive very limited copyright protection. These decisions are not binding on courts in most of the country, but it is likely they would follow them. Again, however, you should consult with an attorney before you copy user interfaces contained in copyrighted software.

a. The Apple Case

Apple sued Microsoft, claiming that the user interface of Microsoft's Windows system violated Apple's copyright in the Macintosh user interface.

All of Apple's claims were dismissed at the trial and that decision was upheld after Apple appealed to the U.S. Court of Appeals. The trial court held that the "desktop metaphor" underlying the Macintosh user interface—suggesting an office with familiar office objects such as file folders, documents, and a trash can—was not an idea that could have copyright protection. The court also ruled that most of the individual elements of the user interface at issue in the case

were not protectable, either because Apple had licensed them to Microsoft, because they were not original, or because of the factors discussed in Sections 2 through 4 above. However, the court also held the Macintosh interface might be protected as a whole, at least from virtually identical copying, even though its individual elements were not protected. In other words, although many of the individual elements of the interface were not protectable alone, they still formed part of a larger arrangement, selection, or layout that was protected expression. *Apple Computer, Inc. v. Microsoft Corp.*, 35 F.3d. 1435 (9th Cir. 1994).

b. The Lotus Case

Lotus Development Corp. sued Borland International, Inc., claiming Borland had infringed on the copyright for Lotus 1-2-3 in Borland's Quattro and Quattro Pro spreadsheet programs. To make the switch from Lotus 1-2-3 to Quattro easy to perform, Borland included an alternate command menu structure in Quattro that was virtually identical to the Lotus 1-2-3 menu command hierarchy. Borland did not copy any of Lotus's computer code. It copied only the words and structure of Lotus's menu commands. Borland lost its case at trial, but won on appeal. The Court of Appeal held that 1-2-3's command hierarchy was a method of operation that was not protected by copyright. The court stated that a software developer should be able to create a program that users can operate in exactly the same way as a competing program. *Lotus Development Corp. v. Borland*

International, Inc., 49 F.3d 807 (1st Cir. 1995).

6. Rule #6: Purely Functional Elements Are in the Public Domain

Copyright protects only works of authorship. Things that have a purely functional or utilitarian purpose are not considered to be works of authorship and cannot be protected by copyright. For example, there is no copyright protection for the purely functional aspects of machinery, refrigerators, lamps, or automobiles. However, if the design of a useful article incorporates artistic features that are independent of the article's functional aspects, such features can be protected. For example, the decorative hood ornament on a Jaguar automobile is an artistic feature that is separable from any functional aspects of a Jaguar; therefore it has copyright protection.

Elements of a computer program that are purely functional may also be denied copyright protection. For example, certain aspects of the Apple Macintosh graphical user interface were found by a court to be purely functional, the same as the dials, knobs, and remote control devices of a television or VCR, or the button and clocks of a stove. These functional aspects included the ability to move a window partially off the screen, and the presence of menu items allowing a user to create a new folder within an existing folder.

Are Computer Languages Protected by Copyright?

Although no court has ruled on whether high-level computer languages like C++ can themselves be protected by copyright, they are almost certainly in the public domain. The Copyright Office is so sure of this that it refuses to register a work consisting solely of a computer language. No one has challenged this Copyright Office policy.

The Copyright Office is following court decisions stretching back many decades involving telegraphic codes and stenographic systems. The courts in these cases ruled that the component elements of shorthand systems and telegraphic codes—that is, the individual coined words or symbols that form the vocabulary of the system—are not protected by copyright. But a particular arrangement of such symbols is protected if it meets the basic requirements for copyright protection discussed in Chapter 2. *Hartfield v. Peterson*, 91 F.2d 998 (2d Cir. 1937).

Therefore, anyone is free to write any program in any computer language. Although the language itself is not protected, a particular program written in that language is. Similarly, the English language is not copyrighted, but a poem written in English can be.

F. Sources of Public Domain Software

By far the most common and easiest way to find public domain software is to use the Internet. There are thousands of websites that have public domain software you can download. You can find these websites by using an Internet search engine—try using the phrase "public domain software" as a search term. The following websites have public domain software. (Note, not all of the software on these sites is public domain):

- www.freeware.com
- www.freewarefiles.com
- www.freewarehome.com
- www.freewareweb.com
- www.shareware.com.

Computer programming textbooks and journals are another possible source of public domain software.

Architecture

Architectural Plans Checklist

1. Have the plans been published? (See Section B1.)

 ☐ Yes: Continue.

 ☐ No: Skip to line 3.

2. Date of publication: _____

 Country of publication: _____

3. Has the copyright in the plans expired? (See Section B2.)

 ☐ Yes: Plans are in the public domain. Do not continue.

 ☐ No: Continue.

4. Are the plans in the public domain because they lack a copyright notice? (See Section B3.)

 ☐ Yes: Plans are in the public domain. Do not continue.

 ☐ No: Continue.

5. Were the plans created by U.S. government employees? (See Section B4.)

 ☐ Yes: Plans are in the public domain. Do not continue.

 ☐ No: Continue.

6. Are the plans original? (See Section B5.)

 ☐ Yes: Plans are not in the public domain. Continue.

 ☐ No: Unoriginal elements are in public domain.

7. Is it OK to use copyrighted plans? (See Section B6.)

 ☐ Yes: No permission needed for your use.

 ☐ No: Permission needed for your use.

You may be surprised to learn that copyright law not only protects words, pictures, and music, but architecture, which includes:

- the plans, blueprints, renderings, drawings, or models for buildings and other structures (referred to here as "plans"), and
- actual constructed buildings themselves.

Luckily, however, most buildings and many plans are in the public domain. Copyright protection differs for plans and buildings, and the two are covered separately below.

⚠ **Many Works in the Public Domain in the United States Are Still Protected by Copyright Abroad and Vice Versa.** This chapter only covers the public domain in the United States. For a detailed discussion of the public domain outside the United States, see Chapter 16.

A. What Good Is Public Domain Architecture?

Architects have been copying from each other for millennia. Take a look at the buildings around you and it's very likely you will see echoes of public domain architecture. Older public buildings such as courthouses, libraries, banks, post offices, and city halls—with their reliance on columns and arches—frequently copy ancient Greek and Roman architecture.

Visit any major university, and there's a good chance you'll see buildings modeled after medieval cathedrals, such as Salisbury or Westminster in England. Look at the skyline of any modern city and you'll see skyscrapers whose design is heavily influenced by the work of such 20th century architectural giants as Walter Gropius, Mies van der Rohe, and Philip Johnson.

Many of the most famous buildings in America are copied from, or heavily influenced by, prior works. For example, the design of the Lincoln Memorial is similar to the Parthenon in Athens, while Thomas Jefferson's design for his home, Monticello, was heavily influenced by the work of the 16th century Italian architect Andrea Palladio.

Perhaps the most extraordinary modern examples of copying of public domain buildings can be seen in Las Vegas, Nevada. Along the famed Las Vegas "Strip" one can see copies of Egyptian pyramids, the Casino at Monte Carlo, and the Paris Opera House. Most extraordinary of all is the New York, New York, Casino and Hotel. It contains one-third scale replicas of many of the most famous buildings in the Manhattan skyline, including the Empire State Building and Chrysler Building.

All this copying is perfectly legal because all buildings constructed before 1990 are in the public domain. Millions of architectural plans for existing buildings and those yet to be built—along with other types of structures—are also in the public domain. Modern-day architects are free to draw upon this

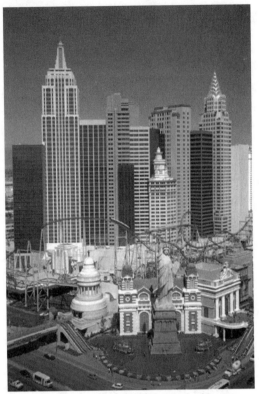

New York, New York, Hotel and Casino, Las Vegas, Nevada. © copyright 1999 by Joe Schwartz

architectural heritage in any way they desire—from outright imitation like that seen in Las Vegas to far more sophisticated and subtle forms of borrowing.

Nonarchitects such as building contractors and ordinary people who just want to build a home or other structure can also benefit from the public domain. Millions of architectural plans and blueprints are in the public domain and may be freely copied and used to build new structures without having to go to the time and expense of hiring an architect.

B. Architectural Plans

Once architectural plans enter the public domain, they may be freely copied and distributed and new buildings may be built from them. Copyrighted plans may not be copied, but in many cases buildings can be constructed based on the plans without obtaining permission from the copyright owner (see Section B6).

How to Use This Section

To help you determine the status of an architectural plan, we have created the checklist at the beginning of this chapter for you to follow. Each step is described in the checklist and each line refers to one or more sections listed below or to other chapters of this book. If you have a particular architectural plan you are researching, start at Line 1 on the checklist. As you answer each question you will be led to the appropriate section or chapters necessary to answer the next question on the checklist. At the end of the process you will know whether the plans you want to use are in the public domain.

We have also included a worksheet (Appendix C) that you may use to document how you decided that a particular work was in the public domain. By filling out the sheet, you will be able to document your research and conclusions should anyone challenge your right to use the work.

1. Have the Plans Been Published?

You must first determine whether the plans you're interested in have been published and, if so, when. This will determine how long their copyright protection lasts and what rights the copyright holder has to protect and determine how those plans are used.

Like any other work of authorship, architectural plans are published for copyright purposes when the copyright owner, or someone acting on his or her behalf, makes the plans available to the *general* public. In other words, any interested member of the public may obtain a copy. *Burke v. National Broadcasting Co.*, 598 F.2d 688 (9th Cir. 1979).

Publication occurs, for example, when plans are published in newspapers, magazines, books, advertising brochures, promotional flyers, or otherwise made available to the general public. However, the following activities do *not* result in publication of architectural plans:

- where a person engages an architect to create custom plans for a building and the plans are not made available to the general public
- where copies of plans are sent to potential contractors and subcontractors for bidding purposes or to actually construct a building
- where copies of plans are placed in public files, such as filed with a local zoning board or planning department, or

- where photographs of a building are published—for example, in a magazine, newspaper, or book.

a. Date of Publication

If you determine that the plans have been published, you should also find out the date of publication. The date in the copyright notice for the plans themselves or the work in which the plans were published— for example, an architecture book—is the date of publication. If there is no copyright notice, but you have nonetheless determined that the plans have been published, you'll have to look elsewhere for clues about the publication date. Try the following:

- **Examine the work for a date.** Examine the plans and the work in which the plans were published—for example, a brochure or book—for a publication date. Most published works contain some indication of when they were published. Look on the title page, the page after the title page, and anywhere else that seems logical.
- **Check the Library of Congress.** Check the Library of Congress card catalogue to see if it has as a record for the plans themselves or the work in which they were published. You can do this in person at the Library in Washington, DC, or online through the Library's Web page (http://catalog.loc .gov). The Library's catalogue contains the publication dates for millions of works in the Library's collection.

- **Check Copyright Office records.** If either the individual plans or any larger work in which they were published was registered with the U.S. Copyright Office, checking Copyright Office registration records will reveal the publication date. Many of these records can be researched online. (See Chapter 21.) However, not all published works are registered with the Copyright Office, so there may be no record for it.

- **Check reference works.** There are hundreds of reference works that may be able to tell you when a work was published. Go to a public or university library with a good reference section and ask the reference librarian for assistance. If you're too busy to go to a library, you can post your research questions on the Internet at www.ipl .org and a reference librarian will email you with advice.

- **Contact the architect.** Contact the architect or the architectural firm that created the plans and ask when they were published.

- **Use the Internet.** Search the Internet using the name of the architect, the name of any larger work in which the plans were published, and the name of the author and publisher of that work. There may be a website devoted to the architect, or some online reference with detailed information about the plans. A good place to find a list

of Internet reference resources is the Internet Public Library at www.ipl.org.

- **Contact the publisher.** If the plans were published in a larger work such as a book, contact the work's publisher and ask them to tell you when the work was first published.

b. Country of Publication

You also need to know the country in which the plans were published. If this isn't readily apparent by examining the plans themselves or any larger work in which they were published—for example, an architecture book—try using the resources listed above.

If you determine that the plans have been published, check "yes" in Line 1 of the checklist at the beginning of this chapter, note the date and country of publication in Line 2, and proceed on to Line 3. If the plans have not been published, skip to Line 3.

2. Has Copyright in the Plans Expired?

Copyright protection does not last forever. When it ends the work enters the public domain where it will forever remain. Plans published as recently as 1963 could be in the public domain. However, the copyright for plans published any time after 1963 will not expire for many decades.

If the plans were published before 1964, carefully review Chapter 18 for a detailed discussion of how to determine whether the copyright has expired. If the plans have never been published, they could enter the public domain as soon as Jan. 1, 2003. See Chapter 18, Section B, for a detailed discussion.

If you determine that the copyright in the plans has expired, check "yes" in Line 3 of the checklist. The plans are in the public domain. Do not continue. If the copyright in the plans has not expired, check "no" and continue to Line 4.

3. Are the Plans in the Public Domain Due to Lack of a Copyright Notice?

If the plans were published before 1989, they could be in the public domain if they lack a valid copyright notice—the familiar "c" in a circle ©, publication date, and name of copyright owner. In one case, for example, the plans for five different styles of tract homes entered the public domain when they were published without a copyright notice in advertising brochures, promotional flyers, and a newspaper advertising supplement. *Donald Frederick Evans & Assocs. v. Continental Homes*, 785 F.2d 897 (11th Cir. 1986).

Read Chapter 19 for detailed guidance on how to determine whether a published work is in the public domain because it lacks a valid copyright notice. If the plans have never been published, they do not need a notice and you need not read Chapter 19

If you determine that the plans are in the public domain because they lack a copyright notice, check "yes" in Line 4 of the checklist. Do not continue. If the plans have a copyright notice or the lack of notice was excused, check "no" and continue to Line 5.

4. Were the Plans Created by U.S. Government Employees?

All works of authorship created by U.S. government employees as part of their jobs are in the public domain. This rule applies to architectural plans as well as to all types of writings (see Chapter 3, Section C). The National Archives houses the plans for 28,000 U.S. government buildings across the country, such as post offices, courthouses, and military installations. For information on these holdings contact:

Cartographic and Architectural Branch (NWDNC)
National Archives
8601 Adelphi Road
College Park, MD 20740-6001
Phone: 301-713-7040
email: carto@arch2.nara.gov.

The National Archives also has an extensive website at www.archives.gov.

If the plans were created by U.S. government employees, check "yes" in Line 5. The plans are in the public domain. Do not continue. Check "no" if the plans were not created U.S government employees. Continue to Line 6.

5. Are the Plans Original?

Architectural plans are protected by copyright only if, and to the extent, they are original. Elements copied from other plans or constructed buildings that are themselves in the public domain are not protected. Thus, for example, standard design features that have been used over and over again for decades or centuries are not protected by copyright—for example, the standard design for a Georgian window, with the window divided into several small panes, has been in use for centuries and is not protected.

If the plans are not original, check "yes" in Line 6 of the checklist. All unoriginal portions of the plans are in the public domain. If the plans also contain original elements, continue to Line 7. If not, do not continue. If the plans are original, they are not in the public domain. Continue to Line 7 to determine if you may still use the copyrighted plans.

6. Is It Okay to Use Copyrighted Plans?

If you've gotten to this point and determined that the plans are not in the public domain for any of the reasons described above, then they are protected by copyright. However, this doesn't necessarily mean you are barred from constructing a building based on the copyrighted plans. This depends on whether the plans are only copyrighted as a pictorial work or also receive copyright protection as an "architectural work" under a special provision of the copyright law.

If the plans are only protected as a pictorial work, you can't photocopy or otherwise duplicate them without the copyright owner's permission. But you can construct a building based upon them. If the plans are protected as an architectural work, not only can't you photocopy them, you can't construct a building based upon them either.

a. All Copyrighted Plans Are Protected From Photocopying

All copyrighted plans are protected as pictorial or graphic works—that is, they receive the same type of protection as a painting, photograph, or drawing. Any type of plan can be protected in this way, whether for a building or for any other structure such as a parking garage, bridge, dam, or walkway. Landscape architecture designs can also be protected.

This form of protection gives the copyright owner the exclusive right to copy, distribute, and create derivative works from the plans. For example, an architect who creates a building plan can sue for copyright infringement against anyone who photocopies the plans without permission.

However, there is a huge limitation on this form of copyright protection for plans: The copyright owner has no right to prevent others from constructing the work described in the plans. This is because the copyright owner of a drawing of a useful article (such as a building) can't prevent others from building the article. He or she can only prevent unauthorized copying of the drawing itself. *Demetriades v. Kaufmann*, 680 F.Supp. 658 (S.D. N.Y. 1988).

As a practical matter, however, it may be difficult (if not impossible) for you to construct a building or other structure based on preexisting plans without first making copies of those plans. The unauthorized making of the copies would constitute copyright infringement, even if the actual construction would not. In one case, for example, the defendant copied house plans on tracing paper and used the unauthorized copy to build the house. The copyright owner of the plans sued and the court held that the copying of the plans was copyright infringement, although the construction was not. The court issued an order impounding the unauthorized copies of the plans, which effectively shut down construction. *Demetriades v. Kaufmann*, 680 F.Supp. 658 (S.D. N.Y. 1988).

However, it might be possible for you to obtain multiple copies of the plans without making the copies yourself. For example, if the plans have been published in a book or magazine, you could obtain numerous copies of the book or magazine.

b. Some Plans Are Protected as Architectural Works

In addition to being protected as pictorial works, some architectural plans qualify for copyright protection as architectural works. In this event, the copyright owner of architectural plans has the exclusive right to construct a building based on the plans. A person who constructs a building based on such plans without authorization would be guilty of copyright infringement even if he or she didn't actually make copies of the plans.

This form of copyright protection for plans began on Dec. 1, 1990 and applies only to buildings, which includes structures that are habitable by humans and intended to be both permanent and stationary, such as houses and office buildings. Also covered are other permanent and stationary structures designed for human occupancy such as churches, museums, gazebos, and garden pavilions. Structures not designed for human occupancy such as dams, chicken coops, or barns, are not covered; neither are elements of the transportation system such as highways, bridges, and walkways.

In addition, there are important limitations on the extent of this form of copyright protection for architectural plans:

- All plans created after Dec. 1, 1990—whether or not they are published—are protected as architectural works.
- Unpublished plans created before Dec. 1, 1990 are covered only if the building described in the plans was *not* actually built by Dec. 1, 1990. If the building described in the pre-1990 plan is still not built by Dec. 31, 2002 this form of copyright protection for the plans will end (but they would still be protected as pictorial works). If the building is constructed by that deadline, the full term of copyright applies—the plans would usually receive 95 years of copyright protection, but never less than 70. (See Chapter 18 for a detailed discussion of copyright terms.)
- Plans that were published before Dec. 1, 1990 are not protected as architectural works.

(See Section B1 for a detailed discussion of when architectural plans are published for copyright purposes.)

7. Sources of Architecture Plans

One good place to find copies of public domain architectural plans is a library. Outstanding public or university libraries may have good collections of architecture materials. There are also several libraries that specialize in architecture. Among the finest architecture libraries in the United States are:

Columbia University
Avery Architecture and Fine Arts Library
1172 Amsterdam Ave.
Mail Code 0301
New York, NY 10027
212-854-3501
www.cc.columbia.edu/cu/libraries/
 indiv/avery

Harvard Design School
Frances Loeb Library
Gund Hall, 48 Quincy Street
Cambridge MA 02138
Circulation Desk: 617-495-9163
Reference Desk: 617-496-1304
www.gsd.harvard.edu/library

SUNY Buffalo Architecture and
 Planning Library
Hayes Hall
State University of New York at Buffalo
Buffalo, NY 14214
Phone: 716-829-3505
email: ulcdebor@acsu.buffalo.edu

University of Florida, Architecture & Fine
Arts Library
P.O. Box 111017
University of Florida
Gainesville, FL 32611
http://afalib.uflib.ufl.edu/afa

University of Nevada

Las Vegas Architecture Studies Library

Paul B. Sogg Architecture Building

4505 Maryland Parkway

Las Vegas, NV 89154-4018

702-895-3031

http://library.nevada.edu/arch/index.html.

A number of private publishers also republish public domain architecture plans. One publisher that is especially active in this field is Dover Publications—for example, it publishes a book called *100 Turn-of-The-Century Brick Bungalows With Floor Plans*. You can obtain a catalogue of Dover's books by writing them at Dover Publications, Inc., 31 East 2nd St., Mineola, NY 11501. Mention that you're interested in architecture.

Another good way to find such books is to do a search at online bookseller's websites, such as Amazon.com and Barnesandnoble .com.

Used booksellers may also have books of public domain architecture plans. Online used booksellers such as alibris.com, powells .com, and bibliofind.com are especially good places to search.

C. Constructed Buildings

Determining whether the design of a constructed building like the Empire State Building or White House is in the public domain is relatively easy. You just have to know whether the building was constructed before or after Dec. 1, 1990.

1. Was the Building Constructed Before Dec. 1, 1990?

Copyright does not protect any building constructed before Dec. 1, 1990. This means that, unless the building is protected by trademark laws (see Section C3), anyone can photograph or draw such a building or other structure and construct a new building or structure based upon the picture or drawing they made. For example, this is what the creators of the New York, New York, Casino in Las Vegas did. The plans for such a building may also be used, but they may not be photocopied or otherwise duplicated unless they are also in the public domain (see Section B6).

However, structures other than buildings that were built before Dec. 1, 1990 can be protected as works of sculpture if they serve no functional (that is, practical) purpose— for example, cemetery monuments are protected as artworks, as long as they are original.

Copyright protection is also available for separately identifiable sculptural or pictorial elements or ornamentation attached to a building—for example, statues, friezes, or frescoes. These kinds of structures or elements receive the same term of copyright protection as sculptures or other works of art. But only these artistic elements are protected, not the building itself. For example, if a building contains an ornamental frieze still under copyright, you couldn't copy the frieze, but you could copy the rest of the building. These types of

structures or building elements built before December 1990 receive the same copyright protection as other works of art. (See Chapter 5 for a detailed discussion of when artworks enter the public domain.)

2. Was the Building Constructed After Dec. 1, 1990?

Buildings constructed after Dec. 1, 1990 are entitled to copyright protection as architectural works. This means they are protected against unauthorized reproduction. Only buildings receive such protection. "Buildings" means structures that are habitable by humans and intended to be both permanent and stationary, such as houses and office buildings. Also included are other permanent and stationary structures designed for human occupancy such as churches, museums, gazebos, and garden pavilions.

Structures not designed for human occupancy such as dams, dog houses, chicken coops, or barns are not covered; neither are elements of the transportation system such as highways, bridges, and walkways.

a. Copyrighted Elements of Buildings

Copyright protection for buildings constructed after Dec. 1, 1990 extends only to the "overall form as well as the arrangement and composition of spaces and elements of the design." This vague definition seems broad enough to cover just about any original design element in a building whose purpose is not purely functional (see below).

Copyright does not extend to "individual standard features." 17 U.S.C. Section §101. Such standard features include, for example, windows, doors, and other standard building components. However, windows, doors, and other features that are not "standard" presumably would be protected—for example, highly stylized or unusual windows, doors, or other components.

No copyright protection is given to design elements that are functionally required. In other words, no copyright protection is available for those elements of a building whose purpose is to keep the rain and wind out or prevent the building from falling down. Only design elements whose purpose is aesthetic or decorative may be protected.

A two-step analysis is required to determine which elements of a building are protectable. First, the work should be examined to determine whether there are original design elements present, including overall shape and interior architecture. If such elements are present, go on to step two and examine whether the design elements are functionally required. If the design elements are not functionally required, the work is protected.

An outstanding example of a building whose overall shape and interior architecture is clearly original and nonfunctional is the Guggenheim Museum of Modern Art

in Bilbao, Spain. The highly imaginative form of this building, designed by Frank Gehry, obviously serves an aesthetic, rather than functional, purpose.

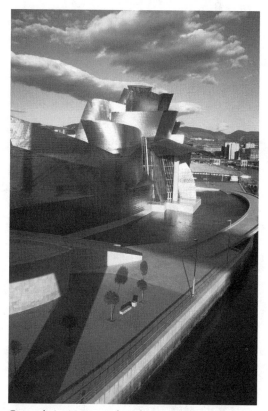

Guggenheim Museum of Modern Art, Bilbao, Spain.
© copyright Rosmi Duaso/Time Pix

In addition, as with all works of authorship, buildings are protected by copyright only to the extent they are original. Design elements copied from other buildings or standard in the field of architectural design cannot hold a valid copyright. Examples include common architecture moldings or the volute used to decorate the capitals of Ionic or Corinthian columns.

b. Photographing Permissible

There is one important limitation on copyright protection for a building constructed after Dec. 1, 1990. If a building is located in or visible from a public place (for example, the sidewalk), the owner may not prevent others from making, distributing, or displaying photographs, movies, paintings, drawings, or other pictorial representations of the building. You can use such architectural photographs, drawings, or other copies in almost any way you desire. For example, you could use them in books, magazines, posters, or postcards. There is one exception: If a building qualifies as a trademark, you can't use a picture, drawing, or other representation of it as a trademark—that is, to identify goods or services in advertising, product packaging, on merchandise, etc. (See Section C3a for a discussion of trademark protection of architecture.)

EXAMPLE: Part of the movie *Batman Forever* was filmed at a building in downtown Los Angeles that contained sculptural elements such as a vampire figure on a series of towers. The designer of the towers sued the movie's producers for copyright infringement, claiming that the sculptural elements he designed were copyrighted and could not be used in the film without his permission. He lost. The court held that

the towers were part of the building; since they were part of an architectural work, the public was entitled to photograph them without permission. The right to photograph publicly accessible buildings includes not just the building itself, but sculptural elements the building contains. *Leicester v. Warner Brothers, Inc.*, 232 F.3d 1212 (9th Cir. 2000).

If a building is not located in or visible from a public place, you need permission to photograph or otherwise copy it. Photographing such a building without permission constitutes copyright infringement. Moreover, entering private property without permission to photograph a building may cause you to be charged with trespassing. To avoid such claims, photographers, publishers, and filmmakers have the property owner sign a property release (also known as a location release) in which the owner agrees to permit the photographing or other copying.

For a sample property release form, refer to *Getting Permission: How to License & Clear Copyrighted Materials Online & Off,* by Richard Stim (Nolo).

3. Is the Building Protected by Trademark or Patent Laws?

Some buildings are entitled to legal protection under the state and federal trademark laws. A few buildings have actually been patented. Such protection is available for buildings constructed before or after Dec. 1, 1990 and—unlike copyright protection—is not limited to structures habitable by humans.

a. Trademark Protection for Buildings

The design or appearance of a building can be protected by state and federal trademark laws if it is used to identify and distinguish goods or services that are sold to the public. For example, trademark protection was extended to the distinctive design of White Tower hamburger stands, consisting of a white structure designed like a miniature castle. White Tower was able to prevent a competitor from using a similar design for

Courtesy of White Castle System, Inc.

a competing hamburger stand. *White Tower System v. White Castle System*, 90 F.2d 67 (6th Cir. 1937).

Over 50 years later, a court held that the design of the façade of the New York Stock Exchange building was an inherently distinctive trademark that could have been infringed upon by a replica at the New York, New York casino in Las Vegas. *New York Stock Exchange, Inc. v. New York, New York Hotel*, 293 F.3d 550 (2d Cir. 2002).

Distinctive decorative portions of buildings can also be trademarked, such as the golden arches that used to appear on all McDonald's hamburger stands.

However, most buildings don't qualify for trademark protection. The building must become associated in the public's mind with a particular product or service. One way for this to occur is for the building design to be used to market a product or service—for example, by using it on menus, letterheads, in newspaper and magazine advertising, and so forth. The distinctive design of the Transamerica Pyramid building in San Francisco is a good example of a building design that is used to market a service—in this case, Transamerica Corporation's financial and insurance services. The design has been registered as a trademark.

Distinctive interior design can also qualify for trademark protection. For example, the interior design of the decor used by the restaurant chain Taco Cabana was protected. *Two Pesos, Inc. v. Taco Cabana*, 112 S.Ct. 2753 (1992).

Of course, most building designs are not used to identify a product or service and are not protected as trademarks. Also, keep in mind that trademark protection does not confer an absolute monopoly on the use of the mark. Even if a building design is trademarked, it still may be copied without permission in many situations without violating the trademark laws. Moreover, trademarks cannot protect the purely functional aspects of building design. (See Chapter 20 for a detailed discussion of trademarks.)

b. Design Patent Protection

Architectural designs and structures can also be protected by design patents. To qualify, the design or structure must be ornamental, nonfunctional, and not obvious—for example, a design patent was obtained for a spaceship-shaped restaurant building. However, this form of protection is not often used. (See Chapter 5 for a detailed discussion of design patents.) ∎

Chapter 10

Maps

Map Checklist

1. Has the copyright in the map expired? (See Section A.)

 ☐ Yes: Map is in the public domain. Do not continue.

 ☐ No: Continue.

2. Is the map in the public domain due to lack of a copyright notice? (See Section B.)

 ☐ Yes: Map is in the public domain. Do not continue.

 ☐ No: Continue.

3. Was the map created by U.S. government employees? (See Section C.)

 ☐ Yes: Map is in the public domain. Do not continue.

 ☐ No: Continue.

4. Is the map eligible for copyright protection? (See Section D.)

 ☐ Yes: Map as a whole is not in the public domain. Continue to determine if map elements are in the public domain.

 ☐ No: Map is in the public domain. Do not continue.

5. Are elements of the map in the public domain? (See Section E.)

 ☐ Yes: Elements may be freely used.

 ☐ No: No part of map is in the public domain.

When we talk about maps we mean flat maps, atlases, globes, marine charts, celestial maps, and three-dimensional relief maps. Maps generally receive less copyright protection than most other graphic or pictorial works because they are used to describe as accurately as possible the physical world, a world that is itself never copyrightable.

Many maps are in the public domain, including hundreds of thousands of maps made by the U.S. government. These public domain maps may be freely copied, republished, used to create new maps, or for any other purpose.

How to Use This Chapter

To help you determine the copyright status of a map, we have created the checklist at the beginning of this chapter for you to follow. Each step is described in the checklist and each line refers to one or more sections listed below or to other chapters of this book. If you have a particular map you are researching, start at Line 1 on the checklist. As you

answer each question you will be led to the appropriate section or chapters necessary to answer the next question on the checklist. At the end of the process you will know whether the map you want to use is in the public domain.

We have also included a worksheet (Appendix C) you may use to document how you determined that a particular work was in the public domain. By filling out the sheet, you will be able to document your research and conclusions should anyone challenge your right to use the work.

What If the Work Is Not in the Public Domain? If you find that the map you want to use is not in the public domain, there may be parts of the material you can use, even if the entire work is not in the public domain (see Section E). It may also be possible to use the entire work under a legal exception called "fair use" (see Chapter 22). If you do not qualify for this exception, you will need to obtain permission to use the work. For a detailed

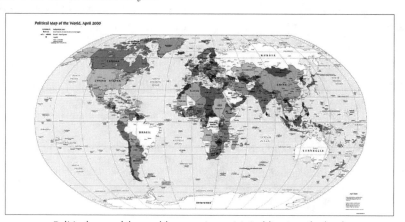

Political map of the world, www.cia.gov/cia/publications/factbook

discussion of how to obtain copyright permissions refer to *Getting Permission: How to License & Clear Copyrighted Materials Online & Off*, by Richard Stim (Nolo).

Mapping in the Public Domain

The U.S. Geological Survey has entered into a partnership with the Microsoft Terra Server website to place digital copies of thousands of its maps and aerial photographs on the Internet. Because these maps were created by the USGS, a U.S. government agency, they are in the public domain (see Section C). They may be freely downloaded, copied, distributed, and used in any way you desire. The map reproduced below shows a portion of the city of San Francisco. You can obtain a USGS map of your own hometown by visiting the Terra Server website at http://terraserver.microsoft.com.

Portion of map of San Francisco, USGS

A. Has Copyright in the Map Expired?

The copyright for all maps published in the United States before 1923 has expired. You may use these maps for whatever purpose you desire. They are in the public domain. The copyright for many other maps published from 1923-1963 has expired as well. In addition, many unpublished maps entered the public domain on January 1, 2003. (See Chapter 18 for a detailed discussion of copyright duration.)

You cannot know whether the copyright in a map has expired unless you know whether or not it has been published and the date and country of publication. The rules for publication of maps are the same as for written works—publication occurs when the work is made available to the general public. (See Chapter 3, Section D, for a detailed discussion.)

If you determine that the map's copyright has expired, check "yes" in Line 1 of the checklist at the beginning of this chapter. The map is in the public domain. Do not continue. If the map's copyright has not expired, check "no" in Line 1 and continue to Line 2.

B. Is the Map in the Public Domain Due to Lack of a Copyright Notice?

A map published before 1989 could be in the public domain if it lacks a copyright notice. Examine the map carefully to determine if it has a notice. A copyright notice on a map must contain at least two elements —the familiar © symbol, the word Copyright or abbreviation "Copr.," and name of copyright owner—for example: © Mel Mercator. Maps published after 1977 must also include the publication year-date in the notice. Maps published before 1978 did not need a date.

If the map has been published as part of a larger work—for example, in an atlas containing many maps or in a book, encyclopedia, magazine, newspaper, or other work—it is sufficient that the larger work has a proper notice. For example, a notice in the name of an atlas publisher will cover all the maps in the atlas.

If the work has a notice in the format described above, you can forget about it being in the public domain for lack of a notice. There is no need to read Chapter 19, which explains copyright notice requirements in detail. Go on to Section C below.

However, if the work has no notice or if the notice lacks one of the elements described above, it could be in the public domain. Read Chapter 19 for detailed guidance on how to determine whether a published map is in the public domain because it lacks a valid copyright notice.

Unpublished maps have never required a copyright notice. So if the map you're interested in has never been published, you need not read Chapter 19.

If you determine that the map is in the public domain because it lacks a copyright notice, check "yes" in Line 2 of the checklist. The map is in the public domain. Do not continue. If the map has a notice or the lack of notice is excused, check "no" and continue to Line 3.

C. Was the Map Created by the U.S. Government?

All maps created by U.S. government employees as part of their jobs are in the public domain. This includes all the maps created by the U.S. Geological Survey (USGS), the U.S. Forest Service, and the Bureau of Land Management. However, maps created by state and local government employees may be protected by copyright—for example, a map created by a state highway or forestry department, or a county tax map. *County of Suffolk v. First American Real Estate Solutions*, 261 F.3d 179 (2d Cir. 2001).

The USGS alone has nearly 70,000 maps available for sale. These include topographic maps, thematic maps, and even maps of the moon. Many more USGS maps are out of

print and are available from the National Archives, libraries, or from map dealers. Since all these maps are in the public domain, it would be possible for a person or company to sell them to the public without having to pay the government any fees at all.

To obtain free map indexes and catalogues and to order USGS maps contact the USGS at:

USGS Information Services
Box 25286
Denver, CO 80225
Phone: 888-ASK-USGS
Fax: 303-202-4693.

The USGS also has a very informative website at www.usgs.gov.

USGS maps can also be obtained from thousands of private dealers. A list of these can be found on the USGS website at http://rockyweb.cr.usgs.gov/acis-bin/choosebylocation.pl?statechoice=none.

The National Archives Cartographic and Architectural Branch houses millions of maps, some dating back to the 1700s. These include not only maps of the United States, but of many foreign countries as well. For information contact:

Cartographic and Architectural Branch (NWDNC)
National Archives
8601 Adelphi Road
College Park, MD 20740-6001
Phone: 301-713-7040
email: carto@arch2.nara.gov
URL: www.archives.gov.

If the map was created by U.S. government employees, check "yes" in Line 3. The map is in the public domain. Do not continue. If the map was not created by U.S. government employees, check "no" and continue to Line 4.

Map of California as an island, 1650,
Library of Congress, Geography and Map Division

D. Is the Map Eligible for Copyright Protection?

To be protected by copyright, a mapmaker's selection and arrangement of the elements that make up the map must be original and minimally creative. If the components selected to create the map are entirely obvious, the map will not be copyrightable. For example, an outline map of the United States showing the state boundaries is not copyrightable.

And a survey map of a building site that used standard cartographic conventions was not copyrightable since there was no originality used to show boundaries, zoning districts, plot lines, streets, elevations, and buildings. *Sparaco v. Lawler, Matusky & Skelly Engrs.*, 303 F.3d 460, (2d Cir. 2003).

It's far from clear what types of maps, other than simple outline maps, are so obvious as not to be protected by copyright. What may seem obvious to you may not seem so obvious to a mapmaker or publisher. See Chapter 1 for detailed guidance on how to deal with such public domain gray areas.

If the map is ineligible for copyright protection, check "no" in Line 4 of the checklist. The map is in the public domain. Do not continue. If the map is eligible for copyright protection, check "yes" in Line 4. The map as a whole is not in the public domain. Continue to Line 5 to determine if elements of the map are in the public domain.

E. Are Elements of the Map in the Public Domain?

Even if a map as a whole is not in the public domain, it will ordinarily contain many individual elements that are in the public domain and may be freely copied. These public domain elements include the following:

1. Elements Copied From Other Maps

To create a new map, a cartographer will typically use preexisting maps as a starting point. Often, U.S. Geological Survey maps are used or other maps that are in the public domain. The cartographer selects and rearranges the information on these

maps and adds new information to create a "new" map. For example, one mapmaker created real estate ownership maps by drawing the location of real estate tracts onto topographical maps obtained from the USGS. *Mason v. Montgomery Data, Inc.*, 967 F.2d 135 (5th Cir. 1992).

A mapmaker's copyright only extends to the new authorship he or she adds to the preexisting materials, not material that is borrowed or copied from previous maps. Typically, this consists of the selection, arrangement, and presentation of the component parts of the map. The preexisting materials remain in the public domain and may be freely copied.

EXAMPLE: A mapmaker created a map of an Idaho county by starting with a map prepared by the Idaho Highway Department that was in the public domain and adding to it the location and names of rifle ranges, landing strips, motorcycle and jeep trails, landmarks, and subdivisions all obtained from other sources. The resulting map was a copyrightable "synthesis," but the elements copied from the Highway Department map remained in the public domain. *United States v. Hamilton*, 583 F.2d 448 (9th Cir. 1978).

2. Place Names

The names shown on maps for cities, streets, mountains, rivers, and other geographic features are always in the public domain. This is so even if a cartographer creates

a place name. For example, a court ruled that the names a cartographer devised for over 200 lakes, streams, creeks, and tourist camps in the Sierra Nevada mountains of California were in the public domain. *Hayden v. Chalfant Press, Inc.*, 281 F.2d 543 (9th Cir. 1960).

3. Signs and Symbols and Colors

Signs, symbols, and keys used on maps cannot obtain copyright protection, even if they are original. This includes, for example, the use of particular symbols to indicate the comparative populations of cities. *Andrews v. Guenther*, 60 F.2d 555 (S.D. N.Y. 1932).

Similarly, the use of particular colors to identify topographic features is not protected by copyright. For example, one can't copyright the use of the color green to delineate a forest, blue the sea, or brown a desert.

4. Geographic Features

Geographic or topographic features are facts or discoveries that are in the public domain. Thus, no one can hold a copyright on topographic features such as the shape of the state of Florida or on the location of boundaries, cities, or roads. This applies even to geographic features newly discovered by a cartographer. For example, if a cartographer discovers a river, island, or even a new shopping mall and depicts them on a map, the name and location would not be protected by copyright.

Fictional and Humorous Maps

Are maps of fictional places in the public domain? Can anyone use the famous map drawn by author William Faulker of Yoknapatawpha County, the fictional area of Mississippi where most of his stories and novels took place? And what about the humorous maps of the late *New Yorker* Magazine cartoonist Saul Steinberg. His most famous joke map depicts the world from a New Yorker's point of view—the map presents a bird's eye view across a portion of the western edge of Manhattan (which dominates the map) and a telescoped version of the rest of the United States and the Pacific Ocean, to a red strip of horizon, beneath which are three flat land masses labeled China, Japan, and Russia.

Fictional or humorous maps receive far more copyright protection than ordinary maps that describe the real geographical world. They are more like works of art than maps. Unless they are in the public domain due to copyright expiration or lack of notice, copying such maps is not advisable. You could get sued and easily lose. This is what happened when Columbia Pictures copied many of the elements of Steinberg's New York map in a poster for the movie *Moscow on the Hudson*. Steinberg sued the movie studio for copyright infringement and won. *Steinberg v. Columbia Pictures Industries*, 663 F.Supp. 706 (S.D. N.Y. 1987).

F. Sources of Public Domain Maps

1. Libraries

Large public libraries and university libraries often have good map collections. In addition, there are a number of libraries that specialize in collecting maps. A list of weblinks to map libraries and map library organizations around the world may be found at www-map.lib.umn.edu. Another website that lists map libraries and collections is Oddens' Bookmarks at http://oddens.geog.uu.nl/main.html.

The largest map collection in the world is held by the Geography and Map Division of the Library of Congress in Washington, DC. It contains more than 4.5 million maps. The Map Division has a terrific website at http://lcweb.loc.gov/rr/geogmap/gmpage.html. It contains digital copies of many public domain maps that you can download.

The following reference books list map libraries and other cartographic resources. These are all in print or may be found in a library with a good reference section.

- *Map Collections in the United States and Canada* (Special Libraries Assn., 1985)
- *Archives and Manuscripts: Maps and Architectural Drawings,* by Ralph E. Ehrenberg (Society of American Archivists, 1982)

- *Guide to U.S. Map Resources*, David A. Cobb (Editor) (American Library Assn. Editions, 1990)
- *Scholars' Guide to Washington, D.C. for Cartography and Remote Sensing* (Smithsonian Institution Press, 1987)
- *World Directory of Map Collections* (Ifla Publications, No. 63), Lorraine Dubreuil (Editor) (K G Saur, 1993).

2. The Internet

Many public domain maps have been digitally copied and placed on the Internet. The Library of Congress website mentioned above is one example. One way to find these sites is to conduct a search with a search engine such as Google. Try using the search terms "maps" and "public domain." By far the most comprehensive list of weblinks to map sites can be found at a website called Oddens' Bookmarks. The URL is http://oddens.geog.uu.nl/main.html.

3. Private Map Dealers

Another source of public domain maps is private map dealers. Some dealers specialize in antiquarian (old) maps that are in the public domain because their copyrights have expired. A comprehensive list of private map dealers around the world can be found at the Oddens' Bookmarks website at http://oddens.geog.uu.nl/main.html. ∎

Choreography

Choreography Checklist

1. Has the choreography been fixed? (See Section A1.)
 - ☐ Yes: Continue.
 - ☐ No: Do not continue.

2. Has the choreography been published? (See Section A2.)
 - ☐ Yes: Continue.
 - ☐ No: Continue.

3. Has the copyright in the choreography expired? (See Section A3.)
 - ☐ Yes: Work is in the public domain. Do not continue.
 - ☐ No: Continue.

4. Is the choreography in the public domain due to lack of a copyright notice? (See Section A4.)
 - ☐ Yes: Work is in the public domain. Do not continue.
 - ☐ No: Continue.

5. Is the choreography eligible for copyright protection? (See Section A5.)
 - ☐ Yes: Work is not in the public domain.
 - ☐ No: Work is in the public domain.

This chapter covers all forms of chore-
ography, including ballet and modern
dance. The owner of the copyright in
a work of choreography has the exclusive
right to perform it in public or grant licenses
permitting others to do so. Such licenses
usually cost money. But once a ballet or
dance enters the public domain, anyone
can perform it without obtaining permission
from the former copyright owner. Public
domain choreography can also be freely
adapted and revised to form new dance
works.

⚠️ **Many Works That Are in the Public
Domain in the United States Are
Still Protected by Copyright Outside the
United States and Vice Versa.** This chapter
only covers the public domain in the United
States. For a detailed discussion of the
public domain outside the United States, see
Chapter 16.

A. Deciding If Choreography Is in the Public Domain

How to Use This Chapter

*To help you determine the status of a
choreographic work, we have created the
checklist at the beginning of this chapter
for you to follow. Each step is described
in the checklist and each line refers to
one or more sections listed below or to
other chapters of this book. If you have a
particular work of choreography you are*

*researching, start at Line 1 on the checklist.
As you answer each question you will be
led to the appropriate section or chapters
necessary to answer the next question on
the checklist. At the end of the process you
will know whether the choreography you
want to use is in the public domain.*

*We have also included a worksheet
(Appendix C) you may use to document
how you determined that a particular work
is in the public domain. By filling out the
sheet, you will be able to document your
research and conclusions should anyone
challenge your right to use the work.*

📖 **What If the Work Is Not in the Public
Domain?** If you find that the work
you want to use is not in the public
domain, you may be able to use it anyway
under a legal exception called "fair use"
(see Chapter 22). If you do not qualify for
this exception, you will need to obtain
permission to use the work. For a detailed
discussion of how to obtain copyright
permissions refer to *Getting Permission:
How to License & Clear Copyrighted
Materials Online & Off*, by Richard Stim
(Nolo).

1. Has the Choreography Been Fixed?

The first question you need to answer to
determine whether choreography is in the
public domain is whether or not it has been
fixed in a tangible medium of expression.

Only choreography that has been recorded in some concrete way can be in the public domain.

There are a variety of ways choreography can be fixed, including:

- on film or videotape
- written down using dance notation (the most popular forms of dance notation are Labanotation and Benesch; for a good introduction to such notation see www.dancenotation.org)
- by writing down or tape-recording a detailed verbal description
- by creating pictorial or graphic diagrams
- by using computer dance notation software programs, or
- by a combination of any of the above.

A good deal of choreography has been fixed using one of these methods. However, most choreography has never been fixed. Instead, it exists in the memories of dancers and choreographers and is passed down orally and by repetition from generation to generation.

Federal copyright law does not protect choreography that has never been filmed, written down, or otherwise fixed in a tangible medium of expression. But this does not mean that such unfixed works are in the public domain. To the extent a work is original, state copyright law—also known as common law copyright—protects unfixed choreography. Such state law protection lasts as long as the work remains unfixed; in other words, it could last forever. As a practical matter, though, it can be difficult to enforce legal rights in an unfixed work. Without a concrete record of the work (such as a film or dance notation) it can be difficult to prove the exact contents of the work. Nevertheless, such unfixed works are *not in the public domain* and using them without permission invites legal trouble.

 Seek legal advice from a copyright attorney before using an unfixed choreographic work without permission.

The remainder of this chapter covers federal copyright protection for choreography that has been fixed.

If the choreography has been fixed, mark "yes" in Line 1 of the checklist at the beginning of this chapter and continue to Line 2. If the choreography has not been fixed, mark "no" and do not continue. Obtain permission to use the work or seek legal advice.

2. Has the Choreography Been Published?

If the choreography has been fixed in a tangible medium of expression (see Section 1, above), you must then determine whether it has been published. This will determine how long the copyright in the work lasts and whether it needed a copyright notice.

A choreographic work is published for copyright purposes when the copyright owner, or someone acting on his or

her behalf, makes the work available to the *general* public. In other words, any interested member of the public may obtain a copy. *Burke v. National Broadcasting Co.*, 598 F.2d 688 (9th Cir. 1979).

For example, a choreographic work is published if it is filmed and copies of the film are offered for sale or rent to the public. Likewise, a dance that is written down in Labanotation is published if copies of the writing are made part of a dance book that is offered for sale to the public. Distributions of copies of choreographic works to limited or restricted audiences do not count as publication. For example, providing copies of dance notation to the cast of a dance group is not a publication.

If the choreography has been published, mark "yes" in Line 2 of the checklist; if not, mark "no." Continue to Line 3.

1001 Cartoon-Style Illustrations, Dover Publications

3. Has the Copyright in the Choreography Expired?

Copyright protection does not last forever. When it ends the work enters the public domain where it will forever remain. The copyright in a choreographic work expires when the copyright in the work in which it is fixed expires.

> **EXAMPLE:** If a dance has been filmed, the copyright in the dance expires when the film enters the public domain. This means, for example, that when the 1935 musical *Top Hat* enters the public domain in 2031, the famous dances it contains will also enter the public domain. Similarly, if a choreographic work has been fixed in a book of photographs, the work will enter the public domain when the book does.

Unfortunately, determining whether a copyright has expired can be somewhat complex. You need to determine which of several possible copyright terms apply to the work in question. Choreography published as recently as 1963 could be in the public domain. On the other hand, choreography created over 100 years ago (and more) could still be protected by copyright.

The copyright terms are the same no matter what type of work is involved (writings, music, art, etc.). They are discussed in detail in Chapter 18. Turn to that chapter to determine whether the copyright in a work you're interested in has expired.

⚠ Beware the Right of Publicity. If a film or photograph of a dance enters the public domain, you may copy the dance steps, but this doesn't mean you may freely copy a film or picture of the dancers. Doing so may violate their right of publicity if the photo or film is used for advertising or other commercial purposes. For example, you can't use a photo of Fred Astaire to advertise a product even if the photograph is in the public domain (See Chapter 20).

If the copyright in the work has expired, mark "yes" in Line 3. The work is in the public domain. Do not continue. If the copyright has not expired, mark "no" and continue to Line 4.

4. Is the Choreography in the Public Domain Due to Lack of a Copyright Notice?

Copyright expiration is not the only way choreography may enter the public domain. Choreography published in the United States before 1989 had to contain a copyright notice—the familiar "c" in a circle © or the word Copyright or abbreviation Copr., publication date, and name of copyright owner. Choreography published without such a notice could be in the public domain.

Examine the work carefully—whether a book, article, movie, video, or work in which the choreography has been fixed.

If the work lacks a copyright notice or if the notice lacks one of the three elements described above (copyright symbol or word, publication date, copyright owner's name) it could be in the public domain. Read Chapter 19 for detailed guidance on how to determine whether a published work is in the public domain because it lacks a valid copyright notice.

If the choreography has never been published, it needs no notice and you need not read Chapter 19.

If you determine that the choreography is in the public domain because it was published without a copyright notice, mark "yes" in Line 4. Do not continue. If the choreography has a notice or the lack of notice is excused, mark "no" and continue to Line 5.

5. Is the Choreography Eligible for Copyright Protection?

Not all choreography is protected by copyright under either federal or state law. For example, choreography copied from previous public domain choreographic works is not protected.

EXAMPLE: Serge, a modern dance choreographer, finds a little-known modern ballet described in Labanotation in a book published in 1928. The book and the ballet it describes are in the public domain because the copyright

expired. Serge copies the ballet step-for-step and claims credit for the "new" ballet. The ballet is later published in a written collection of Serge's works. However, because Serge copied the ballet from a public domain work, the ballet cannot be protected by copyright. It is in the public domain.

In addition, social dance steps and simple routines do not have copyright protection. Thus, for example, the basic waltz step, the hustle step, basic classical ballet movements —such as the second position—cannot be protected by copyright. Social dance steps, folk-dance steps, and individual ballet steps may be utilized as the choreographer's basic material in much the same way that words are the writer's basic material. *Horgan v. MacMillan*, 789 F.2d 157 (9th Cir. 1986).

If you determine the work is not eligible for copyright protection, mark "no" in Line 5. The work is in the public domain. If the work is eligible for protection, mark "yes." The work is not in the public domain. Do not continue.

For a detailed discussion by a dance expert of what elements of choreography are copyrightable, refer to the article "Copyright of Choreographic Works," by Julie Van Camp, published in *1994-95 Entertainment, Publishing and the Arts Handbook*, edited by Stephen F. Breimer, Robert Thorne, and John David Viera (Clark Boardman Callaghan). This article may be downloaded from the World Wide Web at www.csulb.edu/~jvancamp/copyrigh.html.

B. Sources of Public Domain Choreography

Collections of choreographic materials may be found in university libraries, some outstanding public libraries, and in many special performing arts libraries.

The nation's leading repository of choreography materials is the Jerome Robbins Dance Division of the New York Library for the Performing Arts located at:

40 Lincoln Center Plaza
New York, NY 10023-7498
212-870-1657
www.nypl.org/research/lpa/dan/dan.html.

This is the largest dance archive in the world. It holds over 30,000 reference books and over 10,000 films on all forms of dance.

The Internet Archive has digitally copied over 200 public domain dance manuals and made them available for free on its website (www.archive.org/texts/danceman.php). ∎

Databases and Collections

This chapter is about a special type of work of authorship: what the copyright law refers to as a "compilation." This is a work that is created by collecting data or materials that already exist.

There are two types of compilations:

- Raw data or facts—for example, a list of names, addresses, and phone numbers in a phone book. These are called databases.
- A collection of works of authorship, such as a collection of short stories, drawings, or photographs. These are called collections.

As you can imagine, there are millions of databases and collections. As this chapter explains in detail, such works can receive limited copyright protection if a minimal amount of creativity was required to create them. But many databases and collections fail the creativity requirement and receive no copyright protection at all. However, those databases and collections that are not copyrighted are not always freely available, because the people who created them may attempt to use means other than copyright law to protect them, such as licenses, trade secrecy, or encryption.

Part I covers databases and Part II covers collections.

It is possible for a database or collection to be in the public domain in the United States but protected by copyright in a foreign country, and vice versa. This chapter only covers the public domain in the United States. If you want to know whether a work is in the public domain outside the United States, see Chapter 16.

Part I. Databases

Database Checklist

1. Is the work a database? (See Section A.)

 ☐ Yes: Continue.

 ☐ No: You are reading the wrong section. See Part II.

2. Does the database lack creativity? (See Section B.)

 ☐ Yes: Skip to line 6.

 ☐ No: Continue.

3. Was the database created by the U.S. government? (See Section C.)

 ☐ Yes: Skip to line 6.

 ☐ No: Continue.

4. Has the copyright expired? (See Section D.)

 ☐ Yes: Skip to line 6.

 ☐ No: Continue.

5. Is the database in the public domain for lack of a copyright notice? (See Section E.)

 ☐ Yes: Continue.

 ☐ No: Database's selection and arrangement is protected by copyright.

6. Is the database protected by a means other than copyright? (See Section F.)

 ☐ Yes: Use may be prohibited or restricted.

 ☐ No: Database may be freely used.

When a database is in the public domain and not protected by the other legal restrictions discussed in this chapter, you can use the data it contains in any way you want without obtaining permission from the person or entity that originally created the database—permission that often must be paid for. You can use the data to create and publish your own database or use it in any other way you desire. For example, you can take U.S. State Department statistics about worldwide terrorism and write your own article, book, or report on terrorism and even sell it at a profit. You could even post these statistics on your website to warn overseas travelers about dangerous destinations. (Most U.S. government databases are in the public domain; see Section C.)

Unfortunately, determining which databases are and are not protected can require that you navigate a complex legal maze. For a variety of reasons explained below, many databases are not protected by copyright at all; and, even where copyright protection is available, it is extremely limited. As a result, database creators and owners frequently resort to other means to protect their works, including using licenses. The extent to which these other means of protecting databases are legally effective is not always clear.

However, it is clear that database owners have become increasingly aggressive in asserting ownership claims in their data. For example, *The New York Times* sued the online bookseller Amazon.com when it began posting the *Times's* weekly list of best-selling books on its website. The case was settled when the *Times* agreed that Amazon could post the list in alphabetical order, rather than by sales volume.

As a result, you should exercise caution before you copy any database. If you're not sure it is in the public domain, seek legal advice.

How to Use Part I

To help you determine the copyright status of a database, we have created the checklist at the beginning of this chapter for you to follow. Each step is described in the checklist and each line refers to one or more sections listed below or to other chapters of this book. If you have a particular work you are researching, start at Line 1 on the checklist. As you answer each question you will be led to the appropriate section or chapters necessary to answer the next

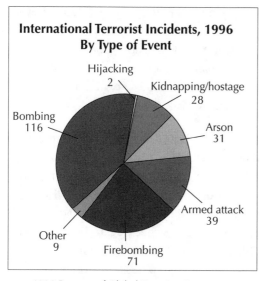

International Terrorist Incidents, 1996 By Type of Event

Hijacking 2
Kidnapping/hostage 28
Bombing 116
Arson 31
Armed attack 39
Other 9
Firebombing 71

1996 Patterns of Global Terrorism Report,
U.S. State Department

question on the checklist. At the end of the process you will know whether the database you want to use is in the public domain.

We have also included a worksheet (Appendix C) you may use to document how you determined that a particular work was in the public domain. By filling out the sheet, you will be able to document your research and conclusions should anyone challenge your right to use the work.

What If the Work Is Not in the Public Domain? If you find that the database you want to use is not in the public domain, you may be able to use it (or at least part of it) anyway under a legal exception called "fair use" (see Chapter 22). If you do not qualify for this exception, you will need to obtain permission to use the work. For a detailed discussion of how to obtain copyright permissions refer to *Getting Permission: How to License & Clear Copyrighted Materials Online & Off*, by Richard Stim (Nolo).

A. Is the Work a Database?

A database (also known as a fact compilation) is a work created by selecting and arranging facts. "Data" is just a fancy word for facts. The facts in a database can take any form—for example, they can consist of numbers, names, dates, addresses, or just about anything else.

EXAMPLE: Cynthia Powell, a romance novel fan in Michigan, created a website called the Romance Novel Database. Here she lists 244 romance novels and rates them by quality—five hearts is best, one heart is worst. Cynthia's website is a database consisting of 244 facts—the names of 244 romance novels—unprotected by copyright. You can view the list at www-personal.umich .edu/~sooty/romance.

EXAMPLE: Key Publications, a publisher of phone book Yellow Pages, compiles a Yellow Pages directory for New York City's Chinese-American community. Key selects which businesses qualify for inclusion in its Yellow Pages and arranges the directory into categories such as Accountants, Shoe Stores, and Bean Curd & Bean Sprout Shops. Key's Yellow Pages are a database consisting of hundreds of public domain facts— the names, addresses, and phone numbers of Chinese-owned businesses in New York City.

You probably create databases all the time. For example, your personal rolodex or other list of phone numbers you frequently call is a database. So is a shopping list, Christmas card list, daily "to do" list, list of appointments, or checking account register. Other types of databases include such works as bibliographies, directories, price lists, real estate and stock listings, listings of scientific data, and catalogues of all types.

Prior to the computer age, databases typically took the form of a list or a paper card system or file. With the advent of computer technology, traditional hard copy databases have been largely eclipsed in importance by electronic databases. These may be accessed on the Internet, via online subscription services like Nexis and Dialog, or are available on computer CD-ROMs.

1. Limited Copyright Protection for Databases

Databases receive limited copyright protection. All that is protected is the *selection and arrangement* of the material making up the database, *not the preexisting material itself*. This is sometimes referred to as a thin copyright.

For example, the only protected element of Cynthia's romance novel list mentioned in Example 1 above is her selection and arrangement of the names of the novels in her catalogue. Cynthia had to employ creativity and judgment in deciding which of the thousands of romance novels in existence belonged on her list of 244 novels and in deciding what rating each novel should receive. The exercise of this creativity and judgment is the type of authorship that can obtain copyright protection.

When we speak of a database as being in the public domain, we mean that—for one reason or another—the particular selection and arrangement is not protected by copyright. As explained below, the raw

facts contained in a database can never be copyrighted, but might be protected by other means.

2. Raw Facts in Databases Not Protected by Copyright

Since the copyright in a database extends only to the selection and arrangement of the facts, the raw facts or data themselves are never protected by copyright. The U.S. Supreme Court has stated that the raw facts may be copied at will without violating the copyright law. This means that a database creator is free to use the facts contained in an existing database to prepare a competing database. *Feist Publications, Inc. v. Rural Telephone Service Co.*, 111 S.Ct. 1282 (1991). But, the competing work may not feature the same selection and arrangement as the earlier database and must be minimally creative.

> **EXAMPLE:** A website called Who's Alive and Who's Dead (www.whosaliveandwhosdead.com) contains the birth and—where applicable—death dates for over 1,700 celebrities, political figures, sports stars, and others. This information is organized in a variety of interesting ways. For example, you look up your favorite television show and see when the cast members were born and if any are dead. This website is a simple database. The creators of this database are entitled to copyright protection for the way they have

selected and arranged the material on their website. However, they do not have a copyright in the individual facts in their database—meaning they don't own the birth and death dates of celebrities. These facts are not protectable by copyright. Anyone writing an article or book about a celebrity can look up his birth date in the database and use that date in the article or book without obtaining permission from the creators of the database. There is no need to go back to the original sources the database's creators used to compile their database, such as newspaper obituary records or government records of births and deaths.

It may seem unfair that the facts contained in a database gathered at great trouble and expense may be used by others without violating the copyright laws. However, the purpose of copyright is to advance the progress of knowledge, not to enrich authors. If the first person to compile a group of raw facts acquired a monopoly over them, progress would be greatly impeded. This might not seem so serious if we were only talking about birth and death dates of celebrities. But many databases contain far more vital information that no one should be allowed to monopolize.

But, don't get the idea that raw facts in databases may always be freely copied. Database owners often try to use laws other than copyright to prevent the public from doing just that. (See Section F below.)

Opinions Are Not Facts

Facts themselves cannot be protected by copyright. This is particularly true for numerical or statistical data. However, some things you might think are facts in the public domain really aren't. At least that's what two federal appellate courts have held. These cases involved copying of databases containing pricing data. In one case, someone copied the price quotations in coin dealer newsletters. In the other, the prices for used cars listed in a used car price guide called the *Red Book* were copied. In both cases, the courts held that the individual price quotations involved were copyrighted because they were entirely subjective— they were simply estimates devised by the publishers of the guides. They represented the publishers' *opinions* of what the coins and used cars were worth, not what someone actually paid for them. The courts held that sufficient creativity was required to devise these estimates for them to be protected by copyright. *CCC Info. Servs., Inc. v. Maclean Hunter Mkt. Reports*, 44 F.3d 61 (2d Cir. 1994); *CDN Inc. v. Kenneth A. Kapes*, 197 F.3d 1256 (9th Cir. 1999).

If you have determined that the work you're interested in is a database, check "yes" in the checklist at the beginning of this chapter and continue to Line 2. If the work is not a database, check "no."

Turn to Part II below to see if the work is a collection. If not, do not continue reading this chapter.

B. Does the Database Lack Creativity?

A work of authorship must be the product of a minimal amount of creativity to be protected by copyright. This requirement applies to databases as well as all other work. The amount of creativity required for a work to be protected by copyright is very small. A work need not be novel, unique, ingenious, or even any good to be sufficiently creative for copyright purposes. It need only be the product of a very minimal creative spark.

Most types of works easily satisfy the creativity requirement. However, many databases don't make the grade. The data contained in a database need not be presented in an innovative or surprising way, but the selection or arrangement cannot be so mechanical or routine that it requires no creativity at all. If no creativity was employed in selecting or arranging the data, the database is not eligible for copyright protection—that is, the selection and arrangement of the data will be in the public domain as well as the data itself. This selection and arrangement may be copied freely unless it's protected through a means other than copyright (see Section F).

In a landmark decision on databases, the U.S. Supreme Court ruled that the selection and arrangement of white pages in a typical telephone directory fails to satisfy the creativity requirement and is therefore not protected by copyright. The selection wasn't creative because the compiler of the phone book included all the residents and businesses in the geographic area covered. No selectivity was needed to do this. The arrangement wasn't creative because the phone book was arranged alphabetically. Alphabetizing a list of names and phone numbers is a purely mechanical act—that is, you just follow the alphabet. *Feist Publications, Inc. v. Rural Telephone Service Co.*, 111 S.Ct. 1282 (1991). There are doubtless many other types of databases that are in the public domain for the same reason.

To tell if a database is sufficiently creative to be protected by copyright, you need to answer two questions:

1. Is the *arrangement* of the data minimally creative?
2. Is the *selection* of the data minimally creative?

A database is eligible for copyright protection if either the selection or arrangement is minimally creative. Of course, many databases satisfy both criteria.

1. Is the Arrangement of the Data Creative?

Famed "information architect" Richard Saul Wurman, in his book *Information Architects*, points out that there are only six ways to arrange data. You may use:

- location
- alphabet
- time
- number
- category, or
- hierarchy.

Common sense tells us that of these six methods only location, category, and hierarchy can require minimal creativity and can be protected by copyright. No creativity is involved in arranging a database by alphabet, time, or number. These types of organization are purely mechanical—that is, they require no exercise in judgment. You just have to know the alphabet, how to tell time, or count to arrange a database by these methods.

2. Is the Selection of the Data Creative?

The selection of the data in a database satisfies the minimal creativity test only if the compiler has:

- chosen less than all of the data in a given body of relevant material, regardless of whether it is taken from one or more sources, and
- the selection is based on the compiler's opinion about something.

For example, no selectivity is required to compile a directory of *all* the restaurants in New York City. The compiler of such a directory need not employ any judgment in deciding which restaurants belong in the directory.

But a list of the 100 "best" restaurants in New York City is minimally creative and protected by copyright. Here, the compiler must use selectivity and judgment to decide which 100 of the thousands of restaurants in New York City are "best."

3. Examples of Databases That Lack Creativity

Representatives of the Copyright Office have indicated that, in their view, the following types of databases will usually fail to satisfy the minimal creativity requirement. The Copyright Office's views don't have the force of law, but the courts likely would follow them.

- **Street address directories, alumni directories, membership lists, mailing lists, and subscriber lists.** Works such as these often require no more creativity to compile than the white pages in a phone book. This would be the case where (1) the material is arranged in alphabetical or numerical order, and (2) no judgment was needed to decide which names and addresses should be included.

EXAMPLES: An alphabetical list of all Harvard alumni, all the members of the ACLU, or all the subscribers to *Time* Magazine; a mailing list in numerical order according to zip code of all persons who have contributed more than $1,000 to the Republican Party.

- **Parts lists.** An alphabetical or numerical list of all the parts in a given inventory clearly fails the creativity test: If the list is exhaustive, no selectivity is required to compile it; if it is arranged in alphabetical or numerical order, no creativity is required to arrange it.

- **Genealogies.** A genealogy (that is, a table or diagram recording a person's or family's ancestry) consisting merely of transcriptions of public records, such as census or courthouse records, or transcriptions made from headstones in a few local cemeteries, are also deemed by the Copyright Office to lack minimal creativity. On the other hand, the creativity requirement may be satisfied where the creator of a genealogy compilation uses judgment in selecting material from a number of different sources.

Humorous Office Spot Illustrations, Dover Publications

- **De minimis compilations.** De minimis in Latin means trifling or insignificant. A de minimis compilation is one that contains only a few items. The Copyright Office considers a compilation of only three items to be clearly de minimis and not protected by copyright. Even if a de minimis compilation meets the minimal creativity requirement, the Copyright Office will refuse to register it. This means the compiler can't file a copyright infringement suit if anyone else uses their list of three or fewer things.

⚠️ **Beware of Databases Containing Protected Authorship.** A database author may add additional material to a database that is protected by copyright. If such material is included throughout a database, it will be much more difficult and risky to copy the entire work or large chunks of it. By doing so, you would be copying not only unprotectable facts but the protected expression in the database as well.

EXAMPLE: Robert compiles a bibliography containing the titles, authors, and publishers of every book published in the United States on the Civil War (about 50,000 in all). The bibliography is simply in alphabetical order and lists every work in its category, so it probably lacks sufficient creativity to be protected by copyright. However, Robert also includes an introduction and annotates

some of the selections with explanatory notes. Both the introduction and notes constitute expression that can be protected by copyright. Thus, if someone copied the entire bibliography they would be copying protected authorship, and therefore committing copyright infringement. Of course, anyone could still copy the individual bibliographic entries so long as they left the protected authorship alone.

If you determine that the database lacks creativity, it is in the public domain. Check the "yes" box in Line 2. The database may be freely used unless it is protected by a means other than copyright. Skip to Line 6. If the database is sufficiently creative to be copyrighted, check the "no" box and continue to Line 3.

C. Was the Database Created by the U.S. Government?

Most U.S. Government databases are in the public domain. U.S. government employees and contractors have compiled millions of databases on nearly every conceivable subject. Many of these databases can be accessed through the Internet. For example:

- all types of population data can be found at the U.S. Census Bureau website at www.census.org
- statistics on all aspects of the U.S. education system can be found at the

Department of Education website at www.ed.gov
- statistics on crime and the justice system can be found at a Department of Justice website at www.ojp.usdoj .gov/bjs.

The U.S. government has created a Web portal (www.firstgov.gov) containing links to its many websites.

Most of these and other U.S. government databases are in the public domain—that is, not just the data itself, but the selection and arrangement of the database, is free for the taking.

For example, you can take Census Bureau statistics about population growth in the United States selected and arranged by state, race, education, and many other ways and write your own report on U.S. population growth and even sell it at a profit. If your selection and arrangement is minimally creative, you may even claim a copyright in your database, even though all the data came from a public domain source. You cannot, however, prevent others from using the public domain data.

However, the material in U.S. government databases is not always freely available. Some of it may be copyrighted in the United States, it might be copyrighted outside the United States, or there may be other legal restrictions on its use. Government databases ordinarily contain warning statements or lists of terms and conditions of use describing any limitation on use of the database. You need to read these carefully.

1. Copyrighted Materials in Government Databases

Some material on U.S. government databases has been created by outside contractors and is copyrighted by them. For example, the U.S. Department of Commerce National Technical Information Service (NTIS) maintains the AGRICOLA Database, which contains over 3,300,000 citations to journal articles and other materials related to agriculture. Some of the material in the AGRICOLA Database is copyrighted. The Database contains the following statement:

You understand that these databases may contain copyrighted material. You may not publish, distribute, broadcast,

retransmit, sell or otherwise reproduce any copyrighted item to anyone in any media, or create a derivative product, without the permission of the copyright owner.

Similarly, a database containing millions of citations to medical articles maintained by the United States National Library of Medicine (NLM) contains a warning that states:

Some material in the NLM databases is from copyrighted publications of the respective copyright claimants. Users of the NLM databases are solely responsible for compliance with any copyright restrictions.

Countries Ranked by Population: 2000

Rank	Country	Population	Rank	Country	Population
1	China	1,261,832,482	6	Russia	146,001,176
2	India	1,014,003,817	7	Pakistan	141,553,775
3	United States	275,562,673	8	Bangladesh	129,194,224
4	Indonesia	224,784,210	9	Japan	126,549,976
5	Brazil	172,860,370	10	Nigeria	123,337,822

Note: Data updated 05-10-2000.
Source: U.S. Census Bureau, International Data Base.

2. Copyright Claims Outside the United States

While works created by U.S. government employees are always in the public domain in the United States, the U.S. government is legally entitled to claim copyright outside the United States if the foreign country involved allows government materials to be copyrighted under its own laws. For example, the U.S. government may claim copyright protection for its materials in Canada or Great Britain because their laws provide copyright protection for most government works.

Ordinarily, the United States does not assert such claims, but it has for some of its databases. For example, the AGRICOLA Database mentioned above contains a statement that states:

With respect to the database as a whole, outside the United States, NTIS reserves all copyright protections under applicable law and treaty.

If the U.S. government claims copyright protection for a database outside the United States, you will have to get government permission to use it in a foreign country. You could be sued if you do not obtain permission.

3. Privacy and Security Limitations

Many U.S. government databases contain sensitive information that is not made publicly available—for example, databases maintained by the Department of Defense or the Department of Health and Human Services. Privacy and national security laws and regulations may prevent the data in such databases from being disseminated.

4. U.S. Department of Commerce Databases

The U.S. Department of Commerce runs something called the Standard Reference Data Program. This program creates publications and databases of technical data regarding metals, chemicals, industrial fluids and materials, and similar items for solving technical problems, research, and development by scientists and engineers. The Commerce Department is allowed to claim a copyright in such standard reference data so it can sell it and help earn extra income to support its programs. 15 U.S.C. Section 290(e).

5. State and Local Databases

In addition, databases created by state and local government agencies are entitled to copyright protection if a minimal amount of creativity is evident. Thus, for example, a list compiled by your state department of fish and game about the places to catch fish can be copyrighted if minimally creative.

Private Databases Containing U.S. Government Materials

Many private publishers and other companies maintain and sell to the public databases that contain U.S. government data. These private companies may claim copyright protection for their selection and arrangement of the data in their databases if it is minimally creative, as described in Section B above. However, they often also require users to agree to licenses restricting how they may use the data. By using these licenses, they attempt to obtain far more legal protection for their databases than can be obtained under the copyright law. Whether these licenses are legally enforceable is unclear; see Section F1 below.

If the database was created by the U.S. government, check "yes" in Line 3. The database is in the public domain. The database may be freely used unless it is protected by a means other than copyright. Skip to Line 6. If the database was not created by the U.S. government, check "no" and continue to Line 4.

D. Has the Copyright in the Database Expired?

Like any other work of authorship, a database enters the public domain when its copyright expires, at which time its selection and arrangement no longer receives copyright protection. Databases published as recently as 1963 could be in the public domain due to copyright expiration.

Copyright duration rules are discussed in detail in Chapter 18. But before you can know whether a database's copyright has expired, you must first determine whether it has been published. This is because published and unpublished works receive very different copyright terms.

A database is published for copyright purposes when the copyright owner—or someone acting on his or her behalf—makes one or more copies of the work available to the *general* public. In other words, any interested member of the public may obtain a copy. *Burke v. National Broadcasting Co.*, 598 F.2d 688 (9th Cir. 1979).

The copies don't necessarily have to be sold for a publication to occur—they can also be leased or rented, loaned, or even given away. For example, a telephone directory is published when it is given away to customers. Nor is it necessary for large numbers of copies to be distributed. So long as the work has been made freely available to the general public, it makes no difference if just one copy has been sold or distributed. *Gottsberger v. Aldine Book Publishing Co.*, 33 Fed. 381 (C.C.D. Mass. 1887).

Obviously, a database has been published if copies were made and offered for sale to the general public in bookstores, through mail order, or by any other means of public distribution. In contrast, a publication

does not occur where copies are limited to a definitely selected group of people for a limited purpose without the right of further reproduction, distribution, or sale. For example, a customer list distributed to the sales employees of a company for marketing purposes, but carefully kept secret from the general public, would not be considered published.

Once you have determined the publication date, you should refer to Chapter 18 to determine if and when the database has entered the public domain.

If you determine that the copyright in the database has expired, check "yes" in Line 4. The database may be freely used unless it is protected by a means other than copyright. Skip to Line 6. If the copyright has not expired, check "no" and continue to Line 5.

E. Is the Database in the Public Domain for Lack of a Copyright Notice?

If the database was never published, it doesn't need a copyright notice. You don't need to read any more of this section. Go on to Section F.

If a database was published before 1989, it could be in the public domain if it lacks a copyright notice. Examine the database carefully to determine if it has a notice.

A copyright notice on a database must contain three elements—the familiar © symbol or the word Copyright or abbreviation "Copr.," the publication date, and name of copyright owner—for example: © DataBest, Inc. 1975.

If the database has a notice in the format described above, you can forget about it being in the public domain for lack of a notice. There is no need to read Chapter 19, which explains copyright notice requirements in detail. Go on to Section F below.

However, if the database has no notice or if the notice lacks one of the three elements described above (copyright symbol © or word Copyright, publication date, copyright owner's name), it could be in the public domain. Read Chapter 19 for detailed guidance on how to determine whether a published work is in the public domain because it lacks a valid copyright notice.

If you determine that the database is in the public domain because it lacks a copyright notice, check "yes" in Line 5 of the checklist. The database may be freely used unless it is protected by a means other than copyright. Continue to Line 6. If the database has a notice or the lack of a notice was excused, check "no" in Line 5. The selection and/or arrangement of the data in the database is copyrighted. Continue to Line 6 to see if the database is protected by other legal means as well.

F. Is the Database Protected by Means Other Than Copyright?

Given the limitations on copyright protection for databases and the fact that many databases don't qualify for any protection at all, the owners of valuable databases often try to use other ways to protect their creations. These means are used not only to protect the selection and arrangement of the data, but the data itself.

1. Licenses

A database license is a contract restricting what a person can do with the data. These licenses are commonly used to protect databases that are not made freely available to the public. People who use the database must agree in advance to the terms of the license.

Database licenses take many forms. Some are form contracts, while others are negotiated agreements tailored to particular individuals or institutions. They may appear in traditional print form, under the shrink-wrapping of a computer disk or CD-ROM, on a computer screen as part of software, online, or in a combination of these formats.

The terms of database licenses also vary, but they generally restrict or limit how the database can be used. For example, an online license typically dictates when the database can be downloaded or disseminated to others. These restrictions put limits on a user's ability to use the contents of the database beyond what copyright law allows.

Licenses also usually establish enforcement procedures and remedies should the licensee violate the terms of the license. Such terms can include terminating a subscriber's access, suspending services, or suing the subscriber for damages.

a. Are Licenses Legally Enforceable?

Many database owners resort to licenses when their databases cannot be protected by copyright law because they do not meet the standards for copyright protection outlined earlier in this chapter. In other words, they are probably in the public domain. It is not entirely clear whether a license can be used to restrict access to public domain data. Several courts have permitted it.

However, if you sign a licensing agreement, you must be aware that the owner of a database can sue you if you violate the license. This is true even if the material you use is in the public domain. Even if you win in court the legal expenses could be ruinous. And it's also possible you could lose.

> **EXAMPLE:** Matthew Zeidenberg purchased from a company called ProCD a CD-ROM containing a database of 95 million business telephone listings. This database was not entitled to any copyright protection at all because there was nothing even minimally creative about the selection or arrangement of the listings. ProCD simply took the contents of 3,000 telephone alphabetical directories and

placed them on a CD-ROM. However, when Zeidenberg loaded the CD-ROM onto his computer, he was required to agree to a "click-wrap" license agreement obliging users to agree to certain restrictions before they could access the data on the disk. For example, the license barred purchasers of the CD-ROM from copying, adapting, or modifying the listings. Zeidenberg agreed to the license terms, but then went ahead and violated them by copying the listings and placing them on his website where they were sold to the public for far less than ProCD charged. ProCD sued Zeidenberg for violating the license agreement and won. The court held that the license restrictions were legally enforceable even though the listings were in the public domain. *ProCD v. Zeidenberg*, 86 F.3d 1447 (7th Cir. 1996).

(See Chapter 2 for more on the legal enforceability of licenses.)

b. The Privity Limitation

An important limitation of database licenses is the legal requirement of privity. A license (or any other contract) is enforceable only against a person who signs it or otherwise agrees to it. People who don't agree to it are not legally bound by it.

> **EXAMPLE:** Applied Technologies of Wisconsin created a computer program, Market Drive, to help Wisconsin county assessors' offices compile real estate data, such as property addresses and the names of the owners, in an electronic database. The counties used the data for tax assessment purposes. Applied required the counties to license Market Drive from it; the license forbade them from releasing the raw data in the database created with Market Drive to others, even though this raw data was in the public domain. A company called WIREdata attempted to obtain the raw data from the counties to create its own database for use by real estate brokers. A court held that Applied could not sue WIREdata for violating the license because it had never signed it, only the Wisconsin counties had. Applied could only sue WIREdata for copyright infringement, but this suit failed because the raw data WIREdata wanted was public domain. *Applied Technologies of Wisconsin v. WIREdata, Inc.*, 2003 U.S. App. LEXIS 23938 (7th Cir. 2003).

So, if you can obtain access to a database without signing a license, you can't be sued for violating the license. Unfortunately, this may be difficult or impossible to do in many cases.

2. Trade Secrets

We've seen above that databases get extremely limited copyright protection or, in many cases, none at all. For this reason,

database owners often attempt to use state trade secrecy laws to protect their works. For example, computer databases that are maintained by companies on their internal —that is, nonpublic—computer networks are usually protected as trade secrets. This form of legal protection may be used to supplement copyright protection. If the database cannot be protected by copyright, it may be the owner's main line of defense against unauthorized use.

a. What Is a Trade Secret?

A trade secret is information that is not generally known in the business community and that provides its owner with a competitive advantage in the marketplace. This can, and often does, include information in databases such as customer lists, formulas, and technical data of all kinds.

If a trade secret owner takes reasonable steps to keep the confidential information secret, the courts will protect the owner from unauthorized disclosures of the secret to others by:

- the owner's employees
- other persons with a duty not to make such disclosures, such as nonemployees who work for the company and people who sign nondisclosure agreements promising not to disclose the secret
- industrial spies, and
- competitors who wrongfully acquire the information such as through theft or bribery.

This means that the trade secret owner may be able to sue the person who stole or disclosed the secret and obtain an injunction (a court order preventing someone from doing something, like stealing or disclosing trade secrets) and damages. However, the trade secret owner must truly take steps to preserve the trade secret; the more widely known a trade secret is, the less willing the courts are to protect it.

b. Databases That Are Trade Secrets

Not everything can be a trade secret. The database owner must take reasonable steps to keep the data in the database secret—for example, carefully restrict access by keeping it in a password-protected computer system. Databases that are published or otherwise made available to the public cannot be protected as trade secrets; nor can databases that contain information that is generally known in the industry involved. Data that everybody knows cannot provide anyone with a competitive advantage. However, the information in a database need not be novel or unique to qualify as a trade secret. All that is required is that the information not be generally known by people who could profit from its disclosure and use.

c. Do You Have a Duty of Confidentiality?

Generally, it is very easy for you to know whether you might run afoul of someone's trade secret rights if you copy or otherwise use a database. First, the company or

person who developed it must keep the database secret. In addition, your use or disclosure of the data must constitute a breach of an obligation to keep the material confidential. Such a confidential obligation may arise because you work for the person or company that developed the database. Or, you agreed not to disclose it—for example by signing a nondisclosure agreement. Or you must have improperly learned or obtained the data from someone else who had a duty not to disclose it. For example, you obtained a company's idea for a new product by bribing an employee of the company or by theft.

3. Encryption

Another form of protection for electronic databases is encryption—that is, encoding the data in an unreadable form that can be "unlocked" and read only with the proper key. This is not a legal protection, but it makes it difficult or impossible to obtain access to a database, even if it is in the public domain. The government has been encrypting its sensitive data for years. Powerful encryption technologies that can prevent unauthorized access to and changes in databases are now commercially available. Moreover, recent changes to the copyright laws generally make it illegal for anyone to obtain access to a database or other work by circumventing technological measures such as encryption.

The use of encryption technologies may make it impossible for you to obtain access

to many databases that are in the public domain. And there may be nothing you can do about it.

If the database is protected by a means other than copyright, check "yes" in Line 6 of the checklist. Your use of the database may be restricted or prohibited. You must determine if this is the case. If the database is not protected by means other than copyright *and* is not protected by copyright, it may be freely used.

Enigma Coding Machine. During World War II, the Germans developed the Enigma, an electromechanical cipher machine, to send coded messages. There were 150,000,000,000,000,000,000 possible solutions. The Allies were eventually able to crack its code and intelligence from the decoded German messages helped the Allies to win the war. Online CIA Exhibit Center (www.cia.gov/cia/information/artifacts/enigma.htm)

Part II: Collections of Public Domain Works

Collection Checklist

1. Is the work a collective work? (See Section A.)

 Yes: Continue.

 No: You are reading the wrong chapter. If the work is a database, see Part I.

2. Does the collection lack creativity? (See Section B.)

 Yes: Collection is in public domain. Skip to line 6.

 No: Continue.

3. Is it a de minimis collection? (See Section I.)

 Yes: Collection is in public domain. Skip to line 6.

 No: Continue.

4. Was the collection created by the U.S. government? (See Section J.)

 Yes: Collection is in public domain. Skip to line 6.

 No: Continue.

5. Has the collection's copyright expired? (See Section K.)

 Yes: Collection is in public domain. Skip to line 6.

 No: Continue.

6. Is the collection in the public domain for lack of a copyright notice? (See Section L.)

 Yes: Collection is in public domain. Continue.

 No: Collection's selection and arrangement is protected by copyright. Do not continue.

7. Is the collection protected by a means other than copyright? (See Section M.)

 Yes: Continue.

 No: Collection may be freely used.

Publishers and others are constantly collecting and republishing public domain materials. This includes, for example, collections of public domain fiction and poetry, drawings and other artwork, photographs, and sheet music. Often, a public domain work is readily accessible only because it has been republished (or published for the first time) as part of such a collection.

Collections of preexisting works of authorship are called "collective works" by the copyright law. But, for the sake of convenience, we'll refer to them simply as collections. Collections differ from databases because they are created from works of authorship, such as writings, while databases are created from facts or data.

Good examples of collections are news-papers, magazines, and other periodicals in which separate articles are combined into a collective whole. However, the preexisting material in a collection can consist of any work of authorship, including any type of writing, music, photographs, or drawings or other artwork.

Copyright notices are routinely included on such collections. However, it's important for you to understand that copyright protection for collections of public domain materials is extremely limited, if it is available at all.

How to Use Part II

To help you determine the copyright status of a collection, we have created a checklist for you to follow. Each step is described in the checklist and each line refers to one or more sections listed below or to other chapters of this book. If you have a particular work you are researching, start at Line 1 on the checklist. As you answer each question you will be led to the appropriate section or chapters necessary to answer the next question on the checklist. At the end of the process you will know whether the collection you want to use is in the public domain.

We have also included a worksheet (Appendix C) you may use to document how you determined that a particular work was in the public domain. By filling out the sheet, you will be able to document your research and conclusions should anyone challenge your right to use the work.

What If the Work Is Not in the Public Domain? If you find that the collection you want to use is not in the public domain, you may be able to use it (or at least part of it) anyway under a legal exception called "fair use" (see Chapter 22). If you do not qualify for this exception, you will need to obtain permission to use the work. For a detailed discussion of how to obtain copyright permissions refer to *Getting Permission: How to License & Clear Copyrighted Materials Online & Off,* by Richard Stim (Nolo).

G. Are the Collected Materials in the Public Domain?

The first question you must answer to determine whether a collection is in the public domain is whether the works of authorship gathered together to create the collection are themselves in the public domain. When public domain materials are used, the author of the collection does not need to obtain permission to use them and neither do you. Here are some real examples of collections consisting of public domain materials:

- Fourteen public domain short stories culled from the over 60 the author Frank Norris published during his lifetime were published together by Ironweed Press under the title *The Best Short Stories of Frank Norris*. Each story is a separate and independent work. However, Ironweed has created a new copyrighted collection by selecting and arranging the stories into a collective whole—that is, a collection of the best short stories of Frank Norris.
- The original sheet music for dozens of public domain songs originally published during 1901-1911 was collected and published together under the title *Alexander's Ragtime Band* by Dover Publications. Dover's collection is entitled to copyright protection because it has selected and arranged the materials to form a new work—a collection of songs from 1901-1911.
- 132 public domain postcards were collected and reproduced in a book called *Delivering Views: Distant Cultures in Early Postcards*, published by the Smithsonian Institution Press. Each postcard is a separate work of authorship, but the collection is nonetheless entitled to its own copyright protection because it is a new collection.

On the other hand, a collection may contain materials that are still protected by copyright. In this event, you need permission to use the materials in the collection. A good example is both the current print and online edition of the *Encyclopaedia Britannica*. Each article in the encyclopedia is protected by copyright and you need permission to copy or republish them.

To determine whether the materials included in a collection are in the public domain, turn to the chapter covering the types of works involved. For example, if the collection consist of written works, go to Chapter 3, covering writings. If the collection contains sheet music, turn to Chapter 4, covering music.

If you determine that the materials in the collection are copyrighted, the collection isn't in the public domain and you need not read the rest of this chapter. If, on the other hand, the materials are in the public domain the entire collection may be in the public domain as well, or it may receive

the extremely limited copyright protection described below.

1. Copyright Protection for Public Domain Collections

When an author creates a collection consisting of public domain materials it may be entitled to copyright protection, but such protection is very limited. All that can be protected is the *selection and/or arrangement* of the preexisting material, not the preexisting material itself. In some cases both the selection and arrangement are copyrighted. In others, only one or the other is. This limited form of copyright protection is sometimes called a thin copyright.

> **EXAMPLE:** The copyright in Ironweed Press's Frank Norris short story anthology extends only to its selection and arrangement, not to the stories themselves. This means that anyone could reprint any one of the stories contained in the collection without violating Ironweed's compilation copyright. But another publisher could not, without Ironweed's permission, publish a book of the best short stories of Frank Norris using the exact same stories in Ironweed's book, printed in the exact same order.

As the above example shows, the copyright status of the preexisting material used to create a collection is unaffected by the collection's existence. Thus, if the preexisting material was in the public domain, it remains in the public domain.

When we speak of a collection as being in the public domain below, we mean that—for the reasons stated—the selection and arrangement are not protected by copyright.

2. Copying Collections of Public Domain Works

Since a thin copyright protects only the selection and/or arrangement of the material in a collection, none of the individual public domain works in the collection are protected. This means you may copy any individual work included in the collection. However, you may not copy the copyrighted selection and/or arrangement. This would occur where you copy the *entire* collection (or a substantial portion of it) and leave it unchanged.

This is exactly what happened with a collection called *Easy Classic to Moderns* published by Consolidated Music Publishers. The collection contained the sheet music for 142 individual piano pieces by over two dozen classical composers, almost all of which were in the public domain. Consolidated's collection included a selection of six piano pieces by Bela Bartok published under the title *Six Miniatures*. This was the first time these six pieces had ever been published together. One of Consolidated's competitors later published a collection of its own entitled *World's Favorite Classic*

to Contemporary Piano Music. This collection included the same six Bartok pieces. Consolidated sued the publisher for copyright infringement and won. The court held that the selection and arrangement of the six Bartok pieces was original and that Consolidated's copyright was violated when all six were copied in the subsequent collection. *Consolidated Music Publishers, Inc. v. Ashley Publications, Inc.*, 197 F.Supp. 17 (S.D. N.Y. 1961).

However, you may copy any amount of a collection as long as you don't copy the publisher's copyrighted selection and/or arrangement. Let's take as an example Dover Publication's collection *Alexander's Ragtime Band and Other Favorite Song Hits, 1901-1911,* mentioned above. The selection of 49 songs included in this collection is copyrighted, but the grouping is not because it is in alphabetical order. You may copy all 49 songs and sell them individually. This would not infringe on Dover's selection—that is, its decision as to which songs to include in a collection of 49 favorite songs originally published during 1901-1911. But you could not sell all 49 together, since this would be copying Dover's selection. You could, however, copy all 49 songs, add another 51 songs, and publish a collection called *100 Best Songs 1901-1911.* Again, this would not be copying Dover's selection of 49 favorite songs, 1901-1911.

Let's consider an example where only the arrangement is copyrighted. A collection of all of Edgar Allan Poe's short stories (which are all in the public domain because their copyrights have expired) arranged by theme would have a copyright in the arrangement, but not in the selection, since every Poe story is included. No creativity was required to make such a selection. You could copy every story in the collection and group them in some other way without violating the publisher's copyright in its selection—for example, you could group them alphabetically or chronologically.

If you determine that the materials in the collection are in the public domain, check "yes" in Line 1 of the checklist and continue to Line 2. If the materials are not in the public domain, check "no" and do not continue.

H. Does the Collection Lack Minimal Creativity?

A collection is entitled to limited copyright protection because the author had to use creativity and judgment to create it. For example, a person who compiled an anthology of the 25 "best" short stories of the 19th century would have to use creativity and judgment in selecting which of the thousands of short stories published during the 19th century belonged in the anthology, and in deciding on the arrangement (that is, order) of the stories.

However, if a collection was created without using even minimal creativity and judgment, it would not be entitled to any

copyright protection at all—that is, the selection and arrangement of the work would be in the public domain.

How can you tell if a collection contains sufficient creativity to be entitled to thin copyright protection? A collection is copyrightable if either the selection or arrangement of the material is minimally creative.

A selection is minimally creative if it is based on the author's opinion about something subjective—for example, the author's selection of the "best" short stories written by O. Henry or the "100 Greatest Romantic Poems Ever Written." But an anthology of every short story O. Henry ever wrote would not be an example of a minimally creative selection.

An arrangement is entitled to copyright protection only if it is created in some nonmechanical way. For example, an alphabetical, chronological, or numerical arrangement is purely mechanical and not entitled to copyright protection. An arrangement on some other basis such as category or hierarchy could be—for example, an arrangement of O. Henry's short stories from the worst to the best in the editor's opinion, or according to a theme, would be copyrightable. (See Section B1 above for a more detailed discussion of the type of arrangements that are entitled to copyright protection.)

Thus, for example, an anthology consisting of ten stories arranged in chronological order by the same author who wrote only those ten stories in her entire life would probably not be

protectable, because compiling such an anthology would require no selectivity or judgment. Anyone could publish an identical anthology.

If you determine that the collection lacks even minimal creativity, check "yes" in Line 2 of the checklist. The collection is in the public domain. Skip to Line 7 to determine if the collection is protected by a means other than copyright. If the collection is minimally creative, check "no" in Line 2 and continue to Line 3.

I. Is It a De Minimis Collection?

In addition to the minimal creativity requirement, a collection must consist of more than a small number of elements to be copyrightable. The Copyright Office has stated that a collection consisting only of three or fewer items does not meet this threshold. For example, a collection of three one-act plays is not protectable as a collection. If the plays are in the public domain, the collection as a whole will be too.

If you determine that the collection is a de minimis collection, check "yes" in Line 3 of the checklist. The collection is in the public domain. Skip to Line 7 to determine if the collection is protected by a means other than copyright. If the collection is not de minimis, check "no" in Line 3 and continue to Line 4.

J. Is It a U.S. Government Collection?

Collections compiled by U.S. government employees as part of their jobs are also in the public domain. But this rule does not apply to collection by state or local employees. (See Chapter 3, Section C, for a detailed discussion).

If the collection was created by the U.S. government, check "yes" in Line 4. The collection is in the public domain. Skip to Line 7 to determine if the collection is protected by a means other than copyright. If the collection was not created by the U.S. government, check "no" in Line 4 and continue to Line 5.

K. Has the Collection's Copyright Expired?

Like any other work, a collection enters the public domain when its copyright expires. The copyright term for a collection begins to run when the work is created or published, not when the works it contains were created or published. The rules for determining whether a collection has been published for copyright purposes are the same as the rules for databases (see Section D above). Copyright terms for published and unpublished collections differ greatly, so read this section carefully. Once you understand these rules you can determine

African-American Sheet Music 1850-1920, Library of Congress. Selected from the collections of Brown University

how long a copyright will last in a particular work by reading Chapter 18.

If you determine that the collection's copyright has expired, check "yes" in Line 5. The collection is in the public domain. Skip to Line 7 to determine if the collection is protected by a means other than copyright. If the collection's copyright has not expired, check "no" and continue to Line 6.

L. Is the Collection in the Public Domain for Lack of a Copyright Notice?

A collection published before March 1, 1989 had to contain a valid copyright notice. A collection published without such a notice may have entered the public domain. See Chapter 19 for a detailed discussion.

If you determine that the collection is in the public domain because it lacks a copyright notice, check "yes" in Line 6. The collection is in the public domain. Continue to Line 7 to determine if the collection is protected by a means other than copyright. If the collection had a copyright notice or the lack of notice is excused, check "no." The collection's selection and arrangement is not in the public domain. Do not continue.

M. Is the Collection Protected by Means Other Than Copyright?

Because copyright protection for collections is so limited, people who create them often attempt to use means other than copyright to protect them. For example, some collections may be protected as trade secrets (see Section F2 above).

Far more common, however, is the use of licenses to protect collections. For example, legal publishers who collect public domain court decisions and place them online or on CD-ROMs typically require purchasers to agree to licenses restricting how they

may use the materials. Among other things, these licenses typically bar users from republishing the decisions. If you violate the terms of the license, the publisher might sue you for breach of contract. (The publisher couldn't sue for copyright infringement, since the decisions are in the public domain.)

This is what happened when a website called Jurisline placed online thousands of legal decisions it copied from 60 CD-ROMs purchased from the legal publisher Lexis. Lexis immediately filed suit, claiming that the copying violated the terms of a license that the person who bought the CD-ROMs had agreed to. Following a preliminary trial court ruling that the license was legally enforceable, Jurisline settled the case by agreeing to remove from its website all of the legal decisions it had copied from the CD-ROMs. (See Chapter 2, Section B2, for a detailed discussion of licenses.)

If the collection is protected by a means other than copyright, check "yes" in Line 7 and determine if your intended use is prohibited or restricted. If the collection is not protected by noncopyright means, check "no." The collection may be freely used. ∎

Chapter 13

Titles

S hakespeare may have asked, "What's in a name?" but in today's world, a title can be as valuable as a work itself. For this reason, it's important to understand when titles can be legally protected and when they are in the public domain.

This chapter covers titles of literary and artistic works, including titles of books, magazines, newspapers, periodicals, journals, plays, movies, television shows, songs and other musical compositions, and sound recordings. Titles of copyrighted works receive more legal protection than those for works in the public domain, so we'll cover them first.

A. Titles of Copyrighted Works

If a work of authorship is still under copyright—that is, it's copyright has not expired or been lost—its title may receive some legal protection, but only if it is very well known.

1. No Copyright Protection for Titles

Copyright law does not protect titles, even if the work itself is protected by copyright. This is because titles are not considered to be works of authorship with their own copyright protection. Instead, they merely describe and identify a work of authorship.

2. Protection for Titles Under Trademark and Unfair Competition Laws

Although titles are never protected by copyright, state unfair competition laws and state and federal trademark laws may protect them. If a title is protected, you may be legally prevented from using it.

Unfair competition and trademark laws are designed to protect the public from deception and preserve the good will that a company builds when it sells a product or service to the public.

For a title to be protected under these laws, it must meet two requirements:

- the title must be strongly identified in the public's mind with the underlying work, and
- the owner or publisher must prove that:
 1. the public will be confused if the title is used in another work, or
 2. the unauthorized use of the title dilutes or tarnishes the title's value as a trademark.

Let's look at each requirement separately.

a. Identification

For a title to be protected, it must be associated in the public's mind with one work. In other words, when a member of the general public hears the title, he or she automatically thinks of a single work. For example, if you hear the title *A Chorus Line*, it's likely you immediately think of the famous Broadway musical known by

that name. Lawyers call this "secondary meaning."

Other examples of titles that have secondary meaning include:

- *Gone With the Wind*
- *Conan the Barbarian*
- *Jaws*
- *The Green Hornet*
- *Chanticleer,* and
- *The Sensuous Woman.*

However, most titles of individual literary works don't have secondary meaning and are therefore not protected by unfair competition or trademark laws.

Whether a title has acquired secondary meaning is a judgment call that depends on a variety of factors, including:

- how long it's been used
- the amount of advertising and other publicity the title has been given, and
- the number of people who bought or viewed the work. The better known a work, the more likely it has acquired secondary meaning.

Ordinarily, a literary work must be published and widely circulated before its title can acquire secondary meaning. However, it is possible for a title to acquire secondary meaning before it's published where the work has been given substantial prerelease publicity.

It's not necessary that the public know the name of the author or publisher of the work for the title to have secondary meaning. It's sufficient that it identifies the title with the work itself.

How can you tell whether a title makes the grade and has achieved secondary

meaning? It can be impossible to come up with a conclusive answer. If you're dealing with a title for an extremely well-known work like those listed above, secondary meaning has very likely been achieved. On the other hand, if the title is for a work that is so obscure or sold so poorly that only a few people have ever heard of it, there is no secondary meaning. In between these two extremes there is a vast gray area.

One way to help determine if a title has secondary meaning is to have a title availability search done. A private search firm researches the complete history of a title, showing you how its been used in the past—for example, whether it's been used for movies, books, articles, or other works. Companies that sell liability insurance to producers of television shows and movies may require that such a search be done.

The best known title availability search company is Thomson & Thomson in Washington, DC. You can call them at 800-356-8630 to order a search or receive additional information.

If you're unsure whether a title has achieved secondary meaning, consult with an attorney before using it.

b. Confusion

In addition, to prevent others from using a title, an author or publisher must prove that the public would likely be confused as to the source of the work. Public confusion exists if the public is deceived into buying one work, believing it to be another.

Confusion also is found where the public is deceived as to the sponsorship or approval of a work. For example, if a film is called *Rocky VII*, the public is likely to believe the creators of the original *Rocky* film produced it or at least approved it.

Factors considered by the courts to determine if someone challenges your use of a title include:

- whether the title has artistic relevance to the underlying work—that is, does the title describe or conjure up the work
- the design of the works involved
- the similarity between the two titles
- the similarity in the contents of the works
- how the works are marketed
- the care likely to be exercised by purchasers
- whether the defendant intended to confuse the public, and
- the distinctiveness of the prior title.

EXAMPLE: *Playboy* Magazine brought suit to stop a competitor from using the title *Playmen* Magazine and won. The court held that a likelihood of confusion existed because some consumers would mistake *Playmen* for *Playboy*. Moreover, even those consumers who wouldn't confuse one magazine with the other might believe *Playboy* and *Playmen* were both published by Hugh Hefner. *Playboy Enterprises v. Chuckleberry Publishing*, 486 F.Supp. 484 (S.D. N.Y. 1980).

PLAYBOY

c. Trademark Dilution

Trademark dilution occurs when the integrity of a famous trademark is "muddied" by an offensive association, either by a vulgar or insulting affiliation (tarnishment) or by a connection with a lesser product (blurring).

- **Tarnishment.** The image of a famous trademark is used in such a way that it image may be tarnished in the public's mind—for example, using the title "Braveheart" for a sexually explicit website.
- **Blurring.** A use that blurs the identity of a famous trademark—for example, using "The X Files" on toilet paper.

Dilution is a vague concept, often used by companies to justify going after an offensive use of a trademark. Critical book or movie reviews or other editorial uses of titles are not considered dilution. News reporting and commentary and other noncommercial uses are also exempted from the federal dilution law. A use is noncommercial if it does more than propose a commercial transaction. For example, a court held that the song title "Barbie Girl" did not dilute

Mattel's trademark in the Barbie doll. The song was noncommercial speech because it lampooned Barbie's image—thus, the title did more than "propose a commercial transaction"—that is, act just to get consumers to buy the song. *Mattel, Inc. v. MCA Records, Inc.*, 296 F.3d 894 (9th Cir. 2002).

d. Series Titles

Titles of a series of works receive much more legal protection than titles of single works. These include titles of newspapers, magazines, and other periodicals; titles for a series of books—for example, the popular *Dummies* series of reference books or the series of novels known as the *Hardy Boys Mysteries*; titles of television series or a series of movies; and encyclopedia and dictionary titles.

Unlike titles of individual works, series titles can be registered as trademarks with the U.S. Patent and Trademark Office (PTO). When such a series title is registered, it is presumed to have secondary meaning. This makes it much easier for the owners of such titles to win trademark infringement suits.

Because of this, you should not use such a series title—for example, you should not use the words *Dummies Guide to...* in a title. Doing so will likely result in a lawsuit that you will probably lose. Indeed, you'll likely be threatened with litigation if your title is similar, though not identical, to a well-known series title. For example, *The Wall Street Journal* recently threatened a student publication called *The Small Street*

Journal with a lawsuit if it didn't change its name.

An easy way to tell if a series title has been registered is to check if the ® symbol is used near it. If it is, the title has been registered. However, the ® symbol is not always used for registered trademarks, so its absence doesn't necessarily mean the title is not registered. You can determine for certain if a title is registered by conducting a trademark search—that is, a search of the PTO's trademark registration records. You can do this yourself online or hire someone to do it for you.

For a detailed discussion of trademark searches, see *Trademark: Legal Care for Your Business & Product Name*, by Stephen Elias and Kate McGrath (Nolo).

e. Use in Other Media

If the title of a copyrighted work has secondary meaning as described above—whether it is a title of an individual work or a series title—courts are particularly likely to protect it against unauthorized exploitation in different media. For example, the magazine *National Lampoon* was able to prevent the use of the words "National Lampoon" or "lampoon" in the title for a television series. *National Lampoon, Inc. v. American Broadcasting Cos.*, 497 F.2d 1343 (2d Cir. 1974). This is because the reason such a title is being used is not to describe the work, but to make the public believe that the creator of the original work is in some way connected with the new work.

⚠ **Avoiding Title Lawsuits.** Unless you're prepared to get involved in litigation, you should avoid using extremely well-known titles of non-public-domain works. This is true even though you think your use will not lead to public confusion or dilution. The prior user of the title may disagree with you.

Registering Movie Titles

The major Hollywood film studios have established their own private system of movie title protection and registration. Through the auspices of the Motion Picture Association of America (MPAA), a film industry trade group, they have established a title registration bureau. MPAA members (which include all the major film studios) and independent producers may apply to register a film title. If the title has not been used, registration is granted. But if a subscriber objects that the title is confusingly similar to one of its own titles, the dispute is referred to an MPAA arbitration panel that holds a hearing and issues a decision resolving the dispute. The studios and producers who use the registration system have agreed by contract to be bound by the panel's decision. However, the panel's decisions are not binding on the public, only on those who have agreed to participate in the registration system. The MPAA title registration bureau can be reached at 818-995-6600.

B. Titles of Public Domain Works

When a work enters the public domain, its title receives much less legal protection than titles of works still under copyright. Ordinarily, the unfair competition and trademark laws described in Section A2 cannot protect the title of a public domain work, but there can be exceptions.

1. Republishing a Public Domain Work

If you republish a public domain work, you are ordinarily free to use the title to identify it. However, there is one very limited exception: If the title has acquired such strong secondary meaning that the public identifies it with its original publisher or other distributor, the title cannot be used in a way that deceives the public as to the source of the work.

Very few public domain titles qualify for protection under this exception because they don't have strong enough secondary meaning. Remember, the public must not only identify the title with the public domain work, it must also identify it with the original publisher or other source. This is very difficult to show. Only rarely does the public identify a work's title with a particular publisher or other source. For example, do you know who first published *Alice in Wonderland* or the Irving Berlin song "Alexander's Ragtime Band"? You

probably recognize the title, but not the source.

One of the few times this exception was successfully invoked involved the classic reference book *Webster's Dictionary*. The Merriam Publishing Company acquired the right to publish the dictionary from Noah Webster's heirs and published many editions throughout the 19th century. When the original dictionary entered the public domain in 1899, many publishers produced "Webster's Dictionaries" based on the work. Merriam brought numerous suits against these competitors. The U.S. Supreme Court held that the word "Webster's" as applied to dictionaries had acquired a secondary meaning and indicated dictionaries that were published by Merriam. However, this didn't mean other dictionary publishers couldn't use the title "Webster's." All they had to do was make sure the public was not confused into believing that Merriam published their dictionaries. This could be accomplished by including the following disclaimer on their dictionaries: "This dictionary is not published by the original publisher of Webster's dictionary or their successors." *G. & C. Merriam Co. v. Syndicate Publishing*, 237 U.S. 618 (1914).

Even where a title of a public domain work has acquired such strong secondary meaning, it may still be used so long as the public isn't misled into believing the original publisher or other source is behind the new publication. Ordinarily, you don't have to use a disclaimer like that in the *Webster's*

Dictionary case. It's enough that the name of the new publisher or other distributor is clearly identified on the work.

> **EXAMPLE:** A John Wayne movie called *McClintock!* entered the public domain when it was not renewed with the U.S. Copyright Office in the 28th year after its publication. About 20 years later, a video distributor called Goodtimes Home Video began selling a videocassette of the movie. The cassette contained a label clearly identifying Goodtimes as producer of the video. A court held this was sufficient to prevent public confusion about the source of the video. *Maljack Productions v. Goodtimes Home Video Corp.*, 81 F.3d 881 (9th Cir. 1996).

However, if you really want to make sure there is not even a possibility of public confusion, you can use a disclaimer (see Section C).

2. Public Domain Titles on Derivative Works

What if you want to create a derivative (new) work based on a public domain work and use the work's title to identify it—for example, create a movie based on Mark Twain's novel *Huckleberry Finn* and call it *Huckleberry Finn*? Ordinarily, this doesn't pose a problem.

However, if someone has already created a similar derivative work with the same title, there could be trouble. The creator of the prior work might be able to prevent your using the title on the grounds of unfair competition. He would have to prove in court that the public identifies the title with his particular derivative work (whether or not it also identifies the title with the public domain work).

This is hard to establish, at least where the public domain work is well known. In one case, for example, Walt Disney studios created an animated cartoon based on the public domain novel *Alice in Wonderland* and brought suit against the producer of a movie based on the novel that used the same title. The suit was unsuccessful because Disney was unable to show that, as far as movies were concerned, the public identified the title *Alice in Wonderland* solely with the Disney movie, not a film based on the book *Alice in Wonderland*. *Walt Disney Prods. v. Souvaine Selective Pictures, Inc.*, 192 F.2d 846 (2d Cir. 1951).

If a title of a derivative work based on a public domain work has attained such secondary meaning, you may be able to avoid liability for unfair competition or trademark violations by using a disclaimer making clear to the public that your work is not connected with the prior work (see below).

C. Using Disclaimers to Avoid Public Confusion

A disclaimer is a statement that makes clear to the public that even though your work has a title that is the same or similar to the title of a previous work, the creator or publisher of the previous work has not produced or approved it.

Courts have held that even if the title of a public domain work has attained secondary meaning, anyone may use it so long as the title is used in a way that does not deceive or confuse the public. A good way to help avoid such confusion is to use a disclaimer.

If you're using a title of a work that is not in the public domain, use of a disclaimer may limit or avoid liability for unfair competition or trademark violations. Courts sometimes require the use of disclaimers rather than prohibit use of a title, so if you already have a disclaimer you're way ahead of the game.

Using a disclaimer may not always avoid problems with unfair competition or trademark laws, but it can only help. Such a disclaimer should be clearly written, prominently displayed, and permanently affixed to your work.

Here is an example of a disclaimer you can use when you republish a public domain work. It makes clear to the public that the original publisher of the work is not involved with your republication of the work:

This work is not published by the original publishers of [TITLE OF WORK] or by their successors.

Where a title of a new work is the same or similar to that of a copyrighted work, the words "based on" or "derived from" are often used in a disclaimer to make clear that the work doesn't owe its origin to the prior work with the same title.

> **EXAMPLE:** The producers of the film *Elephant Man* used the following disclaimer to make clear to the public that their film was not connected with a previous Broadway play of the same title:
> *"Based upon the life of John Merrick, The Elephant Man, and not upon the Broadway play or any other fictional account."*

D. Titles Used on Merchandise and Other Products

Some titles are used on merchandise, such as cups, toys, T-shirts, and other clothing. This is often the case with movie titles such as *Star Wars* or *Godzilla*. Titles used in this way may be registered with the U.S. Patent and Trademark Office. Such uses receive strong trademark law protection. You ordinarily need permission to use a well-known title on merchandise. If you don't, you'll likely receive a call or letter from a lawyer.

Titles of public domain works can also be used to identify goods and services. For example, the words *Moby Dick* could be used to identify a chain of seafood restaurants or a company could come up with a line of *Scarlet Letter* chocolates. Titles used in this way may receive trademark protection, but only against uses that would confuse the public or dilute the value of the trademark. For example, even if there is a *Moby Dick* seafood restaurant chain, you may continue to use the title for purposes not related to selling seafood.

E. The First Amendment and Titles

Trademark and unfair competition laws apply only to commercial uses of titles— that is, using them to identify products or services. Informational or "editorial" uses of a trademark do not require permission. These are uses that inform, educate, or express opinions or ideas protected under the First Amendment of the United States Constitution (protecting freedom of speech and of the press). For example, permission is not required to use a book title in a book review, even if the review is very negative.

Chapter 14

Public Domain Elements in Copyrighted Writings

f you have concluded that a work you want to use is protected by copyright, all is not lost. You cannot use the whole work, or substantial portions of it, without first obtaining permission from the copyright owner, and possibly paying a fee for its use. However, almost all copyrighted works contain elements that are in the public domain. These elements consist of things other than the actual words or other creative building blocks the author uses to create the work. Such public domain elements include:

- ideas, facts, systems, and discoveries
- a fictional work's themes, settings, plots, stock characters, and standard scenes
- a nonfiction work's research, interpretations, quotations, fictional elements, and unoriginal organization.

This chapter focuses on public domain elements in written works—that is, works consisting of words—because these kinds of works contain more public domain elements than any other. However, the basic principles discussed here apply to all types of copyrighted works.

A. Ideas

Copyright only protects the particular way an author expresses his or her ideas, not the ideas themselves. Ideas, procedures, processes, systems, methods of operation, concepts, principles, and discoveries are all in the public domain, free for all to use. (See 17 U.S.C. Section 102(b) for the exact

wording of this statute.) There is a good reason for this: If authors were allowed to obtain a monopoly over their ideas, the copyright laws would end up discouraging new authorship and the progress of knowledge, which are the two goals copyright is intended to foster.

Copyright does not protect three kinds of ideas:

- **The idea to create a work.** The idea to create a particular type of work is never protected by copyright. For example, the idea to write a biography of Winston Churchill is not copyrighted. Anyone can write such a work. The fact that many such biographies have already been written does not prevent an author from writing a new one. But this doesn't mean you can copy or closely paraphrase the words contained in a previous Churchill biography.
- **Creative building blocks.** The building blocks of creative expression are also in the public domain. If these were protected by copyright, it would be virtually impossible for anyone to fashion a new creative work. What these building blocks consist of depends on the nature of the work involved. In the realm of fiction, they include a work's theme, settings, plot, stock characters and situations, and literary devices (see Section C). In the case of a nonfiction work, they include the facts contained in the work (see Section D).

When Does Copying Become Plagiarism?

Ideas, facts, research, concepts, principles, and discoveries are ordinarily in the public domain. So are the words contained in books and other writings that are in the public domain. This means you can copy or otherwise use these things without obtaining permission. But this doesn't necessarily mean you shouldn't provide credit for the source of such words, ideas, facts, or research. Failure to do so may constitute plagiarism.

A plagiarist is a person who poses as the originator of words he did not write, ideas he did not conceive, or facts he did not discover. "Plagiarism" is not a legal term; it's an ethical term. If a plagiarist only copies public domain materials, he can't be sued for copyright infringement. But there still could be severe consequences. College professors and journalists have been fired because of plagiarism.

To avoid charges of plagiarism, authors of scholarly works (histories, biographies, legal and scientific treatises, student papers, etc.) must always give proper credit to the sources of their ideas and facts, as well as to any words they borrow. Authors of less serious works—for example, how-to books or newspaper or magazine articles—should always attribute direct quotations, but may not always need to give credit for ideas and facts they borrow (authors of such works should discuss this with their editors or publishers).

It is neither customary nor necessary for authors of works of fancy, such as novels, screenplays, or stage plays to credit the sources of their inspiration, whether other works of fancy, newspaper accounts, or histories. But they should, of course, give proper attribution for direct quotations from public domain materials.

It was the best of times, it was the worst of times,
it was the age of wisdom, it was the age of foolishness,
it was the epoch of belief, it was the epoch of incredulity,
it was the season of Light, it was the season of Darkness,
it was the spring of hope, it was the winter of despair,
we had everything before us, we had nothing before us,
we were all going direct to Heaven, we were all going direct

First paragraph from *A Tale of Two Cities*, Charles Dickens (1812-1870)

- **Methods, systems, and processes.** In addition, copyright protection does not extend to methods of operation, systems, or processes. Thus, for example, copyright did not protect a bookkeeping system described in a book. Copyright protected the words the author used to describe the system, but not the system itself. Anyone was entitled to use the system without the author's permission, or even write another book about it, but could not copy the author's description without permission. *Baker v. Selden*, 101 U.S. 99 (1879).

While copyright law does not protect ideas, they can receive legal protection in other ways.

1. State Contract Law

As a general rule, ideas are as free as air. However, if you promise to pay someone for telling you an idea, your promise may constitute an enforceable contract. This means that if you fail to pay as promised, the person who disclosed the idea may be able to sue you in court and collect the promised payment. The suit would be for breach of your contract, not for copyright infringement, and would be brought under your state's contract law. In real life, however, such suits are rarely brought because it's very unusual for a person to agree to pay for an idea before he or she knows what the idea is.

Survivor Reality Game Show an Unprotected Idea

The producers of the reality game show *Survivor* sued the creators of the show *Celebrity* for copyright infringement. They claimed that *Survivor* was a "new genre" of television show with a unique format combining the elements of "voyeur verite, hostile environment in the deserted island sense, building of social alliances, challenges arising from the game show element and serial elimination." The court found that this new genre of television show was an unprotectable idea, as is any genre. Thus, anyone could produce a show based on the basic idea of contestants in a "reality" situation eliminating each other. *Celebrity* would infringe on *Survivor* only if it copied a substantial amount of *Survivor*'s specific details, which it did not do. There were many differences between the two shows—for example, the way the contestants were eliminated—and *Celebrity* had an audience participation element and a comedic tone, unlike the serious *Survivor*. *CBS Broadcasting, Inc. v. ABC, Inc.*, 2003 U.S. Dist. LEXIS 20258 (S.D. N.Y. 2003).

Usually there is no express (stated) promise to pay for an idea. Instead, person A tells person B an idea without an advance promise from B to pay for it. B later uses the idea and A claims he should therefore be paid for it. Courts will sometimes hold that an implied (unstated) contract was created under these circumstances and make B pay A. However, A must prove that B actually received the idea from A and actually used it. Moreover, A must show that B agreed to pay for the idea, but did not expressly say so. This might arise on the basis of prior dealings between A and B (for example, B paid A for previous similar ideas), or the custom in the trade A and B are engaged in.

In addition, most courts require that the idea be both novel and concrete. An idea is novel when it is not commonly known. An idea is concrete when it is ready for immediate use without any additional embellishment.

You don't need to worry about contract law protection for ideas you obtain from a book or other written work you buy or obtain from a library. You must have personal contact with the idea creator for an express or implied contract to be formed. That is, the idea originator must have personally told you the idea (either orally or in a writing directed to you) and you must have acted in such a way as to create an express or implied contract.

2. Trade Secret Laws

There is a very important exception to the general rule that ideas, procedures, processes, systems, methods of operation, concepts, principles, and discoveries are in the public domain. All of these things can be protected under state trade secret laws.

A trade secret is information or know-how that is not generally known in the business community and that provides its owner with a competitive advantage in the marketplace. The information can be an idea, written words (such as an instructional manual), formula, process or procedure, technical design, list, marketing plan, or any other secret that gives the owner an economic advantage.

If a trade secret owner takes reasonable steps to keep the confidential information or know-how secret, the courts will protect the owner from unauthorized disclosures of the secret to others by:

- the owner's employees
- other persons with a duty not to make such disclosures, such as nonemployees who work for the company and people who sign nondisclosure agreements promising not to disclose the secret
- industrial spies, and
- competitors who wrongfully acquire the information such as through theft or bribery.

This means that the trade secret owner may be able to sue the person who stole or disclosed the secret and obtain an injunction (a court order preventing someone from doing something, like stealing or disclosing trade secrets) and damages. However, the trade secret owner must truly take steps to preserve the trade secret; the more widely known a trade secret is, the less willing the courts are to protect it.

Not everything can be a trade secret. Ideas and information that are public knowledge or generally known in the industry involved cannot be trade secrets. This is because things that everybody knows cannot provide anyone with a competitive advantage. However, information constituting a trade secret need not be novel or unique. All that is required is that information not be generally known by people who could profit from its disclosure and use.

Generally, it is very easy for you to know whether you might run afoul of someone's trade secret rights. First of all, the company or person who developed it must keep the idea secret. Ideas you find in published books, articles, and other works distributed to the public cannot be trade secrets. On the other hand, if you discover an idea in a closely guarded internal company memo marked "Confidential," you may not have the legal right to use or disclose it to the public.

In addition, your use or disclosure of the idea must constitute a breach of an obligation to keep the idea confidential.

Such a confidential obligation may arise because you work for the person or company that developed the idea or you agreed not to disclose it, for example by signing a nondisclosure agreement. Or you must have improperly obtained the idea from someone else who had a duty not to disclose it. For example, you obtained a company's idea for a new product by bribing an employee of the company or by theft.

As mentioned above, you don't have to worry about trade secrecy when you're dealing with published works. The issue arises only when you're dealing with unpublished documents that contain economically valuable ideas or information that a person or company has sought to keep secret from competitors and the general public.

3. Federal Patent Law

This book is about works of authorship such as writings, movies, music, and art. However, you should be aware that ideas, methods, and systems embodied in inventions can be protected under U.S. and foreign patent laws. Inventions are not works of authorship and generally cannot be protected by copyright. In the United States, patentable inventions include:

- a process or method of getting something useful done (such as a genetic engineering procedure, a manufacturing technique, or computer software)

- a machine (usually something with moving parts or circuitry, such as a cigarette lighter, laser, or photocopier)
- a manufactured article (such as a tire, transistor, or hand tool)
- a composition of matter (such as a chemical composition, drug, soap, or genetically altered life form),
- the unique, ornamental, or visible shape or design of an object (such as a unique ornamental design of a lamp or desk), or
- an asexually reproduced plant.

Patents can also be obtained for methods of doing business. For example, a patent was obtained by a mutual fund company for a method by which mutual funds could pool their assets in an investment portfolio organized as a partnership. See *State Street Bank & Trust Co. v. Signature Financial Group, Inc.*, 149 F.3d 1368 (Fed. Cir. 1998).

Filing for and obtaining a patent from the U.S. Patent and Trademark Office grants an inventor a monopoly on the use and commercial exploitation of an invention for up to 20 years. That is, the inventor has the legal right to prevent others from making, using, or selling the invention claimed in the patent.

For example, an inventor who obtains a patent on a new type of mousetrap can prevent others from copying and selling the trap to others. But such an inventor could not prevent anyone from writing a book or creating a film or video about how to catch mice, even if the book, film, or video described how to use the inventor's new mousetrap.

For a detailed discussion of patents, see *Patent It Yourself*, by David Pressman (Nolo).

B. Facts

Copyright does not protect facts, whether scientific, historical, biographical, or news of the day. If the first person to write about a fact had a monopoly over it, the spread of knowledge would be greatly impeded. Another reason why copyright law does not protect facts is that an author does not independently create facts; at most, he or she may discover a previously unknown fact. For example, Nicholas Copernicus did not create the fact that the earth revolves around the sun when he wrote his landmark book *De Revolutionibus Orbium Caelestium* in 1543. This fact existed in nature and Copernicus discovered it through close observation and the exercise of his genius. Copyright does not protect discoveries (17 U.S.C. Section 102(b)).

So, the facts contained in works such as news stories, histories, biographies, and scientific treatises are not protected by copyright. Subject to the important limitation of the merger doctrine discussed in Section B3 below, all that is protected is the author's original expression of the facts contained in such works—that is, the words the author uses to describe the facts and possibly the way he or she organizes or shapes the material. Thus, for example, anyone who writes a novel, play,

or other fictional work based on Marilyn Monroe's life is free to cull the historical facts about her from biographies and other sources and use them in the fictional work. The events of Marilyn Monroe's life—for example, her marriages to baseball great Joe DiMaggio and playwright Arthur Miller—are unprotectable facts. Moreover, incorporating these facts into a fictional work does not give the author a copyright over them. Only the way the author expresses such facts, to the extent original, is protectable. (*Whitehead v. CBS/VIACOM*, 315 F. Supp.2d 1 (D.C. 2004).)

However, state trade secret laws may protect economically valuable facts not generally known to the public that have been kept secret. (See Section A2 above.)

1. Legal Protection for Fictional "Facts"

One reason facts are not protected by copyright is that authors do not create them. Facts exist in nature or history. Authors simply discover them and express them in words. It's the author's words that are copyrighted, not the facts themselves.

However, "fictional facts" contained in a television show, movie, play, or novel *are* created by the author, as are the words used to express them. Such "facts" are entitled to copyright protection. For this reason, a trivia quiz book that contained detailed information about the *Seinfeld* television show was found to have infringed upon the producers' copyright. The book

didn't ask questions about who acted in the program, who directed each show, or how many seasons it ran. These are nonfiction facts that are not protected by copyright. Instead, the book posed questions about the fictional events depicted during the episodes. These events were created by the authors of the shows and were copyrighted. See *Castle Rock Entertainment v. Carol Publishing Group*, 955 F.Supp. 260 (S.D. N.Y. 1997).

In contrast, the creators of the board game Trivial Pursuit did not commit copyright infringement when they used the facts contained in two trivia encyclopedias to write the questions for their game. The facts contained in these encyclopedias— *The Complete Unabridged Super Trivia Encyclopedia*, volumes 1 and 2—were in the public domain, free for all to use. These books contained facts about geography, art, literature, sports, and history, not fictional facts such as contained in the *Seinfeld* TV show. Unlike the case of the authors of the *Seinfeld* show, the author of the encyclopedias did not create the facts expressed in his works. *Worth v. Selchow and Righter Co.*, 827 F.2d 569 (9th Cir. 1987).

Check the Facts. Copyright protection for "fictional" facts makes it important for anyone using a fact from a work of authorship to make sure that what they are using is actually a fact. Failure to check whether a fact is actually a fact could cause you to unintentionally violate someone's copyright in a "fictional" fact.

2. Legal Protection for Hot News

Although facts are not protected by copyright, unfair competition laws in the 50 states might protect them in certain narrowly defined situations. For example, a court has held that hot news is protected under such laws if:

- a person or company generates highly time-sensitive factual information at some cost or expense
- another person's or entity's use of the information constitutes free-riding on the fact gatherer's costly efforts to collect the information
- the use of the information is in direct competition with a product or service offered by the fact gatherer, and
- other people free-riding on the fact gatherer's efforts would threaten its ability to stay in business.

EXAMPLE: It would probably be unlawful for a newspaper to copy news stories contained in a competing newspaper and print them as its own. But a company that used pagers to transmit to subscribers real-time NBA game scores and other information tabulated from television and radio broadcasts of basketball games did not commit misappropriation because there was no free-riding involved. The company collected the scores itself; it didn't steal them from the NBA. See *National Basketball Assoc. v. Motorola, Inc.*, 105 F.3d 84 (2nd Cir. 1996).

3. The Merger Doctrine—When Ideas, Facts, and Their Expression Merge

Sometimes there is just one way, or only a few ways, to adequately express a particular idea or fact. If the first person to write about such an idea or fact could copyright his expression, he would effectively have a monopoly over that idea or fact itself—that is, no one else could write about it without his permission. The copyright law does not permit this, since it would discourage authorship of new works and thereby retard the progress of knowledge. In these cases, the idea or fact and its particular expression are deemed to merge and the expression—the way the author placed the words—is either treated as if it were in the public domain or given very limited copyright protection.

The merger doctrine applies mainly to factual works such as histories, biographies, and scientific treatises, rather than to works of fancy such as novels, plays, and poems. This is because the ideas and facts in factual works can often be expressed only in one particular way or only in a few ways, while the ideas contained in novels and similar works can usually be expressed in a wide variety of ways.

For example, assume you wish to write an unadorned factual account of Paul Revere's famous midnight ride during the Revolutionary War. You research Revere's life and create a work containing, in part, the following sequence of words:

On April 18, 1775, the Boston minute-
men learned that the British intended to
march on Concord with a detachment
of 700 men. Paul Revere arranged for a
signal to be flashed from the steeple of the
Old North Church in Boston. Two lan-
terns would mean that the British were
coming by water, and one, by land.

The particular selection and arrangement
of words in the above paragraph appears
to satisfy the three requirements for
copyright protection: fixation, originality,
and minimal creativity. (See Chapter 2,
Section A4, for a detailed discussion of
these requirements.) Does this mean that if
anyone used these three sentences without
your permission they would be liable for
copyright infringement? Because of the
merger doctrine, the answer is probably
not. This is because if anyone else wrote
a brief factual account of Paul Revere's
ride, it would necessarily have to contain
sentences looking very much like those
in your paragraph. This would be so even
though the author had never read your
account, because there are just not many
different ways to express the facts described
in your paragraph. For example, how many
different words can an author use to explain
that one lantern meant that the British were
coming by land and two by sea? The facts
pretty much dictate the form of expression
here.

As a result, if your paragraph were pro-
tected by copyright, nobody else could ever
write a factual account of Paul Revere's ride

without your permission. Copyright law
does not permit this kind of control, since
it would effectively give you a monopoly
over the facts concerning Paul Revere's ride.
To prevent this, the facts of Paul Revere's
ride and the words you used to express
them would be deemed to merge. Many
courts would hold that your paragraph
was in the public domain, and could be
copied verbatim (or used in any other way)
without your permission. Other courts
would not go quite this far; they would give
your paragraph limited protection by holding
that your paragraph was protected from
unauthorized verbatim copying, but nothing
else. See *Kregos v. Associated Press*, 937 F.2d
700 (2d Cir. 1991).

In contrast, the merger doctrine would
not be applied to a work of fancy—for
example, a poem—about Paul Revere's ride.
Consider this:

Listen, my children, and you shall hear
Of the midnight ride of Paul Revere,
On the eighteenth of April, in Seventy-five.
Hardly a man is now alive
Who remembers that famous day and
* year.*
He said to his friend, If the British march
By land or sea from the town tonight,
Hold a lantern aloft in the belfry arch
Of the North Church tower as a signal
* light,*
One, if by land, and two, if by sea.

These stanzas were written by Henry
Wadsworth Longfellow over 100 years ago

and are thus in the public domain because the copyright has expired. But let's pretend, for purposes of our example, they were written just the other day.

This verse conveys almost exactly the same factual information as your paragraph above, yet the facts and expression would not be deemed to merge. Why? Because the author's words are embellished and highly distinctive. The sequence of words has not been dictated solely by the facts. Indeed, it is the unique word sequence itself, not the facts, that is the work's main attraction. No one must copy this particular word sequence in order to convey the same facts or to write another work of fancy about Paul Revere's ride. A person who copied even the first two lines would probably be found to have infringed on the copyright in the poem.

A work need not be written in poetic meter to obtain copyright protection. But the more distinctive an author's words, the more protection his or her work will receive. An elegantly written biography of Paul Revere will receive more copyright protection than an unadorned factual account.

You may have trouble determining when a work receives little or no copyright because of the merger doctrine. This is an issue about which reasonable minds can easily differ. See Chapter 1 for detailed guidance on how to deal with such public domain gray areas.

C. Unprotected Elements in Works of Fiction

Works of fiction include novels, short stories, poems, and plays. There are elements in works of fiction that do not secure copyright protection and are, thus, in the public domain.

1. Themes

In fictional works, the theme is simply its underlying idea, which is never protected. Only the original way an author expresses his or her theme is protected. For example, anyone can write a work expressing the theme of man against nature, but this doesn't mean you can copy wholesale from Ernest Hemingway's famous novel *The Old Man and the Sea*.

2. Factual Settings

A fictional work's factual setting—that is, the factual time and place in which the story occurs—is likewise not protected by copyright. For example, anyone can write a story set on the RMS *Titanic* or in New York City. However, the particular words an author uses to describe a setting are protected. Fictional settings are another matter, however. Where a story takes place in an entirely imaginary world—such as the world created by J.R.R. Tolkien in his *Lord of the Rings* novels—the setting is probably

protected by copyright. You shouldn't copy such an imaginary setting without permission.

3. Plots

The plot of a fictional work—the sequence of events by which the author expresses her theme or idea—is a selection and arrangement of ideas. While ideas themselves are not protected, an author's selection and arrangement of ideas are protected as long as they are original, that is, independently created. Thus, a plot constitutes protected expression only to the extent it was independently created by an author.

Since there are, in reality, few independently created plots, it is rare for a plot to have copyright protection. One literary critic has noted that "authors spin their plots from a relatively small number of 'basic situations,' changing characters, reversing roles, giving modern twists to classic themes." *The Thirty-Six Dramatic Situations*, by Polti (The Writer, Inc.). For example, authors have recycled the time-tested plot of boy meets girl, boy gets girl, boy loses girl, boy gets girl back over and over again throughout the centuries. Naturally, these basic plots are all in the public domain; otherwise, it would be very difficult, if not impossible, for anyone to create a "new" work of fiction.

Independently created variations or twists on basic plots would constitute protected expression. But there aren't very many new plot twists either. For example, can you think of any variations on the boy-meets-girl scenario that haven't been done before?

Although a plot itself usually cannot be protected by copyright, the particular way an author expresses a plot ordinarily is—that is, the particular words an author uses to flesh out and advance a plot are protected. For example, if Shakespeare's play *Romeo and Juliet* was protected by copyright (it isn't, of course, because it was created so long ago; see Chapter 18), anyone could write a play about young lovers from feuding families who commit suicide, but no one could copy the words Shakespeare used in *Romeo and Juliet* to express this plot.

4. Stock Characters

There are many standard character types that have developed in fiction over time—for example, the eccentric little old lady; the wicked stepmother; the tall, silent, strong cowboy; the two-fisted, hard-drinking private detective; the street-wise, fast-talking urban hustler. Since they are not original creations, these character types are not protectable by copyright; they are part of the stock of ideas that all fiction writers may draw upon. Again, however, the particular way an author describes a stock character is protectable to the extent it's original.

However, once a written work of fiction enters the public domain, any element of the work can be used without permission, including the characters.

Some well-known characters take on a life of their own and end up appearing over

Distinctive Characters Are Not in the Public Domain

In contrast to stock characters, distinctive characters are *not* in the public domain, unless the work they are based on has entered the public domain. This means that no one can copy the particular original combination and selection of qualities—such as personality traits, physical attributes, and mode of dress—that make the character distinctive. An author's selection and combination of such distinctive qualities (ideas) is deemed to be copyrighted.

Unfortunately, there are no uniform standards for judging when a character is, or is not, sufficiently distinctive to be protectable. Copyright protection has been extended to such disparate characters as Tarzan, Amos & Andy, Hopalong Cassidy, and E.T., and denied to Sam Spade and the Lone Ranger. Is Sam Spade any less distinctive than Hopalong Cassidy? The only general rule is that "the less developed the characters, the less they can be copyrighted." See *Nichols v. Universal Pictures Corp.*, 45 F.2d 119 (2d Cir. 1930).

Since the legal standards in this area are far from clear, never use a well-known character from a copyrighted work—either by name or detailed description—without first consulting a copyright attorney or disguising the character to such an extent that it is not recognizable. Even if the character doesn't seem sufficiently distinctive to you to merit protection, its creator and publisher may feel quite differently and sue you for copyright infringement. In one case, for example, the son of the late novelist Vladimir Nabokov filed suit when an author wrote and attempted to publish a fictional diary by Lolita Haze, the main character of Nabokov's novel *Lolita*. (The suit was settled and the book subsequently published to mixed reviews.)

864 Humorous Cuts from the Twenties and Thirties, Dover Publications (modified)

a number of years in a variety of works, often in different media—for example, both novels and movies or television. The literary character Sherlock Holmes is a good example. Arthur Conan Doyle first created Holmes in a series of short stories in the late 19th century. Since then he has been the subject of numerous plays, movies, television shows, and even a novel based on the idea that Sigmund Freud cured Holmes of a cocaine addiction (*The Seven Percent Solution*, by Nicholas Meyer). All the original Conan Doyle stories about Holmes are in the public domain in the United States because their copyrights have expired. But most of these more modern works involving Holmes are still under copyright.

This leads to an important question: When the first work in which a character appears enters the public domain, is the character available for use in new stories and contexts despite the fact that other works containing the same character are still under copyright? In other words, can you use the Holmes character even though he is portrayed in many works that are still copyrighted?

The answer is yes. You can copy the character as it appeared in its original public domain source. But you cannot copy any new traits or other character changes that were added in the later copyrighted works. For example, you can copy Sherlock Holmes as he appeared in the original Conan Doyle stories. But you can't copy any new material later authors added to their own works about Holmes that are still under copyright.

> **⚠ Other Laws Besides Copyright Law Have Been Used to Legally Protect Characters, Particularly Visual Characters Such as Cartoon Characters.** These laws include state and federal trademark laws and state unfair use and misappropriation laws (see Chapter 20).

5. Standard Situations (*Scènes à Faire*)

There are certain sequences of events, scenes, situations, or details that necessarily follow from a fictional work's given theme or setting. The French call these *scènes à faire* (that which must follow from a certain situation). *Scènes à faire* are indispensable, or at least standard, in the treatment of a given topic. They flow conventionally from the situation being portrayed and are therefore in the public domain. Examples of scènes à faire include:

- a scene in the reality game show *Survivor* in which the contestants on a hostile deserted island who were deprived of food ate worms. *CBS Broadcasting, Inc. v. ABC, Inc.*, 2003 U.S. Dist. LEXIS 20258 (S.D. N.Y. 2003).
- scenes involving attempted escapes, flights through the woods pursued by baying dogs, and the sorrowful or happy singing of slaves, in a novel about slavery. *Alexander v. Haley*, 460 F.Supp. 40 (S.D. N.Y. 1978).

- scenes involving hard-drinking Irish cops, drunks, prostitutes, vermin, and derelict cars, in a story about police work in the South Bronx. *Walker v. Time-Life Films*, 784 F.2d 44 (2d Cir. 1986).

- scenes involving treasure hidden in a cave inhabited by snakes, the use of fire to repel the snakes, and seeking solace in a tavern, in the movie *Raiders of the Lost Ark*. *Zambito v. Paramount Pictures*, 613 F.Supp. 1107 (E.D. N.Y. 1985).

However, to the extent they are original, the particular words an author uses to describe or narrate a *scène à faire* are protected by copyright, even though the idea for the scene is not. Thus, although any author can write a police novel that includes a scene involving a high-speed chase, he could not copy the words another author used to describe a similar chase in a previously published police novel.

6. Literary Devices

Literary devices such as the story-within-a-story, flashbacks, the epistolary novel (novels consisting of fictional letters), stream of consciousness, prosodic forms, and rhetorical devices such as alliteration, are all unprotectable ideas. These and most other literary devices are all in the public domain. Only the particular way an author uses such a device is copyrighted, not the device itself.

D. Unprotected Elements in Works of Fact

Works of fact include histories, biographies, political science, philosophy, law, the social and hard sciences, reference works, and similar works. This includes not just books devoted to these subjects, but magazines, journals, and periodicals as well. There are elements contained in works of fact that are in the public domain.

1. Research

The facts that an author discovers in the course of research are in the public domain, free to all. This is so even if an author spends considerable effort conducting the research. Copyright does not protect the fruits of creative research, no matter how grueling or time-consuming the research may have been. Copyright only protects the way an author expresses the facts.

EXAMPLE: Otto Eisenschiml, a renowned Civil War historian, wrote a book on Abraham Lincoln's assassination. The book contained much original research, including facts obtained from police records that had never before been analyzed. Subsequently, a freelance writer wrote a magazine article on Lincoln's assassination that used many of the new facts unearthed by Eisenschiml. The freelancer could have

Reward poster; Rocking chair used by President Lincoln in Ford's Theater; President Lincoln's box at Ford's Theater, Old Ford's Theater, where Lincoln was assassinated; President Lincoln's funeral procession on Pennsylvania Avenue

examined the police records himself, but he didn't. He simply used in his own article the facts as represented by Eisenschiml. Eishenschiml sued the writer and magazine for copyright infringement and lost. The court held that the facts he had unearthed were in the public domain. *Eisenschiml v. Fawcett Publications*, 246 F.2d 598 (7th Cir. 1957).

2. Interpretations

An author's interpretation of facts is itself a fact (or a purported fact) that is deduced from other facts. Interpretations are therefore also in the public domain. This is so whether or not they are really true. For example, an author's theory that the *Hindenburg* dirigible crashed because of sabotage was held to be in the public domain. This meant that a screenwriter was free to write a screenplay based on the idea that the *Hindenburg* blew up due to sabotage. *Hoehling v. Universal City Studios*, 618 F.2d 972 (2d Cir. 1980).

3. Quotations

The author of a news story, biography, history, oral history, or similar work may not claim copyright ownership of statements made by others and quoted in the work. This is because a verbatim quotation of what someone else says is not original.

EXAMPLE: The author of a book about motion pictures conducted an interview with Michael Wayne, John Wayne's son, and included quotes from the interview in the book. Subsequently, *Newsweek* magazine published an obituary of Wayne that used some of these quotations. The author sued *Newsweek* for copyright infringement and lost. The court held that the author held no copyright in the quotations because they were not original—that is, the author didn't say them, Michael Wayne did. *Suid v. Newsweek Magazine*, 503 F.Supp. 146 (D. D.C. 1980).

However, this doesn't mean that quotations are always in the public domain. If the quote is written down or otherwise recorded with the speaker's authorization, federal copyright law protects it.

Typically, the person who writes down or records the speaker's words will have the speaker's permission to use the quotes. Such permission may be express or implied by the fact that the speaker consented to an interview. In some cases, the interview subject may transfer his or her copyright rights to the interviewer. A written transfer agreement must be signed to accomplish this.

EXAMPLE: In the case involving Michael Wayne mentioned above, the author had Wayne sign a release giving him the right to use Wayne's words in his book. Michael Wayne could have sued *Newsweek* for copying his words without permission. However, it's highly likely such a lawsuit would have been unsuccessful. News organizations have broad latitude under the fair use privilege to use quotations without permission.

In addition, a conversation reconstructed by an author from memory, rather than quoted verbatim from written notes or a recording, may be protectable by the author (not the person who made the original remarks) if some originality was involved in reconstructing the conversation. *Harris v. Miller*, 50 U.S.P.Q. 306 (S.D. N.Y. 1941).

EXAMPLE: Imagine that a famous writer named Evelyn writes a memoir about her experiences over many decades. She discusses all the famous writers and other interesting people she has known. She also includes in her book many fascinating and witty conversations she has had with the great and near-great. However, none of these conversations contain verbatim quotations. Rather, she has reconstructed them from memory. She has embellished or even made

up the words in these reconstructed conversations. Evelyn is entitled to a copyright in these reconstructions.

If a person creates a book of quotations that are in the public domain because they are copied from public domain books, articles, and other sources, the book may be a copyrighted compilation, although the individual quotations are not protected. *Quinto v. Legal Times of Washington*, 506 F.Supp. 554 (D. D.C. 1981). One or more of the individual quotations in such a book could be copied without the compiler's permission, but verbatim copying of the entire book would infringe on the compiler's copyright.

There are many instances where quotations *are* in the public domain. For example:

- A quotation by a federal government employee spoken as part of his duties is in the public domain. (See Chapter 3, Section C2). This includes official speeches by the president and members of Congress.
- Quotations that are written down and published enter the public domain when the copyright in the published work expires (see Chapter 18) or, in some cases, if the work is published without a valid copyright notice (see Chapter 19).
- Quotations that are simply short phrases may also be in the public domain (see Chapter 3).
- Quotations from public domain sources—for example, from a book whose copyright has expired, such as

Even if you are on the right track, you'll get run over if you just sit there.

Will Rogers, Illustration from *864 Humorous Cuts from the Twenties and Thirties*, Dover Publications

the King James Version of the Bible—are in the public domain. Republishing them in a new work does not revive their copyright.

In addition, for a quotation to be copyrightable, it must be written down or recorded *with the speaker's authorization.* A quotation recorded without the speaker's authorization is not protected by copyright. Good examples are the many phone conversations Linda Tripp had with Monica Lewinsky that Tripp secretly recorded without Lewinsky's permission. Lewinsky's portions of these conversations are not protected by copyright. Unless they can be protected under state law (see below), they are in the public domain.

The above discussion applies only to quotations that are written down or otherwise recorded. What about things people say that are not written down or recorded at the time or soon after? Are they entitled to any legal protection? The federal copyright laws do not protect a quotation that is spoken by someone but not recorded in any way, but it might be protected under state law. State copyright laws, also called common law copyright, can protect works of authorship that have never been written down or otherwise fixed in a tangible medium of expression (see Chapter 2, Section A4a).

However, the extent of such protection is far from clear. Several state courts have been reluctant to extend such protection very far. For example, a New York state court refused to give state law protection to a conversation the author Ernest Hemingway had with his biographer A.E. Hotchner, which Hotchner reproduced in the book *Papa Hemingway* many years after Hemingway's death. The court held that for an oral statement to be protected by state law, the speaker would have to "mark off the utterance in question from the ordinary stream of speech" and indicate that he or she wished to exercise control over its publication. *Hemingway v. Random House*, 296 N.Y.S. 2d 771, (N.Y. 1969). Of course, people rarely do this in ordinary conversation.

When people testify in court, is their testimony in the public domain or is it protected by copyright? There is no clear answer to this question. It is clear that a court reporter who takes down a verbatim transcript of court testimony has no copyright in the transcript. Making such a transcript is a purely mechanical act that does not qualify as authorship for copyright purposes. *Lipman v. Mass.*, 475 F.2d 565 (1st Cir. 1973). So does the person who testified own a copyright in his or her words? If the testifier was a federal employee or official and the testimony was given as part of his or her job—for example, court testimony by an FBI agent—the testimony would definitely be in the public domain (see Chapter 3, Section C2). But if the testifier was not a federal official, it's not clear whether he or she could hold a copyright in the testimony. Some copyright experts believe that such testimony should be in the public domain because it is a public document, but no court has ever held this way. However, court testimony is commonly copied and published in newspapers, magazines, books, on websites, and other places. Such copying almost certainly qualifies as a fair use. (See Chapter 22 for a detailed discussion of fair use.)

The extent of legal protection for quotations that have never been written down or recorded is a gray area of the law. See Chapter 1 for a detailed discussion about how to deal with such public domain gray areas.

4. Fictional Elements

Fictional elements in otherwise factual works are entitled to full copyright protection. For example, a biographer who finds his subject's actual life story boring and embellishes his biography with a fictional love affair is entitled to copyright protection for the fictional portions of the work. *DeAcosta v. Brown*, 146 F.2d 408 (2d Cir. 1944).

However, if an author represents his work to be completely factual, he may not bring a copyright infringement suit against someone who relied on that representation and copied a portion of it thinking it was unprotectable fact when it was really protectable fiction. In other words, an author cannot trick the public into thinking that a fictional element is really factual and then sue for copyright infringement. *Houts v. Universal City Studios*, 603 F.Supp. 26 (C.D. Cal. 1984).

If the work involved is a news story, there need be no express statement in the story that it is completely factual. News stories are presumed by the public to be factual. *Davies v. Bowes*, 209 Fed. 53 (S.D. N.Y. 1913). But, if the work is a history

or biography, the author must expressly state that the work is completely factual. For example, the author of a biography of Wyatt Earp was not allowed to sue for copyright infringement when someone copied fictional elements contained in the biography because the book stated that it was "in no part a mythic tale." *Lake v. CBS*, 104 F.Supp. 707 (S.D. Cal. 1956).

This means that if the author of a history, biography, or other nonfiction work does *not* expressly state that the work is completely factual, a person who copies fictional elements from such a work could be liable for copyright infringement. One way to avoid such liability, of course, is to double-check the author's work to make sure you are only using facts.

5. Organization of Material

To write a factual work, the author must select and arrange the factual material. The facts themselves are in the public domain, but the author's selection and arrangement of them can be copyrightable if it's original.

However, where the range of choices available to an author as to how to arrange the work is severely limited, there will be little or no copyright protection for the arrangement. For example, an author of a work of history who selects and arranges the historical facts in chronological order cannot claim copyright in such arrangement. Obviously, any other historian who wishes to write about the same events in chronological order—the most common method of organizing historical material—must follow a similar or identical selection and arrangement. Moreover, an historical chronology is itself a fact that is not copyrightable. *Norman v. CBS*, 333 F.Supp. 788 (S.D. N.Y. 1978).

But, an historian who writes about an event in an unconventional—that is, a non-chronological—way, could likely claim copyright protection for his selection and arrangement. For example, if an author writes a history of the kings and queens of England and organizes the material on the basis of the monarchs' astrological signs, this eccentric selection and arrangement would likely be copyrightable. If a second author copied this same selection and arrangement, he would likely be guilty of copyright infringement. ∎

Chapter 15

Copyrights Restored From the Public Domain

On January 1, 1996 something unprecedented in the history of American copyright law occurred. Because of an international trade treaty called GATT, millions of foreign works in the U.S. public domain had their copyrights restored. In other words, many works first published outside the United States were withdrawn from the public domain.

Among the foreign works whose copyright protection was restored were many masterpieces of world cinema, including *Grand Illusion* (France, 1937), *Breathless* (France, 1959), *The Bicycle Thief* (Italy, 1949), *The Blue Angel* (Germany, 1931), and *The Third Man* (United Kingdom, 1949).

Untold thousands of foreign musical works that used to be in the public domain in the United States also had their protection restored. This includes virtually the complete works of the great Soviet composers Sergei Prokofiev, Aram Khachaturian, and Dimitri Shostakovich.

No one can even guess how many foreign written works have had their copyrights restored, but the number must be enormous.

You need to clearly understand which foreign works have had their copyrights restored before you can conclude that any work first published outside the United States is in the public domain in the United States.

If the work you're interested in was first published in the United States, it doesn't qualify for copyright restoration and you don't have to read this chapter. Nor does copyright restoration apply to any unpublished work.

A. The GATT Agreement

The copyright restoration came about as a result of longtime efforts by the U.S. government to enter into comprehensive international trade agreements reducing or eliminating tariffs and otherwise freeing up world trade. In 1994, the United States signed the General Agreement on Tariffs and Trade (known as GATT), an extensive international treaty dealing with many aspects of international trade. The GATT agreement required that the United States restore copyright protection for foreign works that had entered the public domain because the foreign copyright owners failed to comply with certain copyright formalities or because the United States had no copyright relations with the foreign country where the work was published.

The U.S. copyright law has, in fact, been rewritten to implement this provision, and works meeting the GATT requirements had their copyrights automatically restored on January 1, 1996.

B. What Works Were Restored?

Foreign works in the public domain as of January 1, 1996 qualified for copyright restoration if they were published:

- between January 1, 1923 and March 1, 1989 without a proper copyright notice (see Chapter 19), or
- during the years 1923-1963 but never had their copyrights renewed by filing an application with the U.S. Copyright Office during the 28th year after publication (see Chapter 21), or
- in countries with which the United States had no copyright relations.

1. Three Requirements for Restoration

Any foreign published work falling into any one of the three categories listed above had its U.S. copyright automatically restored on January 1, 1996 if:

- it had at least one author who was a citizen or resident of a country other than the United States that has copyright relations with the United States, which includes all the countries of the world except for those listed in Section C4 below.
- it was *first* published in a country with which the United States has copyright relations, but not published in the United States within 30 days following the foreign publication, and

- its copyright protection had not expired under the copyright laws of the country of foreign publication as of January 1, 1996 (see below).

Works meeting these requirements receive the same term of copyright protection in the United States that they would have had if they had never entered the public domain.

EXAMPLE: Assume that in 1950, Thames Press, a British publisher, published in Great Britain a novel called *Sticky Wicket*, by the English writer John Jones. Thames failed to file a renewal registration for the book in 1978, and as result it entered the public domain in the United States on January 1, 1979. However, the U.S. copyright in the book was automatically restored by the GATT agreement on January 1, 1996. This is because the work was written by a British subject, first published in a country with which the United States has copyright relations, and the British copyright on the book had not expired as of 1995, because British copyrights last for the life of the author plus 70 years.

The book receives the same term of copyright protection in the United States that it would have had a renewal been filed on time—a term of 95 years from the date of publication. The novel will be protected by copyright in the United States until December 31, 2045.

Where a Work Was First Published

Copyright restoration applies only to works first published outside the United States. There is no single source for finding where a work was first published. You may have to look in a variety of places and do extensive research. There is no one best way to make this determination. How you go about your research depends on the type of work involved, how much time you have, and whether you have access to the Internet. Here are some useful resources and techniques you can use:

Examine the work. If possible, obtain a copy of the work and examine it carefully. Books, magazines, newspapers, sheet music, films, maps, and other published works often say where they were published or printed. But even if the work you obtain shows it was published in the United States, it may not have been originally published there. Many works initially published outside the United States are republished in the United States. Very often, the work will indicate where it was first published.

If the work is in a language other than English or was translated into English from a foreign language, it likely was first published outside the United States; but this isn't always the case.

Check library catalogues. You may be able to determine whether a work was published by checking the Library of Congress Online Catalog at http://catalog.loc.gov. The catalogue contains over 12 million records for books, magazines, newspapers, and other serials, cartographic materials, music, and visual materials in the Library's collection. The Library's records typically give a work's country of publication.

Check Copyright Office records. If the work was registered with the U.S. Copyright Office, checking Copyright Office registration records will reveal in what country it was first published. Many of these records can be researched online. (See Chapter 21.) However, not all published works are registered with the Copyright Office, so there may be no record for it.

Check reference works. There are hundreds of reference works that may be able to tell you where a work was published. For example, in the realm of literature these include such works as *Contemporary Authors*, *Contemporary Literary Criticism*, and the *Dictionary of Literary Biography*, all published by Gale Research. Go to a public or university library with a good reference section and ask the reference librarian for assistance. If you're too busy to go to a library, you can post your research questions on the Internet at www.ipl.org and a reference librarian will email you with advice.

Research the author. Researching the author of the work may reveal where the work was published. First, determine the author's home country. Works by authors who are not U.S. citizens or residents are

Where a Work Was First Published (continued)

typically first published outside the United States and vice versa. However, this isn't always the case. If the author is well-known, a biography or critical study may have a detailed publication history for his or her works.

Use the Internet. Many helpful reference works and information about authors and their works are available on the Internet. Do a Web search using the author's name, the name of the work involved, and the publisher. There may be a website devoted to the author or even to the particular work, or some online reference with detailed information about the work. Other specialized websites may prove helpful. For example, the Internet Movie Database at www.imdb.com lists the country of origin for most theatrical films. A good place to find a list of Internet reference resources is the Internet Public Library at www.ipl.org.

Contact the publisher. Contact the work's publisher and ask them to tell you if the work was first published in the United States or abroad.

No Restoration for Works by Americans

The copyright restoration law applies only to works with at least one non-American author. Works authored solely by Americans don't qualify, even if they were first published outside the U.S. An American photographer named George Barris found this out the hard way. In 1962, he took a series of photographs of Marilyn Monroe which were published that year in the British newspaper *The Daily Mirror*. Two or three years later an American artist used the photos without Barris's permission in a collage. Unfortunately, Barris never timely renewed the photos. So, by the time he got around to suing the artist and others for copyright infringement in the late 1990s, his photos had entered the public domain in the United States. The restoration law didn't help Barris because he was an American. Had he been British (or any other non-American), the copyright in the photos would have been restored on Jan. 1, 1996 and he could have had a successful lawsuit. Who said life was fair? *Barris v. Hamilton*, 51 U.S.P.Q. 2d 1191 (S.D. N.Y. 1999).

A Useful Rule of Thumb: It's *very* likely that any work first published within the last 50 years in any foreign country other than those listed in Section C4 qualifies for copyright restoration. You can assume that such works are not in the public domain. Or, if you wish, you can research the work's publishing history to make sure.

2. How Many Works Have Been Restored?

Nobody has any idea of the exact number of foreign works that had their U.S. copyrights restored, but the number is large. This is because substantial numbers of foreign copyright owners failed to comply with U.S. copyright formalities. Foreign authors and publishers often failed to place copyright notices on their published works, since notices have never been required in most foreign countries. Even more common, however, they failed to renew works published before 1964. Renewal was required even for works published outside the U.S. The Copyright Office estimates that only about 15% of pre-1964 published works were ever renewed. The percentage may be even lower for foreign works. The result of this noncompliance with U.S. copyright formalities was that millions of foreign works entered the U.S. public domain even though they were still protected in their home countries and most other countries.

Moreover, a surprisingly large number of works were in the public domain in the United States because it had no copyright relations with the country of publication. For example, until 1973 the United States had no copyright relations with the Soviet Union. All works published before 1973 in the Soviet Union were in the public domain in the United States. Most of these works have now had their copyrights restored.

You can visit the Copyright Office website at www.copyright.gov and view lists the Copyright Office has compiled of some of the works whose copyrights have been restored. These lists were complied from legal notices that foreign copyright owners filed with the Copyright Office informing the Office and the world that they intended to enforce their newly restored copyrights (see Section E2). Most of the works on the lists are foreign films and musical works. However, these lists represent only a tiny fraction of all the foreign works whose copyrights have been restored.

C. Which Works Were Not Restored?

Don't get the idea that *every* foreign work has had its U.S. copyright restored. Millions of foreign works are still in the public domain in the United States. These include the following:

1. Works in the Public Domain for Reasons Other Than Noncompliance With Formalities

The only foreign works whose copyright has been restored are those that were in the public domain due to failure to comply with copyright formalities such as copyright notice and renewal requirements; and those that never had copyright protection because

they were published in countries with no copyright relations with the United States.

Works in the public domain for reasons other that these did not qualify for restoration. Two enormous groups of works fit into this category:

- Foreign works published before 1891, when the United States first started giving copyright protection to works published outside its borders.
- Foreign works that received a full term of U.S. copyright protection and had their copyrights expire in the normal course of events. This includes any work first published outside the United States during 1891 through July 1, 1909 and many published during July 1, 1909 through December 31, 1922.

L'absinthe (1876) by Edgar Degas (1834–1917)

See Chapter 16 for a detailed discussion of copyright terms for foreign works.

2. Works in the Public Domain in Their Home Countries

Another significant group of foreign works that does not qualify for copyright restoration is works whose copyright expired in their home countries as of January 1, 1996, the date U.S. copyright restoration took effect.

To know if this exception applies, you need to know the copyright term of the foreign author's country. You also need to know when the author died. This is because, in most foreign countries, the copyright terms for most works last for a given number of years after the author dies.

Copyright terms differ from country to country, and also differ according to the type of work involved. However, copyrights last for at least 50 years in almost all foreign countries, so this exception could only apply to works published before 1946. In the case of most individually authored works such as books, music, and art, copyrights in most countries last for the life of the author plus 50 years, or the life of the author plus 70 years.

EXAMPLE: Ken published a song with a copyright notice in Canada in 1940. The song was never renewed and so entered the public domain in the United States on January 1, 1969. Ken died in 1942, so the song entered the public domain in Canada on January

1, 1993 because copyrights last for the life of the author plus 50 years in Canada. Because the song was in the public domain in Canada on January 1, 1996 it didn't qualify for U.S. copyright restoration. It remains in the public domain in the United States.

Unlike Canada, virtually all Western European countries extend copyright protection for 70 years after an author dies. So this exception would apply only to works published by most European authors who died before 1926.

See Chapter 16 for a detailed discussion of foreign copyright terms.

3. Works Simultaneously Published in the U.S. and Abroad

Before 1989, U.S. publishers could obtain copyright protection in many foreign countries only by publishing a work simultaneously at home and in a foreign country that had signed a major international copyright treaty called the Berne Convention. The work had to be published in both countries within 30 days. American publishers commonly had their works published simultaneously in the United States and Canada or Great Britain. This fact was usually indicated on the same page as the copyright notice. These works do not qualify for copyright restoration because they are really American works that were also published abroad.

4. Works Published in Countries With No U.S. Copyright Relations

Works published in almost all foreign countries are entitled to full U.S. copyright protection. However, there are a handful of countries with which the United States has no copyright relations. These are:

Afghanistan	Iraq
Bhutan	Nepal
Ethiopia	Oman
Iran	San Marino

A work first published in any of these countries by a citizen or resident of any of these countries is not entitled to U.S. copyright protection. Nor does it qualify for copyright restoration. In other words, it is in the public domain.

Painting by Ostad Ali Asghar Tajvidi, 1300s

5. Works That Were Property of the Alien Property Custodian

There is one more extremely obscure group of works that have not had their copyrights restored. These are works that were at any time owned or administered by the Alien Property Custodian and whose copyright a foreign government owned. 17 U.S.C. Section 104A(a)(1)(B)(2).

You need to read this section only if you're interested in World War II era materials, such as German or Japanese propaganda films. If not, you can skip to Section D below.

You need to know a little history to understand this exception. Following World War II, the U.S. government seized hundreds of thousands of works from Germany, Japan, and other enemy countries. These consisted of such things as propaganda films and government and military records. Congress transferred copyright ownership in these works to the U.S. Attorney General and the Alien Property Custodian administered them. In 1962, most of these items were returned to their countries of origin, though the Library of Congress retained copies of many films.

Many of these items entered the U.S. public domain because their copyrights were never renewed. Such items do not qualify for copyright restoration if a foreign government, rather than an individual, would own the restored copyright. For

example, a Nazi propaganda film that was seized in 1945 and not renewed on time in 1973 would not qualify for restoration if the copyright in the film was in the name of the German government. The reason for this rule is to prevent Germany, Japan, and our other former World War II enemies from using copyright to suppress or prevent public access to these war-related materials, many of which are very embarrassing or painful to these countries.

Determining whether a particular work falls within the exception is complicated. But you don't have to worry about it unless you are first able to obtain access to such World War II materials. If you find such materials in an archive, library, or private collection, the first thing you should do is check U.S. Copyright Office renewal records to see if the item has been renewed and, if so, whether the renewal copyright is owned by an individual or a foreign government. You can search these records online from your computer if you have an Internet connection. See Chapter 21 for a detailed discussion of how to do renewal searches.

If the work was renewed by and owned by a private individual or company, it's not in the public domain. If there is no renewal record or the renewal claimant is Germany, Japan, or another one of our former World War II enemies, this exception may apply. In this event, you have to determine:

1. whether the item was held or administered by the Alien Property Custodian, and

2. whether the restored copyright would be owned by a foreign government.

First, see if the Alien Property Custodian ever held the item. Unfortunately, there is no single list of all the works administered by the Alien Property Custodian. However, the following resources are available at the U.S. Copyright Office or Library of Congress in Washington, DC.:

- the *Annual Reports of the U.S. Office of Alien Property, 1942-1949*, on file at the Copyright Office, and
- a list called *Motion Pictures of German Origin Subject to Jurisdiction of the Office of Alien Property*, on file at the Motion Picture, Broadcasting, and Recorded Sound Division of the Library of Congress.

In addition, you can conduct searches under "Alien Property Custodian" in the Copyright Office online Documents File.

If the Alien Property Custodian held the item, you must next determine if the copyright is owned by the government of the former enemy country involved or by a private individual or company. The place where you found the item—whether a library, archive, or collector—may be able to help you. There may also be government war records or copyright records you can search.

If you determine that the copyright in the work you are considering is privately owned, you must then consult the laws of the foreign country involved to see if the copyright is still in effect.

D. Who Owns Restored Works?

The author initially owns the U.S. copyright in a restored work. The laws of the country where the work was first published defined who the author is. If the author died before January 1, 1996 ownership is determined under the inheritance laws of the author's country. U.S. federal courts, applying the law of the country of origin, decide disputes concerning initial ownership of restored foreign copyrights.

If the author at any time assigned, licensed, or otherwise transferred all or part of his or her rights, the transfer is supposed to be given effect according to the terms of the agreement. Disputes concerning copyright transfers must be resolved in U.S. state courts applying U.S. copyright law.

E. Copyright Infringement of Restored Works

No one can use a restored work *for the first time* after January 1, 1996 without obtaining the copyright owner's permission. "Use" means exercising any of the copyright owner's exclusive rights to copy, distribute, create derivative works from, or publicly display or perform the work. The owner of a restored work can bring a copyright infringement action against anyone who unlawfully uses the work after January 1, 1996 just as for any other work still under copyright.

But what if you used a restored foreign work before January 1, 1996, when it was in the public domain? There's no need to worry about this. You aren't liable for any uses you made of the work before 1996.

1. Liability for Continuing to Use Restored Works

Things are more complicated, however, if businesses or people used a restored work without permission before January 1, 1996 and *continued to use the work in the same way* after that date. Such people are called "reliance parties." They can't be sued for copyright infringement unless:

- the owner of the restored copyright sends them directly a Notice of Intent to Enforce Copyright, or
- the owner filed such a notice with the Copyright Office between 1996 and 1997 when such notices were permitted to be filed there.

The filing of a Notice of Intent to Enforce Copyright starts a 12-month clock running, during which time the copyright owner is not allowed to enforce the copyright against the reliance party. During this 12-month period, the reliance party may sell off previously manufactured stock, publicly perform or display the work, or authorize others to do so. A reliance party cannot make new copies of the restored work during this period or use it differently than it was used before January 1, 1996, unless permission is obtained from the work's copyright owner.

After the 12 months are up, the reliance party must stop using the restored work unless a licensing agreement is reached with the copyright owner for continued use of the work. If the copyright owner filed the Notice of Intent to Enforce Copyright with the Copyright Office between 1996 and 1997, the 12-month period is already up.

If a licensing agreement is not reached and the reliance party continues to use the restored work, the copyright owner can sue for copyright infringement for any unauthorized uses occurring after the 12-month period expires. But a copyright owner cannot sue a reliance party for any unauthorized uses that occurred before the 12-month notice period ended, provided the party used the work the same way before January 1, 1996.

However, the rules are different if the reliance party created a derivative work from the restored work while it was in the public domain. In this event, the reliance party may continue to exploit the derivative work—and may do so forever, even after being sent a Notice of Intent to Enforce Copyright. But the reliance party must pay the copyright owner of the restored work a reasonable license fee for using the work after its copyright was restored. This is a mandatory license—that is, the owner of the restored work must let the reliance party exploit the derivative work so long as it is compensated.

EXAMPLE: In the 1950s, a Danish woodcarver named Thomas Dam created a troll doll out of rubber for his daughter. The doll proved very popular with children, and Dam eventually opened his own factory to manufacture and sell it. He exported the doll into the U.S. in 1961. Unfortunately, proper copyright notice was not included on the dolls and as a result they entered the public domain in the U.S. under the law then in effect. A few years later, Russ Berrie began manufacturing and selling a very similar troll doll in the U.S. The Danish company that manufactured the authorized Dam trolls could do nothing about it at the time because the Dam troll doll was public domain in the U.S. On Jan. 1, 1996 the U.S. copyright in the Dam troll doll was automatically restored. On Feb. 13, 2001 Dam gave Berrie a Notice of Intent to Enforce Copyright in the doll, and litigation ensued. The trial court held that the copyright in the doll had been restored and therefore Berrie had to stop selling his troll doll after Feb. 13, 2002 one year after it received Dam's Notice. Berrie appealed, and the court agreed that Dam's U.S. copyright in the troll doll had been restored. However, the court threw a wrench in the works because it held that it was unclear whether Berrie's troll doll was a derivative work based upon Dam's original troll doll. If true, this meant Berrie could continue to sell his doll in the U.S., but would have to pay Dam reasonable compensation for its mandatory license. The matter was sent back to a trial court for a determination as to whether Berrie's doll was a derivative work, and the parties eventually settled. *Dam Things from Denmark v. Russ Berrie & Co., Inc.*, 290 F.3d 548 (3d Cir. 2002).

2. Notice of Intent to Enforce Copyright to Reliance Parties

As discussed above, the owner of a restored work has no rights against a reliance party unless a Notice of Intent to Enforce Copyright (NIE) is sent to them or unless the owner filed an NIE with the copyright office during the years 1996-1998.

EXAMPLE: In 1960, Thomas Hoepker, a German artist, photographed a woman holding a large magnifying glass over her left eye. The photo was published in Germany in 1960, but the U.S. copyright in the photo was never renewed; thus, it entered the U.S. public domain on Jan. 1, 1989, 28 years after publication. In 1990, Barbara Kruger, an American collage artist, used a copy of the photo in a collage. In 2000, Hoepker filed a copyright infringement suit against Kruger and a museum that had licensed her work. He lost, even though the U.S. copyright

in his photo was automatically restored on Jan. 1, 1996. The reason was that Kruger was a "reliance party"—that is, she had used the photo while it was in the public domain in the U.S. and then continued to use it after the copyright was restored. As such, she could be liable for infringing the photo only if she was given notice by Hoepker of his intent to enforce his restored copyright, and only for infringing acts occurring 12 months or more after such notice was given. Hoepker never gave Kruger or the museum such notice. Therefore, neither Kruger nor the museum were liable for copyright infringement. *Hoepker v. Kruger*, 200 F.Supp.2d 340 (S.D. N.Y. 2002).

An NIE is a short document identifying the title and owner of the work that has had its copyright restored. A sample NIE is reproduced below.

As of the time you're reading this book, the NIE must be sent directly to the reliance party. The Copyright Office no longer accepts NIEs. NIEs can be sent to reliance parties until the end of the U.S. copyright term for the restored work. After that date, the U.S. copyright expires and the work re-enters the public domain.

It is not necessary to file an NIE to have the copyright in a foreign work restored. As explained above, they only need be filed to obtain legal rights against people who used the restored work before January 1, 1996 when it was in the public domain.

What to Do If You're a Reliance Party

If you're a reliance party—here's what you should do:

First, check Copyright Office records to see if the owner of the work filed an NIE with the Copyright Office during 1996-1997. The Copyright Office has posted a list of all filed NIEs on its website at www .copyright.gov. You can also search for them by using the Copyright Office's online database, which is accessed from the same website.

If an NIE has been filed, stop using the work. You'll be liable for any unauthorized uses of the work that occurred 12 months after the NIE was filed, even though you were not aware of the filing. You could seek out the copyright owners of the restored work and obtain their permission to use it again. Be aware, however, that this could bring your infringement to the owners' attention and open you up to a lawsuit if you can't reach an agreement on licensing the work.

If no NIE was filed with the Copyright Office or sent to you directly, you may decide to continue to use the restored work. But you must use it in the *exact* same way as you did before 1996. You won't be liable for that kind of use until one year after the copyright owner sends you an NIE, if they ever do. Alternatively, you may stop using the work or obtain permission from the copyright owner to continue using it.

Notice of Intent to Enforce a Copyright Restored
Under the Uruguay Round Agreements Act (URAA)

1. Title: <u>Sticky Wicket</u>

 (If this work does not have a title, state "No title.")

 OR

 Brief description of work (for untitled works only).

2. English translation of title (if applicable):

3. Alternative title(s) (if any):

4. Type of work (e.g., painting, sculpture, music, motion picture, sound recording, book):

 <u>book</u>

5. Name of author(s)

 <u>Eric Blair</u>

6. Source country: _____<u>United Kingdom</u>_____

7. Approximate year of publication: ___<u>1935</u>___

8. Additional identifying information (e.g., for movies: director, leading actors, screenwriter, animator; for photographs: subject matter; for books: editor, publisher, contributors, subject matter):

 <u>Published by Thames Press</u>

 <u>Edited by John Malcolm</u>

9. Name of copyright owner (statements may be filed in the name of the owner of the restored copyright or the owner of an exclusive right therein):

 <u>Sally Blair</u>

10. If you are not the owner of all rights, specify the rights you own (e.g., the right to reproduce/distribute/publicly display/publicly perform the work, or to prepare a derivative work based on the work).

11. Address at which copyright owner may be contacted. (Give the complete address, including the country, and an "attention" line, or "in care of" name, if necessary.)

Sally Blair

123 Mayfield Road

Walton-on-Thames, Surrey

United Kingdom

12. Telephone number of owner: 123-555-6789

13. Telefax number of owner: 123-555-8900

14. Certification and signature

I hereby certify that, for each of the work(s) listed above, I am the copyright owner, or the owner of an exclusive right, or one's authorized agent, the agency relationship having been constituted in a writing signed by the owner before the filing of this notice, and that the information given herein is true and correct to the best of my knowledge.

Signature: Sally Blair

Name (printed or typed): Sally Blair

As agent for (if applicable): _____

Date: 2/1/99

Note: Notices of Intent to Enforce must be in English, except for the original title, and either typed or printed by hand legibly in dark, preferably black, ink. They must be on 8 1/2" and 11" white paper of good quality, with at least a one-inch (or three cm) margin.

Chapter 16

The Public Domain Outside the United States

To explain the rules of copyright around the world would take a whole book. Here, we give you a general idea of how long copyright lasts in most major countries and explain why many works created in the United States are still under copyright here, but in the public domain outside the United States.

⚠️ **If You Want to Know Whether a Work Is in the Public Domain in a Foreign Country You Must Research That Country's Copyright Laws.** You can do this yourself with the aid of the resources listed in Section D below, or hire an experienced international copyright attorney to help you.

A. Introduction

There is no single international copyright law that applies in all the countries of the world. Instead, each country has its own copyright law that operates within its own borders. However, through a series of international treaties, almost every nation has agreed to give citizens of other nations the same protection they give their own citizens.

This means that you must look at the laws of the country where you want to use the work to determine whether it is in the public domain. For example, if you want know whether a book published in Germany in 1925 is in the public domain in the United States, you must rely on U.S. copyright law for the answer. If you want to know whether the book is in the public domain in Germany, you must look to German copyright law. If you want to know whether the book is in the public domain in Canada, you must look to Canadian copyright law.

Because the copyright laws of various countries often differ dramatically, a work in the public domain in the United States is not necessarily in the public domain outside the United States.

1. Different Copyright Terms

In 1998, the United States amended its copyright law, bringing the length of copyright terms more in line with Western Europe (see Section B1). However, for works published before 1978, the U.S. copyright terms are still very different than most foreign terms. As a result, millions of works that are in the public domain in the United States are still under copyright in many foreign countries. For example, all the songs of Irving Berlin published before 1923 are in the public domain in the United States because the copyright has expired. However, all of these songs are still under copyright in Canada because Canadian copyright lasts for the life of the author plus 50 years (Berlin died in 1990). This means if you want to use the songs in Canada, you must obtain permission from Berlin's heirs.

There are also many works that are protected in the United States that are in

the public domain in many foreign countries because their copyrights have expired in those countries.

On the other hand, because of something called the rule of the shorter term, works that are in the public domain in the United States are automatically in the public domain in a number of foreign countries as well, including most of Western Europe. Countries that use the rule of the shorter term treat works in the public domain in the United States as in the public domain in their own countries as well (see Section C).

2. Different Coverage of Copyright Laws

There are also major differences in what can obtain copyright protection in the United States and many foreign countries. Here are just a few examples:

- U.S. government publications are in the public domain under U.S. copyright law, while many foreign governments, including the United Kingdom and Canada, claim copyright in their publications under their own copyright laws.
- In most of Western Europe, commercial databases are given a unique form of copyright protection prohibiting unauthorized extraction of the data for ten years. This is not the case under U.S. law, though Congress is currently considering similar legislation (see Chapter 12).

- In France, a building may not be photographed without permission from the architect, even though it's in public view. This is not the case in the United States (see Chapter 9).
- In many countries, including the United Kingdom and Italy, copyright protection is granted to new typefaces. If a public domain work is republished with a copyrighted typeface, the work may not be photocopied or otherwise reproduced in a manner that reproduces the typeface, although the words of the public domain work can be copied by hand or typed. U.S. copyright law does not protect typefaces (see Chapter 5).

3. Moral Rights

Another major difference between U.S. copyright law and the copyright laws of most foreign countries is what are called moral rights, which consist of:

- the right of integrity—the author's right to control alterations of his or her work and to prevent its destruction
- the right of paternity—the right to be recognized as author of a work, or, if the author so chooses, the right to disclaim authorship, and
- the right of divulgation (also called the right of dissemination), which is the author's right to decide when to release his or her work into the public arena.

Moral rights last at least as long as a work's copyright and in many countries they last longer. In numerous countries, the rights of integrity and paternity last forever.

For example, because of moral rights it may be illegal in some countries to:

- colorize a black and white movie, even if its copyright has expired
- republish a public domain work without identifying the author, or
- destroy or deface a work of art in the public domain.

United States copyright law gives some limited moral rights—the rights of attribution and paternity—to visual artists, but the rights don't apply to any works that are in the public domain in the United States.

Ordinarily, you don't need to worry about moral rights if you plan to republish a work that has been published and is now in the public domain in the country where you want to use it and you are careful to give credit to the author. However, if you plan to alter the work in any way, you could end up violating the author's moral rights unless you get permission for the changes.

Moral rights laws differ from country to country. To know how they may affect your use of a work in a particular country, you must research that country's copyright laws (or hire an attorney to do so for you). See Section D for a list of foreign copyright law resources.

Among the countries that recognize one or more of the moral rights described above are:

Argentina	Hungary
Australia	India
Belgium	Israel
Brazil	Italy
Canada	Japan
China	Netherlands
Czech Republic	Poland
France	Spain
Germany	Sweden
Greece	Switzerland
Hong Kong	United Kingdom

4. If a Work Is in the Public Domain in the United States but Not Abroad

What should you do if a work is in the public domain in the United States, but not in the public domain in a foreign country such as Canada or the United Kingdom? If you want to use the material copyrighted in that country, you'll have to get permission.

EXAMPLE: Repulsive Pictures creates a movie based on a play that is in the public domain in the United States, but not in Canada. Repulsive needs permission from the copyright owner of the play to distribute the movie in Canada.

If you fail to get such permission, you could be sued for copyright infringement in the foreign country. It might even be possible for the copyright owner to sue you in the

United States for violating his or her foreign copyright rights.

To avoid such potential legal liability, some companies won't sell copies of works in the U.S. public domain in the United States in foreign countries where they are still protected by copyright. For example, Dover Publications, Inc., a U.S. company that publishes many public domain works in the United States, won't ship such works to any country in which they still have copyright protection.

B. Copyright Duration in Other Countries

Almost all of the world's developed countries have signed an international copyright treaty called the Berne Convention, requiring them to grant copyright protection for 50 years after the author dies. However, this is a minimum requirement. Many countries grant authors much longer copyright terms.

This section explains the copyright terms of many of the largest countries. If the country you are interested in is not discussed here, refer to Section D below for resources you can use to learn about its copyright term, or consult with a copyright attorney.

1. European Union

The European Union (EU) is made up of most of the nations of Western Europe, including Austria, Belgium, Cyprus, Czech Republic, Denmark, Estonia, Finland, France, Germany, Greece, Hungary, Ireland, Italy, Latvia, Lithuania, Luxembourg, Malta, the Netherlands, Poland, Portugal, Slovakia, Slovenia, Spain, Sweden, and the United Kingdom.

The countries of the EU are in the process of integrating their economies and adopting a single currency. They are also standardizing (also called harmonizing) many aspects of their legal systems, including their copyright laws. Every EU country has its own copyright law, but they have all adopted a single set of copyright duration rules.

a. The Basic Copyright Terms

The copyright terms discussed below apply throughout the EU to any work authored by an EU national. It makes no difference if the work was published in an EU country, or a country outside the EU such as the United States. Thus, for example, a work published in the United States by a French national receives the same copyright term in the EU as if it were published in France or another EU country (but its copyright term in the United States would be determined under American, not EU, copyright law).

Works by Americans are also given these copyright terms within the EU unless the rule of the shorter term requires that the

U.S. copyright term be applied (see Section C). Subject to some minor variations, the copyright terms in all the EU countries are as follows (all terms run to the end of the calendar year):

- The general copyright term is the life of the author plus 70 years—this applies to both published and unpublished works. If a work has more than one author, the copyright term lasts for 70 years after the death of the last living author. If a work is published anonymously or if the author uses a pseudonym, the copyright lasts for 70 years from the date of publication. However, if the identity of the real author is not in doubt, the copyright protection lasts for 70 years after the author dies.
- The copyright in movies lasts for 70 years after the death of the last of the following people: the principal director, the author of the screenplay, the author of the dialogue, and the composer of any music created for the movie.
- Collective works such as magazines, periodicals, and encyclopedias are protected for 70 years from the date of publication. However, if the individual authors who have contributed to such a work are identified by name, the copyright continues until 70 years after the author's death. But, if the individual author was anonymous or used a pseudonym, the copyright lasts for 70 years from the date of publication, instead of 70 years from the author's death.
- If the copyright in an unpublished work has expired—because the author died over 70 years ago—the first person to publish the work is entitled to a copyright in the work that lasts for 25 years from the first publication. The copyright in media productions, such as performances, sound recordings, and broadcasts lasts for 50 years from the date of first publication. If a production is never published, the copyright lasts for 50 years after the production was made.

b. Wartime Extensions

Many of the EU countries were directly involved in both World War I and World War II. WWI lasted from August 1914 through November 1918. WWII in Europe lasted from September 1939 though May 1945. It was often difficult or impossible for authors and publishers to profit from their works during these war years. For this reason, many European countries granted special wartime extensions of their copyright terms.

For example, Belgium extended its copyright term by ten years in 1921, while Italian copyright law provides a six-year extension for works published before the end of WWII. Some of the EU countries eliminated these wartime extensions when they adopted the new standard EU copyright terms discussed above. However, others did not. It's unclear whether the

50-Year Public Domain Rule for Non-U.S. Sound Recordings

In the European Union (EU), Canada, Australia, and New Zealand the copyright in sound recordings lasts for 50 years after the recording is published; or, if it's never published, 50 years after the recording was made. Thus, all recordings made over 50 years ago are in the public domain in these countries. However, this doesn't mean that the music that was recorded is public domain. The copyright in a musical composition, as opposed to a recording, lasts for 70 years after the composer's death in the EU (50 years in Canada). Thus, the music on many old sound recordings is still under copyright in these countries, even though the recording itself is not. For example, a 1950 recording of a song by Irving Berlin would be in the public domain in the EU, but the song itself would not be public domain because Berlin died in 1989 (at the age of 101). Thus, anyone who wanted to copy the recording would need to get permission from the copyright owner of the song. But no permission would be needed from the former copyright owner of the recording for use in the EU since it is public domain there.

Recordings of musical compositions by composers who have been dead over 70 years are completely public domain in the EU. This includes, of course, a vast classical music repertoire. Thus, for example, famous recordings made in the early 1950s by legendary opera singer Maria Callas have, or soon will, enter the public domain in the EU. It's expected that several companies will publish these because they still sell extremely well. Early recordings by many post-World War II popular music greats such as Elvis Presley will also soon become public domain as well. However, the musical compositions Presley and the others recorded will remain copyrighted unless the composer is dead more than 70 years.

As you might expect, record companies are adamantly opposed to their recordings entering the public domain anywhere in the world. Music industry groups such as the Recording Industry Association of America are attempting to get the EU to extend the copyright in sound recordings beyond 50 years, and to make the extension retroactive. As of yet, they've proved unsuccessful.

What does this mean for people living in the U.S.? Theoretically, it will have no effect since the recordings involved are all still under copyright in the U.S. or protected by state law (see Chapter 4, Section K). As a practical matter, however, it's likely that many of these public domain recordings will be placed on the Internet in Europe and elsewhere; and it's hard to see how the RIAA or anyone else can stop Americans from downloading them, even though downloading into the U.S. from a foreign Internet server recordings that are copyrighted in the U.S. is likely a copyright infringement.

extensions are still enforced in these countries. The conservative approach is to assume that they are. It's advisable to be conservative. This way you know you won't be sued for copyright infringement in the foreign country.

This means you need to add ten years to the normal Belgian copyright term for works published before August 4, 1924. The Italian copyright terms for works published before 1946 need to be increased by six years. However, this applies only to works published by non-Italians.

France has the most complex wartime extensions. Works published before or during WWI receive an extension of six years and 152 days. Another extension covers WWII, and runs for eight years and 120 days. An additional extension of 30 years applies to authors who "died for France." An annotation to this effect must be on the deceased author's death certificate. These extensions must be added to the normal copyright term of 70 years after an author dies.

c. Restoration of Public Domain Works

Before the members of the EU harmonized their copyright terms in the late 1990s, most of the EU countries had copyright protection during the life of the author and for 50 years after his or her death. For example, this was the basic copyright term in the United Kingdom before January 1, 1996.

However, Germany had a much longer copyright term: The basic copyright term under German law was the life of the author plus 70 years after the author died. Germany refused to reduce its copyright term to the life of the author plus 50 years. So, to achieve a single uniform copyright term within the EU, the other EU countries had to change their copyright laws to match Germany's copyright term.

To achieve this uniformity, EU law requires that any work still under copyright in Germany on July 1, 1995 must be given the full German term of protection in every EU country. This is required even if it means restoring the copyright in a work that had previously entered the public domain. This required most of the EU countries to extend their copyright protection by 20 years.

EXAMPLE: All of the works of James Joyce entered the public domain in the United Kingdom and most of the rest of Europe on January 1, 1991 (Joyce died in 1941). However, Joyce's works were still under copyright in Germany on July 1, 1995 because Germany allowed copyright protection to extend for 70 years beyond the death of the author. Under EU law, this meant that Joyce's works were entitled to 70 years of copyright protection throughout the EU. As a result, the UK copyright in Joyce's works was restored on January 1, 1996 and will now last until December 31, 2011.

As a result of this change, millions of works that had been in the public domain in most EU countries have had their copyrights restored for an additional 20

years. To prevent this copyright restoration from causing economic hardship, the EU nations adopted special copyright provisions allowing the owners of copies of restored works to sell their stock and to continue to publish derivative works based on restored works. These provisions vary from country to country.

2. Canada

The basic copyright term in Canada ends 50 years after an author dies. If a work has more than one author, the copyright lasts for 50 years after the last author dies. All copyright terms last until the end of the year in which the author dies and then continue for an additional 50 calendar years. However, different terms apply to the works listed below.

a. Photographs

The term of protection for photographs depends upon the author. There are three possible terms of protection:

- First, where the author is a human being (as opposed to a business entity such as a corporation), the copyright lasts for 50 years after the author dies.
- If the author of a photograph is a corporation in which the majority of voting shares are owned by a human being who is the author of the photograph, the copyright lasts 50 years after the photographer dies.
- If the author of the photograph is a corporation in which the majority of voting shares are not owned by a human being who is the author of the photograph, the copyright lasts 50 years after the photo was taken or derived.

Canadian Rockies, copyright © 2000 by Terri Hearsh

b. Movies

Canadian copyright differentiates between films (including videos) that have a dramatic quality and those that do not. Films with dramatic quality usually have actors and tell stories. Theatrical films and videos ordinarily have dramatic quality. Examples of works that don't have a dramatic quality are home movies.

Films and videos made since 1944 that do not have a dramatic quality are protected for 50 years from the date of their creation. However, if they are published within 50 years from creation, the copyright lasts for 50 years from the date of publication. Films and videos of this type that were made before 1944 were protected for 50 years from the date of creation and are therefore in the public domain in Canada.

Films and videos that have a dramatic quality are protected for the life of the author plus 50 years. It's not entirely clear who the author of a film is under Canadian copyright law. It appears to be either the person who shoots the film or controls how it is shot. This could be the film director or producer. So if you are considering the use of a work that falls into this category, you should determine the years when all of these people died (if they have). Only if they have all been dead for over 50 years should you treat the film as in the Canadian public domain due to copyright expiration.

c. Sound Recordings

The copyright in a sound recording lasts for 50 years from the end of the year in which the original master or tape was created. But this does not mean that the composition played in the recording is in the public domain, since copyright protection for the sheet music lasts for the life of the author and for 50 years after his death. If you want to use a public domain recording, you may still need permission from the song's creator or owner.

d. Canadian Government Works

Works created by Canadian federal and provincial government employees are protected by Crown copyright. Copyright in these works lasts for 50 years from the year of creation. However, anyone may, without charge or request for permission, reproduce laws enacted by the Government of Canada, decisions and reasons for decisions of Canadian federal courts and administrative tribunals. The copier must exercise "due diligence"—in other words, reasonable care —to ensure the accuracy of the materials reproduced and that the reproduction is not represented as an official version.

e. Unknown Authors

The copyright in a work written by an anonymous or pseudonymous author lasts for either 50 years after publication or 75 years after creation, whichever is shorter. However, if the author's identity becomes known, the copyright will last for 50 years after the author dies.

f. Posthumous Works

Literary works, engravings, lectures, and dramatic or musical works that were unpublished or never performed in public when the author died receive a perpetual copyright term—that is, copyright protection lasts forever. However, if such works are published or performed in public after the author died, the copyright lasts for 50 years after the first publication or performance. Permission would be required from the dead author's heirs to publish or perform such works for the first time.

3. China

The basic copyright term in China lasts for the life of the author plus 50 years. If a work has more than one author, the copyright lasts for 50 years after the last author dies. The copyright in an anonymous or pseudonymous work lasts for 50 years from publication.

In cases where a copyright is owned by a business entity such as a corporation, the copyright lasts for 50 years from publication. If the work is never published, the copyright lasts for 50 years after it was created. These terms apply to works created by employees for their employers and works commissioned by business entities.

The copyright in a movie, television broadcast, or photograph lasts for 50 years from publication. If the work is never published, the copyrighted lasts for 50 years after it was created.

Sound recordings are protected for 50 years after publication. If a sound recording is never published, its copyright lasts for 50 years after it was created.

Computer software is eligible for two 25-year copyright terms, running from the year of publication. To obtain the second 25-year term, the copyright owner must apply to the Software Registration Organization for an extension of protection.

4. Japan

The basic copyright term in Japan is the life of the author plus 50 years. If a work has more than one author, the copyright lasts for 50 years after the last one dies.

The copyright in an anonymous or pseudonymous work lasts for 50 years from publication. But if the author's pseudonym is as well known as his real name, the normal term of 50 years after the author's death applies.

In cases where a copyright is owned by a business entity such as a corporation, the copyright lasts for 50 years from publication, or, if the work has not been published, 50 years from creation. This term applies to works created by employees for their employers and works commissioned by business entities.

The copyright in a movie lasts for 50 years after publication; or, if it's not published, 50 years from creation.

Photographs are protected for the life of the photographer and for 50 years after his death.

Sound recordings and television broadcasts are protected for 50 years after publication.

Finally, Japanese copyright provides an extension of copyright terms for works created or owned by nationals of the Allied Powers—that is, the nations who fought Japan in World War II. This extension applies to all works copyrighted when the war started—Dec. 7, 1941—or created or acquired during the war, which officially ended in September 1945.

Works created by Americans have their copyright protection extended by 3,794 days—for example, if a book was published in the United States during WWII, 3,794 days have to be added to the normal life-plus-50 Japanese copyright term. This means that such works are protected in Japan for the life of the American author plus 60.3 years, instead of life plus 50 years.

5. Russia

The basic copyright term in Russia is the life of the author plus 50 years. If there are two or more authors, copyright lasts until 50 years after the death of the last survivor.

The copyright for a work published anonymously or under a pseudonym lasts for 50 years after the date of its authorized publication. If the author's identity is revealed, copyright protection lasts for the life of the author plus 50 years more.

The copyright for a work published for the first time after the author's death lasts for 50 years after its publication.

During the rule of Soviet dictator Josef Stalin from the late 1920s until his death in 1953, millions of Soviet citizens were imprisoned, had their property confiscated, and were often murdered. After Stalin's death, many of these victims were rehabilitated—meaning they were allowed to rejoin Soviet society and their "crimes" were forgiven. Russian copyright law provides that if an author was repressed and rehabilitated posthumously, the applicable copyright period begins on January 1 of the year following the year of rehabilitation.

A Beauty, Kitagawa Utamaro (1753-1808), color woodblock

If the author worked during World War II or participated in it directly, the copyright protection period lasts throughout the author's life and for 54 years beyond his death.

C. The Rule of the Shorter Term

When it comes to calculating how long the copyright in a foreign work lasts, many countries use something called the "rule of the shorter term." This rule provides that copyright in a work created or published in a foreign country lasts the *shorter* of either:

1. the term the work receives in its home country, or
2. the term the work would receive under the laws of the foreign country involved.

> **EXAMPLE:** John wrote a song that was published in the United States in 1925. John died in 1930. John's heirs renewed the copyright in the song in 1953. The U.S. copyright in the song lasts for 95 years from the year of publication, or until 2020. Japan uses the rule of the shorter term. Under Japanese law, a song is protected for the life of the author plus 50 years. An addition 10.3 years must be added due to Japan's wartime extension of copyright terms. So under Japanese law, the copyright

in John's song expired in 1991. Since this term is shorter than the song's U.S. copyright term, it is the term that applies in Japan. As a result, the song in the public domain in Japan.

1. Impact of Rule on U.S. Works

A work created or first published in the United States that is now in the public domain in the United States will also be in the public domain in the many foreign countries that follow the rule of the shorter term. This will be the case even though the work would not be in the public domain under the foreign country's own copyright law.

For example, all works first published in the United States before 1923 are in the public domain in the United States and are, therefore, in the public domain in all the countries that follow the rule of the shorter term. Without the rule, many of these works would not be in the public domain in these foreign countries, based on their own copyright laws.

> **EXAMPLE:** Irving wrote and published a song in the United States in 1920. He died in 1960. The song entered the public domain in the United States on Jan. 1, 1996 (75 years after publication). The work is in the public domain in Italy as well because Italy follows

the rule of the shorter term. The U.S. copyright term for the song is shorter than the Italian term of life plus 70 years.

The rule of the shorter term is particularly important for works first published in the United States during the years 1923-1963 that were never renewed. These works entered the U.S. public domain on the 29th year after publication and will be in the public domain in countries that use the rule of the shorter term.

EXAMPLE: Nathaniel published a novel in the United States in 1950 but did not renew it 28 years after publication. As a result, the work entered the U.S. public domain in 1969. The work is in the public domain in France as well, even though a novel published in France in 1950 would not be in the public domain, since it would retain copyright protection for 70 years after the author dies. Because the novel was not renewed, the U.S. copyright term is far shorter than the French term.

2. Countries That Follow the Rule

The following chart lists many countries that do and don't use the rule of the shorter term.

Countries That Use the Rule of the Shorter Term	Countries That Don't Use the Rule of the Shorter Term
Argentina	Canada
Australia	China
Belgium	Switzerland
Brazil	United States
France	
Greece	
Hungary	
India	
Israel	
Italy	
Japan	
Netherlands	
Poland	
Spain	
Sweden	

3. Two Exceptions—The UK and Germany

Two significant EU countries—Germany and the United Kingdom—require special consideration.

The United Kingdom followed the rule of the shorter term before 1956. This means works published in the United States during 1923-1928 and not renewed on time are in the public domain in the UK. During the years 1956-1996, the UK didn't follow the rule of the shorter term. Starting in 1996, the UK began following the rule again. Works published in the United States during the

years 1929-1963 that were not renewed on time receive the copyright term the UK used before 1996. This is generally the life of the author plus 50 years. Thus, for example, if a work was originally published in the United States in 1930, not timely renewed 28 years after publication, and the author died in 1940, the work is in the public domain in the UK.

German law in this area is unclear because a number of complex and ambiguous German laws and treaties are involved and no German court has yet figured out how they should be interpreted. The rule of the shorter term may not be applicable to works published in the United States before Sept. 16, 1955 or even Sept. 16. 1965. However, no German court has ruled on this question. The conservative approach is to assume that the rule of the shorter term doesn't apply to any U.S. work. As a result, works not renewed in the United States would still be entitled to a full German copyright term.

One additional note: EU countries don't use the rule of the shorter term when determining the copyright term applicable to works authored by nationals of other EU countries.

D. Researching Foreign Copyright Laws

Following are some suggested resources you can use if you need to research the copyright law of a foreign country.

1. Books

The best book available in English on international copyright law is the two-volume treatise *International Copyright Protection*, edited by Paul Geller. It's published by Matthew Bender and can be found in many law libraries. This work contains in-depth discussions of the copyright laws of most large countries. However, it does not cover every country of the world. For example, Russia and Mexico are not included.

The three-volume work *Copyright Laws and Treaties of the World* was compiled by the United Nations Educational, Scientific and Cultural Organization (UNESCO) and published by BNA Books. It contains summaries of the copyright laws of every country and copies of all the major international copyright treaties. This treatise costs over $750 and you're likely to find it only in a large law library. However, you can access many of these copyright laws for free at the UNESCO website listed in the next section below.

An excellent book on Canadian copyright is called *Canadian Copyright Law*, by Lesley Ellen Harris. It's published by McGraw-Hill Ryerson.

The standard work on British copyright law is *Copinger and Skone James on Copyright*, by Kevin Garnett QC, Jonathan Rayner James QC, and Gillian Davie. It is published by Sweet & Maxwell.

2. Websites

A number of websites contain information on foreign copyright laws.

This website, maintained by UNESCO, contains the text of the copyright laws of most of the countries of the world, translated into English: http://portal.unesco.org /culture/en/ev.php@URL_ID=14076&URL _DO=DO_TOPIC&URL_SECTION=201.html.

The World Intellectual Property Organization (a United Nations agency) has a website with useful information on international copyright. The URL is: www.wipo.int.

The following copyright websites are listed by the countries they cover.

Australia

- www.copyright.org.au (a superb government-sponsored website with a vast store of information).

Canada

- http://cipo.gc.ca.

United Kingdom

- www.patent.gov.uk/copy/index.htm.

Unless you've been living in a cave for the past several years, you almost surely have come into contact with the Internet, which is playing an ever-growing role in commerce and communications.

Most of the material on the Internet is not in the public domain; but much is. Unfortunately, material on the Internet is not always clearly or correctly identified as in the public domain or protected by copyright. There is widespread confusion both among purveyors and users, of content on the Internet about what can be used for free and what must be licensed.

A. Overview of the Internet

The Internet is a vast collection of large and small interconnected computer networks extending around the world. Anyone with a computer and modem can gain access to it by obtaining an account with an Internet Service Provider (ISP) or by using someone else's account, often available through schools or libraries. A person with an Internet account can also send and receive email—electronic messages that can be sent almost anywhere in the world.

The World Wide Web is the most well-known and rapidly growing part of the Internet. Technically, it consists of all computers and their content that can be accessed using the HyperText Transport Protocol (the familiar "http:" that precedes a website address). The term "World Wide Web" is often used interchangeably with Internet because so much of the Internet is commonly accessed in this way.

The World Wide Web also includes content on all these computers, consisting of pages of text, graphics, sounds, video, and software that are linked to other pages or to other Internet resources. Multiple Web pages linked together at the same Internet address are called a website. The main or default page of a website is called the home page. Most websites contain hypertext links. These are like postal addresses. By clicking on a link, a Web user can access a particular file anywhere on the World Wide Web.

Some websites have become world famous and are used by millions of people each day—for example, the Internet auction site ebay.com and the Internet directory yahoo.com. However, you don't have to be a multibillion-dollar company to have a website. Anyone with an account with one of the thousands of Internet service providers can arrange to have his or her own website placed on the Internet. There are millions of websites in existence on every conceivable subject.

The Internet as a whole is not owned or controlled by anybody, although several organizations perform housekeeping functions such as assigning site addresses (known as domain names). Much of the material on the Internet is freely accessible by anyone with a computer, modem, and Internet account. However, there is a good

deal of Internet content that may only be accessed by users who agree to subscribe to the website involved. Usually payment is required for such subscriptions. For example, *The Wall Street Journal* requires that users pay a subscription fee to read the complete daily edition of the *Journal* on its website.

1. Commercial Online Services

Although they are not technically part of the Internet, some of the best-known parts of the online world are commercial online services such as America Online. These services are owned and run by private companies. To access these systems, a person must become a subscriber and pay a fee. These systems typically offer electronic mail services, online "chats" with other users, vast collections of electronic databases, and Internet access.

2. Private Internets

Many organizations, such as private companies and public and private universities, operate their own private "in-house" computer networks. These are used for email, document transfer, database storage, and Internet access. These private internets, which are often called "intranets," are not open to the public. Only members of the organization that runs them are allowed access.

B. Two Preliminary Rules

Before we discuss in detail what works on the Internet are in the public domain, here are two simple rules you should learn. Applying them will help you avoid stupid mistakes.

Rule #1: Works on the Internet Are Not Automatically in the Public Domain

There is a widespread belief among people using the Internet that simply placing a work on the Internet automatically places it in the public domain. Many people wrongly believe that if they find something on the Internet they are free to download, copy, retransmit, and use it in any other way they like. No—this is simply not true. A work does not lose copyright protection just because it's on the Internet.

Although many works on the Internet are in the public domain, this is not simply because they were published in this medium. Rather, they are in the public domain for some other reason—for example, because their copyright expired, they are U.S. government works, or the copyright owner dedicated them to the public domain (see Section C below).

Rule #2: The Presence or Lack of a Copyright Notice Is Meaningless

There is no requirement that a copyright notice accompany a protected work on the Internet, just like material in any other format—a novel, for example. Put another way, as long as material is protected by copyright, it makes no difference whether or not it has a notice claiming copyright ownership. Of course, many people place copyright notices on their websites and on individual items posted on the Internet, such as photographs. If a work contains a copyright notice, you know someone *claims* it is copyrighted. While that claim may be valid, it also may not be. It's not uncommon for people to place notices on public domain materials, either out of ignorance or because they want to deceive others into thinking they own the materials.

Moreover, many websites contain a mix of copyrighted and public domain materials. The owners of these sites are legally entitled to use copyright notices. Unfortunately, there is no requirement that they indicate in their notices (or anywhere else) which portions of their site are copyrighted and which are in the public domain. As a result, these copyright notices can mislead people into believing that public domain materials are protected by copyright.

Here's just one example. The magazine *Atlantic Monthly* has reproduced President Abraham Lincoln's Gettysburg Address on its website with the following notice at the end: *"Copyright © 1999 by The Atlantic Monthly Company. All rights reserved."* You can see it at the following Web page: www .theatlantic.com/issues/99sep/9909lincgetty .htm.

Of course, the official speeches of every president, including Lincoln, are in the public domain. (All works by U.S. government employees, including presidents, are in the public domain; see Section C1.) *The Atlantic Monthly* was perfectly entitled to place a copyright notice on its Web page to protect such elements as the format of the Web page and the computer code used to create it. However, *The Atlantic Monthly* does not own Lincoln's words. Placing a copyright notice at the end of the speech doesn't change this.

On the other hand, the *absence* of a copyright notice means nothing. For example, one issue of *The Atlantic Monthly* has an article on faulty software (www .theatlantic.com/unbound/digicult/dc2000-03-15.htm). This article has a copyright notice at the end but, even if it didn't, the article would not be in the public domain because notices are not required on published works. The March 15, 2000 edition of *The Atlantic Monthly* will not enter the public domain until Jan. 1, 2096 when its copyright expires. Remember: use of copyright notices on the Internet is purely optional. People who don't use them don't lose their copyright rights, if they have any, in the published work.

Downloading Public Domain Material From the Internet

You need to be careful when you download public domain material from the Internet that you don't also download copyrighted material as well. For example, if you downloaded a complete copy of *The Atlantic Monthly* Web page containing the Gettysburg Address you would download not only the speech itself, but the HTML (Hypertext Markup Language) code used to design the Web page. This code may be copyrighted. You can avoid this by downloading only the public domain elements of a website instead of the whole site. For example, you could download just the words of the Gettysburg Address and save them with a word processing program such as Microsoft Word without copying any of the website's code. It is also possible to remove HTML coding with text editor software.

C. Internet Content in the Public Domain

Never assume that anything you find on the Internet is in the public domain. Public domain works on the Internet fall into one of three broad categories:

- works not protected by copyright
- works that were in the public domain before they were placed on the Internet, and

- works dedicated to the public domain.

Any work you find on the Internet that does not fall into one of these categories is not in the public domain.

1. Works Not Protected by Copyright

Probably the largest category of public domain works on the Internet are those that are not eligible for copyright protection.

a. U.S. Government Works

All works of authorship created by U.S. government employees as part of their jobs are in the public domain. Almost all federal agencies have websites, and virtually

IRS home page (www.IRS.gov) on 10/13/00

everything on them is in the public domain and free for the taking. This includes, for example, the excellent IRS website (www .irs.gov) and the Copyright Office website (www.copyright.gov).

For more information on the types of U.S. government materials that are in the public domain and additional Web links refer to the following chapters:

- writings (see Chapter 3, Section C2)
- artwork (see Chapter 5, Section F8)
- maps (see Chapter 10, Section C)
- photography (see Chapter 6, Section C4)
- film and video (see Chapter 7, Sections E1 and J)
- software (see Chapter 8, Section B)
- databases (see Chapter 12, Section C).

However, state, local, and foreign governments can claim copyright ownership in materials created by their employees. For example, materials on a website maintained by your state motor vehicle agency may be copyrighted.

Even highly sensitive documents by super-secret government agencies—like the Central Intelligence Agency—are in the public domain. They are protected from disclosure by other laws. But once they are declassified and released, they are in the public domain.

b. Laws and Court Decisions

All laws, whether federal, state, local, or even foreign, are in the public domain in the United States. Written legal decisions by all American courts (whether federal or state) are also in the public domain. Copies of these decisions are available on various websites. However, some of these websites charge users subscription fees and require them to agree to licenses restricting how they may use these public domain materials. (For a detailed discussion, see Chapter 3, Section C3.)

c. Databases

Huge numbers of databases are on the Internet. Many of these are in the public domain because their selection and arrangement are not sufficiently creative to be protected by copyright. However, licenses and other means are frequently used to protect such databases. (For a detailed discussion, see Chapter 12, Section F.)

d. Blank Forms

Many websites contain blank forms that users fill out to register with the site or order goods or services. Blank forms used solely to record information are in the public domain. (For a detailed discussion, see Chapter 3, Section C5.)

e. Information That Is Common Property

Information that is common property is in the public domain. Examples include standard calendars, height and weight charts, tape measures and rulers, schedules of sporting events, and lists or tables taken from

public documents or other common sources (37 C.F.R. Section 202.1(d)). Any such information on a website is in the public domain. Likewise, there is no copyright protection for the format of a Frequently Asked Questions (FAQ) page on a website. The FAQ format, used in thousands of websites, is common property. *Mist-On Systems, Inc. v. Gilley's European Tan Spa*, 303 F.Supp2d 974 (D. Wis. 2002).

However, new material added to such works is protectable. For example, although a standard calendar is not copyrightable, photos, illustrations, or quotations added to a calendar can be protected. But copyright protection only extends to this new material, not to the standard calendar itself.

f. Typefaces

Typefaces are in the public domain in the United States. However, computer software used to generate typefaces is protected by copyright. (For a detailed discussion, see Chapter 5, Section F7.)

g. Food and Drink Recipes

Food and drink recipes are also in the public domain. (For a detailed discussion, see Chapter 3, Section C7.)

2. Works in the Public Domain Before Being Placed on the Internet

The other large body of public domain material on the Internet consists of copies of materials that were in the public domain before being placed on the Internet.

Digital copies of such public domain works have been posted on many websites. The vast majority of these works are in the public domain because their copyrights expired before they were placed on the Internet. Thousands of copyright-expired books, magazines, and other written works, photographs, maps, and even some old films have been scanned and placed on the Internet where the public can view them and, if they wish, download them to their own computers.

The Public Domain on the Internet

One person who is busy making digital copies of public domain books and placing them on the Internet is Eric Eldred, a Massachusetts-based technical analyst and founder of Eldritch Press. Eldred has digitally scanned and placed on his website copies of dozens of public domain works, including books by Nathaniel Hawthorne, Oliver Wendell Holmes, William Dean Howells, and Joseph Conrad. Also included on the site are public domain works about small boats, 19th century natural histories, and children's stories. In 1997, the National Endowment for the Humanities recognized Eldritch Press as one of the 20 best humanities sites on the Web. You can find the Eldritch Press website at www.ibiblio.org/eldritch.

To determine whether a particular work was public domain before it was placed on the Internet, turn to the chapter covering that type of work and read the detailed discussion there. Each of these chapters also contains a list of websites on which public domain materials can be found.

- writings (see Chapter 3)
- music (see Chapter 4)
- artwork (see Chapter 5)
- architectural plans (see Chapter 9)
- maps (see Chapter 10)
- photography (see Chapter 6)
- film and video (see Chapter 7)
- computer software (see Chapter 8).

3. Works Dedicated to the Public Domain

A good deal of material on the Internet has been dedicated to the public domain—in other words, the copyright owner has elected to give up his or her copyright protection. The author of any work that can be protected by copyright is free to reject that protection and dedicate the work to the public domain. By doing this, the author gives up all ownership rights in the work, which permits anyone to copy or otherwise use the work without permission.

Much of this dedicated material consists of computer software. See Chapter 8 for a detailed discussion of how to determine whether software has been dedicated to the public domain. There are also graphics, writings, and even sound files that have been dedicated to the public domain.

There is no prescribed formula for dedicating a work to the public domain. The author or other copyright owner simply has to make his or her intention to do so clear. For example, by stating "This work is dedicated to the public domain" on a Web page would be sufficient.

EXAMPLE: A website containing a number of simple graphics for use by website designers has an excellent unequivocal public domain dedication: "Anywhere you see my cute face on these pages—the graphics were created by me and are 100% public domain. Modify any way you wish, use as you see fit, business or personal. No link back required, or credit given to me for them. No strings!"

! Double-Check the Status of a Dedicated Work. Anyone can put a digital copy of any work on the Internet and say it has been dedicated to the public domain. This doesn't necessarily mean it's true. For this reason, you need to be careful. Before you distribute such materials to the public—for example, by placing them on your own website—double-check to make sure they really have been dedicated to the public domain. Send an email to the webmaster (person in charge) of the site where you got the materials. Ask if the webmaster or someone else created the material. If it was created by someone else,

Dedicating Works to the Public Domain Through the Creative Commons

The Creative Commons, a nonprofit organization designed to foster the public domain, has established a program to help copyright owners dedicate their works to the public domain. Copyright owners may dedicate their works to the public domain immediately; or, they can elect to use what the Commons calls "Founders' Copyright"—the original copyright term adopted by the first copyright law in 1790. This consists of an initial term of 14 years after publication, and an additional 14 years if the copyright owner wants it. The copyright owner fills out an online application and sells the copyright to the Creative Commons for $1, and then the organization gives them an exclusive license to the work for 14 or 28 years. If desired, users of the dedicated works can be required to provide attribution to the original author. Works so dedicated to the public domain are listed in the Creative Commons website so people can easily find them. It is also possible to conduct Internet searches for works that have been dedicated to the public domain through the Creative Commons. Those who dedicate their work are also given the following Creative Commons dedication, below. For detailed information, see the Creative Commons website (www.creativecommons.org).

(cc) creative commons
P U B L I C D O M A I N D E D I C A T I O N

Copyright-Only Dedication (based on United States law)

The person or persons who have associated their work with this document (the "Dedicator") hereby dedicate the entire copyright in the work of authorship identified below (the "Work") to the public domain.

Dedicator makes this dedication for the benefit of the public at large and to the detriment of Dedicator's heirs and successors. Dedicator intends this dedication to be an overt act of relinquishment in perpetuity of all present and future rights under copyright law, whether vested or contingent, in the Work. Dedicator understands that such relinquishment of all rights includes the relinquishment of all rights to enforce (by lawsuit or otherwise) those copyrights in the Work.

Dedicator recognizes that, once placed in the public domain, the Work may be freely reproduced, distributed, transmitted, used, modified, built upon, or otherwise exploited by anyone for any purpose, commercial or non-commercial, and in any way, including by methods that have not yet been invented or conceived.

find out who and send this person an email asking if the person dedicated it to the public domain. Explain that this means that, not only is the material free, but that it is not protected by copyright and can be used by the public in any way, even sold. Be sure to use the public domain worksheet in the back of this book to keep track of your research and attach printouts of emails and responses to the worksheet.

a. Watch for Mixed Messages

Be careful, however, where an author sends mixed messages. For example, if an author states that his work is in the public domain, but then attempts to restrict how the public may use it—for example, "This work is public domain but may not be used for commercial purposes without my permission." When a work is dedicated to the public domain, the author may not restrict how it is used. A statement like this leaves it unclear whether the author really intended to dedicate the work to the public domain. It's wise to seek clarification from the author or ask permission for the restricted use.

Similarly, use of the phrase "copyright free" does not mean the work is dedicated to the public domain. The words "copyright free" are often used to describe works (particularly photos and clip-art) that are under copyright, copies of which are sold to the public for a set fee rather than under

a royalty arrangement. "Copyright free" is also used where copyrighted materials are licensed to the public for free. For example, a website called the Primate Gallery contains a number of illustrations of monkeys that are described as "copyright free." However, the website's copyright statements says that the "images are not in the public domain" and restricts users to downloading them for free solely for personal and educational use.

b. Nonexclusive Licenses Are Not Public Domain Dedications

People and companies that post material on the Internet frequently grant users permission to use the material in particular ways without obtaining specific permission. For example, you'll often see a statement somewhere on a website's home page or on a "Terms and Conditions" Web page that the material can be downloaded for personal use. Some website owners even grant users permission to email the content to anyone in the world, as long as they do not charge for it.

Statements like this are what the copyright law terms nonexclusive licenses, permitting free public use of the material. But the materials are still protected by copyright and there are restrictions on how they may be used. This type of license does not dedicate the material to the public domain. Typically, commercial uses are not permitted.

c. When Public Domain Doesn't Mean Dedicated to the Public

Many (perhaps most) of the people who use the Internet don't really understand what the phrase "public domain" means. You'll often see it used in conjunction with works that clearly haven't been dedicated to the public domain and aren't public domain for any other reason. For example, there are tens of thousands of websites that contain digital copies of photographs of actors, fashion models, and other celebrities. These photos have been scanned from magazines and other sources and placed on the Internet, where they are often recopied thousands of times. Virtually none of these photos are in the public domain.

Often, these sites contain statements that the images are "presumed," "deemed," "believed," or "assumed" to be in the public domain. For example, one such website contains the following statement: "ALL IMAGES FOUND WITHIN THESE PAGES WERE OBTAINED FROM THE WEB AND WERE DEEMED IN THE PUBLIC DOMAIN."

The people who make statements like this apparently believe that anything they find on the Internet is in the public domain and can be freely copied unless someone tells them otherwise. Of course, this is not true. A statement like this should tip you off that the materials on the site are very likely not in the public domain. It certainly does not constitute a dedication of the materials to the public domain. Nor will it protect the people who include these statements on their websites from getting sued for copyright infringement, or protect you from a lawsuit if you copy the material for use on your website.

D. Potential Problems Using Public Domain Materials on the Internet

People who place digital copies of public domain works on the Internet often claim that they are protected by copyright or attempt to use licenses to restrict how the public may use them. You need to understand how to recognize and deal with such claims.

1. Copyright Claims in Digital Copies of Public Domain Works

Obviously, you can't place a public domain book or photograph on the Internet. The work has to be reduced to digital form—a series of ones and zeros that can be read and stored by computers. This is typically done using a digital scanner—a device similar to a photocopy machine, except it makes digital rather than physical copies.

Sometimes the people who create digital copies of public domain writings or photographs claim that the copies are protected by copyright, even though the original works are not. This is particularly common for photographs. For example,

Nolo's website (www.nolo.com)

corbis.com, one of the largest stock photo agencies in the world, has digitized tens of thousands of public domain photos and placed them on its website. Corbis claims that these digital copies are copyrighted. Corbis puts copyright notices on these copies and requires anyone who licenses the photos to include the notices as well.

Any claim that digitally scanning a book or other text document is copyrightable is almost certainly not legally enforceable. This is so even if the typeface is changed or the text rehyphenated, spellchecked, or reformatted. These types of changes are not copyrightable because they do not meet a legal standard of being a minimally creative change to the original public domain work. (See Chapter 3, Section G1, for a detailed discussion.)

A stronger argument might be made that a digitally scanned photograph should be copyrighted. This would be the case, for example, where the original photo is altered—for example, where a black and white photo is colorized. But, if the digital copy is an exact copy of the original photo, copyright claims are much more difficult

to justify. (See Chapter 6, Section B6, for a discussion of this question for photographs in general, and see Chapter 5, Section N2, for a discussion of copyright claims in photos of public domain artworks such as paintings.)

2. Websites as Collective Works

A collective work is a work created by selecting and arranging more than one work of authorship into a single new work. Good examples of collective works are newspapers, magazines, and other periodicals in which separate articles are combined into a collective whole. However, the preexisting material can consist of any work of authorship, including any type of writing, music, photographs, or drawings or other artwork.

Most websites that have public domain materials qualify as collective works. Sometimes this will be made clear in a statement next to a copyright notice on the website or in an area called "terms and conditions." For example, *The Atlantic Monthly* magazine website contains the following statement: "The Atlantic Monthly retains the copyright in all of the material on these Web pages as a collective work under copyright laws."

However, a website need not include a notice like this to have a collective work copyright. If a site qualifies as a collective work, it will automatically be protected as such by American copyright law the moment it is created.

Fortunately, these collective work copyrights usually don't pose much of a problem. This is because copyright protection for a collective work is extremely limited. All that is protected is the selection and/or arrangement of the preexisting material, not the preexisting material itself.

a. How Much of a Collective Work Website Can You Copy?

Since the copyright on a collective work protects only the selection and/or arrangement of the material, none of the individual public domain works in the collection are protected. This means you may copy any individual public domain work included in the collection. However, you may not copy the copyrighted selection and/or arrangement. This would occur where you copy the entire collection (or a substantial portion of it).

For example, *The Atlantic Monthly*'s collective work copyright in its website extends only to the way articles and other materials are arranged or ordered. It does not extend to the individual articles themselves. For example, as mentioned in Section B above, the *Monthly*'s editors have placed a copy of Lincoln's Gettysburg Address on their website. Their collective work copyright does not protect Lincoln's public domain speech. However, most articles on the website, as with any site, are probably protected by copyright individually. If you want to use a particular work from a website you must still check to see if it is in the public domain. If it is not, you must

obtain permission, and often pay a fee, for using the work.

You are not limited to copying individual items. You may copy any amount of a collection as long as you don't copy the website creator's copyrighted selection and/or arrangement.

EXAMPLE: Let's assume that a website called The Presidents Speak contains digital copies of 50 presidential speeches arranged in order from the best to the worst, according to the website creator's opinion. This selection and arrangement is copyrighted, but the speeches aren't because there is no copyright protection for speeches of any president. You are free to copy them all, so long as you don't duplicate the selection and arrangement. For example, you could use them all in a website containing copies of 500 important historic speeches arranged chronologically. This would duplicate neither the selection nor arrangement of The Presidents Speak site.

b. Minimal Creativity Required

Not all websites qualify for even the minimal copyright protection afforded to collective works. A website is protected as a collective work only if the author/compiler had to use creativity and judgment to create it. If not even minimal creativity was employed to select and/or arrange the materials on a website, it will not be protected as a collective work.

How can you tell if a website contains sufficient creativity to be entitled to copyright protection as a collective work? A website is copyrightable as a collective work if either the selection or arrangement of the material is minimally creative. In some websites, both the selection and arrangement are minimally creative. In others, only one or the other is.

i. Selection

A selection is minimally creative if:

1. it consists of less than all of the data in a given body of relevant material, regardless of whether it is taken from one or more sources, or
2. it is based on the compiler's opinion about something subjective.

For example, *The Atlantic Monthly's* editors had to select which articles included in the physical magazine over the years should be posted on their website. This selection is copyrightable. Similarly, a website consisting of a collection of the "greatest" speeches by U.S. presidents would be copyrightable.

But a selection is not minimally creative if it does not require individual judgment. For example, no judgment is needed to compile a website containing a copy of every presidential speech or every article ever published in *The Atlantic Monthly.*

ii. Arrangement

Similarly, the way the individual items on a website are ordered or placed is entitled to copyright protection only if done in a way that requires the exercise of the website creator's subjective judgment. An ordering or placement is not entitled to copyright protection if done in a mechanical way. An alphabetical or chronological arrangement is purely mechanical and not entitled to copyright protection. Thus, for example, a collection of the sheet music for Stephen Foster's songs placed in alphabetical order by title would not be entitled to copyright protection for the grouping. But an arrangement on some other basis could be—for example, according to theme or from worst to best in the opinion of the website creator.

3. Use of Licenses to Protect Internet Content

A license is a type of contract that gives someone permission to do something. People who own copyrights often license their works—for example, a photographer will grant a license allowing a magazine or website to copy and publish a photo.

Licenses are being increasingly used by website owners to restrict how the public may use the content on the Internet. These licenses usually take one of two forms. Websites that require users to pay for access to the site's content, often display the license agreement in a window or Web page and require the user to agree to the license terms by clicking a "yes" or "I agree" box before he or she can access the site. For example, the online databases Nexis

and Lexis require subscribers to agree to such licenses. Licenses such as these are sometimes called "click-wrap" licenses.

However, most websites don't require users to click a "yes" box or otherwise indicate that they have read and agree to the terms of the license. Indeed, the user isn't even required to read the license before accessing the website's content. Instead, the license is more or less hidden in a "Terms and Conditions," "Terms of Service," or "Terms of Use" page on the website. Only users who click on the Terms and Conditions link at the bottom of the site's home page will even know the purported license exists. These Terms and Conditions typically include a statement that by simply using the website the user agrees to the restrictions listed in the Terms and Conditions. Or it may say that use of the website is conditioned upon agreement to the Terms and Conditions. For example, the website jurisline.com contains the following Terms of Service:

THIS WEB SITE IS OFFERED TO YOU CONDITIONED ON YOUR ACCEPTANCE WITHOUT MODIFICATION OF THE TERMS, CONDITIONS, AND NOTICES CONTAINED HEREIN (COLLECTIVELY, THE "TERMS OF SERVICE"). YOUR USE OF THIS WEB SITE CONSTITUTES YOUR AGREEMENT TO ALL SUCH TERMS OF SERVICE.

a. License Restrictions

Whatever form a website license takes, it ordinarily imposes restrictions on how the public may use the material on the site. Typically, users are permitted only to use the material for their personal use—for example, the Ticketmaster website contains the following license restriction: "You agree that you are only authorized to visit, view and to retain a copy of pages of this Site for your own personal use."

"Personal use" means that you may download the material to your own computer and read and view it and make a copy for yourself. You can't make multiple copies or republish the material on your own website or in some other form—for example, in a book or magazine. You also can't adapt the material into a new work.

Unfortunately, many websites that contain public domain materials attempt to use restrictive licenses. For example, the Lexis website, an online database containing copies of thousands of public domain court decisions and state and federal laws, requires all users to agree to the following license restriction:

With respect to Materials that are court cases, [you are granted the] right to retrieve via downloading commands … and store in machine-readable form, primarily for one person's exclusive use, a single copy of insubstantial portions of those Materials included in any individual file.…

Translated into English, people who subscribe to the Lexis website are only allowed to download and store in their computers a single copy of any public domain court case.

Another website called harpweek.com consists of a database of digital copies of the magazine *Harper's Weekly*. All the magazine copies on the website were originally published during the 19th century and are in the public domain because their copyrights have expired. Nevertheless, harpweek requires subscribers to its database (primarily university libraries) to agree to a license restricting how they may use these public domain materials. Only limited numbers of pages from the harpweek database may be printed out for purposes of teaching and research.

b. Are Licenses Enforceable?

Clearly, these websites are attempting to use licenses to obtain and keep control over public domain materials that are supposed to be free to us all. Is this legal? There is no clear answer to this question.

Many copyright experts believe that licenses that attempt to impose copyright-like restriction on how the public may use public domain materials are legally unenforceable. This is because the federal copyright law preempts (supersedes) state contract law and prevents people from using contracts to create their own private copyrights. Moreover, there are sound policy reasons for holding such license restrictions

unenforceable—their widespread use diminishes the public's access to the public domain.

However, one court has held that a license restricting the use of public domain materials was enforceable. The case involved a CD-ROM containing 95 million business telephone listings. The listings were all in the public domain (see Chapter 12), but the CD-ROM contained a license agreement requiring users to agree to certain restrictions before they could access the information. For example, the license barred purchasers of the CD-ROM from copying, adapting, or modifying the listings. When Matthew Zeidenberg copied the listings and placed them on his website, the company that owned the CD-ROM sued him for violating the license and won. The court held that the license restrictions were enforceable even though the listings were in the public domain. The court reasoned that people should have the right to use contracts and licenses to restrict the use of public domain materials in their possession and that such contracts didn't conflict with the federal copyright law because they only applied to people who agreed to them. *ProCD v. Zeidenberg*, 86 F.3d 1447 (7th Cir. 1996).

This decision is simply the opinion of one federal appellate court. It does not establish the law for the entire United States. Moreover, many copyright experts have criticized it. However, it has led to more widespread use of licenses, both on and off the Internet.

It's important to note, moreover, that the *ProCD* case involved a CD-ROM that contained a "shrink-wrap" license in its printed user guide; and, before a user could access the listings on the CD, a field appeared on the computer screen warning users that the listings on the CD-ROM were subject to a license agreement. This type of license is similar to the "web-wrap" licenses used by Nexis, Lexis, and many other websites that charge users subscription fees (see the discussion above).

Many websites don't use these highly obtrusive web-wrap licenses. Instead, they simply place their license terms in a page on their website called "Terms and Conditions" or some similar name. Users of the website are not required to read or agree to the terms by clicking on a "yes" box. Indeed, many users aren't even aware the terms exist. These types of purported licenses were not considered by the court in the *ProCD* case.

Whether such "browse-wrap licenses" are legally enforceable is unclear. Some courts have said that they may be enforceable, reasoning that such licenses are similar to the terms and conditions found on airplane or cruise ship tickets. Consumers are deemed to agree to such conditions (typically, limiting the liability of the airline or cruise ship company if there is an accident) by purchasing and using the ticket. *Ticketmaster Corp. v. Tickets.com*, 2003 U.S. Dist. LEXIS 6483 (C.D. Cal. 2003); *Pollstar v. Gigmania, Ltd.*, 170 F.Supp.2d 174 (E.D. Cal. 2000).

On the other hand, one court held that a website license is not enforceable by a website that invited its users to download free software. The website, through its license, tried to restrict how consumers used the software after they downloaded it; but the license-limiting language was visible to users of the site only if they scrolled down the screen. Under these circumstances, the court held that users could not be deemed to have agreed to the license merely by downloading the purportedly free software. *Specht v. Netscape Communs. Corp.*, 306 F.3d 17 (2d Cir. 2002).

c. What to Do About Licenses

You should carefully read any license agreement or terms and conditions posted on any website. It's possible that your intended use of the public domain materials on the site won't be prohibited by the license or terms. But, if it is, you'll be faced with a difficult decision. Even if you think a license is not legally enforceable, the website owner may disagree, complain, and even sue you for violating the license, just as Ticketmaster did to Tickets.com. Even if you win such a suit, the legal expenses could be ruinous, and it's always possible you could lose.

Probably the best advice is to try to obtain the public domain materials from another source that doesn't require you to agree to a license or have restrictive terms and conditions. The exact same public domain materials could be available on another website that doesn't use licenses or they

could be available at a library or some other site in the real world.

If the material is not readily available elsewhere, try asking for permission for your intended use. Sometimes, permission is available for free or may be very inexpensive.

E. Hyperlinks and the Public Domain

One of the major features of the World Wide Web is the use of hypertext links (also called hyperlinks) that allow users to instantly move from one website to another by clicking on the hyperlink. Since there are so many websites on the Internet, users typically save hyperlinks to useful or interesting sites on lists in their computer. Hyperlinks are often gathered together and placed on websites. Indeed, many websites consist of nothing but collections of hyperlinks. For example, the On-Line Books Page (http://digital.library.upenn.edu/books) contains a collection of over 10,000 hyperlinks to websites containing digital copies of public domain books and other writings.

A "hyperlink" consists simply of the address of a particular Web page or other location on the Internet. An individual Web address is not protected by copyright or any other law. It's as much in the public domain as a street address. For example, the Internet address of Nolo's website home page is www.nolo.com. Its street address is 950 Parker St., Berkeley CA. Both addresses are public domain.

Moreover, since no copying is involved, placing a hyperlink to another website on your own website does not constitute a copyright violation. In the words of one court, "This is analogous to using a library's card index to get reference to particular items, albeit faster and more efficiently." *Ticketmaster Corp. v. Tickets.com*, 54 U.S.P.Q. 2d 1344 (C.D. Cal. 2000).

However, a collection of Web hyperlinks is a type of database (also called a compilation). Although the individual hyperlinks in a hyperlink collection are public domain and may be freely copied and used, the collection as a whole may be copyrighted. Some website owners expressly claim protection for their hyperlink collections in copyright notices or terms and conditions statements. For example, the On-Line Books Page contains a copyright notice that, "The On-Line Books Page and its compilation of listings are copyright 1993-2000 by John Mark Ockerbloom." However, it is not necessary to use such a notice or statement to have copyright protection for a hyperlink collection. If such a collection qualifies for copyright, U.S. copyright law will protect it automatically the moment it is created.

But, as with collective works discussed in Section D2 above, this form of copyright protection is extremely limited. All that is protected is the selection and/or arrangement of all the hyperlinks in the collection, not the individual hyperlinks themselves. But even this won't be protectable if the selection or arrangement is not at least minimally creative. For example, a collection of every

Deep Linking May Violate Laws Other Than Copyright

Generally, the first page you visit on a website is the "home page," which has many links to other pages on the website. But it is possible to link to any page on a website that has more than one page. A link that bypasses a website's home page and instead goes to another page within the site is often called a "deep link." Some website owners object to the use of deep links. They want all the people who use their website to go first to the home page, usually because advertising is posted there.

The use of deep links can cost a website advertising revenue if visitors bypass the home page. In one of the first cases of its kind, Ticketmaster sued a competitor called Tickets.com partly because it linked from its website to pages deep within Ticketmaster's site. In the very first ruling of its kind on hyperlinking, the court held that deep linking does not violate the copyright laws because no copying is involved. However, the court held that Ticketmaster might have a claim against Tickets.com on other legal grounds, such as violation of a website license agreement. *Ticketmaster Corp. v. Tickets.com*, 2003 U.S. Dist. LEXIS 6483 (C.D. Cal. 2003).

It's prudent to be careful before deep linking to advertising-rich commercial sites. Many such sites have linking policies posted. Some well-known websites such as Amazon.com welcome deep links. If a commercial website has no posted linking policy or says that deep links are not allowed, it's wise to ask for permission before deep linking. Otherwise, you could end up getting a "cease and desist" letter from a lawyer.

1001 Cartoon-Style Illustrations, Dover Publications

hyperlink on the Web concerning the writings of the Bronte sisters arranged in alphabetical order wouldn't be minimally creative. See Section D2 above on what constitutes minimal creativity.

⚠️ **Domain Names Are Not Free to Use.** An Internet domain name is the unique part of an Internet address (Universal Resource Locator or URL). The Nolo URL, for instance, is www.nolo.com. The last part—nolo.com—is the domain name. Domain names are not protected by copyright, but this does not mean they can be freely used. Trademark laws often protect domain names. They must also be registered for use on the Internet. You can't use a domain name somebody else has already registered. For a complete discussion of everything you'd ever want to know about domain names, refer to *Domain Names: How to Choose & Protect a Great Name for Your Website*, by Stephen Elias and Patricia Gima (Nolo).

F. Copyright and the Internet's Global Dimension

One unique feature of the Internet is that it can be accessed from almost anywhere in the world. For example, a website maintained by a person or company in the United States can easily be accessed by people in Canada, France, South Africa, Brazil, and Japan.

The Internet's global dimension leads to a unique copyright problem: Many works are in the public domain in the United States, but not in a number of other countries. There are several reasons for this. The most important is that copyright terms differ in the United States and in many foreign countries (see Chapter 16). Thus, for example, all of Irving Berlin's songs published before 1923 are in the public domain in the United States because their copyrights have expired (works published in the United States before 1923 received a maximum copyright term of 75 years; see Chapter 18). However, these songs are still under copyright in Canada, where copyrights last for the life of the author plus 50 years—Berlin died in 1989 (see Chapter 16).

If you're located in the United States and place such a work on your website, can you be sued for copyright infringement in

"Alexander's Ragtime Band" sheet music (1911) by Irving Berlin

a foreign country where the work is still under copyright? Could you even be sued in the United States for violating a foreign copyright law? Unfortunately, there are no clear answers to these questions. No one has as of yet brought a lawsuit alleging such copyright violations, thus no court has had the chance to rule on these issues. Most public domain works probably don't have enough economic value to justify the time, trouble, and expense of this type of litigation. It's likely, moreover, that in most cases where copyright owners have complained, the website owners simply removed the offending material from the Internet or obtained permission to use it, so no lawsuit was necessary.

In any event, it is possible that you could be sued in a foreign country for violating that country's copyright laws. It might even be possible for you to be sued in the United States for violating the copyright laws of a foreign country. Consider the following fictional example:

> **EXAMPLE:** Jim has his own website on which he places copies of public domain books. Jim lives in California, his Web server is in California, and his Internet access provider is in California. Jim scans the short story collection *Dubliners* by James Joyce and places it on his website. *Dubliners* is in the public domain in the U.S. because the copyright expired—it was published in 1914 and the U.S. copyright for all

works published before 1923 lasted a maximum of 75 years. However, *Dubliners* is not in the public domain in the United Kingdom, where copyrights last for the life of the author plus 70 years (Joyce died in 1941). People who live in the United Kingdom can easily access Jim's website and download a copy of *Dubliners*. Joyce's heirs sue Jim for copyright infringement in a British court.

If you live in the United States and want to post public domain materials on your website, there are a couple of things you can do to limit the possibility that someone will accusing you of violating a foreign copyright law.

1. Check Foreign Copyright Terms

Chapter 16 covers the public domain in foreign countries. Read it carefully, particularly the section on the copyright term in the European Union (EU), which consists of most of Western Europe. If a work's copyright term has expired in the EU, it's in the public domain in almost all of the rest of the world as well. Very few countries have longer copyright terms than the EU. Generally, for copyright protection to expire in the EU, the author must have died more than 70 years ago (see Chapter 16, Section B1).

2. Use a Disclaimer

Another approach is to use a disclaimer. Place a notice in large type and bold letters on your home page stating that the website is intended only for U.S. residents, or residents of countries where the work is in the public domain. Also state that the material on your site may only be downloaded from within the U.S. or the other foreign countries on your list. Here's an example:

> THIS WEBSITE IS INTENDED ONLY FOR INTERNET USERS RESIDING IN THE UNITED STATES. THE MATERIAL ON THIS WEBSITE MAY ONLY BE DOWNLOADED WITHIN THE UNITED STATES. ALL OTHER USES ARE PROHIBITED.

Disclaimers are used all the time on websites. For example, many websites that contain medical information contain disclaimers that the site can't take the place of a doctor. Whether website disclaimers are actually effective in avoiding liability is far from clear. However, they cost nothing to use and can only help. At the very least it shows that you are aware of the problem and are trying to protect the copyright owner's foreign copyright rights. This can only make you look better in the eyes of a judge or jury if your use of some material is challenged. ■

Chapter 18

Copyright Protection:
How Long Does It Last?

Copyright protection does not last forever. When a work's copyright expires, it enters the public domain. Works with expired copyright protection form the largest category of works in the public domain.

Unfortunately, the law describing how long copyright protection lasts is somewhat complex. There is no single time limit for copyright protection. This is because copyright laws have been amended many times, and the old time limits were often left in place or only modified. So we are left with a hodgepodge of different time limits for copyright protection.

To know whether the copyright for a work has expired, you need to know which term applies. This chapter shows you how to do just that. The discussion of copyright terms is divided into three sections:

- Section A covers works published in the United States
- Section B covers all unpublished works, and
- Section C covers works published outside the United States.

Before you can know how long any work's copyright lasts you must first determine whether or not it has been published and, if so, when. This is because copyright terms often differ depending on whether or not a work is published. If you haven't done so already, turn to the chapter covering the particular type of work involved—for example, writings, music, art, or photography—and read the detailed discussion of when the work is considered published for copyright purposes.

You also need to know whether the work was published in the United States or in a foreign country. U.S. copyright terms may differ for some foreign works.

Copyright Runs in a Calendar Year. All copyright terms run until the end of the calendar year in which they expire— that, is until December 31. For example, the copyright in a work that was published in the United States in 1920 expired on December 31, 1995 regardless of what month and day during 1920 it was published.

Holidays, Graphic Source Clip Art, Graphic Products Corporation

Cheat Sheet: What's in the Public Domain Right Now

It's not necessary that you memorize all the copyright terms explained below. If you just want to know what material is in the public domain right now because of copyright expiration, you only need to learn five rules. Only works falling within these rules have had their copyrights expire. Note, however, that on Jan. 1, 2003 the copyrights for many unpublished works expired (see Section B).

Rule #1: Everything Published in the United States Before 1923 Is in the Public Domain

Copyright protection on every work of authorship published before 1923 has expired and all those works are now in the public domain in the United States. This is so whether the work was first published in the United States or was originally published outside the United States and republished here.

Rule #2: Works Initially Published 1923-1963 in the United States and Not Renewed Are in the Public Domain

Any work initially published in the United States during 1923-1963 has had its copyright expire if the copyright wasn't renewed 28 years after publication.

Rule #3: All Unpublished Works by Authors Dead Over 70 Years Are in the Public Domain

All unpublished works created by authors who died 70 or more years ago are in the public domain in the United States. This is so whether the author was American or a non-American. Unpublished works made for hire created more than 120 years ago are also in the U.S. public domain.

Rule #4: Foreign Works Published Before 1909 Are in the Public Domain

Any work published outside the United States before July 1, 1909 has had its copyright expire or was never protected by copyright in the United States.

Rule #5: Foreign Works Published 1909-1923 With Copyright Notices Are in the Public Domain

Any work published outside the United States during July 1, 1909 to December 31, 1922 has had its U.S. copyright expire *if* it contained a copyright notice when it was published. (See Section C2 for a detailed discussion.)

A. Works First Published in the United States

This section covers the copyright terms for works that were first published in the United States.

1. Works Published Before 1923

The year 1923 is the great cutoff date for the public domain. The copyright for any work first published in the United States before 1923 (that is, during 1922 or any prior year) lasted a maximum of 75 years. This means that the copyrights for all pre-1923 published works have expired and such works are now in the public domain in the United States. This category includes many of the most famous public domain works.

(Technically speaking, works published before 1790 when the first U.S. copyright law was adopted were never protected by copyright at all. These works have always been in the public domain.)

Determining whether a work is in the public domain can sometimes be a complex process, but not for this category of works. If you know a work was first published in the United States before 1923, it is almost certainly in the public domain.

Copyright Duration Chart for Works First Published in the U.S.	
Date and Nature of Work	Copyright Term
Published before 1923	The work is in the public domain
Published in the U.S. 1923-1963 and never renewed	The work is in the public domain
Published 1923-1963 and timely renewed	95 years from the date of first publication
Published between 1964-1977	95 years from the date of publication (renewal term automatic)
Created 1978 or later (whether or not published)	Single term of life plus 70 years (but if work is made for hire (see Section A4) or anonymous or pseudonymous, 95 years from the date of publication or 120 years from date of creation, whichever ends first)
Created, but not published or registered, before 1978	Single term of 120 years from creation for unpublished works made for hire, and unpublished anonymous or pseudonymous works (that is, unpublished works written under a pen name)
Created before 1978 and published 1978-2002	Copyright will expire Dec. 31, 2047

The only possible exception would be where the work was published before 1923 without the copyright owner's permission. Such a publication does not start the copyright term clock ticking. However, it's highly unlikely you'll ever run into this problem. There is no reported case where a copyright owner (or his or her heirs) has ever claimed that a work was not in the public domain because it was published before 1923 without permission. If such a claim was made and turned out to be valid, the work would receive the term of protection provided for unpublished works (if it was never subsequently published with the owner's permission).

"Out of Print" Does Not Mean Out of Copyright

Some people mistakenly believe that when a book or other written work is "out of print" the copyright expires and the work enters the public domain. Not so. A book is out of print when its publisher is out of stock and it can't be obtained from normal distribution channels. This has nothing to do with the work's copyright status and certainly doesn't mean that the copyright has expired. A book published as recently as one year ago could be out of print, but the copyright will not expire for at least 70 years. Similarly, books and other works published decades ago are often out of print but their copyright has yet to expire.

2. Works Initially Published in the U.S. Between 1923 and 1963 That Were Not Renewed on Time

Many works first published in the United States between 1923 and 1963 are also in the public domain because their copyrights have expired. However, you'll usually need to check records at the U.S. Copyright Office to determine the public domain status of such works.

This is because works first published before 1978 were protected for 28 years from the date of publication. This protection could be extended for an additional 47 years (the "renewal term") by filing a renewal registration with the Copyright Office. The initial and renewal terms together added up to 75 years of copyright protection, the maximum term of protection that used to be available. In 1998, the renewal term was extended from 47 to 67 years, but the extension didn't apply to works already in the public domain in 1998.

Until 1992, the renewal term could only be obtained by filing a renewal registration with the Copyright Office during the 28th year after a work was first published. (After 1992, however, the renewal term was made automatic and the copyright owner did not have to file a renewal.) As you might expect, many authors, publishers, and other copyright owners failed to file a renewal for their works on time. The Copyright Office estimates that only about 15% of all works published during 1923-1963 were ever renewed.

This means that all works first published in the United States from 1923 though 1963 for which no renewal was filed are in the public domain.

> **EXAMPLE:** The John Wayne movie *McClintock!* was published in 1963, but no renewal was filed by the movie's copyright owner during the 28th year after publication. This meant that the movie entered the public domain on Jan. 1, 1992. Had a renewal been filed, the movie would have received an additional 67 years of copyright protection and been protected until December 31, 2058.

It is impossible to know how long the copyright will last in a work first published in the United States between 1923 and 1963 unless you know whether a renewal registration was filed on time. You'll usually need to research the Copyright Office's records to find out. Many of the renewal records can be searched online. (See Chapter 21 for a detailed discussion of how to research copyright renewals.)

Exception to the Renewal Requirement for Foreign Works. There is one very important exception to the rule that works published during 1923-1963 had to be renewed after 28 years or the copyright expired. This rule does not apply to most works that were first published outside the United States and were never renewed. This is so whether such works were later republished in the United States or were never published in the United States. Such works used to be in the public domain, but most of them had their copyrights restored on Jan. 1, 1996. See Chapter 15 for a detailed discussion of this issue.

3. Works Published Between 1964 and 1977

The renewal requirement for published works discussed in Section 2 above means that a vast body of work entered the public domain 28 years after publication due to failure to comply with a mere technical formality. This seemed unfair to many people, and as a result the law was changed in 1992. The new law made copyright renewals automatic—in other words, the renewal term was obtained whether or not a renewal registration was filed. Renewal registrations were made purely optional.

This means that works first published in the United States between January 1, 1964 and December 31, 1977 receive 95 years of copyright protection whether or not a renewal was (or is) filed on time. The earliest any such work will enter the public domain because of expiration of copyright is January 1, 2060 (for works published during 1964).

Note, however, this change in the law was not made retroactive. In other words, the copyright in works initially published in the United States that were already in the public domain before 1992 because no renewal application was filed was not resurrected. They remain in the public domain.

4. Works Published After 1977

Works published on January 1, 1978 or later receive a very different term of copyright protection than those published before that date. A work published after 1977 is protected by copyright as long as the author is alive and for 70 years from the date of his death. If there are multiple authors, the copyright lasts for 70 years after the last surviving author dies. This means that the earliest any work published after 1977 will enter the public domain because of copyright expiration is January 1, 2049 (if the work was created and the author died during 1978).

Works made for hire—that is, works created by employees as a part of their job or by independent contractors who have signed a work-for-hire agreement—are protected for 95 years from the date of first publication, or 120 years from the date of creation, whichever comes first. The earliest any such work will enter the public domain through copyright expiration is January 1, 2074.

Works for which the author employed a pseudonym (pen name) instead of his or her real name or which were written anonymously (for example, the novel *Primary Colors*, which was later revealed to have been written by former *Newsweek* journalist Joe Klein) receive the same copyright term as works made for hire. If a pseudonymous or anonymous author's identity is subsequently revealed, the work automatically switches to the life-plus-70-year copyright term.

So, the upshot of all this is that you'll have to wait until the year 2049 for any works published after 1963 to enter the public domain due to copyright expiration.

Determining a Work's Publication Date

It's easy to determine the year a work was published if it contains a copyright notice. You just have to look at the year date in the copyright notice. (See Chapter 19 for a detailed discussion of copyright notices.) If the year in the notice is 1922 or earlier, the work is in the public domain.

> Copyright 1911 by Ted Snyder Co. Inc. 112 W 38th St. N.Y.

Sample 1911 Copyright Notice

If the year is 1923-1963, the work will also be in the public domain if it was initially published in the United States and not renewed on time. When a work is republished following renewal, the copyright notice will often state that the work has been renewed and give the year of renewal. In such cases, you know the work is not in the public domain.

> Copyright © 1946. Copyright Renewed 1973.
> Fred Albert Music Corporation/EMI.

Sample Renewal Copyright Notice

Otherwise, you'll need to search U.S. Copyright Office renewal records to know whether or not the work has been renewed; if not, it is in the public domain (see Chapter 21).

If the year in the notice is 1964 or later, the work's copyright will not expire for many, many years.

However, not all published works contain copyright notices. And copyright notices for the following types of works published before 1978 did not have to contain a date of publication: maps, original works of art and art reproductions, technical and scientific drawings and models, photographs, labels used on products and merchandise, and prints and pictorial illustrations (see Chapter 19).

In this event, you'll have to look elsewhere for clues about when the work was published. It may contain a date of publication somewhere else—for example, on the title page of a written work or the back of a photo, or on a film can. You can also check Copyright Office registration records. If the work was registered, the record will show the date of publication (see Chapter 21). However, not all works are registered with the Copyright Office. Contacting the publisher may work; or the publication date may be listed in a reference work such as an encyclopedia or author's biography.

B. Copyright Term for Unpublished Works

Unpublished works—for example, unpublished manuscripts, photographs, home movies, and computer software— retain copyright protection for 70 years after the author dies. This is true for unpublished works by both American and foreign authors regardless of the country in which the unpublished works were created.

An unpublished work that is a work made for hire or a pseudonymous or anonymous work is protected for 120 years from the date of creation. The reason works by pseudonymous or anonymous authors are protected for 120 years instead of the life of the author plus 70 years is that it can be very difficult to discover exactly when such an author died, since his or her real name may not be publicly known.

1. Unpublished Works Created Before 1978 and Published Before 2003

If an unpublished work was created before January 1, 1978 the copyright in the work will last until 70 years after the death of the author. However, there is one special twist: If the work was published between January 1, 1978 and December 31, 2003 the copyright will not expire before December 31, 2047 no matter when the author died.

EXAMPLE: The famed novelist Ernest Hemingway died in 1961, leaving behind an unpublished novel called *True at First Light* that was published in 1999. The novel would be copyrighted until December 31, 2031 (70 years after Hemingway's death) if the ordinary term of 70 years after death applied. Because of this special rule, the

copyright will last until December 31, 2047.

2. Authors Dead Over 70 Years

On Jan. 1, 2003 all unpublished works by all authors who died in the year 1932 or earlier entered the public domain. This rule applies to all unpublished works by authors dead over 70 years, whenever or wherever created. It also applies to unpublished materials yet to be discovered. Obviously, this was a prodigious body of work. Indeed, none of us will ever live to see again so many works enter the public domain at one time. On January 1 of every year after that date another year's worth of unpublished works will also enter the public domain. For example, on January 1, 2006 unpublished works by authors who died during 1935 entered the public domain; on January 1, 2007 unpublished works by authors who died during 1936 will become public domain, and so on.

The following chart shows the dates unpublished works by individual authors will enter the public domain over the next several years.

Unpublished works made for hire (for example, works created by employees as part of their jobs) are protected by copyright for 95 years after the date of creation. So all unpublished works for hire created over 95 years ago are also in the public domain; and a new year's worth of works will continue to enter the public

domain every January 1. Note that these works enter the public domain one at a time depending on the year they were created. This differs from works not made for hire—all such works by an author enter the public domain 70 years after he or she dies.

When Unpublished Works Enter Public Domain	
Year the Author Died	Date All of the Author's Unpublished Works Entered the Public Domain
1932 or earlier	Jan. 1, 2003
1933	Jan. 1, 2004
1934	Jan. 1, 2005
1935	Jan. 1, 2006
1936	Jan. 1, 2007
1937	Jan. 1, 2008
1938	Jan. 1, 2009
1939	Jan. 1, 2010
1940	Jan. 1, 2011
1941	Jan. 1, 2012
1942	Jan. 1, 2013
1943	Jan. 1, 2014
1944	Jan. 1, 2015
1945	Jan. 1, 2016
1946	Jan. 1, 2017
1947	Jan. 1, 2018
1948	Jan. 1, 2019
1949	Jan. 1, 2020
1950	Jan. 1, 2021

The Saga of *Huckleberry Finn*

In 1990 the long-missing original hand-written manuscript of Mark Twain's classic 1885 novel *The Adventures of Huckleberry Finn* was discovered in an old steamer trunk stored in the attic of a house in Los Angeles. To the surprise of many literary experts, the manuscript contained a good deal of material that never found its way into the published version of Twain's novel. Some material was cut by Twain to keep the book from being too long. Other scenes were apparently omitted to keep the novel from being too dark and disturbing for 19th Century readers. Following a lengthy legal battle, it was determined that the copyright in the manuscript belonged to The Mark Twain Foundation. Such a battle was worth fighting because the unpublished material was not in the public domain, even though the copyright in the published novel expired in 1942. Because of the copyright duration rules discussed in this section, the unpublished material was under copyright at least until Dec. 31, 2002. This was so even though Twain died in 1910. As explained above, the ordinary copyright term for unpublished works—the life of the author plus 70 years after the author dies—

didn't apply because the unpublished material was created before 1978. A new "comprehensive edition" of *Huckleberry Finn* was published in 1996 containing all of the previously unpublished material. Because this unpublished material was published before 2003, its copyright was extended to Dec. 31, 2047.

Steamer trunk, *Picture Sourcebook for Collage and Decoupage*, Dover Publications

Determining When Authors Died

Since all published works by authors dead more than 70 years are now in the public domain, you need to know when an author died to determine whether his or her unpublished works are public domain.

If the author is well-known, reference works such as encyclopedias will probably reveal when (or if) he or she died. The *Encyclopaedia Britannica* is an excellent reference source for this sort of information. It can be accessed for free on the Internet at www.britannica.com and is of course available in libraries. Other Internet resources include the website www.biography.com, which provides the birth and death dates for over 25,000 people, the *Biographical Dictionary* website at www.s9.com/biography, which contains 28,000 birth and death dates and a list of the birth and death dates of many classical composers—it can be found at: www.classical.net/music/composer/dates/comp4.html.

There are also dozens of biographical dictionaries that provide death dates for well-known people. Some of these are general, such as *Merriam-Webster's Bio--graphical Dictionary*. Many specialize in people in particular fields, such as *Baker's Biographical Dictionary of Musicians*, by Theodore Baker and Nicolas Slonimsky (GALE Group).

However, it may be difficult to determine when a particularly obscure or unknown author died. Fortunately, the U.S. Copyright Office has had a procedure in place since 2003 that allows you to safely assume that a work is in the public domain even if it's not possible to determine when the author died.

Since Jan. 1, 2003, once an unpublished work becomes 100 years old you are legally entitled to assume that the work is in the public domain. But you must obtain a certified report from the Copyright Office stating that they have no information that the author has been dead for less than 70 years. If it later turns out that the author in fact died less than 70 years ago, the existence of the report is a complete defense to any claim of copyright infringement. However, there is one exception: You are required to act in good faith. If you knew all along that the author died less than 70 years ago, you are not entitled to rely on such a Copyright Office report.

The only difficulty with the rule is that you must know that an unpublished work was created more than 100 years ago for it to apply. It may be difficult or impossible to date many unpublished works.

C. Works First Published Outside the United States

This section covers the term of U.S. copyright protection for works that were first published outside the United States.

Until 1996, copyright experts generally believed that works first published outside the United States received the exact same copyright term as works first published in the United States. However, during that year a federal appellate court in California held that this was not always so. As explained below, according to this court ruling, many works first published outside the United States during 1909-1977 receive a very different copyright term than those published in the United States at the same time. It all depends on whether the work was published with a proper copyright notice.

1. Works Published Before July 1, 1909

Any work first published outside of the United States before July 1, 1909 is in the public domain in the United States. This is because before 1891 the United States provided no copyright protection at all for works published in foreign countries. Between 1891 and July 1, 1909 the United States granted copyright protection to some foreign published works, but these are all now in the public domain because their copyrights have expired.

2. Works Published From July 1, 1909 through Dec. 31, 1977

The U.S. copyright term of a work first published outside the United States from July 1, 1909 through Dec. 31, 1977 differs depending on whether it contained a copyright notice valid under U.S. law. Copyright notices have never been required for published works in most foreign countries, but they were often used anyway.

A copyright notice valid under U.S. law consists of the © symbol or the word Copyright or abbreviation Copr., followed by the publication date and copyright owner's name. However, the date could be left off maps, original works of art and art reproductions, technical and scientific drawings and models, photographs, labels used on products and merchandise, and prints and pictorial illustrations.

a. Works Published 1909-1977 With Copyright Notice

Any work first published in a foreign country between July 1, 1909 and Dec. 31, 1977 with a copyright notice receives the same copyright term in the United States as works published in the United States during these years (with one big exception, noted below, for works whose copyright was never renewed). The term begins with the year of publication of the foreign work. The copyright terms for such works are as follows:

- **Works published before 1923:** All these works received a 75-year U.S.

copyright term and, therefore, are all in the public domain in the United States.

- **Works published 1923-1963:** The vast majority of these works received a 95-year copyright term, dating from the year of publication with a copyright notice.

 Note that many works published during 1923-1963 used to be in the public domain in the United States because their U.S. copyrights were not renewed with the U.S. Copyright office during the 28th year after publication. However, most foreign works published during 1923-1963 that were never renewed had their U.S. copyright protection restored in 1996 and are protected for a full 95 years. But a few foreign works didn't qualify for copyright restoration and are still in the public domain in the United States. These are primarily works that were in the public domain in their home countries as of Jan. 1, 1996. Also, works by Americans first published outside the United States during 1923-1963 are not eligible for copyright restoration. Thus, for example, photographs of Marilyn Monroe by an American photographer that were initially published in a British newspaper in 1962 with a copyright notice and not timely renewed 28 years later were not eligible for restoration. As a result, the photos were in the U.S.

public domain. *Barris v. Hamilton,* 51 U.S.P.Q. 2d 1191 (S.D. N.Y. 1999). (See Chapter 15, Section C2, for a detailed discussion of restoration of copyrights in foreign works.)

- **Works published 1964-1977:** Any work first published outside the United States during the years 1964 through 1977 with a copyright notice receives a 95-year copyright term, from the date of publication with notice. This means that the earliest any foreign work published between 1964 and 1978 will enter the public domain in the United States because of copyright expiration is January 1, 2060.

b. Works Published 1909-1977 Without a Copyright Notice

Many works first published outside the United States did not contain copyright notices because they were not required in the country of publication. These works get special treatment in the United States.

A work first published in a foreign country between July 1, 1909 and December 31, 1977 without a copyright notice is not in the public domain. This is because a court has ruled that these works should not be considered as having been published under the U.S. copyright law in effect at the time. *Twin Books v. Walt Disney Co.,* 83 F.3d 1162 (9th Cir. 1996). Since the court held that these works should be viewed as unpublished for American copyright purposes, they receive the same copyright term as unpublished works: They are

protected for the life of the author and for 70 years after his or her death.

> **EXAMPLE:** Jules, a French citizen, published a musical composition in France in 1950, but it did not contain a copyright notice. Jules died in 1980. The composition is protected in the United States until the year 2050, 70 years after Jules died.

However, there is an important exception to this rule. If the work was later republished before 1978 with a valid copyright notice, whether in the United states or abroad, it received the same term of U.S. copyright protection as if it were first published in the United States that year. These copyright terms are listed in the previous section.

> **EXAMPLE:** The children's book *Bambi: A Life in the Woods,* by Felix Salten, was originally published in Germany without a copyright notice in 1923. It was then republished in Germany with a copyright notice in 1926. The

1926 publication triggered the 95-year copyright term provided for U.S. works published at this time. This means *Bambi* won't be in the public domain in the United States until 2022. Had *Bambi* not been republished with a copyright notice, it would have been protected for 70 years after Salten died. *Twin Books v. Walt Disney Co.*, 83 F.3d 1162 (9th Cir. 1996).

Not all copyright experts agree with the decision reached by the Court of Appeals in the *Twin Books* case. They believe there should be no difference in copyright terms for works published in the United States or abroad. However, the court's ruling is a binding legal precedent in the entire Ninth Judicial Circuit of the United States. All federal trial courts in Alaska, Arizona, California, Hawaii, Idaho, Montana, Nevada, Oregon, and Washington are obliged to follow it. Courts in other parts of the country are not required to follow it, and it's possible that they may not. However, to date no other court has ruled on this issue. The only prudent course is to follow the Ninth Circuit's ruling and act as if the foreign works it affects are not in the United States public domain.

3. Works Published After 1977

Works published in almost all foreign countries after 1977 receive the same U.S. copyright term as works published in the United States (see Section A). This is true

Old-Fashioned Animal Cuts, Dover Publications

whether or not they contain a copyright notice. None of these works will enter the public domain due to copyright expiration for many decades. (However, some works published abroad without a copyright notice during 1978 through 1989 may have entered the United States public domain due to the lack of a copyright notice (but not due to copyright expiration); see Chapter 19.)

The only exception is for works from countries with which the United States has no copyright relations. (See below.)

Copyright Duration Chart for Works Published Outside the U.S.

Date and Nature of Work	Copyright Term
Before July 1, 1909	The work is in the public domain
July 1, 1909-1922 with a copyright notice	The work is in the public domain
1923-1977 with a copyright notice	95 years from the year of publication
July 1, 1909-1977 without a copyright notice	Single term of at least life plus 70 years, but cannot expire before Dec. 31, 2047 (if work is republished during 1978-2003)
1978 or later, with or without a copyright notice	Single term of life plus 70 years (but if work is made for hire or anonymous or pseudonymous, 95 years from the date of publication or 120 years from date of creation, whichever ends first)

Works Published in Countries With Which the U.S. Has No Copyright Relations

Today, works published in almost all foreign countries are entitled to U.S. copyright protection. However, there are a handful of countries with which the United States has no copyright relations. These are:

Afghanistan Iran Oman
Bhutan Iraq San Marino
Ethiopia Nepal

Works published in these countries by citizens of these countries receive no protection at all under U.S. law.

The Frozen Public Domain:
Impact of the Sonny Bono Copyright Term Extension Act

Before 1998, copyright protection for works published in 1977 and earlier lasted 75 years from the date of publication. This meant that all works published in 1923 were due to enter the public domain in 1999; those published in 1924 would have become public domain in 2000; those published in 1925 would have become public domain in 2001; and so on every year until all works published before 1978 entered the public domain.

However, in 1998 this process was frozen for 20 years when Congress passed the Sonny Bono Copyright Extension Act. This law extended all copyright terms by 20 years. Works published between 1923 and 1978 are now protected for 95 years from the year date of publication. This means works published in 1923 won't enter the public domain until 2019, those published in 1924 won't enter the public domain until 2020, and so on.

Eric Eldred, an individual who maintained a website on which he placed public domain writings, challenged the constitutionality of the copyright extension all way to the United States Supreme Court. Eldred and his supporters argued that by increasing the copyright term over and over again, Congress was in effect making copyright protection perpetual, something the Constitution does not allow. Eldred's suit turned into the most highly publicized copyright case in a generation, spawning "Free the Mouse" bumper stickers (referring to Mickey Mouse, who would have entered the public domain in 2003 but for the extension). To the profound regret of public domain proponents, the Court held that the extension was perfectly legal. *Eldred v. Ashcroft*, 537 U.S. 186 (2003). Thus, the extension will remain in place (unless Congress acts to change the law again).

The Sonny Bono Act has had a devastating effect on the public domain. The chart below shows how the many copyright extensions enacted by Congress have shrunk the public domain. Who was behind this latest copyright extension?

The heirs of famous songwriters such as George Gershwin and Irving Berlin, the Hollywood film studios, and other major corporations that owned old copyrights. The law greatly benefits them—it has been estimated that the windfall to the Gershwin family trust alone from the copyright extension exceeds $4 million for each song. But the law is a tragedy for the American people as a whole. It means we'll all have to pay for permission to use many great works that should have been freely available to all.

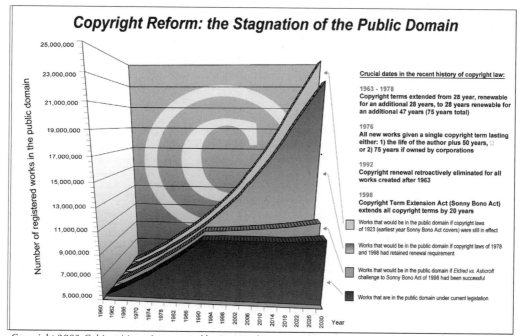

Copyright Reform: the Stagnation of the Public Domain

Number of registered works in the public domain (y-axis): 5,000,000 to 25,000,000

Year (x-axis): 1960, 1962, 1966, 1970, 1974, 1978, 1982, 1986, 1990, 1994, 1998, 2002, 2006, 2010, 2014, 2018, 2022, 2026, 2030

Crucial dates in the recent history of copyright law:

1963 - 1978
Copyright terms extended from 28 year, renewable for an additional 28 years, to 28 years renewable for an additional 47 years (75 years total)

1976
All new works given a single copyright term lasting either: 1) the life of the author plus 50 years, or 2) 75 years if owned by corporations

1992
Copyright renewal retroactively eliminated for all works created after 1963

1998
Copyright Term Extension Act (Sonny Bono Act) extends all copyright terms by 20 years

Works that would be in the public domain if copyright laws of 1923 (earliest year Sonny Bono Act covers) were still in effect

Works that would be in the public domain if copyright laws of 1978 and 1998 had retained renewal requirement

Works that would be in the public domain if Eldred vs. Ashcroft challenge to Sonny Bono Act of 1998 had been successful

Works that are in the public domain under current legislation

Copyright 2003 *Cabinet* Magazine, created by Jay Worthington and Luke Murphy

Copyright Notice Requirements

If you find a work published before March 1, 1989 without a copyright notice—the © symbol followed by the copyright owner's name and publication date—it could be in the public domain. This chapter shows you how to determine whether a work lacking a proper copyright notice is in the public domain in the United States.

You may skip this chapter if the work you are researching was published after March 1, 1989 or was never published. These works do not need copyright notices.

A. Copyright Notices and the Public Domain

One unusual feature of U.S. copyright law is that before March 1, 1989 all published works had to contain a copyright notice —the familiar © symbol or the word "copyright" along with the publication date and the name of the copyright owner. The punishment for failure to comply with this rule was severe: A work published before January 1, 1978 without a copyright notice automatically entered the public domain at the moment of publication unless one of the many exceptions discussed below applied.

> **EXAMPLE:** Sally self-published a book of her poetry in 1975. Since she wasn't familiar with copyright law, she failed to place a copyright notice on the book. As a result, the work automatically entered the public domain upon the date of publication.

Works published without valid notices beginning in 1978, and continuing through March 1, 1989, did not automatically enter the public domain upon the date of publication. Instead, owners of such works were given five years after the publication to cure the omission. They automatically entered the public domain after that time if the owner failed to add a proper notice. (See Section D5.)

It is impossible to know how many works published before 1989 lacked proper copyright notices. Most American publishers routinely included copyright notices on their products. As a result, there aren't many famous works that were published without copyright notices. Perhaps the most famous work that entered the public domain because it was published without a notice is the children's book *The Tale of Peter Rabbit* by Beatrix Potter. More often, notices were left off works that were thought to have limited or only temporary value—for example, advertisements, postcards, or newspapers.

However, before you start trolling libraries, archives, flea markets, and other places for works published without a copyright notice, be aware that there are several exceptions to the notice requirement. Because of these exceptions, discussed below, it can be very difficult to know for sure if a work lacking a valid notice is in the public domain or not.

To determine if a work without a valid copyright notice is in the public domain, you must answer three questions:

- Does the work lack a notice or is the notice invalid?
- If the work lacks a valid notice, is it because a notice was not required?
- If notice was required, is the lack of a valid notice excused?

The work will be in the public domain only if it lacks a notice or has an invalid notice, if a notice was required, and if none of the excuses for failing to have a notice apply.

Before moving ahead to answer these difficult questions, first make sure the work is not in the public domain for some other reason. Turn to the chapter covering the type of work involved—for example, writings, music, art, photographs—to make sure you have considered these other ways the work might have entered the public domain. For example:

- Is the work eligible for copyright protection? Works created by the U.S. government and certain other types of works are not copyrightable and are always in the public domain.
- Has the copyright expired? Any work published in the United States before 1923 is in the public domain because its copyright has expired.
- If the work was first published in the United States during 1923-1964, was the copyright renewed? All works published during these years had to be renewed 28 years after publication

or they entered the public domain. It's likely that most works published without a valid copyright notice during these years were never renewed (indeed, it's estimated that 85% of all works published during 1923-1964 are in the public domain because they were never renewed). It will usually be much easier to determine that a work is in the public domain because it was not renewed than for lack of a valid copyright notice (see Chapter 21). Now, let's examine each question in turn.

In many cases, it will be impossible for you to know for sure whether a work is in the public domain because it lacks a valid copyright notice, though it may seem likely that it is. In these cases, refer to Chapter 1 for detailed guidance on how to deal with such public domain gray areas.

B. Does the Work Lack a Valid Notice?

The first step you should take is to check the work carefully to see if it contains a valid copyright notice. If it has a valid notice, you don't need to read the rest of this chapter.

Some published works contain some, but not all, of the required elements for a valid notice. If the omissions or errors in the notice are serious enough, the notice will

not be legally valid. A work with an invalid notice is treated just the same as if it has no notice at all.

A valid copyright notice ordinarily contains three elements:

1. the copyright symbol—©—or the word "Copyright" or abbreviation "Copr."
2. the publication date (however, the date is not required for some types of works), and
3. the copyright owner's name.

These elements don't have to appear in any particular order (although they are usually in the order listed here).

In the past, courts were very strict about enforcing complex rules concerning the format and placement of copyright notices. Today, however, they tend to be much more lenient. A notice must contain a truly serious error or omission for the copyright to be invalidated.

The following errors or omissions will render a notice invalid:

1. The Copyright Symbol

A copyright notice must contain either the copyright symbol "©," or the words "Copyright" or "Copr." The word "Copyrighted" is also acceptable. If one of these is not present on the work, the notice is invalid.

Sometimes the copyright symbol is not in the proper form—for example, where the letter "c" is not completely surrounded by a circle. A letter c surrounded by parentheses, hexagon, or some other geometric form has been found acceptable by several courts. *Videotronics, Inc. v. Bend Elecs.*, 586 F.Supp. 478 (D. Nev. 1984). But courts have held that use of the letter c alone renders the notice invalid. *Holland Fabrics, Inc. v. Delta Fabric, Inc.*, 2 U.S.P.Q. 2d 1157 (S.D. N.Y. 1987).

There is one exception to the rule that a copyright notice must contain the © symbol or words Copyright or Copr. Copyright notices for sound recordings are supposed to contain a capital P in a circle (℗) instead of the © symbol or the words Copyright or Copr. A sound recording notice without the ℗ is invalid. The P stands for phonorecord. However, the word phonorecord may not be used in place of the ℗. But note that notices are only required for sound recordings published from Feb. 15, 1972 through March 1, 1989 (see Section C4).

2. Publication Year

Subject to the important exceptions noted below, the notice must also contain the date the work was published. The date can be in either Arabic or Roman numerals. A notice without a date is invalid. In addition, a copyright notice with a publication date more than one year in the future—that is, more than one year after the actual date of publication—is treated as if it had no notice at all. This is so even if only a small number of copies were distributed with the defective notice.

EXAMPLE: Isaac's book was first published in 1987, but the copyright notice lists 1989 as the publication date. The notice is invalid.

On the other hand, where the publication date is for any year *prior* to the actual publication date, the notice's validity is not affected. However, the year stated in the notice becomes the official legal publication date for copyright duration purposes.

EXAMPLE: Abraham's book was first published in 1948, but the copyright notice lists 1946 as the publication date. The notice is valid, but 1946 is now considered the date of publication for purposes of computing the duration of Abraham's copyright.

However, not all works need to have a publication date in their notice. Whether a date was required depends on the type of work involved and the date of publication.

a. Works Published Before 1978

If a work was published before 1978, it needs to have a year in the copyright notice only if it is a printed literary, musical, or dramatic work. Such works include books, magazines, periodicals, newspapers, lectures, speeches, plays, sheet music and musical scores, screenplays and movies. Also included are sound recordings, published from Feb. 15, 1972 through Dec. 31, 1977. (Sound recordings published before 1972 didn't need copyright notices; see Section C4.)

The following types of works published before 1978 didn't have to have a year in the copyright notice:

- maps
- original works of art and art reproductions
- technical and scientific drawings and models
- photographs
- labels used on products and merchandise, and
- prints and pictorial illustrations.

b. Greeting Cards, Stationery, Jewelry, Toys, and Useful Articles Published After 1/1/78

Starting on January 1, 1978 the copyright law was changed to require a year in copyright notices for all types of works except greeting cards, postcards, stationery, jewelry, toys, dolls, and useful articles when they contain pictorial or graphic works. For example, a Christmas card with a drawing or photo of Santa Claus need not contain a publication date in the copyright notice. Useful articles are utilitarian items such as furniture, clothing, pottery, dishes, glassware, silverware, and rugs.

Although dates are not required in the notices for such works, they are often included anyway, or a publication date may be placed elsewhere on the work. If not, you may need to do some research. See Section C2. below for a discussion of ways to determine the date a work was published.

c. New Editions and Derivative Works

When a published written work is later revised and republished as a new edition, the notice need only include the publication date and copyright owner of the revised edition. The same rule holds true when an original work is later adapted into a new work—for example, a novel is transformed into a screenplay or stageplay. Such a work is called a derivative work (see Section C6).

3. Owner's Name

The copyright owner's name must also be included in the notice. The word "by" need not be used before the name, though it often is. The name can appear in almost any form, including:

- the copyright owner's full legal name (if the owner is a corporation, the word "Inc." need not appear in the notice)
- the owner's surname (family name) alone or with the owner's first initial
- an abbreviation, trade name, nickname, or initials by which the copyright owner is generally known—for example, IBM, or
- for photos, sculpture, art, or graphics published before 1978, the owner's initials can be used even if the owner isn't generally known by such initials, so long as the full name appears somewhere on or in the work.

Omission of the copyright owner's name from a notice makes the notice legally invalid and will place the work in the public domain unless one of the exceptions discussed in Section D applies.

> **EXAMPLE:** A Massachusetts manufacturer of sewing machine parts published an illustrated catalogue containing drawings of its parts. However, the copyright notice included in the catalogue said only "copyright-1933." The company's name—the copyright owner—was omitted. A court held that the catalogue entered the public domain when it was published due to the failure to include the copyright owner's name in the notice. This meant that one of the company's competitors was free to copy the drawings in its own catalogues. *W.S. Bessett, Inc. v. Albert S. Germain Co.*, 18 F.Supp. 249 (D. Mass. 1937).

However, minor spelling or other minor errors in a name in a notice do not affect the copyright's validity. For example, misspelling John Smith's name as "John Smythe" in a copyright notice would not affect the copyright's validity.

But what if the wrong name is used in the notice—that is, the person or company named in the notice is not really the copyright owner? This is obviously a much more serious error than misspelling the name. Nevertheless, the copyright law provides that if the work was published during January 1, 1978 through March 1, 1989 it is not placed in the public domain

if the name in the notice is not the actual copyright owner.

The rule as to works published before 1978 is not entirely clear. The law mentioned above does not apply to these works. Forty or 50 years ago courts would usually hold that a work entered the public domain if the person or company named in the notice was not the true copyright owner. In more recent years, however, courts have tended to be much more lenient. For example, a court held that sound recordings published in 1973 with the wrong name in the copyright notice did not enter the public domain. The court reasoned that no one was harmed by the improper name because the company listed in the notice referred all inquiries regarding the recording to the true copyright owner. *Fantastic Fakes, Inc. v. Pickwick Int'l, Inc.*, 661 F.2d 479 (5th Cir. 1981). To be on the safe side, you should assume that such works do not enter the public domain—that is, it is sufficient that they have any name in the notice, even if it turns out not to be the true copyright owner.

4. Wrong Placement

Subject to the exceptions explained below, a copyright notice can be placed anywhere on a work so long as it gives the public "reasonable notice of the claim of copyright." 17 U.S.C. Section 401(c). In other words, it can be placed anywhere a person could be reasonably expected to find it.

Very Old Copyright Notices

If you examine books or other written works published in the United States before 1909 you'll find that the copyright notice looks different than as described above. It was not until 1909 that Congress required that a copyright notice include the word "copyright" or the © symbol along with the date of publication and copyright owner's name.

Between 1874 and 1909 copyright owners had the option of using the word "Copyright" along with the date the work was entered (filed) with the Library of Congress and the name of the party who entered it. Or, they could use a notice like the following, which was used for a book published in New York City in 1847:

Entered according to Act of Congress, in the year 1847, by Wm. H. Onlerdonk, in the Clerk's Office of the District Court for the Southern District of New York.

Between 1802 and 1874, all copyright notices had to be like or similar to the example above.

Of course, the copyright in all such works has expired (see Chapter 18). Therefore, it makes no difference whether they contain a valid notice. But the date in the notice helps make it clear that the copyright has in fact expired.

However, there are three important exceptions to this general rule for works published *before 1978*. Notices for such works must be in the locations indicated below or the notice is invalid:

- **Books:** On the page immediately following the title page or on the title page itself.

ISBN: 0-226-06577-4 *(clothbound)*; 0-226-06578-2 *(paperbound)*

Library of Congress Catalog Card Number: 61-14947

THE UNIVERSITY OF CHICAGO PRESS, CHICAGO 60637
The University of Chicago Press, Ltd., London

© 1961 by The University of Chicago. All rights reserved
Published 1961. Eleventh Impression 1975. Printed in the
United States of America

Sample Pre-1978 Copyright Notice

- **Magazines, newspapers, journals, and other periodicals:** On the title page, the first page of text, or under the title heading. The notice may also appear in a magazine's masthead.

National Geographic Magazine Copyright Notice

- **Musical works:** On the title page or first page of music.

Sample Copyright Notice for Sheet Music

C. Is a Copyright Notice Required?

Even if the work you're interested in has no notice or has an invalid notice, it may not be in the public domain. This is the case if a notice is not required for the type of work involved. Copyright notices are only required for works that were published for the first time in the United States before March 1, 1989. Notices are not required for:

- unpublished works
- works published after March 1, 1989, or
- works first published outside the United States.

In addition, contributions to collective works such as magazines and newspapers don't need their own copyright notices.

If you determine that a notice is not required, you don't need to read the rest of this chapter. If a notice is required and the work lacks a valid notice, go on to Section D to determine if the lack of a valid notice is excused.

After March 1, 1989 the law was changed so that any published or unpublished work has copyright protection, even without a copyright notice. Any work created after that date automatically obtains copyright protection. (See Chapter 2 for a detailed discussion of copyright law.)

1. Unpublished Works

Although authors occasionally place copyright notices on their unpublished works, they have never been legally required. The lack of a valid copyright notice does not place a work in the public domain. Publication has a specific legal meaning for each kind of creative work. To learn the requirements for publication, read the chapter on the specific type of work you are considering—for example, if the work you want to use is a photograph, read Chapter 6 on photographs to learn the legal definition of publication.

2. Works Published After March 1, 1989

Copyright notices were made optional as of March 1, 1989, bringing U.S. law in line with the laws of most foreign countries. As a result, a copyright notice is not required on any copies of a work published on or after March 1, 1989. This is so regardless of whether other copies of the same work were previously published before that date—in other words, if a work is published both before and after March 1, 1989 the copies published after that date don't need notices.

EXAMPLE: Bruno self-published a book of poetry in 1988. The work contained a valid copyright notice. By 1990, the work sold out and Bruno published a second edition. However, this time he forgot to include a copyright notice. Even so, the book did not enter the public domain. Because the second edition was published after March 1, 1989 no notice was required.

Even though copyright notices are not required for works published after March 1, 1989, they are usually included anyway. There are a number of reasons for this, including:

- force of habit
- because including copyright notices helps make it clear to the public that the work is copyrighted, and
- because including a notice provides certain limited advantages if the copyright owner ever files a copyright infringement lawsuit, because the alleged infringer can't claim he didn't know the work was copyrighted.

But inclusion or exclusion of the proper notice has no bearing on when a work published after March 1, 1989 enters the public domain.

How can you tell whether a work was published after March 1, 1989? Here are some ways:

- Most published works are dated in some way (see the examples in Section B4 above). Examine the work carefully to see if it contains a publication date or some other evidence of when it was published.

- Look at the condition of the work. If it looks old, it was probably published long before 1989, which, after all, isn't very long ago. For example, a book with yellowing pages and a crumbling leather binding was likely published long before 1989.

- If you have Internet access, do a search under the author's name and the name of the work. There may be an entire website devoted to the author that provides a publication date. Or there may be an online encyclopedia (for example, britannica.com) or other reference work or database that provides this information.

- If the work was registered with the U.S. Copyright Office, checking Copyright Office records will also reveal when it was published (see Chapter 21). However, many works were never registered.

- If the publisher or printer's name is listed on the work, contact the company and ask them when the work was published.

- The work may be listed in library catalogues, many of which can be searched online. Turn to the chapter covering the type of work involved—for example, writings or music—and you'll find a list of library resources for that type of work.

- Various printed reference works may also reveal when the work was published. For example, a music or art encyclopedia may reveal when a particular work was published. A biography about the author may also have this information. Turn to the chapter covering the type of work involved—for example, writings or music—and you'll find a list of reference resources for that type of work. You may find more resources by visiting or calling the reference department of a good library.

If you cannot determine the publication date after following the steps outlined above, the safest course of action is to assume that a work was published after March 1, 1989, and is, therefore, not in the public domain.

3. Works Published Outside the U.S.

If the work you're interested in was first published outside the United States and lacks a valid copyright notice, it is still not in the public domain. Works published outside the United States from January 1, 1978 through March 3, 1989 without a valid notice used to be in the public domain in the United States unless the omission was

excused by one of the exceptions explained in Section D below. However, the U.S. copyrights in almost all these works was automatically restored on January 1, 1996. (See Chapter 15 for a detailed discussion of this issue.)

4. Sound Recordings

Before February 15, 1972 the federal copyright law did not protect sound recordings—for example, phonograph records. They were and are protected by state law instead. For this reason, such works did not have to contain copyright notices. Federal copyright protection replaced state law protection in 1972. So sound recordings published in the United States from February 15, 1972 through March 1, 1989 did have to contain a copyright notice. A recording published

during this time without a notice is in the public domain unless the omission is excused as described in Section D. But this does not mean that the words or music on the recording are in the public domain. The music and lyrics reproduced on a sound recording need not contain a copyright notice. A notice is only needed to protect the recording of the performance of the music and lyrics, not the music and lyrics themselves.

⚠ You Do Not Need Permission to Use a Sound Recording That Fell Into the Public Domain Because It Lacked a Proper Copyright. That means you do not need to obtain permission from the former copyright owner, performers, or record company to use the recording of the performance. But you would need to obtain permission from the copyright owner of the music performed on the recording.

Photograph of President Harding speaking into recording apparatus, Library of Congress, Prints and Photographs Division

5. Contributions to Collective Works

A collective work is a work that is created by selecting and arranging preexisting materials that are separate and independent works entitled to copyright protection in their own right. Examples of collective works include anthologies; newspapers, magazines, and other periodicals in which separate articles (with copyright protection of their own) are combined into a collective whole; and encyclopedias consisting of

articles on various topics. Individual articles or other contributions to a collective work need not contain their own copyright notices. The single notice for the work as a whole is sufficient.

EXAMPLE: Steve wrote an article on filmmaking and sold the right to publish it the first time to *Film Weekly* Magazine. He retained all his other rights and was, therefore, the copyright owner of the article. When his article was published in *Film Weekly* in 1988, it did not contain its own copyright notice in his name. The only notice in the magazine was the notice that *Film Weekly* placed on its title page in its own name. However, this was sufficient to satisfy the notice requirement for Steve's article.

However, there is one exception to this rule. Advertisements published in magazines, newspapers, and other collective works must contain their own copyright notices.

6. Derivative Works

A derivative work is one that is based upon or adapted from a preexisting work. Good examples are movies based on novels or plays, and translations and new editions of existing works.

What if an original work published with a proper notice is later incorporated into a derivative work that is published before 1989 and the derivative work lacks a notice? Is the original work thrown into the public domain along with the derivative work? The courts disagree with each other on this question. Some have held it does place the original work into the public domain. Others have said it doesn't so long as the copyright owner of the original work did not intend to abandon his or her copyright through the publication that occurred without the proper copyright notice. *L&L White Metal Casting Corp. v. Joseph*, 387 F.Supp. 1349 (E.D. N.Y. 1975); *Baldwin Cooke Co. v. Keith Clark, Inc.*, 505 F.2d 1250 (5th Cir. 1974). Because of this split among the courts, the safest course is to assume that the original work is not injected into the public domain. However, the new material added to the original work will be in the public domain unless the lack of a notice is excused.

EXAMPLE: Sam finds two editions of a book on forensic science called *Murder for Blockheads*. The first edition was published in 1980 with a proper copyright notice. The second edition—a major revision—was published in 1988 without a copyright notice. Sam should assume that the failure to place a notice on the second edition—a derivative work based on the first edition—does not place the first edition into the public domain. But, the new material added to the second edition will be in the public domain unless one of the excuses discussed below applies.

D. Is the Omission of a Valid Notice Excused?

Even if a work published in the United States before March 1, 1989 lacks a valid copyright notice, it still may have copyright protection. This is because the omission may be excused. Before you can conclude that any work is in the public domain because it lacks a copyright notice, you must first determine that none of these excuses apply.

1. Works Published by Licensees

Most courts do not like to see an author of a creative work lose copyright protection because of failure to comply with a technical formality. This seems particularly unfair where the noncompliance wasn't even the copyright owner's fault. For this reason, the courts created a very important excuse, saving from the public domain many works published without notices. This excuse applies when a copyright owner grants a license to a publisher or anyone else to publish his work and, unbeknownst to the owner, the person fails to include a valid notice on the work.

This excuse came into being because several courts held that an agreement between the author and the publisher includes the implication—whether in writing or not—that the publisher would take whatever steps necessary to preserve the author's copyright protection. This, of course, included placing a valid copyright

notice on all published versions of the work so that it would not enter the public domain. If a licensee failed to live up to this implied promise, the courts held that the faulty publication was made without the copyright owner's authority and therefore did not inject the work into the public domain. *Fantastic Fakes v. Pickwick International*, 661 F.2d 479 (5th Cir. 1981).

Not all courts have applied this exception in every case in the past and it's possible some might refuse to do so today. However, given the trend in the courts to be lenient to copyright owners who have failed to have valid copyright notices placed on their works, it's likely that most courts would apply this exception to save a work from the public domain. It's prudent, therefore, for you to act as though this exception does apply and not treat works falling within this exception as being in the public domain for lack of a valid notice. You'll never get into legal trouble if you follow this approach.

> **EXAMPLE:** Sean, a short story writer, orally agreed in 1975 that the science fiction fan magazine *SciFan* could publish one of his stories one time only (what's called a nonexclusive license). Sean retained all his other copyright rights in the story—for example, the right to republish the story in anthologies, to create a movie from it, or to translate it into other languages. *SciFan*'s publisher failed to include a copyright notice in the issue containing Sean's story. Although Sean's story

was published without a notice, it's likely that a court would hold it's not in the public domain. By publishing it without a notice, *SciFan* breached an implied (unspoken) promise to Sean that it wouldn't do anything to harm his copyright rights in the story. This in turn meant that for copyright purposes the story was published without Sean's permission.

a. Rule Changes for 1978 and Beyond

Starting in 1978, a new copyright law took affect that tightened up the rules for works published without copyright notices by licensees. A work published without a valid notice between Jan. 1, 1978 and March 1, 1989 is saved from the public domain only if there was a *written license agreement* that required the licensee to include a copyright notice on the work. Without such a requirement in writing, the work entered the public domain unless one of the other exceptions discussed below applies.

> **EXAMPLE:** In 1987, Mavis signed a contract with Hackneyed Publications granting it a license to publish her book in North America. Mavis retained all her other copyright rights. The contract contained a clause requiring Hackneyed to include a proper copyright notice on the book when it was published. Somehow, the notice was left off all the copies Hackneyed published in 1988. Even so, the work is not in the public domain because the unnoticed publication violated a written license agreement.

Because of this rule, if a work without a copyright notice was licensed, you can generally forget about it being in the public domain if it was published before 1978. If the work was published after 1978, you must obtain and read a copy of the license agreement to know for sure whether it's in the public domain. As a practical matter, this will often be impossible. Some license agreements are recorded with the U.S. Copyright Office, so you may be able to get a copy there (see Chapter 21). However, most licenses have never been recorded. It's doubtful that either the licenser/copyright owner or licensee would agree to give you a copy or otherwise help you establish that the work is in the public domain. After all, why should they risk losing copyright in the work?

b. If the Author Knew the Work Was Published Without Notice

However, there is an exception to this excuse: If the copyright owner/licenser knew that the licensee was publishing the owner's work without a valid notice and did not object or otherwise attempt to stop the publication, the owner can't later claim the licensee breached a promise to include such a notice. In this event, the work *will* be deemed to have entered the public domain by the courts.

EXAMPLE: Assume in the example above that Sean was sent an advance copy of the issue of *SciFan* containing his story. Sean saw that the issue lacked a copyright notice but did not object to the publisher or attempt to halt the unnoticed publication. Sean's story would be deemed to have entered the public domain because it was published without a notice with his knowledge.

c. Authors Who Don't License Their Work

In addition, the rules discussed here only apply to copyright owners who *license* their work to be published by others—that is, sell some, but not all, of their copyright rights. See *House of Hatten, Inc. v. Baby Togs, Inc.*, 668 F.2d 251 (S.D. N.Y. 1987). It does not apply, for example, to:

- A person who publishes his or her own work.

EXAMPLE: Assume that Grandma Jacobs, a well-known primitive artist, completed a painting and offered it for sale to the public in her Arizona studio in 1960. She failed to place a copyright notice on the work. The painting is considered to be published (see Chapter 5), so the failure to include a notice on it injected it into the public domain.

- Works created by employees and published by their employers.

EXAMPLE: Assume that David, a newspaper reporter employed by the *New York Inquirer*, wrote a lengthy expose of the meat packing industry that was published in the paper in 1985. The newspaper did not contain a copyright notice. Since David was an *Inquirer* employee, the story was a work made for hire for which the newspaper owned all the rights and was considered the author for copyright purposes. Therefore, the unnoticed publication injected the story into the public domain.

- Works for which the author transfers all of his or her copyright rights to the person or entity who publishes it (such a transfer is termed an assignment, not a license).

EXAMPLE: Assume that Suzy, a novelist, created a novel called *Golgotha* and sold all her copyright rights to Acme Press. Acme, not Suzy, then owned the copyright in the novel. Acme published the novel without a valid copyright notice in 1968. The unnoticed publication injected the novel into the public domain.

In some cases it will be fairly obvious that a work has not been licensed. For example, any work written by an employee and published by the employer is not licensed (see the example above). Another area where licensing is uncommon is fine art. Painters and sculptors ordinarily do not

license their work for publication by other people. Instead, they publish their works themselves by offering them for sale to the general public, museums, or galleries (see Chapter 5). As a result, a great deal of fine art has entered the public domain because artists often did not include copyright notices on their works. But note carefully, that this only applies to art published in the United States before March 1, 1989. After that date a notice on the work was not necessary.

In other cases, you may be familiar with the work's publishing history. However, in many cases it will be very difficult, if not impossible, for you to know whether a work was licensed. The first thing you need to do in these cases is check to see if the work has been registered with the U.S. Copyright Office and, if so, obtain a copy of the registration application (see Chapter 21). This will show you if the publisher of the work is the same person or entity as the copyright owner. If so, the work has not been licensed and an unnoticed publication will place it into the public domain unless one of the other exceptions discussed below applies.

If the work has not been registered, it will be much harder to determine if it has been licensed. You'll need to contact the publisher or copyright owner. It's probably wise not to mention that you're investigating to determine whether the work is in the public domain. Doing this kind of research can be time consuming; therefore it's only worthwhile for a very valuable work.

2. Notice Removed Without Owner's Permission

A published work does not enter the public domain if it originally had a valid copyright notice and the notice is later removed, destroyed, or obliterated without the copyright owner's permission. For example, a book whose title page has been torn out is not in the public domain if the page had a valid notice.

3. Notice Omitted by Accident or Mistake Before 1978

There is another much more limited exception to the rule that works published before 1978 without a valid copyright notice are in the public domain. This is where the copyright owner failed to provide notice on a *particular copy or copies* by accident or mistake. Accident or mistake meant that there was an accident in the printing process or similar mechanical error.

This exception has been successfully invoked only where a notice was omitted due to a printing or similar mechanical problem. For example, lack of notice was excused where the printing plate on which a copyright notice appeared was damaged. *Strauss v. Penn Printing & Publishing Co.,* 220 Fed. 977 (E.D. Pa. 1915).

Moreover, the exception applies only if the notice was left off only a very few copies of the total number published. For example, the exception was applied where

the copyright notice was accidentally obliterated on five jeweled pins out of hundreds that were manufactured when the words Tiffany & Co were stamped over the notice. *Herbert Rosenthal Jewelry Corp. v. Grossbardt*, 528 F.2d 551 (2d Cir. 1970).

People who unwittingly use a work like this have some legal protection because the owner of the work would have to prove that the user actually knew the lack of a copyright notice was a mistake but used the work anyway.

4. Only Small Number of Unnoticed Copies Distributed 1978-1989

A much broader exception than the accident or mistake rule was created for works published between January 1, 1978 and March 1, 1989. Copyright protection was not lost for such works if the notice was omitted from no more than a "relatively small" number of copies distributed to the public. It doesn't matter if the omission was by accident or on purpose.

The "relatively small" criterion was deliberately left vague by the copyright law in order to give courts maximum flexibility to decide the question on a case-by-case basis. Courts have held that omission of a proper notice from 1% and 4% of the total copies published satisfied the criterion. Courts have also ruled that the criterion was not met when notice was omitted from 10%, 22%, and 39% of the total number

of published copies. When applying this criterion, courts ask whether notice was left off so many copies that a diligent copyright owner should have been aware of the problem.

The problem is to discover how many copies of the work you want to use were published without a notice. If you find a single copy that lacks a notice, it could be the only one and fall into the "relatively small" category. Such a work would not be in the public domain. If you can find multiple copies lacking a notice, it's likely that a proper copyright notice was omitted from a substantial number of copies. However, even then you can't be absolutely sure how many copies were published without a notice. The publisher may not know and probably wouldn't tell you if it did. This is yet another reason why it can be very difficult to know for sure whether a work published without a notice is in the public domain or not.

5. Corrective Measures Taken to Cure Omission for Works Published 1978-1989

If the work was published between January 1, 1978 and February 28, 1989 there is one final exception to the rule that publication without notice injected the work into the public domain: The copyright owner could take certain corrective steps to cure the omission. If this was done, the work did not enter the public domain.

To cure the omission, the copyright owner was required to:

- register the work with the U.S. Copyright Office within five years after the unnoticed publication
- send certified letters to all distributors of the work instructing them to return their old copies for replacement, or offering to supply them with labels containing the proper copyright notice to affix to the copies, and
- if economically feasible, attempt to notify every purchaser that could be located that the work was protected by copyright.

If you find a work published during 1978-1989 without a valid notice you'll need to check the Copyright Office records to see if the work was registered within the five-year time limit. If it was registered, it's likely the work is not in the public domain. (See Chapter 21 for how to search Copyright Office records.)

If the work was not registered, it could be in the public domain unless one of the other exceptions discussed previously applies.

E. What If You Make a Mistake?

As the above discussion demonstrates, it can be difficult—often, impossible—to know for sure whether a work published without a notice is in the public domain or not. What if you make a mistake and use a work that you wrongly thought was in the public domain. In this event, the copyright law gives you some important relief.

If, unbeknownst to you, the failure to include a valid notice on a published work is excused because of any of the last four exceptions discussed above (that is, removal of notice, accident or mistake, small number of copies, or corrective measures taken to cure the omission), you will not be liable for damages for copyright infringement if you prove the following three things:

1. You were misled by the lack of notice into thinking the work was in the public domain.
2. You acted in good faith and reasonably under the circumstances.
3. Your copying was completed before you learned that the work had been registered with the Copyright Office (if it was). 17 U.S.C. Section 405(b).

EXAMPLE: In 1999, Sally obtained several copies of a self-published book by Sam. All the copies lacked a copyright notice, but stated that they were published in 1988. Sally checked the Copyright Office records and discovered that the work had never been registered. Sally therefore concluded that the work was in the public domain because it was published before 1989 without a valid notice and no steps had apparently been taken to cure the omission. Sally then copied most of the book onto her website. Sam later discovered Sally's copying and

filed suit for copyright infringement. Sally will not be liable for damages if she convinces the court that she reasonably believed in good faith that Sam's book was in the public domain.

Note carefully, however, that this rule applies only to authorized publications by the copyright owner. It won't apply, for example, where the copy lacking a notice was itself a pirated version of the original work; and it may be impossible for you to tell if the work you have is a pirated version or not.

Nor will it usually apply where a licensee published the work before 1978 (see Section D1). It also won't apply where the work was published between 1978 and March 1, 1989 by a licensee and a written license agreement required that a notice be included on the work (see Section

D1). Such publications by licensees are not considered to be authorized by the copyright owner. The book in the example above was not published by a licensee, since the copyright owner published it himself.

To convince a judge or jury that you acted reasonably and in good faith, you should, at the very least, always check to see if a work published without a notice between 1978 and March 1, 1989 was subsequently registered with the Copyright Office. If the work was published between 1978 and March 1, 1989 it is also a good idea to try to find more than a single copy without a notice and document your efforts to do so. We have included a worksheet (Appendix C) to help you keep track of your efforts to document the public domain status of any work. ■

Traps for the Unwary:
Trademark and Publicity Rights

I f you intend to use public domain works in commercial advertising or on merchandise, you may face special problems. In these circumstances, simply proving that a particular work is in the public domain—meaning it lacks copyright protection—is not sufficient. You must also be sure, in many cases, that you are not using protected trademarks or images of people, living or dead.

A. Should You Worry About Trademark or Publicity Problems?

You need to read this chapter if you want to use a public domain work—particularly photographs or film footage—for the following purposes:

- in advertising for a product or service
- as part of a product's identification or packaging, or
- on merchandise such as posters, buttons, patches (whether or not they advertise a product), bumper stickers, T-shirts, postcards, running shoes, dishes, cups, clocks, games, and calendars that contain advertisements for products or services.

If you plan to use a public domain work in any of these ways, your use may violate state right of publicity laws if the work contains a person's picture, name, signature, likeness, or voice. Right of publicity laws are discussed in Section B. Your use could violate state and federal trademark laws if

the work contains a trademark. Trademarks are discussed in Section C below.

You don't need to worry about the restrictions covered in this chapter if you're using public domain materials for informational, editorial, or entertainment purposes. Uses such as these—which inform or educate the public or express opinions—are protected under the First Amendment of the United States Constitution, which protects freedom of speech and of the press. You will not have a problem if you are using a public domain work in:

- literary works such as books, stories, and articles, whether or not they are fiction or nonfiction
- theatrical works such as plays
- musical compositions
- film, radio, or television programs (with an exception for trademarks used in commercial films and television programs discussed in Section C3 below)
- any form of news reporting such as newspaper or magazine articles on the news of the day, television news programs, documentaries on political or other newsworthy issues, campaign posters, or
- original works of art.

It makes no difference whether your project is profit or nonprofit. Either way, the First Amendment applies to you and you don't have to worry about the publicity and trademark issues covered in this chapter.

B. The Right of Publicity

The laws in a majority of states give people something called the right of publicity. This is not the right to be famous. Rather, it is the legal right to control how a person's name, likeness, or other elements of personal identity are used for advertising and other commercial purposes. Because of the right of publicity, companies or individuals must get permission before they can use a person's photo or name in an advertisement or TV commercial, and must usually pay for such permission.

If a public domain work such as a photo, film, or video footage, portrays a person, the right of publicity may make it illegal for you to use it for advertising purposes without first obtaining the person's permission.

The definitive work on the right of publicity is *The Right of Publicity and Privacy*, by J. Thomas McCarthy (Clark Boardman Callaghan).

1. What Is the Right of Publicity?

A majority of states give all living human beings (and many dead ones) a right of publicity that protects a person's identity or "persona" from unauthorized commercial exploitation. The right of publicity protects against unauthorized commercial use of a person's:

- name (including nicknames and professional, former, and group names)
- image (including photographs, film, and videos)
- likeness (including drawings and portraits)
- signature, and
- voice.

Celebrities usually claim the right of publicity, but it applies to noncelebrities as well. Even politicians are covered.

If you violate a person's right of publicity, they can sue you for damages, which can be substantial, particularly if a well-known celebrity is involved.

2. Limitations on the Right of Publicity

The right of publicity is far from absolute. There are significant limitations on when it applies. Indeed, it often does not apply in situations where public domain materials are used.

a. Only Protects Against Commercial Uses

The most important limitation on the right of publicity is that it only protects against the *commercial exploitation* of a person's identity. That is, when you use a person's name or identity solely to help sell a product or service. For example, an artist violated the Three Stooges' right of publicity when he created a drawing of their faces and reproduced it on T-shirts. The court held that the artist's use was purely commercial—that is, solely to sell the T-

shirts. *Comedy III Productions, Inc. v. Gary Sadreup, Inc.*, 25 Cal.4th 387 (Cal. Sup. Ct. 2001).

Entertainment, informational, or "editorial" uses are not protected by the right of publicity. These uses include anything that informs, educates, or expresses opinions protected under the First Amendment of the United States Constitution, which protects the freedom of speech and of the press. For example, California's right of publicity law does not apply to "a play, book, magazine, newspaper, musical composition, audiovisual work, radio or television program, single and original work of art, work of political or newsworthy value, or an advertisement or commercial announcement for any of these works … if it is fictional or nonfictional entertainment, or a dramatic, literary, or musical work." Calif. Civil Code Section 3344.1.

Common examples of uses that don't violate the right of publicity are using a person's name or photograph in a newspaper or magazine article, an educational program, film, nonfiction book, or webzine (a magazine published on the World Wide Web). However, informational uses are not limited to nonfiction works. The First Amendment also protects fictional stories such as novels, plays, and movies.

For example, there are probably hundreds of photographs of Babe Ruth that are in the public domain because the copyright has expired (all those published before 1923 and those published 1923-1963 that never had their copyrights renewed). You may freely use such a photo without permission in a biography of Babe Ruth, a history of baseball, a newspaper or magazine article on baseball records, a TV documentary about the roaring 1920s, or a novel or movie based on Babe Ruth's life. These are all clearly informational uses.

But, even if it's in the public domain, you may not use a photo of Babe Ruth in an advertisement without permission from Ruth's estate. The ad for the drug Viagra reproduced below containing Babe Ruth's picture is one example of a use that is clearly a commercial use.

On the other hand, courts have held that uses that combine the commercial with the editorial do not violate the trademark laws.

EXAMPLE: *Los Angeles* Magazine published an article in which digital technology was used to alter famous film stills to make it appear that the actors were wearing Spring 1997 fashions. The magazine used a still of the actor Dustin Hoffman, from the film *Tootsie*. The photo was altered so that Hoffman's head was placed on an image of a male model wearing an evening dress. The text on the page read "Dustin Hoffman isn't a drag in a butter-colored silk gown by Richard Tyler and Ralph Lauren heels." Hoffman sued the magazine for violating his right of publicity, since it never got his permission to use his face in the article.

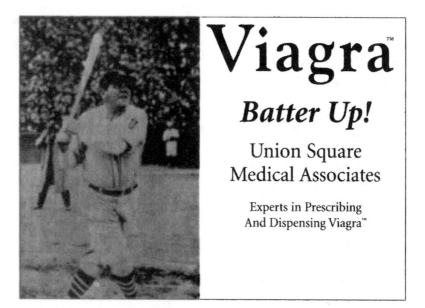

Hoffman ultimately lost the case. The court held that although one of the purposes of the article was to help sell new fashions, it also contained humor, and visual and verbal editorial comment on classic films and famous actors. Thus, the article was not a purely commercial use of Hoffman's image. *Hoffman v. Capital Cities/ABC, Inc.*, 255 F.3d 1180 (9th Cir. 2001).

b. Incidental Use Exception

When a work such as a book or musical composition is in the public domain, anyone may copy it and sell or rent the copies to the public. In this event, it is legally permissible to use the author's name, photo, or identity in advertisements for the work. For example,

when musical arrangements created and published by big-band leader Artie Shaw fell into the public domain, others were free to rerecord them and state in magazine advertisements for the recordings that the arrangements had been created by Shaw. They could also use pictures of Shaw to advertise their product. This did not violate Shaw's right of publicity. *Shaw v. Time-Life Records*, 38 N.Y.S. 2d 201 (1975).

In addition, a media company may reproduce news items containing a celebrity's name or identity in its own advertising. For example, a photo of football player Joe Namath was featured on the cover of *Sports Illustrated* and later used in advertisements to sell subscriptions to *Sports Illustrated*. No permission was required because the initial use of the photo

was editorial and the subscription ads were "merely incidental," indicating the nature of the magazine contents. *Namath v. Sports Illustrated*, 371 N.Y.S. 2d 10 (1975).

c. Insignificant or Fleeting Use Exception

The right of publicity is also not violated when a person's name or image appears only briefly and insignificantly in an advertisement. For example, courts have ruled that there was no publicity violation where:

- a photo of a police officer on a *Rolling Stone* magazine cover was shown for four seconds in a 29-minute television "infomercial" for a rock music anthology. *Aligo v. Time-Life Books, Inc.*, 23 Media L. Rep. 1315 (N.D. Cal. 1994), or
- a photo used in an advertising brochure showed a man standing behind a stack of lumber wearing a hat and was so small and fuzzy he was unrecognizable. *Epic Metals Corp. v. Confec, Inc.*, 867 F.Supp. 870 (M.D. Fla. 1994).

In these cases, there is no direct connection between the use of the person's identity and the commercial purpose of the advertisement. In other words, the use of the person's image or name is so insignificant that the company or person who created the advertisement could not possibly profit from it commercially.

Crowd Shots Are Covered

A photograph, film, or video of a group or crowd of people may violate the publicity rights of any members of the group or crowd who can be individually recognized from the photo if the photo, film, or video is used for commercial purposes. In one case, for example, a company reproduced a team photo of the 1969 New York Mets baseball team on baseball jerseys it sold commercially. The Mets players sued the company for violating their right of publicity and won. The court held that each member of the Mets team had his own individual right of publicity which was violated when the group photo was sold to the public on the jerseys without the players' permission. *Shamsky v. Garan, Inc.*, 632 N.Y.S. 2d 930 (1995).

One way to avoid this problem, is to crop or retouch the work so no individual can be recognized. Of course, this is not a viable option where you want the public to recognize the members of the group or crowd. In these cases, permission must be obtained from the subjects in the photo, film, or video.

3. Right of Publicity for Dead People

The right of publicity always lasts for as long as a person lives. Moreover, in 12 states the right of publicity survives death. How long the right lasts varies from state to state—from as few as ten years to as many as 100 years after death. The publicity statutes of some of these states reach back to cover people who died long before the publicity law was enacted. For example, California's publicity statute applies to any one who died within 70 years before it was enacted in 1985—that is, to anyone who died in 1915 or later. Indiana's publicity statute may reach back 100 years, though it's not entirely clear because the statute is ambiguously written.

You don't need to research each state's publicity law to figure out how far back the right of publicity goes. You can safely assume that anyone who died over 100 years ago is not covered by any right of publicity—no publicity law goes back farther than this. But, anyone who died after that could be protected in one or more states. For example, you don't have to worry about publicity rights if you want to use a photo of Abraham Lincoln in an advertisement, since Lincoln died in 1865 (though the tastefulness of such an ad may be debatable).

4. No National Right of Publicity Law

There is no single federal right of publicity law that applies in every state. Instead, those states that recognize the right have their own publicity laws, which may be very different from other states. Some states don't recognize the right of publicity at all, including: Alaska, Arizona, Colorado, Idaho, Louisiana, Mississippi, New Hampshire, New Mexico, North Dakota, Oregon, South Carolina, Vermont, and Wyoming.

However, this does not mean you can ignore the right of publicity issue if you plan to use a person's name or likeness solely within one of the states that doesn't have a publicity law. Even in these states you could be sued for violating the federal trademark laws if you use a person's name or image in a way that it gives the false impression that the person is endorsing a product or service (see Section C below).

Moreover, it's probably impossible to prevent an advertisement or merchandise from finding its way into one of the states that do recognize a right of publicity. For example, even if you use a public domain picture of Elvis Presley in an advertisement that will appear only in a local paper in Mississippi—a state that has no right of publicity law—there is no way to be sure copies of the paper won't find their way

to other states that do have this right. Even if the paper never leaves Mississippi, the Presley Estate will complain if it finds out about the ad and may sue you anyway. Smart lawyers can always find some way to claim that the law of a state that has a right of publicity should be applied.

The Restatement (Third) of Unfair Competition

As mentioned above, there is no single national right-of-publicity law. Each state has its own publicity law. However, a model law called the Restatement (Third) of Unfair Competition, Sections 46-49, has been very influential on the development of the right of publicity. It was drafted in 1993 by nationally recognized legal experts. You can find it on the Internet at www.hllaw .com/a_personality.html#V. It can also be found in law libraries. Reading this short model law will give you a good overview of the right of publicity.

5. Obtaining Publicity Releases

If you want to use a public domain photo, film clip, video, or other work of authorship to advertise a product or service, you must obtain a publicity release from the subject, or the subject's heirs, if the subject died less than 100 years ago. A publicity release is a legally binding promise not to sue for violating a right of publicity. A release can be

oral, but it's always wise to get it in writing because it is almost impossible to prove that someone gave you verbal permission if they later challenge you in court.

Since the works we're dealing with in this book are in the public domain—that is, not protected by copyright—you do not need to obtain permission from whoever used to own the copyright. But you will need a release from the individual or the heirs of an individual whose likeness you wish to use.

For a detailed discussion of how to obtain a publicity release and sample forms, see *Getting Permission: How to License & Clear Copyrighted Materials Online & Off,* by Richard Stim (Nolo).

C. Trademarks

A trademark is any word, symbol, or device that identifies and distinguishes a product or service. It is a violation of a trademark owner's rights to use the trademark in a commercial context in a way that confuses consumers—that is, makes them think that the trademark owner is in some way associated with your (or somebody else's) product or service. A trademark owner can sue someone who violates his rights and obtain monetary damages and a court order preventing the trademark from being used.

EXAMPLE: Copyright does not protect simple ornamentation such as chevron stripes (see Chapter 5, Section F1). However, the chevron logo used by

the Chevron Corporation to identify its gas stations and petroleum products is protected by the state and federal trademark laws. Anyone who used the same or similar chevron design for a gas station sign or advertisement, or in the packaging or advertising for any petroleum-related product, would almost certainly violate Chevron's trademark rights. Use of the logo for such similar products or services would likely lead the public to believe that Chevron Corporation sponsored or was in some way associated with the product.

There are many different types of trademarks, including:

- **Brand names.** The most common form of trademark is a brand name—for example, *Coca-Cola* or *Ivory Soap*. Brand names are usually words, although they can be a combination of words, letters, and numbers such as *7-UP*.
- **Slogans.** A combination of words used as a slogan for a product or service qualifies as a trademark—for example, "I'd walk a mile for a Camel" for Camel cigarettes.
- **Logos.** A graphic image or symbol may serve as a trademark—for example, the open-banded cross used by Chevrolet.
- **Titles.** Titles of literary works, especially newspapers and magazines, can be trademarks (see Chapter 13).

- **Trade dress.** Any distinctive combination of elements used in a product may serve as a trademark—for example, the combination of the yellow border and distinctive lettering used in *National Geographic* Magazine, or a website's distinctive combination of colors, graphic borders, and buttons.
- **Product configurations.** Distinctive product packaging that is primarily nonfunctional is protected as a trademark—for example, the distinctive shape of the Coca-Cola bottle.
- **Fictional characters.** Trademark law protects fictional characters used to sell products or services (see Section C2).

Trademarks used to identify services are also known as service marks. For example, *Western Union* designates a company that provides messaging services. Normally, a trademark for a product appears on the product or on packaging, while a service mark appears in advertising for the service. Service marks have the same legal rights and follow the same rules as trademarks.

1. How Do You Know If Something Is a Trademark?

Most trademarks—such as brand names, slogans, and logos—are easy to spot because the trademark owner displays them in a distinctive manner, often using stylized lettering—for example, capitals or

italics. The symbols ®, TM, or SM are also frequently used to identify trademarks (see Section C4). However, many trademarks are more difficult to discern, particularly trade dress, product configurations, colors, and other nontraditional trademarks.

Another way to tell if something is a trademark is to conduct a trademark search. Trademarks can be registered by their owners with the U.S. Patent and Trademark Office in Washington, DC (PTO), and with the Secretary of State offices of the 50 states. Registration is not required to obtain trademark protection, but it gives trademark owners many legal benefits if they file trademark infringement suits. You can conduct online searches of these trademark registration records to see if someone claims that a particular word, slogan, or other item is being used as a trademark.

You can do your own search for free on the Internet by visiting the U.S. Patent and Trademark Office's website at www.uspto .gov. Or you can visit one of the Patent and Trademark Depository Libraries, available in every state. These libraries offer a combination of hardcover directories of federally registered marks and an online database of both registered marks and marks for which a registration application is pending. Most of these libraries also have step-by-step instructions for searching registered and pending marks. A listing of Patent and Trademark Depository Libraries can be found on the PTO website at: www.uspto.gov.

For more detailed information on trademarks and trademark searches, see *Do Your Own Trademark Search* and *Trademark: Legal Care for Your Business & Product Name*, by Stephen Elias (Nolo).

However, trademark searches are not foolproof, because a business may be able to claim that something is a trademark even if it is not registered.

2. Trademarks and Public Domain Materials

The vast majority of the time users of public domain materials don't need to worry about trademarks. There are only three common situations where you might violate someone's trademark rights when you use public domain materials:

- If you use public domain photos or other materials containing trademarks in advertising or on merchandise
- If you copy all or part of an existing trademark in a product's name or packaging, or
- If you use a trademarked character in advertising or on merchandise.

a. Trademarks in Public Domain Photos and Other Materials

A public domain photo, film, magazine, or newspaper advertisement may contain a trademark such as a product name, logo, or slogan—for example, a public domain photograph may contain a Coca-Cola sign.

Since the photo is in the public domain—that is, is not protected by copyright—anyone may copy it or republish it without violating the photographer's copyright rights.

However, if you use such a photo in a manner that is likely to confuse consumers into believing that there is some connection or sponsorship between the Coca-Cola Company and you or someone else, you may violate the Coca-Cola Company's trademark rights in its name and logo. This could occur, for example, if you used such a photo on a T-shirt, coffee mug, or other merchandise or in an advertisement for a product or service such as a newspaper advertisement for a soft drink vending machine company. You would need to obtain Coca-Cola's permission for these types of uses. But, other uses that are purely informational in nature wouldn't involve Coca-Cola's trademark rights (see Section C3).

b. Creating Product Names or Packaging

Individual words, names, short phrases, slogans, colors, simple geometric designs, distinctive lettering, standard symbols such as an arrow or a five-pointed star, and standard ornamentation such as chevron stripes are not protected by copyright—they are all in the public domain. You can copy items such as these freely without violating anyone's copyright rights.

However, state and federal trademark laws can protect all of these things if they are used to identify a product or service. If they do, and you use them in a commercial context without permission from the trademark owner, you could find yourself on the receiving end of a trademark infringement lawsuit.

For example, the words "Ivory Soap" are not protected by copyright. But they are a trademarked brand name. You may not use these words as the name for a new soap product or any other related product without violating Ivory's trademark rights. Again, however, these words may be used for purely informational purposes—for example, in an article on the history of the soap industry, or in a novel or play (see Section C3).

For a detailed discussion of the trademark issues involved in choosing product names, logos, slogans, symbols, and packaging, see *Trademark: Legal Care for Your Business & Product Name*, by Stephen Elias (Nolo).

c. Using Characters

Trademark law protects characters that are used to sell products or services or used on merchandise. Trademark can protect such a character's name, appearance, and costume. Trademarked characters can be:

- graphic cartoon characters such as Mickey Mouse
- literary characters, such as Dracula or Tarzan of the Apes, or

- characters portrayed by human actors in movies, plays, and television shows, often based on literary characters such as Dracula or Tarzan.

Trademarked characters may be associated with a specific product or service—for example, Jeeves the butler from the P.G. Wodehouse novels has become associated with an Internet search engine.

Or a character—Dracula, for example—may be used to sell a variety of merchandise. Trademark permission is not required to reproduce a graphic character such as Woody Woodpecker for informational purposes such as in a magazine article or TV documentary about the history of cartoons. Likewise, using a photograph of an actor portraying Tarzan for an informational use such as in a news story does not require trademark permission.

Permission is required for the commercial use of a trademarked character in an advertisement or on merchandise. So long as a character has continuously been used as a trademark, it remains protected even if its original literary source is in the public domain. This is the case, for example, with the Tarzan character. Many of the Tarzan novels are in the public domain, but the name and appearance of Tarzan have been registered as trademarks and are used to sell a variety of merchandise. Companies such as PepsiCo, Toyota, and KFC have used the Tarzan character to advertise their products. If you use Tarzan for a commercial purpose without permission, you can expect to hear from his lawyers.

Note that if you use a photo or other representation of an actor portraying a character in an advertisement or for other commercial purposes, you need to obtain permission from the actor or you'll violate his or her right of publicity (see Section B).

For detailed information about licensing trademarked materials for use on merchandise and sample license agreements, see *Getting Permission: How to License & Clear Copyrighted Materials Online & Off,* by Richard Stim (Nolo).

3. Limits on Trademark Rights

There are significant limitations on trademark protection. Using trademarks for informational or editorial purposes is always permitted. Moreover, the rights of trademark owners to control the trademark usually don't last forever—they end when a trademark is abandoned. Finally, there are some words or symbols that can't be trademarks because they are considered to be generic.

a. No Attribution Required

In a case involving documentary film footage, the United States Supreme Court ruled that people who use public domain materials don't violate trademark laws by failing to provide credit to the creator of the materials.

In 1949, Twentieth Century Fox hired Time, Inc., to produce a 26-episode

television documentary about General Dwight Eisenhower's role in World War II. However, Fox failed to file a copyright renewal for the series in 1977, so it entered the public domain. In 1995, Dastar, a company that manufactured and sold music CDs, decided to enter the home video market. It purchased eight copies of the original 1949 series and copied and edited them into a new series of its own. Dastar's documentary was half as long as Fox's and contained a new narration. Dastar sold the documentary as its "Campaigns" series. Neither the documentary itself, nor its packaging, made any mention of the original 1949 series or Twentieth Century Fox or Time, Inc.

Fox sued Dastar for violating the federal trademark laws. It claimed that Dastar's failure to provide attribution for the copied material in its documentary amounted to "reverse passing off"—that is, Dastar was posing as the originator of the material in the documentary, when it really wasn't. The Supreme Court held that this trademark law doctrine does not apply to works of authorship that have passed into the public domain. Once a work becomes public domain, anyone may copy it without providing credit to the original author. *Dastar Corp. v. Twentieth Century Fox Film Corp.*, 124 S.Ct. 371 (2003).

The *Dastar* decision is a major victory for proponents of the public domain. As the court noted in its opinion, requiring people who use public domain materials to give credit to their originators would

have caused enormous practical problems. In many cases, it would be difficult to figure out who should be credited as the originator of a public domain work. For example, Fox's original 1949 documentary was actually created by Time, Inc., and then sold to Fox; but much of the war footage in the series was taken by unknown military cameramen, not by Time or Fox. So would Dastar have to give credit to Fox, Time, and the military cameramen? Fortunately, this attribution mess was avoided by the Supreme Court's decision.

b. No Permission Required for Informational Uses

Trademark infringement can occur only when someone's trademark is used without permission *as a trademark* to help consumers identify the source of goods or services. This can occur only in a commercial context—that is, where a trademark is used in advertising or on a product or merchandise.

Informational or "editorial" uses of trademarks are always permitted—especially where they are the only way to refer to or discuss a particular product or service. Uses such as these inform, educate, or express opinions or ideas protected under the First Amendment of the United States Constitution, which protects freedom of speech and of the press. For example, permission is not required to use the Chevrolet logo in an article describing Chevrolet trucks, even if the article is critical of the company. Similarly, permission is not needed if a

Green Giant Company. Designed by Lippincott & Marguilies, Inc.

Coca-Cola sign appears in a news report or documentary film.

However, it's not clear whether the use of trademarks in commercial motion pictures is informational and, as a matter of course, film studios and attorneys recommend clearance of all trademarks that appear in commercial TV and film. This is especially true if the trademark figures into the plot or title. (See Section B2 above for a more detailed discussion on how to determine the difference between informational and commercial uses.)

c. Trademark Abandonment

The fact that a trademark has an ® or TM or SM symbol next to it doesn't always mean it's a valid trademark. Many trademarks are no longer legally enforceable because they have been abandoned.

Trademark rights are created *only* when the mark is used in commerce—that is, to sell a product or service. Unlike copyright protection, which expires after a specified number of years, trademark protection lasts for as long as a business continuously uses a trademark to help sell goods or services. Many trademarks have been protected for over a century—for example, the Coca-Cola name and logo. However, trademark protection is lost if a company stops using a mark to identify products or services sold to the public. Any trademark is presumed to be abandoned if it hasn't been used to sell a product or service for more than three years.

Many public domain photos probably contain images of abandoned trademarks. The older the work, the more likely it is that the product or service for which the trademark was used is no longer being sold to the public.

One way to tell if a trademark has been abandoned is to call or write the company and ask if it is still being used. Another way is to conduct a trademark search. (For information on conducting trademark searches, refer to *Trademark: Legal Care for Your Business & Product Name*, by Stephen Elias (Nolo), available online at www.nolo .com.)

d. Generic Words and Symbols

On rare occasions, trademark rights end if the public believes that the trademark is a generic term. For example, aspirin and escalator were trademarks that lost protection once the public used the names for all versions of these products, not for just one manufacturer's version. Nowadays, companies such as Kimberly-Clarke (manufacturer of Kleenex) and Dow Chemical (manufacturer of Styrofoam) aggressively oppose this loss of trademark rights (known as "genericide") by educating the public. For example, a journalist who mistakenly writes "styrofoam cup" will receive a letter from Dow indicating that its trademarked Styrofoam product is not used in cups (it's used primarily in boat and house insulation).

Moreover, certain words and symbols are deemed to be inherently generic. These are words or symbols commonly used to describe an entire category or class of products or services, rather than to distinguish one product or service from another. For example, the words "bread" and "computer" are generic. Generic words are in the public domain and cannot be registered or enforced under the trademark laws.

4. Using Trademark Symbols: ®, TM, and SM

Typically, the symbols ®, TM, or SM are used along with trademarks—for example, GROK®. The symbol ® indicates that a trademark has been registered at the U.S. Patent and Trademark Office (PTO). The "TM" symbol is not an official designation—it means that the company believes it has trademark rights. The "SM" symbol is the same as the "TM" symbol except it is used for service marks. The TM and SM have no legal significance other than the fact that the owner is claiming trademark rights. There is no legal requirement that the ® be used, but the failure to use it may limit the amount of damages that the trademark owner can recover in an infringement lawsuit.

When using a trademark in a text format for informational purposes, it is not necessary to include the ®, TM, or SM symbols. However, it is good trademark etiquette to distinguish a trademark from other text—for example, "The house was constructed with *Styrofoam* insulation." or "He always bathed with *Ivory Soap*." ■

Researching Copyright Office Records

Millions of works first published in the United States during the years 1923 through 1963 are in the public domain because their copyrights were never renewed in the 28th year after they were first published. But to determine that a particular work is in the public domain ordinarily requires a search of records in the U.S. Copyright Office. This chapter shows you how to do just that. We also show you how to research other Copyright Office records that often contain valuable information for the public domain researcher.

864 Humorous Cuts from the Twenties and Thirties, Dover Publications

A. Researching Copyright Renewal Records for Works Published 1923-1963

This section shows you how to determine if the copyright for a work initially published in the United States during the period 1923-1963 was renewed. If it wasn't, the work is now in the public domain in the United States and many foreign countries as well.

If the work you're interested in was never published or was not published during 1923-1963 it cannot be in the public domain for failure to renew its copyright and there is no reason to read this section. Skip to Section B below.

1. What Are Copyright Renewals

The U.S. copyright law in effect from 1909 to 1978 had a unique feature: there were two copyright terms instead of one. Any work published in the United States with a valid copyright notice automatically received copyright protection for an initial period of 28 years. In the 28th year a renewal notice had to be filed with the Copyright Office for copyright protection to be extended for an additional 28 years, which was called the renewal term. If no renewal was filed, the work entered the public domain.

The renewal term was later extended from 28 to 47 years and then again to 67 years. Here we are only concerned with works that were never renewed and entered the public domain in the 29th year after publication.

> **EXAMPLE:** Richard published a song in the United States in 1960, but failed to file a renewal application with the Copyright Office in 1988. As a result, the work entered the public domain in 1989 and can be used freely by anyone. Had Richard or his heirs renewed the

work, it would have been protected for a total of 95 years—the 28-year initial term plus the 67-year renewal term—or until the end of the year 2055.

a. Only Works Published 1923-1963 Are Affected

You only need to be concerned with copyright renewals for works that were first published in the United States during the years 1923-1963. Works published before 1923 are in the public domain whether or not they were renewed. If such works were renewed, their copyrights expired by 1998 at the latest. If they were not renewed, they entered the public domain in 1951 at the latest.

There is also no need to research renewals for any works published after 1963. A 1992 amendment to the copyright law made renewals automatic for all works published during 1964-1977. All these works receive a 95-year copyright term. Works published in 1978 and later never had to be renewed. The copyright in such works usually lasts for the life of the author plus 70 years after his death. (See Chapter 18 for a detailed discussion of copyright terms.)

b. How Many Works Published 1923-1963 Were Not Renewed?

How many works publishing during 1923-1963 are in the public domain because they were not renewed on time? No one knows for sure, but the Copyright Office estimates

that only about 15% of all such works were ever renewed. The renewal percentage varies for the type of work involved. Most movies and many musical works were renewed, but most books and other written works were not.

The following chart shows the results of a survey conducted by the Copyright Office in 1960 to see how many works originally published and registered with the Copyright Office in 1931-32 were renewed during 1958-59.

Copyright Renewal Rates (1958-59)	
Type of Work	**Renewal Percentage**
Books	7%
Periodicals	11
Lectures, Speeches, Sermons, and Other Works for Oral Delivery	0.4
Drama	11
Music	35
Maps	48
Works of Art	4
Technical Drawings	0.4
Art Prints	4
Movies	74

With the exception of maps, music, and movies, the vast majority of works published during 1931-32 were never

renewed and are in the public domain. This includes an incredible 93% of all books. And, in fact, the numbers on the chart may be skewed upward because they only count renewals for works that were registered with the Copyright Office. Many published works were never registered and, thus, never renewed. These works are not reflected in the chart, but are in the public domain.

Renewal rates may have increased somewhat in the years after 1960 as the value of older works (particularly movies) became more apparent to copyright owners, but most works were still never renewed.

Why were so few works renewed? Sometimes it was due to ignorance of the renewal requirement or by mistake. Very often a work was not renewed because it was viewed as having no economic value 28 years after it was first published. But the fact that a work may have been viewed as worthless 20, 30, or 40 years ago doesn't necessarily mean it's valueless today. There are doubtless thousands of hidden jewels among the huge number of works that were not renewed.

However, most well-known works published during 1923-1963 were renewed. This includes, for example, the novels of Hemingway and Fitzgerald, the music of Irving Berlin and George Gershwin, and most classic movies such as *Gone With the Wind* and *Citizen Kane*. But such famous works represent only a tiny fraction of all the works published during 1923-1963.

c. Most Foreign Works Published 1923-1963 Don't Need to Be Renewed

Renewal rules for works first published outside the United States are different than for works first published in the United States. Before 1996, works published in foreign countries *with a copyright notice* had to be renewed just like works published in the United States. Many such works were in the public domain because they were not renewed. However, the law was changed so that on January 1, 1996 most foreign works that had not been renewed had their copyright protection restored.

Any work first published outside the United States during 1923-1963 with a copyright notice has 95 years of copyright from its publication date, even if it was not renewed, as long as:

- the work was still under copyright on Jan. 1, 1996 in the country where it was first published, and
- at least one author is a citizen or resident of a country with which the United States has copyright relations, which includes almost all countries in the world. For a list of countries not included, see Chapter 15, Section C4.

EXAMPLE: Sammy, a citizen of Ireland, published a poem in Ireland with a copyright notice in 1960. The poem was never renewed and therefore entered the public domain in the United

States on January 1, 1989. However, the U.S. copyright in the poem was automatically restored on Jan. 1, 1996 and will last until December 31, 2055 (1960 plus 95 years equals 2055).

However, there are some foreign works that don't qualify for copyright restoration. These are works that are no longer under copyright in their home countries because the copyright has expired. In almost all foreign countries, copyrights last for 50 or 70 years after an author dies (Western Europe uses the life-plus-70-year term). Thus, if the author of the foreign work died long ago, the work may not have qualified for copyright restoration in the United States.

EXAMPLE: Ken published a song with a copyright notice in Canada in 1940. The song was never renewed and so entered the public domain on January 1, 1969. Ken died in 1942, so the song entered the public domain in Canada on January 1, 1993 (copyrights last for the life of the author plus 50 more years in Canada). Because the song was in the public domain in Canada on January 1, 1996 it didn't qualify for copyright restoration. It remains in the public domain in the United States.

You need to know the copyright term of the foreign author's country and when the author died to know if this exception applies. See Chapter 16 for a detailed discussion of foreign copyright laws.

Note that the above discussion only applies to works first published in foreign countries with copyright notices (the © followed by a publication date and name of the copyright owner). Although most foreign countries have never required that such notices be used, many foreign authors and publishers used them anyway. But many foreign works were published in their home countries without notices. A U.S. Appeals Court has held that foreign works without copyright notices are entitled to the same copyright term as unpublished works (see Chapter 18, Section C2). Although it's possible that other courts may disagree with this court ruling, it's prudent to assume that such foreign works don't have to be renewed.

d. Nonrenewed Works Are in the Public Domain in Many Foreign Countries

Works that are in the public domain in the United States because they were not renewed are also in the public domain in a number of foreign countries, including most of Western Europe and Australia (but not the United Kingdom or Canada). This is because these countries use something called the "rule of the shorter term" in calculating how long the copyright for a work first published in the United States lasts in their own countries. Applying this rule, if the work is in the public domain in the United States because it was not renewed, it will be in the public domain in

the foreign country as well. (See Chapter 16, Section C, for a detailed discussion.)

2. How to Determine If a Work Was Renewed

Most of the time the Copyright Office's renewal records must be checked to determine whether or not a work was renewed. There are several ways you can do this:

- you can have the Copyright Office conduct a search for you (see Section A3)
- you can hire a private search firm to do a search (see Section A3), or
- you can conduct the search yourself (see Section A4).

You'll save money if you do it yourself. It will require some time and effort, but it is not necessary to have special training to perform a renewal search and many of the records can be searched online.

a. Preliminary Information for Search

Before you do a renewal search yourself or hire someone else to do one, you should obtain the following information about the work:

- the title
- the author
- the year the work was published, and
- the country in which the work was first published.

If the work was published as part of a magazine, newspaper, periodical, anthology, or collection, you will also need to know the name, volume or issue number, and any other available identifying information for the magazine or other publication in which the work appeared.

b. Avoiding Searches for Republished Works

If the work has been republished more than 28 years after its original publication (in other words, after it should have been renewed) you may be able to avoid having to do a renewal search. If you have access to a copy of the republished work, take a good look at the copyright notice. Usually, the copyright notice for a republished work will indicate that the work was renewed. For example, the copyright notice for a recent paperback edition of the 1952 novel *Shiloh* by Shelby Foote says:

Copyright © 1952 by Shelby Foote

Copyright renewed 1980 by Shelby Foote

This tells you that the work was originally published in 1952 and was renewed in 1980, 28 years after publication. This means there is no need to check the Copyright Office renewal records. The work is not in the public domain.

However, there is no legal requirement that a renewed work's copyright notice state that the work was renewed. For this reason, you can't rely on the fact that a republished work does not state it has been renewed.

3. Hiring Someone to Do a Search for You

If you have access to a computer connected to the Internet, it is relatively easy to research renewals for works published during 1950-1963, because the records are available online. But researching works published during 1923-1950 can be much harder, because you may have to manually search through the U.S. Copyright Office Catalog of Copyright Entries (CCE) in a library that has a copy or at the Copyright Office in Washington, DC.

You may wish to hire someone to do such searches for you if you just don't want to take the trouble to do it yourself or especially if you are unable to locate a copy of the CCE you can use to research works published 1923-1950.

a. Hiring the Copyright Office

You can have the Copyright Office search its records for you. They charge $75 an hour for this service, and most searches take one hour. Unfortunately, it takes the Copyright Office six to eight weeks to conduct a search and report back to you. You can obtain much faster service for just a few dollars more by using a private search firm as described below. The Copyright Office will conduct an expedited search that takes just five business days, but this costs a minimum of $250. Again, you can obtain faster service for less by using a private search firm.

There is no advantage to using the Copyright Office, except that it will save you a few dollars. But if you decide to use it, you should call the Reference & Bibliography Section at 202-707-6850 and ask for an estimate of how long they think your search will take. Then, send a letter to the Copyright Office Reference & Bibliography Section with the following information:

- the title of the work
- the author's name
- the copyright owner's name (usually listed in the copyright notice)
- the year of publication
- the type of work involved—for example, a book, play, or photograph and,
- the name, volume or issue number, and other identifying information for the periodical, if the work was published as part of a periodical or collection.

Send the letter and your check payable to the Register of Copyrights in the amount of the search estimate to:

Reference & Bibliography Section, LM-451
Copyright Office
Library of Congress
Washington, DC 20559.

In about six to eight weeks the Copyright Office will send you a written report indicating whether the work was renewed. An example of such a report is reprinted below. This report shows that the book *Plagiarism and Originality,* by Alexander Lindey, published in 1951, was renewed in 1980.

COPYRIGHT OFFICE	FL 22g

DATE:
June 3

Mr. Stephen Fishman

LIBRARY
OF
CONGRESS

The results of our search in the indexes and catalogs of the Copyright Office are stated below. The extent of the search was governed by the information you furnished us; please see the other side of this sheet concerning what a search report is. The fee for searching is charged at the statutory rate of $20 an hour.

Sincerely yours,

REGISTER OF COPYRIGHTS *CaJ*

Results of Search:

This refers to your request of recent date.

Washington
D.C.
20559

PLAGIARISM AND ORIGINALITY; by Alexander Lindey. 1st edition. Registered in the name of Alexander Lindey, under A 66481 following publication May 7, 1952. Renewed under RE 69-493, November 20, 1980, by Alexander Lindey, as author.

Sample Search Report

b. Hiring a Private Search Firm

There are several private search firms that conduct copyright renewal searches. They may charge a little more than the Copyright Office, but they usually report back in two to ten working days. For example, Thomson & Thomson, the best known of these firms, charges $90 for a renewal search and will report back in six business days. This is a much better deal than paying $75 to the Copyright Office and having to wait up to two months for the results.

Following is a list of copyright search firms. Thomson & Thomson is by far the largest, oldest, and best known of these firms, but we are not endorsing any particular firm. Call several to see which offers the best deal and/or service.

Copyright Resources
616 South Carolina Ave. SE, Suite No. 1,
Washington, DC 20003
202-544-6235
www.copyright-resources.com
email: larhoades@copyright-resources.com

Government Liaison Services, Inc.
3030 Clarendon Blvd., Suite 209
Arlington, VA 22201
800-642-6564 or 703-524-8200

Thomson & Thomson
Copyright Research Group
500 E St. SW, Suite 970
Washington, DC 20024
800-356-8630
www.thomson-thomson.com

Public Domain Research Corp.
P.O. Box 3102
Margate, NJ 08402
800-827-9401.

4. Researching Copyright Renewals Yourself

Paying $75 or more to do a renewal search can really add up if you need to search several titles. You can avoid paying these fees by doing the search yourself. This is relatively easy to do if the work was published during 1950-1963, because the search can be done through the Internet. But renewal searches for works published from 1923 through 1950 can be much more difficult to do yourself. The mechanics of doing a search are covered in Sections A5 and A6 below. But first, we'll discuss some basic guidelines for copyright renewal searches and discuss some special problems.

Your goal in conducting a copyright renewal search is to determine if Copyright Office records show that a work published from 1923 through 1963 was renewed 28 years after publication. If you can't find any record of a renewal, you may usually assume that the work has not been renewed and is therefore in the public domain. There are no records made of works that were not renewed, only records of works that were renewed.

However, researching renewals can be tricky, and if you're not careful you may

overlook a renewal record for a work. Here are some special problems to be aware of:

a. Works Created as Part of Larger Works

Many works were created and published as part of larger works—for example:

- articles or stories published in newspapers, magazines, and periodicals
- photographs or drawings published in books, newspapers, magazines, and other works, and
- musical compositions published as part of a Broadway show, opera, revue, or other larger work.

Generally, there are no separate copyright renewal records for such works. Instead, you must look to see if the larger work was renewed. For example, if you want to know if an article that appeared in *The New Yorker* Magazine was renewed, you'd need to check if that issue of the magazine was renewed. You'd look under the name *The New Yorker* for the year and date involved. If it was renewed, you should assume that article was renewed as well.

On the other hand, if the larger work was not renewed, don't assume that the portion of it you're interested in is in the public domain. Instead, try to see if it was separately renewed. For example, if you're interested in a photograph contained in a book published in 1950 and find no renewal record for the book, check the Copyright Office records to see if the photo was separately renewed. Look under the name of the photographer, if you can find it. Examine the book and photo carefully. See if the photo has its own copyright notice in the photographer's or other copyright owner's name. Check to see if there is an "acknowledgment" section in the book giving copyright information for the photograph.

Articles and other contributions to magazines and other periodicals were especially likely to be separately renewed, particularly if they contained their own copyright notices. The Copyright Office Catalog of Copyright Entries has a separate section called "Contributions to Periodicals" that lists renewals for articles.

Only if you find no renewal information for both the larger work and the portion you want to use, may you conclude it is in the public domain.

b. Works Incorporating Other Works

What if you want to use an entire work that contains many separate works of authorship? For example, you want to post a book on the Internet that contains photographs, drawings, or other separate works of authorship. In this event, you should check to see if each work of authorship has been renewed. Use the approach described in the preceding section.

If, for example, you discover no renewal record for the text of a book you want to use—but there is a renewal on file for photographs included in the book—you'll either have to get permission to use the photographs or simply not use them.

c. Derivative Works

Derivative works are works that are based upon or adapted from previously existing works. Examples of derivative works include:

- movies adapted from novels or plays
- new editions or versions, of previously published works
- translations from one language to another
- works adapted into a new medium— for example, a photograph of a painting, and
- new arrangements of musical compositions.

A derivative work is a separate work for copyright purposes, even though it is based on the original work. Each work must have been renewed separately. Renewing a derivative work did not automatically renew the original work and vice versa. In other words, when a derivative work was renewed, the renewal only covered the new material added to create the derivative work. When an original work was renewed, the renewal only covered the original version of the work, not any derivative works created from it.

> **EXAMPLE:** Arthur writes a novel in 1940 that Eugene adapts into a Broadway play in 1950. The novel is timely renewed in 1968 and the play in 1978. This means that nether is in the public domain.

If the derivative work is not renewed but the original work is, you can't use those portions of the original work contained in the derivative work.

> **EXAMPLE:** Assume that Arthur's novel is renewed, but Eugene's derivative play is not. All the material in the play copied from the novel is still under copyright. Only the new material Eugene added to adapt the novel into a play is in the public domain—for example, new dialogue and the way he cut and restructured the novel to function as a three-act play.

If the derivative work is renewed, but the original work is not, you can't use any of the new material in the derivative work.

> **EXAMPLE:** Assume that Arthur's novel was not renewed, but Eugene's play was. Both the original novel and all the elements copied by Eugene to create his derivative play are in the public domain. But the new material Eugene added to create the play is still under copyright.

If you're dealing with a derivative work initially published in the United States during 1923-1963 based on an original work initially published in the United States during 1923-1963, you must determine if both the derivative work and the original work were renewed.

Derivative works present a particular problem when you wish to determine the copyright status of many movies. See Chapter 7, Section C, for a detailed discussion of these and other special issues that arise when researching copyright renewals for movies.

d. Changing Titles

Some works were originally published under one title, and then renewed 28 years later under another title. This was particularly common for movie and television cartoons whose names were often changed for marketing purposes.

The book *Of Mice and Magic, a History of American Animated Cartoons*, by Leonard Maltin, lists many alternative cartoon titles. Movies also sometimes had different titles. The book *The Film Buff's Bible of Motion Pictures,* by Richard Baer, has an index of alternative titles.

e. New Matter Added to Public Domain Works

Often when public domain works are republished, new material is added to them. For example, a new edition of Shakespeare's plays may contain new annotations, drawings, or photographs. Such new material is entitled to copyright protection, even though the public domain material is not. The author or publisher of the new material is entitled to renew the copyright in it, but this does not mean the original public domain material has been renewed. It remains in the public domain.

When you search the Copyright Office records (particularly the online records) you may find a record for a registration or renewal of such new matter added to a public domain work. This can confuse you into believing that the original work is under copyright, when in fact it is in the public domain. Normally, the online records contain a listing of what new material was added to a work in the public domain. This is listed after the code "LINM" which stands for limitation of claim or new matter. The registration or renewal only covers this new matter.

Here's an example: Nathaniel Hawthorne's novel *The Scarlet Letter* was originally published in 1850 and is therefore in the public domain because the copyright expired in 1879. However, the Copyright Office online records contain the renewal record for *The Scarlet Letter* shown in Figure 1.

We will explain what most of the record means below, but for now you should look at the last line after the code LINM:NM. This tells you that the renewal only applies to the foreword written by Leo Marx and added to an edition of the novel originally published by Penguin in 1959 and renewed in 1987. The text of the novel itself remains in the public domain.

```
┌─────────────────────────────────────────────────────────────┐
│ ▣ ▤▤▤▤▤▤▤▤▤▤▤▤ locis.loc.gov ▤▤▤▤▤▤▤▤▤▤▤▤ ▣▣ │
├─────────────────────────────────────────────────────────────┤
│ RE-346-132           (COHM)        ITEM 5 OF 160 IN SET 4     │
│ TITL: The Scarlet letter.  By Nathaniel Hawthorne, foreword by Leo  Marx. │
│ CLNA: acN A L Penguin, Inc. (PWH)                             │
│             DREG: 10Aug87                                     │
│ ODAT: 27Jul59;                                                │
│ OREG: A427734.                                                │
│ OCLS: A                                                       │
│ LINM: NM: foreword.                                           │
├─────────────────────────────────────────────────────────────┤
│ ▥                                                    ◀ ▶ ▨ │
└─────────────────────────────────────────────────────────────┘
```

Figure 1: Renewal Record for *The Scarlet Letter*

f. Collections of Public Domain Material

Sometimes, a number of public domain works are republished together in a new collection. For example:

- Twelve well-known ghost stories originally published during the 19th century were collected and published by Oxford University Press under the title *12 Victorian Ghost Stories*.
- The original sheet music for dozens of public domain songs originally published during 1901-1911 was collected and published together under the title *Alexander's Ragtime Band* by Dover Publications.
- Fourteen public domain short stories were culled from over 60 stories author Frank Norris published during his lifetime and published together by Ironweed Press under the title *The Best Short Stories of Frank Norris*.
- 132 public domain postcards were collected and reproduced in a book called *Delivering Views: Distant Cultures in Early Postcards*, published by the Smithsonian Institution Press.

When public domain works are republished in this way their copyright is not revived, but the compiler of the collection is entitled to a copyright in the selection and arrangement of the public domain works (see Chapter 12, Section G). Such a copyright in a collection published from 1923 through 1963 could be renewed. But such a renewal only extended to the selection and arrangement of the collection, not to the original works themselves, which remain in the public domain.

5. Online Searches for Works Published 1950-1963

If you have access to the Internet, researching copyright renewals for works published during 1950-1963 is relatively easy. The Copyright Office has placed all its renewal records for these years online and they can be accessed from the Copyright Office website. There are two methods available

to search for copyright registration renewals on the Copyright Office website: the old method, and the new method. The Copyright Office describes the new method as "an alternative, experimental search method for short, simple searches and occasional users."

To do a search using the new method, you simply click the "Search Copyright Records" "Registrations and Documents" link on the home page of the Copyright Office website (www.copyright.gov). This directs you to a search page.

You may do a key word search by the name of the author, title of the work, registration number, copyright claimant's name, or all of these at once. This method is extremely easy to use. Unfortunately, the Copyright Office does not appear to have confidence that this method, installed on its website in 2001, will give completely accurate search results.

Instead of searching with the easy-to-use new method, the Copyright Office recommends that your perform serious renewal searches with its hard-to-use old method which has been in place since the late 1970s. This method requires that you use the ancient Telnet terminal emulator to access LOCIS—the Library of Congress Information System. This is the Copyright Office's original electronic database. If you don't have Telnet, you can download it for free from many websites; you can find a list of these at www.telnet.org.

It will take some time and effort for you to learn to do a copyright renewal search using the LOCIS database and Telnet.

The following example will show you how to conduct an online search. The goal in this example is to determine if the novel *Lolita,* written by Vladimir Nabokov and published in 1955, has been renewed.

First, log on to the database by going to the Copyright Office website. Click on the link titled "Connect to LOCIS using Telnet." Users of the default Windows telnet program may have to click on "Terminal" on the telnet toolbar, then click on "Preferences," and then checkmark "Local Echo."

The Telnet application should engage and you'll see the following opening screen shown in Figure 2.

Type "1" after the word "Choice:" and hit return. You may not see the number 1 appear, but you should press the return key anyway. This takes you to the Copyright Office records. (Hit return after every command you enter.)

The next screen you see will look like Screen 3.

To see the renewal records for any type of work other than a serial publication, enter 1 after "Choice." To see the records for a serial publication such as a magazine, newspaper, journal, or other periodical, enter 2. Since we want to find out if a novel was renewed, we enter 1.

The next screen looks like Figure 4.

This is where you need to enter your search terms. The database can be searched by the author's name or by title. You should search both ways if you don't find a

```
┌────────────────────────────────────────────────────────────┐
│              locis.loc.gov                                   │
│                                                              │
│       L O C I S:  LIBRARY OF CONGRESS INFORMATION SYSTEM     │
│                                                              │
│         To make a choice: type a number, then press ENTER   │
│                                                              │
│    1    Copyright Information    -- files available and up-to-date │
│                                                              │
│    2    Braille and Audio        -- files frozen mid-August 1999 │
│                                                              │
│    3    Federal Legislation      -- files frozen December 1998 │
│                                                              │
│  *   *   *   *   *   *   *   *   *   *   *   *   *   *   *   │
│                                                              │
│               The LC Catalog Files are available at:         │
│                  http://lcweb.loc.gov/catalog/               │
│                                                              │
│  *   *   *   *   *   *   *   *   *   *   *   *   *   *   *   │
│                                                              │
│    8    Searching Hours and Basic Search Commands           │
│    9    Library of Congress General Information             │
│   10    Library of Congress Fast Facts                      │
│                                                              │
│   12    Comments and Logoff                                 │
│         Choice:                                             │
│                                                              │
└────────────────────────────────────────────────────────────┘
```

Figure 2: LOCIS Opening Screen

```
┌────────────────────────────────────────────────────────────┐
│                   COPYRIGHT INFORMATION                      │
│  CHOICE                                               FILE   │
│                                                              │
│    1    Works registered for copyright since 1978.  These include    COHM │
│         books, films, music, maps, sound recordings, software, │
│         multimedia kits, drawings, posters, sculpture, etc. │
│         Serials are in the COHS file.                       │
│                                                              │
│    2    Serials (periodicals, magazines, journals, newspapers, etc.)  COHS │
│         registered for copyright since 1978.                │
│                                                              │
│    3    Documents relating to copyright ownership, such as name   COHD │
│         changes and transfers.                              │
│                                                              │
│                                                              │
│   12    Return to LOCIS MENU screen                         │
│                                                              │
│         Choice:                                             │
│                                                              │
└────────────────────────────────────────────────────────────┘
```

Figure 3: LOCIS Opening Screen

```
***COHM- THE COPYRIGHT MONOGRAPH FILE
         is now available for your search.
         The Term Index, updated on 09/09/00, contains 13,478,467 terms.

         To learn about the contents of this file, type
         HELP and transmit.
         For a description of available commands, type
         SHOW COMMANDS and transmit.

    READY FOR NEW COMMAND:
Lolita█
```

Figure 4

renewal record by the first method. Authors' names must be entered last name first, followed by a comma; like this: Nabokov, Vladimir. If a title contains the word "the," leave it out. If a name has variant spellings, enter it in every spelling you can think of until you find a listing.

We enter the name of the book, *Lolita*.

The screen in Figure 5 appears.

This screen shows the first five of 137 items in the database with the title "Lolita." The oldest items are listed first. The prefix "RE" indicates the item is a renewal record.

You only need to check the records with this prefix.

Item 3 seems to be what we're looking for. To view item 3, type "display item 3." You need to type "display item" followed by the item number whenever you want to see a record listing.

The screen in Figure 6 appears.

This is the detailed renewal record for the novel *Lolita*. Here's how to decipher it:

The prefix RE followed by the numbers 163-993 means that this is a record for a renewal with that number.

```
ITEMS 1-5 OF 140              SET 4: BRIEF DISPLAY              FILE: COHM
                                  (ASCENDING ORDER)
1. RE-12-739: Lolita.  Authors & composers: acBillie  Wagner & acJimmie
              Carlyle.   CLNA: Billie Wagner & Jimmie Carlyle (A)
2. RE-23-438: Lolita.  Piano & chant.  Paroles francaises & espagnoles de
              Louis  Poterat & Oscar  Calle, musique de Robert  Zerbib.
              CLNA: Lucienne Veill, veuve Zerbib (W), Louis  Poterat & Oscar
              Calle (A)
3. RE-163-993: Lolita.  By Vladimir Nabokov i.e. Vladimir Vladimirovich
              Nabokov   CLNA: Vera  Nabokov (W) & Dmitri  Nabokov (C)
4. RE-181-530: Contributions by Dorothy Parker    CLNA: Lillian
              Hellman (E)
5. RE-199-851: Lolita.  Words: acLola Viola  Gilmore, music: Irene
              DeVoll.   CLNA: Lola Viola Gilmore (A)

NEXT PAGE:         press transmit or enter key
SKIP AHEAD/BACK:   type any item# in set        Example--> 25
FULL DISPLAY:      type DISPLAY ITEM plus an item#   Example--> display item 2
READY:
display item 3█
```

Figure 5

TITL means the title of the work renewed.

CLNA means the copyright claimant of the renewed work—in other words, the person who owns the copyright. The copyright claimants are Vera Nabokov (the (W) following her name means she's the author's widow) and Dmitri Nabokov.

DREG means the date the renewal registration was filed, in this case April 8, 1983.

ODAT means the date the work was originally published, in this case Sept. 15, 1955.

OREG means the original registration number for the work.

OCLS means the old class code for the work. In years past, the Copyright Office assigned letter codes defining the type of work being registered. "A" means the work is a book. Since a number of different works could be registered under the same title, it's useful to know the class code (see below for a list of all the codes).

To sum up, this record tells us that a book named *Lolita* by Vladimir Nabokov was originally published on Sept. 15, 1955 and renewed on April 8, 1983. We know the work has been timely renewed and is not in the public domain. The U.S. copyright will last until the end of 2050 (the copyright in any work published in the United States during 1923-1963 that was timely renewed lasts for 95 years after publication). Had the work not been renewed, it would have entered the public domain in the United States on Jan. 1, 1984.

a. Search Commands

The database contains online help screens that explain the commands. However, you only really need to know two.

First, when you search by the author's last name, you may find a series of authors with the same name.

To see the file for the author you want, enter the letter "f" followed by the letter and number of the file. For example (see Figure 7), you'd enter f b8 to view the records for the author Stephen Fishman who was born in 1955.

Next, you use the command "display item" followed by the item number to view a particular renewal record listed under the author's name or title.

Figure 6

```
locis.loc.gov
B01+FISHMAN, SARA GOLDA BRACHA, 1946-//(CLNA=1; AUTH=1)
B02 FISHMAN, SARAH, 1934-//(CLNA=1; AUTH=1)
B03 FISHMAN, SARAH, 1957-//(AUTH=1)
B04 FISHMAN, SCOTT, 1959-//(CLNA=1; AUTH=1)
B05 FISHMAN, SIDNEY, 1919-//(CLNA=1; AUTH=1)
B06 FISHMAN, SILVI, 1964-//(CLNA=1; AUTH=1)
B07 FISHMAN, SOLOMON//(AUTH=1)
B08 FISHMAN, STEPHEN//(AUTH=5)
B09 FISHMAN, STEPHEN D., 1944-//(CLNA=1; AUTH=1)
B10 FISHMAN, STEPHEN J., 1950-//(CLNA=1; AUTH=1)
B11 FISHMAN, STEPHEN M//(AUTH=1)
B12 FISHMAN, STEPHEN, 1955-//(CLNA=13; AUTH=13)
```

Figure 7: Search for Fishman, S.

Word Soup From the Copyright Office Website

Here is a list of all the abbreviations you will find in the Copyright Office online records:

ADTI Additional titles

APAU Name(s) of author(s) on application if different from deposited copy

APTI Additional title(s) appearing on the application

CAST Major cast members of a motion picture

CLNA Name of claimant(s)

CONT Contributions (for group renewals and group registrations)

COTI Contents titles (for sound recording claims only)

CRED Credits of a motion picture

DCRE Date of creation according to application

DPUB Date of publication according to application

DREG Effective date of registration from application

EDST Edition statement(s)

IMPR Imprint information (place of publication, publisher, date of publication or copyright)

INAN Title of the larger work in which the copyrighted work appears

INND Date in copyright notice if different from application

INNN Name in the copyright notice, different from application

ISBN International standard book number

ISSN International standard serial number

LINM Limitation of claim; new matter

MISC Miscellaneous information (including indication of correspondence with the Copyright Office, etc.)

NOTE Notes describing the deposit copy

OCLS Old class code

ODAT Original date of publication

OREG Original date of registration

PHYS Physical description

PREV Information on previously registered related works and other data regarding preexisting material

SEST Series title(s)

SREG Supplementary registration

TITL Title(s), subtitle(s), and author(s) from the deposit copy.

More Word Soup From the Copyright Office

As mentioned above, the Copyright Office used to assign a letter code to each work that was registered indicating the type of work it was—for example, a book, movie, or musical work. It's useful to know these codes when you search the online records.

A	=	books and pamphlets
B	=	periodicals
C	=	lectures and other works for oral delivery
D	=	dramas (stage plays)
E	=	music
F	=	maps and atlases
G	=	works of art
L and M	=	movies.

6. Renewal Searches for Works Published 1923-1949

Conducting a renewal search for a work published during 1923-1949 can be more difficult than for works published 1950-1963 because you may have to manually search the renewal records contained in a massive series of catalogues called the Catalog of Copyright Entries (CCE). The CCE contains the registration and renewal records for all works published during these years.

a. Are the CCE Records You Need Online?

The Catalog of Copyright Entries (CCE) is a series of hardcover books. In the past, it was necessary to find a library that had a copy of the CCE and manually search through it or go to the Copyright Office and manually search through their card catalogue. However, this is changing. The Universal Library Project, supported by Carnegie-Mellon University, is in the process of scanning the CCE renewal records and placing digital copies of each page online at a website called the On-Line Books Page. This means that instead of having to go to a library to find a physical copy of the CCE, you can search it over the Internet.

Unfortunately, not all the CCE is online. As of January 2006, all the CCE renewal records for books had been placed online. But the renewal records for most other types of works had not yet been digitized. However, more and more of the CCE is gradually being placed online, so be sure to check to see if the portions you need are available this way.

The URL for the On-Line Books Page is: www.digital.library.upenn.edu/books/cce. Instructions for searching the site are clear and easy to use. Portions of the CCE are also available at: www.kingkong.demon.co.uk/ccer/ccer.htm.

b. Where to Find the CCE

If the CCE records you need are not online or you don't have Internet access, you must find a physical copy you can manually search. This can be difficult. If you happen to live in or around Washington, DC, you can do your search at the Copyright Office. It's located at:

Room LM 401
James Madison Building
Library of Congress
101 Independence Ave., SE
Washington DC 20559.

The Copyright Office Card Catalogue

If you go to the Copyright Office to do a renewal search, instead of using the CCE, you may use a huge card catalogue the Copyright Office has created listing all copyright renewals. The CCE is basically this same card catalogue in book form. Experience has shown, however, that using the card catalogue is no better than using the CCE: they both contain the same records. In fact, the CCE seems to be easier to use. So don't feel you need to go to the Copyright Office to conduct a renewal search. You can do a perfectly good search anywhere you can find a copy of the CCE.

If you don't live near Washington, you'll need to find the CCE somewhere else. Many major metropolitan libraries such as the Los Angeles, New York, and Boston public libraries have the CCE. It may also be found in research libraries at many universities, such as the University of California at Berkeley, the University of Chicago, and Cornell University. However, university libraries are not always open to the public. You should check before making the trip.

Government depository libraries may also have a copy of the CCE. You can find a list of these libraries at the following website: www.gpoaccess.gov/libraries.html, or check with your local library for a list.

c. What Years to Search

CCE catalogues were issued each year. Normally, you'll have to search the CCEs for several years to make sure no renewal was filed. This is because works published during 1923-1949 could be renewed any time during the 28th year after publication. This one-year period was measured from the actual date of publication. For example, a work published on June 1, 1930 could be renewed anytime during June 1, 1957 through June 1, 1958. The renewal record for such a work could be found in the CCE for 1957 or 1958. If the work had been published late in 1930—December, for example—the renewal record might be in the CCE for 1959.

For this reason, you need to search at least three years' worth of CCEs to make sure no renewal was filed—those covering the 27th, 28th, and 29th years after publication. The chart below shows you which years to search.

Year of Publication	27th Year After Publication	28th Year	29th Year
1923	1950	1951	1952
1924	1951	1952	1953
1925	1952	1953	1954
1926	1953	1954	1955
1927	1954	1955	1956
1928	1955	1956	1957
1929	1956	1957	1958
1930	1957	1958	1959
1931	1958	1959	1960
1932	1959	1960	1961
1933	1960	1961	1962
1934	1961	1962	1963
1935	1962	1963	1964
1936	1963	1964	1965
1937	1964	1965	1966
1938	1965	1966	1967
1939	1966	1967	1968
1940	1967	1968	1969
1941	1968	1969	1970
1942	1969	1970	1971
1943	1970	1971	1972
1944	1971	1972	1973
1945	1972	1973	1974
1946	1973	1974	1975
1947	1974	1975	1976
1948	1975	1976	1977
1949	1976	1977	1978

d. Conducting a Search

The CCE is available in printed form through 1979, after which it was issued in microfiche form until 1982. It was discontinued after 1982 because the renewal records were placed online. The CCE is divided into parts according to the type of work. Depending on the year you search, there may be separate volumes for books, periodicals, music, dramas, maps, prints and labels, art, and motion pictures.

Each volume of the CCE contains entries for registrations made during a particular year, with the entries for renewals in a separate section, usually in the back. For most years, renewal data was compiled twice a year, so there are two separate renewal listings: one for the first six months of the year and one for the last six months of the year. You need to check both listings.

For most years, renewals are listed by the name of the author or copyright owner. If you don't know the name of the author or copyright owner, you can look in the title index for each CCE volume. If a title is followed by an (R) it means the work has been renewed.

But note carefully: if the work was originally published as part of a larger work—for example, an article published in a magazine—you need to look to see if the larger work was renewed. (See Section 4b above.) You also must check to see if the individual article was renewed. If either the larger work or individual contribution has been renewed, the work is not in the public domain. The CCE has a separate section called Contributions to Periodicals that lists renewals for individual articles.

In addition, be aware that there is no standardization of alphabetizing or name usage in the CCE. For example, names beginning with "Mc" and "Mac" are alphabetized in various ways. A name like "Tschaikowski" may be spelled "Chaikovskii." Non-English names such as "de Mille" and "von Franz" may appear under both the prefix and the surname. A corporate entity such as "Walt Disney Productions" may appear under that form or under "Disney (Walt) Productions."

Following is the renewal record for the 1925 novel *The Great Gatsby* by F. Scott Fitzgerald. It was found in the renewal section of the Books volume of the 1953 CCE.

FITZGERALD, FRANCIS SCOTT
The Great Gatsby © 10Apr25, A855444.
R109367, 23Mar53, Frances Scott
Fitzgerald Lanahan (C)

Let's decipher this entry line by line:

- The first line lists the author of the work (the famed novelist F. Scott Fitzgerald).
- The second line shows the title of the work. The © symbol followed by the date 10Apr25 means *The Great Gatsby* was first published on April 10, 1925. The entry A855444 is the original Copyright Office registration number for the work.

- The third line begins with the entry R109367, which is the renewal registration number for the novel. The date 23Mar53 means the work was renewed on March 23, 1953.
- The entry "Frances Scott Fitzgerald Lanahan" on the third and fourth lines is the name of the copyright owner of the novel following the renewal. The (C) following her name means that she is the child of the deceased author.

This entry tells you that *The Great Gatsby* was timely renewed during the 28th year after its initial publication and therefore receives a 95-year copyright term. Its copyright will not expire until Jan. 1, 2021.

864 Humorous Cuts from the Twenties and Thirties, Dover Publications

Abbreviations Used in the CCE

Following is a list of the main abbreviations used in the CCE:

(A) author

a.k.a. also known as

(C) child or children of the deceased

© copyright claimed by

© **(followed by date)** year of publication as stated in copyright notice

ca. circa

comp. compiler, compiled by

d.b.a. doing business as

(E) executor(s) of the author

ed. edited by, editor, edition

(NK) next of kin of the author who is not living, there being no will

p. page, pages

(P) proprietor of a commercial print or label

(PCB) proprietor of a work copyrighted by a corporate body otherwise than as assignee or licensee of the author

(PCW) proprietor of a composite work

(PPW) proprietor of a posthumous work

pseud. pseudonym

(PWH) proprietor of copyright in a work made for hire

rev. revised by, reviser, revision

t.a. trading as

tr. translator, translated by

v., vol. volume, volumes

(W) widow of the author

(Wr) widower of the author

B. Researching Copyright Registration Records

When a work is registered with the Copyright Office, the copyright claimant must file an application form that contains some basic information about the work, such as who wrote it, if it was published, when and where it was published, and the nature of the authorship involved. When the work is registered, the Copyright Office stamps a registration number and seal on the application and it serves as the work's certificate of registration.

The registration certificate contains a good deal of information about the work that may be very useful to determining whether it's in the public domain, including:

- the title, and whether it had any previous titles
- in the case of writings, whether the work was published as a contribution to a magazine, newspaper, or other serial publication
- the name of the author(s)
- where and when the work was published (if it was)
- the author's nationality or where he or she lives
- the name of the copyright owner
- whether the work is a derivative work or compilation and, if so, what new material was added to create the derivative work or compilation (see Chapter 3 for a detailed discussion of derivative works and Chapter 12 for a discussion of compilations).

1. Online Registration Records

Since 1978, some, but not all, of the information contained in copyright certificates has been placed in an online Copyright Office database. This is the same database that contains the online renewal records discussed above and is accessed and searched in the exact same way.

Here is an example of the online registration record for a book by the late English author Eric Ambler.

```
┌──────────────────────── locis.loc.gov ────────────────────────┐
│ TX-1-595-748          (COHM)        ITEM 25 OF 26 IN SET 18    │
│ TITL: Here lies : an autobiography / acEric  Ambler.          │
│ IMPR: London : Weidenfeld and Nicolson, 1985.                 │
│ PHYS: 234 p.                                                   │
│ CLNA: Eric Ambler                                              │
│ DCRE: 1985        DPUB: 13Jun85          DREG: 20Jun85        │
│ ECIF: 1/B/L//A                                                 │
└────────────────────────────────────────────────────────────────┘
```

Figure 8: Registration Record for a Book by Eric Ambler

Among other things, this record tells when and where the book was published—in London in 1985. This information is in the line beginning with the abbreviation IMPR, which stands for imprint information. (See Section A5 above for a detailed explanation of how to read these online records.) Information such as this enables you to determine how long the copyright in a work lasts.

When a public domain work is republished with new material, the registration record will ordinarily contain a brief statement of what the new matter consists of. This is in the line followed by the abbreviation LIMN. (See Section A4 above for an example.) This statement may be helpful to determine which parts of the work are and are not copyrighted. However, it's often too general to be of much help. So, to really determine what new material is contained, you must actually examine a copy of the republished work.

2. CCE Registration Listings

There are no online registration records, other than renewals, for works published before 1978. There aren't even online renewal listings for works published before 1950. However, the Catalog of Copyright Entries (CCE) contains summaries of the registration records for works published before 1978. As with the online records, these may be helpful to determine when and where a work was published, who the

owner is, and what new matter was added to a republished public domain work. See Section A6 for a detailed discussion of how to use the CCE.

3. Obtaining a Copy of the Registration Certificate

If you want to see all the information on a work's registration certificate, you can have the U.S. Copyright Office send you a copy. To do this, you must send a letter with the following information:

- the title of the work
- the registration number
- the year of publication or registration, and
- any other information needed to identify the work.

The letter must be accompanied by a check for $30 payable to the Register of Copyrights. The letter and check should be sent to:

Library of Congress
Copyright Office
Certifications and Documents Section, LM-402
101 Independence Ave., SE
Washington, DC 20559-6000
202-707-6787.

You may also inspect these records in person at the Copyright Office at the address listed above.

Finding the work's registration number may be a problem. If the work was

published and registered after 1978, you can check the Copyright Office online records. If the work was published before 1978, you may have to check the Catalog of Copyright Entries (CCE). Checking the online records and CCE to determine if a work was renewed is discussed in detail in Sections A5 and A6 above. The procedure to check for a registration number is largely the same, except that you're looking for the work's original registration record, not a renewal.

If you can't find the registration number, you can request the Copyright Office to do a search, but this will cost a minimum of $65.

For more information on obtaining access to Copyright Office records, see the Copyright Office publication called Circular 6, *Obtaining Access to and Copies of Copyright Office Records and Deposits*. You can download a copy from the Copyright Office website (www.copyright.gov). You can also have the Copyright Office send you a copy by postal mail by calling the Copyright Office's forms hotline at 202-707-9100. ■

Chapter 22

What If a Work Is Not in the Public Domain?

I f you determine that a particular work you want to copy, adapt, or otherwise use is not in the public domain, you have three alternatives:

- find something else that is in the public domain
- obtain permission to use the work, or
- use the work without permission, relying on the fair use privilege which allows copyrighted material to be used for free in limited situations.

We discuss each option below.

A. Find Another Public Domain Work

As this book makes clear, millions and millions of works are in the public domain. If you find that a particular work is not public domain, you can simply forget about using it and continue searching for a work that is in the public domain. The next public domain work you find may be just what you're looking for. The drawback to this approach, of course, is that it can be time consuming and there is no guarantee you'll ever find a public domain work that meets your needs.

B. Obtain Permission to Use the Work

If you are dead set on using a particular copyrighted work, you can go ahead and do so if you obtain permission from the copyright owner for the use. Unfortunately, obtaining permission to use a copyrighted work can be a difficult and time consuming process and it's usually not free.

For a detailed explanation of how to go about getting permission and all the forms you may need, refer to *Getting Permission: How to License & Clear Copyrighted Materials Online & Off*, by Richard Stim (Nolo).

Expect permissions to take anywhere from one to three months to negotiate and obtain. The first step is to learn how much a particular work would cost to use. Depending on your budget for obtaining permissions, the cost might make your decision for you, if it is beyond your means. Often copyright owners have a sliding scale of fees for different uses. Commercial uses are usually more costly than nonprofit uses.

It is best to obtain written permission before you begin using the copyrighted work. But you should absolutely obtain it before your project is completed. It is sometimes more difficult and more expensive to obtain permission after a book, film, or recording is completed. If the copyright owner becomes aware that you have a vested interest in obtaining permission (for example, your book is already in production), the price may rise. In addition, if you can't obtain permission, you'll have to re-do the work, which is expensive and time consuming. The best policy is to start

seeking all required permissions as soon as possible.

Obtaining permission involves these steps:

Step 1: Find Out Who Owns the Work

The first step is to find out who owns the copyright in the work you want to use. Sometimes, this task is simple. Often, you may be able to locate the rights owner just by looking at the copyright notice on the work. For example, if the notice reads "Copyright 1998, Jones Publishing," you would start by finding the Jones Publishing company. Sometimes, more detailed research is required. Copyright ownership may have passed through several hands since your copy of the work was published.

In addition, some kinds of works, such as film and recorded music, can involve multiple owners or rights holders, each with separate rights to different parts of the work. For example, in order to use a music recording, you would have to obtain permission from the record company, the music publisher (the owner of the song), and in some cases from the performers.

The method of identifying owners differs from industry to industry. For example, photographic reproduction rights are often owned by stock photo organizations, while collectives known as performing rights societies own music performance rights.

Orphan Works

One problem that constantly bedevils people who want to obtain permission to use copyrighted works is that the copyright owner cannot be identified or located. This is particularly common for older works with little economic value. Such works are often called "orphan works." The Copyright Office conducted a detailed study of orphan works and issued a report in 2006 recommending that legislation be passed barring owners of orphan works from obtaining monetary damages in a copyright infringement suit against those who use their works without permission provided that: (1) a good faith, reasonably diligent search was made to locate the owner of the orphan work, and (2) attribution was provided to the author and copyright owner of the work, if possible and as appropriate under the circumstances. If the orphan work was used for commercial purposes, a reasonable fee would have to be paid to the copyright owner; but, if the work was not used for any direct or indirect commercial advantage, no fee need be paid if the user stops using the work upon receiving notice from the copyright owner. It remains to be seen whether this legislation will be enacted. The Copyright Office's *Report on Orphan Works* can be obtained from the Office's website (www.copyright.gov).

Step 2: Identify the Rights You Need

The next step in getting permission is to identify the rights you need. Each copyright owner controls a bundle of rights related to the work, including the right to reproduce, distribute, and modify the work. Because so many rights are associated with copyrighted works, you need to specify the rights you need. This can be as simple as stating your intended use—for example, you want to reproduce a photograph in your book.

Step 3: Negotiate Whether Payment Is Required

Next, you need to determine whether payment is required for the permission. In most cases there are no standard fees for using a work.

Sometimes, the owner of the work will not require payment if the amount of the work being used is quite small or the owner wishes to contribute to an educational or nonprofit effort.

However, some types of permission almost always require payment. For example, using a photo owned by a stock photo agency usually requires a payment of $100 or more. Using a song in a commercial usually requires a payment of several thousand dollars. As a general rule, expect to pay at least $50 or more for each copyright permission.

Generally, fees are linked to the popularity of your work. Commercial uses, such as advertisements, cost more than nonprofit or educational uses. The fees for website uses may depend upon on the number of visitors to the site.

If you can't afford the permission fee, you'll have to find another work to use unless you decide to use it without paying on the grounds of fair use, as discussed in Section C. This is why it's so important to find out what the fee will be as soon as possible.

Humorous Office Spot Illustrations, Dover Publications

Step 4: Get It in Writing

Finally, get your permission agreement in writing. Relying on an oral or implied agreement is almost always a mistake. You and the rights owner may have misunderstood each other or remembered the terms of your agreement differently.

This can lead to disputes. If you have to go to court to enforce your unwritten agreement, you'll have difficulty proving exactly what the terms are.

C. Use the Work Without Permission on the Grounds of Fair Use

The final—and riskiest—option is to use the work without obtaining permission on the grounds of fair use. The law allows the use of copyrighted material for free in limited circumstances when the use is considered a fair use. However, determining when a use is a fair use requires a delicate balancing of several rather vaguely defined factors discussed below.

This is the problem with the fair use privilege—it's an amorphous area of the law and it's hard to be sure whether a use is or is not a fair use. Moreover, always keep in mind that claiming fair use will not keep you from being sued. It is simply a defense you can raise if a copyright owner, claiming you infringed their ownership rights, sues you. You'll win such a suit if the judge or jury concludes that your use is a fair use, but the expense and trauma involved could be enormous.

For a detailed analysis of how to weigh the risks involved in using a work without permission, see Chapter 1.

No Fair Use Outside the United States. This discussion only covers using copyrighted material within the United States. The fair use provisions contained in American copyright law are unique. No other country in the world gives the public such broad latitude to use copyrighted works without permission. Some countries do allow limited unauthorized copying, but only for the purposes of private study or research, not for publication. In the United Kingdom, Canada, Australia, and New Zealand this limited copying privilege is called "fair dealing"; no country other than the United States uses the term "fair use." If you want to use a work outside the United States without permission, you need to refer to the law of the country involved. (See Chapter 16 for a detailed discussion of foreign copyright laws.)

1. What Is the Fair Use Privilege?

The purpose of the copyright laws is to advance the progress of knowledge by giving authors an economic incentive to create new works. Authors and their heirs are automatically granted the exclusive right to reproduce, adapt, perform, and display their works for many years; they are in effect, granted a monopoly over the use of their work.

However, there are situations where strict enforcement of an author's monopoly would hinder, rather than promote, the growth of knowledge. An obvious example is that of a researcher or scholar whose own

work depends on the ability to refer to and quote from prior works. No author could create a new work if she were first required to repeat the research of every author who had gone before her.

Of course, scholars and researchers could be required to bargain with each copyright owner for permission to quote from or refer to prior works. But this would likely prove so onerous that many scholars would hunt for another line of work, and the progress of knowledge would be greatly impeded.

To avoid this result, the fair use privilege was created. Under the fair use rule, an author is permitted to make limited use of another author's work without asking permission. All authors and other copyright owners are deemed by U.S. law to give their automatic consent to the fair use of their work by others. The fair use privilege is the most significant limitation on a copyright owner's exclusive rights.

2. When Is a Use a Fair Use?

The following four factors must be considered to determine whether an intended use of a copyrighted work is a fair use:

- the purpose and character of the use
- the type of work involved
- the amount and importance of the material used, and
- the effect of the use upon the market for the copyrighted work.

These factors are intended to be a highly flexible set of general guidelines. The courts do not apply them in a mechanical or numerical way. For example, a use is not always fair if three of the four factors above are met. Moreover, not all factors are equally important in every case and it's up to the courts to decide what weight to give them. This makes determining whether a use is a fair use a highly subjective and unpredictable exercise.

Can Fair Use Apply Where Permission Is Denied?

If you ask a copyright owner for permission to use her work and she refuses, can you then use it without permission on the grounds of fair use? The Supreme Court has said yes: "If the use is otherwise fair, no permission need be sought or granted. Thus, being denied permission to use a work does not weigh against a finding of fair use." *Campbell v. Acuff-Rose Music, Inc.*, 114 S.Ct. 1164 (1994).

This means that even though you're certain that your intended use is fair, you can go ahead and seek permission for the use from the copyright owner because you want to avoid the possibility of expensive litigation. If the copyright owner proves to be unreasonable and withholds permission, you can then go ahead and use the material on the basis of fair use. But, of course, the copyright owner could still sue you. If the use really is fair, you would win the suit even though you had unsuccessfully sought permission.

a. The Purpose and Character of the Use

First, the purpose and character of your intended use must be considered. The test here is to see whether your own work merely serves as a substitute for the original or "instead adds something new, with a further purpose or different character, altering the first with new expression, meaning, or message." *Campbell v. Acuff-Rose Music, Inc.*, 114 S.Ct. 1164 (1994). The Supreme Court calls such a use "transformative."

This is a very significant factor. The more transformative a work is, the less important are the other fair use factors that may weigh against a finding of fair use. Why should this be? It is because the goal of copyright to promote human knowledge is furthered by the creation of transformative works. "Such works thus lie at the heart of the fair use doctrine's guarantee of a breathing space within the confines of copyright." *Campbell v. Acuff-Rose Music, Inc.*

Following are very typical examples of transformative uses where copyrighted material is used to help create new and different works. These types of uses are most likely to be fair uses:

- **Criticism and comment**—for example, quoting or excerpting a work in a review or criticism for purposes of illustration or comment.
- **News reporting**—for example, summarizing an address or article, with quotations, in a news report.
- **Research and scholarship**—for example, quoting a passage in a scholarly, scientific, or technical work for illustration or clarification of the author's observations.

Parodies are also transformative uses that often qualify as fair uses (see Section C3).

Although not really transformative, photocopying by teachers for classroom use may also be a fair use since teaching also furthers the knowledge-enriching goals of the copyright laws (see Section C4).

1001 Cartoon-Style Illustrations, Dover Publications

Note that the uses listed above, with the possible exception of news reporting, are primarily for nonprofit educational purposes. Although some money may be earned from writing a review or scholarly work, financial gain is not usually the primary motivation— disseminating information or otherwise advancing human knowledge is.

If permission were required for these socially helpful uses (presumably for a fee), it is likely that few reviews or scholarly works would be written; neither the authors nor publishers of works that earn such modest sums could afford to pay for the necessary permissions. (Newspapers probably could afford to pay for permissions, but requiring them to do so in all cases would inevitably impede the free flow of information, and might also violate the free press guarantees of the First Amendment of the U.S. Constitution.)

In contrast, an author and/or publisher of a work created primarily for commercial gain usually can afford to pay for permission to use other's protected expression. It also seems inherently fair to require him to do so. In the words of one court, fair use "distinguishes between a true scholar and a chiseler who infringes a work for personal profit." *Wainwright Securities, Inc. v. Wall Street Transcript Corp.*, 448 F.2d 91 (2d Cir. 1977).

For these reasons, a judge or jury in a copyright infringement case would be less likely to find a valid fair use claim on a work that was published primarily for private commercial gain than a nonprofit or scholarly work. However, the fact that your primary motive is commercial does not always mean you can't exercise the fair use privilege. If the other fair use factors are in your favor, the use may be considered a fair use. This is particularly likely where the use benefits the public by furthering the fundamental purpose of the copyright laws —the advancement of human knowledge.

EXAMPLE: The authors of an unauthorized "popular" biography of Howard Hughes quoted from two *Look* Magazine articles about Hughes. All four fair use rules were satisfied. Only a small number of words were quoted and the authors had provided proper attribution for the quotes. In addition, the copyright owner of the articles (who turned out to be Hughes himself) had no intention of using the articles in a book, so the use was not a competitive use. A court held that the quotations qualified as a fair use. Although the biography had been published primarily to earn a profit, it also benefited the public. The court stated that "while the Hughes biography may not be a profound work, it may well provide a valuable source of material for future biographers (if any) of Hughes or for historians or social scientists." *Rosemont Enters. v. Random House, Inc.*, 336 F.2d 303 (2d Cir. 1966).

Attribution Does Not Make a Use Fair, But Should Always Be Provided

Some people have the mistaken idea that they can use any amount of material so long as they give the author credit. This is simply not true. Providing credit for a quotation or other form of copying will not, in and of itself, make the use of the quote a fair use. For example, if you quote an entire chapter from another author's book without permission, your use wouldn't be considered fair even if you give that author credit.

Although the Copyright Act does not explicitly require authors to provide attribution for quoted or paraphrased material, it is a factor that courts consider. It is likely that a judge or jury would look with disfavor on an author who attempts to pass off the work of others as his own and then has the nerve to cry "Fair use!" if he's sued for copyright infringement. They might be inclined not only to find that the use is not a fair use, but to impose particularly heavy damages in an infringement suit. If you copy someone else's work, always give that person credit. Copying with attribution is a very good hedge against getting sued, or losing big if you are sued.

b. The Type of Work Involved

To preserve the free flow of information, less copyright protection is given to factual works (scholarly, technical, scientific works, etc.) than to works of fancy (novels, poems, plays, etc.). Thus, authors have more leeway in using material from factual works than from fanciful ones, especially where it's necessary to use extensive quotations to ensure the accuracy of the factual information conveyed.

In addition, you will have a stronger case of fair use if the material copied is from a published work than from an unpublished work. The scope of fair use is narrower for unpublished works because an author ordinarily has the right to control the first public appearance of his expression.

EXAMPLE: A well-known literary biographer named Ian Hamilton attempted to write an unauthorized biography of the notoriously reclusive novelist J.D. Salinger. During his research, he found 44 unpublished letters written by Salinger in university libraries. When Salinger learned that Hamilton intended to include extensive quotations from these letters in his biography, he filed suit for copyright infringement and won. The court held that the quotations did not constitute a fair use, in large part because Salinger, not Hamilton, had the right to decide if and when to first publish his private letters. *Salinger v. Random House, Inc.,* 811 F.2d 90 (1987).

However, the fact that a work is unpublished does not mean it can never be the subject of fair use. If all the other factors are in favor of fair use, they may outweigh this factor. See Section C2c, below, for an example of a case where a court held it was a fair use to publish excerpts from an author's unpublished letters and journal.

On the other hand, the drafters of the copyright law and the Supreme Court have suggested that a user may have more justification for reproducing a work without permission if it is out of print and unavailable for purchase through normal channels. *Harper & Row v. Nation Enterprises*, 471 U.S. 539 (1985). Thus, most courts give users more leeway when they quote from or photocopy out-of-print works. But this does not mean that any amount of material from out-of-print works may be used without permission.

c. The Amount and Importance of the Material Used

The more material you take the more likely it is that your work will serve as a substitute for the original and adversely affect the value of the copyright owner's work, making it less likely that the use can be a fair use. However, contrary to what many people believe, there is no preestablished limit for fair use. For example, it is not always okay to take one paragraph or less than 200 words from a written work or less than two bars from a song.

Copying 12 words from a 14-word haiku poem wouldn't be fair use. Nor would

copying 200 words from a work of 300 words likely qualify as a fair use. However, copying 2,000 words from a work of 500,000 words might be fair. It all depends on the circumstances—for example, it may be permissible to quote extensively from one scientific work to ensure the accuracy of another scientific work.

The quality of the material you want to use must be considered as well as the quantity. The more important it is to the original work, the less likely is your use a fair use.

EXAMPLE: *The Nation* magazine obtained a copy of Gerald Ford's memoirs prior to their publication. The magazine published an article about the memoirs in which only 300 words from Ford's 200,000-word manuscript were quoted verbatim. The Supreme Court held that this was not a fair use because the material quoted—dealing with the presidential pardon of former President Richard M. Nixon—was the "heart of the book … the most interesting and moving parts of the entire manuscript." *Harper & Row Publishers, Inc. v. Nation Enterprises*, 471 U.S. 539 (1985).

EXAMPLE: In the late 1970s a television advertising campaign was conducted to promote New York City. A song called "I Love New York" accompanied the commercials. The song consisted in part of the phrase, "I Love New York" repeated again and again, accompanied

by the four notes, D C D E. The television show *Saturday Night Live* created and performed a comic sketch in which it copied the four notes and changed the lyric to "I love Sodom." The court held that the use was not a fair use even though *SNL* only copied four notes and the words "I love" from a song that contained a 45-word lyric and 100 measures. The court reasoned that the copying was not a fair use because these four notes were "the heart of the composition." *Elsmere Music, Inc. v. NBC*, 482 F.Supp. 741 (1980).

d. The Effect of the Use on Potential Market

The fourth fair use factor is the effect of the use upon the potential market for, or value of, the copyrighted work. You must consider not only the harm caused by your act of copying, but whether similar copying by others would have a substantial adverse impact on the potential market for the original work.

For example, in the case involving J.D. Salinger's unpublished letters mentioned above, Salinger's literary agent testified at trial that Salinger could earn as much as $500,000 if he published his letters. Thus, if biographers were permitted to publish portions of his most interesting letters first, it could have cost Salinger substantial royalties. The court ruled this was not a fair use.

Since fair use is simply a defense to a copyright infringement lawsuit, it is up to the defendant—the copier—in an infringement case to show there is no harm to the potential market for the original work. This can be difficult. The more transformative the subsequent work—the more it differs from the original and is aimed at a different market—the less likely will it be deemed to adversely affect the potential market for the original.

But you'll have a very hard time proving that there is no harm to the potential market for the original work if your own work is similar to the original and aimed at the same market. This makes it much harder for a court to view your use as a fair use.

e. Doing Your Own Fair Use Analysis

To determine whether an intended use is a fair use, you need to pretend you're a judge and carefully weigh each of the four factors discussed above. List each factor in turn on a piece of paper or your computer and see whether it favors or disfavors a finding of fair use. To help you, here are two well-known examples of how judges conducted fair use analyses:

> **EXAMPLE 1:** In 1980, a professional photographer named Art Rogers made a photograph of a man and his wife holding eight puppies. Rogers owned the copyright in the photo and exhibited and licensed it many times. Well-known artist and sculptor Jeff Koons obtained a copy of the photo and decided to recreate it as a sculpture. He gave the photo to artisans in his employ who

proceeded to make four astonishingly faithful three-dimensional copies out of wood. Koons sold three of the sculptures for $367,000. Rogers filed suit claiming that Koons had infringed on his copyright in his photo by creating the sculptures without his permission. Koons claimed the sculptures were a fair use. The court disagreed, concluding that all four fair use factors discussed above went against a finding of fair use.

Purpose and character of the use: The court concluded that the main reason Koons had the sculptures created was to sell them and make a lot of money. This militated against a finding of fair use.

Type of work involved: The photo was a creative and imaginative work, not a factual work like a biography. This also weighed against fair use.

Amount and importance of material used: Koons copied virtually the entire photo. This also weighed against fair use.

The effect of the use on the market value of the original: Although Koons's sculpture was in a different medium than Rogers's photo, the court held that it did have a detrimental impact on the potential market for the photo. The court reasoned that the existence of Koons's sculpture made it less likely that any other artist would be willing to pay Rogers for permission to make another sculpture based on the photo. Moreover, Koons could take and sell photographs of the sculpture, which would reduce the market for Roger's original photo. *Rogers v. Koons*, 960 F.2d 301 (2d Cir. 1992).

EXAMPLE 2: In 1988 Dr. Margaret Walker wrote a biography of the late author Richard Wright, best known for his novel *Native Son*. Walker included in the biography ten brief quotations and five short paraphrases from unpublished letters Wright had written to Walker, and 14 short passages from Wright's unpublished journal. Wright's widow sued Walker and her publisher for copyright infringement for using the material without permission. The court held the use was a fair use. Here's how the court analyzed the four fair use factors:

Purpose and character of the use: This factor clearly favored Walker because her work was a scholarly biography. Walker's use was transformative because her "biography furthers the goals of the copyright laws by adding value to prior intellectual labor."

Type of work involved: Since the material used by Walker was unpublished, this factor weighed against a finding of fair use.

Amount and importance of the material used: This factor favored a finding of fair use because Walker used no more than 1% of the letters or journal entries Wright had written. Moreover, although the material Walker used enhanced the

biography, it was not of earthshaking importance and certainly did not form the heart of the biography. No one would buy the biography in order to read these passages.

Effect on the market: Finally, the court held that the biography did not pose a threat to the potential market for Wright's letters or journals. Since so little material was copied, the biography could in no way supplant the letters or journals. *Wright v. Warner Books, Inc.*, 953 F.2d 733 (2d Cir. 1991).

3. Parody

A parody is a work of fancy that ridicules another, usually well-known, work by imitating it in a comic way. Peruse the humor section of your local bookstore and you'll find many examples, such as parody versions of well-known magazines like *Cosmopolitan* (called *Catmopolitan*). Someone has even published a parody of the SAT exam called the "NSAT" (No-Sweat Aptitude Test) and a book of parody sequels to famous literary works, including titles such as *A Clockwork Tomato, 2000: A Space Iliad*, and *Satanic Reverses*.

To parody a work, it is usually necessary to copy some of the work's material so that readers will be able to recognize what's being parodied. However, it is rarely possible to get permission to parody or satirize someone else's work. Thus, parodies can exist only because of the fair use privilege. Recognizing this, courts

have historically held that parody and satire deserve substantial freedom, both as entertainment and a form of social and literary criticism.

The U.S. Supreme Court, in a case involving a parody of the song "Pretty Woman" by the rap group 2 Live Crew (*Campbell v. Acuff-Rose Music, Inc.*, 114. S.Ct. 1164 (1994)), has provided specific guidance on how the fair use factors discussed above should be evaluated in a parody case.

a. Purpose and Character of the Use

The Supreme Court stated that the heart of a claim of fair use for a parody is that an author's preexisting work needed to be copied in order to create a new work that, at least in part, comments on or criticizes the prior author's work. However, a self-proclaimed parodist who copies a prior work merely to get attention or to avoid the drudgery in working up something fresh has a weak claim to fair use.

Does it matter that a parody might be seen to be in bad taste? The Supreme Court said no. All that matters is that the work can reasonably be perceived to contain a parodic element—in other words, it comments on or criticizes the original work in some way. Whether a parody is in good or bad taste does not matter to fair use. However, as a practical matter, the copyright owner of a work being parodied is probably more likely to complain if the parody is in bad taste. The fact that a parody is commercially motivated weighs

Parody Must Target Copied Work

For a parody to qualify as a fair use, it must target the work it borrows from, not something else. By its very definition, a parody is a work that uses elements from a prior author's work to create a new work that comments on the previous work in some way. It's fine for a parody also to have other purposes—for example, to make fun of modern society—but the copied work must be, at least in part, an object of the parody, otherwise there would be no need to conjure up the original work.

Two authors ran afoul of this rule when they created a poetic satire of the O.J. Simpson murder trial titled *The Cat NOT in the Hat! A Parody by Dr. Juice*. The authors told the story of the Simpson murder trial through poems and sketches that were similar to those in the famous *The Cat in the Hat* children's books by Dr. Seuss. The work was narrated by a "Dr. Juice," a character based on Dr. Seuss, and contained a character called "The Cat NOT in the Hat."

The owners of the copyrights in the Dr. Seuss books sued, alleging copyright infringement. The authors claimed their work constituted a fair use because it was a parody of Dr. Seuss. The court disagreed. Although it's likely that many individual elements of the work did not infringe, the court held that the work as a whole did infringe on Dr. Seuss. The authors' poems and illustrations simply retold the Simpson tale. Although they broadly mimicked Dr. Seuss's characteristic style, they did not hold it up to ridicule or otherwise make it the object of the parody. The authors merely used the Cat's stovepipe hat, the narrator ("Dr. Juice"), and the title "The Cat NOT in the Hat" to get attention or avoid the drudgery of working up something fresh. The court upheld an injunction that barred Penguin Books from distributing 12,000 books it had printed at a cost of $35,000. *Dr. Seuss Enterprises v. Penguin Books USA, Inc.*, 109 F.3d 1394 (9th Cir. 1997).

against a finding of fair use, but is not a deciding factor in and of itself.

b. Type of Work Involved

As a general rule, a use is more likely to be a fair use when the work involved is a utilitarian factual work like a newspaper account or scientific work rather than a work of fancy like a novel or play (see Section C2 above). However, this isn't usually the case with parodies. People rarely bother to parody boring utilitarian factual works that no one has ever heard of. Instead, they parody highly creative well-known works. This is so whether they are nonfiction or fiction. For this reason, the U.S. Supreme Court has stated that the type-of-work factor is not helpful in determining whether a parody is a fair use.

c. The Amount and Importance of the Material Used

To be effective, a parody must take enough material from the prior work to be able to conjure it up in the reader's or hearer's mind. To make sure the intended audience will understand the parody, the parodist usually has to copy at least some of the most distinctive or memorable features of the original work. But a parody composed primarily of an original work with little new material added is not likely to be considered a fair use.

d. Effect of the Use on the Market for the Prior Work

A finding that a parody has a detrimental effect on the market for, or value of, the original work weighs against fair use. However, the Supreme Court stated that a parody generally does not affect the market for the original work because a parody and the original usually serve different market functions. A parody is particularly unlikely to affect the market for the original where the copying is slight in relation to the parody as a whole.

But what if a parody is so scathing or critical of the original work that it harms the market for it? Does this weigh against fair use? The Supreme Court answered this question with a resounding no. Biting criticism is not copyright infringement, even if it effectively destroys a work both artistically and commercially.

e. Applying the Fair Use Factors

Applying these fair use factors is a highly subjective exercise. One judge's fair use might be another's infringement. A parody will probably be deemed a fair use so long as:

- the parody has neither the intent nor the effect of fulfilling the demand for the original
- the parodist does not take more of the original work than is necessary to accomplish the parody's purpose (the

more recognizable the original work, the less needs to be taken to parody it), and

- the original work is at least in part an object of the parody (otherwise there would be no need to use it).

EXAMPLE: Disc jockey Rick Dees created and recorded a parody version of the song "When Sunny Gets Blue." Dees's version was called "When Sonny Sniffs Glue" and copied the first six of the song's 38 bars. Dees changed the song's opening lyrics—"When Sunny gets blue, her eyes get gray and cloudy, then the rain begins to fall" to "When Sonny sniffs glue, her eyes get red and bulgy, then her hair begins to fall." The composers of "When Sunny Gets Blue" sued Dees for copyright infringement and lost because the court held that the parody was a fair use. Here's how the court analyzed the three fair use factors that the Supreme Court says are important in parody cases:

- **Purpose and character of use:** The court noted that Dees's song was intended to poke fun at "When Sunny Gets Blue," something a parody must do to be a fair use. While the parody was created as part of a recording sold for a profit, the court held it was "more in the nature of an editorial or social commentary than … an attempt to capitalize on the plaintiff's original work."

- **Effect of the use on the market for the prior work:** The court held that the parody would not have a substantial effect on the market for "When Sunny Gets Blue" because it could not fulfill the demand for it. The court noted that "When Sunny Gets Blue" was a romantic nostalgic ballad, while the parody was a song about a woman who sniffs glue. It was not likely that consumers who wanted to hear a romantic ballad would purchase the parody instead of the original song.

- **The amount and substantiality of the portion used:** Finally, the court held that the parody copied no more of the original song than was necessary to conjure it up in listeners' minds. The court noted that "a song is difficult to parody effectively without exact or near-exact copying." *Fisher v. Dees*, 794 F.2d 432 (9th Cir. 1986).

4. Educational Fair Use Guidelines

Publishers and the academic community have established a set of educational fair use guidelines to provide "greater certainty and protection" for teachers. While the guidelines are not part of the federal copyright law, judges recognize them as minimum standards for fair use in education. A teacher or pupil following the guidelines

can feel comfortable that a use falling within these guidelines is a permissible fair use and not an infringement

The educational use guidelines can be found in Circular 21, published by the Copyright Office. You can download a free copy from the Copyright Office website (www.copyright.gov/circs/circ21.pdf); or you can have a copy mailed to you by calling the Copyright Office at 202-707-3000.

a. What Is the Difference Between the Guidelines and General Fair Use Principles?

The educational fair use guidelines were created and agreed upon by representatives of author, publisher, and educational organizations and unofficially endorsed by the Congressional committee that drafted the copyright law. They are similar to a treaty that has been adopted by copyright owners and academics. Under this arrangement, the copyright owners will permit uses that are outlined in the guidelines. In other fair use situations, there are no adopted guidelines and the only way to prove that a use is permitted is to submit the matter to court or arbitration to evaluate the four fair use guidelines discussed in Section C2 above. In other words, in order to avoid lawsuits, the various parties have agreed in these guidelines as to what is permissible for educational uses.

b. What Is an "Educational Use"?

The educational fair use guidelines apply to material used in educational institutions and for educational purposes. Examples of educational institutions include K-12 schools, colleges, and universities. Libraries, museums, hospitals, and other nonprofit institutions also are considered educational institutions under most educational fair use guidelines when they engage in nonprofit instruction, research, or scholarly activities for educational purposes.

"Educational purposes" means:

- noncommercial instruction or curriculum-based teaching by educators to students at nonprofit educational institutions
- planned noncommercial study or investigation directed toward making a contribution to a field of knowledge, or
- presentation of research findings at noncommercial peer conferences, workshops, or seminars.

c. Rules for Reproducing Text Materials for Use in Class

The guidelines permit a teacher to make one copy of any of the following:

- a chapter from a book
- an article from a periodical or newspaper
- a short story, short essay, or short poem

- a chart, graph, diagram, drawing, cartoon, or picture from a book, periodical, or newspaper.

Teachers may photocopy articles to hand out in class, but the guidelines impose restrictions. Classroom copying cannot be used to replace texts or workbooks used in the classroom. Pupils cannot be charged more than the actual cost of photocopying. The number of copies cannot exceed more than one copy per pupil. And a notice of copyright must be affixed to each copy.

Examples of what can be copied and distributed in class include:

- a complete poem if less than 250 words or an excerpt of not more than 250 words from a longer poem
- a complete article, story, or essay if less than 2,500 words, or an excerpt from any prose work of not more than 1,000 words or 10% of the work, whichever is less; or
- one chart, graph, diagram, drawing, cartoon, or picture per book or per periodical issue.

Not more than one short poem, article, story, essay, or two excerpts may be copied from the same author, nor more than three from the same collective work or periodical volume (for example, a magazine or newspaper) during one class term. As a general rule, a teacher has more freedom to copy from newspapers or other periodicals if the copying is related to current events.

The idea to make the copies must come from the teacher, not from school administrators or other higher authority.

Only nine instances of such copying for one course during one school term are permitted. In addition, the idea to make copies and their actual classroom use must be so close together in time that it would be unreasonable to expect a timely reply to a permission request. For example, the instructor finds a newsweekly article on capital punishment two days before presenting a lecture on the subject.

Teachers may not photocopy workbooks, texts, standardized tests, or other materials that were created for educational use. The guidelines were not intended to allow teachers to usurp the profits of educational publishers. In other words, educational publishers do not consider it a fair use if the copying provides replacements or substitutes for the purchase of books, reprints, periodicals, tests, workbooks, anthologies, compilations, or collective works.

d. Rules for Reproducing Music

A music instructor can make copies of excerpts of sheet music or other printed works, provided that the excerpts do not comprise a "performable unit" such as a whole song, section, movement, or aria. In no case can more than 10% of the whole work be copied and the number of copies may not exceed one copy per pupil. Printed copies that have been purchased may be edited or simplified provided that the fundamental character of the work is not distorted or the lyrics altered or added.

A student may make a single recording of a performance of copyrighted music for evaluation or rehearsal purposes, and the educational institution or individual teacher may keep a copy. In addition, a single copy of a sound recording owned by an educational institution or an individual teacher (such as a tape, disc, or cassette) of copyrighted music may be made for the purpose of constructing aural exercises or examinations, and the educational institution or individual teacher can keep a copy. Instructors may not:

- copy sheet music or recorded music for the purpose of creating anthologies or compilations used in class
- copy from works intended to be "consumable" in the course of study or teaching, such as workbooks, exercises, standardized tests, and answer sheets and like material
- copy sheet music or recorded music for the purpose of performance, except for emergency copying to replace purchased copies which are not available for an imminent performance (provided purchased replacement copies are substituted in due course), or
- copy any materials without including the copyright notice which appears on the printed copy.

If copyrighted sheet music is out of print (not available for sale), an educator can request permission to reproduce it from the music publisher. A library that wants to reproduce out-of-print sheet music can use a system established by the Music Publishers Association (www.mpa .org). Download the "Library Requisition for Out-of-Print Copyrighted Music"; write to the Music Publishers Association, PMB 246, 1562 First Avenue, New York, NY, 10028; or call 212-327-4044.

e. Rules for Recording and Showing Television Programs

Nonprofit educational institutions can record television programs transmitted by network television and cable stations. The institution can keep the tape for 45 days, but can only use it for instructional purposes during the first ten of the 45 days. After the first ten days, the video recording can only be used for teacher evaluation purposes or to determine whether or not to include the broadcast program in the teaching curriculum. If the teacher wants to keep it within the curriculum, permission must be obtained from the copyright owner. The recording may be played once by each individual teacher in the course of related teaching activities in classrooms and similar places devoted to instruction (including formalized home instruction). The recorded program can be repeated once, if necessary, although there are no standards for determining what is and is not necessary. After 45 days, the recording must be erased or destroyed.

Only individual teachers may request and use a video recording of a broadcast. A television show may not be regularly recorded in anticipation of requests—for

example, there can't be a standing request to record each episode of a PBS series. Only enough copies may be reproduced from each recording to meet the needs of teachers, and the recordings may not be combined to create teaching compilations. All copies of a recording must include the copyright notice on the broadcast program as recorded, and as mentioned above, must be erased or destroyed 45 days after having been recorded.

5. Reproductions by Libraries and Archives

Fair use analysis becomes difficult when copying by libraries and archives is involved. These institutions play a vital role in preserving and disseminating knowledge. Yet if they were permitted to engage in unfettered copying, the market for many works would be reduced and authors' economic incentives to create new works would be diminished.

Congress has determined that certain types of unauthorized copying by libraries and archives must be permitted whether or not it would constitute a fair use under the standards discussed above.

There are two separate exemptions avail able for libraries and archives: the first exemption gives libraries and archives the right to make up to three physical or digital copies of any work for certain purposes. The second exemption allows copies to be made only of those works that have entered the 75th year of their copyright term.

a. Copying for Archival or Replacement Purposes or at User's Request

Books or other written works are often lost or become worn out. Replacing them may be difficult where the work is out of print. In this event, can a library make a new copy itself without obtaining permission from the copyright owner? Library users often ask librarians to photocopy articles from periodicals. Can a library legally make the copy? The answer to both questions may be yes if the following special exemption applies.

i. Which Libraries and Archives May Benefit From Special Exemption?

The exemption applies to all nonprofit libraries, and archives—for example, municipal libraries, university and school libraries, or government archives. However, a library or archive need not be nonprofit to qualify. A library or archive owned by a profit-making enterprise or private institution may qualify for the exemption so long as

Humorous Office Spot Illustrations, Dover Publications

the photocopying itself is not commercially motivated. This means that a profit may not be earned from the photocopies themselves—for instance, they could not be sold for a profit—but the information contained in the photocopies may be used to help a company make a profit-making product. For example, the exemption might be claimed by research and development departments of chemical, pharmaceutical, automobile, and oil companies; the library of a private hospital; and law and medical partnership libraries.

However, if the library or archive is not open to the general public, it must be open at least to persons doing research in the specialized field covered by the library collection who are not affiliated with the library or its owner. This requirement eliminates many libraries and archives owned by private companies that are open only to employees.

ii. When Does the Exemption Apply?

The special exemption may be claimed only if:

- the library or archive owns the work as part of its collection
- no more than three physical or digital copies of the work are made at one time
- no charge is made for the copying beyond the costs of making the copy, and
- the copies contain the same copyright notice that the work itself contains; if the work contains no notice, a legend must be included in the copies stating that the work may be protected by copyright.

If these requirements are met, it is permissible for a library or archive to make an authorized photocopy of a work under the following four circumstances:

Archival reproductions of unpublished works. Up to three copies of any unpublished work may be made for purposes of preservation or security, or for deposit for research use in another library or archive. The work may be photocopied or otherwise physically reproduced or digital copies may be made. However, if the work is digitally copied, the digital copies may not be made available to the public outside the library or archive premises. This means the digital copies could only be read on computers at the library or archive. They may not be placed on a network that people outside the library may access or on the Internet.

Replacement of lost, damaged, or obsolete copies. A library or archive may also make up to three physical or digital copies of a published work that is lost, stolen, damaged, deteriorating, or is stored in an obsolete format. A format is considered obsolete when the device necessary to read the work is no longer manufactured or is no longer reasonably available in the commercial marketplace. As with unpublished works, if digital copies are made, they may not be made available to the public outside the library or archive premises.

Library user requests for articles and short excerpts. A library or archive may make one copy of an article from a periodical or a small part of any other work at the request of a library user or at the request of another library on behalf of a library user, provided that:

- the copy becomes the property of the library user
- the library has no reason to believe the copy will be used for purposes other than private study, scholarship, and research, and
- the library displays a copyright notice at the place where reproduction requests are accepted. The notice must appear in the form shown below:

NOTICE: WARNING CONCERNING COPYRIGHT RESTRICTIONS

The copyright law of the United States (Title 17, United States Code) governs the making of photocopies or other reproductions of copyrighted material. Under certain conditions specified in the law, libraries and archives are authorized to furnish a photocopy or other reproduction. One of these specified conditions is that the photocopy or reproduction is not to be "used for any purpose other than private study, scholarship, or research." If a user makes a request for, or later uses, a photocopy or reproduction for purposes in excess of "fair use," that user may be liable for copyright infringement. This institution reserves the right to refuse to accept a copying order if, in its judgment, fulfillment of the order would involve violation of copyright law.

Library user requests for entire works. A library or archive may also make a copy of an entire book or periodical at a library user's request (or at the request of another library on behalf of a library user) if the library determines after reasonable investigation that a copy cannot be obtained at a reasonable price, either because the work is out of print or for some other reason. The same type of investigation must be conducted as for replacement of lost or damaged copies (above). In addition, the same good faith and posting requirements must be met as for reproduction of articles and short excerpts (above).

iii. No Multiple Copies

The library and archive exemption extends only to isolated and unrelated reproductions of a single copy. It does not authorize related or concerted reproduction of multiple copies of the same material, whether at the same time or over a period of time. This is so whether the copies are intended for one individual or a group. For example, if a college professor instructs her class to read an article from a copyrighted journal, the school library would not be permitted to reproduce copies of the article for the class.

iv. No Systematic Copying

Systematic copying is also prohibited. This means that a library or archive may not make copies available to other libraries or groups of users through interlibrary networks and similar arrangements in such

large quantities so as to enable them to substitute the copies for subscriptions or reprints which they would otherwise have purchased themselves.

v. Photocopying Beyond the Scope of the Exemption

Unauthorized copying that is not covered by, or goes beyond the limits of, the special exemption is permissible only if it is a fair use under the more flexible fair use factors discussed in Section C2, above.

b. Copying Works Over 75 Years Old

In 1998, the Sonny Bono Copyright Term Extension Act extended the copyright term for works published before 1978 from 75 to 95 years (see Chapter 18). The Act also included a new exemption for libraries and archives. Under this new exemption, a library, archive, or nonprofit educational institution functioning as a library or archive, may reproduce, display, or perform in physical or digital form for purposes of preservation, scholarship, or research a copy of a work that has entered the last 20 years of the 95-year copyright term. However, three requirements must first be met: Following a reasonable investigation, the library or archive must have determined that:

- the work is not subject to normal commercial exploitation—that is, cannot be purchased from the publisher or booksellers
- a copy of the work cannot be obtained at a reasonable price, and

- the copyright owner of the work has not filed a notice with the Copyright Office that either of the first two conditions cannot be met (see Subsection ii below).

The exemption does not apply to unpublished works and may only be claimed by libraries or archives themselves, not by people who use them.

i. Few Works Are Covered by Exemption

Since the exemption only applies to works that have entered their 76th year of copyright protection, few works are currently covered. In 1999, only works published in 1923 (and renewed on time in their 28th year after publication, if published in the United States) were covered. In 2000, only works published in 1923 and 1924 were covered. In 2001 only works published from 1923 through 1925 were covered. And so on.

The majority of works first published in the United States before 1963 are in the public domain because their copyrights were never renewed. Such works may be copied freely for any purpose. Therefore, libraries and archives should first check to see if an old work they want to copy has been renewed before bothering to investigate whether this exemption applies. Note, however, that works first published outside the United States before 1963 don't have to be renewed. (See Chapter 18 for detailed discussion.)

ii. Notice to Libraries and Archives

Copyright owners who own works in their last 20 years of copyright protection are allowed to file a notice with the Copyright Office stating that the work is subject to normal commercial exploitation or that a copy can be obtained at a reasonable price. If such a notice is filed, a library or archive may not utilize the exemption discussed here. ■

Chapter 23

Help Beyond This Book

U sing the information in the book, you should be able to determine whether most of the works you're interested in are in the public domain. However, there may be instances where you need more detailed information about the various laws and court decisions discussed here. You'll often be able to find the information you need by doing your own legal research. This chapter provides a list of some basic resources you can use to research copyright and the other intellectual property laws that govern the public domain.

In addition, as mentioned throughout the book, there are situations where it can be extremely difficult or impossible to determine on your own whether a work is in the public domain. In these cases you may wish to consult with an attorney. This chapter provides some advice on how to find and use an attorney.

Library of Congress, Prints and Photographs Division, Historic American Buildings Survey

A. Doing Your Own Legal Research

Throughout this book we refer to legal cases and laws. You may want to read these cases and laws or pursue more detailed research on your own. For example you may want to learn more about when copyright does and does not protect blank forms or analyze your state's right of publicity law. Finding out more on a specific legal question generally involves reading legal books and finding law and cases that apply to your situation.

Conducting legal research is not as difficult as it may seem. Nolo publishes a basic legal research guide, *Legal Research: How to Find & Understand the Law*, by Stephen Elias and Susan Levinkind. It walks you through various sources for finding laws and cases and shows you how to use them to answer your legal question.

1. Using the Law Library

There are many good online sources for legal research. For detailed legal research however, you may have to visit a local law library. If there's a public law school in your area, it probably has a law library that's open to the public. Other public law libraries are often run by local bar associations or the local courts. Law libraries associated with private law schools often

allow only limited public access. Call to speak with the law librarian to determine if you can use private libraries. You can always call your local bar association to find out what public law libraries are in your area.

Law libraries may seem intimidating at first. It may be helpful to know that most law librarians have a sincere interest in helping anyone who desires to use their library. While they won't answer your legal questions, they will often put your hands on materials that will give you a good start.

2. Researching Case Citations

Throughout this book you'll see case citations like this: *Harper & Row Publishers, Inc. v. Nation Enterprises,* 723 F.2d 195 (2d Cir. 1983). This identifies a particular legal decision and tells you where the decision may be found and read. Any case decided by federal courts of appeals can be found in a series of works called the Federal Reporter. Older cases are contained in the first series of the Federal Reporter or "F." for short. More recent cases are contained in the second and third series of the Federal Reporter, or "F.2d" and "F.3d" for short.

Opinions by the federal district courts (these are the federal trial courts) are in a series called the Federal Supplement or "F.Supp." For example, 501 F.Supp. 848 (S.D. N.Y. 1980).

Cases decided by the U.S. Supreme Court are found in three publications:

United States Reports (identified as "U.S."), the Supreme Court Reporter (identified as "S.Ct.") and the Supreme Court Reports, Lawyer's Edition (identified as "L.Ed."). Supreme Court case citations often refer to all three publications; for example, *Harper & Row Publishers, Inc. v. Nation Enterprises,* 471 U.S. 539, 105 S.Ct. 2230, 91 L.Ed. 405 (1985).

After you find the name and citation for a court decision you want, you'll need to obtain a copy. You can get copies of most court decisions from the Internet, often for free. The www.findlaw.com website contains a comprehensive list of links to online court decisions. Court decisions can also be obtained from subscription websites such as www.versuslaw.com, www.westlaw.com, and www.lexis.com.

Alternatively, you can find a physical copy in a law library. For example, to obtain a copy of the case *Harper & Row Publishers, Inc. v. Nation Enterprises*, 723 F.2d 195 (2d Cir. 1983), you could go to a law library that has the Federal Reporter, Second Series (almost all do), locate volume 723, and turn to page 195.

B. More Information on Intellectual Property Law

The primary focus of this book is on copyright law, with much briefer discussions of trademark law, trade secret law, design patent law, and the right of publicity. All these laws together make up a body of law

called intellectual property. The resources in this section deal with researching intellectual property law.

Nolo's website at www.nolo.com offers an extensive legal encyclopedia that includes a section on intellectual property. You'll find answers to frequently asked questions about patents, copyrights, trademarks, and other related topics, as well as sample chapters of Nolo books and a wide range of articles. Simply click on "Legal Encyclopedia" and then on "Patents, Copyright, & Trademark."

If you have any questions on copyright or other intellectual property laws that have not been answered by this book, we suggest a three-step process:

- If you have access to the Internet, check one or more of the websites listed below to see if there is an article or other discussion answering your question.

 If you need more in-depth information, take a look at explanations of the law by experts in the field to get a background and overview of the topic being researched. You will probably need to go to a law library to find these materials.

- If you need still more information, read the law itself (cases and statutes) upon which the experts base their opinions.

1. Copyright Information

The Copyright Handbook: How to Protect & Use Written Works, by Stephen Fishman (Nolo), is available to answer many questions about copyright law. The book discusses copyright protection for writings, but the general principles are applicable to all types of works.

a. Internet Resources

If you have access to the Internet, you can find valuable information about copyright by visiting any of the following websites:

- www.copyright.gov. This site, run by the Library of Congress, offers regulations, guidelines, and links to other helpful copyright sites.
- www.findlaw.com. This search engine offers a comprehensive list of copyright resources on the Web. Click intellectual property under the topic heading on the home page and click copyright from the subcategory list on the intellectual property page.
- www.kuesterlaw.com. Lawyer Jeffrey R. Kuester provides an online reference service that will lead you to other copyright resources on the World Wide Web.
- www.datadepth.com. An excellent set of links to copyright websites maintained by a copyright permission service called icopyright.

b. Background Resources

The most authoritative source on copyright law is *Nimmer on Copyright*, a ten-volume legal treatise written by the late Professor Melville B. Nimmer and updated annually by his son David, a copyright lawyer. It is published by Matthew Bender. Most public or university law libraries have this treatise. It contains thorough discussions on virtually every legal issue concerning U.S. and international copyright law.

Each point made by the treatise is supported by exhaustive citations to the relevant legal decisions, sections of the copyright statutes, and Copyright Office regulations, where appropriate. Volume 10 of *Nimmer* contains a topic index, and a detailed table of contents precedes each chapter. Volume 10 also contains a table of cases and a table of statutes. These can be used to find where *Nimmer* discusses a particular copyright decision, copyright code section, or Copyright Office regulation. By using *Nimmer* you can find citations to the primary copyright materials of interest to you.

Another, much shorter, treatise is *Copyright Principles, Law and Practice,* by Paul Goldstein, a law professor at Stanford University.

If you are interested in copyright protection and the public domain outside the United States, the best starting point for your research is *International Copyright Protection*, edited by David Nimmer and Paul Geller and published by Matthew Bender. Unfortunately, this two-volume treatise does not contain an index.

If you have a very unusual copyright question that is not covered by *Nimmer* or other books on copyright law, or a problem in an area in which the law has changed very recently, the best sources of available information may be articles appearing in scholarly journals called law reviews. You can find citations to all the law review articles on a particular topic by looking under "Copyright" in the *Index to Legal Periodicals* or *Current Law Index,* available in law libraries. A key to the abbreviations used in these indexes is located at the front of each index volume. Substantial collections of law reviews are usually found only in large public law libraries or university libraries. Law review articles can also be accessed through the subscription websites www .westlaw.com and www.lexis.com.

c. Primary Source Materials on Copyright

Statutes. The primary law governing all copyrights in the United States is the Copyright Act of 1976. The Copyright Act is located in Title 17 of the United States Code. A complete copy of the Copyright Act is available for free at the Copyright Office website (www.copyright.gov/title17) and on Cornell University's Legal Information Institute website (www4.law.cornell.edu/ uscode/17). If you don't have Internet access, the Copyright Act can be found in libraries that have either the United States Code Annotated (U.S.C.A.) or United States Code Service, Lawyers Edition (U.S.C.S.). All

law libraries have these volumes and many public libraries do as well. The Act has also been reprinted in the Nimmer and Goldstein copyright treatises mentioned above.

Court Decisions. There are several ways to find court decisions on a particular legal issue. As mentioned above, intensive background sources such as *Nimmer on Copyright* and law review articles contain many case citations. In addition, the United States Code Annotated and United States Code Service both cite and briefly summarize all the decisions relevant to each section of the Copyright Act. These are located just after each section of the Act.

d. Materials on the Public Domain

The following books, written for the popular reader, concern the importance of the public domain and the dangers it's facing:

- *The Future of Ideas: The Fate of the Commons In a Connected World*, by Lawrence Lessig (Random House, 2001)
- *Copyrights and Copywrongs*, by Siva Vaidhyanathan, (New York University Press, 2001)
- *Silent Theft: The Private Plunder of Our Common Wealth*, by David Bollier (Routledge, 2002)
- *Owning the Future,* by Seth Shulman, (Houghton-Mifflin, 1999)
- *Playing Darts with a Rembrandt: Public and Private Rights In Cultural Treasures*, by Joseph L. Sax (University of Michigan Press, 1999).

You can download a useful and interesting short report on the public domain, called *Why the Public Domain Matters*, by David Bollier (www .newamerica.net/Download_Docs/pdfs/ Pub_File_867_1.pdf).

The public domain has also become the subject of serious scholarly study. For example, in 2001, Duke University Law School sponsored the first-ever Conference on the Public Domain, in which law professors presented several papers on the subject. These can be found at the Center for the Study of the Public Domain website (www.law.duke.edu/cspd).

2. Trademark Information

Trademark: Legal Care for Your Business & Product Name, by Stephen Elias (Nolo). This guide provides an overview of trademark law and explains how to conduct trademark searches.

a. Internet Resources

If you have access to the Internet, you can find valuable information about trademarks by using any of the following sites:

- FindLaw at www.findlaw.com. This search engine offers an excellent collection of trademark-related materials on the Web, including trademark statutes, regulations, classification manuals, and articles of general interest. Click the intellectual property

link in the topics section on the FindLaw home page and then click trademark in the subcategory section on the intellectual property page.

- GGMARK at www.ggmark.com. This site, maintained by a trademark lawyer, provides basic trademark information and a fine collection of links to other trademark resources.
- Sunnyvale Center for Invention, Innovation and Ideas at www.sci3 .com. This site, maintained by the Sunnyvale Center for Innovation, Invention and Ideas (a Patent and Depository Library), provides information about their excellent, low-cost trademark search service conducted by the Center's librarians.
- Kuesterlaw at www.kuesterlaw.com. This site, maintained by an Atlanta, Georgia, intellectual property law firm, also is an excellent springboard for finding trademark statutes, regulations, court cases, and articles.
- U.S. Patent and Trademark Office at www.uspto.gov. The U.S. Patent and Trademark Office is the place to go for recent policy and statutory changes and transcripts of hearings on various trademark law issues.

b. Background Resources

For truly in-depth information on trademarks, consult the following works:

- *Trademarks and Unfair Competition*, by J. Thomas McCarthy (Clark Boardman Callaghan), is the most authoritative scholarly work on trademark law. This multivolume treatise discusses virtually every legal issue that has arisen regarding trademarks.
- *Trademark Law—A Practitioner's Guide*, by Siegrun D. Kane (Practicing Law Institute), contains practical advice about trademark disputes and litigation.

You can find law review articles on trademark law by looking under "trademark" or "unfair competition" in the *Index to Legal Periodicals* or *Current Law Index*. A key to the abbreviations used in these indexes is located at the front of each index volume. Substantial collections of law reviews are usually located in large public law libraries or university libraries. You can also find a number of articles on the World Wide Web. You can access many articles on the Web through the FindLaw and Kuesterlaw sites mentioned above.

c. Primary Source Materials on Trademark Law

Statutes. The main law governing trademarks in the United States is the Lanham Act, also known as the Federal Trademark Act of 1946 (as amended in 1988). It can be found at Title 15, Chapters 1051 through 1127, of the United States Code. You can find it in either of two books:

- United States Code Annotated (U.S.C.A.), or

- United States Code Service, Lawyers Edition (U.S.C.S.).

All law libraries carry at least one of these series. To find a specific section of the Lanham Act, consult either the index at the end of Title 15, or the index at the end of the entire code. A copy of the complete Lanham Act is located on the World Wide Web at www.law.cornell.edu/uscode/15/ch22.html.

Court Decisions. You'll find citations to relevant court decisions in the treatise *Trademarks and Unfair Competition*, by J. Thomas McCarthy, mentioned above, or in a law review article. In addition, the U.S. Code Annotated and U.S. Code Service both refer to and briefly summarize all the decisions relevant to each section of the Lanham Act. To understand how court decisions are named and indexed, see the instructions in Section A2, above.

Books, Reading and Writing Illustrations,
Dover Publications

3. Right of Publicity

The right of publicity is the newest form of intellectual property and is not recognized in every state. For these reasons, there has not been as much written about this subject as the other intellectual property laws.

a. Internet Resources

- www.hllaw.com/a_personality.html. This website, maintained by a Seattle law firm, provides a good short overview of the right of publicity.
- www.law.cornell.edu/topics/publicity .html. Another brief introduction with links to publicity legal decisions.

b. Background Resources

By far the most widely used and authoritative background resource on the right of publicity is the treatise *The Rights of Publicity and Privacy*, by J. Thomas McCarthy. It's published by Clark Boardman Callaghan. Professor McCarthy is recognized as the leading national expert on right of publicity law. This treatise is the first place to turn if you want in-depth information on this topic. It can be found in many law libraries.

Citations to law review articles dealing with the right of publicity can be found in *The Rights of Publicity and Privacy* or by looking under "right of publicity" in the *Index to Legal Periodicals* or *Current Law Index*. A key to the abbreviations used in these indexes is located at the front of each

index volume. Substantial collections of law reviews are usually located in large public law libraries or university libraries.

c. Primary Source Materials on the Right of Publicity

Statutes. Each state that recognizes the right of publicity has its own right of publicity statute. A list of these state right of publicity laws can be found in the treatise *The Rights of Publicity and Privacy* mentioned above. Virtually all state laws are available on the Internet. The website findlaw.com contains a comprehensive list of these state law websites. You can find state privacy laws by conducting a key word search on the website containing the state statutes for the state you're interested in. You can also find state laws published in book form in law libraries and many public libraries. Look under "right of publicity" or "publicity" in the index accompanying the statutes of the state in question.

Cases. The best place to find case citations dealing with the right of publicity is in the treatise *The Rights of Publicity and Privacy* mentioned above. You can also find them in law review articles dealing with the right of publicity.

4. Trade Secrets

Information that is not protected by copyright or any of the other laws discussed in this book could be protected as a trade secret.

a. Internet Resources

If you have access to the Internet, you can find valuable information about trade secrets by visiting the Trade Secret Home Page (www.rmarkhalligan2.com/tshp). This site provides discussions of recent developments and general background information on trade secrets.

b. Background Resources

Useful legal treatises on trade secret law include:

- *Milgrim on Trade Secrets*, a comprehensive treatment of trade secret law published by Matthew Bender as Volume 12 of its Business Organizations series. This is probably the most complete resource regarding trade secret issues, especially if you have a specific or detailed question.
- *Trade Secret Law Handbook*, by Melvin F. Jager (Clark Boardman Callaghan), contains small discussions of most trade secret related concepts as well as references to cases and statutes where appropriate.
- *Trade Secrets*, by James Pooley (Unacom), is an excellent book written for nonlawyers. You will find this book more understandable than the treatises cited above.

For law review articles on trade secrets, look under "Trade Secret" in the *Index to Legal Periodicals* or *Current Law Index*. A key to the abbreviations used in these indexes is located at the front of each

index volume. Substantial collections of law reviews are usually located in large public law libraries or university libraries.

c. Primary Source Materials on Trade Secrets

Statutes. There is no national trade secret law; instead, it consists of individual laws for each state. For direct access to state statutes governing trade secrets, look under "Trade Secret," "Proprietary Information," or "Commercial Secret" in the index accompanying the statutes of the state in question. You can find state statutes in law libraries, many public libraries, and on the Internet. Refer to the findlaw.com website for a collection of links to state laws on the Internet.

Most states have based their trade secret laws on something called the Uniform Trade Secrets Act. This is a model law drafted by legal scholars. A model law is one that is intended to serve as an example when Congress and the state legislatures draft real laws. Reviewing the Uniform Trade Secrets Act will help give you an idea what state trade secret laws are like. You can find the Uniform Trade Secrets Act on the Internet at: www.law.upenn.edu/bll/ulc/fnact99/ 1980s/utsa85.htm.

Cases. You can find citations to legal cases dealing with trade secrets in the background resources listed above. In addition, summaries of cases involving trade secret principles can be found in the West Publishing Company state or regional digests under "Trade Regulation," "Contracts," "Agency," and "Master and Servant." These volumes are available in law libraries. You can also find cases dealing with trade secrets at the FindLaw website at www. findlaw .com.

5. Design Patents

Design patents can be used to protect the ornamental or decorative features of manufactured items such as a chandelier or Rolls Royce hood ornament. The first place to go for more information on patents is *Patent It Yourself*, by David Pressman (Nolo).

a. Internet Resources

- www.uspto.gov. This is the website of the U.S. Patent and Trademark Office, the federal agency that issues patents. This is the place to go for recent policy and statutory changes and transcripts of hearings on various patent law issues.
- www.bitlaw.com/patent/design.html. This website contains a helpful short introduction to design patents.
- www.carolinapatents.com/pat_articles/ pat_article10.htm. This is another good introduction to design patent law.

b. Background Resources

Legal treatises on patents include:

- *Patent Law Fundamentals*, by Peter Rosenberg (Clark Boardman Callaghan), is the best legal treatise for patent law. This publication is generally considered by patent attorneys to be the bible of patent law. Because it is written for attorneys, it might be somewhat difficult sledding for the nonlawyer.
- *Patent Law Handbook*, by C. Bruce Hamburg (Clark Boardman Callaghan), is another useful book. A new edition of this book is issued every year.
- *Patent Law Essentials: A Concise Guide*, by Alan L. Durham (Quorum), is a good short introduction to patent law.

c. Primary Source Material on Design Patents

Statutes. All of the provisions of the patent law dealing with design patents can be found at the U.S. Patent and Trademark Office website at www.uspto.gov/web/ offices/pac/design/laws.html. If you don't have Internet access, the U.S. patent law is located in Title 35, United States Code, Section 101 and following. This can be found in the United States Code Annotated (U.S.C.A.) or United States Code Service, Lawyers Edition (U.S.C.S.) These volumes can be found in any law library and many public libraries.

Cases. You'll find citations to relevant court decisions in *Patent Law Fundamentals* or a law review article. In addition, the U.S. Code Annotated and U.S. Code Service both refer to and briefly summarize all the decisions relevant to each section of the patent law. You can also find short summaries of patent law decisions in West Publishing Company's *Federal Practice Digest* under the term "patent."

C. Working With an Attorney

There are two main situations where you may wish to seek an attorney's advice. First, if you are unable to determine whether a work is in the public domain, an attorney may be able to make the determination for you. Second, you will need an attorney's help if someone threatens to sue (or actually does sue) you for using a work they claim is not in the public domain.

Attorneys have various specialties. You need to make sure you select a lawyer qualified to provide the advice you need. The public domain is governed primarily by copyright law, so you should find a lawyer who is very familiar with copyright law. Copyright is part of a larger specialty known as intellectual property law, which also includes trade secrets, patents, and trademarks. Many lawyers who advertise as intellectual property lawyers can competently handle all of these types of cases. But some are primarily patent attorneys who don't keep up with copyright

law. Do your best to find someone who specializes primarily in copyrights.

In addition to all these specialties, some intellectual property lawyers focus on litigation, meaning they specialize in cases that end up in court. Not all intellectual property attorneys are litigators. If someone has threatened to sue you, you will need an intellectual property attorney who specializes in litigation. Litigators usually bill on an hourly basis, though sometimes they may take a case on contingency. Under this arrangement, if you win, the attorney receives a percentage—usually one-third to one-half—of any money recovered in the lawsuit. If you lose, the attorney receives nothing.

1. Finding an Attorney

The best way to locate an attorney is by referrals through friends or others in your field. It is also possible to locate an attorney through a state bar association or through a local county or city bar association. Check your local Yellow Pages and ask the bar association if they have a lawyer referral service. The American Intellectual Property Law Association (AIPLA) may be able to assist you in locating attorneys in your area. Contact it at 2001 Jefferson Davis Highway, Suite 203, Arlington VA 22202, 703-415-0780. The Intellectual Property Law Association of the American Bar Association also has a listing of intellectual property attorneys. You can reach it at 312-988-5000.

When interviewing an attorney, ask questions about clientele, work performed, rates, and experience. If you speak with one of the attorney's clients, ask questions about the attorney's response time, billing practices, and temperament.

2. How to Keep Your Fees Down

Most attorneys bill on an hourly basis ($150 to $300 an hour) and send a bill at the end of each month. Here are some tips to reduce the size of your bills:

a. Keep It Short

If your attorney is being paid on an hourly basis, keep your conversations short (the meter is always running) and avoid making several calls a day. Consolidate your questions so that you can ask them all in one conversation.

b. Get a Fee Agreement

Get a written fee agreement when dealing with an attorney (such a written agreement is required in some states). Read it and understand your rights as a client. Make sure that your fee agreement includes provisions that require an itemized statement along with the bill detailing the work done and time spent, and that allow you to drop the attorney at any time. Ask your attorney to estimate fees for work and ask for an explanation if the bill exceeds the estimates.

c. Review Billings Carefully

Your legal bill should be prompt and clear. Do not accept summary billings such as the single phrase "litigation work" used to explain a block of time for which you are billed a great deal of money. Every item should be explained with the rate and hours billed. Late billings are not acceptable, especially in litigation where the bills may be substantial. When you get bills you don't understand, ask the attorney for an explanation—and ask the attorney not to bill you for the explanation.

d. Be Careful If You Engage a Law Firm

If you sign a fee agreement with a law firm (rather than a single attorney), be careful to avoid a particular billing problem sometimes referred to as multiple or "bounced" billings. This occurs when several attorneys perform the same work. For example, two attorneys at the firm have a 15-minute discussion about your case. Both attorneys bill you. To avoid this, make sure that your fee agreement does not bind you to this type of arrangement. If you are billed for these conferences, send a letter to your attorney at the firm explaining that you only want that attorney to work on your case and that you should be contacted before work is assigned to another attorney at the firm.

e. Watch Out for Hidden Expenses

Your written fee agreement should specify all the expenses you must pay, such as court filing fees, computerized legal research charges, deposition transcript fees, consultant fees, messenger fees, mileage and other travel expenses, and expert witness fees. Today, in addition to billing for fees such as these, many law firms attempt to bill their clients for their overhead charges such as secretarial time and word processing. These are often called "administrative expenses." Try to avoid agreeing to such overhead charges.

It's a nearly universal practice to charge clients for photocopying and faxes. You may not be able to avoid paying such charges, but at least insist that they be reasonable. Many law firms charge far more for photocopying and faxes than the actual cost. For example, in a large law firm with high-speed photocopiers, photocopies typically cost less than 10 cents a page. Yet many large firms bill clients 20-30 cents per page. Insist that you be billed no more than the actual cost for photocopying. Likewise, insist that you be charged the actual phone charge for sending a fax instead of a hefty per-page fee.

What Is a Retainer?

A retainer is an advance payment to an attorney. The attorney places the retainer in a bank account (in some states, this must be an interest-bearing account) and the attorney deducts money from the retainer at the end of each month to pay your bill. When the retainer is depleted, the attorney may ask for a new retainer. If the retainer is not used up at the end of the services, the attorney must return what's left. The amount of the retainer usually depends on the project. Retainers for litigation, for instance, are often between $2,000 to $5,000.

f. Don't Take Litigation Lightly

As a general rule, beware of litigation. If you are involved in a lawsuit, it may take months or years to resolve. Moreover, litigation is extremely expensive. A 1985 survey found that the average cost of trying a copyright infringement suit in New York City ranged from $58,000 to $107,000. Copyright litigation costs even more today.

If you're in a dispute, ask your attorney about dispute resolution methods such as arbitration and mediation. Often these procedures can save money and they're faster than litigation. If those methods don't work or aren't available, ask your attorney for an assessment of your odds and the potential costs before filing a lawsuit. The assessment and underlying reasoning should be in plain English. If a lawyer can't explain your situation clearly to you, he probably won't be able to explain it clearly to a judge or jury.

However, if you do go to court and ultimately win your case, you may be able to collect some or all of your attorney fees from the plaintiff. Under a special provision of the copyright law, if someone is sued for copyright infringement and wins, the judge can order the losing plaintiff to pay all or part of the defendant's attorney fees. In the past, many courts would award such fees to a defendant only if they found that the plaintiff's suit was frivolous or brought in bad faith. But these courts would not require this in making fees awards to plaintiffs. In 1994 the Supreme Court held that this approach was incorrect and that fees must be awarded to plaintiffs and defendants in an evenhanded manner. In other words, the same criteria must be applied to both plaintiffs and defendants. *Fogerty v. Fantasy, Inc.*, 114 S.Ct. 1023 (1994).

The criteria courts use to decide whether to award attorney fees to the winning side include whether the losing party's suit was frivolous or brought in bad faith; or whether the losing party otherwise acted unreasonably. Many courts will be especially likely to award fees to a prevailing party whose actions helped to advance the copyright law or defend or establish important legal principles. ■

Appendix A

Popular Songs in the Public Domain

This chart lists over 450 of the most popular songs in the U.S. public domain because their copyright protection has expired. All were published before 1923. Note carefully, however, that although the original versions of these songs are in the public domain, arrangements of them published after 1922 could still be under copyright. (See Chapter 4 for a detailed discussion of copyright protection for arrangements of public domain songs.)

Song Title	Composer(s)	Publication Date
Aba Daba Honeymoon	Arthur Fields, Walter Donovan	1914
Abide With Me	Henry Francis Lyle	1861
After the Ball	Charles K. Harris	1892
After You've Gone	Henry Creamer, Turner Layton	1918
Ah! Sweet Mystery of Life	Victor Herbert, Rida Johnson Young	1910
Ain't We Got Fun	Gus Kahn, Raymond Egan, Richard Whiting	1921
Alexander's Ragtime Band	Irving Berlin	1911
All by Myself	Irving Berlin	1921
All Through the Night	Unknown	1784
Alouette	Unknown	1879
America the Beautiful	Katherine Lee Bates, Samuel A. Ward	1895
American Patrol	F.W. Meacham	1891
Anchors Aweigh	Alfred Hart Miles, R. Levell	1906
Annie Laurie	William Douglas, Lady John Scott	1830
Any Old Place With You	Lorenz Hart, Richard Rodgers	1919
April Showers	B.G. De Sylva, Louis Silvers	1921
Arkansas Traveler, The	Unknown	1851
Asleep in the Deep	Arthur Lamb, Henry Petrie	1897
At the Devil's Ball	Irving Berlin	1912
Auf Wiedersehen	Herbert Reynolds, Sigmund Romberg	1915
Auld Lang Syne	Robert Burns	1799
Aura Lee	W.W. Fosdick, George R. Poulton	1861
Baby, Won't You Please Come Home	Charles Warfield, Clarence Williams	1922
Ballin' the Jack	James Henry Burris, Chris Smith	1913
Baltimore Buzz	Noble Sissle, Eubie Blake	1921
Band Played On, The	John Palmer, Charles Ward	1895
Battle Hymn of the Republic	Julia Ward Howe, William Steffe	1862
Beautiful Dreamer	Stephen Foster	1864
Because You're You	Henry Blossom, Victor Herbert	1906
Bells of St. Mary's	Douglas Fuber, Emmett Adams	1917
Bill Bailey, Won't You Please Come Home?	Hughie Cannon	1902
Billboard March	John N. Klohr	1901
Bird in a Gilded Cage	Arthur Lamb, Harry Von Tilzer	1900
Blow the Man Down	Unknown	1830
Broken Hearted Melody	Gus Kahn, Isham Jones	1922
Buffalo Gals	Cool White	1844
Bulldog, Bulldog	Cole Porter	1911
By Heck	L. Wolfe Gilbert, S.R. Henry	1914

Song Title	Composer(s)	Publication Date
By the Beautiful Sea	Harold Atteridge, Harry Carroll	1914
By the Light of the Silvery Moon	Edward Madden, Gus Edwards	1909
By the Waters of Minnetonka	J.M. Cavanass, Thurlow Lieurance	1914
Call Me Up Some Rainy Afternoon	Irving Berlin	1910
Canadian Capers	Gus Chandler	1915
Can't You Hear Me Calling Caroline	William Gardner	1914
Careless Love	W.C. Handy, Spencer Williams	1921
Carolina in the Morning	Gus Kahn, Walter Donaldson	1922
Carry Me Back to Old Virginny	James Bland	1878
Casey Jones	T. Lawrence Seibert, Eddie Newton	1909
Charmaine	Lew Pollock, Erno Rapee	1913
Cherie	Leo Wood, Irving Bibo	1921
Chicago (That Toddling Town)	Fred Fisher	1922
Chinatown, My Chinatown	William Jerome, Jean Schwartz	1906
Clementine (Oh My Darling)	Percy Montrose	1884
Colonel Bogey March	Kenneth J. Alford	1916
Columbia, The Gem of the Ocean	David T. Shaw, T.A. Beckett	1843
Come Back to Sorrento	Ernesto de Curtis, Claude Aveling	1904
Comin' Thro' the Rye	Robert Burns	1796
Crinoline Days	Irving Berlin	1922
Crooning	Al Dubin, William F. Caesar	1921
Cucaracha, La	Unknown	1916
Cuddle Up a Little Closer, Lovey Mine	Otto Harbach, Karl Hoschna	1908
Daddy, You've Been a Mother to Me	Fred Fisher	1920
Daisy Bell	Harry Dacre	1892
Dance-O-Mania	L. Wolfe Gilbert, Joe Cooper	1920
Dancing Fool	Harry B. Smith, Francis Wheeler, Ted Snyder	1922
Danny Boy	Fred Weatherly	1913
Daring Young Man on the Flying Trapeze	George Laybourne, Alfred Lee	1868
Darktown Strutters Ball	Shelton Brooks	1917
Daughter of Rose O'Grady	Monty C. Brice, Walter Donaldson	1918
De Camptown Races	Stephen Foster	1850
Dear Little Boy of Mine	Keirn Brennan, Ernest Ball	1918
Dear Love, My Love	Brian Hooker, Rudolf Friml	1920
Dear Old Girl	Richard Henry Buck, Theodore Morse	1903
Dear Old Southland	Henry Creamer, Turner Layton	1921
Deck the Halls With Boughs of Holly	Unknown	1784
Deep River	Unknown	1917

Song Title	Composer(s)	Publication Date
Dixie	Daniel Decatur Emmett	1860
Do It Again	Irving Berlin	1912
Do It Again	B.G. De Sylva, George Gershwin	1922
Do You Ever Think of Me	Harry D. Kerr, John Cooper, Earl Burtnett	1920
Don't Send Your Wife to the Country	B.G. De Sylva, Con Conrad	1922
Down Among the Sheltering Palms	James Brockman, Abe Olman	1914
Down by the O-Hi-O	Jack Yellen, Abe Olman	1920
Down by the Old Mill Stream	Tell Taylor	1910
Down by the Riverside	Unknown	1865
Down in the Valley	Unknown	1917
Down South	B.G. De Sylva, Walter Donaldson	1921
Down the Field	Caleb O'Connor, Stanleigh Friedman	1911
Down Yonder	L. Wolfe Gilbert	1921
Drifting Along With the Tide	Arthur Jackson, George Gershwin	1921
Drink to Me Only With Thine Eyes	Ben Jonson	1780
Dry Bones	James Weldon Johnson, J. Rosamund Johnson	1865
Dying With the Blues	W. Astor Morgan, Fletcher Henderson	1921
East Side West Side (The Sidewalks of New York)	Charles B. Lawlor, James W. Blake	1894
Eileen	Henry Blossom, Victor Herbert	1917
Every Day Is Ladies Day With Me	Henry Blossom, Victor Herbert	1906
Every Little Movement (Has a Meaning All Its Own)	Otto Harbach, Karl Hoschna	1910
Every Time I Feel the Spirit	Unknown	1865
Everybody's Doing It	Irving Berlin	1911
Everything Is Peaches Down in Georgia	Grant Clarke, Milton Ager, George W. Meyer	1918
Eyes of Texas, The	John L. Sinclair	1903
First Noel, The	Unknown	1833
Flow Gently, Sweet Afton	Robert Burns, James E. Spilman	1838
For Me and My Gal	Edgar Leslie, Ray Goetz, George W. Meyer	1917
Forty Five Minutes From Broadway	George M. Cohan	1905
Frankie and Johnny	Unknown	1870
Frere Jacques	Unknown	1811
From the Land of the Sky Blue Water	Nelle Richmond Eberhart, Charles Wakefield Cadman	1909
Funiculi-Funicula	Luigi Denza	1880
Gee! But I Hate to Go Home Alone	Joe Goodwin, James F. Hanley	1922
Georgette	Lew Brown, Ray Henderson	1922

Song Title	Composer(s)	Publication Date
Georgia Blues	Billy Higgins, W. Benton Overstreet	1922
Giannina Mia	Otto Harbach, Rudolf Friml	1912
Girl on the Magazine Cover	Irving Berlin	1915
Girls of My Dreams	Irving Berlin	1920
Girls, Girls, Girls	Adrian Ross, Franz Lehar	1907
Give Me My Mammy	B.G. De Sylva, Walter Donaldson	1921
Give My Regards to Broadway	George M. Cohan	1904
Go Down Moses	Unknown	1860
Go Tell It on the Mountain	Unknown	1865
God Rest Ye Merry Gentlemen	Unknown	1827
Goin' Home	William Arms Fisher	1922
Golden Slippers	James Bland	1879
Goober Peas	Johnny Reb	1864
Good King Wenceslas	Unknown	1853
Good Morning Dearie	Anne Caldwell, Jerome Kern	1921
Good Night Ladies	Unknown	1853
Goodbye Dolly Gray	Will D. Cobb, Paul Barnes	1900
Grandfather's Clock	Henry Clay Work	1876
Gypsy Blues	Noble Sissle, Eubie Blake	1921
Gypsy Love Song	Harry B. Smith, Victor Herbert	1898
Hail, Hail, the Gang's All Here	D.A. Estrom, Theodore Morse	1917
Hail to the Chief	Unknown	1812
Hand Me Down My Walking Cane	Unknown	1865
Hark, The Herald Angels Sing	Charles Wesley, Felix Mendelssohn	1855
Harrigan	George M. Cohan	1907
He's a Devil in His Own Home Town	Grant Clark, Irving Berlin	1914
He's a Rag Picker	Irving Berlin	1914
Hearts and Flowers	Mary D. Brine, Theodore Moses Tobani	1899
Heaven Will Protect the Working Girl	Edgar Smith, A. Baldwin Sloane	1909
Hello Frisco Hello	Gene Buck, Louis A. Hirsch	1915
High Society	Walter Melrose, Porter Steele	1901
Hindustan	Oliver Wallace	1918
Hinky Dinky Parlay Voo	Unknown	1918
Hold Me	Art Hickman, Ben Black	1920
Home on the Range	Unknown	1873
Hot Lips	Henry Busse, Henry Lange, Lou Davis	1922
Hot Time in the Old Town Tonight	Joseph Hayden, Theodore M. Metz	1896

Song Title	Composer(s)	Publication Date
How Dry I Am	Phillip Dodridge, Edward F. Rimbault	1921
How Ya Gonna Keep 'Em Down on the Farm	Sam Lewis, Joe Young, Walter Donaldson	1919
How'd You Like to Spoon With Me	Edward Laska, Jerome Kern	1906
I Ain't Got Nobody	Roger Graham, Spencer Williams, Dave Peyton	1916
I Didn't Raise My Boy to Be a Soldier	Alfred Bryan, Al Piantadosi	1915
I Don't Care	Jean Lenox, Harry O. Sutton	1905
I Dreamt I Dwelt in Marble Halls	Alfred Bunn, Michael William Balfe	1843
I Found a Four Leaf Clover	B.G. De Sylva, George Gershwin	1922
I Found You and You Found Me	P.G. Wodehouse, Jerome Kern	1918
I Got Shoes	Unknown	1865
I Love a Piano	Irving Berlin	1915
I Love Her, She Loves Me	Irving Caesar, Eddie Cantor	1922
I Love You Truly	Carrie Jacobs-Bond	1912
I Never Knew I Could Love Anybody Like I'm Loving You	Tom Pitts, Raymond Egan, Roy Marsh	1920
I Used to Love You But It's All Over Now	Lew Brown, Albert Von Tilzer	1920
I Wish I Could Shimmy Like My Sister Kate	Armand Piron	1919
I Wonder If You Still Care for Me	Harry B. Smith, Francis Wheeler, Ted Snyder	1921
I Wonder Who's Kissing Her Now	Will M. Hough, Frank R. Adams, Joe Howard, Harold Orlb	1909
I'd Love to Live in Loveland	Will Rossiter	1912
I'd Build a Stairway to Paradise	B.G. De Sylva, Ira Gershwin, George Gershwin	1922
I'll Forget You	Annalu Burns, Ernest Ball	1921
I'll Take You Home Again Kathleen	Thomas Westendorf	1876
I'm a Vamp From East Broadway	Burt Kalmar, Harry Ruby, Irving Berlin	1921
I'm an Indian	Blanche Merrill, Leo Edwards	1922
I'm Craving for That Kind of Love	Noble Sissle, Eubie Blake	1921
I'm Falling in Love with Someone	Rida Johnson Young, Victor Herbert	1910
I'm Forever Blowing Bubbles	Jean Kenbrovin, John Kellette	1919
I'm Goin' South	Abner Silver, Harry MacGregor Woods	1921
I'm Just Wild About Harry	Noble Sissle, Eubie Blake	1921
I'm Nobody's Baby	Benny Davis, Milton Ager, Lester Santly	1921
I've Been Working On the Railroad	Unknown	1894
I've Got My Captain Working for Me Now	Irving Berlin	1920
I've Got Rings on My Fingers (Bells on My Toes)	R.P. Weston, Maurice Scott	1909
Ida, Sweet As Apple Cider	Eddie Leonard, Eddie Munson	1903

Song Title	Composer(s)	Publication Date
In a Chinese Temple Garden	Albert Ketelby	1920
In My Harem	Irving Berlin	1913
In the Evening by the Moonlight	James Bland	1878
In the Garden	C. Austin Miles	1912
In the Good Old Summertime	Ren Shields, George Evans	1902
In the Land of Beginning Again	Grant Clarke, George M. Meyer	1918
In the Shade of the Old Apple Tree	Harry H. Williams, Egbert Van Alstyne	1905
In the Sweet Bye and Bye	Vincent P. Bryan, Harry Von Tilzer	1902
Indiana (Back Home In)	Ballard MacDonald, James F. Hanley	1917
Irene	Joseph McCarthy, Harry A. Tierney	1919
It Came Upon a Midnight Clear	Edmund Hamilton Sears, Richard Storrs Willis	1850
It's a Long Way to Tipperary	Jack Judge, Harry H. Williams	1912
It's Always Fair Weather When Good Fellows Get Together	Richard Hovey, Frederic Field Bullard	1898
It's Delightful to Be Married	Anna Held, Vincent Scotto	1907
It's Nice to Get Up in the Morning	Sir Harry Lauder	1913
Italian Street Song	Rida Johnson Young, Victor Herbert	1910
Ja-Da	Bob Carleton	1918
Japanese Sandman, The	Raymond Egan, Richard Whiting	1920
Jazz Me Blues, The	Tom Delaney	1921
Jeanie With the Light Brown Hair	Stephen Foster	1854
Jimmy Crack Corn	Daniel Decatur Emmett	1846
Jimmy Valentine	Edward Madden, Gus Edwards	1911
Jingle Bells	J.S. Pierpont	1857
John Henry	Unknown	1873
John Peel	John Woodcock Graves	1820
Joshua Fit the Battle of Jericho	Unknown	1865
Joy to the World	George Frederic Handel	1839
Juanita	Unknown	1850
Just a Baby's Prayer at Twilight	Sam Lewis, Joe Young, M.K. Jerome	1918
Just a Wearyin' for You	Frank L. Stanton, Carrie Jacobs-Bond	1910
K-K-K-Katy	Geoffrey O'Hara	1918
Kind Lovin' Blues	Ethel Waters, Fletcher Henderson	1922
Kiss in the Dark	B.G. De Sylva, Victor Herbert	1922
Kiss Me Again	Henry Blossom, Victor Herbert	1916
Kitty From Kansas City	Harry Rose, Jesse Greer, Rudy Vallee, George Bronson	1921
L'Amour, Toujours, L'Amour (Love Everlasting)	Catherine Chisholm, Rudolf Friml	1922

Song Title	Composer(s)	Publication Date
Lady of the Evening	Irving Berlin	1922
Leave It to Jane	P.G. Wodehouse, Jerome Kern	1917
Left All Alone Again Blues	Anne Caldwell, Jerome Kern	1920
Let Me Call You Sweetheart	Beth Slater Whitson, Leo Friedman	1910
Let the Rest of the World Go By	J. Keirn Brennan, Ernest Ball	1919
Listen to the Mockingbird	Septimus Winner, Richard Milburn	1855
Little Annie Roonie	Michael Nolan	1890
Little Bit of Heaven, Sure They Call It Ireland	J. Keirn Brennan, Ernest Ball	1914
Little David, Play on Your Harp	Unknown	1921
Loch Lomond	Unknown	1881
London Bridge Is Falling Down	Unknown	1744
Long, Long Ago	Thomas Bayly	1833
Look for the Silver Lining	B.G. De Sylva, Jerome Kern	1920
Lorelei	Anne Caldwell, Jerome Kern	1920
Lost Chord	Adelaide Proctor, Sir Arthur Sullivan	1877
Love Here Is My Heart	Adrian Ross, Lao Silesu	1915
Love Nest	Otto Harbach, Louis A. Hirsch	1920
Love Sends A Little Gift of Roses	Leslie Cooke, John Openshaw	1919
Loveless Love	W.C. Handy	1921
Lovin' Sam, The Sheik of Alabam'	Sophie Tucker	1922
M-I-S-S-I-S-S-I-P-P-I	Bert Hanlon, Ben Ryan, Harry A. Tierney	1916
M-O-T-H-E-R	Howard Johnson, Theodore Morse	1915
Ma! He's Making Eyes at Me	Sidney Clare, Con Conrad	1921
Macnamara's Band	John J. Stamford, Shamus O'Connor	1917
Macushla	Josephine V. Rowe, Dermot MacMurrough	1910
Mandy	Irving Berlin	1919
Marcheta	Victor Schertzinger	1913
Marching Through Georgia	Henry Clay Work	1865
Margie	Benny Davis, Con Conrad	1920
Marie From Sunny Italy	Irving Berlin	1909
Mary's a Grand Old Name	George M. Cohan	1905
Maryland, My Maryland	James Ryer Randall	1861
Massa's in De Cold Cold Ground	Stephen Foster	1852
Meet Me in St. Louis, Louis	Andrew B. Sterling, Kerry Mills	1904
Meet Me Tonight in Dreamland	Beth Slater Whitson, Leo Friedman	1909
Memories	Gus Kahn, Egbert Van Alstyne	1915
Memphis Blues	George A. Norton, W.C. Handy	1912

Song Title	Composer(s)	Publication Date
Mexican Hat Dance	Unknown	1919
Mighty Lak' a Rose	Frank L. Stanton, Ethelbert Nevin	1901
Mischa, Jascha, Toscha, Sacha	Ira Gershwin, George Gershwin	1921
Missouri Waltz	James R. Shannon, Frederick Knight Logan	1914
Mister Gallagher and Mister Shean	Ed Gallagher, Al Shean	1922
Molly Malone	Unknown	1750
Moonbeams	Henry Blossom, Victor Herbert	1906
Moonlight Bay, On	Edward Madden, Percy Wenrich	1912
Mother Machree	Rida Johnson Young, Theodore Morse	1910
My Bonnie Lies Over the Ocean	Unknown	1881
My Buddy	Gus Kahn, Walter Donaldson	1922
My Gal Sal	Paul Dresser	1905
My Honey's Lovin' Arms	Herman Ruby, Joseph Meyer	1922
My Mammy	Sam Lewis, Joe Young, Walter Donaldson	1918
My Man	Channing Pollock, Maurice Yvain	1920
My Melancholy Baby	George A. Norton, Ernie Burnett	1912
My Sunny Tennessee	Bert Kalmar, Harry Ruby	1921
My Wild Irish Rose	Chauncey Olcott	1899
Neapolitan Love Song	Henry Blossom, Victor Herbert	1915
Nearer, My God, to Thee	Sarah Adams	1859
Nellie Kelly, I Love You	George M. Cohan	1922
Nobody	Alex Rogers, Bert Williams	1905
Nobody But You	B.G. De Sylva, George Gershwin	1919
Nobody Knows and Nobody Seems to Care	Irving Berlin	1919
Nobody Knows de Trouble I've Seen	Unknown	1865
Nola	Felix Arndt	1916
O Come All Ye Faithful	Frederick Oakeley, John Francis Wade	1782
O Little Town of Bethlehem	Phillips Brooks, Lewis H. Redner	1868
O Sole Mio	Giovanni Capurro, Eduardo di Capua	1899
O, Katharina	Wolfe Gilbert, Richard Fall	1922
Oh Bury Me Not on the Lone Prairie	E.H. Chapin, George N. Allen	1849
Oh by Jingo, Oh by Gee, You're the Only Girl for Me	Lew Brown, Albert Von Tilzer	1919
Oh Johnny, Oh Johnny Oh!	Ed Rose, Abe Olman	1917
Oh Me! Oh My!	Arthur Francis, Vincent Youmans	1921
Oh Promise Me	Clement Scott, Reginald de Koven	1890
Oh You Beautiful Doll	Seymour Brown, Nat D. Ayer	1911
Oh! Susanna	Stephen Foster	1848

Song Title	Composer(s)	Publication Date
Oh! What a Pal Was Mary	Edgar Leslie, Pete Wendling	1919
Oh, How I Hate to Get Up in the Morning	Irving Berlin	1918
Oh, That Beautiful Rag	Irving Berlin, Ted Snyder	1910
Old Black Joe	Stephen Foster	1860
Old Dog Tray	Stephen Foster	1853
Old Fashioned Garden	Cole Porter	1919
Old Folks at Home (Way Down Upon the Swanee River)	Stephen Foster	1851
Old Macdonald Had a Farm	Unknown	1917
Old Oaken Bucket, The	Samuel Woodworth, George Kiallmark	1843
On the Alamo	Gus Kahn, Joe Lyons, Isham Jones	1922
On the Beach at Waikiki	G.H. Stover, Henry Kailimaie	1915
On the Road to Mandalay	Rudyard Kipling, Oley Speaks	1907
On With the Dance	Clifford Grey, Jerome Kern	1920
Onward Christian Soldiers	Sabine Baring, Sir Arthur Sullivan	1871
Over There	George M. Cohan	1917
Pack Up Your Sins and Go to the Devil	Irving Berlin	1922
Pack Up Your Troubles in Your Old Kit Bag and Smile, Smile, Smile	George Asaf, Felix Powell	1915
Peg O' My Heart	Walter Becker, Donald Fagen	1913
Peggy O'Neil	Harry Pease, Ed Nelson, Gilbert Dodge	1921
Perfect Day, A	Carrie Jacobs-Bond	1910
Play a Simple Melody	Irving Berlin	1914
Polly Wolly Doodle	Unknown	1883
Pop Goes the Weasel	Charles Twiggs	1853
Put Your Arms Around Me Honey	Junie McCree, Albert Von Tilzer	1910
Ragtime Cowboy Joe	Lewis F. Muir, Grant Clarke, Maurice Abrahams	1912
Ragtime Violin	Irving Berlin	1911
Red River Valley	Unknown	1896
Roamin' in the Gloamin'	Sir Harry Lauder	1911
Rock of Ages	Unknown	1832
Rock-A-Bye Your Baby With a Dixie Melody	Sam Lewis, Joe Young, Jean Schwartz	1918
Roll Jordan Roll	Unknown	1865
Rose of the Rio Grande	Edgar Leslie, Harry Warren	1922
Rose of the Tralee, The	Charles Glover, C. Mordaunt Spencer	1912
Rose of Washington Square	Ballard MacDonald, James F. Hanley	1920
Rose Room	Harry H. Williams	1917

Song Title	Composer(s)	Publication Date
Roses of Picardy	Fred Weatherly, Haydn Wood	1916
Runnin' Wild	Joe Grey, Leo Wood, A. Harrington Gibbs	1922
Sailing Over the Bounding Main	Godfrey Marks	1880
Sally	Clifford Grey, Jerome Kern	1920
San	Lindsay MacPhail, Walter Michels	1920
Say It With Music	Irving Berlin	1921
Scandal Walk	Arthur Jackson, George Gershwin	1920
School Days	Will D. Cobb, Gus Edwards	1907
Second Hand Rose	Grant Clarke, James P. Hanley	1921
Sheik of Araby, The	Harry B. Smith, Francis Wheeler, Ted Snyder	1921
She'll Be Coming Round the Mountain	Unknown	1899
Shenandoah (Across the Wide Missouri)	Unknown	1826
Shine on Harvest Moon	Jack Norworth, Nora Bayes	1908
Shuffle Along	Noble Sissle, Eubie Blake	1921
Singin' the Blues (Till My Daddy Come Home)	Sam Lewis, Joe Young, Con Conrad	1920
Skip to My Lou	Unknown	1844
Smiles	J. Will Callahan, Lee G. Roberts	1917
So Long! Oh-Long (How Long You Gonna Be Gone?)	Bert Kalmar, Harry Ruby	1920
Some of These Days	Shelton Brooks	1910
Some Sunny Day	Irving Berlin	1922
Somebody Else—Not Me	Ballard Macdonald, James F. Hanley	1920
Somebody Stole My Gal	Leo Wood	1918
Sometimes I Feel Like a Motherless Child	Unknown	1918
Somewhere a Voice Is Calling	Eileen Newton, Arthur F. Tate	1911
Song of Love	Dorothy Donnelly, Sigmund Romberg	1921
Song of the Islands	Charles E. King	1915
Songs of Long Ago, The	Arthur Jackson, George Gershwin	1920
Spaniard that Blighted My Wife, The	Billy Erson	1911
St. Louis Blues	W.C. Handy	1914
Star Spangled Banner, The	Francis Scott Key, John Stafford Smith	1814
Steamboat Bill	Ron Shields, Leighton Brothers	1910
Stein Song	Lincoln Colcord, E.A. Fenstad	1910
Stumbling	Zez Confrey	1922
Sunbonnet Sue	Will D. Cobb, Gus Edwards	1906
Swanee	Irving Caesar, George Gershwin	1919
Sweet Adeline	Richard H. Gerard, Henry W. Armstrong	1903

Song Title	Composer(s)	Publication Date
Sweet and Low	Alfred Lord Tennyson, Joseph Barnby	1863
Sweet Genevieve	George Cooper	1869
Sweet Rosie O'Grady	Maude Nugent	1896
Sweetheart of Sigma Chi, The	Bryan Stokes, F. Dudleigh Vernor	1912
Sweethearts	Robert B. Smith, Victor Herbert	1913
Swing Low Sweet Chariot	Unknown	1917
Sylvia	Clinton Scollard, Oley Speaks	1914
Ta-Ra-Ra-Boom-Der-E	Henry J. Sayers	1891
Take Me Out to the Ball Game	Jack Norworth, Albert Von Tilzer	1908
Tammany	Vincent P. Bryan, Gus Edwards	1905
Tell Me Pretty Maiden (Are There Any More at Home Like You)	Owen Hall, Leslie Stuart	1900
Tell Me, Little Gypsy	Irving Berlin	1920
That International Rag	Irving Berlin	1913
That's a Plenty	Henry Creamer, Bert A. Williams	1909
There'll Be Some Changes Made	Billy Higgins, W. Benton Overstreet	1921
There's a Tavern in the Town	Unknown	1883
They Call It Dancing	Irving Berlin	1921
They Didn't Believe Me	Herbert Reynolds, Jerome Kern	1914
Three O'Clock in the Morning	Dorothy Terriss, Julian Robledo	1921
Throw Me a Kiss	Louis A. Hirsch, Gene Buck, Dave Stamper	1922
Till the Clouds Roll By	Guy Bolton, P.G. Wodehouse, Jerome Kern	1917
Till We Meet Again	Raymond Egan, Richard Whiting	1918
Timbuctoo	Bert Kalmar, Harry Ruby	1920
Tit-Willow	William S. Gilbert, Arthur Sullivan	1885
Too-Ra-Loo-Ra-Loo-Ral (That's an Irish Melody)	James R. Shannon	1914
Toot Toot Tootsie	Gus Kahn, Ernie Erdman, Ted Fiorito, Robert A. King	1922
Trail of the Lonesome Pine	Ballard MacDonald, Harry Carroll	1913
Tramp!Tramp!Tramp! Along the Highway	Rida Johnson Young, Victor Herbert	1913
Tramp, Tramp, Tramp (The Boys Are Marching)	George F. Root	1863
Tuck Me to Sleep in My Old 'Tucky Home	Sam Lewis, Joe Young	1921
Turkey in the Straw	Unknown	1834
Twelfth Street Rag	Euday L. Bowman	1914
U.S. Field Artillery Song (The Caissons Go Rolling Along)	Edmund L. Gruber	1918

Song Title	Composer(s)	Publication Date
Under the Bamboo Tree	Robert Cole, J. Rosamund Johnson	1902
Under the Yum Yum Tree	Andrew B. Sterling, Harry Von Tilzer	1910
Wabash Blues	Dave Ringle	1921
Wait 'Til the Sun Shines Nellie	Andrew B. Sterling, Harry Von Tilzer	1905
Waiting for the Robert E. Lee	L. Wolfe Gilbert, Lewis F. Muir	1912
Waiting for the Sun to Come Out	Arthur Francis, George Gershwin	1920
Waltz Me Around Again Willie	Will D. Cobb, Ben Shields	1906
Waltzing Matilda	A.B. Patterson, Marie Cowan	1903
Wang Wang Blues	Leo Wood, Gus Muller, Buster Johnson, Henry Busse	1921
Water Boy	Avery Robinson	1922
Way Down Yonder in New Orleans	Henry Creamer, Turner Layton	1922
We Three Kings of Orient	John Henry Hopkins	1857
Were You There When They Crucified My Lord?	Unknown	1865
What Do You Want to Make Those Eyes at Me For	Joseph McCarthy, Howard Johnson, Jimmy Monaco	1916
When a Maid Comes Knocking at Your Heart	Otto Harbach, Rudolf Friml	1912
When Buddha Smiles	Arthur Freed, Nacio Herb Brown	1921
When Francis Dances With Me	Ben Ryan, Sol Violinsky	1921
When Hearts Are Young	Cyrus Young, Sigmund Romberg	1922
When I Leave the World Behind	Irving Berlin	1915
When I Lost You	Irving Berlin	1912
When Irish Eyes Are Smiling	Chauncey Olcott, George Graff Jr., Ernest Ball	1912
When It's Apple Blossom Time in Normandy	Harry Gifford, Huntley Trevor, Tom Mellor	1912
When It's Night Time in Dixie Land	Irving Berlin	1914
When Johnny Comes Marching Home	Patrick Gilmore	1863
When My Baby Smiles at Me	Andrew B. Sterling, Ted Lewis, Bill Munro	1920
When Shall We Meet Again	Raymond Egan, Richard Whiting	1921
When the Black Sheep Returns to the Fold	Irving Berlin	1916
When the Midnight Choo Choo Leaves for Alabam'	Irving Berlin	1912
When the Saints Go Marching In	Katherine E. Purvis, James M. Black	1896
When You and I Were Young Maggie	George W. Johnson, James Austin Butterfield	1866
When You Wore a Tulip and I Wore a Big Red Rose	Jack Mahoney, Percy Wenrich	1914
When You're Away	Henry Blossom, Victor Herbert	1914

Song Title	Composer(s)	Publication Date
Where Did Robinson Crusoe Go With Friday on Saturday Night	Joe Young, Sam Lewis, George W. Meyer	1916
Where Did You Get That Girl	Bert Kalmar, Harry Puck	1913
Where Do They Go When They Row, Row, Row?	Bert Kalmar, George Jessel, Harry Ruby	1920
Where Do We Go From Here!	Howard Johnson, Percy Wenrich	1917
Where Is the Man of My Dreams?	B.G. De Sylva, George Gershwin	1922
Where the Black Eyed Susans Grow	Dave Radford, Richard Whiting	1917
Where the Morning Glories Grow	Gus Kahn, Raymond Egan, Richard Whiting	1917
Whiffenpoof Song	Meade Minnigerode, George S. Pomeroy	1911
While Strolling Through the Park One Day	Ed Haley, Robert A. Keiser	1884
Whip-Poor-Will	Clifford Grey, Jerome Kern	1921
Whispering	John Schonberger, Richard Coburn	1920
Whispering Hope	Alice Hawthorne	1868
Whistler and His Dog	Arthur Pryor	1905
Who Ate Napoleons With Josephine When Bonaparte Was Away	Alfred Bryan, Ray Goetz	1920
Who Cares	Jack Yellen, Milton Ager	1922
Who Threw the Overalls in Mrs. Murphy's Chowder	George L. Giefer	1899
Whose Baby Are You	Anne Caldwell, Jerome Kern	1920
Whose Little Heart Are You Breaking Now	Irving Berlin	1917
Why Don't They Dance the Polka Anymore	Harry B. Smith, Jerome Kern	1914
Why Worry?	Seymour Simons	1920
Wicked Blues	Perry Bradford	1922
Wild Rose	Clifford Grey, Jerome Kern	1920
Will She Come From the East?	Irving Berlin	1922
Will You Love Me in December As You Do in May	James J. Walker, Ernest Ball	1905
Will You Remember (Sweetheart)	Rida Johnson Young, Sigmund Romberg	1917
Woman Is Only a Woman, But a Good Cigar Is a Smoke	Harry B. Smith, Victor Herbert	1905
Wonderful One, My	Dorothy Terriss, Paul Whiteman, Ferde Grofe	1922
Woodman, Woodman Spare That Tree	Irving Berlin	1911
World Is Waiting for the Sunrise, The	Eugene Lockhart, Ernest Seitz	1919
Yaaka Hulaa Hickey Dula	Ray Goetz, Joe Young, Pete Wending	1916
Yankee Doodle	Unknown	1775
Yankee Doodle Blues	Irving Caesar, B.G. De Sylva, George Gershwin	1922

Song Title	Composer(s)	Publication Date
Yankee Doodle Boy	George M. Cohan	1904
Yoo-Hoo	B.G. De Sylva, Al Jolson	1921
You Ain't Heard Nothin' Yet	Al Jolson, Gus Kahn, B.G. De Sylva	1919
You Cannot Make Your Shimmy Shake on Tea	Irving Berlin	1919
You Can't Keep a Good Man Down	Perry Bradford	1920
You Know You Belong to Somebody Else So Why Don't You Leave Me Alone	Eugene West, Jimmy Monaco	1922
You Made Me Love You	Joseph McCarthy, Jimmy Monaco	1913
You Need Someone, Someone Needs You	Oscar Hammerstein II, Lewis E. Gensler	1922
You Remind Me of My Mother	George M. Cohan	1922
You Tell Me Your Dream	Charles N. Daniels, Jay Blackton, A.H. Brown, Seymour Rice	1908
You'd Be Surprised	Irving Berlin	1922
Young Man's Fancy	John Murray Anderson, Jack Yellin, Milton Ager	1920
Your Eyes Have Told Me So	Gus Kahn, Walter Blaufuss, Egbert Van Alstyne	1919
You're a Grand Old Flag	George M. Cohan	1906

Roman Numeral Conversions

Some copyright notices use Roman numerals for their publication dates—for example, © MCMLVII Paramount Pictures. This is particularly common for movies. If you need help to convert these dates into Arabic numbers (numbers containing the numerals 0-9 we commonly use today) you can use the information below. Or, if you have access to the Internet, you can log on to one of these two websites that contain Roman numeral conversion calculators: www.guernsey .net/~sgibbs/roman.html, or www.ivtech .com/roman. Simply enter the Roman numeral date where indicated and these websites will automatically convert it into Arabic numbers.

In the Roman system of numbering, capital letters represent numbers as follows:

I = 1
V = 5
X = 10
L = 50
C = 100
D = 500
M = 1,000

A letter placed after another of equal or greater value adds to its value—for example, II = 2, LX = 60, and MM = 2,000.

A letter placed before one of greater value subtracts from its value—for example, IV = 4, XL = 40, and CM = 900.

Utilizing these simple rules, you can decipher any Roman number date. For example:

> MCMXXII = 1922. The first M stands for 1000. The C before the second M means we subtract 100 from 1000 to get 900. The two XXs stand for 20 and the two IIs stand for 2. Thus the number consists of 1000 + 900 + 20 + 2 = 1922.

Here's a list of years in Roman numerals and Arabic numbers by decade for the 20th century:

MCM or MDCCCC = 1900
MCMX = 1910
MCMXX = 1920
MCMXXX = 1930
MCMXL = 1940

MCML = 1950

MCMLX = 1960

MCMLXX = 1970

MCMLXXX = 1980

MCMXC = 1990

MM = 2000

All dates for the 1800s will begin with the letters MDCCC.

Individual years added to these dates will take the following form:

I = 1

II = 2

III = 3

IV = 4

V = 5

VI = 6

VII = 7

VIII = 8

IX = 9.

■

Appendix C

Public Domain Documentation Worksheet

Public Domain Documentation Worksheet

Type of Work _____

Title _____

Source/Location _____

Author _____

Publisher _____

Identifying Numbers _____

Date of Publication _____

Country of Publication _____

How the Work Is Used _____

Reason Work Is in the Public Domain _____

Index

Remember:
Little publishers have big ears.
We really listen to you.

Take 2 Minutes & Give Us Your 2 cents

Your comments make a big difference in the development and revision of Nolo books and software. Please take a few minutes and register your Nolo product—and your comments—with us. Not only will your input make a difference, you'll receive special offers available only to registered owners of Nolo products on our newest books and software. Register now by:

PHONE
1-800-728-3555

FAX
1-800-645-0895

EMAIL
cs@nolo.com

or **MAIL** us
this registration card

fold here

Registration Card

NAME _____ DATE _____

ADDRESS _____

CITY _____ STATE _____ ZIP _____

PHONE _____ EMAIL _____

WHERE DID YOU HEAR ABOUT THIS PRODUCT? _____

WHERE DID YOU PURCHASE THIS PRODUCT? _____

DID YOU CONSULT A LAWYER? (PLEASE CIRCLE ONE) YES NO NOT APPLICABLE

DID YOU FIND THIS BOOK HELPFUL? (VERY) 5 4 3 2 1 (NOT AT ALL)

COMMENTS _____

WAS IT EASY TO USE? (VERY EASY) 5 4 3 2 1 (VERY DIFFICULT)

We occasionally make our mailing list available to carefully selected companies whose products may be of interest to you.

❑ If you do not wish to receive mailings from these companies, please check this box.

❑ You can quote me in future Nolo promotional materials.
Daytime phone number _____.

PUBL 3.0

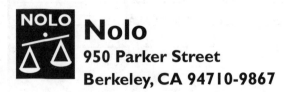